.

THE PHILOSOPHY OF
G. E. MOORE

THE LIBRARY OF LIVING PHILOSOPHERS

PAUL ARTHUR SCHILPP, FOUNDER AND EDITOR 1939–1981
LEWIS EDWIN HAHN, EDITOR 1981–

Paul Arthur Schilpp, Editor
THE PHILOSOPHY OF JOHN DEWEY (1939, 1971, 1989)
THE PHILOSOPHY OF GEORGE SANTAYANA (1940, 1951)
THE PHILOSOPHY OF ALFRED NORTH WHITEHEAD (1941, 1951)
THE PHILOSOPHY OF G. E. MOORE (1942, 1971)
THE PHILOSOPHY OF BERTRAND RUSSELL (1944, 1971)
THE PHILOSOPHY OF ERNST CASSIRER (1949)
ALBERT EINSTEIN: PHILOSOPHER-SCIENTIST (1949, 1970)
THE PHILOSOPHY OF SARVEPALLI RADHAKRISHNAN (1952)
THE PHILOSOPHY OF KARL JASPERS (1957; aug. ed., 1981)
THE PHILOSOPHY OF C. D. BROAD (1959)
THE PHILOSOPHY OF RUDOLF CARNAP (1963)
THE PHILOSOPHY OF C. I. LEWIS (1968)
THE PHILOSOPHY OF KARL POPPER (1974)
THE PHILOSOPHY OF BRAND BLANSHARD (1980)
THE PHILOSOPHY OF JEAN-PAUL SARTRE (1981)

Paul Arthur Schilpp and Maurice Friedman, Editors
THE PHILOSOPHY OF MARTIN BUBER (1967)

Paul Arthur Schilpp and Lewis Edwin Hahn, Editors
THE PHILOSOPHY OF GABRIEL MARCEL (1984)
THE PHILOSOPHY OF W. V. QUINE (1986)
THE PHILOSOPHY OF GEORG HENRIK von WRIGHT (1989)

Lewis Edwin Hahn, Editor
THE PHILOSOPHY OF CHARLES HARTSHORNE (1991)
THE PHILOSOPHY OF A. J. AYER (1992)

In Preparation:

Lewis Edwin Hahn, Editor
THE PHILOSOPHY OF PAUL RICOEUR
THE PHILOSOPHY OF HANS-GEORG GADAMER
THE PHILOSOPHY OF PAUL WEISS
THE PHILOSOPHY OF DONALD DAVIDSON
THE PHILOSOPHY OF RODERICK M. CHISHOLM
THE PHILOSOPHY OF SIR PETER F. STRAWSON
THE PHILOSOPHY OF THOMAS S. KUHN
THE PHILOSOPHY OF JÜRGEN HABERMAS
THE PHILOSOPHY OF SEYYED HOSSEIN NASR

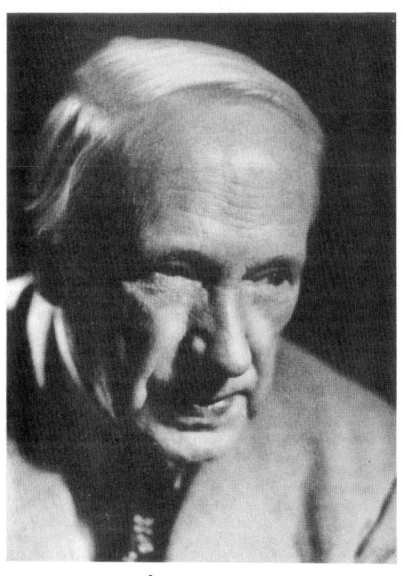

G. E. Moore

THE LIBRARY OF LIVING PHILOSOPHERS

VOLUME IV

THE
PHILOSOPHY
OF
G. E. MOORE

EDITED BY

PAUL ARTHUR SCHILPP

NORTHWESTERN UNIVERSITY &
SOUTHERN ILLINOIS UNIVERSITY

LA SALLE, ILLINOIS • OPEN COURT • ESTABLISHED 1887

Cover photograph courtesy of Timothy Moore, Cambridge.

 THE PHILOSOPHY OF G. E. MOORE

OPEN COURT and the above logo are registered in the U.S. Patent and Trademark Office.

THIRD EDITION

First printing 1968
Second printing 1992

Printed and bound in the United States of America.

The Philosophy of G. E. Moore

Library of Congress Catalog Card Number: 68-57206

ISBN 0-87548-136-1
ISBN 0-87548-285-5 (pbk.)

The Library of Living Philosophers is published under the sponsorship of Southern Illinois University at Carbondale.

GENERAL INTRODUCTION*
TO
"THE LIBRARY OF LIVING PHILOSOPHERS"

ACCORDING to the late F. C. S. Schiller, the greatest obstacle to fruitful discussion in philosophy is "the curious etiquette which apparently taboos the asking of questions about a philosopher's meaning while he is alive." The "interminable controversies which fill the histories of philosophy," he goes on to say, "could have been ended at once by asking the living philosophers a few searching questions."

The confident optimism of this last remark undoubtedly goes too far. Living thinkers have often been asked "a few searching questions," but their answers have not stopped "interminable controversies" about their real meaning. It is none the less true that there would be far greater clarity of understanding than is now often the case, if more such searching questions had been directed to great thinkers while they were still alive.

This, at any rate, is the basic thought behind the present undertaking. The volumes of *The Library of Living Philosophers* can in no sense take the place of the major writings of great and original thinkers. Students who would know the philosophies of such men as John Dewey, George Santayana, Alfred North Whitehead, Benedetto Croce, G. E. Moore, Bertrand Russell, Ernst Cassirer, Léon Brunschvicg, Martin Heidegger, *et al.*, will still need to read the writings of these men. There is no substitute for first-hand contact with the original thought of the philosopher himself. Least of all does this *Library* pretend to be such a substitute. The *Library* in fact will spare neither effort nor expense in offering to the student the best possible guide to the published writings of a given thinker. We shall attempt to

* This *General Introduction*, setting forth the underlying conception of this *Library*, is purposely reprinted in each volume (with only very minor changes).

meet this aim by providing at the end of each volume in our series a complete bibliography of the published work of the philosopher in question. Nor should one overlook the fact that the essays in each volume cannot but finally lead to this same goal. The interpretative and critical discussions of the various phases of a great thinker's work and, most of all, the reply of the thinker himself, are bound to lead the reader to the works of the philosopher himself.

At the same time, there is no blinking the fact that different experts find different ideas in the writings of the same philosopher. This is as true of the appreciative interpreter and grateful disciple as it is of the critical opponent. Nor can it be denied that such differences of reading and of interpretation on the part of other experts often leave the neophyte aghast before the whole maze of widely varying and even opposing interpretations. Who is right and whose interpretation shall he accept? When the doctors disagree among themselves, what is the poor student to do? If, finally, in desperation, he decides that all of the interpreters are probably wrong and that the only thing for him to do is to go back to the original writings of the philosopher himself and then make his own decision—uninfluenced (as if this were possible!) by the interpretation of any one else—the result is not that he has actually come to the meaning of the original philosopher himself, but rather that he has set up one more interpretation, which may differ to a greater or lesser degree from the interpretations already existing. It is clear that in this direction lies chaos, just the kind of chaos which Schiller has so graphically and inimitably described.[1]

It is strange that until now no way of escaping this difficulty has been seriously considered. It has not occurred to students of philosophy that one effective way of meeting the problem at least partially is to put these varying interpretations and critiques before the philosopher while he is still alive and to ask him to act at one and the same time as both defendant and judge. If the world's great living philosophers can be induced to coöperate in an enterprise whereby their own work can, at least to some ex-

[1] In his essay on "Must Philosophers Disagree?" in the volume by the same title (Macmillan, London, 1934), from which the above quotations were taken.

tent, be saved from becoming merely "desiccated lecture-fodder," which on the one hand "provides innocuous sustenance for ruminant professors," and, on the other hand, gives an opportunity to such ruminants and their understudies to "speculate safely, endlessly, and fruitlessly, about what a philosopher must have meant" (Schiller), they will have taken a long step toward making their intentions clearly comprehensible.

With this in mind *The Library of Living Philosophers* expects to publish at more or less regular intervals a volume on each of the greater among the world's living philosophers. In each case it will be the purpose of the editor of *The Library* to bring together in the volume the interpretations and criticisms of a wide range of that particular thinker's scholarly contemporaries, each of whom will be given a free hand to discuss the specific phase of the thinker's work which has been assigned to him. All contributed essays will finally be submitted to the philosopher with whose work and thought they are concerned, for his careful perusal and reply. And, although it would be expecting too much to imagine that the philosopher's reply will be able to stop all differences of interpretation and of critique, this should at least serve the purpose of stopping certain of the grosser and more general kinds of misinterpretations. If no further gain than this were to come from the present and projected volumes of this *Library*, it would seem to be fully justified.

In carrying out this principal purpose of the *Library*, the editor announces that (in so far as humanly possible) each volume will conform to the following pattern:

First, a series of expository and critical articles written by the leading exponents and opponents of the philosopher's thought;

Second, the reply to the critics and commentators by the philosopher himself;

Third, an intellectual autobiography of the thinker whenever this can be secured; in any case an authoritative and authorized biography; and

Fourth, a bibliography of the writings of the philosopher to

provide a ready instrument to give access to his writings and thought.

Future volumes in this series will appear in as rapid succession as is feasible in view of the scholarly nature of this *Library*. The editor hopes to publish at least one new volume each year. In its realization this hope is, of course, subject to the vicissitudes of war-conditions which may have to qualify the regularity of the publishing of these volumes.

It is a real pleasure, finally, to make grateful acknowledgment for the financial assistance which this project has already received. Without such help the work on this *Library* could never have been undertaken. The first four volumes have been (and are being) made possible in large part by funds granted by the Carnegie Corporation of New York. Additional financial assistance, for the first volume, came from the Alumni Foundation Fund of the College of Liberal Arts of Northwestern University, for the third volume from Mr. Lessing Rosenthal of Chicago, and for the third and fourth volumes also by small grants of the Social Science Research Council of Northwestern University. To these donors the editor desires to express his sincere gratitude and deep appreciation. Neither the Carnegie Corporation nor the other donors are, however, in any sense the authors, owners, publishers, or proprietors of this *Library* and they are therefore not to be understood as approving by virtue of their grants any of the statements made in this or in any preceding or succeeding volume.

PAUL ARTHUR SCHILPP
FOUNDER AND EDITOR, 1939–1981

TABLE OF CONTENTS

xi

PREFACE

THE publication of *The Philosophy of G. E. Moore,* constituting Volume Four in our *Library of Living Philosophers,* needs little editorial comment. Although the work of Professor G. E. Moore, Fellow and now Professor Emeritus of Philosophy at Trinity College, Cambridge University, is not perhaps as widely known in the United States as is that of Messrs. Dewey, Santayana, and Whitehead, his profound and lasting influence upon the technical philosophical thought of the English-speaking world and far beyond its boundaries is beyond question. Ever since the first appearance of his epoch-making article on "The Refutation of Idealism" in *Mind* in 1903 and of the publication of his *Principia Ethica* in the same year, Professor Moore has been the spearhead of the attack and one of the major leaders of the modern movement known as philosophical realism. His editorship of *Mind,* since 1920, has been one of the most distinguished in philosophical history. His work occupies a place of unique significance and of lasting value in contemporary philosophy. It is with great pleasure and with a sense of profound appreciation, therefore, that we present this volume to the philosophical reading public.

Although the present volume was contemplated and preparations on it had been in progress for some time before the autumn of 1940, one of the lucky—and we might add, almost wholly unexpected—breaks of fortune occurred that fall when, upon his retirement from Trinity College, Cambridge, Professor and Mrs. Moore arrived in the United States, where he has been occupying a series of visiting professorships in some of the foremost colleges and universities of America. This volume would have appeared in any case, even if Professor Moore had never set his foot on the soil of the Western hemisphere. But it can readily be seen how much more difficult and involved the task of getting the volume together would have been—in the midst of the

present international conflagration—if it had been necessary to carry on all the voluminous correspondence across the reaches of the Atlantic Ocean. In fact, even the securing of the five contributions from British philosophers, which will be found in these pages, turned out to be a by no means simple problem. On the other hand, it would have been inconceivable to publish such a volume as this on Moore's philosophical work without a fair representation, among the commentators and critics, of Professor Moore's philosophical colleagues in Great Britain. But it must be recorded that Professor Moore's personal presence in the United States during most of the time that this volume has been in preparation has greatly facilitated a task which, under present war-time conditions, might easily have become next to insuperable.

This task has also been greatly lightened and enriched by the tireless help and never failing patience of Professor Moore himself. He has given ceaselessly of his time, efforts, and interest and has been so willingly and helpfully coöperative throughout that the editor is moved publicly to express here his profound gratitude and deep appreciation. It is obvious, of course, that, without such help and coöperation, this volume could never have come into existence. If, however, the reader wants to convince himself of just how seriously Professor Moore has taken his obligation to reply to his critics, let him turn to Part III of this volume, where, in "A Reply to My Critics," he will find as painstaking efforts to clarify concepts, judgments, and ideas as he is ever likely to have seen in any philosophical discussion. Although, in next to the last paragraph of his "Reply," Professor Moore himself complains of being an "unsatisfactory answerer," a careful perusal of that "Reply" will convince anyone that the reason for such a complaint lies not in any lack of effort on Professor Moore's own part. No man could have tried harder or applied himself more seriously than did Professor Moore in his "Reply." The entire philosophical world will be deeply indebted to him. (This, however, is by no means the same as saying that everyone will be satisfied! The day when *all philosophers* will be satisfied by *one* philosopher's reply to his critics will probably never come. Perhaps philosophers "*must* disagree.")

It has, perhaps, become a work of supererogation to acknowl-
edge at this point the editor's great indebtedness to each of the
contributors to this volume. Be that as it may, an indebtedness
as great as this one dare not remain unexpressed. And this all the
less so when the editor recalls the fact that at least two of the con-
tributors wrote under the very severe difficulties and strain of per-
sonal illness, that two others wrote against an exceedingly heavy
pressure of time, that all of our British contributors wrote in the
midst of an increasing number of war-duties, that one of our
American contributors sent his manuscript just as he was leaving
for duty with the armed forces, and that all of the contributors
have undoubtedly taken their task seriously and have made a
sincere effort to interpret and come to terms with the philosophy
of G. E. Moore. The editor's sincere gratitude and appreciation
is also due and gladly expressed to Mr. Emerson Buchanan, of
the staff of Columbia University Libraries, who, with the kind
aid and coöperation of Professor Moore, undertook the compila-
tion of the Moore bibliography.

In conclusion the editor ventures to express the hope that the
Anglo-American coöperation, of which this volume is a construc-
tive example, may be a harbinger of such coöperation in the
creative tasks of building a different—because coöperative instead
of competitive—world in the days which every decent human
being prays are not too far off.

<div align="right">P. A. S.</div>

DEPARTMENT OF PHILOSOPHY
NORTHWESTERN UNIVERSITY
EVANSTON, ILLINOIS
November 15, 1942

PREFATORY NOTE TO THE SECOND EDITION

THE CONTENTS of the second edition of this volume differ from that of the first edition in two respects, viz., (1) Professor Moore's "Addendum" to his "Reply," which will be found on p. 677 (and which, as the careful reader will note, was written almost exactly ten years after the original "Reply"); and (2) the items which were added to the Bibliography—on p. 699—in order to bring the Bibliography completely up-to-date. The editor wishes to express his deep gratitude to Professor Moore for his kindness and willingness to write an addendum to his "Reply" "ten years after."

<div align="right">P. A. S.</div>

August 1952

ACKNOWLEDGMENTS

GRATEFUL ACKNOWLEDGMENT is hereby made to the publishers of all of Professor Moore's books as well as to the editors and publishers of philosophical and literary journals and magazines for their kind permission to quote from the works of Professor Moore as well as for their courtesy in not insisting upon a detailed enumeration of the books and articles quoted. Exact title, name of publisher, and place and date of publication of each of Professor Moore's works are given in the bibliography, which will be found on pages 689 to 699 of this volume.

Grateful acknowledgment is further made to the publishers of other works quoted in the following pages, who have also been kind enough not to require the specific enumeration of the works thus quoted.

PREFATORY NOTE TO THE THIRD EDITION

The third edition now extends the list of published writings of G. E. Moore to cover the last period of his life and his posthumous writings to date.

The editor wishes to express his appreciation to the new publishers of the Library—The Hegeler Foundation and the Open Court Publishing Company—for undertaking to keep all of the volumes of the Library permanently in print; to the Advisory Board of the Library, for their help in planning future volumes (the present membership of the Board is listed below); and to the National Endowment for the Humanities, Washington, D. C., for generous grants for the years 1967-1969.

<div align="right">Paul A. Schilpp</div>

Department of Philosophy
Southern Illinois University
Carbondale, Illinois

G. E. Moore

AN AUTOBIOGRAPHY

AN AUTOBIOGRAPHY

I. Home and School. 1873-1892

I WAS born in 1873 in a suburb of London called Upper
Norwood, situated in Surrey about eight miles from the
centre of London and nearly due south of it. When I was born,
I already had two elder sisters and two elder brothers; and,
after I was born, two more sisters and one more brother were
added to the family, so that I grew up as a member of a family
of eight, half of whom were boys and half girls. There were
enough of us to make plenty of company for one another.

My father and mother had moved from Hastings to Upper
Norwood about two years before I was born. One of their prin-
cipal reasons for making this move was, I have always under-
stood, that they wished to be able to send their sons as day-boys
to a large boys' school, called Dulwich College, which had been
established, about twelve years previously, by order of the
Charity Commissioners, out of funds provided by the immense
increase in the value of the estates of a much older foundation,
called by the same name. The founder of the original Dulwich
College was an actor called Edward Alleyn, who lived in the
reigns of Elizabeth and James I. The new Dulwich College,
when I attended it, was a school of much the same type and
much the same standing as the more famous St. Paul's School.
Both were principally attended by day-boys who were the
children of middle-class parents resident in London or its
suburbs: the proportion of boarders at Dulwich was, I should
say, never more than about ten per cent. My parents had heard
good reports of the new school under its first head-master, and
my three brothers and I all went there as day-boys in due course.
The College, which lay in the valley at the bottom of Sydenham
Hill, was only about one mile's walk from our house, which

3

was on the western slope of the hill. The upper part of that slope was (and, I believe, still is) largely covered with oak-woods, so that the neighbourhood was rather unusually attractive for a suburb so near London. Our house was on a fairly steep road; and starting up that road you could, in less than ten minutes' walk, reach the Crystal Palace, which then crowned the top of the hill. As we grew up, we all for several years had Season-tickets for the Palace; and it was a great privilege for us as children to be able to play in its immense grounds on the eastern slope of the hill. Our house itself was a typical middle-class suburban house of that period. I believe that my father and mother were its first occupants, the immediate neighbourhood having been only very recently developed. It was a detached house, built of red bricks, and standing in a garden of about half an acre, in which were at least three good-sized oak trees—relics of the oak-wood which till recently had covered the whole slope of the hill and which, I suppose, formed part of the wood from which Norwood took its name. In our road and neighbouring roads there were ever so many houses of a similar type.

My father had the degree of M.D., and had been in general practice for some years at Hastings; but after his move to London he soon gave up practice altogether. His father, who came originally from Plymouth, was also a medical man of some distinction; but, in addition to practising medicine, my grandfather was an author, having written several semi-psychological or semi-philosophical works, some of which went into more than one edition. The title of one was *The Power of the Soul over the Body;* that of another *The First Man and his Place in Creation.*

My mother came of a Quaker family, the Sturges, well known in Birmingham and Bristol and in various places in the region between those two towns. One of her paternal uncles, Joseph Sturge, was in his time a prominent philanthropist, and, among other things, toured parts of the United States, before the Civil War, in support of the abolition of slavery. More than one biography of him has been published. My mother's father and mother were both of them Sturges and

were first cousins; and I think I have heard that they were ejected from the Society of Friends, because the marriage of first cousins was disapproved. At all events my mother, at the time of her marriage to my father, was not a member of the Society. She and my father were both regular attendants at Baptist services; and for many years all of us used to walk regularly twice every Sunday to a small Baptist chapel in Upper Norwood, where the minister, the Rev. S. A. Tipple, was, I think, unusually unorthodox, broad-minded, gentle and refined.

My father gave to all of us the first rudiments of education, teaching us to read (from *Reading without Tears*), to write, and some elementary arithmetic, geography and English history. He also, as soon as we were three years old, began to teach us the piano; but those of us who showed no taste or talent for piano-playing were allowed to drop this after a time. As soon, however, as I was eight years old, I was sent, like my two elder brothers before me, to Dulwich College; and, so long as we lived at Upper Norwood, I used to walk (or partly run) the mile there and the mile back twice every week-day, except Wednesdays and Saturdays which were half-holidays. I stayed at the College for no less than ten years and two terms in all. I showed some aptitude for learning Greek and Latin, and had no particular preference for anything else; and so I stayed on what was called the Classical Side. I went up the school quickly so that my last six years were all spent in the two top forms on that Side—the last four in the Classical Sixth, which was the top form, and the two before in what was called the Classical Remove. During these six years almost all my time was spent on Greek and Latin, very few hours per week being given to French and German and to some mathematics; and during the last four of these years, of the time given to Greek and Latin a very large part was spent in translating pieces of English prose into Greek and Latin prose, and pieces of English verse into Greek and Latin verse. We had, in fact, to do four "compositions," as they were called, every week—one piece of Greek Prose and one piece of Latin Prose, one piece of Greek Verse and one piece of Latin Verse. I do

not, in fact, at all regret that so much of my time was spent in this way, although perhaps I ought to regret it. Possibly it would have been better for me if some of those hours had been spent upon some of the Natural Sciences, of which I learned absolutely nothing at school, and some of them on Mathematics, of which I learned very little and for which I showed very little aptitude. But I have no settled opinion as to whether much of the time spent in translating English into Greek and Latin could, in my case, have been better spent in other ways. I think I did get a good education, and I am not at all sure that I should have got a better one by a different distribution of my time. One definite benefit I think I can ascribe to my having had to translate so many pieces of English. I became very well acquainted with a large number of very excellent examples of English prose and verse writing; and I thus learned to appreciate some qualities in English prose and poetry, which I doubt if I should have appreciated so well, had I not been forced to pay so much attention to so many specimens which exhibited these qualities.

As regards my intellectual development while at school, I think I was probably extraordinarily lucky in that no less than four of the masters with whom I had most to do, were, each of them, though very different from one another, men of unusual originality and force of character, with wide intellectual interests.

The one among these four, with whom I came into contact earliest, was E. D. Rendall, the head of the musical department at the school. Rendall was an enthusiastic musician, a fertile composer, and a very energetic conductor of the school orchestra and school choir. I first came under his influence as a member of the school choir; but I came to know him better and to be more influenced by him, owing to the fact that he gave me some private lessons in singing solos and duets, while I was still a little boy with a treble voice. At this time he introduced me to some of the best of Schubert's songs. I admired him and looked up to him; and I have no doubt that occasional remarks and comments which he threw out, as well as his general spirit, did a great deal towards opening my mind. During my last

year at school I came to know him still better, since I then took private lessons from him in organ-playing and in the elements of harmony.

The next, in order of time, with whom I came in contact, was C. Bryans, a scholar of Eton and of King's College, Cambridge, who was master of the Classical Remove during the whole of the two years I spent in it. Bryans was as enthusiastic about classical studies as Rendall was about music. He made everything interesting that he talked about, and what he talked about included not only classical subjects; he was continually making *obiter dicta* upon all sorts of different topics. He was a humorist, and we liked his jokes; he had established the most friendly and human relations between himself and his class. But, besides all this, there were two special debts which I owe to him. He was a great admirer of German commentators on the Classics, and used to bring in to class his German editions of Thucydides and Livy, and discuss their notes to us; and he suddenly got the idea of teaching us German himself, although it was quite outside the ordinary curriculum. He set us to work at once on Goethe's *Faust* and Schiller's *Dreissigjähriger Krieg*. To him, therefore, I owe my start in learning German. I continued having lessons in it after I left his Form; and I thus got a grounding in German, which was very useful when later I wanted to read German philosophers in the original. The other debt I owe to him was due to the fact that he was concerned about my English style. Upon some essay which I had to write for him he wrote the comment "child-like and bland;" and, in order to help me to be less child-like, he lent me, to read in the holidays, Saintsbury's book of selections from English prose-writers—a book which, whether it helped or not to improve my style of writing, certainly opened my eyes to a good many things to which they had been closed before. That my style of writing was still greatly in need of improvement several years later seems to be shown by the fact that, when I went up to Cambridge, the classical scholar, A. W. Verrall, who was my tutor, was also concerned about it. The remedy which he recommended was that I should read Macaulay's speeches. I obediently took that remedy also, but

whether with any effect upon my style, I have not the least idea.

With the other two masters at Dulwich, whom I take to have had a great influence on my intellectual development, I came into close contact simultaneously, namely when I was moved into the Sixth Form just before I was fifteen years old. One of these was the Classical Sixth master, W. T. Lendrum (who later changed his name to "Vesey"), and the other was the Headmaster, A. H. Gilkes.

Lendrum was a first-rate classical scholar, both learned and accurate, and having, in addition, a very genuine literary taste. It must have been a rare thing for so fine a scholar to be teaching in a school (Lendrum used, with a smile, to refer to his position at Dulwich as that of a mere "usher"), and at the end of 1890 he was in fact elected to a Fellowship at Caius College, Cambridge—a position of a dignity more suitable to the fineness of his scholarship. He was an Irishman, though an Ulster Irishmen from Antrim, and there was a pleasant Irish tang in his way of speaking. He was fastidious, and quick-tempered, and had very violent dislikes; and he could make himself very unpleasant to people whom he despised or disliked. Now and then he made himself unpleasant to one of us, when he thought we needed taking down a peg or two; but, in spite of these rare outbursts, we all loved him, and very deservedly. His occasional remarks on English writers impressed me more than anything of the kind I had so far heard: they were the remarks of a man who felt strongly, and who had completely assimilated a very fine cultural tradition. And I was also, no doubt, impressed by the pains he took to be accurate—to get everything *exactly* right. To mention a less important matter, it was undoubtedly mainly due to the very thorough training he gave me for a period of more than two years, that I was able subsequently to win, first, a Major Scholarship at Trinity, then to obtain the highest honours then possible in the First Part of the Classical Tripos, and finally to win the Craven University Scholarship.

But remarkable as Lendrum was, I think there is no doubt that by far the most remarkable man of the four was the Headmaster, A. H. Gilkes. Whereas the other three were Cambridge

men, Gilkes was from Oxford: he had been a Junior Student of Christ Church. He had also been a pupil, and subsequently an under-master, at Shrewsbury School, and was proud of the wonderful succession of classical scholars which that school produced for many years in the nineteenth century. Merely as a scholar, however, he himself was not to be compared to Lendrum. I remember feeling at the time a great contempt for some rules about Greek conditional sentences, which I thought he was far too fond of repeating to us, and which to me, trained by Lendrum on the basis of Goodwin's *Greek Moods and Tenses,* seemed to be hopelessly antiquated and inaccurate and unequal to the subtlety of the facts. Gilkes' eminence lay in other directions. He was a great admirer of Socrates, as depicted by Plato; and some of us thought (I think with some justice) that he himself had some, by no means negligible, resemblances to Socrates. To begin with, I think he produced the impression of being, in a pre-eminent degree, a *good* man—both good *and* benevolent; although, as regards the latter quality, he was capable of extreme severity when he met with any action, which he thought to be thoroughly vicious or base: I have seen him angry, and am very glad that I, personally, never excited his anger. But, as was, I think, also the case with Socrates, his goodness was rendered more attractive by its combination with a delicious and a subtle sense of humour: he was always ready, when occasion offered, to make quiet fun of us (or of other things) with a charming delicacy. And even in purely intellectual qualities he had, I think, some resemblance, though farther off, to Socrates. He used to take the whole Sixth Form once a week for a lesson, which was, I think, called "Divinity," but in which, in fact, he talked about an astounding variety of different subjects. We had to write an essay for him every week on the subject on which he had talked; and he thus put before us an enormous number of different questions, on every one of which he had something interesting and enlightening to say. He had, I think, in a wide sense, a very philosophic mind, though I do not remember to have ever seen any sign that he was interested in the sort of technical philosophical questions, with which I have been chiefly occupied and worried for the greater part of my life.

However that may be, I was in close contact with him for no less than four years, from just before I was fifteen to just before I was nineteen; and I think his influence on me (as it certainly was on others) must have been, in one way or another, enormous.

I have singled out these four masters, because I think they had much the most to do with my intellectual development; but there were, of course, other masters at Dulwich, whom I remember with gratitude. There were besides clever boys, both in the Remove and in the Sixth, whose conversation and outlook certainly made a difference to me. But I never became very intimate with any of these. I was indeed rather lonely at school; but this never made me, to any serious degree, unhappy or discontented: I was always on very good terms with the vast majority of my class-mates. Nor was I at all inclined to criticise or condemn the masters. Certainly I liked some better than others; but I think that I actively disliked none at all, and was always inclined to think that each was doing the best possible under the circumstances. I remember that, very early, this attitude of mine seemed to surprise some of the boys, who had violent antipathies to some of the masters and thought very ill of them. I, on my side, was equally surprised that they could see any reason to take up such an attitude. On the whole, I enjoyed my life at school, and was very well satisfied with it; and I left Dulwich with a strong affection both for the school as a whole, and for very many people in it.

One incident, which occured during my school life, ought, I think, to be recorded. When I was eleven or twelve years old, I was led to adopt the religious views of a group of young men who conducted what was called a "Children's Special Service Mission" on the beach at a sea-side place where my family had gone for the summer holidays. These views were of a type which I think can be called "ultra-evangelical," and which can perhaps be better described as very similar to the type characteristic of the Salvation Army. They were views in which much stress was laid "on the love of Jesus"—both the love which we ought to feel towards him, and the love which he feels towards us. And it seemed to me (and I still think this reasoning correct) that if

all that was said in the New Testament was true, and if Jesus was really the Son of God and was still alive, (things which, at that time, I did not think of questioning), then we ought far more often to be thinking of him, and ought to love him far more intensely, then most people who professed to be Christians (including my own parents) seemed to me to do. Accordingly I tried to think very constantly of Jesus, and to feel a great love for him, and also to follow a rule of conduct which the young men who converted me had recommended—namely, in all cases of doubt as to what I ought to do, to ask the question "What would Jesus do?" But this was not all. It seemed to me also to follow that it was my duty to try to persuade other people to do the same—in short, to try to convert other people, as these young men had converted me. And my conviction that this was my duty led to one of the most painful continued mental conflicts I have ever experienced. I did make efforts to do what I conceived to be my duty in this respect, but I had to fight against a very strong feeling of reluctance. There seemed to be something utterly inappropriate and out of place in trying to persuade my school-fellows, for instance, to love Jesus. I did drive myself to distribute tracts along the promenade at the sea-side (and this was not the hardest thing I actually drove myself to do), though I positively hated doing it, all the more because there happened to be at the same place the family of two other boys from Dulwich, whom I greatly admired, and I was desperately unwilling that they should see me distributing tracts. But I constantly felt that I was not doing nearly as much as I ought to do. I discovered that I was very deficient in moral courage.

This intense religious phase, with its conflict, cannot, I think, have lasted more than about two years, though I still continued for several more years to read daily by myself passages from the Bible, in addition to what my father read with us at family prayers every morning before breakfast. But my religious beliefs gradually fell away, and so quickly that, long before I left school, I was, to use a word then popular, a complete Agnostic. How in detail this change was brought about, I do not remember. But I think it must have been largely due to the influence

of a fifth person, whom I have not yet mentioned, but who, I think, had probably as much to do with the course of my mental development as the four Dulwich masters I have named. This fifth person was my eldest brother, Thomas Sturge Moore, who has since become known as a poet, as a critic, and for his wood-cuts. My brother, who was at that time an art-student, was more than three years older than I was, and was consequently much more intellectually mature during the latter part of my period at school. Moreover he was (and is) a far readier talker than I, and far more fertile of ideas. I think there is no doubt that his conversation, including discussions which he sometimes had with my father at meal-times, had a great deal of influence on the formation of my opinions.

II. First Twelve Years at Cambridge. 1892-1904

(a) Four undergraduate years: 1892-1896

I went up to Trinity College, Cambridge, in October 1892; and for the first two years of my residence there was working for Part I of the Classical Tripos. In this line, in spite of the brilliance of some of my teachers—especially A. W. Verrall—, I do not think that I learned anything startlingly new. I had been so well taught by Lendrum, at Dulwich, that my work during these two years at Cambridge consisted almost exclusively in merely learning more of the same kind of things which he had already taught me.

It was in quite other directions that these first two years at Cambridge made a great difference to me. Towards the end of my first year I began to make the acquaintance of a set of young students—most of them a year or two my seniors, both in ages and academic standing—whose conversation semed to me to be of a brilliance such as I had never hitherto met with or even imagined. They discussed politics, literature, philosophy and other things with what seemed to me astounding cleverness, but also with very great seriousness. I was full of excitement and admiration. My own part in these discussions was generally merely to listen in silence to what the others said. I felt (and was) extremely crude compared to them; and did not feel able to make any contributions to the discussion which would bear

comparison with those which they were making. I felt greatly flattered, and rather surprised, that they seemed to think me worthy of associating with them. I have said that at Dulwich I never became really intimate with any of the clever boys I met there. At Cambridge, for the first time, I did form intimate friendships with extremely clever people; and, of course, this made an enormous difference to me. Until I went to Cambridge, I had had no idea how exciting life could be.

Among the young students with whom I began to make acquaintance at the end of my first year was Bertrand Russell; and it was mainly owing to his advice and encouragement that I began to study philosophy. Russell was two years my senior in academic standing; and hence, when I was in my second year (and it was only in that year that I began to know him at all well), he was already in his fourth year and completing his academic course by working for Part II of the Moral Sciences Tripos: he left Cambridge at the end of that year. In the course of it he must have formed the opinion, from hearing me argue with himself or with friends of ours, that I had some aptitude for philosophy: at all events at the end of the year he urged me strongly to do what he had done and to take Part II of the Moral Sciences Tripos for my Second Part; and if he had not urged me, I doubt if I should have done so. Until that year I had in fact hardly known that there was such a subject as philosophy. I came up to Cambridge expecting to do nothing but Classics there, and expecting also that afterwards, all my life long, my work would consist in teaching Classics to the Sixth Form of some Public School—a prospect to which I looked forward with pleasure. I had indeed at Dulwich read Plato's *Protagoras* under Gilkes; but I certainly was not then very keenly excited by any of the philosophical questions which that dialogue raises, and I do not think I had read any other philosophy at all. What must have happened, during this second year in Cambridge, was that I found I was very keenly interested in certain philosophical statements which I heard made in conversation. One such occasion I can remember. Russell had invited me to tea in his rooms to meet McTaggart; and McTaggart, in the course of conversation had been led to express

his well-known view that Time is unreal. This must have seemed to me then (as it still does) a perfectly monstrous proposition, and I did my best to argue against it. I don't suppose I argued at all well; but I think I was persistent and found quite a lot of different things to say in answer to McTaggart. It must have been owing to what I said on such occasions as this that Russell came to think I had some aptitude for philosophy. And I think this example is also typical of what (if I am not mistaken) has always been, with me, the main stimulus to philosophise. I do not think that the world or the sciences would ever have suggested to me any philosophical problems. What has suggested philosophical problems to me is things which other philosophers have said about the world or the sciences. In many problems suggested in this way I have been (and still am) very keenly interested—the problems in question being mainly of two sorts, namely, first, the problem of trying to get really clear as to what on earth a given philosopher *meant* by something which he said, and, secondly, the problem of discovering what really satisfactory reasons there are for supposing that what he meant was true, or, alternatively, was false. I think I have been trying to solve problems of this sort all my life, and I certainly have not been nearly so successful in solving them as I should have liked to be.

I have here mentioned one debt which I owe to Russell, and, since I have mentioned his name, I think I had better now (although it will interrupt my narrative) try to give as complete an account as I can of all that I owe to him. His name has often been publicly coupled with mine and, since I came to the United States in 1940, I have found that some misapprehension exists as to the relations between us. For one thing, I discovered that some people supposed that I was the elder of the two. That, of course, is, in itself, a mistake of no importance whatever; but I think it was probably due to another mistake, which is perhaps of some importance, though not much. I have heard it publicly stated (and I think I have also seen the same in print) that Russell was a pupil of mine! Nothing could be further from the truth. It would be far nearer the truth to say that I was a pupil of his, since I really have attended no less than three complete

courses of lectures given by him, whereas he has never done more than attend one single lecture given by me. I imagine that this mistake must have been due to a passage in Russell's Preface to his *Principles of Mathematics* in which he acknowledges some indebtedness to me; but, of course, what Russell there says, though it may have been the origin of the mistake, gives no sort of excuse for it. The main facts about the connection between his work and mine are, I think, as follows. I have said that Russell left Cambridge in June 1894, at the end of my second year. But, though he had left Cambridge, I used, for some six or eight years after that date, to see him frequently and discuss philosophical questions with him. These discussions took place either when I visited him at his house in the country or when he visited Cambridge. For several years in succession he and his wife took a house in Cambridge for the whole of the Lent term, and I had much discussion with him during these visits. In these discussions there was, of course, mutual influence. It is to ideas which he thought he owed to me as a result of them that Russell was referring in the Preface to his *Principles;* and we both of us subsequently discovered that these ideas were largely mistaken. I do not know that Russell has ever owed to me anything except mistakes; whereas I have owed to his published works ideas which were certainly not mistakes and which I think very important. After about 1901 we met but rarely for a period of about ten years, until, from 1911 to 1915, we were both of us lecturing in Cambridge, and both had rooms in Trinity; and I then attended his lectures on the Foundations of Mathematics. I certainly owe much to all this personal contact with Russell; but I think I owe even more to his published works. I have certainly spent more time in studying what he has written than in studying the works of any other single philosopher. I reviewed for *Mind* his first philosophical book, the *Essay on the Foundations of Geometry,* which was developed out of the dissertation by which he won a Fellowship at Trinity. I read the proofs of his *Philosophy of Leibniz.* Later I worked very hard indeed for a very long time in trying to understand his *Principles of Mathematics;* and I actually wrote a very long review of this work, which was however never published. As for his

Introduction to *Principia Mathematica,* his *Problems of Philosophy,* his Lowell Lectures, a series of articles which he published in the *Monist,* beginning with four entitled "Logical Atomism," his *Introduction to the Philosophy of Mathematics,* and his *Analysis of Mind* (which last I reviewed in the *Times Literary Supplement*), I have, in the case of all these six works, lectured in detail on particular passages in them on various occasions during my lectures at Cambridge. Of course, I have not agreed and do not agree with nearly everything in his philosophy; and my lectures on what he has written have always been partly critical. But I should say that I certainly have been more influenced by him than by any other single philosopher. Perhaps I should have owed to him even more than I do if I had taken another piece of advice which he gave me. About 1900 or a little later he urged me strongly to take private lessons from Whitehead in Mathematics, particularly in the Differential Calculus. This advice I did not take, not, I am afraid, for any well-considered reasons, but mainly from mere inertia and doubt whether it would do me any good. I still have no settled opinion as to whether, if I had taken it, it would have made any great difference to me.

To return from this digression, I took Russell's advice in 1894, and decided to study for Part II of the Moral Sciences Tripos, but decided also to study simultaneously for the Greek Philosophy Section of Part II of the Classical Tripos, taking two years for the combined courses. And here again I think I was very lucky in the men I had to teach me. For the Moral Science Tripos I attended the lectures of Henry Sidgwick, James Ward, G. F. Stout, and J. E. McTaggart; and for the Classical Tripos those of Henry Jackson.

Of these five men, I think I gained least from personal contact with Sidgwick. His personality did not attract me, and I found his lectures rather dull. From his published works, especially, of course, his *Methods of Ethics,* I have gained a good deal, and his clarity and his belief in Common Sense were very sympathetic to me. But his lectures were, I think, too formal to be very interesting: he simply read out to us, not in a very stimulating manner, things that he had written in a finished

form, fit for publication as they stood. I think I could have gained more by reading them to myself than by hearing him read them. And moreover their subject-matter was not very interesting to me: they were what was subsequently published as *Lectures on the Ethics of Green, Spencer and Martineau*. Perhaps I should, as in Russell's case, have owed more to Sidgwick than I did, if I had taken a piece of advice which he gave me. In 1898, just after I had got my fellowship, he advised me to spend a year or two at some German university. This advice also I did not take: I had reasons for wishing, at the time, to continue to reside in Cambridge, and I still feel very doubtful whether I should have got as much benefit by studying in Germany as I did by staying at home.

From personal contact with Ward, on the other hand, I think I gained a very great deal. Ward was not at that time a Professor: the Professorship which he subsequently held, and in which I succeeded him, had not yet been founded. He was at that time Lecturer in Moral Science at Trinity, and as such was responsible for advising me as to what books I should read and what lectures I should attend so far as the Moral Sciences Tripos was concerned. He actually took no end of trouble for me. He had a high opinion of Lotze, whose lectures he had attended in Germany; and he set me to read pieces of Lotze's *Metaphysics* and to write essays on those pieces, which essays he then discussed privately with me. His lectures, which were attended by three or four of us, were also very stimulating. They were on what in Cambridge is officially called "Metaphysics" or "Metaphysical Philosophy"—a subject which includes the whole of philosophy except Moral Philosophy. We sat round a table in his rooms at Trinity, and Ward had a large notebook open on the table before him. But he did not read his lectures; he talked; and, while he talked, he was obviously thinking hard about the subject he was talking of and searching for the best way of putting what he wanted to convey. Later on, and very soon too, I became very critical of a great deal in his philosophy: I thought, and still think, that his thinking was apt to be often very confused. But this does not prevent me from thinking that I owe a great deal to him. And I do think, also, that he was the

very finest kind of man: I think I look back on him with warmer feelings of admiration than on any other of my teachers. I think this is partly because of his extreme sincerity and conscientiousness, but partly also because of his melancholy. He was a man who found things very difficult. I remember his once quoting to me, as expressive of his own feelings, *"Das Denken ist schwer."*

To Stout also I think I owe a great deal. The lectures of his which I attended were on the History of Modern Philosophy, from Descartes to Schopenhauer and beyond; and here again we sat round a table in his rooms at St. John's, and Stout simply talked to us. I did not know enough about the philosophers of whom he was talking to appreciate properly nearly everything that he said; but he was always interesting and exciting. It seems to me that Stout has a quite exceptional gift for seizing on some particular point of importance, involved in a confused philosophical controversy, and putting that point in the simplest and most conversational language: he is peculiarly direct, and utterly free from anything approaching pretentiousness or pomposity. I have since, from time to time, had a good deal of discussion with him; and discussion with him is always profitable. I feel very grateful for having known him.

But of the four men, whose lectures I attended for the Moral Sciences Tripos, I think I was undoubtedly most influenced by the youngest, McTaggart. This may have been partly due to the fact that I saw a good deal more of him outside the lecture-room, and partly also, perhaps, to the fact that he was nearer to me in age. He produced the impression of being immensely clever and immensely quick in argument; but I think that what influenced me most was his constant insistence on clearness—on trying to give a precise meaning to philosophical expressions, on asking the question "What does this mean?" That he himself, in his own philosophical works, did not by any means always succeed in being perfectly clear, has, I think, been conclusively shown by Broad, in his *Examination of McTaggart's Philosophy;* but how clear he was, as compared to the majority of philosophers! and what immense pains he took to get clear, even though he did not always succeed! McTaggart used often

to use the word "woolly" as a name for a characteristic of some philosophers to which he particularly objected. "Woolliness" was, of course, incompatible with the kind of clarity at which he aimed; and one of his objects in aiming at clarity was to avoid "woolliness." But a philosopher might, of course, be obscure without being "woolly." Hegel, for instance, I do not think Mc-Taggart would have accused of being "woolly," though he would certainly not have denied that he was very obscure. It was to the philosophy of Hegel that the lectures of McTaggart's which I attended at this time were devoted, since this was the "special subject" in the History of Modern Philosophy appointed for the Tripos of 1894. These lectures, again, took place in McTaggart's own rooms at Trinity; but, instead of sitting down at the same table with us, as Ward and Stout did, Mc-Taggart preferred to stand up and walk about while he was lecturing. He, however, like them, did not simply read his lectures, though I think perhaps he followed his notes more closely. I think it can fairly be said that what McTaggart was mainly engaged with was trying to find a precise meaning for Hegel's obscure utterances; and he did succeed in finding many things precise enough to be discussed: his own lectures were eminently clear. But I think most Hegelian scholars would agree that many of the comparatively clear doctrines which he attributed to Hegel were very unlike anything which Hegel could possibly have meant—certainly Hegel never meant anything so precise. After these two years in which I was obliged to read some Hegel, I never thought it worth while to read him again; but McTaggart's own published works I have thought it well worth while to study carefully, and have both written and lectured on particular points in them.

Henry Jackson, who gave me by far the greater part of the teaching which I got in Greek philosophy for Part II of the Classical Tripos, was a man of a very marked and forcible personality. He was a man to whom all sorts of people applied for advice on all sorts of different subjects; and I myself owe him deep gratitude for advice which he gave me, at no small trouble to himself, on at least one occasion. Very many people, including, to my knowledge, both Ward and McTaggart, looked up to

him and valued his opinion at least as much as I did. But, so far as philosophy is concerned, I owe, I think, scarcely anything to his own personal philosophical opinions. What I do owe to his lectures (and this seems to me a very important debt) is the acquaintance I made, under his guidance, with some of the chief works of Plato and Aristotle. He was a very good lecturer, informal and clear. I have just said that, after reading parts of Hegel's works for my Tripos, I never thought it worth while to read any part of his works again. But with regard to Plato and Aristotle my feeling and practice have been different. I have, at intervals, spent a considerable amount of time in reading various parts of their works and trying to learn from them.

In speaking of these two years from 1894 to 1896, I ought perhaps to mention that, in the middle of them, that is to say, in the summer vacation of 1895, I went, by Ward's advice and with an introduction from him, to spend about five weeks at the University of Tübingen. I there attended a course of lectures on Kant by Sigwart, and also (at seven o'clock in the morning) a few lectures by a Professor Crusius on Plato. This visit advanced my knowledge of German very considerably, but, so far as philosophy was concerned, it had, I think, no effect on me at all. I did not really understand German well enough (nor perhaps Kant either) to be able to profit from Sigwart's lectures.

(b) Two years working for a Fellowship: 1896-1898

I did well enough in the Moral Sciences Tripos to make my advisers think it worth while that I should compete in Philosophy in the annual Fellowship examination at Trinity. In order to compete, it was necessary to submit a dissertation; and, after consulting Ward, I decided to try to write one on Kant's Ethics. Accordingly for the next two years, 1896-1898, I was engaged in trying to do this; and, of course, a great deal of my time was spent in puzzling over Kant's three *Critiques*, his *Prolegomena*, and his *Grundlegung zur Metaphysik der Sitten.*

During the first of these two years the part of Kant's ethical doctrines with which I was chiefly concerned was some of the things he said about freedom. He seemed to me to say or imply that each of us had two "selves" or "Egos," one of which he

called a "noümenal" self, the other an "empirical" self, and he
seemed also to say or imply that the "noümenal" self was free,
whereas the "empirical" self was not; and what I wrote during
this first year can, I think, be described as, in the main, an at-
tempt to make sense of these extremely mysterious assertions.
I found something which seemed to me at the time to give them
an intelligible meaning, but I have no doubt that the meaning I
found was as far as or further from anything which Kant actually
meant, as was McTaggart's interpretation of Hegel's "Absolute
Idea" from anything which Hegel meant. The substance of
what I wrote on this topic was published shortly afterwards as
an article in *Mind*, entitled "Freedom;" and, though I have not
looked at that article for a long time, I have no doubt that it was
absolutely worthless. I expect that Sidgwick, who was the repre-
sentative of Philosophy among the Fellowship Electors in that
year (1897), must have felt about my dissertation much the
same as he is said to have felt about the dissertation on Hegel
by which McTaggart won his fellowship a few years earlier.
Sidgwick is reported to have said about McTaggart's disserta-
tion (and I believe this is authentic): "I can see that this is
nonsense, but what I want to know is whether it is the right kind
of nonsense." I think he must have decided about my nonsense,
as he had decided about McTaggart's, that it was the right kind;
for, though I was not elected that year, Ward told me that in
the next year (1898), when he had taken Sidgwick's place on
the Board of Electors, Sidgwick spoke to him just before the
final meeting of the Electors and warned him that he must be
careful not to ruin my chances of election by failing to speak
sufficiently favourably of my work.

In my second year's work (1897-98) I got on to what I think
was a much more profitable line of inquiry, though one which
had a much less direct connection with Kant's Ethics—had, in-
deed, a more direct connection with the *Critique of* Pure *Reason*
than with the *Critique of* Practical *Reason*. It seemed to me that
it was extremely difficult to see clearly what Kant meant by
"Reason." This was a term which occurred not only in the title
of both these works, but also frequently in the text, and, as it
seemed to me, in a very mystifying manner. What on earth did

Kant mean by it? He must be referring, more or less directly, to something which was to be found in the world, and which could be described in other terms. But to what exactly? This was what I set myself to think about; and it led me to think first about the notion of "truth," since it seemed to me that, in some of its uses at all events, Kant's term "Reason" involved a reference to the notion of "truth;" and, in thinking about truth, I was led to take as my text a passage from the beginning of Bradley's *Logic*, in which after saying that "Truth and falsehood depend on the relation of our ideas to reality," he goes on to say that the "meaning" of an idea consists in a part of its content "cut off, fixed by the mind, and considered apart from the existence" of the idea in question. It seemed to me, if I remember right, that the meaning of an idea was not anything "cut off" from it, but something wholly independent of mind. I tried to argue for this position, and this was the beginning, I think, of certain tendencies in me which have led some people to call me a "Realist," and was also the beginning of a breakaway from belief in Bradley's philosophy, of which, up till about then, both Russell and I had, following McTaggart, been enthusiastic admirers. I remember McTaggart once saying of an occasion when he met Bradley at Oxford that, when Bradley came in, he felt "as if a Platonic Idea had walked into the room."

I added what I had written this year about "reason" and "ideas" as a concluding chapter to what I had written the year before. and submitted the whole at the Fellowship Examination in 1898. This time I was elected. The substance of the new chapter was published soon afterwards in *Mind* under the title of "The Nature of Judgement;" and though I am sure that article must have been full of confusions, I think there was probably some good in it.

Ward, although he had secured my election to a Fellowship, was not very happy about me. When I went to see him after the election, he told me he thought I was too sceptical, and that I seemed to take a pride and pleasure in picking holes in accepted views: this he did not like, and he compared me in that respect to Hume.

(c) Six Years as a Fellow of Trinity: 1898-1904

The kind of Fellowship to which I had been elected, then generally called a "Prize" Fellowship, was at that time given unconditionally for six years. Every such Fellow was entitled to a dividend each year—a dividend which at that time was in the neighbourhood of £200. Residence was not required, nor was any sort of work; and it was not unusual for a newly elected Fellow to go to London to study for the bar, for instance, and to use his dividend to help tide him over the long period before he could expect to be able to earn his living as a barrister. If, however, a Fellow did choose to reside in College he was entitled, in addition to his dividend, to a set of Fellows' rooms in College and his dinner in Hall, free of charge. For my part I wished to reside in College and to work at philosophy; and accordingly for the next six years I was living in a set of Fellows' rooms on the north side of Nevile's Court—a very pleasant place and a very pleasant life.

The first piece of philosophical work which I undertook during this period was to write some articles for Baldwin's *Dictionary of Philosophy*. I took very great pains over these articles, aiming particularly at analysing out the fundamental notions involved in the use of the terms I was asked to define, and trying hard to make the meaning of everything I said perfectly clear. I certainly learned a good deal myself in this process, and I think my efforts after clear analysis gave the articles a sort of merit which might enable other people to learn something from them. But nevertheless the articles were extraordinarily crude, and were very far from giving a really adequate account of the use of the terms in question. I am rather surprised that the editors accepted them without making more effort to get me to correct them.

A little later I had my first experience of lecturing. I was asked to give two courses of lectures at the Passmore Edwards Settlement in London. Each course was of ten lectures—one every week; and the first course was on Kant's Ethics, and the second on Ethics simply. On these occasions I wrote out each lecture complete, and merely read what I had written; and after each lecture there was some opportunity for questions and

discussion from my audience, which was never a large one.

It was in writing the course on Ethics that I developed the main outline of *Principia Ethica;* but *Principia* was almost entirely a new, and was a much longer, work, and the latter part of those six years was mainly occupied in writing it. I found this an extremely troublesome business. I write very slowly and with great difficulty; and I constantly found that I had to re-write what I had written, because there was something wrong with it. Of course, even after all this alteration, there still remained an immense deal that was wrong with it; but I did not see that clearly at the time, though I constantly felt vaguely dissatisfied.

It must have been about 1898 that I was asked to become a member of the Aristotelian Society of London; and during these six years I went very often to London to attend their weekly meetings. It is to my membership of this society that the existence of what, I suppose, constitutes considerably the greater part of my published work is due. I was constantly being asked to write a paper or to take part in a "Symposium" for them; and, until very recent years, I did not like to refuse and thought I had no good excuse for refusing: I have always found it very difficult to say "No" to a request. Having promised to write a paper, I had to write one; and, but for this stimulus, I doubt if I should have published half as much as I have published.

Besides these three pieces of work—the *Dictionary* articles, the lectures, and *Principia*—I wrote several papers or articles and several reviews during those six years; and I also, for most of the time, was acting, under J. S. Mackenzie, as review-sub-editor for English books in the *International Journal of Ethics.* Taking everything together, I think I did a respectable amount of work during my tenure of this Fellowship. *Respectable,* I think; but, I am afraid, not more than respectable. I cannot claim that during this period I worked *very* hard, nor perhaps as hard as I ought. Indeed I do not think that for any considerable period of my life I have ever worked *very* hard, except perhaps for four or five years while I was at school. The fact is that, by disposition, I am very lazy; and there is almost always something which I would much rather be doing than working: more often than not, *what* I would much rather be

doing is reading some novel or some history or biography—some *story*, in fact; for stories, whether purporting to be true or avowedly mere fiction, have a tremendous fascination for me. The consequence is that I have always been having constantly to struggle to force myself to work, and constantly suffering from a more or less bad conscience for not succeeding better. This state of things seems to me so natural, that I find it difficult to believe that it is not the same with everyone; and if it were the same with everyone, it would not be worth mentioning—it would go without saying. But I have met with facts which seem to me to suggest that, unintelligible though it may seem, there are some people who don't need to struggle so hard to make themselves work as I do, and are not so constantly or strongly tempted to do something else. Perhaps such people form only a small minority; but, if there are any of them at all, it is perhaps worth mentioning that I have never, since I grew up, been one of them. Certainly during these six years I spent a very great deal of time in reading novels and in talking to friends. But a good deal of the time spent in the latter way was by no means without profit for my philosophical work. I have already mentioned that during part of these years I had a good deal of discussion with Russell; and I also learned a good deal from discussion with other friends. To mention one particular instance, the whole plan of the last chapter of *Principia* was first formed in a conversation with a friend.

III. Seven Years Away from Cambridge. 1904-1911

My Fellowship elapsed at the end of September 1904. I had applied for its continuation in the form of a Research Fellowship; but election to a Research Fellowship was, and still is, a very rare and exceptional thing at Trinity, and I was not surprised that my application was refused. Nor was I, I think, at all sorry; I think I was glad to have the prospect of a change from Cambridge life. My mother and my father had both very recently died; and, owing to the facts that two of my mother's maternal uncles, both of them childless, had been rich men, and that my mother, being the only child of her mother and having been left an orphan very early, had been almost in the place of a daughter to them, I and my brothers and sisters had now suf-

ficient private means to enable us to live in moderate comfort without needing to earn anything. I was therefore in a position to go on working at philosophy, which was what I wanted to do, without a Fellowship and without needing to try to obtain any paid employment. The only question was where I should live. Having ceased to be a Fellow, and having no official post in the University, I should not be able any longer to live in College; and I did not like the idea of living at Cambridge in lodgings after having spent so many years in College. But a close friend of mine had been recently appointed to a post on the teaching staff of Edinburgh University; I was anxious to be near him, and also Edinburgh had a romantic attraction for me, chiefly owing to its association with Scott and his novels, which I loved and was in the habit of reading again and again. We decided that I should move to Edinburgh, and that we should take an apartment there together. We found one which suited us admirably, at the bottom of a huge forbidding building of dark grey stone on the south side of Buccleuch Place just opposite to George Square where Scott's father had lived at the time when Scott was a boy. At the back our house looked clear out towards the Meadows, with no houses intervening. We lived there for three years and a half, and I was not at all disappointed with Edinburgh: it still seemed to me very romantic, and I became very fond of it.

In the spring of 1908, however, my friend had to move to London, having been appointed to a post in the Board of Education; and it happened that at the same time two of my sisters wished to set up house together somewhere near London and wished that I should join them. After house hunting in a good many different directions in the neighborhood of London, we found a house on The Green, at Richmond, Surrey, which we thought would suit us. The Green has a good deal of charm, with the row of red-brick Georgian houses called "Maids of Honour" Row, along one side of it, and the still older red-brick palace in which Elizabeth died in its far corner. Our house moreover looked out behind over the old Deer Park. I lived at Richmond, as I had at Edinburgh, for three years and a half, and I became very fond of Richmond also.

During these seven years, half of which were spent at Edinburgh and half at Richmond, I worked at philosophy as hard as, though no harder than, I had worked during the six years of my Fellowship. At the beginning of the period I spent at Edinburgh what I was chiefly occupied with was trying to understand Russell's *Principles of Mathematics*, a thing which I found very difficult since the book was full of conceptions which were quite new to me. Many parts of it I never did succeed in understanding, but the earlier fundamental parts about logic I think I did in the end succeed in understanding pretty thoroughly. I was helped in understanding by the fact that, as I mentioned before, I did not merely think about and read over and over again what seemed to me to be of cardinal importance, but actually wrote a long review of the book. When I try to write about a thing I always find that there are points about it which I had not understood, although, so long as I merely thought about it, I had supposed I was quite clear. But, besides this work on the *Principles of Mathematics*, I also at Edinburgh wrote several papers. One of these was my paper on William James' little book called *Pragmatism*, which I still think to have been a good piece of work, although at the end of it I slide over some difficulties, which ought to have been fully thought out.

At Richmond I was again invited to give two courses of ten lectures each, this time at the Morley College in Waterloo Road. These lectures, which were called lectures on Metaphysics, I wrote out in a completely finished form and merely read them to my audience, just as I had done earlier with my lectures on Ethics. And later on at Richmond I was mainly occupied in writing my small book called *Ethics* for the Home University Library. This book I myself like better than *Principia Ethica*, because it seems to me to be much clearer and far less full of confusions and invalid arguments.

IV. Twenty-eight Years' Teaching at Cambridge.
1911-1939

In 1911 I was asked if I would return to Cambridge, in order to hold one of the two University Lectureships in Moral Science. The Lectureship in question was being vacated, owing to

the fact that Dr. J. N. Keynes, the author of *Formal Logic*, who had held it for many years, had now been elected to the office of Registrary of the University. The salary attached to a University Lectureship at Cambridge at that time, unless it was specially endowed, as this one was not, was only £50 *per annum*. In addition, a Lecturer was entitled to the fees paid by those who attended his lectures; but, since the number of students taking Moral Science at Cambridge is always very small, these fees could hardly amount to as much as £100 *per annum*. This system was only possible, because, in general, University Lecturers were also Fellows of some college. I, if I were appointed to this Lectureship, should not be a Fellow of any College; but I had sufficient private means to make the scantiness of the pay a matter of no importance to me whatever, and, the moment the suggestion was made to me, I felt no doubt at all that I should like to hold the Lectureship: in fact, I jumped at the suggestion. Why I did, I really do not know. No doubt, partly, the idea of teaching was attractive to me. Also, no doubt, after seven years' absence from Cambridge, I now liked the idea of going back there. But yet I should never have thought of going back there, as I quite easily might have done, if no official position had been offered to me. Whatever the reasons may have been, I wanted to accept, if possible. But there was one difficulty in the way. The two Lectureships in Moral Science were not appropriated to any particular subject. How the subjects, on which it was necessary that lectures should be given for the Tripos, should be distributed among the Professors and Lecturers was a matter of mutual arrangement. But, in fact, if I held this Lectureship, I should be wanted to lecture either on Logic or on Psychology for Part I of the Tripos. Neither of these was my subject, and I had never received any teaching in either of them, as I had never taken Part I of the Tripos. On Logic I felt at once that I really was not competent to lecture. For one thing, I knew that the Lecturer in Logic would be expected to deal in some detail with the theory of the Syllogism as expounded, for instance, in Keynes' *Formal Logic;* and, though I had read that book and others on the subject, I had never been much interested in the Moods and Figures, and had never taken any pains to

familiarise myself with the different technical terms and the technique of the subject. Perhaps I ought to have felt that I was equally incompetent to lecture on Psychology; but here the case seemed to me to be different. I knew, of course, practically nothing of Experimental Psychology; but the teaching of that subject in Cambridge was already well provided for by Dr. C. S. Myers, and it seemed to me that a great part of what was required to be taught, under the name of Psychology, for Part I of the Tripos, was really not an empirical science at all but a part of philosophy—something which might fairly be said to belong to the Philosophy of Mind. The chief books that were recommended for the subject—such books as Ward's article in the *Encyclopaedia Britannica,* Stout's *Manual* and *Analytic Psychology,* and James' *Principles of Psychology*—seemed to me largely to consist of what was strictly philosophy; I had read all these books with a good deal of attention, and a good many of the subjects discussed in them were subjects on which I had thought a great deal and thought as hard as I could. It seemed to me, therefore, that, if I might lecture on Psychology, I was already fairly competent to deal with a good part of the subjects I should be expected to cover, and might reasonably expect to be able to fill up *lacunae* by further reading. But Keynes, whose Lectureship I was to fill, had lectured on Logic, not on Psychology. The lecturing on Psychology for Part I had hitherto been done by the other University Lecturer, Mr. W. E. Johnson; so that, if I was to lecture on Psychology, Mr. Johnson would have to change over from Psychology to Logic. Mr. Johnson was willing to do this, and I hope and believe that he was positively glad to make the change, since Logic had always been the subject at which he had worked most and in which he was primarily interested. Thus it came about that I was appointed to the vacant Lectureship, with the understanding that I was to lecture on Psychology for Part I of the Tripos.

Accordingly in October 1911 there began a succession of twenty-eight years, during every term in which I was lecturing at Cambridge. As regards the amount of lecturing I did and the subjects on which I lectured, the whole period may be divided into three parts. From 1911 to 1918 I only gave three lectures a

week, nominally on Psychology for Part I. But in 1918 Ward, knowing that I should like to lecture on other philosophical subjects, proposed that I should undertake part of the work which he had hitherto included in his course on "Metaphysics" for Part II of the Tripos. For each subject in the Tripos a schedule is officially published summarising the topics which that subject is supposed to cover. The part of the subject of "Metaphysics" which Ward proposed to hand over to me was what was called in the schedule "Philosophy of Nature;" and I accepted his offer very gratefully. It was arranged that I should only lecture two days a week on this new subject; and accordingly for the next seven years I was lecturing five days a week, instead of only three as heretofore, continuing to give three days to my original course on Psychology, and adding two more for the new course on Philosophy of Nature. Finally, in 1925, when I succeeded Ward as Professor of Mental Philosophy and Logic, I reverted to my original practice of giving only three lectures a week, dropping entirely my course on Psychology, which could then be taken over by someone else, and giving three lectures a week, nominally on "Metaphysics" for Part II of the Tripos. Accordingly for the fourteen years from 1925 to 1939, in which latter year I had reached the age of 65 at which Professors under the new Statutes are obliged to retire, I was again only lecturing three days a week, except for one year in which it happened to be convenient for my colleagues that I should also undertake the course on "Elements of Philosophy" for Part I of the Tripos, and in which consequently I was again lecturing five days a week. But throughout the whole period of twenty-eight years, from 1911 to 1939, I followed the example of McTaggart in holding, in connection with each course, what McTaggart called a "Conversation Class" for one hour a week. This was an opportunity for the audience to ask questions and discuss topics in connection with the lectures of the week; and it seems to me that such discussion classes form a very important and necessary adjunct to any course of lectures on philosophy.

When I was appointed to this Lectureship, I had had no experience of lecturing as often as three times a week, and I thought, very naturally, that I had better try to prepare in the

vacation, before the term began, the greater part of the lectures which I should have to give in the first term. Accordingly I set about doing this. I found at once that every point I wanted to talk about required a great deal of thinking before I could get as clear about it as I wanted to be; and I proceeded to spend the necessary amount of time in doing this. But, following this method, I found that at the end of a month I had scarcely prepared enough material for a single lecture! Consequently, when term began, I found that, for the greater part of my lectures, I should have to depend upon preparing each in the two days which intervened between it and the one immediately preceding it. And this method of preparing my lectures—from hand to mouth, so to speak—has been the method which I have followed in the case of far the greater part of my Cambridge lectures right from the beginning in 1911 to the end in 1939. It might be thought that, having prepared a course one year, I could repeat it again next year; and I have in fact done this to some extent, especially in those years in which I had to lecture five days a week. But in most years I have only repeated to a very slight extent what I had said in a previous year: as a rule, I have prepared a new set of lectures each year. I did this chiefly because I was always each year dissatisfied with what I had said on any given point the year before, and wanted to think more about it and improve my treatment, and because also I generally wanted to deal with some new points—points on which I had never lectured at all before; but I am afraid it must be owned that it was partly because I felt a great reluctance to read through again what I had written a year or several years before, and much preferred to try to think out the same topic or a new one afresh. I think that this habit of preparing new lectures every year must have involved some waste of effort. I sometimes forgot how I had treated a particular point, and had to think it all out again, when, if I had only re-read my earlier treatment, I could have reached the same conclusion in less time. But I think my method had one advantage—namely, that what I said in any year was almost always something in which I myself was keenly interested at the moment and which had the charm of novelty for me. Of course, it does not follow that,

because you yourself are keenly interested in what you say, your audience will be so too; but I think that, other things being equal, it makes it more likely that they will be.

I never simply read these official Cambridge lectures, as I had read my London ones, nor did I ever write them out in finished form—in a form such that they could have been published as they stood, which I had done with the London ones. What I did was to write out very full notes—notes so full that, if I had merely read them out, to do so would have taken up almost the whole fifty minutes of lecture-time; and then, having written them out, I made a point of having an hour or more of free time immediately before each lecture, in which I read them through and fixed in my mind as well as I could just what I wanted to say. After this, I needed in lecturing hardly to refer to my notes at all: I just talked; and in talking of course I added some things which were not in my notes, and sometimes, I am sorry to say, left out things which were in them and which ought to have been said. It has happened to me, though very rarely, that I forgot to take my notes with me to the lecture-room; but I found that I could lecture just as well without them as with them.

I have to confess that never, in any year, did I come anywhere near to covering the whole of the topics upon which I was supposed to be lecturing, and which were given in the official Schedule. I went into such detail upon earlier parts of the programme, that later parts had to be omitted altogether. I dare say that some of my audience were annoyed, and justly annoyed, at my failure to cover the ground; but I think that some at least were glad to have the detailed treatment of particular points, which could not have been given to any, if I had tried to deal with all.

Since, for the whole of each term, I was occupied in preparing new lectures, I could hardly ever, in term-time, write anything for publication. Fortunately the Cambridge terms are very short, two of them of eight weeks each, and the third (so far as lecturing is concerned) of six at most; and in the vacations there was time for reading and writing. On some occasions I had to write for publication in term-time in addition to preparing my

lectures; and on such occasions I think I really did, for a time, work *very* hard indeed.

There are a few other matters, falling within these years from 1911-1939, which I think ought to be mentioned.

In 1912 I became acquainted with Wittgenstein. During the first year in which he was at Cambridge he attended my lectures on Psychology; but it was only during the next two years that I got to know him at all well. When I did get to know him, I soon came to feel that he was much cleverer at philosophy than I was, and not only cleverer, but also much more profound, and with a much better insight into the sort of inquiry which was really important and best worth pursuing, and into the best method of pursuing such inquiries. I did not see him again, after 1914, until he returned to Cambridge in 1929; but when his *Tractatus Logico-Philosophicus* came out, I read it again and again, trying to learn from it. It is a book which I admired and do admire extremely. There is, of course, a great deal in it which I was not able to understand; but many things I thought I did understand, and found them very enlightening. When he came back to Cambridge in 1929 I attended his lectures for several years in succession, always with admiration. How far he has influenced positively anything that I have written, I cannot tell; but he certainly has had the effect of making me very distrustful about many things which, but for him, I should have been inclined to assert positively. He has made me think that what is required for the solution of philosophical problems which baffle me, is a method quite different from any which I have ever used—a method which he himself uses successfully, but which I have never been able to understand clearly enough to use it myself. I am glad to think that he is my successor in the Professorship at Cambridge.

At sometime in the years 1912-1914 Stout asked me to review for *Mind* Prof. C. D. Broad's first published work, *Physics, Perception and Reality*. I gladly undertook to review it, but I never fulfilled my promise! After about four years, during which I had failed to produce a review, Stout asked Russell to review it instead; and he, of course, produced a review promptly and efficiently. I should like hereby to tender to Broad my

apologies for my failure: I hope that he has, at least partially, forgiven me. I can assure him that my failure was not for any want of trying. I did in fact write an immense amount about his book; but I found myself entangled with fundamental problems, which it seemed to me that I must solve before I could review the book as well as it deserved. I do not think I have often failed to fulfil, in some fashion or other, a promise which I had definitely given: this is the most scandalous instance! Of all living philosophers, it is Broad's work, next to Russell's and Wittgenstein's, that I have thought it worth while to study most carefully; and I have several times lectured in detail upon particular points in it.

At the end of the year 1916 I had the great good fortune to be married to Miss D. M. Ely, a young lady with whom I had become acquainted when she attended my lectures in the academic year 1915-1916. We have since had the happiness of being the parents of two sons. The elder, Nicholas, who is already becoming known as a poet, was born in November, 1918, a few days after the Armistice which concluded the Great War of 1914-1918. The younger, Timothy, was born a little more than three years later in February, 1922; and, before he was seventeen, he won an Entrance Scholarship at Trinity, of maximum value, for "Moral Science." He got a First Class in Part I of the Moral Sciences Tripos in 1941, but since then his University career has been interrupted owing to the present war.

From 1911 to 1916 I was allowed, as a Past Fellow who was also holding a University office, to occupy rooms at Trinity, though not Fellows' rooms—a privilege which I greatly valued. For these five years I dined regularly in Hall and thus came to renew my acquaintance with many members of the High Table whom I had scarcely seen since my Fellowship elapsed in 1904, and to make the acquaintance of others who had become Fellows since that time. On my marriage at the end of 1916, I, of course, ceased to reside in Trinity; and from that date till 1925, when I was elected to a Professorial Fellowship on the occasion of my appointment to the Professorship in the University, I visited the College almost as rarely as during the seven years which I spent away from Cambridge. On my re-election to a Fellowship in

1925 I adopted the practice, common among married Fellows, of dining in the Hall regularly every Sunday, and thus renewed contact with the College, though, of course, not so closely as when I was living in College. I continued this practice down to September 1940, when I went to the United States, and have greatly valued my association with the Fellows of Trinity. I am very proud of having been one of their number—an honour which I have shared with many of the philosophers whom I have had occasion to mention, Sidgwick, Ward, McTaggart, Russell, Broad, and Wittgenstein, as well as with one whom I have only mentioned once incidentally, but to whom I owe not a little and whom I regard with the warmest feelings of affection, namely, Whitehead.

In the academic year 1916-1917, besides giving my own lectures on Psychology, I also attended the lectures on Advanced Logic of the other University Lecturer, Mr. W. E. Johnson. During the first twelve years I spent at Cambridge I had seen very little of Johnson, never having attended his lectures, since I did not take Part I of the Tripos. But after my return to Cambridge in 1911, as one of his colleagues, I began to see a good deal of him, and he is one of the Cambridge philosophers whose conversation I have valued most: I loved to talk with him about philosophy. When his *Logic* came out, I read it eagerly; and this is one of the books on points in which I have lectured in detail.

In the early twenties F. P. Ramsey attended at least one course of my lectures. I had soon come to feel of him, as of Wittgenstein, that he was very much cleverer than I was, and consequently I felt distinctly nervous in lecturing before him: I was afraid that he would see some gross absurdity in things which I said, of which I was quite unconscious. In the course of the twenties I had a good deal of discussion with him, and, just before his final illness, he proposed that we should meet regularly once a week to discuss philosophical questions together. How I wish that those discussions had taken place! I think that I might really have learnt a great deal from them. But I need not here say any more about Ramsey, because I have tried to express my feelings about him in the *Preface* which I wrote for

the posthumous collection of his essays entitled *The Foundations of Mathematics.*

In 1920, on Stout's retirement from the Editorship of *Mind*, an office which he had held since the beginning of the "New Series" in 1892, I was asked to succeed him as Editor; I began in 1921, and have now been Editor for more than twenty years. Stout gave me all possible assistance at the start, and explained to me fully the principles on which he had worked. I did not see any need for any change in those principles, and have merely tried to follow his example. Neither he nor I have ever adopted the policy (except, perhaps, on rare occasions) of *asking* for articles: we have relied, in general, so far as articles were concerned, on those which were volunteered to us. And I have found as a rule, that I have had a superfluity of suitable material offered to me, rather than a lack of it. What I have found most difficult has been to decide, as between a number of different articles, all of which seemed to me to display sufficient ability to be worthy of acceptance but which could not all be accepted for lack of space, which was the most deserving; and no doubt my judgment may often have been wrong: I may have accepted what I ought to have refused, and refused what I ought to have accepted. I think, however, that I have succeeded in being impartial as between different schools of philosophy. I have tried, in accordance with the principles laid down when *Mind* was started and repeated by Stout in the Editorial which he wrote at the beginning of the New Series, to let merit, or, in other words, the ability which a writer displays, and not the opinions which he holds, be the sole criterion of whether his work should be accepted. The only departure from this principle which I am conscious of having now and then allowed myself, is that, where a writer had a considerable reputation, I have sometimes thought that I ought to accept an article by him, even though the article in question seemed to me, personally, to fall below the level of ability which I should have required from an unknown writer. The most noticeable difference between *Mind* under me and *Mind* under Stout seems to me to be that under me the number of book reviews has considerably diminished. This has been partly deliberate: under Stout there were a great number of very

short reviews, and I have thought (perhaps wrongly) that very short reviews were hardly of any use. But it is partly, I am afraid, owing to lack of thoroughly business-like habits on my part, and partly also because, knowing what a tax I should have felt it myself to have to write a review, I have been shy about asking others to undertake the task. Whatever the reason, I am afraid it is the case that I have failed to get reviewed a good many books which ought to have been reviewed. To the many reviewers who have reviewed for me I feel deeply obliged. In other respects, I hope that *Mind* under me has not fallen below the high standard of *Mind* under Stout; but of this, of course, I am not a good judge.

In 1913 I applied for and was granted the degree of Litt.D. in my own University. And in 1918 I was elected a Fellow of the British Academy and also received the Honorary Degree of LL.D. from the University of St. Andrews.

V. AFTER SEPTEMBER, 1939

At the end of September 1939 I ceased, in accordance with the University Statutes, to hold my Professorship at Cambridge, though I still continued to be a Fellow of Trinity, in accordance with the College Statutes, which enact that any Fellow who has completed his term of service in a university office shall hold his Fellowship for life. The title of my Professorship had been changed by the University during my tenure of it, so that, whereas Ward, the first holder, had been Professor of Mental Philosophy and Logic, and that had also been my title for several years after I succeeded him, yet when I retired, I had for several years been Professor, not of Mental Philosophy and Logic, but of Philosophy, and am now Emeritus Professor of Philosophy.

When I retired I ceased to lecture at Cambridge, but I did not cease to lecture. I had been invited to lecture once a week at Oxford during the Michaelmas term of 1939, and also, on each occasion when I went over there, to hold a discussion class. I lectured there to a very much larger audience than had ever attended a course of lectures by me before; and, as for the discussions, I thought we had some very good ones. I enjoyed

these weekly visits to Oxford very much indeed, chiefly because of the Oxford philosophers I met there, many of whom I had, of course, known before; but partly also because Oxford, like Edinburgh, is a romantic place to me: it was a pleasure to be sleeping in Christ Church, and to hear Great Tom strike the hours.

And this was not the end of my lecturing; for at the beginning of August, 1940, I received a cable asking me if I would accept a Visiting Professorship at Smith College for the first semester of the academic year 1940-1941. I accepted, and my wife and I succeeded in reaching New York at the beginning of October. At Smith College I lectured once a week, and also held discussion classes; I did the same at Princeton where I was invited for the Spring Semester of 1941; I did the same at Mills College, California, where I was invited for the Autumn semester of 1941; and, at the moment of writing, I am doing the same at Columbia University. All these courses of lectures, as well as the Oxford ones, have been like my Cambridge ones in the respects that each lecture in a course (except the first) was prepared in the interval between it and the one before, that none of them was written out in finished form, and that I talked them and did not read them. And these five courses, taken together, have also resembled any typical five of my Cambridge courses, in that though all of them were supposed to be roughly on the same subject "Sense-perception," yet every one of them was almost completely different from every other. When I lectured on "Metaphysics" at Cambridge I generally, in each year, lectured on a completely different subject. I cannot say that I have done this in these five courses on "Sense-perception," and yet they have been very different indeed from one another. This has been partly because, when I began each later course, I was dissatisfied with what I had said in earlier ones; partly because in the case of each lecture I have allowed myself to be guided as to what I should say in it by what was said in the discussion which followed the one before; and partly because new points have occurred to me, into which, at the moment, it seemed more important to enter.

Besides these four courses in America, I have also given single

lectures at a large number of American Universities; but these were in every case lectures which had been written out in a finished form and which I read to my audience.

I had never visited the United States until October 1940, and had expected that I never should visit them. But I have felt very much at home over here. Americans seem to me, on the whole, very like English people. There is an obvious difference in the way in which the language is spoken, and here I confess I prefer the English way. But the other difference which seems to me most striking is in favour of America. I should not like to seem to imply that English people are not in general very friendly: I think they are. But it has struck me that Americans are more generally and more markedly friendly. Perhaps, however, it is absurd to try to make generalizations about the differences between two such peoples as the people of the United States and the people of Great Britain. What is certain is that my wife and I have experienced over here a kindness and hospitality, for which we are very grateful.

G. E. Moore

NEW YORK, FEBRUARY 27, 1942

I

C. D. Broad

CERTAIN FEATURES IN
MOORE'S ETHICAL DOCTRINES

CERTAIN FEATURES IN
MOORE'S ETHICAL DOCTRINES

FROM the many topics in Moore's ethical writings which might profitably be discussed I am going to choose two in the present paper. They are (1) his attempted refutation of Ethical Egoism, and (2) his distinction between "Natural" and "Non-natural" characteristics, and his doctrine that the word "good" (in one very important use of it) is a name for a certain non-natural characteristic.

(1) ETHICAL EGOISM

I shall begin by defining three opposed terms, viz., "Ethical Egoism," "Ethical Neutralism," and "Ethical Altruism." The second of these is the doctrine which Moore accepts in *Principia Ethica;* the other two are extreme deviations from it in opposite directions. It will therefore be best to start with ethical neutralism.

The neutralist theory is that no-one has any special duty to himself *as such,* and that no-one has any special duty to others *as such.* The fundamental duty of each of us is simply to maximise, so far as he can, the balance of good over bad experiences throughout the whole aggregate of contemporary and future conscious beings. Suppose that *A*, by giving to *B* a good experience at the cost of foregoing a good experience or incurring a bad one himself, can increase this balance more than by any other means; then it is *A*'s duty to do so. Suppose, on the other hand, that *A*, by getting a good experience for himself at the cost of depriving *B* of a good experience or giving him a bad one, can increase this balance more than by any other means; then it is equally *A*'s duty to do so.

43

Ethical Egoism is the doctrine that each man has a predominant obligation towards himself as such. Ethical Altruism is the doctrine that each man has a predominant obligation towards others as such. These doctrines might be held in milder or more rigid forms according to the degree of predominance which they ascribe to the egoistic or the altruistic obligation respectively. The extreme form of Ethical Egoism would hold that each man has an ultimate obligation *only* towards himself. The extreme form of Ethical Altruism would hold that each man has an ultimate obligation *only* towards others. According to the former extreme each man's only duty is to develop *his own* nature and dispositions to the utmost and to give *himself* the most favourable balance that he can of good over bad experiences. He will be concerned with the development and the experiences of other persons only in so far as these may affect, favourably or unfavourably, his own development and his own experience. This doctrine seems to have been held by Spinoza. The extreme form of Ethical Altruism would hold that each man's only duty is to develop to the utmost the natures and the dispositions of all other persons whom he can affect and to give them the most favourable balance that he can of good over bad experiences. He will be concerned with his own experiences only in so far as they may affect, favourably or unfavourably, the development and experiences of other persons.

Now Moore professes to show in *Principia Ethica* (96-105) that Ethical Egoism is self-contradictory; and, if his argument were valid, a very similar argument could be used to refute Ethical Altruism. He alleges that Ethical Egoism involves the absurdity that *each* man's good is the *sole* good, although each man's good is different from any other man's good. In my opinion it involves nothing of the kind; and I will now try to justify that opinion.

First of all, what do we mean by such phrases as "Smith's good" or "Jones' evil?" The good of Smith is just those good experiences, dispositions, etc., which are Smith's; and the evil of Jones is just those bad experiences, dispositions, etc., which are Jones'.

Suppose now that A is an ethical egoist. He can admit that, if

a certain experience or disposition of his is good, a precisely similar experience or disposition of B's will be also and equally good. But he will assert that it is not his duty to produce good experiences and dispositions as such, without regard to the question of who will have them. A has an obligation to produce good experiences and dispositions in *himself*, and no such direct obligation to produce them in B or in anyone else. A recognises that B has no such direct obligation to produce them in A or in anyone else. This doctrine does not contradict itself in any way.

What it does contradict is Sidgwick's second axiom about goodness and our obligations in respect of producing it. This is stated as follows in Book III, Chapter XIII of Sidgwick's *Methods of Ethics* (382, in the sixth edition):—". . . as a rational being I am bound to aim at good generally—so far as it is attainable by my efforts—not merely at a particular part of it." Since Sidgwick was an ethical hedonist, he held that nothing is intrinsically good or bad except experiences. Therefore, to "aim at good" will mean to try to produce good experiences and to avert or diminish bad experiences. Therefore this axiom means that it is each person's duty to try to produce the greatest possible net balance of good over bad experiences among all the conscious beings whom he can affect, and that he has no *direct* obligation to produce such experiences in one rather than in another person or set of persons, e.g., in himself as such or in others as such. Suppose he confines his efforts to himself or to his family or to his social class or to his countrymen, or even to that very extended but still restricted group which consists of everyone but himself; then he will always need some positive justification for this restriction. And the only admissible justification is that, owing to his special limitations or their special relations to him, he can produce more good on the whole by confining his efforts to a certain restricted set of conscious beings. Any restriction in the range of one's beneficent activities needs ethical justification, and this is the only valid ethical justification for it.

It is evident, then, that Sidgwick's axiom is equivalent to the assertion of ethical neutralism, and that ethical egoism is inconsistent with it. But this does not make ethical egoism *self*-con-

tradictory; and, unless Sidgwick's axiom be self-evidently true, the inconsistency of ethical egoism with it does not refute that doctrine.

Precisely similar remarks would apply to any argument against ethical altruism on the same lines as Moore's argument against ethical egoism. Suppose that A is an ethical altruist. He can admit that, if a certain experience or disposition of B's is good, a precisely similar experience or disposition of his own will be also and equally good. But he asserts that it is not his duty to produce good experiences and dispositions as such, without regard to the question of who will have them. A has an obligation to produce good experiences and dispositions in *others*, and no such direct obligation to produce them in himself. A recognises that B has an obligation to produce good experiences and dispositions in A and in everyone except B, and that B has no obligation to produce them in B. This doctrine, again, contradicts Sidgwick's second axiom about goodness and our obligations in producing it. But it is not *self*-contradictory, and, unless Sidgwick's axiom be self-evident, the inconsistency of ethical altruism with it does not refute the latter doctrine.

An illuminating way of putting the difference between ethical neutralism and the other two theories is the following. Ethical neutralism assumes that there is a certain *one* state of affairs— "the sole good"—at which *everyone* ought to aim as an *ultimate* end. Differences in the proximate ends of different persons can be justified only in so far as the one ultimate end is best secured in practice by different persons aiming, not directly at it, but at different proximate ends of a more limited kind. The other two theories deny that there is any *one* state of affairs at which *everyone* ought to aim even as an ultimate end. In fact each theory holds that there are as many ultimate ends as there are agents. On the egoistic theory the ultimate end at which A should aim is the maximum balance of good over evil in A's experiences and dispositions. The ultimate end at which B should aim is the maximum balance of good over evil in B's experiences and dispositions. And so on for C, D, etc. On the altruistic theory the ultimate end at which A should aim is the maximum balance of good over evil in the experiences and dispositions of all *others-*

than-A. The ultimate end at which *B* should aim is the maximum balance of good over evil in the experiences and dispositions of all *others-than-B*. And so on for *C*, *D*, etc. The main difference between the two theories is that for egoism the various ultimate ends are mutually exclusive, whilst for altruism any two of them have a very large field in common.

Now there is nothing self-contradictory in the doctrine that, corresponding to each different person, there is a different state of affairs at which he and he only ought to aim as an ultimate end. And there is nothing self-contradictory in the doctrine, which is entailed by this, that there is no one state of affairs at which everyone ought to aim as an ultimate end. Moore simply assumes, in common with Sidgwick, that there must be a certain state of affairs which is *the* ultimate end at which *everyone* ought to aim; shows that ethical egoism is inconsistent with this assumption; and then unjustifiably accuses ethical egoism of being *self*-contradictory.

Granted that even the extreme forms of ethical egoism and ethical altruism are internally consistent, is there any reason to accept or to reject either of them?

(1) If ethical neutralism were true, they could both be rejected. Now the following argument can be produced in favour of ethical neutralism. On any theory except this it will sometimes be right for a person to do an act which will obviously produce less good or more evil than some other alternative act which is open to him at the time. E.g., it is often the case that *A* could either (i) do an act which would add something to his well-being at the cost of diminishing *B's* by a certain amount, or (ii) do another act which would increase his own well-being *rather less* at the cost of diminishing *B's very much less*. Plainly *A* would in general be producing more good by doing the latter act than by doing the former. But, if ethical egoism be true, it would be his duty to do the former and to avoid doing the latter. Again, it is often the case that *A* could either (i) do an act which would add something to *B's* well-being at the cost of diminishing his own by a certain amount, or (ii) do another act which would increase *B's* well-being *rather less* and diminish his own *very much less*. Plainly *A* would in general be producing more good

by doing the latter act than by doing the former. But, if ethical altruism be true, it would be his duty to do the former and to avoid doing the latter. I think, therefore, that ethical neutralism is the only one of the three types of theory which can be combined with the doctrine that the right act in any situation will always coincide with the optimific act in that situation. Since Utilitarians hold the latter view, they ought to hold the former; and so Sidgwick was right, as a Utilitarian, to lay down an axiom which is equivalent to ethical neutralism.

It is possible, however, to distinguish between what I call an "optim*ising*" act, and what I have called an "optim*ific*" act; and it might be possible to combine ethical altruism with the doctrine that the right act always coincides with the optimising act. I will now explain this distinction and justify this assertion. Suppose that a certain act α is done in a certain situation S, and that the amount of value in the universe is thereby changed. It is possible to distinguish two quite different contributions which this act may make to the amount of value in the world. They may be called its *direct* and its *consequential* contributions. The act may have qualities which make it intrinsically good or bad. Even if it has not, it will have non-causal relations to other factors in the contemporary and the past situation which forms its context; and in virtue of these the whole composed of the act and the situation may be better or worse than the situation by itself or the situation combined with a different act. Any value, positive or negative, which accrues in this way to the universe through the occurrence of this act may be called its "direct" contribution. Again, the act co-operates as a cause-factor with other factors in the contemporary situation and thus leads to a train of consequences which are different from those which would have followed if no act or a different act had been done. Any value or disvalue which accrues to the universe through the values or disvalues of the consequences of an act may be called its "consequential" contribution. The "total" contribution of an act consists of its direct and its consequential contributions. An "optim*ific*" act in a given situation may be defined as one whose *consequential* contribution to the value in the universe is at least as great as that of any alternative act open to the agent. An

"optim*ising*" act in a given situation is one whose *total* contri-
bution to the value in the universe is at least as great as that of
any alternative act open to the agent.

Let us now apply these notions. Suppose that there is a situa-
tion in which A can either (i) do an act which will increase B's
well-being at the cost of considerably diminishing his own, or
(ii) do an act which would add rather less to B's well-being
and diminish his own very much less. Suppose further that an
act of self-sacrifice has, as such, a certain amount of moral value.
Then it might be that the direct contribution which the former
act would make, as an act of self-sacrifice, more than counter-
balances the consequential diminution which it causes by de-
creasing the agent's own well-being. So an altruistic act might
be the optimising act even when it is not the optimific act.

Now common-sense does ascribe considerable positive value
to acts of voluntary self-sacrifice as such. It is therefore conceiv-
able that the right act, on the extreme altruistic view, might
always coincide with the optimising act. But it is not necessary
that it should, and it seems most unlikely that it always would.
For it seems easy to conceive situations in which the most altruis-
tic act possible would increase the well-being of others very
slightly and would diminish that of the agent very much, whilst
some other possible act would increase the well-being of others
only a little less and would positively increase that of the agent.
In such a situation it is most unlikely that the most altruistic act
would be an optimising act, even when its direct contribution to
the goodness in the universe, as an act of self-sacrifice, was taken
into account.

It is quite plain that no attempt on these lines to reconcile
ethical *egoism* with the doctrine that the right act coincides
with the optimising act would be plausible. For common-sense
attaches no positive value to an act of sacrificing others for one's
own benefit, as such. Therefore, when what would be the right
act on the extreme egoistic view fails to coincide with the opti-
mific act, it is impossible that it should coincide with the optimis-
ing act.

The upshot of this discussion is as follows. Many people find
it self-evident that the right act in any situation must coincide

with the optimific act. Anyone who does so can safely reject pure ethical egoism and pure ethical altruism, and will almost be forced to accept ethical neutralism. When the distinction between an optimising and an optimific act is pointed out to them many of those who thought it evident that the right act must coincide with the optimific act would be inclined to amend their doctrine by substituting "optimising" for "optimific." Such people could safely reject pure egoism. It is not impossible that the most altruistic act should coincide with the optimising act even when it fails to coincide with the optimific act. But, even if it always did so, this would be a merely contingent fact; whilst they hold that the coincidence between the right act and the optimising act is necessary, since they find it self-evident. And it is very unlikely that the most altruistic act would in fact always coincide with the optimising act. Therefore the substitution of "optimising" for "optimific" would make no difference in the end. Those who find the coincidence of the right act with the optimising act self-evident could safely reject both pure altruism and pure egoism, and would have to accept ethical neutralism as the only principle of distribution which is compatible with their axiom.

(2) So far we have considered the grounds for accepting ethical neutralism, and therefore the indirect reasons for rejecting ethical egoism and ethical altruism. We will now consider the attitude of common-sense towards each of the three alternatives when judged on its own merits. (i) Common-sense would reject pure ethical egoism out of hand as grossly immoral. It is, I think, doubtful whether anyone would accept *ethical* egoism unless, like Spinoza, he had already accepted *psychological* egoism. If a person is persuaded that it is psychologically impossible for anyone to act non-egoistically, he will have to hold that each man's duties are confined within the sphere which this psychological impossibility marks out. But common-sense does not accept psychological egoism, though many philosophers have done so; and on this point common-sense is right and these philosophers are tricked by certain rather subtle ambiguities of language.

(ii) The attitude of common-sense (at any rate in countries

where there is a Christian tradition) towards pure ethical altruism is different. It would, with an uncomfortable recollection of some rather disturbing passages in the Sermon on the Mount, be inclined to describe the doctrine as quixotic or impracticable but hardly as immoral. Apart from the embarrassment which persons in a Christian country feel at saying or implying that Christ sometimes talked nonsense, there is a sound practical reason for this attitude. We realise that most people are far more likely to err on the egoistic than on the altruistic side; that in a world where so many people are too egoistic it is as well that some people should be too altruistic; and that there is something heroic in the power to sacrifice one's own happiness for the good of others. We therefore hesitate to condemn publicly even exhibitions of altruism which we privately regard as excessive.

(iii) Although common-sense rejects pure egoism and does not really accept pure altruism, I do not think that it is prepared to admit neutralism without a struggle. It would regard neutralism as in some directions immorally selfish and in other directions immorally universalistic. It undoubtedly holds that each of us has more urgent obligations to benefit certain persons who are specially related to him, e.g., his parents, his children, his fellow-countrymen, his benefactors, etc., than to benefit others who are not thus related to him. And it would hold that the special urgency of these obligations is founded *directly* on these special relations.

(iv) The ideal of common-sense then is neither pure egoism nor pure altruism nor neutralism. I think it may be best described as "Self-referential Altruism." I will now explain what I mean by this. Each of us is born as a member of a family, a citizen of a country, and so on. In the course of his life he voluntarily or involuntarily becomes a member of many other social groups, e.g., a school, a college, a church, a trades-union, etc. Again, he gets into special relations of love and friendship with certain individuals who are not blood-relations of his. Now the view of common-sense is roughly as follows.

Each of us has a certain obligation to himself, as such. I do not think that common-sense considers that a person is under *any* obligation to make himself *happy*, i.e., to "give himself a

good time." Possibly this is because most people have so strong a natural tendency to aim at getting the experiences which they expect to like and at avoiding those which they expect to dislike. On the other hand, the obligation to develop one's own powers and capabilities to the utmost, and to organise one's various dispositions into a good pattern is considered to be a strong one. This kind of action often goes very much against the grain, since it conflicts with natural laziness and a natural tendency to aim at the easier and more passive kinds of good experience. The obligation to make others happy and to prevent or alleviate their unhappiness is held to vary in urgency according to the nature of their relation to oneself. It is weakest when the others stand in no relation to the agent except that of being fellow sentient beings. It is strongest when the others are the agent's parents or his children, or non-relatives whom he loves and by whom he is loved, or persons from whom he has received special benefits deliberately bestowed at some cost to the giver.

A person's obligation towards A is more urgent than his obligation towards B if it would be right for him to aim at the well-being of A before considering that of B, and to begin to consider that of B only after he had secured a certain minimum for A. The greater this minimum is, the greater is the relative urgency of his obligation towards A as compared with his obligation towards B.

Now common-sense holds that it is one's duty to be prepared to sacrifice a considerable amount of one's own well-being to secure a quite moderate addition to the net well-being of one's parents or children or benefactors, if this be the only way in which one can secure it. But it does not consider that a person has a duty to sacrifice much of his own well-being in order to secure even a substantial addition to the net well-being of others who stand in no specially intimate relations to him.

Common-sense draws a sharp distinction between making oneself happy, and developing one's own powers and capacities to the utmost and organising one's disposition into a good pattern. The obligation to make oneself happy is held to be vanishingly feeble, whilst the obligation to develop and organise oneself is held to be very urgent. Hence it is felt to be doubtful how

far a person ought to sacrifice self-development and self-culture, as distinct from his own happiness, in order to add to the happiness of others. It is only when the claim is very strong, as in the case of a child on its parents or of aged and infirm parents on a grown-up son or daughter, that common-sense approves of this kind of self-sacrifice. Even here it feels considerable hesitation; and, apart from such cases, it is extremely embarrassed. It realises that it is a good thing on the whole that a certain proportion of people should voluntarily forego the development of a great many valuable aspects of their personality in order to live in the slums and add to the well-being of other persons who have no specially urgent claims on them. But, whilst it admires those who make the sacrifice, it regrets the waste of talent; and it is relieved to think that there is no great danger of too many gifted persons following their example. On the whole it favours a kind of ethical "division of labour." A certain minimum of self-sacrifice and of self-culture is demanded of everyone; but, when this minimum has been reached, common-sense approves of certain persons specialising in self-culture and others in beneficent self-sacrifice.

Lastly, common-sense considers that each of us has direct obligations to certain groups of persons of which he is a member, considered as collective wholes. The most obvious case is one's nation, taken as a collective unity. It is held that an Englishman, as such, is under an urgent obligation in certain circumstances to sacrifice his happiness, his development, and his life for England, and is under no such obligation to Germany; and that a German is under an obligation in similar circumstances to make a similar sacrifice for Germany, and is under no such obligation to England. And so on. It should be noticed that Germans, as well as Englishmen, admit that Englishmen have this peculiar obligation towards England; and that Englishmen, as well as Germans, admit that Germans have this peculiar obligation towards Germany. This is clearly recognised by the saner citizens of both countries even when they are at war with each other.

It seems to me that the fact that an Englishman considers that a German should sacrifice himself for Germany, even when

his doing so is detrimental to England, and that a German considers that an Englishman should sacrifice himself for England, even when his doing so is detrimental to Germany, is of some theoretical importance. It certainly suggests that we are concerned here with a genuine and objective, though limited, obligation; and not with a mere psychological prejudice in favour of one's own nation. Opinion has varied from time to time and from place to place as to what *kind* of group has the most urgent obligation on its members. At present, among most Western peoples and in Japan, the nation is put in this supreme position. Among the Greeks and Romans it was the city. It may be that in future it will be a class rather than a nation or a city. But common-sense has always held that there is *some* group for which all its members, and only they, were bound in certain circumstances to sacrifice their happiness, their chances of culture and development, and their lives.

I said that common-sense accepts a kind of "Self-referential Altruism." My meaning should now be clear. Common-sense is altruistic in so far as it considers that each of us is often under an obligation to sacrifice his own happiness, and sometimes to sacrifice his own development and life, for the benefit of certain other persons and groups, even when it is doubtful whether more good will be produced by doing so than by not doing so. It tends to admire these acts, as such, even when it regrets the necessity for them, and even when it thinks that on the whole they had better not have been done. It has no such admiration for the attempt to make oneself happy, as such, even when it does no harm to others. And, although it admires acts directed towards self-development and self-culture, as such, especially when they are done in face of external obstacles and internal hindrances, its admiration for them is not usually very intense.

On the other hand, the altruism of common-sense is always limited in scope. It does not hold that any of us has an equally strong obligation to benefit everyone whom he can affect by his actions. According to it, each of us has specially strong obligations to benefit certain persons and groups of persons who stand in certain special relations to *himself*. And these special relations to himself are the ultimate and sufficient ground of these

specially urgent obligations. Each person may be regarded as a centre of a number of concentric circles. The persons and the groups to whom he has the most urgent obligations may be regarded as forming the innermost circle. Then comes a circle of persons and groups to whom his obligations are moderately urgent. Finally there is the outermost circle of persons (and animals) to whom he has only the obligation of "common humanity." This is what I mean by saying that the altruism which common-sense accepts is "self-referential."

If this be a fair account of the beliefs of common-sense, what line could a person take who found neutralism self-evident? And, again, what line could a person take who found it self-evident that the right act must coincide with the optimising act and was therefore committed at the second move to neutralism? The problem is the same for both. He would have to do three things.

(i) He would have to hold that common-sense is mistaken in thinking that these special obligations are founded *directly* on these special relations. (ii) He would have to show that all these special obligations, so far as they are valid at all, are derivable from the one fundamental obligation to maximise the balance of good over evil among contemporary and subsequent conscious beings as a whole. He will try to do this by pointing out that each of us is limited in his power of helping or harming others, in the range of his natural sympathies and affections, and in his knowledge of the needs of others. He will argue that, in consequence of this, the maximum balance of good over evil among conscious beings as a whole is most likely to be secured if people do not aim directly at it. It is most likely to be secured if each aims primarily at the maximum balance of good over evil in the members of a limited group consisting of himself and those who stand in more or less intimate relations to him. The best that the neutralist could hope to achieve on these lines would be to reach a system of *derived* obligations which agreed roughly, both in scope and in relative urgency, with that system of obligations which common-sense mistakenly thinks to be founded *directly* upon various special relationships. In so far as this result was achieved he might claim to accept in outline

the same set of obligations as common-sense does; to correct common-sense morality in matters of detail; and to substitute a single coherent system of obligations, deduced from a single self-evident ethical principle and a number of admitted psychological facts, for a mere heap of unrelated obligations. (iii) To complete his case he would have to try to explain, by reference to admitted psychological facts and plausible historical hypotheses, how common-sense came to make the fundamental mistakes which, according to him, it does make. For common-sense rejects the neutralistic principle which he finds self-evident, and it regards as *ultimate* those special obligations of an agent towards certain persons and groups which *he* regards as derivative.

How, if at all, could this last *desideratum* be fulfilled? It seems to me that it might be attempted along the following lines. It must be admitted that any society in which each member was prepared to make sacrifices for the benefit of the group as a collective whole would be more likely to flourish and persist than a society whose members were not prepared to make such sacrifices. It must also be admitted that egoistic and anti-social motives are extremely strong in everyone. Suppose, then, that there were a society in which, by any means, there had arisen a strong additional motive (however mistaken and superstitious) in support of self-sacrifice, and that this motive were conveyed from generation to generation by example and precept and were supported by the sanctions of social praise and blame. Such a society would be likely to flourish and to overcome other societies in which no such additional motive existed. Its ways of thinking on these subjects and its sentiments of approval and disapproval would tend to spread, both directly through conquest and indirectly through the prestige which its success would give to it.

On the other hand, a society in which each member was prepared to sacrifice himself just as much for other societies and for their members as for his own society and its members would be most unlikely to flourish and persist. So, if there were a society in which, by any means, a strong additional motive for *unlimited* altruism or for neutralism had arisen and been propagated, that society would be likely to go under in conflict with

one in which a more restricted self-referential altruism was prac-
tised. It therefore seems likely that the societies which would
still persist and flourish after a long period of conflict would be
those in which there had somehow arisen, in the remote past, a
superstitious approval of altruism within certain limits and a
superstitious disapproval of extending it beyond those limits.
These are exactly the kind of societies which we do find. If one
were asked what is the most formidable society which now exists
and the one which seems to have the best chance of spreading
its ideals throughout the world directly by conquest and in-
directly by the prestige of its success, the answer would be Ger-
many. And, if one were asked what is the nation whose citizens
combine the most intense spirit of self-sacrifice within the group
with the most rigid refusal to extend that spirit beyond the
group, the answer would be the same. *Non est potestas super
terram quae comparetur ei.*

It seems then that, even if neutralism be true and be self-
evident to the philosopher in his study, there are powerful causes
which would make it likely that certain forms of self-referential
altruism would appear to be true and self-evident to most un-
reflective persons at all times and even to reflective persons at
most times. Therefore the fact that common-sense rejects neu-
tralism and accepts certain forms of self-referential altruism as
self-evident is not a conclusive objection to the *truth*, or even
to the *necessary* truth, of neutralism.

(2) "Natural" and "Non-Natural" Characteristics[1]

It is a fundamental doctrine of Moore's ethical theory that
the word "good," in its most fundamental sense, is a name for a
characteristic which is simple and "non-natural." He compares
it in the first respect, and contrasts it in the second, with the
word "yellow."

A complete discussion of this doctrine would have to begin
by raising a question which Moore never did raise but which

[1] This (second) part of this paper is extracted, with some additions and
modifications, from a paper by the author in the Aristotelian Society's *Proceedings*
for 1934, entitled "Is 'Goodness' a Name of a simple non-natural Quality?"
C.D.B.

has become acute in recent years. Is "good" a name of a characteristic at all? Or do sentences like "This is good," though grammatically similar to sentences like "This is yellow" which undoubtedly ascribe a certain characteristic to a subject, really need an entirely different kind of analysis? Is it not possible that the function of such sentences is to express or to stimulate certain kinds of emotion, or to command or forbid certain kinds of action, and not to state certain kinds of fact? There is a vast amount to be said for and against this suggestion, but I do not propose to discuss it here. I shall assume, for the sake of argument, that "good" is a name for a characteristic, and that sentences like "This is good" ascribe this characteristic to a subject.

On this assumption the next topic which would have to be discussed in any full treatment of the theory would be Moore's contention that the characteristic of which "good" is a name is simple and unanalysable. This, of course, implies that it is a pure quality and not a relational property. I do not consider that Moore has produced any conclusive reasons for this opinion, and I am very doubtful whether such an opinion *could* be established. But I propose to waive this point also, and to assume that "good" is a name for a simple characteristic.

If we make these assumptions two questions remain. (1) What exactly is meant by the distinction between a "natural" and a "non-natural" characteristic? (2) What connexion, if any, is there between the doctrine that "good," in its primary sense, denotes a characteristic which is simple and unanalysable, and the doctrine that it denotes a characteristic which is non-natural? We will take these two questions in turn.

(1) Let us begin with complex characteristics. A complex characteristic is natural if it can be analysed without remainder into a set of simple characteristics each of which is natural. A complex characteristic is non-natural if its analysis involves at least one simple characteristic which is non-natural. Suppose, e.g., that "This is good" where "good" is used in the primary sense, could be analysed into "This is something which it would be *right* to desire as an end." And suppose that "right," as applied to desires, were a name for a non-natural characteristic. Then goodness, in this sense, would be a complex non-natural

characteristic. So we are eventually faced with the question: "What is meant by calling a simple characteristic *natural* or *non-natural?*"

Unfortunately we shall get very little light on this question from Moore's published works. The only place, so far as I know, in which it is explicitly discussed is *Principia Ethica*, 40 to 41. We are told there that a "natural object" is any object that is capable of existing in time, e.g., a stone, a mind, an explosion, an experience, etc. All natural objects have natural characteristics, and some of them have also non-natural characteristics. We are told that each natural characteristic of a natural object could be conceived as existing in time all by itself, and that every natural object is a whole whose parts are its natural characteristics. We are told that a non-natural characteristic of a natural object is one which *cannot* be conceived as existing in time all by itself. It can be conceived as existing only as the property of some natural object.

Now it seems to me that *every* characteristic of a natural object answers to Moore's criterion of non-naturalness, and that *no* characteristic could possibly be natural in his sense. I do not believe for a moment that a penny is a whole of which brownness and roundness are parts, nor do I believe that the brownness or roundness of a penny could exist in time all by itself. Hence, if I accepted Moore's account, I should have to reckon brownness, roundness, pleasantness, etc., as *non-natural* characteristics. Yet he certainly counts them as *natural* characteristics.

I think that Moore is intending to explain the distinction between natural and non-natural characteristics in the very difficult essay in his *Philosophical Studies* which is entitled "The Conception of Intrinsic Value." So far as I can understand his doctrine in that essay it may be summarised as follows.

(i) The characteristics of any thing T may be first divided into two great classes, viz., those which do, and those which do not, "depend solely on the *intrinsic nature* of" T. (ii) Those characteristics of a thing T which depend solely on its intrinsic nature may then be subdivided into those which are, and those which are not, "intrinsic characteristics" of T. Consider, e.g., an experience which has a certain perfectly determinate kind and

degree of pleasantness. Suppose that it also has a certain perfectly determinate kind and degree of goodness. Then, if I understand him aright, Moore would say that both its pleasantness and its goodness are characteristics which depend solely on its intrinsic nature. He would say that its pleasantness is an intrinsic characteristic of it. And he would say that its goodness is not an intrinsic characteristic of it. (iii) Although he does not explicitly say so, I think that he would identify the *non-natural* characteristics of a thing with those which *are* determined solely by its intrinsic nature and yet *are not* intrinsic. The *natural* characteristics of a thing would be those which are either (a) intrinsic, or (b) not determined solely by its intrinsic nature.

Unfortunately Moore gives no clear account of this distinction between the intrinsic and the non-intrinsic varieties of the characteristics which depend on the intrinsic nature of a thing. All that he says is this. A complete enumeration of the *intrinsic* characteristics of a thing would constitute a *complete* description of it. But a description of a thing can be complete even if it omits those characteristics of it which, though determined solely by its intrinsic nature, are not intrinsic. E.g., a pleasant experience, which is also good, could not be completely described unless its pleasantness was mentioned. But it could be completely described without its goodness being mentioned.

I find it most difficult to follow or to accept this. I am inclined to think that the fact which Moore has in mind here is that goodness, in the primary sense, is always dependent on the presence of certain non-ethical characteristics which I should call "good-making." If an experience is good (or if it is bad), this is never an ultimate fact. It is always reasonable to ask: "What *makes* it good?" or "What *makes* it bad?" as the case may be. And the sort of answer that we should expect to get is that it is made good by its pleasantness, or by the fact that it is a sorrowfully toned awareness of another's distress, or by some other such non-ethical characteristic of it. We might, therefore, distinguish the characteristics of a thing into the following two classes, viz., *ultimate* and *derivative*. Goodness would certainly fall into the class of derivative characteristics.

Now there is a sense in which one might say that a thing

could not be completely described if any of its ultimate characteristics were omitted, but that it could be completely described without mentioning all its derivative characteristics. In describing a circle, e.g., it is not necessary to mention explicitly any of the innumerable properties of circles which follow of necessity from their definition together with the axioms of Euclidean geometry.

But, although this analogy may throw some light on what Moore had in mind, it certainly does not help us much towards understanding what he means by calling goodness a non-natural characteristic, and pleasantness, e.g., a natural characteristic. In the first place, the way in which the ethical properties of a thing depend on its non-ethical properties seems to be quite unlike the way in which the remaining properties of a circle depend on its defining properties. In the latter case the dependence is equivalent to the fact that the possession of the remaining properties can be *inferred deductively* from the axioms of Euclid and the presence of the defining properties. But the connexion between the non-ethical bad-making characteristic of being an emotion of delight at another's pain and the ethical characteristic of being morally evil is certainly not of this nature.

Moreover, it is surely quite as evident that pleasantness and unpleasantness are derivative characteristics of an experience as that goodness and badness are. If an experience is pleasant, it is always reasonable to ask: "What *makes* it pleasant?" And the answer will always be to mention some non-hedonic "pleasant-making" characteristic of the experience. E.g., if it is a sensation of taste, the answer might be that it is made pleasant by its sweetness; if it is an auditory experience, the answer might be that it is made pleasant by the way in which various simultaneous and closely successive sounds are combined in it; and so on. Now Moore counts pleasantness as a *natural* characteristic. If he is right in doing so, it is impossible to identify the non-natural characteristics of a thing with the derivative sub-class of those of its characteristics which depend solely on its intrinsic nature. For by that criterion pleasantness would be a non-natural characteristic just as much as goodness.

It seems impossible then to extract from Moore's writings

any satisfactory account of the distinction between "natural" and "non-natural" characteristics. Yet one seems to recognize fairly well what is the extension of these two terms, even if the attempts to define them are not successful. I propose now to try a different line of approach, and to suggest an *epistemological description*, as distinct from a logical definition, of the term "natural characteristic." That is to say, I shall try to delimit the class of natural characteristics, not by stating their intrinsic peculiarities, but by stating how we come to form our ideas of them.

I propose to describe a "natural characteristic" as any characteristic which either (a) we become aware of by inspecting our sense-data or introspecting our experiences, or (b) is definable wholly in terms of characteristics of the former kind together with the notions of cause and substance. I think that this covers every characteristic which would be universally admitted to be natural. It would, e.g., cover yellowness, both in the primary non-dispositional sense in which we use the word when we say, e.g., "That looks yellow to me from here now," and in the secondary dispositional sense in which we use it when we say, e.g., "Gold is yellow." It would also cover psychological characteristics, whether non-dispositional or dispositional. We know, e.g., what is meant by the fear-quality, the anger-quality, etc., through having felt afraid, angry, etc., and having introspected such experiences. And we know, e.g., what is meant by timidity, irascibility, etc., because these dispositional properties are definable in terms of the fear-quality, the anger-quality, etc., together with the notions of cause and substance.

A "non-natural" characteristic would be described epistemologically in negative terms derived from the above-mentioned epistemological description of "natural" characteristics. A characteristic would be non-natural if (a) *no-one* could become aware of it by inspecting his sense-data or introspecting his experiences, and (b) it is *not* definable in terms of characteristics of which one could become aware in those ways together with the notions of cause and substance. These epistemological descriptions of the two kinds of characteristic leave open the question whether goodness is of the natural or the non-natural kind and provide us with a criterion for answering it.

(2) We are now in a position to deal with our second question. What connexion, if any, is there between the doctrine that "good," in its primary sense, denotes a characteristic which is *simple,* and the doctrine that it denotes one which is *non-natural?*

It is plain that our epistemological criteria at once plunge us into certain questions which are important in themselves and are never, so far as I am aware, raised in Moore's writings. If "goodness" is a name for a characteristic, how do we become aware of the characteristic for which it is a name? There is lamentably little discussion on this point in works on ethics.

It seems to me evident that goodness is not a characteristic which we can become aware of by inspecting any of our sense-data; so that in this respect it is utterly unlike yellowness, sweetness, squeakiness, etc., when used in the non-dispositional sense. It is plain that, when "good" is used in its primary sense, it does not denote a characteristic whose presence is revealed to us by sight or touch or taste or hearing or smell, or any other sense that we do have or conceivably might have. It is doubtful whether goodness, in this sense, could belong to sense-data or to physical objects. And, even if it can, it is certain that we do not sense or perceive with our senses the goodness of such objects. At most we perceive with our senses certain natural characteristics which are good-*making*, e.g., certain combinations of colour, of sound, etc., which make the object which possesses them intrinsically good.

It seems equally clear that no simple psychological characteristic, such as we could discover by introspecting our experiences, can be identified with goodness. By introspection we become aware of experiences which are pleasant or unpleasant, toned with desire or with aversion, fearful, hopeful, and so on. Now it is true that goodness, in the primary sense, *can* belong to experiences. Indeed, some people would hold that, in this sense, it can belong to nothing else. Yet I think that a moment's reflexion will show that by calling an experience "good" we do not *mean* that it is pleasant, or that it is an experience of desire or of fear or of hope, or that it has any of the simple psychological qualities which we become aware of through introspecting our experiences.

If anyone were tempted to identify goodness with one of these simple psychological characteristics, I think that he would be doing so through the following confusion. What he really believes is that there is one and only one good-*making* quality of experiences, e.g., pleasantness. He then fails to notice the distinction between *goodness itself* and the one and only *good-making quality* which he recognizes. And so he thinks he believes that "good" and "pleasant," e.g., are just two names for a single characteristic. Since pleasantness certainly is a natural characteristic, he will thus think he believes that "good" is a name for a natural characteristic. But I do not think that the belief that "good" and "pleasant" (e.g.) are two names for one characteristic would survive after the distinction between goodness itself and a good-making characteristic had been pointed out. And similar remarks would apply to any other simple psychological quality which one might be tempted to identify with the characteristic denoted by "good."

So we come to the following conditional conclusion, *If* the word "good," when used in its primary sense, denotes a simple quality, then that quality is almost certainly *not* one which a person could become aware of either by inspecting his sense-data or introspecting his experiences. And, if the characteristic which it denotes be simple, it will not be definable at all, and therefore will not be definable in terms of characteristics which a person might have become aware of in one or other of those ways. Therefore it will be a non-natural characteristic, according to our criterion. So, with our criteria, there *is* an important connexion between the doctrine that "good" is the name of a *simple quality* and the doctrine that it is the name of a *non-natural* characteristic.

This, however, does not settle the question whether "good" is in fact the name of a non-natural characteristic. For it is by no means certain that it is the name of a characteristic at all; and, even if it is so, it is by no means certain that this characteristic is simple. Suppose "good," in the primary sense, were a name for a characteristic which is complex. Would there then be any reason to think it non-natural? I believe that there would. I know of no proposed definition of goodness in purely natural

terms which is in the least plausible. But there are definitions of goodness, containing terms which appear to be non-natural, which are not without plausibility. E.g., it would not be unplausible to suggest that "x is intrinsically good" means that x is something which it would be *right* or *fitting* to desire as an end. And it would appear that "right" or "fitting," when used in this sense, answer to our criterion of being non-natural.

The legitimate conclusion then would seem to be that, if "good" in its primary sense be the name of a characteristic, that characteristic, whether simple or complex, is non-natural. Anyone who saw reason to doubt the existence of characteristics answering to our description of "non-natural" might fairly use this conclusion as the basis of an argument to show that "good" is *not* a name of a characteristic at all.

It will be worth while to develop this line of argument a little further. Is there any way of becoming aware of a simple quality belonging to particulars except by inspecting sense-data or introspecting experiences which have that quality? Many people would say that there plainly is no other way. If they are right, it follows that we could not possibly have an idea of goodness if goodness were a non-natural characteristic. For, if "good" denotes a characteristic at all, it certainly denotes one that belongs to particulars and only to them. If goodness were a simple characteristic and were non-natural, the conclusion that we could not have an idea of it would follow at once from the epistemological principle which these people find self-evident. If goodness were a complex characteristic and were non-natural, the same conclusion would follow, at the second move, from the same principle. We could not have an idea of such a complex characteristic unless we had ideas of all its simple components. By hypothesis one at least of these would be non-natural; and, if the epistemological principle be accepted, we could have no ideas of any such components.

Now, although this epistemological principle does seem to me highly plausible, I am not prepared to accept it (or any other) as self-evident. Therefore I am not prepared to assert dogmatically that no characteristic of which anyone could have an idea could be non-natural. But I do think it important to point

out the following conditional conclusion. *If* goodness be a non-natural characteristic, then anyone's idea of it must be an *a priori* notion or contain *a priori* notions as elements. For an *a priori* notion just is an idea of a characteristic which is not manifested to us in sensation or introspection and is not definable wholly in terms of characteristics which are so manifested. Anyone who holds that goodness is a non-natural characteristic and that he has an idea of it is therefore committed to the belief that there are *a priori* notions and that his idea of goodness is one of them. Now as we have seen, if "good" denotes a characteristic at all, the characteristic which it denotes is almost certainly non-natural. Therefore anyone who holds that "good" denotes a characteristic, and that he has an idea of the characteristic which it denotes, will be almost compelled to hold that there are *a priori* notions, and that his idea of goodness is or contains one of them.

There is one other epistemological point to be noticed in conclusion. Suppose a person regards goodness as a non-natural characteristic, and admits that its presence is always dependent on the presence of certain natural characteristics which are good-making. Suppose, further, that he holds that the connexion between a good-making characteristic and the goodness which it confers is *necessary*. Then he will be obliged to hold that there are *synthetically necessary* facts, and that he knows some of them. He will therefore be obliged to admit that he can make *synthetically a priori* judgments. The necessary connexion between those natural characteristics of a thing which are good-making and the goodness which they confer on it could not possibly be analytic. For this would involve the absurdity that the *non-natural* characteristic of goodness is contained as a factor in the analysis of the purely *natural* good-making characteristics.

Now it is fashionable at present to hold that all necessary connexion must be analytic and that there can be no synthetic *a priori* judgments. I do not find this principle in the least self-evident myself, though I think that it has enough plausibility and interest to justify a strenuous attempt to see whether it can be successfully applied in detail. Anyone who does accept it, and also holds that "good" is a name for a characteristic, will

be compelled to draw one or other of the following conclusions. Either (a) goodness is a *natural* characteristic, or (b) the connexion between the good-making characteristics of a thing and the goodness which they confer on it is purely *contingent* and can be known only empirically. He might, of course, consistently combine both these conclusions, as Hume did. For Hume's doctrine, stated very roughly, was (a) that to be good means to be an object of emotions of approval in all or most men, and (b) that it is a contingent and empirically known fact that such emotions are called forth by what is believed to be pleasant or useful and only by objects which have that property.

C. D. BROAD

TRINITY COLLEGE
CAMBRIDGE UNIVERSITY

2

Charles L. Stevenson

MOORE'S ARGUMENTS AGAINST CERTAIN FORMS OF ETHICAL NATURALISM

MOORE'S ARGUMENTS AGAINST CERTAIN FORMS OF ETHICAL NATURALISM

IN the third chapter of his *Ethics*,[1] Moore gave several arguments to show that "right" and "wrong" do not refer merely to the feelings or attitudes of the person who uses them. During the thirty years that have since elapsed, he has become more and more sensitive to the flexibilities of ordinary language, and I doubt whether he would still maintain that "right" and "wrong" are *never* so used. But perhaps he would still take seriously the view that *if* a man uses these terms in that way, he is not using them in any sense that is relevant to the issues with which moralists usually deal. Interpreting some of his arguments in a way that makes them support this latter contention, I wish to determine how much they prove.

The contention of the arguments, stated more formally, is that the definitions,

D1: "X is right" has the same meaning as "I approve of X," and

D2: "X is wrong" has the same meaning as "I disapprove of X,"[2] where "I" in the definiens is to be taken to refer to whoever uses the terms defined, are definitions which distort or ignore the senses that are of most importance to normative ethics.

If Moore's arguments were successful in proving this con-

[1] Henry Holt and Co., N.Y., 1912.

[2] The words "approve" and "disapprove" may be taken to designate feelings which the speaker *tends* to have, thereby permitting him to speak truthfully about his present approval or disapproval even though he has no strong immediate feelings at the time. Moore has mentioned this in connection with Westermarck, in *Philosophical Studies*, 332.

tention, they would undoubtedly be of interest. There is presumably some roughly intelligible sense, or set of senses, in which not only professional writers on normative ethics, but also "amateur moralists" of all sorts, are earnestly trying to decide what is right or wrong, and to argue such matters with others. These people would be helped by definitions which freed their usage of "right" and "wrong" from confusions. They would not be helped, however, by definitions which made these terms refer to something quite foreign to the issues which, confusedly envisaged though these may be, are troublesome to them. If D1 and D2, above, did this and if they were insistently introduced into any ordinary ethical argument, they might only lead people to "change the subject" of their argument; and might do so in a way that would escape attention, because the old words would still be used. They might be "issue-begging" definitions.

This consideration is not, of course, unanswerable. A theorist might reply that the way in which people usually use "right" and "wrong" is *totally* confused—that no clear issue could ever be salvaged from the ordinary sort of ethical argument. He might then wish to *give* the terms a meaning in accordance with D1 and D2, not hoping to remain "faithful" to the confusions of common usage, but hoping rather to shock people into realizing that if they do not use his sense, or naturalistic ones like it, they will be dealing with pseudo-problems. In the same way a behaviorist might define "soul" in terms of processes in the higher nervous system. His purpose (whatever one may think of it) would presumably be to shock people into believing, with him, that "soul" must either mean something like this or else be a label for a confusion.

One *might* proceed in that way, but I for one do not wish to do so. Although ethical terms are used in a manifestly confused way, it is certainly ill-advised to cry "*total* confusion" until all alternatives are carefully tested. It is well, in beginning, to assume that the ethical terms, as usually used, are *not* totally confused. This assumption will lead us to *look for* some salvageable element in their usage. Unless we look for it, we cannot be sure whether or not it exists, and whether or not that very

element is the one which presents normative ethics with its most characteristic difficulties. So let us assume, at least for the present, that ethical terms are not totally confused; and let us further assume that *if* Moore's arguments correctly prove his contention—if D1 and D2 distort or ignore the senses that are most interesting to writers on moral matters—then these definitions are question-begging, and productive of greater confusion, rather than of more clearly envisaged issues.

The first argument may be formulated, without significantly altering the force of Moore's own words,[3] as follows:

(1) It may happen that one man, A, approves of X, and another man, B, disapproves of X.

(2) Thus according to D1 and D2, above, A may say "X is right," and B, "X is wrong," and both be telling the truth.[4]

(3) Hence if "right" and "wrong" are used in accordance with D1 and D2, X may be both right and wrong.

(4) But if "right" and "wrong" are used in any typical ethical sense, then X cannot be both right and wrong. (This is evident to "inspection."[5])

[3] *Ethics*, 91: "If, whenever I judge an action to be right, I am merely judging that I myself have a particular feeling towards it, then it plainly follows that, provided I really have the feeling in question, my judgment is true, and therefore the action in question really is right. And what is true of me, in this respect, will also be true of any other man. . . . It strictly follows, therefore, from this theory that whenever *any man whatever* really has a particular feeling towards an action, the action really is right; and whenever *any man whatever* really has another particular feeling towards an action, the action really is wrong." And, 93: "If we take into account a second fact, it seems plainly to follow that . . . the same action must be quite often both right and wrong. This second fact is merely the observed fact, that it seems difficult to deny, that, whatever pair of feelings or single feeling we take, cases do occur in which two different men have opposite feelings towards the same action."

[4] According to the usual conventions of logic, an "X" may not undergo substitution when it occurs between quotation marks. For the present, however, I wish "X" to be used in a different way. If the reader should erase the mark "X," whether it occurs between quotation marks or not, and replace it, *throughout*, by some one name of a particular action, with the assumption that that name is perfectly unambiguous, he would then have the sort of argument which I intend. This explanation will serve to indicate what I mean in saying that "X is right" may tell the truth. I simply mean that that expression, when the first letter of it is replaced by a name, may tell the truth.

[5] *Ethics*, 86f.

(5) Therefore the sense ascribed to "right" and "wrong" by D1 and D2 is not any typical ethical sense.

Criticism of the first argument must be concerned with the way in which Moore can get to step (3). Is it possible, using innocent premises and valid logic, to prove that if "right" and "wrong" are used in accordance with D1 and D2, X may be both right and wrong? We may properly suspect that it is not possible, simply because a quite different conclusion may be derived from D1 and D2. The last part of (3), namely,

(a) X may be both right and wrong,

becomes equivalent by D1 and D2 (as can be seen by simple substitution, with only trivial grammatical changes) to

(b) I may both approve and disapprove of X.

This latter statement can, within the limits of linguistic propriety, be taken as a contradiction. Hence D1 and D2 imply that (a) may be taken as a contradiction. One may accordingly urge that

(3x) If "right" and "wrong" are used in accordance with D1 and D2, X cannot possibly be both right and wrong.

Note that this conclusion, so far from pointing to a way in which D1 and D2 distort ordinary usage, point to a way in which they are faithful to it. Note further that if we should accept both (3x) and also Moore's (3), we should have to conclude that D1 and D2 imply the contradiction that X may and also cannot possibly be both right and wrong. Now whether or not D1 and D2 distort ordinary usage, it is scarcely plausible that such innocent definitions should imply so flagrant a contradiction. Hence, if we accept the derivation of (3x), we may properly suspect some error in Moore's derivation of (3).

One *need* not, of course, maintain that (b) above is a contradiction; and since we habitually try to make consistent sense out of any utterance, we might be led to more charitable interpretations. We might take it as a paradoxical way of saying, "I may approve of certain aspects of X, and also may disapprove of other aspects of it;" or we might take it as testifying to a possible conflict of attitudes—a paradoxical way of saying, "Certain of my impulses may lead me to approve of X, but others may lead me to disapprove of it." But if we are content

to make these more charitable interpretations of (b), may we not make similarly charitable interpretations of (a), and so proceed to question (4) in the argument? If there is any reason against this, Moore certainly leaves it unmentioned. And in any case there is certainly one way, and a linguistically appropriate way, of interpreting (b) as a contradiction; hence for one use of the definiens, D1 and D2 have not been shown to distort ordinary usage. The definitions may still be objectionable, but Moore's first argument has by no means shown that they are.

It is interesting to see just where Moore's derivation of (3)—in my own, but I think faithful, statement of his first argument—is invalid. This step seems to follow from (2), which in turn is perfectly correct; but it seems to follow only because of a confusion about pronouns.[6] In (2), which reads, "According to D1 and D2, A may say, 'X is right', and B may say, 'X is wrong', and both be telling the truth," the words "right" and "wrong" occur in direct quotations. Hence the word "I," which by D1 and D2 is implicit in the use of the ethical terms, is appropriately taken as referring not to Moore, or any one speaker, but rather to the people quoted as having judged that X was right or wrong. The "I" implicit in "right" refers to A, and the "I" implicit in "wrong" refers to B. But in (3), which may be abridged as, "According to D1 and D2, X may be both right and wrong," the words "right" and "wrong" are not quoted by Moore as having been used by somebody else. Hence by D1 and D2 themselves, which are to the effect that ethical terms refer to the speaker who uses them (as distinct from a speaker who quotes how others used them) the implicit "I" in (3) refers not first to A and then to B, but rather to Moore, or whoever it is that says "X may be both right and wrong." Briefly, the implicitly quoted "I's" in (2) do not refer to the same person as the implicit and unquoted "I's"

[6] The confusion is one which often attends the use of what Dr. Nelson Goodman has called "indicator words." My criticism of Moore's first argument is largely a matter of applying Goodman's work to a special case. See Chapter XI of his *A Study of Qualities*, a doctoral dissertation now available only at the Widener Library, Harvard, but which is to be published by the Harvard University Press.

refer to in (3). By assuming that they do, Moore makes an invalid step in his argument appear valid.

This point can helpfully be put in another way. It would seem that

(a1) If "X is right," said by A, is true, then X is right; and that

(a2) If "X is wrong," said by B, is true, then X is wrong. And it is certainly true that *if* (a1) and (a2) were both true, and *if* their antecedents could both be true, then their consequents could both be true. Thus if D1 and D2 entitled one to accept (a1) and (a2) and also entitled one to accept as possible the conjunction of their antecedents, it would entitle one to accept as possible the conjunction of their consequents, or in other words, to assert that X might be both right and wrong. This is what Moore, by (3), seems to maintain, in part. But unfortunately for Moore's argument, D1 and D2 entitle one to accept *neither* (a1) *nor* (a2). For by D1, (a1) is like:

If "I approve of X," said by A, is true, then I approve of X. And by D2, (a2) is like:

If "I disapprove of X," said by B, is true, then I disapprove of X.

And neither of these statements is true, so long as the quoted "I's" in the antecedents each have a different referent from that of the unquoted "I's" in the consequents. It will thus appear that Moore, who tacitly presupposes (a1) and (a2) in getting from step (2) to step (3) in his argument, fails to show that D1 and D2 lead to what, for ordinary usage, would be an absurdity. In the course of showing the alleged absurdity, he unknowingly rejects an implication of these definitions on the falsity of (a1) and (a2), and so, in effect, *rejects* the definitions in the very course of an argument that tries to show the absurdity of what their *acceptance* would imply.

If D1 and D2 had read, respectively,

"X is right" has the same meaning as "*Somebody* approves of X," and

"X is wrong" has the same meaning as "Somebody disapproves of X,"

where the "somebody" could be a different person in each case,

then Moore would be entitled to step (3), and his argument would be correct in showing that *these* naturalistic definitions distort ordinary usage, so long as (4) is granted. But in showing merely that, he would leave untouched the far more interesting definitions that D1 and D2 actually provide. Moore's own words,[7] but in words which are faithful, no doubt, to D2, A may say, "X is right," and B, "X is wrong," and both be telling the truth. And it may be that Moore could proceed *in another* way from that point on to show that these definitions violate ordinary ethical usage. But the only other plausible way, I think, is that which Moore himself develops in his third argument, as here listed; and that must be discussed in its proper place.

The second argument may be formulated, again not in Moore's own words,[7] but in words which are faithful, no doubt, to their import, as follows:

(1) A may be telling the truth if he says, "I now approve of X, but I formerly disapproved of X."

(2) Hence, by D1 and D2, A may be telling the truth if he says, "X is now right, but X was formerly wrong."

(3) But in any sense of "right" and "wrong" that is typically

[7] *Ethics*, 97: "An action . . . [which a man] formerly regarded with . . . disapproval, he may now regard with . . . approval, and *vice versa*. So that, for this reason alone, and quite apart from differences of feeling between different men, we shall have to admit, according to our theory [i.e., the definitions criticized in the argument in question] that it is often *now* true of an action that it *was* right, although it was formerly true of the same action that it *was* wrong."

I have tried to preserve the force of these words in steps (1) and (2) of my formulation of the argument. It will be obvious that I have taken liberties; but Moore's words become so entangled with the tense of verbs, as well as with "now" and "formerly," and the notion of "truth at one time but not another," that a more complete investigation into what he actually may have meant would be impossible in limited space. The notion of "truth at a time," together with the other sources of confusion, are exhaustively analyzed by Goodman, though without any specific reference to Moore, in the work mentioned in note 6, above; and the reader interested in pursuing these matters will do well to refer to that work. Meanwhile I can only dogmatize in saying that if I had been more faithful to Moore's words, I should have had more fallacies to untangle than my present formulation of the argument involves.

Steps (3) and (4) in my formulation are parallels to the remarks in *Ethics*, 86, and 81ff.

ethical, A may *not* tell the truth in saying "X is now right but X was formerly wrong." This could truthfully be said, perhaps, if each "X" in the statement referred to a *different* action of the *same kind*, for a present and former X could have different consequences; but it would be contradictory, in any ordinary sense of terms, if "X" referred throughout, as is here intended, to the very same action. (This is evident to "inspection.")

(4) Therefore the sense ascribed to "right" and "wrong" by D1 and D2 is not any typically ethical sense.

Criticism of the second argument must be concerned with the derivation of step (2). This seems to follow directly from (1) by substitution in accordance with D1 and D2; but in fact it also requires "corrollaries," so to speak, of D1 and D2, namely:

D1c: "X was (formerly) right" has the same meaning as "I (formerly) approved of X," and

D2c: "X was (formerly) wrong" has the same meaning as "I (formerly) disapproved of X."

These definitions differ from D1 and D2 only in that the temporal reference, in both definiendum and definiens, is shifted from present to past.[8] It is readily obvious that (2) follows from (1), granted that D1 and D2 are taken to have the above "corrollaries," and since I accept the remainder of the argument (though not without hesitations about (3)), I accept the argument. But I do so *only* with the proviso that D1c and D2c are understood to be implied by D1 and D2.

Now it is certainly a natural thing to assume that D1 and D2 *do* imply D1c and D2c. But there is another possibility which is of no little interest. One might insist that "right" and "wrong" always refer to the attitudes that the speaker has *at the time that he uses the words*. Any temporal reference in a sentence that includes these words might always be taken as referring to the time at which the action said to be "right" or "wrong" *occurred*, rather than to the time at which it was *approved*. Such a view is provided by the following definitions, which are revised versions of D1 and D2:

[8] In point of fact, only D2c is needed for the inference from (1) to (2), together with D1; but I list D1c as well simply because the argument could so easily be recast in a way that would require it.

D3: "X $\left\{ \begin{array}{l} \text{is} \\ \text{was} \\ \text{will be} \\ \text{would be} \\ \text{etc.} \end{array} \right\}$ right" has the same meaning as "I now approve

of X, which $\left\{ \begin{array}{l} \text{is} \\ \text{was} \\ \text{will be} \\ \text{would be} \\ \text{etc.} \end{array} \right\}$ occurring."

D4: "X $\left\{ \begin{array}{l} \text{is} \\ \text{was} \\ \text{will be} \\ \text{would be} \\ \text{etc.} \end{array} \right\}$ wrong" has the same meaning as "I now disapprove

of X, which $\left\{ \begin{array}{l} \text{is} \\ \text{was} \\ \text{will be} \\ \text{would be} \\ \text{etc.} \end{array} \right\}$ occurring."

Note that by these definitions one cannot say anything equivalent to "I approved of X" by using "right," unless, perhaps, in such an idiom as "I used to feel X to be right."

It is easy to see that if the second argument were rewritten with references to D1 and D2 replaced by references to D3 and D4, the argument would not be valid. (2) would then not follow from (1). For the statement,

X is (now) right, but X was formerly wrong

would be equivalent, according to D3 and D4, with direct substitution, to,

I now approve of X, which is occurring (now), but I now disapprove of X, which was occurring formerly.

This latter statement could not be true, either on account of the incompatible attitudes asserted or because of the impossibility of making X refer to the same action.[9] Hence the former state-

[9] I am assuming (as one common idiom, at least, permits me to) that the time taken in uttering this sentence is not sufficient to prevent the "nows" from referring all to the same time, and is not sufficient to justify the change in tense from "is" to "was."

ment, being equivalent to the latter, could not be true. But according to (2), in the rewritten argument, the former statement *might* be true; for (2) would read:

By D3 and D4, A may be telling the truth if he says, "X is now right but X was formerly wrong."

Hence (2), being false, could not follow from the innocent premise, (1); and with the collapse of (2) comes the collapse of the remainder of the argument.

Accordingly, although Moore's second argument holds against D1 and D2, provided that certain rather natural assumptions are made about the temporal references involved, it does not hold against D3 and D4, which specifically rule out such assumptions. Since Moore thinks that his argument holds against *any* definition that makes "right" and "wrong" refer solely to the attitudes of the speaker, it is clear that he presses the argument for more than it is worth.

I do not wish to defend D3 and D4 as they stand; for on grounds different from Moore's I consider them misleading, and likely to make people overlook the central issues of ethics. But I do wish to defend these definitions from *Moore's* objections. By so doing I shall be free, as I otherwise should not, to amend the definitions in a very simple way, quite without mention of non-natural qualities, and thereby make them give (as closely as the vagueness of ordinary usage will allow) *one* sense, at least, that I consider to be typically ethical. This will be explained later.

There is one curious consequence of D3 and D4, suggested by Moore's second argument, which may more plausibly cast doubt on the conventionality of these definitions. If A, speaking at t1 should say,

(a) X is right,

and speaking at a later time, t2, should say,

(b) X was wrong,

then his second statement *would not contradict* the first. For by D3 and D4, (a) and (b) would become,

(aa) I now approve of X, which is occurring, and

(bb) I now disapprove of X, which was occurring.

These statements, if A makes them, respectively, at t1 and t2, are

compatible: for the "now" in (aa) would not refer to the same time as the "now" in (bb). And "X" might designate (as it must to make these considerations of interest) the very same action in both statements; since the change from "is occurring" in (aa) to "was occurring" in (bb) would testify to nothing more than that t1, at which (aa) was said, was earlier than t2, at which (bb) was said. Hence, since (aa), said by A at t1, would be compatible with (bb), said by A at t2, it follows, by D3 and D4, that (a), said by A at t1, is compatible with (b), said by A at t2. And *if* (a) and (b) are not compatible, under any circumstances of utterance, so long as "right" and "wrong" are used in any typical ethical sense, then it *would* follow that D3 and D4 do not preserve any typical ethical sense. But is it so obvious that (a) and (b), uttered in the way mentioned, are not compatible? My "inspection" is not so final on this matter as Moore's might be; but further discussion of this point will be easier after we deal with the third argument, to which we must now turn.

The third argument[10] may be formulated as follows:

(1) If A says, "I approve of X," and B says, "I do not approve of X," their statements are logically compatible.

(2) Hence, by D3 and D4,[11] if A says, "X is right," and B says, "X is not right," their statements are logically compatible.

(3) Thus, according to D3 and D4, if A says, "X is right," and B says, "X is not right," A and B, so far as these statements show, do *not* differ in opinion.

[10] *Ethics*, 100ff.: "If, when one man says, 'This action is right', and another answers, 'No, it is not right', each of them is always merely making an assertion about *his own* feelings, it plainly follows that there is never really any difference of opinion between them: the one of them is never really contradicting what the other is asserting. They are no more contradicting one another than if, when one had said, 'I like sugar', the other had answered, 'I *don't* like sugar'. . . . And surely the fact that it [the type of analysis under consideration] involves this consequence is sufficient to condemn it."

[11] In point of fact, only D3 should be mentioned, since the argument does not use the word "wrong" which D4 defines. But I mention D4 simply because the argument could so easily be rewritten, using "wrong" instead of "right," with no effect on its validity or invalidity. D1 and D2 might also have been referred to, since the argument, if it holds at all, would hold against any definition that made ethical terms refer solely to the speaker's own attitudes.

(4) But if A says, "X is right," and B says, "X is not right," then, in any typical sense of the terms, they *do* differ in opinion, so far as these statements show.

(5) Therefore D3 and D4 do not give any typical ethical sense of the terms they define.

Criticism of the third argument must be concerned with the inference from (2) to (3), and with the truth of (4). The inference from (2) to (3) is one that Moore would justify, no doubt, by the assumption:

(a) When A and B each make an ethical statement, they differ in opinion, so far as these statements show, only if their statements are logically incompatible.

Now clearly, if "A and B differ in opinion" is taken as just another way of saying "A and B have beliefs which, if they expressed them verbally, would lead them to make incompatible statements," then (a) above is true. Let us assume that Moore intends "differ in opinion" to be understood in this sense, and that he is therefore entitled to go from (2) to (3) in the argument, *via* (a). In that case we must, in order to make the argument valid, assume that (4) in the argument uses "differ in opinion" in this same sense. And the force of my criticism is that (4), so interpreted, is by no means obvious.

It *is* obvious, I grant, that in any typical ethical sense, when A and B assert "X is right" and "X is not right," respectively, they are in *some* sense differing or disagreeing. But I do not grant that A and B must, in that case, be "differing in opinion" in the sense of that phrase that we are assuming Moore to intend. I think Moore was led falsely to affirm (4) simply because, due to an exaggerated emphasis on the purely cognitive aspects of ethical language, he could not understand how people could differ or disagree in any sense without differing in opinion in the narrow sense above defined.

The sense in which A and B, asserting "X is right" and "X is not right," respectively, clearly do "disagree," is a sense which I shall preserve by the phrase, "disagree in attitude." A and B will be said to disagree in attitude when they have opposed attitudes to something, and when at least one of them is trying to alter the attitude of the other. I have elsewhere argued

that disagreement in this sense is highly typical of ethical arguments, hence I shall not elaborate that point here.[12] It will be enough to point out that disagreement in attitude often leads to *argument*, where each person expresses such beliefs as may, if accepted by his opponent, lead the opponent to have a different attitude at the end of the argument. Attitudes are often functions of beliefs, and so we often express beliefs in the hope of altering attitudes. Perhaps Moore confused disagreement in attitude with "difference of opinion," and this confusion led him to assert (4).

Of course "difference of opinion" *might* be understood to mean the same as "disagreement in attitude;" but if Moore intended that, he would not be entitled to go from (2) to (3), and the third argument would still fail, even though (4) would then be true.

Note that when people disagree in attitude, neither need have any false belief about his own or the other's attitude. If A says, "X is right," and B says, "X is not right," and both accept D3, then it is quite possible that A and B should *both* know that A approves of X and that B does not. They may disagree in attitude none the less. They are not describing attitudes to one another—not, in Frank Ramsey's phrase, "comparing introspective notes." Neither is exclusively interested in knowing the *truth* about the other's *present* attitudes. Rather, they are trying to *change* each other's attitudes, hoping that later on their attitudes will be of the same sort. It is not necessary for their ethical judgments to be logically incompatible if they are to indicate disagreement in attitude.

Granted, then, that one has an introspective feeling that verbally-seeming incompatible judgments about right and wrong are actually incompatible, this feeling might testify only to the presence of disagreement in attitude, rather than to logical incompatibility. Or perhaps the fact that people who disagree in attitude often do, as well, make incompatible assertions about the consequences of the object of attitude, etc., in the course of their argument, may lead one to feel, without warrant,

[12] "The Emotive Meaning of Ethical Terms," *Mind*, Vol. XLVI, n.s., No. 181. I here use "attitude" where I there used "interest."

that the ethical judgments themselves, in any typical sense, must be incompatible. In my opinion, the ethical terms are in fact used so vaguely that people *have not decided* whether "X is right," said by A, and "X is not right," said by B, are to be taken as incompatible or not; nor will Messrs. A and B be likely to have decided it. So *we* may decide it either way we like, so long as we are faithful to the issues which ethical arguments usually raise. We may, under certain circumstances of utterance, though not all, make the judgments incompatible. I have dealt with this in my paper, "Persuasive Definitions,"[13] and have here only time to say that such a procedure can be developed in a way that avoids Moore's objections. On the other hand, we may make the judgments, uttered by A and B respectively, logically compatible, as is done by D3 and D4. Either alternative, so far as I can see, will permit the ethical terms to raise the issues which ethical arguments usually raise in common life, though of course they do not permit the terms to be used in the way that some philosophers, in their confusion, may want to use them. I can pretend to no super-human certainty on this last point, of course, nor can I here expatiate as I should like; but I hope I have said enough to show that D3 and D4 present serious alternatives to Moore's non-natural quality.

I must add, however, that D3 and D4 are misleading in that they do not properly suggest disagreement in attitude. They suggest too strongly a mere "comparing of introspective notes." But this can be remedied by qualifying D3 and D4, as promised on page 80, in a very simple way. "Right," "wrong," and the other ethical terms, all have a stronger emotive meaning than any purely psychological terms. This emotive meaning is not preserved by D3 and D4, and must be separately mentioned. It has the effect of enabling ethical judgments to be used to alter the attitudes of the hearer, and so lends itself to arguments that involve disagreement in attitude. So qualified, D3 and D4 seem to me to be immune from all of Moore's objections.

The consideration that was perplexing on page 80f.—namely, that "X is right," said by A at t1, is logically compatible accord-

[13] *Mind*, Vol. XLVII, n.s., No. 187.

ARGUMENTS AGAINST ETHICAL NATURALISM 85

ing to D3 and D4 with "X was wrong," said by A at t2—can now be explained. It is clear that in any typical sense these statements are "opposed" in some way; but I think it is well within the limits of vague common usage to say that the statements, under the circumstances of utterance mentioned, may be taken as logically compatible, just as D3 and D4, qualified by reference to emotive meaning, would imply. Their *seeming* incompatibility springs from the fact that the judgments exert a different sort of emotive *influence*—that the judgment at t2 undoes the work of the judgment at t1. For instance, if B was led by A's judgment at t1 to agree in attitude with A, he may, if he has not subsequently changed his attitude, find himself disagreeing in attitude with A at t2. So in a rough but intelligible way of speaking, B may properly charge A with "going back on" his former "opinion." But we need not insist that this ready way of speaking maintains that A's statement at t1 was logically incompatible with his statement at t2. May it not be taken to mean that A has come to have an attitude, and to exert an influence, which oppose his former attitude and influence?

It will now be clear that none of the arguments I have criticized is conclusive. Moore's *method* of argument, as I have freely interpreted it, is very useful. It consists of drawing consequences from a proposed definition, and then showing that these consequences are "odd" according to any *usual* sense of the word defined. This "oddness" may suggestively raise the question as to whether the proposed definition is issue-begging. But although the method is useful, it may be misapplied, either in drawing the consequences of the proposed definition, or in judging whether these consequences show that the proposed definition is likely to beg issues. I think that Moore has misapplied the method throughout, in one or another of these ways.

Although Moore's arguments do not prove as much as he thinks (or at least, as much as he thought when writing the *Ethics*), they are by no means useless. I hope that his repudiation of much of *Principia Ethica*[14] will not be interpreted by

[14] See "Is Goodness a Quality," in *Aristotelian Society, Supplementary Volume,* XI, 127.

careless critics as implying that his work in ethics has gone for nothing. However much Moore himself may have been misled by language, he is much more sensitive to its pitfalls than many of his naturalistic opponents, and some of his arguments help one to realize this. In the second and third arguments we have found that D_1 and D_2 cannot be accepted without qualification. Explicit recognition must be added about the confusing character of tense in ethical judgments, of disagreement in attitude, and of emotive meaning. Naturalistic analyses which are content to ignore these matters—which indeed they all were at the time that Moore wrote—are insensitive in a way that the second and third arguments help to point out.

Lest I myself be accused of linguistic insensitivity, I wish to emphasize that D_3 and D_4 require further qualifications than those which I have here given. "Right" and "wrong," being particularly vague and flexible, may be defined in any number of ways, quite within the limits of that muddy continuum which we call "ordinary usage." No *one* definition can possibly deal with their varied usage; and perhaps no *list* of definitions, however long, would be adequate. All that one can do is give "sample" definitions, and then hope to avoid confusion by coming more adequately to understand (as I.A. Richards has so often urged) the flexibility of ordinary language.

In particular, "right" and "wrong" are subject to changes in meaning with different contexts. For instance, when we ask someone the *question*, "Is X right?," we do not usually want the hearer to tell us whether *we* now approve of X, as D_3 and D_4 might readily suggest. We should be more likely to want the hearer to say whether *he* approves of X, and to influence us with regard to our subsequent approval. Or we might want to know what attitudes others have to X, and so on. Or, if we know to begin with that the hearer approves of X, we may use the question "Is X right?" to insinuate that it isn't, and so to indicate that we disagree with the hearer in attitude—a disagreement that may later lead to an argument, in which many beliefs would be expressed of a sort that might lead, as a matter of psychological fact, to the alteration of our own or of our opponent's attitude. And again: if a man is "trying to decide"

whether X is right, he is usually not merely trying to characterize his present attitudes. Such a decision would usually be forced upon him by a conflict of attitudes, and would arise in the course of his efforts to resolve the conflict. It would introduce factual considerations, of precedent, the attitude of society, the nature and consequences of X, etc., that may determine whether or not he will subsequently attain a state of mind in which he approves of X, with all impulses to the contrary being repressed or redirected. These are cases in which "right" is used in a way that varies, greatly or slightly, from the way in which D3 would suggest. They are a few instances among the many which show that D3 and D4 must be taken only as "sample" definitions.

But although only "sample" definitions, D3 and D4, qualified by reference to emotive meaning, are for many purposes very interesting samples. I wish to show that they have consequences which may account for certain of Moore's own conclusions:

It seems quite likely, judging from parallel remarks in *Principia Ethica*, page 7, that Moore would deny that

"If I now approve of X, X is right"

is an analytic statement, in any usual sense of words. By D3 this is analytic; and I am prepared to accept that consequence, and at the same time to insist that D3 is as conventional as any precise definition of a vague common term can be, *if* D3 is qualified with reference to emotive meaning. What I do not admit, however, is that the statement is *trivial*, in the way most analytic statements are. The emotive meaning of "right," in the above statement, might serve to induce the *hearer* to approve of X, provided the speaker does. Any hearer who does not want to be so influenced may accordingly object to the statement, even though it is analytic. Although trivial in regard to its cognitive aspects, the statement is not trivial in regard to its repercussions on attitudes; and one may refuse to make it, as I should, very often, for that reason. There are times when I, and all others, wish to induce others to share our attitudes; but few of us want to do so for every case, or to act as though the hearer is expected to agree with us in attitude even before we

assert more than hypothetically what attitude we ourselves have. For that reason the above statement would rarely be made. That is far from what Moore would conclude, but I think it may explain why Moore, consciously sensitive only to the cognitive aspects of language, should insist that the judgment in question, not being trivial, could not be analytic.

In the *Ethics*, 131, Moore makes some penetrating remarks. He mentions, with apparent agreement, certain theorists who

have assumed that the question whether an action *is* right cannot be completely settled by showing that any man or set of men have certain feelings . . . about it. They would admit that the feelings . . . of men may, in various ways, have a bearing on the question; but the mere fact that a given man or set of men has a given feeling . . . can, they would say, never be sufficient, *by itself*, to show that an action is right or wrong.

With this I entirely agree, and in fact it is implied by D3 and D4, provided these definitions are qualified by reference to disagreement in attitude and emotive meaning. To settle a question about "what is right," is presumably (for this context) to settle a disagreement that may exist between A and B, when the former maintains "X is right," and the latter maintains "X is not right." This disagreement is a disagreement in *attitude*, and will be settled only when A and B come to have similar attitudes. Should any other people take sides with A or B, the settlement of the argument would require these people as well to end by having similar attitudes. Now one cannot hope to bring about such a uniformity of attitudes merely by pointing out what any one man or set of men actually do approve of. Such a procedure may, as Moore says, "in various ways have a bearing on the question," but a knowledge of what any man approves of *may* totally fail to alter the approval of some other man. If approval is to be altered by means of beliefs, all manner of beliefs may have to be utilized. One may, in fact, have to make use of all the sciences; for the beliefs that will collectively serve to alter attitudes may be of all different sorts; and even so, one cannot be guaranteed success in altering them by this means. It is for that reason that the support of an ethical judgment is so very difficult. To support ethical judgments is not

merely to prove their truth; it is to further, *via* changes in beliefs, for instance, the influence which they exert. I accept the above quotation from Moore, then; but it will be obvious how very different my own reasons are.

I wish to make clear that, although an analysis along the lines of D3 and D4, with reference to emotive meaning and disagreement in attitude, stands as an alternative to Moore's non-naturalistic views, it does not positively disprove the view that "right," whether directly or indirectly, has to do with a non-natural quality. What Moore would now say about "right" I do not know, but he *could* say, without rejecting emotive meaning or disagreement in attitude, that "X is right" sometimes means that X has some quality, or is related to something else that has some quality, which is wholly inaccessible to discovery by scientific means. "Right" could then be granted an emotive meaning, but only because it designates such a quality. If the quality is assumed to be one that arouses approval, its name would acquire a laudatory aura. And people could be acknowledged to disagree in attitude about what is right, but only because they approve or do not approve of something, depending on whether or not they believe that this quality is in some way connected with it. If Moore wishes to maintain this, and if he actually is confident that he encounters this quality in his experience or "intuition," and if he is sure that the quality is non-natural, then I cannot pretend to have said anything here which is likely to convince him to the contrary—even though I should privately suspect him of building up elaborately sophisticated fictions in the name of common sense. I do contend, however, that if Moore is to support such a view, he must argue for it in a more positive way. He cannot hold it up as the only alternative to manifest weaknesses of naturalism. The kind of naturalism which he was combatting, which ignores disagreement in attitude and emotive meaning, does indeed require an alternative; but unless new arguments can be found to the contrary, such an alternative can be developed along the lines I have here suggested.[15]

[15] For analyses which closely resemble the one I defend here, see: A. J. Ayer's *Language, Truth and Logic*, Ch. VI; B. Russell's *Religion and Science*, Ch. IX;

The present alternative, I must add, is far from crying that ethical judgments represent a "total confusion." To ascribe to a judgment a meaning that is partly emotive is by no means to insist that it is confused. Should emotive meaning be taken for something that it is not, that would indeed be a confusion; but if emotive meaning is taken for what it is, it remains as an unconfused part of the meaning that ethical judgments manifestly do have. Nor does this type of analysis imply the curious view that ethical issues are "artificial." Issues that spring from disagreement in attitude, so far from being artificial, are the very issues which we all have overwhelmingly compelling motives for resolving. None of us is so remote from society that he can survey the divergent attitudes of others without feeling insurmountable urges to take sides, hoping to make some attitudes preponderate over others. We are none of us "isolationists" on *all* matters, simply because what others do and approve of doing is so often of near concern to us. I have here, temporarily, suspended any taking of sides on moral matters; but that is only to keep my *analysis* of moral judgments distinct from any efforts of mine to exert a moral influence. This temporary detachment in no way implies—as it is scarcely necessary to insist—that I consider ethical issues to be artificial, or that I maintain, with gross paradox, that it is wrong to discuss what is right or wrong.

<div align="right">CHARLES L. STEVENSON</div>

DEPARTMENT OF PHILOSOPHY
YALE UNIVERSITY

W. H. F. Barnes's "A Suggestion about Values," in *Analysis*, Mar., 1934; C. D. Broad's "Is 'Goodness' a Name of a Simple, Non-natural Quality," in *Proceedings of the Aristotelian Society*, 1933-4 (where acknowledgment is given to Duncan Jones); and R. Carnap's *Philosophy and Logical Syntax*, Sect. 4.

3

William K. Frankena

OBLIGATION AND VALUE IN THE
ETHICS OF G. E. MOORE

3

OBLIGATION AND VALUE IN THE
ETHICS OF G. E. MOORE

G. E. MOORE in 1903 thought of himself as enunciating certain "principles of ethical reasoning" which had been neglected by most previous moralists and which should serve as "prolegomena to any future ethics that can possibly pretend to be scientific."[1] These principles are the following:

1. Moralists must distinguish three questions: (a) What is meant by 'good'?, (b) What things are good in themselves?, or, What things ought to exist for their own sakes?, and (c) What actions ought to be done?[2]

2. They must also distinguish between means and ends, or between what is good as a means and what is good as an end; and between the relation of means to end and the relation of part to whole.[3]

3. Intrinsic goodness is a simple, indefinable, non-natural intrinsic quality.[4]

4. Judgments of the form "X is intrinsically good" are synthetic, intuitive, incapable of proof or disproof, logically independent of all judgments of existence (natural or metaphysical) and of all judgments about the relations of X to any minds there may be.[5]

[1] Cf. *Principia Ethica* (hereafter I shall refer to this work simply as *P.E.*), Pref., and *passim;* "Mr. McTaggart's Ethics," *Int. Journal of Ethics,* Vol. xiii (1902-1903); "Brentano's *Origin of Our Knowledge of Right and Wrong,*" *Int. Journ. of Ethics,* Vol. xiv (1903-1904). The only philosophers whom Moore mentions as recognizing any of his principles are Sidgwick and Brentano.

[2] Cf. *P.E.*, viii, 37.

[3] *P.E.*, 21-23, 74, 90, 27-30.

[4] *P.E.*, 6-17, 21, 41, 110-111; *Philosophical Studies,* chaps. viii, x.

[5] *P.E.*, viii-x, 7, 74-76, 118, 143-144; *Ethics,* 223-224; *Phil. Studies,* chap. x; *Intern. Journ. of Ethics,* Vol. xiv (1903-4), 116.

5. 'Intrinsic goodness' is the central or basic notion of ethics.[6]

6. The right act or the act which we ought to do is always and necessarily the act which promotes as much intrinsic good in the universe as a whole as possible. It follows that judgments of the form "X is right" are not intuitive but can be proved by inference from premises of which some are judgments of intrinsic value and the rest judgments about causal connections.[7]

7. In answering the question what things are good in themselves two principles must be observed: (a) ". . . it is necessary to consider what things are such that, if they existed *by themselves*, in absolute isolation, we should yet judge their existence to be good," (b) ". . . the intrinsic value of a whole is neither identical with nor proportional to the sum of the values of its parts."[8]

8. ". . . very many different things are good and evil in themselves, and . . . neither class of things possesses any other property which is both common to all its members and peculiar to them."[9]

In these principles Moore is formulating a non-hedonistic utilitarian or teleological ethics of an intuitionistic or non-naturalistic sort. Its core, as a system of ethics, is a certain view of the connection between intrinsic value and obligation, which is expressed especially in principle (6). It is this view which I wish to discuss. It has, however, two parts. The first part is the doctrine that the intrinsically good ought to be promoted, or that a thing's having intrinsic value so far makes it a duty to produce it if possible. This doctrine is an essential part of any utilitarian or teleological ethics, but it may also be accepted by an 'intuitionist' or deontologist like W. D. Ross. The second part

[6] *P.E.*, xi, 2-3, 5, 21; *Phil. Studies*, 257.

[7] *P.E.*, 23-27, and chap. v; *Ethics*, chaps. i, ii. I use "right" and "ought" as interchangeable, though this is not quite the case.

[8] *P.E.*, 187, 184; cf. also 27-33, 95, chap. vi; *Ethics*, chap. vii. (b) is what Moore calls "the principle of organic unities."

[9] *P.E.*, ix-x; cf. 38 and chap. vi, *passim; Ethics*, chap. vii. This conclusion is especially directed against hedonism.

is the doctrine that the right or obligatory act is always and necessarily the act which is most conducive to intrinsic good, or that our only ultimate duty is to do what will produce the greatest possible balance of intrinsic value. This is the characteristic doctrine of a utilitarian or teleological ethics, as distinguished from such an ethics as that of Ross. Now my purpose is to discuss the first of these two parts of Moore's view of the relation of obligation and value, in the light of other things which he has said, and in the hope that he may be moved to modify his view at some points and to clarify it at others.

A complete discussion of Moore's views concerning the relation of obligation and value should, of course, include a discussion of the second part of principle (6), that is, of the doctrine that the right act is always and necessarily the act which is most conducive to intrinsic good. This is the doctrine which Moore expresses in the *Ethics* by saying that "the question whether an action is right or wrong *always* depends on its *actual* consequences."[10] It has several noteworthy features. (a) It refers only to *voluntary* actions, and says nothing about the question whether or not any non-voluntary actions (among which Moore groups feelings) are right in any sense.[11] (b) It implies that the rightness and wrongness of actions do not depend in any way on any value which the actions themselves may have, but only on that of their effects.[12] (c) It denies that the rightness and wrongness of actions depend on their intrinsic characters in any sense, for example, on their being cases of promise-keeping or not. (d) It holds that the rightness and wrongness of actions do not depend at all on the motives or intentions with which they are done. (e) It insists that the rightness and wrongness of actions depend entirely on the character of their *actual* effects, and not at all on that of their probable effects or of those which the agent had reason to expect.[13] And, finally, (f) it makes

[10] P. 195. In connection with the rest of this paragraph see *Ethics*, chap. v, and *passim*.

[11] *Ethics*, 17. Cf. *Phil. Studies*, chap. x.

[12] But see *P.E.*, 25.

[13] But cf. Moore's review of H. Rashdall's *Theory of Good and Evil*, *Hibbert Journal*, Vol. vi (1907-1908), 447-448.

the rightness and wrongness of actions depend entirely on their promotion of *intrinsic* value.[14] Regarding these features of Moore's view many questions might be asked to which the student of his ethics would like to have answers. I have, however, elected not to raise them here. It seems to me that of the two parts of principle (6) the first is the more fundamental, and hence I have limited my paper to its discussion.

My paper, then, will be devoted to a discussion of Moore's view that the good ought to be promoted by us, or that we have, in Ross' terms, a *prima facie* duty to promote what is intrinsically good.[15] Does it follow from the very nature of intrinsic goodness that it ought to be promoted? Or is the connection between intrinsic value and obligation only a synthetic, even if necessary, one?

We may begin by considering the views which Moore expresses in *Principia Ethica*. Here he opens by carefully distinguishing between the notion of intrinsic value and the notion of duty or of what we ought to do (principle 1). So far it seems as if he means to separate obligation and value. Yet I cannot help feeling, as I read on, that Moore really attaches a connotation of obligatoriness to the notion of intrinsic goodness, and regards the good as somehow having a normative significance as such. This is indicated, I should say, by the fact that he regards "intrinsically good" as synonymous with "ought to exist for its own sake."[16] It is also indicated in his discussion of Mill and Spencer by his tendency to take "good as end" or "intrinsically good" as equivalent to "desirable," "ought to be desired," "ought to be aimed at," etc.[17] It is indicated finally by

[14] *Ethics*, 61, 72-73.

[15] What I shall say applies to W. D. Ross, J. Laird, and N. Hartmann, as well as to Moore.

[16] Pp. viii, 118. This view of Moore's does support my point, I think; but one cannot make much of it by itself, because Moore does not attach much obligatoriness to the notion of what ought to exist for its own sake. The view, of course, is not to be taken as a definition, since Moore regards intrinsic value as indefinable. It is a mere statement of the synonymity of two expressions. Cf. B. Russell, *Philosophical Essays* (1910), 5-6.

[17] Pp. 51-52, 64-66. Cf. 99-100. On p. 17 Moore takes his 'good' as synonymous with Sidgwick's 'ought'. It is true that on pp. 25-26 Moore denies that "X is intrinsically good" is equivalent to "we ought to aim at securing X," but this does not refute my contention.

the fact that he goes on to define 'right' as meaning "productive of what is good in itself." For on this definition the obligatoriness of the right must be derived wholly from an assumed obligatoriness of the good.

It appears, therefore, that in *Principia* Moore is maintaining the first of the two alternatives mentioned above, at least implicitly. Here my troubles begin. For if Moore's explicit conception of intrinsic value is correct, then this alternative must be false. This conception of intrinsic value is familiar; it is, indeed, the central point for which Moore has stood in recent moral philosophy. It runs as follows.[18] According to Moore, 'good' is an ambiguous term.[19] Sometimes it means "good as a means," sometimes it means "good as contributing to a whole which is intrinsically good," sometimes it means "morally good" or "morally praiseworthy," and sometimes, "in a very important sense," it means "being the object of a certain feeling on the part of some mind or minds."[20] But in its primary sense, so far at least as ethics is concerned, it means "good in itself," "good as end," or "intrinsically good."[21] We must, therefore, carefully distinguish what is good in the sense of "intrinsically good" from what is good in the other senses.[22] In all of the other senses of 'good', Moore holds, a thing's goodness depends at least in part on its relations to something else. A thing's intrinsic goodness, however, does not depend in any way on its relations to anything else. Intrinsic goodness is a quality and not a relational property,[23] and it is a quality whose presence in a thing is due entirely to that thing's own character.[24] "X is

[18] My account here is only partly based on *Principia Ethica*. Nevertheless it describes the view of intrinsic value which he expresses there, as well as that expressed in later works.

[19] Cf. *Ethics*, 161; *Proc. of the Arist. Soc.*, Supp. Vol. xi (1932), 117.

[20] Cf. *Ethics*, 69-72, 161, 167, 185-188, 250.

[21] Cf. *P.E.*, 21; Moore takes these phrases as equivalent.

[22] I neglect Moore's distinction between what is intrinsically good and what is ultimately good or good for its own sake. Cf. *Ethics*, 73-76.

[23] Cf. *Proc. Arist. Soc.*, Supp. Vol. xi, 126.

[24] Cf. *Phil. Stud.*, chap. viii. This can hardly be always true of the property of being good as an end. Often, at least, "X is good as an end" seems to mean "X is good as being someone's end." Then its being good as an end is not intrinsic in Moore's sense.

intrinsically good" means "It would be a good thing that X should exist, even if X existed quite alone, without any further accompaniments or effects whatever," or "X is good in a sense such that the question whether X is good in that sense, and in what degree it is so, depends solely on the intrinsic nature of X," or again "X is worth having for its own sake."[25] Moore believes that there are things which are good in the sense indicated by these expressions—good, that is, in the sense of having a goodness which is intrinsic, objective, and absolute.[26] He also believes, of course, that this intrinsic goodness is indefinable and non-natural (principle 3). By saying that it is indefinable he means to say primarily that it is simple or unanalyzable.[27] By saying that it is non-natural he means to say partly that it is not an object of perception, partly that it is not a psychological idea, partly that it depends on a thing's nature in a certain peculiar way, and partly that it is somehow non-existential or non-descriptive.[28]

In short, Moore regards intrinsic value as a quality which is really intrinsic,[29] and which is also simple and non-natural. Now my contention is that if this conception of its nature is correct, then intrinsic value cannot be possessed of any essential normativeness or obligatoriness. It cannot be part of its very meaning that it enjoins us or any other agents to take up a certain attitude toward it. I should even say that if this conception of intrinsic value is correct, then Moore is wrong in saying that "A is intrinsically good" is synonymous with "A ought to exist for its own sake," since the notion of what ought to exist for its own sake has a complexity which the notion of intrinsic value is not supposed to have. It involves the notions

[25] Cf. *Ethics*, 65; *Phil. Studies*, 260; *Proc. Arist. Soc.*, Supp. Vol. xi, 121-124. Moore is inclined to think that all of these expressions have the same meaning, though he confesses that this may not be true, and seems to favor the last as a translation of the first. Cf. the last of the references cited.

[26] Here being intrinsic entails being objective and absolute. Cf. *Phil. Studies*, chap. viii.

[27] Cf. *P.E.*, 6-10.

[28] Cf. *P.E.*, 38-41, 110-112, 123-126; *Phil. Studies*, chaps. viii, x.

[29] It is not a tautology to say that intrinsic value is intrinsic in Moore's sense, as many moralists hold that it is not intrinsic in that sense.

of obligation and of existence and of a kind of relation of the things in question to existence, and can hardly represent a simple quality. In fact, to say that A ought to exist would seem to mean that someone has a duty to bring A into existence.[30] Then certainly "intrinsically good" cannot stand for a simple quality and yet be synonymous with "ought to exist for its own sake." But, however this may be, if intrinsic value is either simple or non-relational, then it cannot contain any obligation in its very nature. For to say that it does is to say that the fact that A is intrinsically good includes or is identical with the fact that certain agents, actual or possible, should do something about A or take a certain attitude toward it. But to say this is to say that intrinsic value may be partially or wholly defined in terms of the notion that certain agents have a duty to do a certain thing—in other words, that it is complex and relational, not simple or qualitative. Intrinsic goodness can have a normative character as such only if it essentially or analytically involves a reference to an agent on whom something is actually or hypothetically enjoined, that is, only if it is not a simple intrinsic quality. If goodness is either simple or a quality, it can be connected with obligation only synthetically. The most that can then be said of it is that it is a characteristic whose presence *makes* things such that they ought to be brought into existence —as pleasantness is sometimes said to be.

What I am saying can also be expressed as follows. Suppose someone asks "Why should (ought) I bring the good into existence?" Then, if goodness is a simple intrinsic quality, he cannot be answered by saying, "Because it is of the nature of the good that it should be brought into existence." For, if goodness is a simple intrinsic quality, then it cannot be of the nature of the good that it should be brought into existence.

This point that intrinsic value cannot as such be possessed of any normative character or obligatoriness, if it is a simple intrinsic quality, is worthy of notice even if Moore did not mean to be holding in *Principia Ethica* that it has such a character. I am not interested merely in pointing out what looks like an

[30] Cf. C. D. Broad, *Five Types of Ethical Theory* (1930), 165; W. D. Ross, *The Right and the Good* (1930), 105.

inconsistency in Moore. If my point is well-taken, then anyone who regards the good as normative, or who holds it to be part of the meaning of the good that it enjoins us to take a certain attitude toward it, must reject the view that goodness is a simple intrinsic quality. Again, if it is well-taken, it will follow, if intrinsic value is a simple quality, that duty cannot be defined in terms of intrinsic value, as Moore in *Principia* holds that it can. It will follow also that there is no place for obligation in the ethics of *Principia*. For if there is no obligatoriness or normative character in the *Principia* notion of intrinsic value, and we have seen that there is none, then there can also be no obligatoriness or normative character in the *Principia* notion of right or duty, since this is defined in terms of the notion of intrinsic value. By regarding goodness as a simple intrinsic quality and defining 'right' as meaning "conducive to as much good as possible," *Principia* transforms statements of the form "We ought to do X" into mere statements of fact. For, if goodness is a simple intrinsic quality, as it teaches, then to say that A is conducive to the greatest possible amount of good is not to say that we ought to do A; it is a simple report or prediction of actual occurrence. Thus there is no obligatoriness or normative character in either its notion of intrinsic value or its notion of right or duty, and hence the ethics of *Principia Ethica*, like any naturalistic or metaphysical ethics, is an ethics *sans obligation*, if not *sans sanction*.

This result leads directly to the next main point which I wish to make, namely, that, if intrinsic goodness is not as such possessed of any normative character or obligatoriness, then there is no reason for regarding it as either indefinable or non-natural. Certainly it need not be indefinable or non-natural in order to be a characteristic whose presence makes things such that they ought to be brought into existence. Thus pleasantness is sometimes said to be such a characteristic, for example by Sidgwick, and there is nothing which makes this view impossible in principle. In fact, natural and definable characteristics are generally regarded by Cambridge and Oxford philosophers as being, some of them, good-making or right-making. But if Sidgwick's view is a possible one, then goodness might be identical with pleasantness and yet be a characteristic in virtue

of which things which have it ought to be produced. Again, goodness need not be indefinable or non-natural in order to be intrinsic in Moore's sense, granting this to be the case. Pleasantness is an intrinsic quality of certain experiences on Moore's own view, and, if this is so, then goodness might be defined as pleasantness and yet be intrinsic.[31] Moore has, of course, given various arguments to show that intrinsic goodness is indefinable, or at least that it is indefinable in psychological terms. But he has himself admitted the arguments of *Principia* to be inconclusive and fallacious,[32] and those given in his other works can be shown to be no better.[33] Moore has also charged all definist theories of value with committing a fallacy, namely "the naturalistic fallacy," but the procedure which he has in mind is not really a fallacy at all, and it cannot even be called a mistake until after it is known that value cannot be defined.[34]

Thus one can appeal only to inspection or intuition to settle the matter, and I must say that I can discern in the things which I judge to be good in themselves no intrinsic quality of goodness which is unique or non-natural. I do not deny that there is something distinctive or unique about experiences which I judge to be intrinsically good as I am having them, or about experiences in which I judge something else to be intrinsically good. But this something different may be due entirely to the presence in these experiences of a value-judgment, with all of its psychological and emotive associations. It does not follow that there is a unique quality of value, nor that the making of a value-judgment involves an awareness of such a quality. As for experiences which I am not having, but which I judge to be intrinsically good, in them I can descry no character of uniqueness other than that which belongs to every experience or every sort of experience.

So far in dealing with my second contention I have been

[31] Here "pleasant" means "containing a balance of pleasure." Cf. *Phil. Studies*, 272-273. D. H. Parker, while defining value as satisfaction, holds it to be intrinsic in Moore's sense. See "The Metaphysics of Value," *Int. Journ. of Ethics*, Vol. 44 (1934).

[32] *Proc. Arist. Soc.*, Supp. Vol. xi, 127.

[33] Cf., e.g., the paper by C. L. Stevenson in this volume. In *Phil. Studies*, 331, Moore confesses that he is not satisfied that his later arguments are conclusive.

[34] Cf. my article, "The Naturalistic Fallacy," *Mind*, Vol. xlviii (1939).

occupied with disposing of the reasons which Moore has given or might give for his view that intrinsic value is indefinable and non-natural. Now I wish to press my contention more directly. The main point which is involved in the view that intrinsic value is indefinable and non-natural, apart from the doctrine that it cannot be defined in terms of rightness or duty, is the doctrine that it is irreducible to natural or to metaphysical terms. Now, to my mind, what makes ethical judgments seem irreducible to natural or to metaphysical judgments is their apparently normative character, that is, the fact that they seem to be saying of some agent that he ought to do something. This fact, so far as I can see, is the only ground on which ethical judgments can be regarded as essentially different from the factual or existential judgments of science or of metaphysics. If this is true, then the apparently normative character of ethical judgments is the basic fact in the intuitionist or non-naturalist assertion of the indefinability and non-naturalness of ethical notions or characteristics. Hence, if intrinsic value is to be indefinable and non-natural, if judgments of intrinsic value are to be different in kind from non-ethical judgments, then intrinsic value must in itself possess a normative character or obligatoriness. If it does not, then it cannot be regarded as essentially irreducible to natural or to metaphysical terms.

Moore's most recent discussion of the unique nature of intrinsic value is instructive in this connection.[35] There he is discussing the difference between intrinsic goodness and the property of containing a balance of pleasure. Both of these properties, he says, are intrinsic in the sense of "depending *solely* on the intrinsic nature of what possesses them." But he feels that there is some great difference in kind between them. This difference he expresses by saying that the latter seems to *describe* the nature of what possesses it in a way in which the former does not. That is, he regards intrinsic value as somehow non-descriptive. More he confesses himself unable to say. I suggest that this is because an intrinsic quality cannot really be non-descriptive, all intrinsic qualities being essentially descriptive. To be non-descriptive a characteristic must be normative; it

[35] *Phil. Studies,* 274.

must involve a reference to an obligation on the part of some agent. But then it cannot be an intrinsic quality. As long, therefore, as he regards value as an intrinsic quality, Moore must fail to make out convincingly that there is an important difference in kind between it and other intrinsic qualities, or that judgments of intrinsic value are unique in the sense of being somehow non-descriptive or non-existential.

The situation, then, seems to me to be this. If saying that intrinsic value is non-natural is to distinguish judgments of intrinsic value from natural and metaphysical judgments, then the notion of obligatoriness must be part of the notion of non-naturalness. And then intrinsic value cannot be non-natural if it is either simple or an intrinsic quality, or if for any other reason it is capable of having only a synthetic connection with obligation. Again, the real reason for thinking that any ethical notion is essentially indefinable in non-ethical terms is its apparently normative character, and, therefore, if intrinsic value is an intrinsic quality, or if its connection with obligation is only synthetic, then there is no reason for regarding it as essentially irreducible to non-ethical terms. Hence Moore's position that intrinsic value is an indefinable, non-natural, intrinsic quality is an indefensible one. Anyone who holds that intrinsic value is a simple intrinsic quality must also take the second of the alternatives pointed out at the beginning, namely, that intrinsic value can have only a synthetic connection with obligation, and if he accepts this alternative he has no grounds for holding that intrinsic value is indefinable or non-natural. If intrinsic value is indefinable, or if it is an intrinsic quality, then it cannot have any normative character, and cannot, in any distinctive sense, be non-natural. And if it is normative and non-natural, then it is definable in terms of 'ought', and is neither simple nor an intrinsic quality. Finally, if it is an intrinsic quality, or if for any other reason it is not normative, then it is probably not even indefinable in non-ethical terms.

In view of what I have been saying Moore might contend that the notion of intrinsic goodness does have its normative associations, and therefore cannot be defined in non-ethical terms. The premise of this argument may be granted, but its

conclusion does not follow. For the normative associations of the term 'good' may be purely emotive, or, if goodness has a synthetic connection with rightness, they may be entirely due to this connection. In fact, Moore must himself explain them in either of these two ways if he continues to regard goodness as a simple intrinsic quality.

All that has been said thus far is about the views which Moore has expressed in *Principia Ethica,* so far as these bear on the topic of this paper. About Moore's later views on such matters as are relevant here it is difficult to speak with certainty. It does seem that in *Ethics* and in *Philosophical Studies* he is no longer regarding rightness and duty as definable in terms of conduciveness to what is intrinsically good. It is quite clear that he still regards intrinsic value as an intrinsic quality.[36] But it is not certain that he holds it to be indefinable.[37] On the whole, however, the view which he seems to favor is the following: (a) intrinsic value is an indefinable non-natural intrinsic quality, (b) obligation is also indefinable and non-natural, and (c) intrinsic value and obligation are related by a synthetic necessary connection. Of this view it does not hold that the ethics based on it must be an ethics without any obligation, for obligation is taken as an ultimate notion. But all the rest of what I have been saying does hold of this view, since it involves the doctrine that intrinsic value is a simple intrinsic non-natural quality which is only synthetically connected with obligation.

My main contentions regarding Moore's position, it will be noticed, are hypothetical in character. Nevertheless, as I have indicated, they lead to the conclusion that his position is indefensible, both in its earlier and in its later forms. In particular, I now wish to point out that they lead to the conclusion that there is no reason for regarding intrinsic value as indefinable, as Moore does. If it has in itself a normative character, then it is definable in terms of 'ought'. If it has not, then it cannot be in principle indefinable in non-ethical terms. There may then still be a practical difficulty in finding a satisfactory definition of the

[36] See *Proc. Arist. Soc.,* Supp. Vol. xi, 121-126.
[37] Here cf. especially *Ethics,* 59-61; the preface to the 1922 edition of *Principia Ethica;* and *Proc. Arist. Soc.,* Supp. Vol. xi, 127.

word 'good' in the sort of usage in which it is equivalent to "intrinsically good." But this difficulty by itself hardly warrants the conclusion that 'good' is indefinable in that usage. It may only be that the term 'good' in that usage is ambiguous, or that it is vague, or that its emotive meaning is somewhat peculiar.

I do not claim, of course, to have proved conclusively that intrinsic goodness is definable. This is, perhaps, impossible. At any rate, it could be done, if at all, only by the actual production of a satisfactory definition, and I am not prepared to give such a definition here. What I do claim is that there is no basis for the view that intrinsic value is indefinable, and that everything points in the direction of its definability. If this claim is correct, then there would seem to be two positions open to Moore, if he wishes still to be a non-naturalist or intuitionist in ethics. The first alternative is to hold that 'ought' represents an indefinable and non-natural relation, and that intrinsic value is definable in terms of 'ought'. The other alternative is to hold that 'ought' represents an indefinable non-natural relation, that intrinsic value is definable in non-ethical terms (e.g., in terms of satisfaction), and that intrinsic value, as defined, makes things such that they ought to be promoted. Both of these positions avoid the difficulties which I have found in the view which Moore has been holding. For, on the first of them, intrinsic value is normative and non-natural, but it is not an intrinsic quality; and, on the second, it is or may be intrinsic, but it is not normative or non-natural. On both views intrinsic value is definable. Moreover, either of these views is *prima facie* more plausible than Moore's view. They are more plausible than his earlier view because they take as ultimate the ethical notion which is most likely to be indefinable, but which it regards as definable, namely the notion of obligation. They are more plausible than his later view because they are simpler, since they involve only one ultimate notion, while it involves two. On both of them the non-ethical properties of a thing or experience directly determine whether or not it ought to be brought into existence. But on Moore's later view the non-ethical properties of a thing or experience directly determine only its intrinsic value, and its intrinsic value determines whether or not it ought to be pro-

duced or achieved. This is harder to believe. For it is just as likely that the non-ethical properties of a thing should make it such that it ought to be produced as it is that they should make it intrinsically good. And it is just as likely that a thing's non-ethical properties should make it such that it ought to be brought into existence as it is that an ethical quality of goodness should do so, if this is simple and intrinsic.[38]

Now, I have argued that, if value is an intrinsic quality, there is no reason for believing it to be indefinable in non-ethical terms. Hence, if Moore wishes to maintain with any plausibility that value is indefinable in non-ethical terms, he must adopt the view that it is definable in terms of 'ought' or 'right'.[39] And, indeed, I cannot see that he has any good reasons for not adopting this view. Suppose we say that "X is intrinsically good" means "X ought to be brought into existence by us." To this Moore would object that the first expression may be true where the latter is not, since the latter implies that we can produce X while the former does not.[40] What we ought to bring into existence depends on our knowledge, powers, and opportunities, whereas the good does not.[41] This objection may, however, be met by saying that "X is intrinsically good" means "If we are capable of producing X then we have a duty to do so," a form of definition which is not always unacceptable to Moore.[42] Another possible objection is that even if X is intrinsically good and we are capable of bringing it into existence it still may not be our duty to produce it, since we may be able to produce something better.[43] But this can again be met by saying that "X is intrinsically good" means "If we are capable of producing X, then we have a prima facie duty to do so," in Ross' sense of "prima facie duty."

[38] I should add that both of the views just described as alternatives to Moore's can be so formulated that in practice they will be equivalent to his.

[39] For suggested definitions of 'good' in terms of 'ought' or 'right' see H. Osborne, Foundations of the Philosophy of Value (1933), 22-23, 67, 93-95, 109, 124-126; A. C. Ewing, "A Suggested Non-Naturalistic Analysis of 'Good'," Mind, 1939.

[40] Cf. P.E., 25-26.

[41] Cf. Russell, op. cit., 6.

[42] Cf. Phil. Studies, 319.

[43] Cf. Ross, loc. cit.; P.E., 30.

This brings us to a consideration of an equivalence asserted by Moore in his *Ethics:*

To say of anything, A, that it is "intrinsically good," is equivalent to saying that, if we had to choose between an action of which A would be the sole or total effect, and an action, which would have absolutely no effects at all, it would always be our duty to choose the former, and wrong to choose the latter.[44]

Why is this statement not a definition? Moore is not certain that it is not,[45] and he must, therefore, be thinking that it may be a definition of "intrinsically good" in terms of 'duty', for the first part of the asserted equivalence can hardly be taken as an analysis of the second part. His only argument for not regarding it as a definition is that it is not a tautology to say that it is always our duty to do what will have the best consequences.[46] But this argument is not conclusive. The fact that a statement seems to be significant does not prove that it is not analytic. Its apparent significance may be due to confusion. Our minds and our usages are not such that we can always recognize an analytic statement as analytic when it is presented to us. In particular, a statement may seem significant to us simply because of the differing emotive meanings of its terms. Now 'duty' and 'good' are precisely terms whose meanings are not at all clear, as is made manifest by the variety of opinion that exists as to their meaning, and they are moreover terms which have emotive meanings which differ in important respects.[47] Hence the seeming significance of the statement in question cannot be taken to show that the second part of the above equivalence is not a correct analysis of the first part. But then Moore seems to have no ground for not accepting this statement as a definition of "intrinsically good."

Moore might argue that it is quite clear that intrinsic value is dependent only on the intrinsic nature of a thing, and that therefore it cannot consist in any normative relation to anything else. Yet, even if we say that "X is intrinsically good"

[44] P. 66.
[45] See *Ethics*, 59-61.
[46] See *ibid.*, 61, 173.
[47] Cf. A. J. Ayer, *Language, Truth, and Logic* (1936), 160

means "Any agent capable of producing X has a *prima facie* duty to do so," there is an important sense in which the intrinsic value of X may depend wholly on its intrinsic nature. For it may be because of its intrinsic nature alone that the agents in question have a *prima facie* duty to produce it.[48]

There remains the possibility of appealing to inspection to show that intrinsic value is a distinct property from that of being right for a competent agent to produce, somewhat as we appeal to inspection to show that the color red is distinct from the color blue or from the shape round or from the relation between. As I indicated earlier, however, the verdict of inspection in my case, as in that of so many others, is negative. I cannot discover in the things which may be considered to be good in themselves any simple intrinsic quality of goodness in addition to their non-ethical qualities and the property of being right for an appropriate agent to pursue or to produce.

My last main contention, then, is that the objections which Moore has given or may give to the view that value is definable in terms of obligation are not conclusive, and can be answered. Moore might reply that the question whether or not value is definable in terms of obligation is not an important one, the important question being whether or not it is definable in non-ethical terms.[49] This may be the import of his statement to the Aristotelian Society that the question whether intrinsic goodness is definable or not is a "comparatively unimportant" one.[50] At any rate, I should say in return that if it is important to hold that value is indefinable in non-ethical terms,[51] then it is also

[48] I do not mean here to be granting that "intrinsic value" *is* clearly intrinsic in Moore's sense.

[49] Cf. J. Laird's remark, *A Study in Moral Theory* (1926), 94, note 2.

[50] *Proc. Arist. Soc.*, Supp. Vol. xi, 127. Moore may also mean that he is not greatly concerned to hold that intrinsic value is indefinable, so long as it is admitted to be an intrinsic quality in his sense. My contention is that, if he insists that value is an intrinsic quality in that sense, then he must be prepared to regard it as definable in non-ethical terms, and he must hold that it is *not* definable in terms of obligation. Moore goes on to say, "I think perhaps it [intrinsic value] is definable: I do not know. But I also think that very likely it is indefinable." In the first part of this passage he seems to be agreeing with me. If so, then it is only the second part that I wish to deny.

[51] I do not myself regard it as important to hold this, at least if obligation is

important to hold that it *is* definable in terms of obligation, since it cannot otherwise have any normative character.

Thus we may say the following of the two views between which, as it seems to me, Moore must choose. He can give no convincing grounds for not accepting the first of them, and he must accept it if he wishes to avoid the other. On the other hand, as we saw earlier, he cannot make a very plausible case against this view either, so long as he regards intrinsic value as an intrinsic quality. Neither view, therefore, is refuted by anything which he has to say in favor of his own intermediate view, nor, so far as I can see, by anything which he might say in its favor.

It is not a part of my present purpose to try to determine which of the two views in question is the correct one. To try to decide which of these views is true presupposes a decision on the antecedent question whether or not any non-naturalistic view is true, and this question I am now leaving to one side. My purpose is only to show that Moore's view is inacceptable in either its earlier or its later form. I am inclined to think, however, that there is some truth in each of the alternative views which I have described, in the sense of being inclined to think that the term 'good', in the usage in which Moore is interested, is ambiguous in such a way that it is definable sometimes in terms of 'ought' and sometimes in non-ethical terms, for example, in terms of desire or satisfaction. Some such ambiguity as this has been recognized in one way or another by E. F. Carritt, J. Laird, W. D. Ross, C. A. Campbell, S. C. Pepper, and others, although none of these writers interpret or implement it in the manner in which I am tempted to.

The points which I have tried to make in this paper concerning Moore's view of the relation of obligation and value may be summarized as follows. (1) Obligation cannot be defined in terms of value, as it is in *Principia Ethica*, if value is either simple or intrinsic in Moore's sense. (2) If value is either simple or intrinsic, as Moore holds, then it cannot be normative, non-natural, or definable in terms of obligation, and then there

held to be indefinable in non-ethical terms. But it is hard to believe that Moore no longer considers it to be important.

is no reason to regard it as indefinable in non-ethical terms, as Moore does. On the other hand, (3) if value is normative or non-natural or indefinable in non-ethical terms, as Moore believes, then it is definable in terms of obligation; it cannot have only a synthetic connection with obligation, and it cannot be either a simple or an intrinsic quality.[52] Moreover, (4) Moore does not seem to have any adequate grounds for rejecting the view that intrinsic value is definable in terms of obligation. Thus (5) it appears that Moore's view that intrinsic value is an indefinable, non-natural, intrinsic quality (principle 3) is an untenable one, that, in particular, his view that intrinsic value is indefinable is very probably false, and that, if he wishes to be non-naturalist in ethics, he must choose between two other views, against neither of which he has any good arguments, namely, (a) the view that intrinsic value is definable in non-ethical terms, even though it is what makes a thing such that it ought to be pursued or brought into being by a competent agent, and (b) the view that intrinsic value is definable in terms of obligation.

The impact of Moore's thought on twentieth-century moral philosophy has been a powerful one. Of that this volume itself bears testimony. Possibly no other living moralist has had so great an influence. Certainly, at any rate, no single book of this century has had an effect in ethics or value-theory comparable with that of *Principia Ethica*. Now I am not one of those who hold that this influence which Moore has had has been wholly unsalutary. I am even somewhat inclined to feel that no recent philosopher has had a more salutary effect on ethical thinking, all things considered. I have, moreover, a certain sympathy or predilection for the sort of position in ethics for which he has stood. Nevertheless, I venture to think that the form into which he has put this sort of position, both in *Principia Ethica* and in his later works, is a mistaken one, and must be given up. This is the opinion which I have sought to communicate.

WILLIAM K. FRANKENA
DEPARTMENT OF PHILOSOPHY
UNIVERSITY OF MICHIGAN

[52] If intrinsic value is definable in terms of obligation in the manner just discussed, then principle (5) is false and both parts of principle (6) are analytic. Cf. Ewing, *op. cit.*

4

H. J. Paton

THE ALLEGED INDEPENDENCE OF GOODNESS

THE ALLEGED INDEPENDENCE OF GOODNESS

I

ONE of Professor Moore's main objects in *Principia Ethica* is, I take it, to refute relativism and subjectivism in ethics. If we set aside things which are good as means, everything that is good is, he holds, good intrinsically or good in itself. Hence the goodness of a thing is wholly independent of the thing's relation to anything else; and in particular it is wholly independent of the thing's relation to feeling or desire or will. The doctrine that goodness is independent in this sense is the one which I wish here to discuss.

If the only alternative to this ethical doctrine were the theories of relativism and subjectivism or, in other words, of scepticism, so widely prevalent to-day, then I for one would be only too pleased if I could find myself convinced by Professor Moore's arguments. I believe it possible, however, *both* to hold that goodness, in one sense of the word 'goodness', is objective and independent of the whims and fancies, the impulses and desires, of individual men, *and* also to hold that the goodness of a thing may vary in different circumstances and must stand in some necessary relation to a rational will. Needless to say it is not my business here to establish such an intermediate doctrine nor to meet the obvious objections to which it lays itself open. But it is against a background of this kind that I wish to examine Professor Moore's arguments and to explain why to me they fail to carry conviction.

In so doing I base my examination on *Principia Ethica*. This may in some ways be unfair to the author, because his theories, as is to be expected, have been modified since this work of his comparatively early youth; and indeed he has himself told us,

with engaging frankness, that some of his arguments were certainly fallacious.[1] Nevertheless *Principia Ethica* will have a permanent place in the history of philosophy, and as such it merits discussion in itself. I have taken occasional note of later modifications in his view, so far as I have remembered them; but writing as I do under war conditions, I have been unable to give to his doctrines the careful scrutiny which they deserve. I can only hope that my comparative haste in writing has not led me to misrepresent his views. Perhaps it would have been wiser to refrain altogether from discussing arguments so subtle in regard to matters of such difficulty; but I wished to take some part in this tribute to one of the most influential thinkers of our time.

II

Professor Moore's whole argument rests on the doctrine that 'good' is indefinable. This, although he himself expressed some doubt on the subject later, may well be accepted, if we assume with him that to define anything is to describe its parts and their arrangement. Goodness is not composed of parts as a horse is composed of parts. In that sense it may be called simple and unanalysable, being in this respect like the quality 'yellow'.[2]

The controversies aroused by this comparison have been largely due to misunderstanding. It has been assumed too readily that a comparison in one respect was meant to be a comparison in other respects. Thus, if the comparison meant that goodness, like yellowness, is simply one of the many qualities which we find in an object, there would be some ground for objection. Professor Moore himself, however, says of goodness, "It is not, in fact, like most of the predicates which we ascribe to things, a *part* of the thing to which we ascribe it."[3] I imagine he would agree with the Provost of Oriel that goodness is a 'totiresultant

[1] *Aristotelian Society Proceedings*, Supplementary Volume XI, 127.

[2] In any individual yellow we can distinguish (apart from size, shape, and duration) colour-tone, intensity, and degree of saturation; but these are not its parts.

[3] *Principia*, 124. See also *Philosophical Studies*, 272-275. I regret that I failed at one time to grasp this side of the doctrine (*The Good Will*, 36).

property',[4] one based on the whole nature of that which has it. This fits in with his doctrine of 'organic unities', the doctrine that a whole has an intrinsic value different in amount from the sum of the value of its parts.

It is to be noted that, according to Professor Moore, where we can define a thing by stating its parts, we can in thinking substitute the parts for the thing itself. Since goodness is not composed of parts, clearly we cannot substitute the parts of goodness for goodness. "There is nothing whatsoever which we could so substitute for good."[5] Here the emphasis must be on the word 'so'; for Professor Moore recognizes that instead of saying that a thing is good we can equally well say that it ought to exist.[6] I take him to hold that 'good' and 'ought to exist' mean precisely the same thing; or, in other words, 'good' means 'ought to exist'.

This view, it seems to me, is a mistake, if only because 'good' is simple, while 'ought to exist' is clearly complex.[7] Knowing that a thing is good, we can still ask, with significance, whether it ought to exist; and a negative answer might be given with significance, for example, on the ground that 'ought' strictly applies only to actions. And there is a special difficulty in this for Professor Moore, for he takes 'ought' to *mean* 'productive of the maximum good'.[8] If this be so, to say that a thing ought to exist is to say that its existence would be productive of the maximum good. This is not the same as to say that the thing itself is good.

The value of the phrase 'ought to exist' as an equivalent for 'good' lies, it seems to me, in the fact that it indicates some sort

[4] Ross, Sir W. David, *The Right and the Good*, 122.

[5] *Principia*, 8.

[6] *Principia*, 17.

[7] Another objection might be that in the case of good actions we should say that they ought to be done rather than that they ought to exist; but Professor Moore may hold—his view is not wholly clear to me—that actions are never good in themselves.

[8] *Principia*, 148. I am taking 'ought' as equivalent to 'is a duty'. Perhaps this point might be met by saying that 'ought' in this sense applies only to actions; but if so, Professor Moore (so far as I know) has not explained what he means by 'ought' in the phrase 'ought to exist'.

of necessary connexion between goodness and existence. It reminds us that a thing is good only if it exists—and that it can be good only if it can exist. As Professor Moore indicates,[9] 'This is good' may mean, 'This would be good, if it existed'. I note this as showing that the simplicity of goodness is compatible with there being a necessary connexion between goodness and something else.

Another phrase which Professor Moore suggests may be equivalent to 'good' is 'worth having for its own sake'.[10] Here again we have something complex substituted as an equivalent for something simple. Here again, knowing that a thing is good, we can still ask with significance whether it is worth having for its own sake; and a negative answer might be given in some cases with significance, for example, on the ground that a good action is not worth having, but worth doing.[11] Apart from this, I do not know what is meant by 'worth having' unless it means 'good to have'. And this, I think, would imply that a thing can be good only if it can be 'had'.[12] This I believe to be the true view in so far as it indicates that a thing can be good only if it stands in some relation—whether a relation of 'being had' or some other—to a rational mind. I do not know whether Professor Moore would accept such an implication; but here again his substitution suggests to me that the simplicity of goodness is compatible with there being a necessary connexion between goodness and something else.

III

On Professor Moore's view it is apparently possible to find complex phrases which we can legitimately substitute for the

[9] *Principia*, 119.

[10] *Arist. Soc. Proc.*, Sup. Vol. XI, 122. On p. 127 he says that he sometimes used 'good' in this sense in *Principia Ethica*. The phrase itself is used in *Principia*, 188. Curiously enough, he speaks of *defining* 'intrinsic value' (which is equivalent to 'goodness') on p. 122 of the Supplementary Volume. Compare also his 'definition' on p. 121.

[11] The phrase 'worth having for its own sake' is too narrow, because it does not apply to good actions, which are worth doing, not worth having; but actions may not be regarded as good in themselves.

[12] It can hardly be meant that if a thing is good, then the having it is also good; for in that case 'good' would not *mean* 'worth having for its own sake'.

word 'good', although these phrases certainly do not state what are the parts of goodness. Some people might regard these phrases as giving definitions of 'good', but the name which we give to them is a matter of little importance. The important question raised is whether perhaps other complex phrases might legitimately be substituted for the word 'good', and whether perhaps these phrases might indicate some kind of necessary connexion between goodness and a kind of willing. For example, could we make statements of the form, 'To be good is to satisfy some desire'?

So far, especially in view of his own substitutions, I cannot see that Professor Moore has disproved the possibility of making true statements in this form. What he does is rather to offer us a method by which all such statements can be tested. Let us, without prejudice, call such statements 'definitions'; then, according to Professor Moore, "whatever definition be offered, it may be always asked, with significance, of the complex so defined, whether it is itself good."[13]

The example which he takes is that 'to be good' may mean "to be that which we desire to desire;" and after a certain amount of argument[14] he comes to this conclusion:

[13] *Principia*, 15.

[14] The argument itself is difficult to follow. 'The complex so defined' is in this case presumably 'that which we desire to desire'; and the question to be asked ought surely to be 'Is that which we desire to desire good?' Instead, Professor Moore asks a question only about part of 'the complex so defined'; for he asks 'Is it good to desire to desire?'; and he further restricts the question to a particular object A, putting his question in the form 'Is it good to desire to desire A?' He answers that this question is clearly not equivalent to the question, 'Do we desire to desire to desire A?'; for the second question is much more complicated than the first.

This answer might not be wholly convincing to a man who accepted the definition. He could reply that the second question seems more complicated only because we do not adequately grasp the full meaning of 'good'; and that 'The desire to desire A is good' really means 'The desire to desire A is something which we desire to desire'.

Professor Moore adds a further argument, the relevance of which I do not understand. He says: 'That we should desire to desire A is good' is *not* merely equivalent to 'That A should be good is good'. Why should he expect his opponent to think that it is? The two statements seem to me not equivalent on any view. The first statement is concerned with the goodness of our desire to desire A, while the second is concerned with the goodness of A itself.

It may indeed be true that what we desire to desire is always also good; perhaps even the converse may be true: but it is very doubtful whether this is the case, and the mere fact that we understand very well what is meant by doubting it, shows clearly that we have two different notions before our mind.[15]

I do not know whether this would convince an upholder of the definition in question, but I agree that 'to be good' does not *mean*, in the strict sense, 'to be that which we desire to desire'. And it may be that (in the strict sense of 'mean') 'to be good' does not mean the same as any other phrase whatever, not even the phrase 'ought to exist' or the phrase 'to be worth having for its own sake'. Each phrase must be examined on its own merits, and it may be doubted whether any such so-called definition can be dismissed *a priori*. Nevertheless, even if we suppose that it can, there still remains open a further possibility, namely, that we may be able to find some property[16] X such that to be good is to be X and to be X is to be good. That is to say, we may be able to find some property X which has what I may call a necessary and reciprocal connexion with goodness.

The word 'mean', it should be noted, is often used ambiguously. In a loose sense we may say that defeat at the present time would mean slavery, indicating thereby a relation of cause and effect between defeat and slavery. Similarly we may say that to be a plane three-sided rectilineal figure means to be a plane three-angled rectilineal figure. In the strict sense the two phrases do not mean the same thing,[17] but the word 'mean' is used loosely to indicate the mutual implication of the two properties mentioned. In the same kind of way we might indicate a mutual implication, or a necessary and reciprocal connexion, by saying loosely that to be good means to be X.

The possibility of such a mutual and reciprocal connexion is perhaps vaguely recognized by Professor Moore above, when he says it may be true that what we desire to desire is always also good and *vice versa*. I believe that he is himself feeling towards such a mutual and reciprocal connexion when he equates

[15] *Principia*, 16.
[16] We might even find more properties than one.
[17] Their connotation is different, though their denotation is the same.

'good' with 'ought to exist' and 'worth having for its own sake'. The main point that I wish to make is, however, the following. We may admit that 'good' cannot be defined by any statement of its parts. We may also admit that 'good' cannot be defined by any complex phrase which is identical in meaning with 'good' and yet brings out something in goodness which may not be obvious at first sight[18]—though I cannot see that this has been proved, especially in view of Professor Moore's own use of phrases like 'ought to exist'. In spite of all these admissions it remains clear that there has been no disproof of the possibility of finding a necessary and reciprocal connexion between goodness and some property X other than goodness. It would be merely a mistake to assume that if there is no relation of identity, there can be no necessary and reciprocal connexion between goodness and some other property X.

No doubt, if Professor Moore were a logical positivist, the last assumption would be justified, since for a logical positivist all necessary statements are analytical or tautological. But Professor Moore, certainly in *Principia Ethica*, is not a logical positivist. He recognises that all propositions in which the goodness of anything is asserted, are, in Kant's phrase, 'synthetic';[19] and at least some of these propositions he regards as true and universal.[20] When he holds that the pleasures of human intercourse and the enjoyment of beautiful objects are good in themselves,[21] I take him to affirm a universal and necessary connexion between these things and goodness, and I take this universal and necessary connexion to be such a connexion in virtue of the intrinsic character of these things. If we can assert such universal and necessary connexions, it is clear that the simplicity of goodness does not exclude the possibility of a necessary connexion between goodness and something else. And if there can be such a necessary connexion, there has cer-

[18] I am deliberately avoiding all logical questions raised by Professor Moore's philosophy, such as the question whether in any definition the predicate-concept can be considered as merely identical with the subject-concept.

[19] *Principia*, 143.

[20] *Principia*, 21.

[21] *Principia*, 188.

tainly been no attempt to disprove the possibility that it might also be reciprocal.

Such a necessary and reciprocal connexion, if there were such, might presumably, on Professor Moore's principles, be self-evident: it might be incapable of proof but apprehensible by intuition.[22]

IV

If it had been proved that there can be no reciprocal and necessary connexion between goodness and any property X, it would at once follow that there can be no necessary and reciprocal connexion between goodness and the property of being related in some way to some thing; it would further follow that there can be no necessary and reciprocal relation between goodness and the property of being related in some way to some kind of will. As, however, the protasis has not been proved, these possibilities remain open.

As regards relation in general, one of Professor Moore's central doctrines is that good is not a relational property. If this means merely that being good is something quite different from being a father or a son, his contention may be readily admitted. The subject, however, raises logical problems, which here, as throughout, I seek to avoid. On the level of common sense we may ask two questions: (1) Can there be goodness unrelated to a mind?; and (2) Does not the goodness of a thing vary according as the thing is related to different circumstances?

As regards the first question, I will merely express my agreement with the Provost of Oriel, who has accepted many of Professor Moore's views. He says,[23] "In any assignment of intrinsic

[22] *Ethics*, 181, perhaps suggests that a necessary and reciprocal connexion between 'being right' and 'being productive of the maximum good' is self-evident. In *Philosophical Studies*, 275, Professor Moore holds that "if X and Y are of different intrinsic values, their nature must be different." This is a necessary connexion presumably grasped by intuition. To hold further that if their nature is different, they must be of different intrinsic values, would be to assert that between nature and value there is a necessary and reciprocal connexion, which would also presumably be grasped by intuition; but I do not know whether Professor Moore would accept this.

[23] *The Right and the Good*, 130-131.

value to a mindless universe or to anything in it there is a sur-
reptitious introduction of a subjective factor, namely of oneself
imagined as contemplating such a universe or the things in it."
Professor Moore himself comes near to this view so far as he
equates 'good' with 'worth having for its own sake', and recog-
nises that only an experience can be 'had'. Being related in
some way to a mind is a necessary condition of goodness; and
in that sense there is a necessary connexion between being good
and being related to a mind. This necessary connexion is not,
however, reciprocal; for a thing may be related to a mind
without being good.

As regards the second question, I do not here seek to argue
that there is a necessary and reciprocal connexion between being
good and being related in a certain way to circumstances. I ask
only the preliminary question whether being good may be par-
tially dependent on being related in a certain way to circum-
stances. To this question Professor Moore gives a clear and
decisive answer. He holds that when a thing is good (except
where it is good merely as a means), its goodness is completely
independent of all relations to surrounding circumstances. If
we want to find out what things are good, "it is necessary to
consider what things are such that, if they existed *by them-
selves*, in absolute isolation, we should yet judge their existence
to be good."[24] And he holds consistently that whatever goodness
things would have in absolute isolation, this very same good-
ness they must have in whatever circumstances they are found.[25]
Indeed this method of absolute isolation he regards as the only
sound method for any kind of ethical enquiry.

I do not know whether Professor Moore thinks that he has
established this view by proof. If, as he holds, the recognition
of the goodness of things is a kind of direct intuition, there
would seem to be no place for proof, but only for inspection.
At any rate, if there is any proof offered in *Principia Ethica*,
I am afraid that I have missed it. And the view itself does not,

[24] *Principia*, 187.
[25] His view is not merely that, to estimate the goodness of a thing, we must
consider it apart from its consequences. The value of doing so no one would
question.

so far as I can see, follow from the view that goodness is simple and unanalysable.[26]

If this is so, we must look to direct inspection for an answer. I will raise no difficulties as to the kinds of thing which could exist by themselves,[27] though I think there are considerable difficulties here. The value of this method of isolation or abstraction is undoubted; and it seems to me that many things, thus considered in abstraction, may be called good. Among these we may reckon health and wealth and pleasure and happiness and personal affection and aesthetic enjoyment and intelligence. We may, if we choose, call these things intrinsically good, though I should prefer to call them *prima facie* good.[28] They are certainly good as a general rule, but are they good universally, good in any and every set of circumstances to which they may be related? The answer to this seems to me to be, 'Certainly not'. They may, in a sense, be good in themselves, but their goodness may be increased or diminished, or even destroyed, according to the circumstances in which they are found. To consider only one example, the pleasure of the torturer in the pains of the tortured is thoroughly bad.

I see no logical difficulty in holding that, however many things may be *prima facie* good in themselves or good in abstraction, their concrete or real goodness is always partly dependent on circumstances and so on relations. This, I take it, is the Hegelian view. But I think that Kant is right in saying that one thing, and one thing alone, is good in all circumstances and that this thing is a good will. If this is true, and if we call all *prima facie* goods 'intrinsic goods', then we must use some

[26] The Provost of Oriel (*The Right and the Good*, 92) holds that on any relational theory 'good' must stand for a complex. I do not know whether he would regard the view I am putting forward here as a relational theory. He himself holds (122) that "value follows from the *whole* intrinsic nature of its possessors," and also (156) that a morally good action is morally good in virtue of its motives. These statements surely imply that goodness is dependent on certain things, and dependence is a relation; but they do not imply that goodness is a complex, nor can I see that my own view does.

[27] I suppose throughout that they exist in some relation to a mind, e.g., as qualities of it or as objects of it.

[28] Compare Ross, *The Right and the Good*, 138.

other term to describe a good will. It alone is, as Kant says, an absolute and unconditioned good.[29]

If the answer to this question depends on inspection, we must leave the matter there. Professor Moore would include virtue or the emotion excited by rightness among the many things which have some intrinsic value;[30] but he does not rank it very high or give to it any pre-eminent place. The really important question for our purposes is, however, the question of whether *prima facie* goods are necessarily good in all circumstances.

V

As I have said above, I do not find in *Principia Ethica* any proof that *prima facie* goods are good in all circumstances. I think, however, that we may with some confidence state the main reasons which, on Professor Moore's view, have prevented some thinkers from grasping what is presumably a self-evident truth. The reasons are two: (1) a failure to distinguish 'good in itself' from 'good as means'; and (2) a failure to grasp the principle of 'organic unities'.[31]

As regards the first reason, when something is absolutely necessary here and now in order to procure the existence of anything good, we may easily suppose that it is good in itself and that its goodness is at the same time dependent on the circumstances. Wealth, for example, may vary in goodness with different circumstances; but this may be due to the fact that wealth is good, not in itself, but merely as a means to happiness, and that sometimes it may make for happiness and sometimes not. In general, what is good as a means is good in relation to the end sought and to the circumstances in which that end must be attained.

This contention is certainly true, and it may explain many of the cases in which we think that the goodness of a thing varies

[29] Kant nowhere says that it is the sole good, but it is the highest good. It should also be remembered that a good will need not be one which wills for the sake of duty, though under human limitations it is.

[30] *Principia*, 179. A good will is for Kant different from virtue and still more different from an emotion.

[31] See *Principia*, 187, although the argument there is directed to a somewhat different point.

with circumstances. But how does it apply to actions, whose goodness, I should have thought, obviously depends in part on their adjustment, and consequently their relation, to actual circumstances? Professor Moore may possibly take the view that they too are good only as means, and that this is the reason why they vary in value according to circumstances.[32] But if so, it seems to me that he is certainly mistaken. Action is not merely the cause of a result external to itself: it is the willing of an end, and the value of the end enters into the action itself. It is partly because of this that the value of an action depends very largely on its motive. Moreover there is the surprising fact— I take it to be a fact—that the value of a good action may be incomparably greater than that of its results: indeed a good volition may have an absolute value even if, as by a sudden stroke of paralysis, it fails to issue in action or to produce any results in the physical world. If this is true, it is fatal to the view that action is good only as a means and also fatal to all utilitarian philosophy. On the other hand, if Professor Moore regards actions as having goodness other than their goodness as means, I cannot see how it can be denied that this goodness varies according to changes in circumstances. But perhaps this point is to be met by Professor Moore's second reason for the blindness of men in this matter.

The second reason is more complicated. Men may imagine that goodness varies with circumstances, because they fail to grasp the principle of 'organic unities'. "*The value of a whole must not be assumed to be the same as the sum of the values of its parts.*"[33] The doctrine is supported by an elaborate discussion, but here may perhaps be put briefly for our purposes. By adding to a whole a part which has little or no intrinsic value, the value of the whole may be increased far beyond the value of the part added. We are therefore tempted to think that the part

[32] On this point Professor Moore's view is not wholly clear to me. He certainly recognises, at least as a possibility, that actions may have intrinsic value and be good in themselves (pp. 24, 25, 147, 149); but he also speaks as if the only question about them is whether they are 'right', that is, whether they are 'the cause of a good result' (pp. 146-147); and in practice he often speaks as if their only value lay in the results which they produce.

[33] *Principia*, 28.

has a greater value in the whole than it has out of it. This, however, is not the case; and we are not justified "in asserting that one and the same thing is under some circumstances intrinsically good, and under others not so."[34]

I take this doctrine to be both true and important in what it asserts.[35] My question here is whether it is right in what it denies. What it denies does not seem to me self-evident, and several difficulties may be suggested.

(1) It may be said that if the part contributes a great additional goodness to the whole, it might at least be allowed the goodness of so contributing. Just as the means to a good end is admitted to be good as means, so the part which is necessary to the additional goodness of the whole must be allowed the special goodness of being such a necessary part. Professor Moore himself seems to take this view later.[36] Whether or not he would regard this contributory goodness of the part as also an element in the goodness of the whole I do not know; but presumably he would regard it as in any case very much less in value than the intrinsic goodness which the part by its presence may add to the whole.

(2) It is certainly true that the goodness of the whole may be very much greater than the goodness of the parts taken in isolation; but does this mean that we can separate the goodness of the whole from the goodness of the parts when the parts are parts of the whole? A whole is a whole of parts and cannot be separated from the parts. Must not the goodness of the whole be similarly, so to speak, spread over, or manifested in, the parts? Perhaps a negative answer can be justified, but it seems to me that some justification is needed.

(3) The intrinsic goodness of a thing may on this view depend partly on the relation of the whole to its parts, or at

[34] *Principia*, 30. See also 187-188.

[35] I pass over his refutation of the Hegelians (which seems to me somewhat lacking in sympathetic understanding), although in so doing I may be overlooking some points seriously affecting the argument.

[36] *Ethics*, 250. Even in *Principia Ethica* he says (30), "And yet we are justified in asserting that it is far more desirable that a certain thing should exist under some circumstances than under others." Does not 'more desirable' mean 'more good'?

least on the relation of its parts to one another. If this is so, can there be any *a priori* ground for asserting either, generally, that goodness cannot depend partly on relations or, particularly, that the goodness of a part cannot depend partly on the relation of the part to the whole?

(4) What is a whole? Could we in principle extend our whole till it included the whole universe as it existed at the time of an event or action? If there could be anything such that by its existence, apart from its consequences, the whole universe was a better universe, it would seem paradoxical to say that the thing itself had no goodness at all, merely because it seemed to have no value when considered in abstraction from all other things. Its value in abstraction is no real value. Its only real value is the value which it has as existing where it does.

(5) These are all general considerations of varying force. The fundamental question is seen more clearly when we consider the goodness of actions. When Sir Philip Sidney in dying resigned to a wounded soldier the cup of water which had been offered him, I take it that his action was a good action and that its goodness depended partly on the circumstances. If he had been himself quite well and had given the cup to a man who was not thirsty, his action would have had nothing like the same value. How are we to explain this? I do not wish to be unfair to Professor Moore, but surely he cannot mean that the two actions are the same in value, but in the one case the total situation is very much better, either because the action produced a good result or because the action, while itself possessing no more intrinsic value, contributed additional goodness to the whole situation of which it was a part. If this were his view, I think that very few would agree with him, and I cannot see what other view he would take consistently with his general theory.[37]

[37] Another method might be to evaluate in isolation, not the action in itself, but the action in the relevant circumstances together with its motive and intention. This, however, would mean that every action has to be evaluated in relation to its relevant circumstances. The main contention would then be reduced to the view that the goodness of an action is independent of the circumstances irrelevant to its goodness—which is a mere tautology.

My conclusion is that Professor Moore has not proved the goodness of everything to be wholly independent of the relations between the thing and the circumstances of which it is a part. He has offered ingenious explanations of the reasons why men sometimes think mistakenly that the goodness of a thing varies with circumstances, when all that varies is its goodness as a means or the goodness belonging to a whole of which it is a part. But these explanations, so far as I can see, do not cover all the possible cases: in particular they do not cover the case of good actions. More generally, I see no proof that goodness is necessarily independent of all relations whatsoever; and so far as my own intuition goes, I incline very strongly to the view that, at least in many cases, goodness is partly dependent on relations.

VI

We must now consider the question whether there can be a necessary and reciprocal connexion between goodness and will, such that, for example, to be good is to be willed in a certain way and to be willed in a certain way is to be good.

The importance of the doctrine lies in the fact that many philosophers, from Aristotle onwards, have attempted to work out a theory of goodness along these lines. Such a doctrine takes many different forms, none of them perhaps satisfactory. To be satisfactory the doctrine cannot be simple; for it has to explain the many different senses of 'good'[38] by the many different relations between will and what is good.[39] Certainly no one, except perhaps a follower of Protagoras, maintains that whatever is willed is good, though it may be the case that whatever is willed seems good, or is good in some special subsidiary sense. To refute the theory that whatever is willed is good is by

[38] I think Professor Moore would admit that there are many more senses than are recognized in *Principia Ethica*.

[39] For example, 'good as means' is naturally opposed to 'good as end'; each of these manifestly involves a relation to the will, and the relation seems to be different. On the other hand, when we speak of 'a good will', we do not consider it to be good as a means, and it is at least doubtful whether we mean that it is good as an end.

no means to refute the theory as a whole. All these complications and difficulties we must here ignore. The only question is whether the arguments of Professor Moore have put all such doctrines *ab initio* out of court.

This type of doctrine is discussed by Professor Moore under the head of "Metaphysical Ethics." He places it under this head on the ground that it makes goodness depend on relations to a real, or timelessly existent, will. The reference to a timelessly existent will is not, however, a necessary and essential part of the doctrine; and his actual discussion is not based on the supposition that it is. I propose to ignore the 'metaphysical' forms of the doctrine. What we are concerned with is the possibility or impossibility of the doctrine in any form.

Professor Moore considers that this type of doctrine has already been refuted in Chapter I of *Principia Ethica.*[40] He says, "That the assertion 'This is good' is *not* identical with the assertion 'This is willed', either by a supersensible will, or otherwise, nor with any other proposition, has been proved; nor can I add anything to that proof."

Our answer to this is now clear. As we have seen,[41] it is doubtful whether Professor Moore has disproved the possibility of making true statements which substitute some other phrase[42] for 'good' in a proposition: at the most he has offered us a method by which all such possibilities can be refuted. But let us grant that he has proved his case, and that the assertion 'This is good' is not *identical* with the assertion 'This is willed in a certain way'.[43] This has done nothing whatever to disprove the quite different assertion that there is a necessary and reciprocal connexion between being good and being willed in a certain way. The possibility still remains open that to be good is to be willed in a certain way and to be willed in a certain way is to be good.

[40] *Principia,* 129.
[41] Section III above.
[42] The phrase 'ought to exist' is so substituted by Professor Moore himself.
[43] The addition of some phrase like 'in a certain way' is necessary, if the doctrine is to have any plausibility. Even this is too narrow, since good things need not be actually willed: it would be enough that they should be such as to satisfy a will which willed in a certain way.

It seems to me that Professor Moore's argument rests on the assumption that a relation of necessary and reciprocal connexion between being good and being willed in a certain way can only be—*per impossibile*—a relation of identity; and this assumption is neither self-evident nor has it anywhere been proved.[44] The fact that he is making this assumption is borne out by the further progress of his argument; for he recognizes the possibility of something very like a reciprocal connexion between being good and being willed in a certain way; but without any attempt at proof he assumes that this connexion, if not one of identity, must be empirical and cannot be necessary.[45] Being willed in a certain way might, he admits, be a criterion of goodness; but this, he says,[46] could be established only by examining a great number of instances. He is able to affirm that an enquiry into will cannot have the smallest reference to any ethical conclusion,[47] only because he assumes that the connexion between will and goodness must be merely empirical. But this assumption has not itself been established: it has not even been discussed.[48]

I conclude that the possibility of establishing a necessary and reciprocal connexion between goodness and will has not been disproved. We must certainly agree with him that a thing is not made good merely by being willed, and still less by being desired. On the other hand it seems at least plausible to say that nothing could be good unless it could satisfy some kind of desire or will or need. All I suggest is that here we have a proper and promising subject for ethical enquiry, one which cannot be set aside from the very start.

[44] It is certainly not true of necessary and reciprocal connexions in general, *pace* the logical positivists.

[45] *Principia*, 129 and 137.

[46] *Principia*, 137.

[47] *Principia*, 129.

[48] Similarly (*Principia*, 133) he assumes that there can be no reciprocal and necessary connexion between being true and being thought in a certain way, unless—*per impossibile*—being true *means* being thought in a certain way. The only other connexion he recognizes as possible is an empirical one which could be established 'only by methods of induction'.

VII

Since Professor Moore regards his case as already proved, he does not offer any further disproof of a necessary and reciprocal connexion between goodness and willing in a certain way. He conceives that his only remaining task is to meet the main lines of defence which may be taken up,[49] and to show what he believes to be the main confusions which are the source of the error he has exposed.

One source is the common supposition that as truth stands to thinking, so goodness stands to willing: the supposed necessary connexion between thinking and truth suggests a similar necessary connexion between willing and goodness. His reply, put very summarily, amounts to this: (1) there is no necessary connexion between thinking and truth;[50] and (2) there is no analogy between the relation of goodness to willing and the relation of truth to thinking.

To discuss these contentions adequately would require a separate paper. Here I can attempt only to separate out, perhaps to the detriment of his argument, what he believes to be the possible connexions between goodness and willing. He assumes throughout, it must be remembered, that there are only two alternatives, either (1) a relation of identity or (2) a relation of mere empirical concomitance.

"It may be admitted," he says,[51] "that when we think a thing good, we *generally* have a special attitude of will or feeling towards it; and that, perhaps, when we will it in a certain way, we do always think it good."

[49] *Principia*, 129.

[50] See *Principia*, 132-133, where "the proposition that for a thing to *be* true it is necessary that it should be thought" is said to be erroneous. His argument is based on a curious confusion of truth and reality, which I suppose he must believe to be present in idealists, though it is certainly not present in Kant. Only things can be real, and only judgements or propositions can be true. If we believe that propositions are timeless existents, then I suppose they may be true independently of thought. I suggest, however, that when we call propositions true, we mean strictly that they would be true if they were thought—just as when we call things good, we mean that they would be good if they existed (and satisfied a rational will). It seems to me obvious that in a world without thinking there would be no truth; and similarly that in a world without willing there would be no good.

[51] *Principia*, 135.

It is, I think, unfortunate that, here and elsewhere, he lumps together will and feeling. The theories which rest on will are very different from those that rest on feeling. Those who rest their theory on will, do so because they believe that will, like thinking, can be rational (no doubt a much abused word and one greatly in need of clarification). Feeling in itself no one regards as rational: it can be rational only in the sense that it can be aroused by rational thinking or rational willing, as in Kant's doctrine of the feeling he calls 'reverence' or 'respect'. In any case the question of feeling is irrelevant to the present discussion.

Professor Moore's admission is only tentative; but so far as it goes it recognizes that to will a thing in a certain way is always also to think it good. To think a thing good, however, is not always also to will it in a certain way, though perhaps it generally is. This last contention seems obviously true: the possibility, however, remains open that to think a thing good is always also to think that it could be willed in a certain way.

If we confine ourselves to the view that to will a thing in a certain way is always also to think it good, how are we to understand this connexion? Is it a mere empirical concomitance to which hitherto we have, as a matter of fact, observed no exception? I hardly think so, and some explanation seems to be required.

Professor Moore does not discuss this in any detail, but he makes some interesting observations. He says:[52] "It is by reflection on our experiences of feeling and willing that we become aware of ethical distinctions." Hence he holds that there is a *causal* connexion between willing and goodness—not of course in the sense that willing makes a thing good, but in the sense that "willing is a necessary condition for the cognition of goodness." I take him to mean that willing gives rise to reflexion on willing, and reflexion on willing leads us to apprehend what things are good and perhaps even—though here I am uncertain —to apprehend what is meant by 'good'.

This account is deserving of further expansion. Unless there is some other connexion than this between willing and good-

[52] *Principia*, 130.

ness, it is hard to see how reflexion upon the first should lead us to apprehension of the second. Ordinarily, if two things are themselves unconnected, reflexion on one does not lead to apprehension of the other.

I do not find in Professor Moore any clear answer to this obvious difficulty, but there are some hints which I hope I have not misunderstood. If I understand him aright, willing, in a wide sense, may be regarded as a complex fact, part of which consists in willing, taken in a narrower sense, and part of which consists in thinking that what is willed, in the narrower sense, is good. Hence, whenever we will a thing (in the wider sense and perhaps also in the narrower sense), thinking it good always occurs as part of our willing (in the wider sense); and generally, though not always, when we think a thing good, this thinking is a part of willing (in the wider sense).[53]

This explanation, if it is an explanation, does not take us very far. It is true that if willing (in the wider sense) contains, as part of itself, thinking that what is willed is good, then reflexion on willing (in this sense) might lead to the apprehension of goodness so far as it made us aware that, however obscurely, we were in this willing thinking that something is good. But the thinking a thing good would apparently be already present and be independent of willing in the narrower sense. Willing, in the narrower sense, would be as before a mere concomitant of thinking a thing good. Hence reflexion on willing, in the narrower sense, would lead us to no apprehension of what is good; and reflexion on willing, in the wider sense, could hardly be a necessary condition of our cognition of goodness, since willing, in this sense, presupposes a cognition of goodness.

On the other hand, if there is more than a mere empirical concomitance between willing a thing and thinking it good, if

[53] This is based on *Principia*, 131. I presume we should add to the word 'will' the qualification 'in a certain way'. It is not true that whenever we will a thing, we think it good (in Professor Moore's sense of 'good'); but it may be true that whenever we will a thing *in a certain way*, we always think it good. Here as always 'in a certain way' requires explanation: it would be a mere tautology to say, for example, that whenever we will a thing, thinking it good, we always think it good.

there is, as I think there must be, some kind of necessary connexion, Professor Moore's theory offers no explanation of this necessary connexion. Indeed this necessary connexion is explicitly denied. But if we will only what we think good, this suggests, at least to me, that what will aims at is the good, that the good alone can satisfy the will, and even that what satisfies the will must be good. If this were true, and if further it were true, as I think it is, that nothing could be good unless it could satisfy some will, we should have precisely that necessary and reciprocal connexion between being good and satisfying the will which Professor Moore supposes to be impossible unless 'being good' *means* the same thing as 'satisfying the will'.

The main conclusion is that Professor Moore has not proved the impossibility of asserting a necessary and reciprocal connexion between goodness and will without falling into what he calls 'the naturalistic fallacy' of *identifying* good with something other than itself. This fallacy is particularly dangerous if the 'something other' is a mere fact containing in itself no element of value, and Professor Moore's discussion has made the danger very clear. But I think it should be added (in defence of any who do identify 'being good' and 'being willed in a certain way') that willing 'in a certain way', for example, willing rationally, is not to be regarded merely as a psychical fact or a psychical state divorced from all considerations of value.

I need hardly add that no attempt has been made here to establish any positive doctrine or even to expound what that doctrine is. To speak of 'willing in a certain way' or even of 'willing rationally' or of 'satisfying a rational will' tells us practically nothing without a great deal of further explanation; and any theory of this kind must be adjusted to the many senses in which the word 'good' is used. In particular I have made no attempt to explain the nature of the reciprocal and necessary connexion which I believe to hold between goodness and willing in a certain way. We have to ask a whole series of questions, such as, 'Is a thing good because it satisfies the will or does it satisfy the will because it is good?' Perhaps it might be true

both that a thing is good because it satisfies the will *and* that it satisfies the will because it is good—just as it is true of a plane rectilineal figure *both* that it must be three-angled because it is three-sided *and* that it must be three-sided because it is three-angled. But on these points I offer here no opinion.

H. J. Paton

Corpus Christi College
Oxford University

5

Abraham Edel

THE LOGICAL STRUCTURE OF G. E. MOORE'S
ETHICAL THEORY

THE LOGICAL STRUCTURE OF G. E. MOORE'S ETHICAL THEORY

WHEN I was a student at Oxford in the late twenties, the controversies raging about the relation of the right and the good were at their height. Prichard had given his inaugural address on *Duty and Interest,* and Ross and Joseph were giving the lectures which were later developed into *The Right and the Good* and *Some Problems in Ethics.* Moore's theories figured in the lectures and still more in the student discussions that ensued on leaving the lecture-halls. Whether right was to be defined in terms of good or was an independent notion, whether good was an indefinable quality or a relation, were questions over which deep passions were roused and on which man's whole welfare in this cosmos seemed to depend. As I recall these discussions, adherence to Moore's definitions symbolized a kind of revolt—but I cannot be sure now whether it was revolt against conventional morality or simply treason to Oxford in identification with Cambridge.

The naturalistic environment of American philosophy allows little place for strong feelings about problems of apparently abstract definition. The positivist stress on language may even tempt one to try an interpretation of these ethical controversies as simply different formulations of the same ethical content. To translate Moore into Ross and Ross into Moore seems not an impossible task and certainly a pleasant pastime. It sharpens the sense of the conventional elements in ethical formulations. But it ignores differences that I am now convinced are profound. What, then, are these differences? Are they contradictory beliefs as to fundamental truths or are they clashes in personal and social values? If the latter, can it be that not merely the

material content of ethical theories but even the logical structures of ethical theories are vehicles for major value-judgments? In the light of such questions the present essay may be seen as an attempt to find a rational basis for the sense of the momentous which I once felt in these issues.

By the logical structure of an ethical theory I shall mean the terms employed in the theory, the definitions and postulates governing their use, the rules for the formation of ethical statements, and the procedures for interpreting ethical terms and determining the truth or falsity of ethical statements. In the broad sense in which the term is here employed, the logical structure of an ethical theory consists of the equipment required to generate the enterprise of ethical inquiry. In examining Moore's ethical theory I shall, therefore, first carry out a purely formal study—simply listing the terms, definitions, postulates and rules to be found in his ethical writings, without raising questions of interpretation, truth or utility. Thereafter I shall attempt to discover what procedures Moore is employing (explicitly or implicitly) for the application of his theory. And finally I shall consider whether the selection of a specific logical structure by Moore constitutes the discovery of truth or the choice of a vehicle for specific values.

I. Moore's Vocabulary of Ethics

Moore's vocabulary of ethical inquiry falls conveniently into four types of terms—ethical, partly ethical, non-ethical and meta-ethical.

(a) *Ethical terms.*

Moore uses two undefined ethical terms—*good* and its converse *bad*. Other terms declared or implied to be synonymous with *good* are: *intrinsic value, intrinsic worth, ought to exist* (PE 17),[1] *absolutely good* (PE 99), *good in itself, ought to be* (PE 118). That *good* is used in the comparative and superlative is indicated by such expressions as "degree of value" (PE 27), "in what degree things themselves possess this property"

[1] In the present essay Moore's works will be referred to as follows: *Principia Ethica* PE; *Ethics* E; *Philosophical Studies* PS. Articles will be referred to in full.

(PE 36), "the greatest good of which the circumstances admit" (PE 23), "more intrinsic value" (E 72).

(b) *Partly ethical terms.*

All other terms commonly regarded as ethical are defined by Moore by means of the above ethical terms together with terms of the various sciences, ordinary discourse, mathematics, etc.

The good or *that which is good* is the substantive to which the adjective 'good' will apply (PE 9). But the expression 'what is good' is ambiguous; as a question it may mean "Which among existing things are good? or else: what *sort of* things are good, what are the things which, whether they *are* real or not, ought to be real?" (PE 118). Similarly *ideal* is ambiguous and may mean "the *best* state of things *conceivable,* the Summum Bonum or Absolute Good" or "the best *possible* state of things in this world," or merely a state of things "good in itself in a high degree" (PE 183-184).

Ultimately good or *good for its own sake* adds to *good* the qualification that the subject to which it refers contains no parts which are not themselves intrinsically good (E 73-75).

Good as a means is defined in terms of *good* and *causation.* We judge of something "both that it will have a particular kind of effect, *and* that that effect will be good in itself" (PE 22).

To assert that a certain line of conduct is *right* or *obligatory* is to assert that "more good or less evil will exist in the world, if it be adopted than if anything else be done instead" (PE 25). The distinction between *right* and related terms is carefully refined in various parts of Moore's ethical writings. "An action is right, only if no action, which the agent could have done instead, would have had intrinsically better results; while an action is wrong, only if the agent *could* have done some other action instead whose total results would have been intrinsically better" (E 61). I am *morally obliged* to do something, I am *morally bound,* I *ought* to do it, it is my *duty* to do it, are analyzed as saying that it is *wrong* of me *not* to do it (PS 312; cf. PE 146-148). The chief difference between *right* and *ought*

is that several courses of conduct in a situation may be right (being productive of equal good) whereas to say that one course ought to be followed implies that another would be wrong (E 32-38). *Morally praiseworthy* and *morally blameworthy* mean simply that it is right to praise or blame a particular act (E 188) and are thus not identical with right and wrong.[2] And to praise a thing is "to assert either that it is good in itself or else that it is a means to good." (PE 171).

The relation of the terms *right* and *duty* on the one hand, and *useful* and *expedient* on the other, is not entirely uniform in Moore's writings. *Right* is sometimes identified with *useful* as simply "cause of a good result" (PE 147); and *duty* with "the expedient, if it is really expedient" (PE 167). A difference between duty and the expedient is found only in fields of usage; duties are, in effect, those expedient actions "with regard to which there is a moral sentiment, which we are often tempted to omit, and of which the most obvious effects are effects upon others than the agent" (PE 169). In *Ethics*, however, in contrast to this view, it is maintained that the meaning of the two words *expediency* and *duty* is not the same, but that in fact whatever is expedient is also a duty and conversely (E 172-173).

A virtue is defined by Moore as "an habitual disposition to perform certain actions, which generally produce the best possible results" (PE 172). *Virtue* is not thus a unique ethical predicate but involves in its definition terms from psychology, ordinary discourse, science or philosophy, etc.

Other partly ethical terms employed and defined are *approving* (PE 60), *fitting* or *appropriate* (PE 100), *justify* (PE 101), *interest* (PE 170-171), and the terms designating specific virtues. The list here given is by no means exhaustive of Moore's ethical vocabulary.

(c) *Non-ethical terms.*

Certain terms appear in ethical statements which are not

[2] This distinction is used effectively to meet the attempt to define right and wrong in terms of *foreseen* consequences rather than *actual* consequences (E 190-195); cf. the discussion of *possible* (PE 150-151).

themselves ethical or even partly ethical terms. Such non-ethical terms are a comprehensive class covering the terms of the various sciences and of ordinary discourse. In addition to the examples noted in the definitions of the partly ethical terms above, Moore uses psychological terms (such as *pleasure, feeling,* etc.), terms designating situations and activities (*to tell the truth*), human relations (*friendship*), demonstratives (*this* and *that*), and so forth. Some non-ethical terms require extended analysis for purposes of ethical inquiry; among the most important of these is the class including such terms as *voluntary, can, possible, choose,* etc. (E 29-31 and ch. VI).

(d) *Meta-ethical terms.*

These are terms that do not as a rule appear in ethical statements but are employed in talking about them. Among those employed by Moore are *quality, natural, non-natural, intrinsic, intuition,* and so forth. Terms like *thing* or *experience* may be used as both non-ethical (Such an *experience* is intrinsically good), and meta-ethical (The only type of subject of which intrinsic goodness may be predicated is an *experience*). Meta-ethical terms are important in discussing such questions as how ethical terms may be interpreted or the truth of ethical statements established.

It is too early to estimate the desirability of the above vocabulary for the purposes of ethical inquiry. It should be noted, however, that other combinations of defined and undefined terms are found in other ethical theories. Brentano, as Moore himself pointed out in a review,[2] analyzed the assertion that a thing is good in itself as meaning that the feeling of love towards it or pleasure in it is right; and the assertion that a thing is bad as meaning that hatred of it would be right. Moore himself at one point makes assertions which suggest a similar approach:

To say of anything, A, that it is "intrinsically good," is equivalent to saying that, if we had to choose between an action of which A would

[2] Moore's review of Franz Brentano's *The Origin of the Knowledge of Right and Wrong,* in *The International Journal of Ethics,* Oct. 1903, 115.

be the sole or total effect, and an action, which would have absolutely no effects at all, it would always be our duty to choose the former, and wrong to choose the latter. (E 66)

In addition to ethical theories making *good* the fundamental undefined term and those giving this place to *right,* there are theories in which both *right* and *good* are coördinated undefined ethical terms; Ross' *The Right and the Good* is a notable example of such a formulation. The same variability is found in dealing with other definitions. Moore includes in his definition of *good as a means* that the result be intrinsically good. Some other systems employ this term in the non-ethical sense of efficacious without reference to the value of the end.

II. POSTULATES OF MOORE'S ETHICAL THEORY

This section will deal with the rules that Moore prescribes, explicitly or implicitly, to govern the construction of ethical statements and the use of ethical terms. I do not expect in this study to discover all the rules to which he adheres, nor to formalize them with entire precision; the attempt is only to distinguish the type of theory Moore is advancing. I shall limit myself, furthermore, to rules governing statements containing the terms *good* and *right.*

Moore's postulates for the use of *good* in the sense of *intrinsically valuable* can be distilled from his essay "The Conception of Intrinsic Value." The following formulation of these postulates was derived by selecting quotations that appeared to summarize adequately the central points of the essay and stating their substance.

1. *The intrinsic value of x depends solely on the intrinsic nature of x.*

> To say that a kind of value is 'intrinsic' means merely that the question whether a thing possesses it, and in what degree it possesses it, depends solely on the intrinsic nature of the thing in question. (PS 260)

2. *The intrinsic value of x depends solely on the intrinsic nature of x, if and only if: the intrinsic value of x is an absolute*

constant and if y is exactly like x then x and y have the same intrinsic value.

By depending solely on the intrinsic nature of the thing in question Moore says he means "(1) that it is *impossible* for what is strictly *one and the same* thing to possess that kind of value at one time, or in one set of circumstances, and *not* to possess it at another; and equally *impossible* for it to possess it in one degree at one time, or in one set of circumstances, and to possess it in a different degree at another, or in a different set . . . (2) . . . if a given thing possesses any kind of intrinsic value in a certain degree, then not only must that same thing possess it, under all circumstances, in the same degree, but also anything *exactly like it,* must, under all circumstances, possess it in exactly the same degree. Or to put it in the corresponding negative form: It is *impossible* that of two exactly similar things one should possess it and the other not, or that one should possess it in one degree, and the other in a different one." (PS 260-261)

3. *y is exactly like x if, and only if, y and x have the same intrinsic nature.*

This is a general statement covering both the obvious case in which y is itself identical with x and the case in which they are numerically distinct. Moore explains of the latter that "we should naturally say of two things which were *exactly alike* intrinsically, in spite of their being *two,* that they possessed the *same* intrinsic nature." (PS 262) He also points out that 'different in intrinsic nature' does not hold between two things merely because they are numerically different; nor is it identical with qualitative difference, which is one particular species of it (PS 262-265).

4. *There is a characteristic C such that all intrinsic properties possess C and no intrinsic values possess C.*

". . . there must be," Moore decides, "some characteristic belonging to intrinsic properties which predicates of value never possess. And it seems to me quite obvious that there is; only I can't see *what* it is." (PS 274)[4]

5. *x and y have the same intrinsic nature if, and only if, x*

[4] A suggestion as to what it is will be offered below.

and y have the same intrinsic properties (i.e., the intrinsic nature of a thing is the set of its intrinsic properties).

> This is clearly intended in the following statement of Moore's: ". . . intrinsic properties seem to *describe* the intrinsic nature of what possesses them in a sense in which predicates of value never do. If you could enumerate *all* the intrinsic properties a given thing possessed, you would have given a *complete* description of it, and would not need to mention any predicates of value it possessed; whereas no description of a given thing could be *complete* which omitted any intrinsic property." (PS 274) It is not necessary to state the last part of this as a separate postulate since it follows from postulate 4 that an intrinsic value is not an intrinsic property.

One very important theorem may readily be derived from these postulates. Postulate 2 states an equivalence and postulate 1 states the truth of its left-hand side. Therefore the right-hand side may be independently asserted. By replacement for the term 'exactly alike' according to postulate 3 and then for 'intrinsic nature' according to postulate 5, we get: *The intrinsic value of x is an absolute constant, and, if x and y have the same intrinsic properties, then x and y have the same intrinsic value.* We shall speak of this theorem hereafter as the *principle of the constancy of value.*

I have used the term 'absolute constant' both in postulate 2 and in this important theorem to express succinctly the kind of necessity Moore believes to characterize the way in which intrinsic property and intrinsic value are related to the thing that possesses them (PS 265-270). By saying that it is impossible for F to possess G, Moore does not mean merely that things which possess F never in fact possess G. Nor does he mean causal impossibility, that F cannot be G because the laws of the universe are what they are. He intends the statement of necessity or impossibility to hold even if causal laws were different from what they are:

> Suppose you take a particular patch of colour, which is yellow. We can, I think, say with certainty that any patch exactly like that one, *would* be yellow, even if it existed in a Universe in which causal laws were quite different from what they are in this one. We can say that any

such patch *must* be yellow, quite unconditionally, whatever the circumstances, and whatever the causal laws. (PS 269) . . . But what precisely is meant by this unconditional 'must', I must confess I don't know. (PS 271)

Moore denies that it is the logical 'must' (e.g., whatever is a right-angled triangle *must* be a triangle); for "I do not see how it can be deduced from any logical law that, if a given patch of colour be yellow, then any patch which were exactly like the first would be yellow too." (PS 272)

In our formulation of the postulates this difficulty about the special meaning of impossibility and necessity disappears. Moore's assertion about yellow becomes, when replacements are made for 'exactly alike' (postulate 3) and 'intrinsic nature' (postulate 5) simply the assertion that if x and y have the same intrinsic properties and yellow is an intrinsic property of x, then yellow is an intrinsic property of y. The only necessity required is logical necessity, and Moore's statement that the assertion about yellow could not be deduced from any logical law is true only if it be taken to mean that postulates and definitions are *also* required for the terms 'exactly alike' and 'intrinsic nature'.

There is one more principle that plays an important part in Moore's ethical theory. This principle is logically independent of the postulates stated above. It does not appear in "The Conception of Intrinsic Value," but is prominent in *Principia Ethica*. I shall refer to it hereafter by the name Moore uses—the *principle of organic unities (or relations): The value of a whole "bears no regular proportion to the sum of the values of its parts."* (PE 27) Thus, from 'A is good and B is good' we may not even infer 'What is both A and B is good', much less 'What is both A and B has more value than A'. I do not number this as one of the postulates because it is not clear to what extent it should be regarded rather as a lesson of experience once the postulates have been interpreted and the theory applied. The significance of this problem will be discussed below.

From this account of Moore's major postulates we turn next to some of the rules that govern the formation of ethical statements in which the terms *good* and *right* appear. These may be conveniently discussed with reference to (a) ethical terms,

(b) non-ethical terms, (c) the logical structure of the statements permitted.

(a) *Rules governing the usage of the fundamental ethical terms.*

Moore intends *good* and *right* to be predicates in ethical statements, e.g., 'friendship is good', 'to tell the truth is right'. In a secondary sense they may, of course, be part of the subject, e.g., 'right actions involve effort'.

Moore also intends these terms to be simple or unqualified predicates. Thus he rejects any attempt to couple *good* with pronominal or prepositional attachments. 'This is my good' or 'This is good for me' is to be gotten rid of by some such translation as 'My having (or being thus affected by) this is good' (PE 97-99). Similarly 'good as a means' is merely 'a means to what is good' (PE 21); and 'good as a part' merely 'a part of that which is good' (PE 35). Such reformulation incidentally precludes all egoistic formulations as well as any interpretation which would regard *good* as a relational property.[5] The fundamental reason for ruling out such proposals is, as we shall see, that they would conflict with the principle of the constancy of value.

(b) *Rules governing the usage of non-ethical terms.*

The very definition of *right* limits its possible subjects to *acts* or *lines of conduct*. In the case of *good,* however, no narrow limitations are imposed on the character of the subject in the earliest of Moore's writings, but there is an increasing limitation in the later writings. In *Principia Ethica* (1903) one of the grounds on which Moore opposes certain ethical theories is that they hold "that there is only *one* kind of fact of which the existence has any value at all" (PE 37), that is, they limit the subject in type, e.g., to pleasure. This desire to keep open the type of subject is certainly one of the reasons why he brands the reduction of good to a natural property as a "naturalistic fallacy" and why he insists so often on the difference between identifying

[5] I.e., an interpretation of 'x is good' as 'x has such-and-such a relation to (e.g., is desired by) so-and-so'.

good with something else and correlating its presence with the presence of some other quality. At one point in *Ethics* (1911), however, Moore declares: "I think it is true that no whole can be intrinsically good, unless it *contains* some feeling towards *something* as a part of itself." (E 167) In a later essay ("The Nature of Moral Philosophy," written in 1921) Moore says: "One thing, I think, is clear about intrinsic value—goodness in Aristotle's sense—namely that it is only actual occurrences, actual states of things over a certain period of time—not such things as men, or characters, or material things, that can have any intrinsic value at all." (PS 327) And in a still later essay, "Is Goodness a Quality?" (in *Aristotelian Society, Supplementary Volume* XI, 1932), Moore suggests translating *good* into *worth having for its own sake*, which involves limiting its subject to *experiences* (122-124).

In *Principia Ethica,* Moore often uses the general term *thing* for the subject of which *good* is asserted. It is implied that the subject is a substantive in some sense or other, that is, a *whole* that could be in some sense *self-existent*. This is made clear in Moore's constant reliance on what he calls "the only method that can be safely used, when we wish to discover what degree of value a thing has in itself." (PE 91) This—which we shall call hereafter the *isolation test*—consists in "considering what value we should attach to it, if it existed in absolute isolation, stripped of all its usual accompaniments" (*ibid.*). Sometimes this is offered as the very meaning of *intrinsically good*, viz., "that it would be a good thing that the thing in question should exist, even if it existed *quite alone*, without any further accompaniments or effects whatever." (E 65) The merits or demerits of this test we shall consider below. Here it is important to note that since *good* as a fundamental ethical term refers to intrinsic value, the subject in a properly constructed ethical statement containing *good* as a predicate *must refer to something capable of being conceived or imagined as if it were the only thing in the world. It must therefore refer to a possibly self-existent whole.*[6]

⁶ That Moore takes absolute isolation strictly to mean absolutely alone or

(c) *Types of ethical statements permitted.*

In the case of *good* Moore refers to both singular statements and universal laws. The singular " 'This is good' may mean either 'This real thing is good' or 'The existence of this thing (whether it exists or not) would be good'." (PE 120-121) Universal moral laws, he says, have the form "This is good *in all cases.*" (PE 126) The difference between these types of statements in the case of *good* almost disappears, however, on analysis. For Moore says: "Judgments of intrinsic value have this superiority over judgments of means that, if once true, they are always true; whereas what is a means to a good effect in one case, will not be so in another." (PE 166) Again, a judgment of what is good in itself "if true of one instance of the thing in question, is necessarily true of all; ... all judgments of intrinsic value are in this sense universal." (PE 27) It would follow that from 'This A is good' we can infer 'All A's are good'. Similarly the universality of moral laws ("This is good *in all cases*") turns out not to mean what might at first have been thought. It does not say that *this* automatically renders good every whole of which it is a part. For the goodness of the whole is to be separately tested and the same part combined with different other parts may produce wholes of different value. Furthermore, since the principle of the constancy of value postulates that the value of a thing remains the same, and since statements of the form 'This A is good and that A is not good' are precluded, it is gratuitous to cast the judgment of a thing's goodness in a mould referring to *all* cases.

There is thus, after all, only one type of statement with *good* as predicate that Moore is really willing to allow. We cannot without danger of misunderstanding formulate it either as a singular or a universal. It might be expressed as 'A *qua* A is good' or, in the light of Moore's use of the isolation test, as

constituting a whole world by itself, is amply clear from his illustrations; for example, "Could we accept, as a very good thing, that mere consciousness of pleasure, and absolutely nothing else, should exist, even in the greatest quantities?" (PE 94)

'A world consisting solely of A would be good.' In the latter form, however, it would be important to note that we could infer by Moore's rules that A is good even when it occurs in nature and not in isolation. For the intrinsic value of a thing in existence, whether as part or whole, remains the same. "The part of a valuable whole retains exactly the same value when it is, as when it is not, a part of that whole. . . ." (PE 30)

It is perhaps unnecessary to add that probability assertions in which *good* appears find little or no place in Moore's theory, and he does not discuss them. Such statements could, however, be translated so as to fit into his theory. 'This sort of thing (A) is good in a certain proportion of the cases' would mean 'Such-and-such a proportion of the wholes of which A happens in this world to be a part, are intrinsically good'. It would tell us how reliably the appearance of a part indicated that the whole would turn out to be good on independent test.

Ethical statements containing the term *right* involve no comparable difficulties. They may be singular statements, probability assertions or universal laws. Moore does not in fact believe that we are likely to construct *true* universal statements, but that is a matter to be subsequently explored.

There are two further qualifications which Moore insists on concerning the use of *right:*

(1) that, if it is true at any one time that a particular voluntary action is right, it must *always* be true of that particular action that it *was* right: or, in other words, that an action cannot change from right to wrong, or from wrong to right; that it cannot possibly be true of the very same action that it is right at one time and wrong at another . . . (2) that the same action cannot possibly *at the same time* be both right and wrong. (E 80)

Since by definition an act is right only if no other action which the agent could have done would have produced in the whole world results that are intrinsically better, these rules are clearly consequences of the principle of the constancy of value and the definition of *right*. Another way of stating these two rules would be to say that Moore intends the expression 'This particular act is right' to be a statement and not a sentential function. That is,

no free variables are to appear in the analysis of 'this particular act'[7] and of 'right', as would be the case if, for example, 'good' were defined as 'pleasing to x'.

The rules described above are so far regarded merely as mandates issued by Moore for the construction of ethical statements which his ethical theory will permit. Similarly the postulate set given above has been regarded up to this point as *uninterpreted*. It contains two fundamental undefined terms— *intrinsic property* and *intrinsic value*. Any question of its applicability to the domain of ethics, its utility or fruitfulness, and its truth, must depend for its answer on the explicit interpretation given to these terms.

It is also important to note that there are conceivable alternatives to each postulate. For example, instead of postulate 1 ("The intrinsic value of x depends solely on the intrinsic nature of x"), another system might have "The intrinsic value of x depends upon the particular psychological field in which x finds itself," or "The intrinsic value of x depends on the intrinsic nature of x and the psychological field in which x finds itself." Clearly one could readily construct an alternative set of postulates in which a principle of variability of value would replace the principle of the constancy of value. Similarly there not merely might be, but have in fact been important ethical theories whose rules of sentence-formation permitted sentences of the form 'A is good under some circumstances and not under others', probability assertions concerning goodness, and the use of the past tense as in 'This was good and no longer is'. Statements in such theories may or may not be translatable into the terms and rules of Moore's theory. In any case, there is no *a priori* reason why Moore's postulates should be preferred to an alternative consistent set altering some of them. Any such decision must wait upon interpretation.

[7] How feasible this is, is another question. For example, if we speak of 'that particular remark made by A', what features are included in its particularity? It certainly includes time, place, person addressed. But what about tone of voice, gesture, intent, or any other concomitant characteristic of A that may later prove relevant to the results which determine the rightness of the act?

III. Procedures for Application of Moore's Theory

Moore definitively rejects any empirical interpretation for the fundamental terms of his ethical theory. He resists any tendency to look for discernible elements in nature or for operations of men as providing an interpretation of *good* in the sense of *intrinsic value*. This is the theme of a great part of his ethical writings. It is bluntly stated in his review of Brentano's *The Origin of the Knowledge of Right and Wrong*. Moore writes:

The great merit of this view over all except Sidgwick's is its recognition that all truths of the form "This is good in itself" are logically independent of any truth about what exists. No ethical proposition of this form is such that, if a certain thing exists, it is true, whereas, if that thing does not exist, it is false. All such ethical truths are true, *whatever the nature of the world may be.*[8]

Moore intends this sweeping rejection to cover not merely empirical but also metaphysical interpretations, e.g., those in terms of supersensible reality, rational will, true self, etc. These are equally regarded as committing the naturalistic fallacy (PE ch. 4; E ch. 4). For they fail to perceive "that any truth which asserts 'This is good in itself' is quite unique in kind—that it cannot be reduced to any assertion about reality, and therefore must remain unaffected by any conclusions we may reach about the nature of reality." (PE 114) The naturalistic fallacy is thus equivalent to offering any interpretation in terms of existence or reality for *good*, that is, any refusal to treat it as a simple indefinable quality. Moore accuses all such interpretations— metaphysical or empirical—of the same error, that is, assimilating all propositions to descriptions of some form of existence or reality (PE 125).

To support his position Moore carries out a critique of major naturalistic and metaphysical theories. Five of the central arguments he employs are here analyzed for the issues on which they focus attention.

(1) One major type of naturalistic interpretation of *good* has been in terms of subjective reactions of men—feelings, at-

[8] *International Journal of Ethics*, Oct. 1903, 116.

titudes, etc. Against this Moore says: "For there is, I think, pretty clearly no subjective predicate of which we can say thus unconditionally, that, *if* a given thing possesses it, then anything exactly like that thing, *would*, under any circumstances, and under any causal laws, also possess it." (PS 269) In short, if we try to interpret 'x is good' in terms of psychology, e.g., as 'x is pleasing' we find that the theorem we called the principle of the constancy of value fails to be confirmed by experience. It is found not to be the case that "the pleasingness of x is an absolute constant, and if x and y have the same intrinsic properties x and y have the same pleasing effect." For subjective reactions are found to depend on causal laws and attendant circumstances. Hence they do not furnish an interpretation for Moore's postulates. This means that if we take this interpretation of *good* we reject Moore's postulates, and if we accept Moore's postulates we reject this interpretation.

(2) Moore refers to a second type of naturalistic theory, one which identifies good as an intrinsic property. For example, the assertion that a state of mind is good would be interpreted as an assertion that it is a state of being pleased (PS 272-273); now 'being a state of pleasure' is an intrinsic predicate like 'yellow', since "if a given thing possesses them, anything exactly like the thing in question must possess them." (PS 273) Such a theory, however, fails to satisfy postulate 4 which says that there is a characteristic C possessed by all intrinsic properties and by no intrinsic values. In fact, Moore introduced this distinction precisely in order to rule out such a naturalistic theory although he felt uncertain what the characteristic in question might be.

(3) One of Moore's central arguments against a naturalistic interpretation, whether of *good* or *right*, is that it renders impossible genuine contradiction. When I say "This is good" and you say "This is not good" we are not contradicting one another if I mean that it pleases me and you mean that it does not please you. Both statements might be true. But Moore is certain that such statements are genuinely contradictory. Hence he feels that the naturalistic type of interpretation must be incorrect.[9] This argument is elaborately developed in *Ethics*, ch. 3, in the case of

[9] It is not necessary for the purposes of this argument to examine whether all naturalistic interpretations must be of this type.

right, and to some extent for *good* in ch. 4. Moore uses such expressions as "no two men can ever differ in opinion as to whether an action is right or wrong" (E 101), and similarly "as to whether a thing is good or bad." (E 158) He also sees as consequences of the naturalistic interpretation that the same act would be both right and wrong and the same thing both good and bad (E 86 and 158). Such conclusions would violate the principle of the constancy of value, and therefore the premises from which they follow are to be rejected.

What Moore has shown is the incompatibility of the usual type of naturalistic interpretation with his postulates. It does indeed follow from interpreting *good* as a relational property (e.g., desired, well-regarded, etc., by x) that there need not be a contradiction between the expressions 'This is good' and 'This is not good' any more than there need be a contradiction between 'This is near' and 'This is not near' where the point of reference is not specified. In short, the analysis of *good* may turn out to involve a concealed free variable and the apparent statements to be only sentential functions. Clearly, to allow such results requires initial postulates for ethical theory quite different from Moore's. I do not think that Moore's argument about the impossibility of genuine contradiction on the naturalistic interpretation proves anything more than this.

In ordinary usage *contradiction* is an equivocal term. We often speak of contradictory attitudes to the same thing, meaning not that there is a difference of judgment about the truth of a statement, but that men have opposing feelings towards it. Again, two men are often said to pursue contradictory aims if it is the case that the achievement of the one will thwart the achievement of the other; that is, if it is true that A will achieve his aim it must be false that B will achieve his. Such senses of *contradiction* are not unimportant in the consideration of ethical problems, and they are permissible under a naturalistic formulation. Even the sense of contradiction Moore is referring to is permissible in those cases where questions of means are involved; and a naturalistic theory might very well maintain that most ethical questions in fact involve a fusion of problems of means and ends.

Furthermore, Moore's theory develops in another quarter an

ailment analogous to the one it is here condemning. For Moore himself regards propositions about what is intrinsically good as *synthetic* (PE 7, 58, 143 ff.); "they all must rest in the end upon some proposition which must be simply accepted or rejected, which cannot be logically deduced from any other proposition . . . the fundamental principles of ethics must be self-evident." (PE 143) What, then, is to be done, if all attempts to reach agreement fail and there *is* difference of opinion on whether A is good or not? Clearly nothing. The only difference then in this respect between a naturalistic interpretation and Moore's interpretation is that in the latter each side will feel that its assertion is true and the other false; in the naturalistic view both will recognize that they are faced with differing attitudes. The fact of ultimate arbitrary difference is the same in both.

That Moore recognizes such arbitrariness as characteristic of necessary synthetic propositions is seen in one passage in his essay, "The Refutation of Idealism." He writes:

We have, then in *esse* is *percipi*, a *necessary synthetic* proposition which I have undertaken to refute. And I may say at once that, understood as such, it cannot be refuted. If the Idealist chooses to assert that it is merely a self-evident truth, I have only to say that it does not appear to me to be so. But I believe that no Idealist ever has maintained it to be so. (PS 11) [And again:] I believe that Idealists all hold this important falsehood. They do not perceive that *esse* is *percipi* must, if true, be *merely* a self-evident synthetic truth: they either identify with it or give as a reason for it another proposition which must be false because it is self-contradictory. Unless they did so, they would have to admit that it was a perfectly unfounded assumption; . . . (PS 12)

(4) Moore's belief that good is a simple *quality* also leads him to oppose a naturalistic interpretation. For any interpretation in terms of a person's being pleased or desiring anything or having any specified feeling or attitude towards something, requires that *good*, since it refers to relational properties, designate a complex. Against this view that *good* designates a complex Moore argues that "whatever definition be offered, it may be always asked, with significance, of the complex so defined, whether it is itself good." (PE 15)

This is indeed the case; but no difficulty is involved if we are careful to make appropriate distinctions. Thus to follow an example used by Moore, translating 'A is good' into 'I desire to desire A' and turns the question 'Is my desiring to desire A itself good?' into 'Is the desire to desire A one of the things I desire to desire?' But there is no essential difficulty although the specific translation may be objectionable. Much of the apparent difficulty is due to the sound of repetition. If we use the term 'approve' as equivalent to 'desire to desire', the question 'Do I approve of my having a feeling of approval of A?' is certainly meaningful. There seems to be no theoretical objection to carrying on the inquiry to a still higher degree, although we do not often find it necessary to do so.[10]

There is in Moore's own theory an analogue to this procedure. Given any good whole, it is possible to make it part of a larger whole and ask of the resultant "Is it good?" The principle of organic unities guarantees that the answer is not predetermined by the established goodness of the part. Similarly, in the naturalistic version it is possible to approve of A but not approve of one's approving A.

This argument of Moore's therefore establishes nothing about the desirability of a naturalistic interpretation, nor does it even show any incompatibility between such an interpretation and Moore's own rules and postulates.

(5) As against both naturalistic and metaphysical theories Moore stresses the indefinability of *good*. Moore's approach rests on the theory that definition consists of analysis into simple elementary constituents which are indefinable. It is not my purpose to reopen here the many controversies that have been carried on over this account. But it is important to note that as a result of this approach he is able to rule out even an interpretation which satisfies his postulates and rules. For he can claim

[10] By a wider interpretation of *good* along these lines—to desire that it be desired, whether by me or others—it is possible to deal with many successive levels. For example, level (i)—to approve of x; level (ii)—to approve of myself and others expressing and urging approval of x; level (iii)—to approve of myself and others teaching people to express and urge approval of x; level (iv)—to approve of myself and others teaching teachers to teach people to express and urge approval of x.

in such a case that the *meaning* of his fundamental terms has not been expressed; rather that where these terms were found applicable the presence of some trait of existence or reality was found correlated with them; e.g., whenever anything was found (indefinably) good, it was also found to be the object of some expression of will. He thereby avoids treating the expression of will as a coördinating or procedural or operational *definition* of the *term* 'good' by assuming that what is going on is correlation of the acts of will with the presence of the intuited *quality* good. Thus he speaks of the search for a *criterion* of the good (PE 55, 91, 137), or, in the case of right, a *sign* (E 46). A criterion of the good would be a characteristic generally found in the things that are good, under the actual conditions of this world. To find it one would have to identify *independently* what was good and show that what was good *also* possessed the other characteristic to be used as a criterion. Moore does not, however, believe that such a criterion exists (PE 138).

The five arguments given above—especially the first three—appear to establish conclusively that no naturalistic interpretation of Moore's fundamental ethical terms satisfies his postulates. This is not in itself an argument against a naturalistic theory of ethics, since the postulates themselves might be rejected in favor of an alternative set. In the case of metaphysical interpretations, however, it is possible that one could be worked out to fit Moore's postulates if his claim of indefinability is disregarded. For the creation of metaphysical entities is bound by few restrictions, as the history of philosophy has shown. It is in fact possible to regard Moore's own approach to *good*, once he rejects an empirical interpretation, as the creation of a fresh set of metaphysical entities, or, as he calls them, *non-natural qualities*. But it is best, since Moore does reject metaphysical interpretations, not to seek one for him.[11]

There is, however, one interpretation suggested by Moore's own writings. It lies in the method he employs to discern the goodness of a thing.[12] This method, which we called above the

[11] At one point Moore draws the comparison of good as a non-natural quality to numbers (PE 111). This is not elaborated, but if it were the result might be a variant of the metaphysical theory of number along Platonic lines.

[12] Whether it is best construed as an empirical interpretation will be discussed below.

isolation test, consisted in considering what value we should attach to a thing "if it existed in absolute isolation." Further light is thrown upon the nature of this procedure in the discussion of natural and non-natural qualities. Moore defines 'nature' as "that which is the subject-matter of the natural sciences and also of psychology. It may be said to include all that has existed, does exist, or will exist in time." (PE 40) But not all properties of natural objects are natural properties. The test offered is:

Can we imagine 'good' as existing *by itself* in time, and not merely as a property of some natural object? For myself, I cannot so imagine it, whereas with the greater number of properties of objects—those which I call the natural properties—their existence does seem to me to be independent of the existence of those objects. They are, in fact, rather parts of which the object is made up than mere predicates which attach to it. (PE 41) [Again:] It is immediately obvious that when we see a thing to be good, its goodness is not a property which we can take up in our hands, or separate from it even by the most delicate scientific instruments, and transfer to something else. (PE 124)

Moore commends the metaphysicians for their recognition that "our knowledge is not confined to the things which we can touch and see and feel" and for their concern with properties "which certainly do not exist in time, are not therefore parts of Nature, and which, in fact, do not *exist* at all." *Good* is said to belong to this class (PE 110). To confuse such properties with natural properties or objects is, of course, an instance of the naturalistic fallacy (PE 13-14).

The following interpretation implicit in his writings may therefore be offered of Moore's postulates. Let us speak of the state of nature as the situation in which a given thing is found, and contrast this with the state of isolation created in imaginary experiment. An *intrinsic property* will then be a property belonging to the thing in both states, and capable of being imagined by itself in a state of isolation. For simplicity of reference, let us call a property belonging to the thing in both states a "common" property, and a property capable of being imagined by itself in isolation an "isolable" property. An intrinsic property of a given thing is thus a common isolable property. The *intrinsic nature* of the thing is the total set of those properties. With reference to any given thing the isolation test thus tells us ex-

plicitly what it is we are talking about when we refer to the thing, i.e., those properties which, each capable of isolation, we transfer from the state of nature to the state of isolation when we imagine "it" (the thing) in isolation. The *intrinsic value* of the thing is a property which the thing has in the state of nature and which is itself not capable of being imagined in isolation but is capable of being found in the state of isolation when intrinsic properties are there found. Moore tells us that intrinsic kinds of value constitute, so far as he knows, "the only non-intrinsic properties which share with intrinsic properties this characteristic of depending only on the intrinsic nature of what possesses them." (PS 273) Accordingly, since the isolation method involves imagining the intrinsic properties of the thing existing together, alone and cut off from their natural setting, intrinsic values may be interpreted as the only non-intrinsic properties of the thing which the thing had in the state of nature which are also found in the state of isolation. Intrinsic values are thus *the non-isolable common properties* of the thing, being the only such properties.[13]

Let us now make the appropriate substitutions and then examine the truth-value of the resulting assertions.

Postulate 1 becomes: The non-isolable common properties of x depend solely on the isolable common properties of x.

Postulate 2 becomes a statement of the equivalence of 1 to something else which, when appropriate substitutions have been made from the definitions given in postulates 3 and 5, is seen to be the principle of the constancy of value. When interpreted, postulate 2 thus states the equivalence of 1 to the following: The non-isolable common properties of x are absolute constants and if x and y have the same isolable common properties they have the same non-isolable common properties.

Postulate 3 becomes: y is exactly like x if, and only if, x and y have the same isolable common properties.

Postulate 4 becomes: There is a characteristic possessed by

[13] Cf. Broad's suggestion that Moore is identifying the non-natural characteristics of a thing with those determined solely by its intrinsic nature and yet not intrinsic. ("Is 'Goodness' a Name of a Simple Non-natural Quality?" in *Aristotelian Society Proceedings*, 1933-1934, 262-263.)

every isolable common property and not possessed by every non-isolable common property.

Postulate 5 becomes: x and y have the same intrinsic nature if, and only if, x and y have the same isolable common properties.

Postulates 3 and 5 are purely definitory of terms and so no problem of truth arises. Postulate 4 is clearly satisfied by the interpretation, since, as its statement reveals, the characteristic in question is isolability. The fact that the interpretation provides a meaning for a distinction which Moore felt should be there, but which he found obscure, strengthens the view that this is the interpretation which he is actually using.

Postulate 1 as interpreted has a certain plausibility. The non-isolable common properties (the value-properties) would appear, at least in the state of isolation, to depend solely on the isolable common properties (the intrinsic properties). For they have nothing else to depend on since in that state of isolation there are only the two types of properties. Nevertheless a number of doubts arise. There is the possibility that the value-properties occur arbitrarily and depend on nothing. There is secondly the possibility that the value-properties depend on the intrinsic properties in the state of isolation but need not in the state of nature. Determination of the truth of the postulate as interpreted thus must await an interpretation for the term 'depend solely on'. This is provided through postulate 2.

Postulate 2 as such raises no problem of truth. It is merely definitory of the notion of 'depending solely on' in the special context of postulate 1. Hence the crucial test on which the truth of postulate 1 as interpreted, and in fact the fate of the whole theory rests, is the truth of the principle of the constancy of value. What reason have we then (taking the first half of the principle) to believe that the value-properties—the non-isolable common properties—are absolute constants?

The first difficulty in the way of testing the truth of this statement lies in identifying what it speaks of. Moore has provided a procedure for judging the value-properties in the state of isolation—we isolate the intrinsic properties of the thing in imagination, and lo and behold, the value-properties are the only non-intrinsic properties we then find also present. (How

practicable a test this is will be considered later, but it is at least a proposed procedure.) But I find no procedure offered by Moore for discerning the intrinsic value of a thing in the state of nature. In fact his method of finding its intrinsic value is to carry out the isolation test. Hence the value-properties common to the thing in the state of nature and the state of isolation are to be discovered by looking at the state of isolation. The constancy of intrinsic value is thus presupposed rather than put to any test. I can see no alternative, therefore, to revising the interpretation of the fundamental term *intrinsic value* in the light of Moore's actual procedure and taking it to be not the properties unimaginable by themselves which the thing has both in the state of nature and in the state of isolation, but the properties unimaginable by themselves which the thing has in the state of isolation. In short, intrinsic values are not the non-isolable common properties but the non-isolable properties found in the state of isolation. *Hence to ask for the intrinsic value of a thing is to call for an investigation of its value-properties in isolation.*

On this revised interpretation the first part of the principle of the constancy of value finds strong grounds on which to rest. To say that the intrinsic value in the state of isolation is absolutely constant means that it is the same under varying conditions (including conceivably different causal laws). But in the state of isolation there are no varying conditions. If the test be performed several times and we have different intrinsic properties we are by definition not dealing with the same thing. Hence unless the value-properties of the thing in isolation exhibit sheer arbitrariness they will exhibit absolute constancy. There is no intermediate since there is nothing else to relate them to by the very conditions of the experiment (except of course the person performing the experiment, but this is ruled out by Moore's whole approach).

What are we to say, however, if the imaginative experiment performed by the same man at different times or different men at the same or different times does not yield the desired result—that is, if the same value-properties are not found associated with the same intrinsic properties in isolation? This involves

the second part of the constancy principle—if x and y (or x and x, if it is the same thing) have the same isolable common properties then x and y have the same non-isolable properties in the state of isolation.[14] It seems to me that such occurrences would refute the constancy principle and that the principle as thus interpreted becomes open to empirical (psychological) verification or refutation. And it is likely (or at least conceivable) that the principle will prove false when so tested.

Moore avoids the recognition that this procedure does in fact involve empirical elements only by failing to analyze carefully the process of value-discernment in the isolation test. He treats it as a type of simple cognition. But since it is a mental process taking place in time, it is hard to see how it can be regarded as anything but a natural psychological process. And if the isolation test is taken literally, *good* is ultimately interpreted precisely in terms of this process of value-discernment. Thus just as some define *good* as 'object of desire', Moore may be taken to be defining it as 'object of a special kind of seeing or beholding'. Moore would not, therefore, have escaped the naturalistic fallacy.

Moore comes very close to admitting the possibility of such a position in one passage of his *Ethics*.

. . . it may, so far as I can see, be true that there really is some very special feeling of such a nature that any man who knows that he himself or anybody else really feels it towards any state of things cannot doubt that the state of things in question is intrinsically good. (E 166)

But against the view that to call a thing intrinsically good may mean merely that this special feeling is felt towards it, Moore simply insists that even if the feeling had not been felt the thing would have been good; he also appeals to the contingency of attitudes and the postulate that once right always right.

Nevertheless many passages in Moore's ethical writings seem to me to point to or require a recognition of the experimenter in the isolation test as an observer making an imaginative choice

[14] Note that I have revised the interpretation of intrinsic value to leave out the reference to the state of nature.

or exercising an imaginative preference. For example, Moore remarks about simple qualities, "They are simply something which you think of or perceive . . ." (PE 7).

Moore sometimes makes a state of mind the last court of appeal. For example, when a man thinks of *good* "his state of mind is different from what it would be, were he asked 'Is this pleasant, or desired, or approved'?" (PE 17); the question whether the same action can be both right and wrong must "simply be left to the reader's inspection." (E 86-87)

Moore notes in criticizing Mill that 'desirable' or 'desirable as an end' is in Mill's usage equivalent to 'good as an end' (PE 65). Moore himself later poses the question whether consciousness of pleasure is the sole good by asking "Suppose we were conscious of pleasure only, and of nothing else, not even that we *were* conscious, would that state of things, however great the quantity, be very desirable?" (PE 95) The formulation of the question in terms of *desirable* in posing the isolation test seems exactly like an invitation to an imaginative experiment and *an act of choice*.

In discussing the relation of willing and the cognition of goodness, Moore says:

Let us admit then, that to think a thing good and to will it are *the same thing* in this sense, that, wherever the latter occurs, the former also occurs as a *part* of it; and even that they are *generally the same thing* in the converse sense, that when the former occurs it is generally a part of the latter. (PE 131)

This at least points towards the view that the cognition of goodness is the intellectual element in the situation of choosing; and although Moore by the use of the term 'generally' means that goodness is a quality prior to and independent of choice, further analysis may regard the cognition of goodness as the recognition of potential choice.

Furthermore it seems to me that Moore relies on choice as the test in using the idea of the sum of two values. The formulation of the principle of organic unities—"The value of a whole must not be assumed to be the same as the sum of the values of its parts" (PE 28)—is meaningful only if there is a separate meaning to 'the value of an A formed of parts B and C' and

'the value of B added to the value of C'. The former can be estimated by the isolation test, but what does the latter involve? The intrinsic value of B is estimated by seeing its value if the whole world consisted merely of B, and similarly of C. What procedure is to be employed for summing them? It cannot be envisaging a single whole world consisting wholly of B and wholly of C, while B and C are separate wholes; this is clearly self-contradiction. The sum of the values of B and C can only mean, on Moore's theory, the value of the sum of B and C.[15] In that case the distinction pointed to by the principle of organic unities must be between a whole consisting of parts and a whole consisting of two independent coexisting wholes. The relations involved in the two cases must clearly be different, and we ought to be told what the relation of two independent coexisting wholes forming a whole consists in (cf. E 245). Otherwise we should never know whether we had not before us in fact an organic whole. Yet Moore not merely provides no procedure for summing, but also rejects any independent test for being a part of an organic whole (in the sense in which he is employing the term) other than the whole having an intrinsic value different from the sum of the values of its parts (PE 36).

It may be, however, that Moore means simply to express briefly a number of statements such as that the value of B may be small and the value of C small and the value of A, composed of parts B and C, very great. In that case the idea of summing is superfluous. But it is more likely that there is an implicit reference to the *observer preferring* and this preference is relied on to give what interpretation is possible for summing.

The question of the comparison of two values and the notion of *better* raises comparable problems. Moore would appear to be committed to the view that in the isolation test we not merely recognize goodness, but the degree of goodness, so that after

[15] On the other hand, note PE 214-215, where Moore speaks of summing the value which a thing possesses as a whole and the intrinsic values belonging to any of its parts. There is also a suggestion of subtraction in such phrases as "a positive good which is greater than the *difference* between the sum of the two evils and the demerit of either singly." (PE 215) Meaning can probably be assigned to such language, but I do not see how it can be done by Moore's procedures.

the separate test of A and B we can entertain the resulting values in mind and see which has a higher degree of goodness. Certainly no direct test can be formulated for *better* in terms of the isolation test, since entertaining *both* A and B in a *single* imaginative isolation would contradict the fact that each was being absolutely isolated. Hence the test for *better* turns out in effect to be an imaginative entertaining of both together and an act of preference, and this is a separate test over and above the isolation test.

All these elements in Moore's account strengthen the view that his implicit test for goodness turns out to be a psychological process of value-discernment which can be analyzed only in terms of choice and preference.

It is clear, however, that Moore does not himself regard the value-discernment process as an empirical psychological procedure interpreting *good*. At the crucial moment in the isolation test when the experimenter looks for the value-property attached to the intrinsic property, the judgment that takes place is regarded by Moore as synthetic and necessary. Since the interpretation offered above is the only one to be found in his writings, its rejection leaves his postulates without interpretation. Moore's claim of truth for his principles thus rests only on an intuitive basis—an intuitive theory of meaning for his fundamental terms and an intuitive theory of self-evident truths.[16] For example, speaking of his claim that one and the same action cannot be both right and wrong, he says: "If the question is reduced to these ultimate terms, it must, I think, simply be left to the reader's inspection. Like all ultimate questions, it is incapable of strict proof either way." (E 86-87) We have also noted above that Moore takes the fundamental principles of ethics to be synthetic and self-evident. And by self-evident, Moore explains in another context (PE 143-145), he does not mean intuition as an alternative to reason. "By saying that a proposition is self-evident, we mean emphatically that its appearing so to us, is *not* the reason why it is true: for we mean

[16] There is an occasional appeal to common usage, but this is not treated as authoritative, nor does Moore hesitate to enunciate a paradox where his theory demands it (e.g., E 195).

that it has absolutely no reason." (143) And, speaking of the principle that 'Pleasure alone is good', whose untruth he claimed was self-evident, Moore says "I could do nothing to *prove* that it was untrue; I could only point out as clearly as possible what it means, and how it contradicts other propositions which appear to be equally true. My only object in all this was, necessarily, to convince." (144-145) Moore also adds the hope of securing universal agreement by clarifying the question at issue, and draws the analogy of arithmetical statements.

Moore does, therefore, speak as if he were enunciating true principles, and the failure to recognize the truth is apparently attributed to confused inquiry on the part of others. Convincing them consists in leading them to a place where they can see more clearly. Moore is not saying, however, that his principles represent a set of attitudes on his part which he is trying to bring others to adopt.

In the absence of an explicit interpretation of Moore's principles and postulates, and in the absence of any consequent confirmatory procedures, why should Moore's set be accepted? Just as Euclidean geometry faced non-Euclidean variants, so the issue between Moore's ethical theory and an alternative ethics should not be obscured. The old plea of self-evidence can be given little weight.

The only remaining path is to seek the values to which the selection of one or another set of principles and postulates may be instrumental, or for which that set may serve as a vehicle.

IV. Values in the Logical Structure of
Moore's Ethical Theory

The instrumental rôle of Moore's postulates and rules is clear from a study of the types of inquiry they generate, the systematic power they have, and the methods they put at our disposal. Since the isolation test is the only procedure he offers and since it embodies his fundamental rules, such a study may well begin at that point.

The isolation test is said by Moore to serve two distinct purposes (PE 93, 187):

(i) It aids the assessment of intrinsic value by removing

consequences and contexts embodying the instrumental value of the thing, which may be confused with its intrinsic value. The test thus ensures separation of means from ends.

(ii) It helps one avoid a violation of the principle of organic unities. Thus without it one might be tempted to assume that when a part of a valuable whole has itself no value all the value resides in the rest. But if that rest is tested by isolation it may be found much less valuable, and it will be seen that the part which itself had no value was an essential ingredient in the whole that had high value.

Since the distinction of means and ends and the relation of parts and wholes play an important rôle in any ethical theory, a method for their separation and estimation is of central importance.

In regard to means and ends, the isolation method is often used to striking advantage by Moore. For example, in his essay "The Nature of Moral Philosophy" he suggests estimating the intrinsic value of a given year by considering what value it would have if it were to be the last year of life on this planet (PE 328). On the other hand, there are occasions when it is difficult to see what isolation can mean, as when Moore asks "whether the predicate that is meant by 'realising the true self', supposing that it could exist alone, would have any value whatsoever." (PE 188) It is not easy to state in general terms what distinguishes the cases in which the result appears meaningful from those in which it does not. I do think, however, that one distinction can be found, and if it is correct it strikes at the very formulation Moore offers of the isolation method. For it seems to me that where the method is significant it is rather a method of *variation* than of absolute isolation.

A method of variation is useful in ethics just as it is in scientific experiment. Suppose that I am tempted to take a certain job and ask myself what intrinsic value there is in my engaging in that work. To find out, I first set up hypotheses as to values for which this may be instrumental. Is it to earn money? I then imagine the whole process going on as I previously conceived it, except that I am not paid a wage. If I am still tempted, then the work is not a mere means to money. Similarly I test other

proposed goals. Is it for the sake of prestige? Let there be no prestige—even worse, let me be looked down upon for doing the work. Am I still tempted? And so on. I may likewise test the effect of varying a combination of factors. But the variation need not consist in removing a factor to leave a blank. Thus when Glaucon in Plato's *Republic* (Bk. II) urges Socrates to show that justice is intrinsically valuable, he paints the picture of the just man going through life in poverty, without shelter, without honor, reckoned as a rascal and ending his life in torture and punishment for crimes he did not commit—that is, having no good except a just character. It is a whole life plan that is here being estimated, not a world in which there is nothing but justice.

The significance of this method lies in the variations it reveals for evaluation *within* possible natural situations. As such, it yields not necessary, but probable results. Even when Moore speaks of a world consisting of the feeling of pleasure in absolute isolation (without even consciousness of being pleased) and asks for its evaluation (PE 88 ff), I wonder whether absolute isolation is really being achieved. For the judgment of low intrinsic value probably takes into account that life is going on round the subject and he is missing it all. Plato, whose *Philebus* Moore quotes on the point, makes the literal comparison of such a man to an oyster.

It may be objected that Moore is simply employing the scientific procedure of isolating one factor in a situation to see what force (in this case, value) it is of itself contributing to the situation. Thus the gravitational force in the case of a falling body is reckoned under the ideal conditions of its fall in a vacuum; the motion of any body under the impact of a given force is studied under the ideal conditions of the absence of friction; and so forth. It is possible that Moore has such a procedure in mind; but the result he achieves differs markedly from the scientific process of isolation. The latter aims at formulae whose consequences will be tested in experience; Moore allows no empirical test for the intrinsic value established in isolation. The scientific process selects the ideal conditions for the removal of specific factors whose relevance in the situation is suspected;

Moore insists on *absolute* removal of *all other factors.* The scientific procedure aims to analyze the situation so that the precise contribution of each factor can be computed in relation to others and to the direction and character of the whole; Moore's principle of organic unities denies this possibility for many wholes in the domain of ethics. Of course the scientific procedure does not imply that every whole has the properties of its parts. If Moore's isolation procedure is comparable to studying the properties of hydrogen and oxygen when they are each separate and not combined into water, then such isolation is intelligible, as is the assertion that water has not the "intrinsic" properties of hydrogen nor of oxygen nor of their mixture. But what meaning is there to the insistence that the hydrogen *in* water has the same intrinsic properties as hydrogen by itself?

The second function of the isolation method—in relation to parts and wholes—presents the special question of the meaning and status of the principle of organic unities itself. Its significance emerges best from comparison with similar assertions in the sciences as noted above. To say that "the value of a whole must not be assumed to be the same as the sum of the values of its parts" (PE 28), seems to be very much like saying that the properties of a chemical product must not be assumed to be the same as the properties of its chemical constituents. Is this assertion partially definitory of a "chemical" as distinguished from a "physical" reaction? Or is it an empirical discovery that all or some chemical reactions yield products with different properties from their constituents? Similarly, is the principle itself a defining mark of an "organic whole" or is it an empirical discovery about all or some organic wholes in relation to their parts? The question is further complicated by the lack of a procedural interpretation for summing, noted above.

Moore specifically rejects any description of organic wholes other than in terms of the principle of organic unities. He says of the term 'organic': "I shall use it to denote the fact that a whole has an intrinsic value different in amount from the sum of the values of its parts. I shall use it to denote this and only this." (PE 36) The principle of organic unities is thus defini-

tory of organic wholes, and in addition, since it tells us that we must not assume all wholes to be non-organic, it is asserting that there *are* organic wholes. The principle thus states a definition and tells us that some entities in the domain of ethics satisfy the definition. In fact Moore believes that most things intrinsically good or bad are organic unities (PE 223).

Which wholes are organic and which are merely sums would seem to be a matter for experience to discover. In the chapter on *The Ideal* (PE ch. 6), Moore offers illustrations of different kinds of organic wholes that are good, and draws some interesting conclusions.[17] The further development of such a science of ethics would clearly involve researches into more specific goods and their mode of combination, the classification of such goods and typical parts, the separate systematization of organic wholes and sums, the discovery of the frequency with which parts of a definite sort are reliable indications of the goodness of wholes to which they may belong, and so forth. Moore does not pursue these inquiries very far—some of them not at all. Here will be found the analogue in Moore's theory of what naturalistic theories call the variation of value under different circumstances. The results of such inquiries would constitute important guides for human striving and human conduct.

How well equipped is Moore's theory for undertaking such important investigations? Would the use of his ethical terms, rules and postulates, make possible a more or a less satisfactory systematization of such inquiries than would an alternative theory? The question is not whether the results secured within the framework of an alternative theory could be translated into Moore's language; for it is one thing to translate results, another to provide instruments capable of unearthing them. Would inquiries formulated according to Moore's theory prove fruitful, or would many problems central to the guidance of conduct be dismissed as not properly ethical questions, as merely matters of 'interest' and not 'good', as merely questions of 'expediency' and not 'right'? Would all sorts of additional techniques, supple-

[17] E.g., "knowledge, though having little or no value by itself, is an absolutely essential constituent in the highest goods, and contributes immensely to their value." (PE 199)

mentary interpretations, and *ad hoc* assumptions be required to make it do the job that an alternative theory might more readily encourage?

It does seem to me to be the case that Moore's theory has a logical structure which inclines investigation away from the types of inquiries we have indicated and towards a kind of contemplative vision. The enterprise generated within the framework of the theory is ethical "star-gazing," not ethical "navigation." This tendency is determined by the postulates which entrench the principle of the absolute constancy of value. Thereafter, empirical and relational interpretations of *good* are ruled out, and the principles governing the formation of ethical statements treat the subject of an ethical statement as an isolated whole. Hence the study of the value relations of subjects is rendered difficult. The only type of interpretation possible under these postulates and rules, as we have seen in part III, is an intuitive one. The dominant test employed by Moore leads to holding up the subject for contemplative vision. In fact the fundamental type of value-assertion turns out to be, in effect, 'A world consisting solely of X would be good.' The ultimate enterprise of ethics thus turns out to be an aesthetic beholding of world-wholes. It is a kind of framing of pictures to which one's contemplative vision may devote its constant attention.

That Moore is presenting an ethics of vision and not of action is clear from his own statements:

> The direct object of Ethics is knowledge and not practice. (PE 20)
>
> What I am concerned with is knowledge only—that we should think correctly and so far arrive at some truth, however unimportant: I do not say that such knowledge will make us more useful members of society. If any one does not care for knowledge for its own sake, then I have nothing to say to him . . . (PE 63)
>
> So far as it [Ethics] enquires What is good? its business is finished when it has completed the list of things which ought to exist, whether they do exist or not. (PE 119)

Although the contrast is here made between knowledge and practice, it must be remembered that the former term is used in a special sense. It is not *scientific knowledge* in its ordinary meaning but a kind of *aesthetic beholding*. It is not accidental

that aesthetic enjoyments rank with personal affections as including "*all* the greatest, and *by far* the greatest, goods we can imagine." (PE 189)

This tendency in Moore's theory is further intensified by the lack of prescribed procedures for transforming acts of vision into instruments for the guidance of men. We have seen that the intrinsic value of parts in nature is merely assumed to be the same as that which they have as wholes in isolation, that there is no procedure for summing, that the notion of degree of value is left unexplored.

The effect of Moore's postulates in the guidance of conduct is perhaps best seen in his discussion of *right*. There is a strange ambivalence in Moore's discussion of conduct and the problem of right. On the one hand there is hard-headed realism and a strong sense of value, and on the other hand there is a sense of frustration. This antithesis merits careful exploration if we are to see clearly to what degree his ethical framework is a vehicle for specific values and attitudes.

It was mentioned at the beginning of this paper that Moore's fundamental linking of *right* to *good* seemed to have the character of a revolt. It was indeed an ultimatum against the Kantian influence, against the traditional religious outlook on virtue and duty. Those who separated the right from the good might be ready to acquiesce in the promptings of existent obligations; in fact they appealed to introspection to find these duties tugging at them. They might be ready to make sacrifices that tradition or the current disposition of affairs in their society demanded without even asking what was the good of it. In fact their theory readily sanctified the obligations it found existing in their society. Not so according to the logical formulation of Moore's theory. His definition of *right* served notice that every duty, every moral rule, every virtue would be called to account.

The accounting is strict. "It is plain that no moral law is self-evident." (PE 148) Since *right* is defined in terms of *causing* what is good the discovery of moral rules, duties and virtues is an empirical problem and the result is relative to the conditions and laws of causation. Had circumstances been otherwise, were human impulses different, were causal laws other

than they are, the resultant moral rules might be different.

. . . we can only shew that one action is generally better than another as a means, provided that certain other circumstances are given. We do, as a matter of fact, only observe its good effects under certain circumstances; and it may be easily seen that a sufficient change in these would render doubtful what seems the most universally certain of general rules. (PE 156)

Similarly Moore distinguishes between ideal rules and rules of duty which rest on what is possible under existential conditions (PS 319 ff.; cf. PE 105). He is hard-headed in his treatment of virtues; most virtues are not intrinsically valuable but instrumentally valuable (PE 174). Duties likewise are praised and enforced by men because there is a temptation to omit them and their performance is instrumentally valuable; they do not necessarily designate intrinsically valuable actions (PE 168 ff.). Indeed "moral rules . . . are, in general, not directly means to positive goods but to what is necessary for the existence of positive goods." (PE 167) All this constitutes a refusal to glorify or sanctify what is predominantly instrumental. Man's spirit in reckoning the goods of its world is freed from bondage to what has to be done because things happen to be so; it is even emancipated from adulation of what has to be done because the world is so constituted causally. It looks for the source of its ideal allegiance straight to the good itself.

What is more, Moore's theory serves notice that the good will not be constricted or coerced into any procrustean bed. His insistence that *good* is indefinable is an explicit vehicle for definite values: "if we recognize that, so far as the meaning of good goes, anything whatever may be good, we start with a much more open mind." (PE 20)[18] The possibility of multiple goods,

[18] There is a certain methodological utility in using the term 'good' as undefined and refusing to equate it with any one interpretation. As Moore says with regard to naturalistic ethics, "if good is *defined* as something else, it is then impossible either to prove that any other definition is wrong or even to deny such definition." (PE 11) The definition, however, might be *changed*, and different interpretations tried out. The utility of the refusal to identify 'good' with any one interpretation is thus to be found in the encouragement given to further analysis and experimentation. Naturalistic ethical theory might thus shift among such interpretations as 'pleasure', 'desire', 'approval', 'striving', 'rule of choice',

of the discovery of goods as yet unsuspected, is increased by not binding ourselves to a definite quality of existence. ". . . for perfect goodness much more is required than any quantity of what exists here and now or can be inferred as likely to exist in the future." (PE 113) And Moore's own examination of goods reveals that "things intrinsically good or bad are many and various." (PE 223)

The weapons that Moore up to this point fashioned for the estimation of human life and conduct thus constituted a formidable set. Nor did he merely manufacture them and then leave others to wield them. He reached positive conclusions about ethics in relation to conduct. What then were the victories won, what the changes proposed to orient the lives of men in the light of their vision of the good?

. . . it seems doubtful whether Ethics can establish the utility of any rules other than those generally practised. But its inability to do so is fortunately of little practical moment. The question whether the general observance of a rule not generally observed, would or would not be desirable, cannot much affect the question how any individual ought to act; since, on the one hand, there is a large probability that he will not, by any means, be able to bring about its general observance, and, on the other hand, the fact that its general observance would be useful could, in any case, give him no reason to conclude that he himself ought to observe it, in the absence of such general observance. (PE 161)

[Again, in the case of established rules:] In short, though we may be sure that there are cases where the rule should be broken, we can never know which those cases are, and ought, therefore, never to break it. (PE 162-163)

[Moore even goes so far as to say:] It is undoubtedly well to punish a man, who has done an action, right in his case but generally wrong, even if his example would not be likely to have a dangerous effect. (PE 164)

etc., as these become more refined by psychological and sociological science. The refusal to identify 'good' with any one interpretation or set of tests points to the ideal of a systematic theory which will unify the results according to different tests including those as yet undiscovered. But the use of 'good' as undefined in this sense does not mean that it is a single simple quality directly discerned; rather it points to the insufficiency of analysis and investigation as yet performed and to the ideal of systematic unification among the various interpretations, present and future, with the most serviceable of which 'good' may eventually be identified.

[He finds that there is:] a strong probability in favour of adherence to an existing custom, even if it be a bad one. (PE 164) [The example given is that] in a society where certain kinds of theft are the common rule, the utility of abstinence from such theft on the part of a single individual becomes exceedingly doubtful, even though the common rule is a bad one. (*Ibid.*)

Most of the ordinary rules in a society are justified in short order. For example, Moore says of respect for property: "In any state of society in which men have that intense desire for property of some sort, which seems to be universal, the common legal rules for the protection of property must serve greatly to facilitate the best possible expenditure of energy." (PE 157)

The net result of Moore's application of the instruments is to entrench the system of existent moral and legal rules and to discourage the individual from any attempt to change them. The individual cannot establish the superiority of any rules other than those practiced. Even if he could prove such superiority there is no reason for him to guide his conduct by the new rule he proposes. He should not violate an existing rule even where he thinks its application in a special case is bad. And, finally, he should adhere even to a bad custom. Of what avail have the critical instruments of Moore's theory been to the individual? They have given him in each case a substitute satisfaction to lighten obedience. Although he cannot establish the superiority of a fresh rule, he knows that the foundations of *any* rule, including the existing one, are merely contingent and dependent on circumstances. Even when he adheres absolutely to a rule, he may thumb his nose at it because he knows it must be defective in some cases. And where he adheres to a bad custom he is not prevented from recognizing it as bad. His vision remains free while the chains of conformity become fixed upon him.

The discrepancy between the promise and the performance of Moore's theory as an instrument for guidance of human life is startling. It is not our present task to analyze it in terms of the attitudes or general social outlook it may embody, but to see to what extent the logical structure of Moore's ethical theory contributes to the result.

This may be shown quite readily. The central difficulty in

Moore's treatment of conduct is the practical impossibility of testing or establishing a given rule as a rule of right. The source of this practical impossibility is clearly exhibited by Moore. It lies in the fact that judgments of right and duty are so difficult to verify that no sensible person wants to gamble on the outcome. In the case of duty, for example, the assertion that a certain action is our duty means that "the whole world will be better if it be performed, than if any possible alternative were taken." (PE 147) In the case of right, it would mean that the action will not cause the whole world to be less good than any possible alternative action.

In order to verify such statements knowledge is required of other conditions which influence the effects of the given act, the effect of these conditions, and "to know all the events which will be in any way affected by our action throughout an infinite future." (PE 149) It is also necessary to know the degree of value of the action and of all its effects, and also how they will affect the value of the universe as an organic whole. Similar knowledge is required for proposed alternatives. And all this is to be done, as we have seen, without even a definite procedure for summing values!

Moore mitigates this extreme position somewhat by recognizing that we make judgments on the assumption that effects of actions in the far future will not outweigh the superiority of one set of effects over another in the near future. If we restrict our judgments to alternatives which are likely to occur to anyone, it is possible to estimate which one will produce the greatest total value. In spite of such mitigation the determination of duty appears as a hopeless task.

The source of this trouble is the reference to the whole world in the definition of *right* and *duty*. And clearly, if Moore referred to anything less than the whole world, there is no guarantee that the same action would not be found both right and wrong—right in one context, wrong in another—even at the same time. The definition of right in terms of the whole world thus ensures the absoluteness of the rightness of a given action. To surrender this position would almost inevitably lead to abandoning the similar position for *good* and, in short, sur-

rendering the principle of the constancy of value. For if we once begin to speak of the same particular act as being 'right in one context (or for one group)' and 'wrong in another context (or for another group)', and if we continue to define *right* in terms of *good* (e.g., as productive of the greatest good), can we avoid speaking of 'good in one context (or for one group)' and 'bad in another context (or for another group)'? The reference to the whole world in the definition of *right* is thus in Moore's theory a consequence of the desire to maintain the principle of the absolute constancy of value. And since the postulates of Moore's theory yield this principle, we may conclude that the difficulties in the application of the theory to conduct are rooted in the structure of the theory.

It is, of course, possible that one beginning with Moore's logical structure might add supplementary elements to provide a different outcome. For no logical structure can determine uniquely the way in which it shall be used. The relation between structure and recommendations for conduct is not that of premises and conclusion; and even if it were there would be possible different minor premises which would vary the result. The relation is rather like that of instrument and use. A particular instrument does not necessarily determine a unique usage; but some uses can usually be accomplished with greater ease and others may be entirely ruled out by the tool chosen.

If the analysis here offered is correct, the logical structure of Moore's ethical theory—his choice of terms, definitions, rules of statement-formation and fundamental postulates—is a vehicle for a number of broad values. Among these are the aesthetic values involved in contemplative vision, speculative boldness, receptivity to fresh values, an unwillingness to bind the spirit by existence and its ways. But equally among these is a disparagement of existence and an extreme conformity in practical affairs. Moore's theory thus contains a dualism as deep as any Kantian one ever was, and it is fundamentally a dualism of value.

ABRAHAM EDEL

DEPARTMENT OF PHILOSOPHY
COLLEGE OF THE CITY OF NEW YORK

6

A. Campbell Garnett

MOORE'S THEORY OF MORAL FREEDOM
AND RESPONSIBILITY

6

MOORE'S THEORY OF MORAL FREEDOM
AND RESPONSIBILITY

TO Utilitarian ethics, as interpreted by Mr. Moore, the problem of freedom is irrelevant. Utilitarianism is said to assume that "many of our actions are in the control of our wills, in the sense that *if*, just before we began to do them, we had chosen not to do them, we *should* not have done them."[1] Any action which a person could have thus prevented *if* he had chosen is called "voluntary." But the theory does not pretend to decide whether there are any cases in which a person really *could* have chosen differently from the way he actually did; nor does it concern itself with the question whether any actions except voluntary ones, can properly be said to be right or wrong. It is taken as a fact that people do distinguish voluntary actions (in this sense) as right and wrong and say that the one ought and the other ought not to be done. And the purpose of utilitarian ethics is to lay down some absolutely universal rules for this distinction among voluntary actions, without deciding whether anything else besides voluntary actions can properly be called right or wrong.[2]

The ethical enquiry is thus limited at two points, both of which are so intimately related to what is stated as the main problem that they have usually been supposed to have a considerable bearing upon it. First let us examine a preliminary point concerning the exclusion of the question whether a person ever *could* choose any other action than the one he actually does choose. Here we should note that the term "voluntary action"

[1] *Ethics*, 13.
[2] *Ibid.*, 17.

is applied, in a broad sense, not only to actions actually and explicitly willed or chosen, but also to unwilled actions which the agent could have prevented if he had chosen to do so.[3] Now actions explicitly willed certainly have, in that fact, a distinguishing mark that justifies their distinct classification as "voluntary." And actions which are *allowed* to occur by the non-performance of an act of voluntary choice, which one could have performed, may also, by a legitimate extension of the term, be called voluntary. But can we legitimately extend the term to cover actions that could not have been prevented by any volition or choice within our power to make? Surely, an action that no possible choice or volition of the agent could have prevented should be described as involuntary. If, therefore, it were the case that no one ever really could make a choice that he does not actually make, then all actions that one does not actually choose to prevent are actions that one could not possibly choose to prevent, and so are involuntary. The class of voluntary actions would then have to be confined to those that are actually chosen or willed. Yet it is certain that we feel moral responsibility for the broader class of actions and express moral condemnation and approval of them. And this we do just so far as we believe it was within the agent's power to make the choice that would have prevented them. If, for example, it is shown that he was in a temporary state of epileptic automatism, then, though it might still be said that he could have avoided the act if he had chosen to do so, we do not hold him morally responsible, or call the act "voluntary," because we know that he was not able to make such a choice.

These facts indicate that the meaning of the concept "voluntary" includes the belief that the agent has it in his power both to make a certain choice and not to make it. And this meaning of the term "voluntary" is certainly relevant to the second question which Mr. Moore sets aside as irrelevant to Utilitarian ethics, i.e., the question whether voluntary actions are the only ones that can properly be called right or wrong in the ethical sense of these terms. Though the question may be an open one

[3] *Ibid.*, 14.

from the Utilitarian point of view, there is no doubt that Mr. Moore follows the common tradition in confining the question of the moral right or wrong of an action to those that are in some sense voluntary. Such a strong tradition must surely have some reason that is significant for the meaning of the term. There are many confusions between the ethical and non-ethical senses of the terms "right" or "wrong," but certainly we always hesitate to apply them in the ethical sense to actions that are known to be automatic or otherwise beyond the voluntary control of the person concerned. The reason is, undoubtedly, that the attribution of moral quality to an action implies that the person not merely knows what he is doing but is responsible for his actions in the sense that he is able to control them—to do or not to do. With this Mr. Moore will probably agree, saying that responsibility merely means that he could have done differently *if* he had chosen, without implying that he *could* have chosen differently. But our examination of the terms "voluntary" and "involuntary" seems to show that the difference between them implies also that there is a stage in voluntary action when one is able either to choose or not to choose to perform a certain act. If so, then the distinction of ethical significance between voluntary and involuntary actions would seem to depend upon this difference; i.e., the ethical distinction of right and wrong is commonly confined to voluntary actions because it is commonly believed that only voluntary actions are such that the agent is able to choose either to do or not to do, and that only to such actions do ethical qualities belong.

These considerations, however, give no more than a preliminary indication of the connection of ethical concepts with that of the power of choice. Much more enquiry is necessary to clarify the connection and to justify the concept of choice involved. The confusions that have hung around these questions certainly justify the brilliant attempt made by Mr. Moore to separate the ethical concepts from the problems connected with the power to choose. And this attempt, though I cannot regard it as successful, certainly clears the air and helps in elucidating the problem.

The central problem of ethics, as Mr. Moore states it, is

this. "Can we discover any characteristic, over and above the mere fact that they *are* right, which belongs to absolutely all voluntary actions which are right, and which at the same time does not belong to any except those which are right?"[4] This criterion, he argues, is to be found in the total consequences of the action and in these alone. Consideration of the motives involved, it is urged, may affect the question as to whether the agent deserves praise or blame for his action, but they do not affect the question whether it is right or wrong.[5] Further, it is the *actual* consequences of the action, not its antecedently probable consequences, that must be considered. Moral praise and blame are deserved according as one, from a good motive, endeavours to produce the best consequences that seem antecedently probable, or chooses some apparently inferior goal. But the action is only *right* if its *actual* consequences turn out to be the *best* possible. And, if it does this, it is still to be regarded as right even though this happy result is the unforeseen consequence of an attempt to produce some very different and bad effect. Thus, "a man may really deserve the strongest moral condemnation for choosing an action which *actually* is right." This paradox Mr. Moore frankly accepts. The theory is given final statement in the form "that an action is only right, when it produces consequences as good as any which would have followed from any other action which the agent *would* have done, *if* he had chosen."[6] Here, "as good" is interpreted as meaning "the best effects upon the whole," not only upon the doer of the action. The rejection of Egoism thus implied is held to be self-evident.[7]

This is the final result of Mr. Moore's analysis of the notion of "right" in ethics. Yet he frankly expresses a certain doubt concerning it, growing out of the question of moral freedom and its relevance to moral judgments.[8] What is the significance of the relative clause at the end of the statement? This qualifying

[4] *Ibid.*, 17.
[5] *Ibid.*, 187-189.
[6] *Ibid.*, 222.
[7] *Ibid.*, 232.
[8] *Ibid.*, 222.

clause—"which the agent would have done, *if* he had chosen" —assumes, as Mr. Moore points out, that the agent *could*, in a sense, have done something else instead. But in *what* sense is it necessary to assume that he could? It means that he could have done differently *if* he had chosen. But does it mean also that he could have chosen to do differently even in those cases where he did not so choose? In the former sense the assumption that the agent could have done differently is not incompatible with a principle of universal, rigid, causal connection, for the act of choice may be as rigidly determined as the subsequent action that depends on it. But the second sense implies that at some stage before the action there was a really open possibility that some different choice might have been made. The question is whether the assumption of power to choose, in this sense, is necessary to the description of an action as ethically right or wrong. And if so it raises the further question as to the actual existence of any such choices and their relation to the causal order of the world. Mr. Moore is inclined to think that the former sense is adequate for ethics, but admits some doubt on the question. The trouble is that the second sense, though it seems to be implied in moral judgments, is very difficult to clarify and justify, because it raises the two difficult questions just stated. It is to these therefore that we must turn our attention.

With regard to the first problem we may begin by asking a question Mr. Moore does not discuss. Why should the relative clause at the end of his definition be included at all? Why not say simply that an action is right when it produces consequences as good as any which would have followed from any other possible action—meaning, by "possible," physically and intellectually possible, but making no reference to the agent's capacity to choose? There is certainly *a* sense in which such an action is right and it is relevant to the ethical concept of perfection, of what ideally ought to be, e.g., of an ideal society which may be regarded as the goal of moral conduct, a society in which the greatest possible good would be fully realized. There is a sense of the term right in which whatever is most conducive to such an ideal is right. For example, the weather is "right" when sun-

shine, rain, wind, etc., "produce consequences as good as any which would have followed from any other action" that these agents could have performed. Here it is nonsense to add "if they had chosen," and it would also be nonsense to say that the action of these agents is *ethically* right or wrong. They are non-moral agents simply because they do not have the power of making choices.

Now let us return to consideration of the case of an action that brings the best possible results and is voluntary in the sense that the agent could have prevented it if he had chosen. While he is away on vacation a certain householder's one lone rose-bush needs watering. One evening his neighbour, who has set up his hose to water his lawn, finds that the force of the water has turned it round so that it waters this parched rose-bush instead. The neighbour could turn the hose immediately back on his lawn *if* he chose, but allows it to give the rose a good soaking instead. His action is therefore voluntary and, since it produces the best possible consequences, is right. Now suppose that this neighbour were afflicted with a compulsion neurosis that made it psychologically impossible for him to exercise the choice to interfere with accidental situations of this kind. It would still be possible for him to turn the hose back on his own lawn *if* he chose; so, on Mr. Moore's definition, the action would still be voluntary and right. But now suppose that in *every* situation conditions just as far beyond our *present* control as those of a compulsion neurosis rigidly determine what choices we shall make and what we shall not make. All our actions would then be neither more nor less voluntary than that of the man with the compulsion neurosis in leaving his hose to pour water on his neighbour's rose instead of on his own lawn. There would be no essential distinction between (1) the action that was allowed to occur because some special psychological abnormality prevented the act of choice that would have prevented it and (2) those that were allowed to occur because normal antecedent conditions prevented such a choice and (3) those that were made to occur because normal or abnormal antecedents completely determined the occurrence of acts of choice that brought them about.

In each of these cases the act could be right in the sense that

it produced the greatest possible good. But the same could be said, sometimes, of the action of a breeze that blows up a shower of rain. Is it not plain that the sense in which such actions may be right or wrong is not the *ethical* sense of those terms? If the action of a breeze that waters an absent householder's garden by blowing up a rain cloud is right, but only in a non-ethical sense, while the action of a man who deliberately waters his absent neighbour's garden for him is right in both an ethical and a non-ethical sense, then the ethical rightness of an action depends, not merely on its consequences (which are the same) but on the type of causation involved. We must therefore enquire as to what is the difference in type of causation and why it has ethical significance. The only difference recognized in Mr. Moore's theory is that in the behaviour of the one agent a factor called choice sometimes enters as a determinant, whereas in the behaviour of the other agent no such factor ever enters. But it is to be noted that actions of the former type of agent may be ethically right or wrong if they are actions that could have been prevented by an act of choice that did not occur, even though no act of choice was instrumental to their occurrence. But what could be the ethical significance of the non-occurrence of an act of choice if the fact of its non-occurrence means that it was quite impossible that it could occur? Surely, the non-occurrence of an impossible event has no moral significance. If an action was not in any way caused by an act of choice, and could not have been prevented by any possible act of choice, then choice is irrelevant to it. The mere fact that the agent might, on some other occasion, be able to perform an act of choice, such as would have prevented it, has no bearing on the action in this particular case. Such an action can have no more moral significance than the digestive processes of the agent. Both it and the digestive processes may, of course, be right or wrong in the sense that they do or do not produce the best possible consequences. But this is not right and wrong in the ethical sense of these terms.

This confusion between the ethical and non-ethical senses of the terms right and wrong is at root a confusion between the ethical goal and the ethical act. The "best possible consequences" is a state of affairs that ought to be. As such it is right. And, con-

sidered as a goal of voluntary action, it is ethically right. But it does not follow that every causal agent that tends to produce situations that "ought to be" is an ethical agent. Good health and good crops both "ought to be," but may be produced by such natural agencies as good digestion and good rains. These agencies are "right" in their own way, but being non-moral agents their actions are not *morally* right. Thus the fact that a result is such as ought to be (is the best possible set of consequences) does not mean that the action that produces it is, morally, either right or wrong, though in a non-ethical sense it is certainly right. If the agency is a human action it *may* be *morally* right, but it may also be entirely non-moral, and it may even be morally wrong. Commonly we regard the action, as does Mr. Moore, as having *some* ethical significance, right or wrong, if it is such as the person "could have prevented if he had chosen."

Upon reflection, I think it becomes clear that the reason for this is because we assume that he could have chosen to prevent it, even though he did not actually do so. We assume that he could have made an effort that he did not actually make. And when we describe a deliberately chosen action as morally right or wrong we likewise assume that he could have refrained from the effort involved in the choice or have made an effort that would have resulted in a different choice. It is because of this assumption (that it is within the agent's power to make or not to make certain efforts that modify the course of his conduct) that we hold him responsible for it. And it is only in so far as the agent can thus be regarded as *responsible* that his conduct can be regarded as moral or immoral.

We must recognize, then, that various factors (including human actions) that produce the best possible consequences are right in a certain non-ethical sense, but may not be right in the ethical sense. And this recognition forces us to look deeper for the distinguishing characteristic of moral right and wrong. It may be the case (and I think it is) that an adequate account of the notion of moral right requires an assertion of the tendency of right actions to produce the best possible consequences;[9] but

[9] For a discussion of the relation of this proposition to that of the Deontologists cf. my article, "Deontology and Selfrealisation" in *Ethics*, July, 1941.

that alone is not enough. A moral action must also be one that somehow depends upon an effort for which the agent is himself responsible. If we connect this concept of effort with that of the best possible consequences we arrive at a theory that is very widely held, i.e., that an action is morally right in so far as it constitutes the individual's best effort to attain the best possible results. This means that an action may be morally right which (for reasons beyond the agent's control) does not actually produce the best possible consequences; i.e., it may be right in one sense but not in another. But here there is no paradox, for the latter is not the *moral* sense of the term, but only the former.

It would take us too far afield to attempt an analysis here of all the senses of the term "right" that might be confused with the ethical. But this much may be said. "Right" means that the thing so described is in some sense as it "ought to be." The "ought" has a reference to potentialities of value. But values are of different kinds, and moral value is one unique kind. Stones and waterfalls do not have it. Some human actions do. A thing is as it ought to be when it has the value it ought to have. A human action that has moral value may have it in the positive or negative sense, and in varying degree. To say that, in relation to this value, it is right, or is as it ought to be, is to say that it has the kind and degree of moral (or ethical) value it ought to have. To say that an action is ethically right, or as it ought to be, is, therefore, not the same thing as to say that it is right, or as it ought to be, in relation to its aesthetic value, its economic instrumental value, or any other value.

This theory as to what makes an action right, in the ethical sense, does not equate the right with the morally good. Moral goodness may vary in degree according as the action approaches or falls short of adopting the best goal and putting forth our best effort. It also varies with the motive. It is quite possible for a man to put forth his best effort to produce the best possible results and to do it from a bad motive, which lowers or destroys the moral worth of the action. He may, for example, do his duty out of hatred for a rival who would otherwise have won more esteem than himself. In such a case the hatred is wrong, but the performance of his duty is not. It would be wrong to neglect the duty simply because he found he had a bad motive for perform-

ing it. So it was right to perform it. Yet the bad motive, if he had no other motive for performing it, deprives the action of all moral worth. And, since it is only moral worth that deserves praise, the action was not really praiseworthy. Thus an action may be morally right and yet not morally good and praiseworthy. Further, many actions that are perfectly right require so little effort that, though certainly not bad, they are not of great moral worth.

The fact that an action is ethically right or wrong, therefore, is not the sole ground for estimation of its moral goodness or worth. But, providing the motive is good, praiseworthiness increases as the action approximates the perfectly right—the best effort toward best results. And if the motive is blameworthy then the blame for it rests on the previous actions that produced and harbored it rather than on the action it now tends to produce. Thus we avoid the paradox admitted in Mr. Moore's own theory—"that a man may really deserve the strongest moral condemnation for choosing an action, which is *actually* right." The paradox is avoided by analysis of the complex whole of motive and action, the moral worth of which we are estimating. We find that the blame rests directly on the actions that produced the bad motive and only indirectly on the right action the bad motive produced. But, on Mr. Moore's theory, the paradox is much more serious. If the attempt to do evil turns out luckily for the best the action is said to be right. And, vice versa, if the attempt to do the best turns out for the worse it is said to be wrong. Thus where motive, aim and execution are all the best possible, but some non-ethical chance event spoils the result, the action immediately concerned has to be declared ethically wrong. On our view, what is made to go wrong by a non-ethical factor is not thereby made wrong in an ethical, but only in a non-ethical, sense.

To clinch the matter this distinction may be more closely examined. Let us take the example used by Sir David Ross[10] of the duty to return a borrowed book. The obligation of the borrower (as Sir David says and Mr. Moore would agree) is actu-

[10] *The Right and the Good*, 43.

ally to produce a certain result, the repossession of the book by its owner. Now it may appear that the best way to produce this result is to send the book through the post office. If, however, the book goes astray in the mail the obligation is not fulfilled. There is a sense in which the act of mailing the book was wrong, though it was (we may suppose) the borrower's best effort to produce the best possible result. But, in such a case no one could say that the act was morally wrong. It was only wrong in a non-ethical sense. Ethically, it was quite the right thing to do. It is that which, *at the time*, the borrower was under obligation to do as means to the end he was obligated to fulfill. Its lack of success merely means that he then comes under obligation to do something else—recover the book and try the mail again, buy another book and send it, or adopt some other equivalent measure. The apparent paradox of saying that the act was morally right though it failed to fulfill the obligation is overcome when we recognize that an obligation to bring about a certain result involves an obligation to put forward one's best efforts to produce the means to that result, and if one means fails, to try another. To fulfill the obligation to attempt the means is right, even though it fails to fulfill the final obligation to achieve the result. It proves to be the wrong means (and thus the wrong action) for the purpose intended. But this is not the ethical sense of the term "wrong."

When the ethical sense of the terms "right" and "wrong" is thus clarified it can be seen that they apply only to the effort or self-exertion that a person may make and that their meaning covers not merely the goal of that effort (the best possible consequences) but also the degree of effort. One must do his best. It is this effort that has moral worth, a unique kind of value, over and above the value of the consequences aimed at or achieved. It is because of this unique value or disvalue, attaching to self-exertion or responsible effort, that the rightness or wrongness of such actions becomes a moral rightness or wrongness—and they are right, as we have seen, when they choose the best possible goal and put forth the best possible effort. Thus, for an action to be morally right or wrong it must be rooted in an effort for which the agent can feel himself responsible. And this, as we

have already seen, involves the assumption that he has the power either to make the effort or not to make it. In retrospect it means that the person could have chosen what he did not choose.

Mr. Moore is quite ready to agree that "there certainly is such a thing as making an effort . . . to *choose* a particular course"[11] and that such an effort may lead to an action different from that which would have been done if the effort had not been made. And he emphatically rejects the fatalistic view that acts of choice make no difference in the course of events.

Reasons of exactly the same sort and exactly as strong as those which lead us to suppose that everything has a cause, lead to the conclusion that if we choose one course, the result will *always* be different in *some* respect from what it would have been if we had chosen another; and we know also that the difference would *sometimes* consist in the fact that *what* we chose would come to pass.[12]

But, as he points out, admission of the causal efficiency of acts of choice and efforts to choose is not inconsistent with the principle that every event has a cause. They may be mere links in a causal chain.

Mr. Moore accepts the common view of causation, that "if everything is caused, it must be true, in *some* sense, that we *never could* have done, what we did not do."[13] This assumes a uniformity and rigidity in the causal chain, such as seems to be well established among macrocosmic, inorganic events. But such uniformity and rigidity, as the Heisenberg principle has shown, must always remain unproven as between microcosmic events. And when psychological events, such as efforts of will and acts of choice among different values, are admitted into the causal chain its uniformity and rigidity are definitely broken. It then becomes a very open question whether we *"never could* have done what we did not do."* And, as our quotation from Mr. Moore shows, there is just as much reason for belief in the occasional efficiency of causes of this psychological type as there is for the belief that every event has a cause. There is therefore no

[11] *Ethics*, 219.
[12] *Ibid.*, 213-214.
[13] *Ibid.*, 211.

reason for believing that the principle of causality itself makes it impossible to believe that we ever could have done what we did not do. The only relevant questions would then seem to be whether the nature of our moral experience implies that we could, and what precisely is meant by such a statement, and what processes are actually involved in such a situation.

To the first of these questions Mr. Moore is inclined to answer that the only sense in which our moral experience implies that we could have done what we did not do is one that does not clash with the rigid interpretation of the principle of causality. It is sufficient, he urges, if

(1) . . . we often *should* have *acted* differently, if we had chosen to; (2) that similarly we often should have *chosen* differently, *if* we had chosen so to choose; and (3) that it was almost always *possible* that we should have chosen differently, in the sense that no man could know for certain that we should *not* so choose.[14]

Not only does he urge that these three facts constitute all that we need to affirm in the way of Free Will, but he also says that, though many people argue that we must be able to choose in some quite other sense, nobody, so far as he knows, has ever been able to tell us exactly what that sense is. I have already given my reasons for thinking that these three conditions, as Mr. Moore interprets them, are not sufficient to provide for responsible moral effort. So it remains for me to try to make clear the different sense in which we sometimes could have done what we did not do and to justify the view that the choices implied in such situations do actually occur.

This, I believe, can be done as well for the flexible type of causation implied as it can for any type of causation. No analysis of causation can do more than point to the various factors in operation and their mode of relation in our experience. Further, it should be noted, we do not pass out of the realm of causal connection when we examine the grounds and antecedents of moral choice. The sort of libertarianism that would assert the occurrence of an uncaused choice, as has frequently been pointed out, would reduce the moral life to chaos. The question at issue

[14] *Ibid.*, 220.

is simply whether the psychological causal processes involved in choice can be so interpreted that it becomes clearly legitimate to say that a person could have chosen differently, and to say this in a sense that justifies that feeling of responsibility for the making of an effort that underlies the appreciation of intrinsic moral value in an action.

On the view here adopted, right action consists in the making of one's best effort to produce the best results. This involves the thoughtful enquiry as to what results are best, and as to the means to them, and the weighing of all the values involved in means and ends. Where the choice to do the best and the use of the appropriate means are difficult it involves the making of the utmost effort we can (so far as needed) thus to choose and execute the choice. Now Mr. Moore admits the facts of effort and choice but does not analyze them. Our analysis has presented it as an effort to produce the *best*. It is thus an effort directed toward values and involves attention to values, and to distinctions of value, and the exercise of preferential selections of one objective rather than another because of its difference in value.

It is sufficiently clear to introspection that these psychological processes do occur and that they tend to be followed by appropriate physical behaviour tending to realize the selected objectives. It is also clear that the point at which a genuinely open choice seems to present itself to us is in the selection of one value-toned objective rather than another. Some duty, for example, presents itself as an interruption of my leisure. It is easy to postpone it and go on with the pursuit of the pleasant interests with which I am occupied. I reflect and see that certain more serious interests of other persons may be affected if I procrastinate. So I make the necessary effort and abandon pleasure for duty. Such a typical situation shows that the decisive moral effort is a response to values conceived as somehow greater than those which would otherwise be pursued. There is an effort of attention to the greater values that redirects conduct from the channels in which it would otherwise habitually and naturally have flowed. The effort required may be extremely slight. The right action may follow, without present effort, from good habits built up in

the past without much effort, under wholesome environmental influences. But, unless the right action is non-moral, there is somewhere in its causal antecedents some such effort or self-exertion—an effort to choose and produce the greatest good.

This determination of conduct by effort of will in response to values seen and foreseen is certainly *self*-determination. For the self is essentially a more or less coördinated system of volitional tendencies, some of them set and habitual, some appetitive, some much less specific and automatic. And the capacity for self-determination is always what we mean by freedom. Political and social freedom is freedom to determine our own conduct rather than being forced to do this and that by pressure of other persons. Moral freedom is freedom of what we recognize as the morally responsible part of the self from control by habits and impulses not responsive to moral values. Thus moral effort is felt as a conflict between the will to produce the best and volitional tendencies driving toward goals of lesser value. Social and political freedom require the self-determination of the self as a whole as against determination from outside the self. But moral freedom requires only the self-determination of the inner self of moral effort, the will to produce the best. A slave may retain his moral freedom—maintaining the inner supremacy of the moral will, the will to produce the best. But it is hard. The social and legal pressures of slavery generally tend to reinforce the lower impulses and habits and restrain his best efforts. The same is true of the pressures of want and fear even where there is political freedom.

The first requirement for the recognition of moral freedom and responsibility is the admission of the causal efficacy of this will to the best. And this, together with that of other volitional tendencies, is granted by Mr. Moore. The second requirement is that this will to the best should be recognized as not entirely determined by factors external to itself. For it is this will that constitutes the inner core of the moral self. If it is not to some extent self-determined then moral choice is not self-determined, not responsible and not free. That this will to the best is limited by all sorts of factors external to itself there can be no doubt. But

to say that its exertion is entirely dependent on external factors is to make assertion without proof. There is certainly no *a posteriori* evidence that amounts to proof. And any *a priori* objections involve metaphysical principles that are themselves beyond proof. To deal with these objections would go far beyond the purposes of this paper. It will be sufficient to point to three possible interpretations of the metaphysical problem involved.

One possible metaphysical interpretation is that of emergent evolution. The will to produce the best may be an emergent tendency, emerging in a growing organism in a growing universe. This tendency having once emerged it may constitute a permanent "set" or drive in the psychological constitution of the individual, manifesting itself as occasion offers and increasing its energy with exercise. Such an emergent theory does not, of course, constitute a complete explanation. The word "emergence" merely states a problem; it does not explain anything. But the theory of emergence, if it can be maintained, does mean at least this—that the world order manifests many new developments in causal agency that can not be wholly interpreted in the light of their known antecedents. It thus would indicate that the causal order of the world appears to be sufficiently flexible to make possible the sort of self-determination our theory of moral freedom requires.

A second metaphysical possibility is a pluralism in which the will to the best could be regarded as a monad, or other active agent, spontaneously expressing itself in interaction with a world of agents of varying kinds. A third, and this is my own preference, would regard it as one line of development of a unique process of response to values that is a permanent and integral part of an organismic world order, a process that ramifies out into many different forms of expression as opportunity offers. Among these and other metaphysical possibilities one may make his choice, or one may hold sceptically aloof from all metaphysics. But these possibilities are sufficient to show that there are no well-established *a priori* grounds for rejection of the possibility of the inner self-determination of the moral personality. If our moral experience implies it we should shape our metaphysics in accord with the implications of that and other expe-

rience rather than press dubious *a priori* principles in opposition to it.

To do full justice to our sense of freedom and responsibility we must, however, carry this theory of the self-determination of the will to produce the best a stage further. This will is always determinate in its direction; i.e., it seeks to produce the greatest possible good. And it is certain that many factors external to it tend to prohibit, allow or stimulate its expression. As we have interpreted it, it is a set tendency of every fully developed moral personality, though, like other set tendencies, it is not always operative and does not operate with uniform vigour. It fluctuates. Whether it is effective in control of attention and conduct depends upon its strength relative to opposing tendencies. Its fluctuations are certainly in part due to causes external to itself. If they were wholly due to external causes it would not be self-determining to any extent and therefore not responsible and free. If there were some permanent causal efficiency in it that maintained a constant pressure or orientation within the personality—a drive that becomes effective as opportunity and stimulus are presented to it—then, in this independence of its own nature as a causal agent, it would have a certain limited power of self-determination. But, if this power were thus limited and fixed, then the moral self, while it would be to that extent causally responsible for its conduct, would not be responsible for an effort to do *better* in the future. Yet this demand of the moral consciousness that we should be spiritually alive and grow, that we should not merely *try*, but sometimes try *harder*, is an essential feature of our moral experience. So, too, is the consciousness that sometimes we could have tried harder than we did. This implies that, not merely a steady orientation toward the good, but, to some extent, the *fluctuations of effort* within that orientation are self-determined by that will to the best itself.

This means that within the psycho-physical causal order, of which we are a part, *will* is a fluctuating factor. It exerts itself in pulses of attention to values. But these pulses are not of uniform and fixed energy, as (perhaps) are the pulsations of energy the physicist describes. They are affected by many factors external to any one stream of pulses. But there is also a spon-

taneous fluctuation of the stream of pulses of attention to values itself. Indeed, each pulse of attention is *effort* and effort is exactly what it seems to be—an output of energy partly determined by external factors, but having a certain spontaneity of its own. Effort of will is, of course, not physical energy. It is effort of attention to value-toned objects by reason of their values. The self of each moment is thus to some extent a *new* effort creatively working toward its goal, the realization of the best; and thus the self of each moment is to some degree uniquely responsible for the result. It is a free agent in its innermost being, able constantly to re-shape to some extent the old self. It can view its destiny with hope and with faith in its own powers. It can bear the responsibility of its own deeds. It can rejoice in its achievements and it can find satisfaction in the maintenance of the integrity and development of its own moral personality.

Finally, I would wish to emphasize that this question of the present responsibility and freedom of the moral will is not a matter of mere academic interest. It is of very great practical importance. In the first place, it affects the justification of praise and blame. Mr. Moore, quite consistently with his theory, finds only a utilitarian justification of praise and blame, as means of stimulating an improvement in other people's conduct.[15] As against this view I should endorse two comments of Sir David Ross.

In the first place, I think we should agree that the denial of responsibility is not the assumption on which we actually praise and blame, reward and punish. Our actual assumption is a belief in responsibility. And secondly, we should think it somewhat dishonest to continue to practice praise and blame, reward and punishment, if we had lost the belief in responsibility. We should be treating people as if they were responsible, when we had really ceased to believe that they were.[16]

Now there is no responsibility in the sense required unless a statement such as that "the man *would* have succeeded in avoiding the crime, *if* he had chosen,"[17] is understood as implying

[15] *Ethics*, 189-193, 215-216.
[16] *Foundations of Ethics*, 247.
[17] Moore, *Ethics*, 215.

that, before he committed the action, he actually had the power to have made such a choice. Mr. Moore justifies the administration of blame, without this assumption, by saying that "where the occurrence of an event *did* depend upon the will, there, by acting on the will (as we may do by blame and punishment) we have often a reasonable chance of preventing similar events from recurring in the future."[18] But blame implies that the man *had the power* to do that which he did not do. So, as stated above, there is a false implication in the blame if the man is blamed for not having made a choice he had no power to make. This falsehood, like the doctor's encouraging lie, may be justified by its good consequences. But, like all lies, it would only be useful so long as it was believed. So, if the man blamed were a rigid determinist and knew that his accuser held the same views he would have good ground for a conclusive retort.

But this sort of determinism has a more serious effect than the undermining of the useful practice of praise and blame upon others. It logically should undermine the individual's own sense of responsibility. The fact that it does not seem to do so to any great extent in practice is probably due in part to the fact that the general practice of society in praising and blaming our actions carries more weight in determining our inner attitude to our own conduct than do our theoretical opinions. Also, the sense of responsibility seems to be an inescapable feature of our moral experience that is not dependent on expressions of opinion by others or on one's own opinions, but is rather the basis of the general belief in responsibility. Nevertheless, a rejection of that belief must affect a person's *reflective evaluation of conduct,* even if it has no effect upon the exercise of his own moral will.

This effect is seen in the fact that libertarians (both philosophers and the general public) tend to see a great intrinsic value in moral conduct, especially where it involves great effort, while necessitarians tend to minimize it. In his contribution to the symposium, "Is Goodness a Quality?" Mr. Moore defined intrinsic value as an experience that is "worth having for its own sake."[19] Now it is my contention that the experience of actively

[18] *Ibid.,* 216.

[19] *Proceedings Aristotelian Society,* Supplementary Volume, No. 11, 122.

doing one's best to produce the best results, an experience that pervades all the best phases of life, is so much "worth having for its own sake" that life would hardly be worth living without it. This is the intrinsic value of moral conduct. Yet Mr. Moore finds little or no place for this in his account of the ideal good.[20] And this minimization of intrinsic moral value is, it seems to me, a logical result of his interpretation of moral volition. To the special virtues he denies all intrinsic value, either in their possession or their exercise, granting them only a value as means to the goods they produce. The only moral characteristics of personality in which any intrinsic value is recognized are (a) the feelings of love for the intrinsically good consequences a man was expecting from his actions, and of hatred for the bad, (b) conscientiousness, or the emotion excited by the idea of rightness as such. But these values are slight, in Mr. Moore's estimation, compared with those of aesthetic enjoyment and personal affection.

Now this estimate of life seems to me to lavish all one's praise on the wines and sweetmeats and forget the *pièce de résistance* that really makes it a satisfying meal. What is life without freedom to call one's soul one's own, to make one's own decisions, win one's own battles and, in general, pursue the good as one sees it? The particular virtues, in so far as they are mere habits or dispositions, and their exercise, in so far as it is the mere automatic expression of these habits and dispositions, certainly have no more than instrumental value. But *virtue* in the broad sense, as its Latin root implies, is not just the possession and operation of a mere set of wholesome habits. It is to be a *man*. It is to be *human*. And nothing else is worth much in a man's life unless he can be both. It is in these days, when this fundamental basis of the good life is threatened, that the reality becomes very clear to us. The basic value of the good life is that of being a responsible human being, free from the restrictive agents of want and fear, and free to speak and religiously to devote oneself to the realization of what seems good. The goods we seek as objectives are the lesser part of the reward. Its greater

[20] *Principia Ethica,* 171ff.

part is the value that rides "on the back of the deed,"[21] the value of living, with integrity of personality, responsible freedom of action, and power to will and pursue what seems to one best. This, whatever the mistakes one makes, is true morality. Its value is such that it is worth while to lose the whole world that one may save one's own soul—the soul of a free man.

The external conditions that most seriously affect this inner moral freedom are the four freedoms so acutely before our minds today. For the value of these four freedoms is not merely, nor chiefly, in the opportunities they provide for satisfying our natural wants and realizing aesthetic and social joys. If a tyranny were able to give these latter things more plentifully it would still be evil, because it would destroy the moral integrity and free, responsible activity of personality. It is because this intrinsic value of the inner moral life, in its free decisions, is instinctively felt to mean so much more than all our other values that men will die for political and religious freedom and surrender economic rewards for freedom to speak and think for themselves. A philosophic theory that tends to obscure so fundamental and vital a value as this, is not thereby proved false, but it is of more than academic importance that its weaknesses should be fully recognized.

A. CAMBPELL GARNETT

DEPARTMENT OF PHILOSOPHY
UNIVERSITY OF WISCONSIN

[21] This phrase is derived from Scheler and Nicolai Hartmann.

7

O. K. Bouwsma

MOORE'S THEORY OF SENSE-DATA

7

MOORE'S THEORY OF SENSE-DATA

I

I WANT in this essay to discuss a few sentences from Professor Moore's "A Defence of Common Sense," published in the volume containing the second series of contributions to *Contemporary British Philosophy*. These sentences are contained in part IV of that contribution. In this part Professor Moore is expounding what he regards as the correct analysis of such sentences as "This is a hand," "That is the sun," "This is a dog," etc. Involved in this exposition is the assertion: "whenever I know or judge such a proposition to be true, there is always some sense-datum about which the proposition in question is a proposition—some sense-datum which is a subject of the proposition in question."[1] Professor Moore goes on to recognize "that some philosophers have . . . doubted whether there are any such things as other philosophers have meant by 'sense-data',"[2] and in order to make sure that his readers may be persuaded, he goes on with the following attempt at definition, which I quote.

Professor Moore writes:

And in order to point out to the reader what sort of things I mean by sense-data, I need only ask him to look at his own right hand. If he does this he will be able to pick out something (and unless he is seeing double, only one thing) with regard to which he will see that it is, at first sight, a natural view to take, that that thing is identical, not indeed, with his whole right hand, but with that part of its surface which he is actually seeing, but will also (on a little reflection) be able to see that it is doubtful whether it can be identical with the part of the surface of his hand in

[1] *Contemporary British Philosophy*, Second Series, 217.
[2] *Ibid.*, 217.

question. Things *of the sort* (in a certain respect) of which this thing is, which he sees in looking at his hand, and with regard to which he can understand how some philosophers should have supposed it to be the part of the surface of his hand which he is seeing, while others have supposed that it can't be, are what I mean by sense-data. I therefore define the term in such a way that it is an open question whether the sense-datum which I now see in looking at my hand and which is a sense-datum of my hand, is or is not identical with that part of its surface which I am now actually seeing.[3]

I propose first to discuss some difficulties in this paragraph. Professor Moore invites his readers to pick out something, but his directions for doing this are not clear. Commonly if one is asked to pick out something, the something is described. Out of this bowl, pick out the red flower; out of this sheaf pick out the longest straw. We should all know how to follow these directions. But Professor Moore's directions are not like this. Apparently you simply pick out something; that is, as you are looking at your hand, and keeping your eye on your hand, you pick out something. Suppose you pick out your knuckles. Certainly that is something you can pick out. Well, is that the sort of thing Professor Moore intended that you should pick out? It is not. And this is the test which what you pick out must satisfy in order to meet Professor Moore's requirement. You must pick out something "with regard to which . . . it is, at first sight, a natural view to take, that that thing is identical with that part of its surface which [you are] actually seeing." So of course, the knuckles won't do. Even the surface of the knuckles won't do. What better could one do, than pick out the surface of the hand one is seeing? Certainly you can pick this out and it would be a natural view to take that that thing is identical with that part of the surface which you are actually seeing. This is a bit doubtful however, since you would scarcely be expected to pick out the whole of the surface which you are seeing, for picking out is selecting, and after selection there would be a remainder, which in this case there would not be. Furthermore if you do pick out the surface of the hand which you are seeing, could you then (on

[3] *Ibid.,* 218.

a little reflection) doubt that it is the surface of the hand you are seeing? For until you manage to do this too you would not have picked out what Professor Moore means by a sense-datum.

I confess that I am unable with these directions to attain the desired result. Looking at my hand I can pick out knuckles, finger-tips, nails, lines, veins, etc., but to none of them does the description which Professor Moore gives apply. If I pick out the knuckles, I am not seized with any doubts that they are the surface of my hand; and so with the finger-tips, nails, etc. And how I should ever be in a position to anticipate that what I do pick out would satisfy the given conditions I do not understand. I can see how if yesterday I had been asked to pick out my thumb, and then a little later doubted that what I had picked out was my thumb (for I had my fingers crossed in an unusual way) then today I might, remembering, pick out what yesterday it seemed very natural to take to be identical with my thumb and then what later I came to doubt was identical with my thumb. But Professor Moore's directions are not like this. He says that there is something which you may pick out and with respect to it, you will have the described difficulty. I have not been able to pick it out.

This, then, is one peculiarity of Professor Moore's directions. One who is unacquainted with sense-data, and so has no information with regard to what to pick out, must resort to random picking, and wish for luck. Professor Moore's directions are something like this: Pick out of this basket something of which you will see that it is, at first sight, a natural view to take that that thing is identical with a red marble, but of which you will also see that it is doubtful whether it can be identical with the red marble. Now one might look at the basket and notice what there is in it. Here is a red marble, here a red pepper, here a red rubber ball, etc. One might notice all these things, and turn away, saying that there was nothing there which seemed at first glance to be a red marble, and then a moment later seemed not to be a red marble. So there was nothing to pick out. On the other hand, there might be something red and round in that basket which did at first appear to be a red marble, and then upon closer inspection turned out to be a red rubber ball. And picking out

the red rubber ball would satisfy the directions. I am trying by these analogies to figure out just what sort of directions these are that Professor Moore is giving, in order to show why I have been unable in looking at my hand to discover anything which I should have some reason to suppose met with Professor Moore's directions.

But this is a general comment. Professor Moore says that there is something about which you first feel sure and then about which you doubt. In seeking for this I do not see how in feeling sure one could anticipate the doubting. But I should like further to notice some peculiarities concerning what it is one is at first to be sure of, and then is to doubt. I have in mind Professor Moore's use of the following types of sentence, in which X symbolizes the something which you are able to pick out:

1. X is identical with the surface of my right hand.
2. X can be identical with the surface of my right hand.
3. X cannot be identical with the surface of my right hand.

I want first to consider the first type of sentence in order to make clear the context in which we should commonly understand it. And for this purpose I am going to define a certain word, parodying the definition which Moore gives of the word sense-datum. This is the parody:

"And in order to point out to the reader what sort of thing I mean by ——, I need only ask him to look at the cook's right hand. If he does this he will be able to pick out something with regard to which he will see that it is at first a natural view to take that that thing is identical not indeed with the cook's whole right hand, but with that part of its surface which one is actually (?) seeing but will also (on a little inspection) be able to see that it is doubtful whether it can be identical with the part of the hand in question. Things of the sort of which this thing is, which he sees in looking at the cook's hand, and with regard to which he can understand how some kitchen visitors should have supposed it to be the part of the surface of the cook's hand at which he was looking, while others have supposed that it can't be, are what I mean by rubber gloves."

This experiment, I think, might do very well for all kitchen visitors. But obviously its success depends upon a familiarity

with the use of the expression "human hand" by which the inspection is guided. Look closely at the hand; does it look like a hand? pinch it, smell it, etc. Does the surface stretch like taffy, is it very smooth, etc? Apparently in a case such as this there is no difficulty in distinguishing the surface of a hand from the surface of rubber gloves. Now then, when the reader in Professor Moore's experiment looks at his hand, and sees the surface of his hand, what happens? Does he think that some new kind of gloves, made to resemble the hand, have come to be worn, and that these gloves are, to smell, and touch, and sight, indistinguishable from the surface of the hand, gloves which you may not know you are wearing unless you remember that you put them on? If in a case of this sort one forgot, would one then be sensing, directly perceiving, a sense-datum? The answer is: No. For what distinguishes the doubt in terms of which Professor Moore defines the sense-datum, is that it cannot be resolved. Once the doubt arises, there is no way of settling the question whether the thing one can pick out is identical with the surface of one's hand or not. It must be remembered that Professor Moore does not say that the sense-datum is not identical with the surface of the hand. He only says that in looking at one's hand one comes to doubt that something, which may be the surface of one's hand, is the surface of one's hand. But, unlike the doubt about the surface of the hand and the rubber gloves, it cannot be settled. Once the doubt has arisen, there's nothing to do but to go on doubting. Scratching, smelling, looking more closely, do not give relief.

I can imagine someone in a facetious vein suggesting that the situation which Professor Moore describes is more like trying to distinguish identical twins occupying the same space. It's as though someone had been told: "He's identical twins," and then whenever that someone saw him, he would shake his head, looking, wondering, asking himself: Am I seeing Hans or Fritz? or when I am directly perceiving Hans, am I indirectly perceiving Fritz? He cannot decide. If someone says: You're seeing Hans, (that seems the natural view to take) he proceeds to doubt: "Maybe it's Fritz." He might in this situation easily come to see that some people would hold that Hans was not twins, and

that Fritz is either an alternative notation for Fritz, or a meaningless expression.

Now I want to try a further experiment, again to exhibit the misleading familiarity of Professor Moore's language. In the experiment designed to test for rubber gloves, the point made was that Moore's language is applicable to such things as hands and gloves. I want now to show that it is also applicable to mirror-images. This is the experiment: "And in order to point out to the reader what I mean by ———, I need only ask him to look into the mirror, holding up his right hand to the glass. If he does this, he will be able to pick out something with regard to which he will see, that it is, at first sight, a natural view to take, that that thing is identical, not indeed with his whole right hand, but with that part of the surface which is reflected there, but will also (smiling to himself) be able to see that it is doubtful whether it can be identical with the part of the surface of his hand in question. Things of this sort of which this thing is, which he sees in looking at the reflection of his hand, and with regard to which he can understand how some creatures, little people and puppies, should have supposed it to be the part of the surface of his hand, while grown-ups supposed that it can't be, are what I mean by hand-mirror-images."

Now the point of these two analogous experiments is this: If you are among those philosophers who doubt that there are any such things as some philosophers have meant by sense-data, and if you try to understand Professor Moore's directions in the attempt to identify a sense-datum, then further if you interpret a philosopher's language as so much English, you are certain to fail. If you look at your hand and try to stir up doubts about what you are seeing, you may object to yourself: But maybe I am wearing rubber gloves. Well, you know how to take care of that. Or you may object: But maybe I am looking into a mirror, and what I see, is just an image. You also know how to take care of that. What other misgiving suggestion remains then? It must be remembered that Professor Moore says that the doubt arises "on a little reflection" though he does not, in this context at least, tell us at all what reflection induces the doubt. It won't do, of course, to object: But maybe there are sense-data, and it is

a property of sense-data to pass for the surfaces of things we look at, both when and if they are, and when and if they are not, the surfaces of objects. For it is by means of some reflection which does not involve that there are sense-data, but that leads to the requisite doubt concerning the surface of one's hand, that one is persuaded that there are sense-data. What I mean to point out here is that the language of the experiment is strange language so long as we are not acquainted with sense-data. Once we distinguish a sense-datum we may come to see how it applies. But before we can do this we must come to doubt. And before we come to doubt we must indulge in a "little reflection." The question is: what reflection? What is it that led Professor Moore and some other philosophers to come to that pass where, when each looks at his hand, he may ask without the slighest perturbation: And is this the surface of a hand? If, actually seeing the surface of his hand, he says: "Maybe not," then he is aware of a sense-datum. The question is: What thoughts lead him to this doubt?

Before I go on to consider what these reflections may be, I should like to discuss the second and third kinds of sentences above:

2. X can be identical with the surface of my right hand.

3. X cannot be identical with the surface of my right hand. For this, notice a case of doubt in which one might have employed language of the sort which Professor Moore uses. Isaac on the day when he was deceived might have asked: Is this the hand of Jacob or the hand of Esau? Isaac was touching the hand and hearing the voice. The voice led him to doubt. We all understand this. And he might, had he attended Cambridge, have said: The hand that I am touching (and which I have picked out) is identical with the hand that is Esau's. I suppose that generally no one ever bothers to say a thing like this unless some doubt has preceded the assertion. So Isaac expected that this was the hand of Esau, but the voice made him doubtful. How could this be Esau's hand, when the voice which accompanied it sounded like Jacob's voice? In a dispute then, and to settle the matter (Isaac was very old!) Isaac may have said: This hand is identical with Esau's hand. He was wrong of

course, but the confusion was one of hands; he mistook Jacob's hand for Esau's hand. The occasion for the use of the sentence arises after doubt and after denial. "What do you see?" "My right hand." "Oh, no you don't." "I say [temper rising] that what I see, is identical with my right hand. It is my right hand." It follows, of course, that we also have a use for: X is not identical with my right hand. If Rebecca on that occasion long ago, had had a mind to, she might have interrupted with: "You're wrong, Isaac. That hand is not identical with the hand of Esau. It's Jacob's hand."

Now we can also make a case for "This hand can be the hand of Esau," and so with "This hand cannot be the hand of Esau." Rebecca might have said: "It can't be." And then she would have given reasons, for such statements as "It can be" and "It can't be" have this sort of reference. So Isaac might have asked: Why can't it be? And the answer might have been: See here: You know that Esau's is a hairy hand. If you pull at the hairs on his hand, it pains him and you can see it on his face. And what is more the hair does not pull out. Try that experiment on this hand. There is no pain. The hair easily pulls off, and under the layer of hair, you will find paste. That's why this cannot be Esau's hand. Esau's hand is a genuine hairy, but this hand is a wolf's hand in sheep's clothing. To which Isaac might have lamented: But I thought it was Esau's. And it could have been for all I knew. The hand was hairy, it smelled of the field and of game, like Esau's hand. And it seemed like a large hand to me. So you see it could have been Esau's hand.

It is clearly, I think, situations such as these which we have in mind in the use of the expressions which Professor Moore employs. There is mistaking one thing for another thing, Jacob's hand for Esau's hand. There are also considerations which are involved in making the mistake, and other considerations which are involved in correcting the mistake. These considerations are of two kinds. If we are clear about what Jacob's hand is like, and clear about what Esau's hand is like, then the respects in which they are similar are likely to involve us in mistaking one for the other. The respects in which they are dissimilar, are the considerations which we draw upon when we correct our mistake,

or when we come to say that "This cannot be so and so."

Accordingly, when Professor Moore says that you can pick out something about which you are inclined to say that it is identical with the surface of your hand, and this arises in a context in which you are inclined to say both that it can be, and that it cannot be, one would expect that some reasons would be at hand in respect to both. What makes you think that what you can pick out, can be identical with the surface of your hand and what makes you think that it cannot be identical with it? Is what you picked out similar in certain respects to the surface of your right hand, and dissimilar in certain other respects to that surface? Professor Moore has said that one would come to doubt by way of "a little reflection," as I noticed before, and the analysis which we have just made would lead one to expect that the reflection would consist in noticing similarities and dissimilarities between what you picked out and the surface of your right hand. Of course, if any dissimilarities were noticed, that ought to settle the matter. If the something is dissimilar, then of course, it is not the surface of one's hand. It looks as though one is aware of nothing but similarities, supposing one has picked out something, and yet that one is suspicious that there may be dissimilarities of which one is unaware. It's as though one were looking at one's hand, and had a suspicion that what one was seeing was not one's hand at all. So one examined one's hand carefully, found out that it was exactly what one expected one's hand to be like and yet concluded: "But maybe there is something I am not seeing, maybe there's a difference I am missing. So maybe after all, this is not my hand." What then planted this suspicion?

There is one further point that I should like to make. The experiment which Professor Moore proposes, takes for granted that each of us knows how to identify the surface of his hand. It is in terms of this identification that we are to come to recognize the something we pick out. Now then, each of us is able to describe his own hand. One might take a print of it, study it carefully for color shadings, shape and surface markings. If then one is well-informed about the surface of one's own hand, the doubt which Professor Moore describes does not arise because of any lack of information about one's hand. Apparently then the some-

thing which you pick out has the same characteristics which the surface of your hand has. If it did not have the same characteristics, obviously it would be different from the surface of your hand, and if it had the same and some others, it would also be different. So, if it has any characteristics at all, it must have the same characteristics as the surface of your hand. How then explain the suggestion that they are different? Are they in different places? This is also out of the question. We do not see the surface of the hand in one place, and pick out the something in a different place. If we did the doubt that the "something" and the surface of my hand are identical, would be settled. This too does not explain the suggestion that the something and the surface of my hand are identical. What then?

If what I have just suggested about knowing the surface of one's hand is not admitted, then what? Then certainly we are at a loss. The experiment presupposes that we know something, and that by way of this we may become aware of something else. If you know the surface of your hand, you can become acquainted with your knuckles. You certainly can, if you look at your hand, pick out your knuckles. In some such way as this you also become acquainted with "a sense-datum." Suppose however that, in a situation in which you did pick out your knuckles, you were seized with a doubt as to whether your knuckles were identical with the surface of your right hand which you are seeing, how would you account for this? If nothing very serious has happened, one might suggest that you had now come to use the expression "the surface of my hand" in a very unusual way. I have an inkling that something of this sort has happened in the sentences from Professor Moore's exposition. If one can think that "the something which one can pick out" is identical with the surface of one's hand, then either one must take for granted the use of the expression "the surface of one's hand" which applies then to something one can see, smell, touch, kiss, etc., and so grant that what one can pick out is also something which one can see, smell, touch, kiss, etc., and otherwise one takes for granted the use of the expression "what one can pick out" knowing well what this is like that one can pick out, and that for instance one cannot touch, taste, smell, etc., what one can pick out,

and so grant also that "the surface of my hand" is something which, like what one can pick out, can be seen, but cannot be touched, tasted, smelled, etc. Either, then, Professor Moore is in effect saying that you can pick out a physical object which is identical with the surface of your hand, or you can pick out something which is not a physical object at all, and that is identical with the surface of your hand. The puzzle is as to how a non-physical object (a sense-datum) can be identical with a physical object. It seems at any rate inevitable that if anything can be conceived to be the surface of my hand, it must be physical; and that if the surface of my hand can be conceived to be a sense-datum, the surface of my hand is not physical. But in that case what has happened to the expression: "the surface of my hand?"

II

I have tried, in what preceded, to point out some of the difficulties which I have met in trying to follow Professor Moore's directions. And I regard as crucial in this respect the three sentences which I discussed, and the use of the phrase: "the surface of my hand." I also noticed that what leads to the doubt in Professor Moore's experiment, is a "little reflection." My suggestion is that it is the same "little reflection" which leads us to use these sentences, and the phrase just noticed. And I want now to describe the reflections which, in my own case, seems to lead me in that direction.

There are especially three sets of facts which lead me to try to distinguish a sense-datum in the prescribed way. One is certain facts concerning sounds, odors and tastes. Another is facts concerning mirror reflections, images, echoes, etc. And a third is the use of such expressions as: It looks like . . . , This looks like . . . , etc. There may be other facts which are relevant as these are. But I have noticed that when I, at any rate, meet the expression sense-data, these are the sorts of fact which come to my mind.

I want, before I go on, to notice how narrowly Professor Moore has conceived the problem of sense-data. It is common among those who say that there are sense-data to say that sounds,

odors, tastes, etc., are sense-data; but it appears, apart from the tell-no-tale phrase "in a certain respect," that Professor Moore means by a sense-datum only that sort of thing which may be taken to be the surface of something or other. In other words, Professor Moore confines his use of the phrase sense-datum only to what others would describe as *visual* sense-data. I find Professor Moore's definition unusual in this respect, or misleading. If he does define "sense-data" in such a way as to include only "visual sense-data" then he defines the term in a way inconsistent with his own use of the term, for in a previous sentence he says, referring to sense-data: "I am at present seeing a great number of them and feeling others." At any rate his exposition excludes smells, tastes, and sounds. However that may be, the problem here is: What reflections would lead one to distinguish something which one would then say can or cannot be identical with the surface of one's hand which one is seeing?

The fact with respect to sounds, smells, and tastes is that they function in perceptual experiences in two ways. I can illustrate this best by a few pairs of sentences. Notice these:

I hear a gnawing sound.
I hear a rat.

I smell an odor.
I smell a rat.

I taste a sour taste.
I taste lemon.

The first of each of these pairs functions independently of the second, and one can describe sounds, odors, and tastes, without committing oneself to any sentence of the sort which is second in each pair. But the second does not function independently of the first. If you say: I hear a rat, then the question: What was the sound like?, is pertinent. In each case one may ask: What was the sound, or the odor, or the taste like? We are all acquainted with the descriptions of sounds, odors, and tastes. I need not, I think, enlarge upon this. If now someone held that there were sense-data and he meant by this that there were sounds, odors, and tastes, and that these are descriptively inde-

pendent of rats and lemons, etc., there would, I think, be no controversy about this. There is no such question as: Is the sound or the odor of the rat identical with the surface of a rat, or the taste of a lemon identical with the surface of a lemon, or of that part of the lemon which I am tasting?

But now there are also certain similarities among facts of this following sort:

I hear a rat.
I smell a rat.
I taste a lemon.
I see a cloud.
I touch velvet.

And here, I take it, one is likely by reflection upon these sets of similarities to suppose that there must be some fact which corresponds to: I see a cloud, as: I hear a sound corresponds to: I hear a rat. And so too with: I touch velvet. Since, in other words, to hearing there corresponds a hearing sense-datum, and to smelling a smelling sense-datum, etc., so to seeing and to touching there must correspond seeing and touching sense-data. Actually, of course, there need not be such; and one part of the suggested parallel between hearing, smelling, and tasting, on the one hand, and seeing and touching, on the other, is missing. There are no descriptions of "sights" and "touches" which are independent conceptually of the descriptive characteristics of rats, lemons, clouds, velvet, etc. If you attempt to describe what you see, the same words which you use to describe the lemon or the cloud, will also serve to describe the purported sense-datum. So, if there is a sense-datum in these last cases, a new vocabulary will have to be engaged to perform the service. And so we get two different meanings for "is red" in the sentences "This (sense-datum) is red," and "This rose is red." This sort of accommodation is the consequence of the assumption that just as there are auditory sense-data so there must be visual sense-data. We make up for the deficiency in the facts from which we start by inventing a new vocabulary. Unfortunately we are compelled to use the same words which have otherwise performed an unambiguous service. It also follows that, if in the respect noted, seeing is like hearing, then as one is able, in hearing a

bird, to distinguish the sound of the bird, so in seeing a hand one is able to pick out a corresponding visual sense-datum. The effect of these analogies may be so strong as to lead one to say that there must be a sense-datum.

These analogies do not however provide the only motive. Consider mirror reflections. Mirror reflections are like sounds and odors and tastes in a certain respect, and they are like lemons and clouds and velvet in another respect. The image of a lemon or a cloud is like a sound or an odor, in that the image is descriptively independent of the description of any lemon or cloud. On the other hand, the description of an image of a lemon or cloud is unlike the description of a sound or odor, in that the descriptive items which compose it are engaged also in describing lemons and clouds. Now how do these facts about images incline one to the belief that when one is looking at one's hand one is seeing a sense-datum, as one hears a sound? Perhaps in this way: If one is already impressed with the analogy between hearing and seeing, then one is inclined to believe that there is something which one is seeing which is distinguishable as the sound is from the bird one hears. Now if you look at your hand and try to discover this corresponding element, you may find your effort encouraged by the fact that there are things which are descriptively identical with what you are seeing which are nevertheless not the surfaces of lemons and clouds at all. That is, here you have in reflections what, since they are described in the same way in which lemons and clouds and hands are described, may very well be taken to be "the surfaces of lemons and clouds." So when you look at your hand, you may describe what you see just as you would describe the reflection of it in the mirror. Since then what you see is taken to be the surface of your hand, you at once understand how something might be described in this same way, and yet not be the surface of your hand at all. For the image in the mirror is not the surface of your hand. It is clear certainly that with this in mind you can, if you look at your hand, pick out something which is like what you saw in the mirror, when you raised your hand to the mirror.

There is one further set of facts which disposes us in the same way. Notice such sentences as these:

This sounds like a horse.
This smells like an onion.
This tastes like a peppermint.
This looks like a million dollars.
This feels like a sponge.
The use of these expressions is parallel to the first set described above. The first three are admittedly statements about a sound, a smell, and a taste. Now how about the fourth and the fifth? Well, they must also be about a "look" and about a "feel," the corresponding sense-data of seeing and touching, respectively. This does not now seem to me at all persuasive, and of course, for the same reason which I gave in discussing sounds, smells, etc. If one wished, for instance, to identify by description or by some other form of direction, the sound or smell in question, as distinguished from the horse or the onion, this is a simple matter. But if you wish to call attention to the "look" or to the "feel" in question there is no resort to doing this, save pointing out or identifying the "million dollars" or "the sponge" or whatever the object may be. In other words, what is called the "look" or the "feel" is not identifiable in the way in which the sound, or smell are identifiable. The use of the word "this" is commonly defined so as to apply to such uses as are involved in these first three sentences. But it is only by analogy that one comes to suppose that in the last two sentences the use is like that in the first three. Of course such a sentence as: "This looks like a million dollars," may apply also to a mirror-image, and we have already noticed what this means. The image of a girl who looks like a million dollars would also look like a million dollars. This means simply that they are described in the same way. Certainly from such facts as these, which we all admit, it does not follow that when you look at your hand, you can pick out something which is not your hand, of which you now say that it looks like your hand.

These are some of the facts upon which I reflect a little, when I am led to the view that what Professor Moore has tried to persuade us is true. I want now to show that, if one does follow the lead of these facts, one is likely to use precisely the sort of language about "sense-data" which Professor Moore does use.

If the analogy between seeing and hearing holds, then it follows in the first place that if you look at your right hand you will be able to pick out something, something which on the assumption given, corresponds to the sound in hearing. But this is a strange sort of direction, for, if I look at my right hand, nothing at all corresponds to the sound in case of hearing. There is simply my hand, or more conveniently as you will see in a moment, the surface of my hand. So I pick that out. Now I reflect, and describe what I see, reminded that what I see is like reflections in mirrors. I know, of course, that mirror-reflections are not identical with the surfaces of any hands, no matter how perfect the image may be. Now, since this is like an image in all these respects, it can't be the surface of my hand at all, and this in spite of the fact that I thought at the outset that I was picking out the surface of my hand. If the only thing I could pick out was what I took to be the surface of my hand, and that is the sense-datum, and this is like the image in the mirror, then see what follows. The reflection in the mirror has no depth. I cannot prick it with a pin. Now then does the surface of my hand have depth? If you say that what you picked out is like the reflection in the mirror, and it has no depth, then if it is identical with the surface of my hand, then the surface of my hand also has no depth. Can that be? On the other hand, if you say that what I picked out is identical with the surface of my hand, and the surface of my hand has depth, are we then to allow that the sense-datum, like a hand's surface, has depth? Can I prick a sense-datum with a pin? This is the puzzle which I noticed previously when I discussed Professor Moore's use of the phrase "surface of my hand," and it arises from conceiving of the sense-datum as like a mirror-reflection, and at the same time as something which one can pick out. If when, on this basis, I look at my hand, and try to pick out a sense-datum, I must be surprised to discover something which, though it may be in certain respects like the image in the mirror, is also remarkably unlike it. For, in spite of what all these facts already noticed lead me to expect, I discover nothing but my hand.

I should like to labour this last point. Imagine the sort of situation you would be in, if, upon the basis of such facts as I

have noticed, you were disposed to expect a sense-datum. What would you say in trying to describe what you expect? First of all, you might tell someone to look at his hand, on the expectation that just as if he heard a bird, there would be a sound to identify, so here there would be something corresponding to the sound. It also follows from the character of what you see, that if there is something corresponding to the sound, that you could pick it out. If this were all, one would be inclined to describe what you might pick out as "a yellow patch," "a red patch," "a canoid patch of brown," etc., and it is easy to see what in a case of this sort has happened. People who invent expressions of this sort are trying to find some expressions which parallel the descriptions of sounds, but the parallel is deceptive. For, if in looking at your hand you now try to pick out "a hand-shape of pink," you will find yourself picking out the surface of your hand, whereas in the case of a sound the relations between the sound and the bird are obviously different. The description of the sound is not a description of the bird. But there is no necessity for pursuing this. It is only necessary that what you pick out should, like the sound, be distinguishable from your hand, or the surface of your hand. As it is, you know that reflections in mirrors and images otherwise are distinguishable from what they reflect and image, though they are not descriptively distinguishable from what they reflect and image. So we formulate a description accordingly: Pick out what has the characteristics of a mirror-reflection. Looking into the mirror, holding your hand to the mirror, I might ask: What do you see?, and what you would then give me as a description would equally apply to your hand. Now then you look at your hand, and describe your hand, for what will satisfy my request is just that. Further, if you have already committed yourself to saying that there is something here which corresponds to the sound in the case of hearing the bird, then you will feel pretty sure that you have picked that out. But you will nevertheless be puzzled. For if you have picked out the sense-datum, then if someone says: Now pick out the surface of your hand, you will be unable to do so unless the sense-datum and the surface of your hand are identical. And if you then ask: Did I pick out the surface of my

hand?, already assured that you did pick out the sense-datum, you will be inclined to say: That may be, for a sense-datum can be the surface of a hand. And you will be inclined to say this because, as I said before, the reflection and the surface of my hand are similar. But you will also be inclined to say that a sense-datum cannot be the surface.

III

I have tried, in the preceding sections, first of all to explore certain difficulties in the directions which Professor Moore gives for discovering what it is he means by a sense-datum, and second to try to discover what motives there are which lead us to expect that there are sense-data, and which lead us also to such curious descriptions of them. My thesis has been this: The obvious distinction between sounds, tastes, and smells in hearing, tasting, and smelling leads us to expect a corresponding something or other in the case of seeing and touching. So when I look at my hand, I am led to expect that there is a sense-datum in this case. So I may say that I can pick it out. But when I try to pick it out I am at a loss. There is only my hand. Now if I still persist in holding that there is a sense-datum present, I am bound to describe it in a peculiar way. I am likely to describe it in analogy with an image or mirror-reflection. I may go on to think of the sense-datum which must be there, as spread exceedingly thin over the surface of my hand, a kind of epi-epidermis, and at the same time as looking just like my hand when the sense-datum has been removed. Now if I keep this fixed in my mind, and look at my hand, and if I am asked: What do you see?, I am supposed not to know what to say. Do I see just an image spread over the surface of my hand like so much surfacing surfaceless paint, or do I see the surface of my hand? I think I can tell an image from the surface of my hand, but I confess that I should be much distressed in the attempt to distinguish the image of the surface of my hand laid neatly on the surface of my hand and defined in such a way as to be indistinguishable from the surface of my hand, from the surface of my hand. But fortunately, as I think, at least, I am not led to expect anything like images spread over the surface of my hand, and if I did, I should try

pricking the epidermis. As I have noticed before, that the attempt to describe what "must" be present is desperate is also apparent in the consequent use of the expression "the surface of his hand." For we do not as a matter of fact have any difficulty in identifying the surface of our hands. If then there is some difficulty, that difficulty has not been properly described. And the point of my essay is that the supposed entity which is defined in terms of a confusion, which is generated by sentential likenesses, misleads us and catches us in linguistic pockets.

Rubber gloves, the image of my hand, another man's hand, all of these I know how to distinguish from my hand, when I look at my hand, and when I am in doubt. But I am not moved by the suggestion that whenever I look at my hand an image of my hand may be interposed between my hand and my eye. In that case we should need to invent the theory of the Pre-Established Harmony between the hand and the sense-datum. But why suggest it?

Having come to the end of my essay I am now full of misgivings. I know that I have not refuted Professor Moore's view. I have tried however, teasing the words of Professor Moore's exposition, to get the matter straight. And this is what has come of it. May my betters rob me of my "darling follies," among which betters I have long counted first Professor Moore.

<div align="right">O. K. BOUWSMA</div>

DEPARTMENT OF PHILOSOPHY
UNIVERSITY OF NEBRASKA ·

8

C. J. Ducasse

MOORE'S "THE REFUTATION OF IDEALISM"

MOORE'S "THE REFUTATION OF IDEALISM"

PROFESSOR MOORE'S "The Refutation of Idealism," published in 1903, is still one of the most famous articles written in philosophy since the turn of the century. Its acute and searching criticism of the proposition that *esse* is *percipi* has been widely held to have finally proved its falsity and thus to have robbed of their basis the idealistic philosophies which in one way or another had been built upon it. It is true that in the preface to his *Philosophical Studies*—in which the article was reprinted in 1922—Professor Moore writes that "this paper now appears to me to be very confused, as well as to embody a good many downright mistakes." These, however, are not specified, and, since he does not repudiate the article as a whole, it may be presumed that he still adheres at least to its essential contention. In any case, because of the influence the wide acceptance of its argument has had on the course of subsequent philosophical thought, the article as published is now a classic and commensurate in importance with the celebrated proposition it attacks. This is enough to justify a critical examination of it on the present occasion.

As against Professor Moore, I believe there is a certain class of cases concerning which it is true that *esse* is *percipi*. This class, moreover, is the very one in terms of an instance of which his discussion is worded. I think it can be definitely proved that, so far as this class is concerned, Professor Moore's argument does not prove, as it claims to do—or even render more probable than not—that *esse* is *percipi* is false. I shall, however, try to show not only this but also that, for this class of cases, *esse* is *percipi* is true. The latter will be more difficult to demonstrate conclusively, but I believe I shall be able to show at least that the

burden of proof definitely rests on those who would deny that even in these cases *esse* is *percipi*.

The considerations I shall set forth, however, will not constitute an argument for idealism, for I believe that there is also another class of cases concerning which it is false that *esse* is *percipi*. Accordingly, even if my argument is successful, its effect will not be to open the way for idealism; but only, on the one hand, to rob of its basis the kind of realism Professor Moore's article has been used to support, and on the other and chiefly, to make clear that certain facts do belong to Mind, which that realism rejects from Mind.

1. *Professor Moore's argument.*—In what I shall say, familiarity on the reader's part with the text of Professor Moore's article will be assumed, but I may state here briefly what I understand to be the essence of its argument. Using the sensation of blue as example, Professor Moore points out that the sensation of blue admittedly differs from the sensation of green, but that both are nevertheless sensations. Therefore they have 1) something in common, which he proposes to call "consciousness," and 2) something else, in respect of which one differs from the other; and he proposes to call this the "object" of each sensation. We have then, he says, "in every sensation two distinct elements;" and therefore assertion that one of them exists, assertion that the other exists, and assertion that both exist, are three different assertions. From this it follows that "if any one tells us that to say 'Blue exists' is the *same* thing as to say that 'Both blue and consciousness exist', he makes a mistake and a self-contradictory mistake."[1] Just because the *esse* of blue is something distinct from the *esse* of the *percipi* of blue, there is no logical difficulty in supposing blue to exist without consciousness of blue.

The point on which turns the validity or invalidity of this argument is of course what sort of distinctness is to be granted between the sensation or consciousness and the blue; for existential independence is not a corollary of every sort of distinctness.

[1] *Philosophical Studies*, Harcourt Brace & Co. (1922), 17-18.

Existential independence is entailed by distinctness of the sort we admit when we say that for instance cat and dog or green and sweet are distinct; but not by the sort of distinctness we admit when we say that cat and spinal cord or blue and color are distinct.

Professor Moore believes that blue and the *percipi* of blue are "as distinct as 'green' and 'sweet';"[2] and if existential independence is to follow from this, "as distinct" must be taken to mean here that the distinctness is of the same logical sort as that of green from sweet. To show that it is of the same sort Professor Moore advances both destructive and constructive considerations. The destructive consist of his criticism (which I do not pause here to summarize) of the hypothesis that blue is "content" of the sensation of blue; the constructive, of the positive account he himself offers of the relation of sensation to blue or, more generally, of awareness or experience to its "objects." This account is substantially as follows. A sensation is a case of "knowing" or "experiencing" or "being aware of" something; and this awareness is not merely

something distinct and unique, utterly different from blue: it also has a perfectly distinct and unique relation to blue. . . . This relation is just that which we mean in every case by 'knowing'[3] . . . the relation of a sensation to its object is certainly the same as that of any other instance of experience to its object[4] . . . the awareness is and must be in all cases of such a nature that its object, when we are aware of it, is precisely what it would be, if we were not aware.[5]

As against these contentions, I shall argue that if "knowing" is taken as the name of a unique relation, then this relation is a generic one and two species of it have to be distinguished; that one of these allows the object known to exist independently of the knowing of it, but the other forbids it; that in the case of the latter relation the known is "content" of the knowing in a sense not disposed of by Professor Moore's criticism of that

[2] *Ibid.*, 16.
[3] *Ibid.*, 26-27.
[4] *Ibid.*, 28.
[5] *Ibid.*, 29.

term; and that in this very sense blue is "content" of the sensation of blue and therefore cannot exist independently of it.

2. *Cognate vs. objective accusative.*—I shall lay the basis for my argument by calling attention to a certain distinction mentioned and used by S. Alexander. It is the distinction between what is expressed in language by, respectively, the cognate accusative and the objective accusative—between, for instance, striking a stroke and striking a man, or waving a farewell and waving a flag.[6]

There is not, I believe, any word in the language to denote *that in general* (or perhaps *that ambiguously*) which has, to the activity a verb names, the same relation that *a noun in the accusative in general*—i.e., in the accusative no matter whether cognate or objective—has to the verb. I shall, however, need a word for this and will therefore borrow for the purpose from grammar the word "accusative" itself—as W. E. Johnson, similarly, borrows from grammar the word "adjective" to refer to the sort of entity which any word grammar calls an adjective stands for.[7] Thus, for example, I would speak of a stroke struck as cognate accusative, but of a man struck as objective accusative, of the sort of activity called "striking." But, for reasons of euphony which will appear later, I shall, instead of "cognate," use the synonymous form "connate." Also, since the relation of "objects" of awareness to the awareness thereof is what we shall ultimately be concerned with, and we must not allow our terminology to prejudge for us surreptitiously the nature of that relation, I shall use the term "alien accusative" for what would otherwise be called "objective accusative." That is, I shall say that an accusative of an activity may be connate with or alien to—homogeneous with or heterogeneous to—the activity. For example, in what is expressed by the phrase "jumping a jump," the jump is *connate accusative* of the activity called "jumping;" whereas in what is expressed by "jumping a ditch," the ditch is *alien accusative* of the jumping.

3. *Accusatives coördinate or subordinate in generality to a*

[6] *Space, Time, and Deity*, Vol. I, 12.
[7] *Logic*, Vol. I, 9.

given activity.—Let us next notice that the relations "connate with" and "alien to" (as they concern an activity and an accusative of it) may each be either symmetrical or unsymmetrical. Each is symmetrical when its terms are of strictly *coördinate* generality as for instance "jumping" and "jump" (connate accusative), or "jumping" and "obstacle" (alien accusative). An activity and an accusative of it, which, like these, are coördinate in generality I shall call respectively *connately coördinate* (or coördinately connate), and *alienly coördinate* (or coördinately alien).

On the other hand, the relations "connate with" and "alien to" are unsymmetrical when the accusative of the activity concerned is *subordinate* in generality to the activity. Accordingly I shall say that an accusative—for instance a leap—which is subordinate in generality to an activity which—like jumping— is connate with it, is *connately subordinate to* (or subordinately connate with) that activity. And similarly I shall say that an accusative—for instance a fence—which is subordinate in generality to an activity which—like jumping—is alien to it, is *alienly subordinate* (or subordinately alien) to that activity.

4. *An accusative connate with a given activity exists only in occurrence of that activity.*—Close attention must now be given to the implications as to existence which go, or do not go, with connate and alien coördinateness and subordinateness. There will be four cases. I list and illustrate all four but the last two will be the ones of special interest for the purposes of my argument.

(1) When an accusative, e.g., an obstacle, is *alienly coördinate* with an activity, e.g., jumping, then obviously this accusative may exist independently of existence, i.e., of occurrence, of the activity: obstacles exist which are not being jumped, have not been jumped, and will not be jumped. On the other hand, in so far as the activity is of the kind represented by a transitive verb, it cannot occur independently of existence of an accusative alienly coördinate with it: jumping, in so far as transitive, obviously cannot occur without existence of some obstacle—some distance or thing—being jumped. Similarly striking, in so far as transitive, cannot occur without existence of some object—be it only empty air—being struck.

(2) When an accusative, e.g., a fence, is *alienly subordinate* to an activity, e.g., jumping, then again this accusative may exist independently of occurrence of the activity: a fence, for instance, which is a species of obstacle, may exist which is not jumped at any time. But here the activity, even when it is of a transitive kind, can occur independently of existence of a *given* accusative alienly subordinate to it: transitive jumping could occur even if for instance no fences existed but ditches did.

We now come to the two cases of special interest for the purposes of this paper—the two where the accusative is connate with the activity.

(3) When an accusative, e.g., a jump, is *connately coördinate* with an activity, viz., jumping, then this accusative cannot exist independently of existence, i.e., of occurrence, of the activity: a jump exists only in the jumping, a stroke in the striking, a dance in the dancing, etc.—the *esse* of a *saltus* is its *saltari*. But, although this obviously is true, it may be well nevertheless to pause here a moment to point out why it is true.

To do so, we must ask what exactly is the logical relation between jump and jumping, between the dance and dancing, etc., i.e., between the connately coördinate accusative of an activity and the occurrences of that activity. The answer is that the *nouns* "jump," "dance," "stroke," name each a *kind,* viz., a kind of activity, considered independently of occurrence of cases of it; whereas the *verbs* "jumping," "dancing," "striking," are the linguistic entities which not only likewise name the kind but in addition allude to *existence, i.e., occurrence, of a case* of the kind of activity they name. The various tenses of which the verb admits express the various possible time-relations between the time *of discourse about* a particular occurrence of an event of the given kind, and the time ascribed *by discourse* to that particular occurrence: the time of that occurrence may be earlier or later than, or the same as, the time of our discourse about it. The noun-form, on the other hand, wholly ignores these temporal relations because it denotes a *kind* of event—not a *case,* i.e., not an occurrence, of that kind—and kinds as such have no dates. Yet the kinds we are here considering are kinds *of events,* i.e., they are kinds the existence of a case of which consists in an

occurrence—a particular event—at a particular time. Attention to these considerations enables us to answer our question: The reason why no jump, for instance, can exist except in the jumping, and why jumping, at whatever time, is always and necessarily the jumping of a jump, is that *jump stands to jumping as kind stands to existence of a case thereof.*

(4) Let us now finally consider an accusative, e.g., a leap, *connately subordinate* to an activity, e.g., jumping. It is obvious that the activity can exist, i.e., can occur, at dates when *the given* accusative does not: jumping may be of a jump of some species other than a leap; dancing may be of a dance of some species other than the waltz; striking, of a sort of stroke other than a jab; etc.

On the other hand, *an accusative connately subordinate to a given activity cannot exist independently of that activity:* a leap exists only in the jumping thereof, a waltz only in the dancing, a jab only in the striking. That this is true is again evident even without explicit mention of the reason why it is true; but in any event the reason is that leap, waltz, jab, etc., respectively, stand to jump, dance, stroke, etc., each as species to genus; that a case of the species cannot exist unless a case of the genus exists; and that, as pointed out above, existence of a case of the genera, jump, dance, stroke, etc., consists in, respectively, jumping, dancing, striking, etc., at some time.

5. *A cognitum connate with the cognizing thereof exists only in the cognizing.*—So much being now clear, it may next be emphasized that although the activities so far used as examples were activities both motor and voluntary, the distinctions pointed out—between connate and alien accusatives and between accusatives coördinate and subordinate in generality to a given activity—in no way depend on the activities' being motor and voluntary ones; and therefore that the implications as to existence which we found rooted in these distinctions do not depend upon these characters either. Rather, the distinctions and their existential implications are perfectly general: any sort of activity whatever has a connate accusative, and any sort of activity which is transitive has in addition an alien accusative; and further, *whatever the nature of the activity, an accusative connate with*

it (*whether coördinately or subordinately*) *exists only in the occurrences of the activity.* Because this is true universally, it is true, in particular, of the sort of activity which is of special interest to us in these pages—viz., the one called "cognizing" or "experiencing"—notwithstanding that it is not like jumping a motor activity and notwithstanding that some species of it, e.g., sensing, are involuntary instead of, like jumping, voluntary. If we now agree to call any accusative of the cognitive activity a *cognitum,* then, in the light of the considerations that precede, it will, I believe, be admitted as evident that *any cognitum connate with a cognitive activity exists only in the occurrences of that activity.*

6. *Nature of the hypothesis I shall oppose to Professor Moore's.*—The question we now face, however, is whether such cognita as blue or bitter or sweet are connate with the species of experiencing called "sensing," or on the contrary are alien to it; for on the answer to this depends, as we have now seen, the answer to the question whether the *esse* of blue or bitter or sweet is their *percipi.* Professor Moore believes they are what I have called alien cognita of the experiencing. My contention will be on the contrary that they are cognita connate with the experiencing. At this point, however, I shall not attempt to prove this contention but only, first, to explain more fully what it means, and second, to dispose of two *prima facie* plausible objections to it. This will make evident that there does exist a genuine alternative to Professor Moore's contention regarding the relation of blue to the sensing of blue; and will enable me to show that it is an alternative he neither disposes of nor considers. To show this, however, will only be to show that his argument does not prove what it claims to prove, i.e., does not prove that the blue can exist independently of the sensing of blue. Only after this has been done shall I give the positive evidence I have to offer in support of my own contention that the blue cannot exist independently of the sensing of blue.

The hypothesis, then, which I present as alternative to Professor Moore's is that "blue," "bitter," "sweet," etc., are names not of objects of experience nor of species of objects of experience but of *species of experience itself.* What this means is perhaps made clearest by saying that to sense blue is then to sense *bluely,*

just as to dance the waltz is to dance "waltzily" (i.e., in the manner called "to waltz") to jump a leap is to jump "leapily" (i.e., in the manner called "to leap") etc. Sensing blue, that is to say, is I hold a species of sensing—a specific variety of the sort of activity generically called "sensing" which, however, (unlike dancing or jumping) is an involuntary and non-motor kind of activity. In this as in all cases where the known is connate with the knowing, what is known by the knowing activity is then *its own determinate nature on the given occasion.*

With regard to the relation between blue and sensing blue, I further contend that the same remarks apply that were made above concerning the relation of jump and leap to jumping: the noun "blue" is the word we use to mention merely a certain *kind* of activity (just as are the nouns "waltz," "leap," etc.); whereas the verb "to sense blue" is the linguistic form we use when we wish not only to mention that same kind of activity but also at the same time to mention some *case,* i.e., some *occurrence,* of that kind of activity—the various tenses of the verb expressing the various possible temporal relations between the *time at which we mention* some case of that kind of activity and the time we mention as *time of that case itself.*

7. *The objection that what is sensed is not "blue" but a case of "blue."*—It might be urged, however—perhaps under the belief that it constitutes a difficulty precluding acceptance of my hypothesis—that what we sense is never blue or bitter in general, i.e., a *kind,* but always *a* blue or *a* bitter, i.e., (it would then be alleged) some *case* of blue or bitter.

To this I reply that "blue" and "bitter" are the names of certain *determinable* kinds, and that *"a* blue" or *"a* bitter" are expressions by which we refer *not to cases but to determinates,* i.e., to *infimae species,* of that determinable kind.[8] That a de-

[8] W. E. Johnson, in his chapter on "The Determinable" (*Logic,* Vol. I, Ch. XI) misleadingly uses the names of the various colors as illustrations of names of determinates; whereas the fact obviously is that blue, for instance, is a determinable having as sub-determinables cerulaean blue, prussian blue, etc.; and that no names exist in the language for the truly determinate colors—for instance for cerulaean blue completely determinate as to hue and as to degree of brightness and of saturation. But we could, if we wished, assign names to the various infimae species of cerulaean blue—calling a certain one, perhaps, Anna cerulaean, another, Bertha cerulaean, etc.

terminate shade of blue is logically not a case but a species, viz., an infima species, of blue is shown by the fact that even a perfectly determinate shade of blue is susceptible of existing many times, or no times, or only once, etc. That is, *qualitative determinateness neither constitutes existence nor entails existence.* Existence of qualitatively determinate blue, bitter, etc., is a matter of presence of them *at some determinate place in time.*

On the basis of these considerations, my reply to the objection mentioned above is then that we do not *sense a case* of blue, but that our sensing blue of a determinate species, i.e., our sensing bluely-in-some-completely-specific-manner, *constitutes occurrence of a case* of blue. That is, it constitutes *presence at a determinate time* of blue of that determinate shade, and therefore of course, of blue; just as our waltzing—which if we do it at all we do in some completely determinate manner—constitutes presence at a determinate time (and place) of that determinate species of waltz, and therefore automatically also of its genus, the waltz.

8. *The objection that one may be aware without being aware that one is aware.*—If in any case of awareness of blue what one is aware of is, as I contend, the determinate nature of one's awareness on that occasion, then, it may be objected, it would follow that being aware of blue would be one and the same thing with being aware that one is aware of blue; whereas obviously they are not the same thing. To meet this objection, I shall first analyze the nature of the difference which is felt and which I acknowledge exists; and then I shall point out why this difference leaves untouched the essence of my contention.

If on an occasion when one has asserted "I am aware of blue" one is asked or asks oneself whether this is really so, one then makes an additional judgment which (if affirmative) one formulates by saying "I am aware that I am aware of blue." I submit, however, that *this* judgment concerns the *appropriateness* of the concept, "being aware" to the fact one is attempting to describe by saying "I am aware of blue." Or similarly, if I have asserted "I know that Mary is eight years old" and I am asked or ask myself whether I "really know" it and conclude "I know that I know that Mary is eight years old," the question this answers is

whether the concept labelled "knowing" fits the status conferred upon my belief that Mary is eight years old by the grounds I have for the belief. I compare the particular sort of relation between grounds and belief, called "knowing," with the actually existing relation between my grounds and my belief in the case of Mary's age, and ask myself whether this actually existing relation is a case of that sort of relation. This comparison—and not the examining of additional evidence as to Mary's age—is the ground of my assertion that I know that I know that Mary is eight years old. Just this sort of difference, I submit, is the difference between knowing and knowing that one knows, or being aware and being aware that one is aware.

But the statement "I am aware that I am aware," which is a correct formulation of the sort of fact just illustrated, would not be a correct formulation of the fact—of a quite different nature—that whenever I am aware at all I am "aware of an awareness" *in the same sense of the accusative* in which it is true that whenever I strike at all I strike a stroke, or that whenever I know at all I know a knowledge, or that whenever I dance at all I dance a dance. To express this sort of accusative of a given verb no *verb form* can correctly be used but only a *noun;* that is, for this sort of accusative of "being aware" we cannot, except misleadingly, use the verb forms "that I am aware" or "of being aware," but must use "of an awareness." In this sense of the accusative, moreover, it is true not only that whenever I dance at all I dance a dance, but also that I dance in some specific manner, e.g., "waltzily." Similarly in this sense of the accusative, it is true not only that whenever I am aware at all I am aware (intuitively, not discursively) of an awareness, but also that I am aware in some specific manner, e.g., bluely.

Having now made clear the nature of my hypothesis as to the relation of blue to sensing blue, and defended that hypothesis from two *prima facie* plausible objections to it, I may add that the relation the hypothesis describes is the one I shall mean whenever I say that blue is *content* of sensing blue. That is, when I so use this term I shall mean that blue stands to sensing blue (or more generally, that any given species of experience or awareness stands to experiencing or being aware) as kind stands

to occurrence of a case thereof. With this understood, let us now turn to Professor Moore's criticism of what he calls the "content" hypothesis.

9. *Professor Moore's criticism of the hypothesis that blue is "content" of the sensing of blue.*—The only place at which Professor Moore's criticism of the contention that blue is content of the sensing or awareness of blue could be considered relevant to the meaning of "content" I have stated to be mine is the place where he raises the question "whether or not, when I have the sensation of blue, my consciousness or awareness is . . . blue."[9] He acknowledges that offence may be taken at the expression "a blue awareness," but asserts that it nevertheless "expresses just what should be and is meant by saying that blue is, in this case, a *content* of consciousness or experience."

As to this, I can only reply that what I mean (as defined above) when I say that blue is the content of my awareness of blue is not properly expressible by saying that my awareness is then blue *unless blue be taken as the name, instead of as an adjective,* of my awareness at the moment. That is, what I mean when I refer to blue as content of my awareness of blue is that my awareness is at the moment of the determinate sort *called "blue,"* and not that it has, like *lapis lazuli,* the property of being blue; for when I assert, *of lapis lazuli,* that it is blue, what I mean is that it is such that, whenever I turn my eyes upon it in daylight, it causes me to experience something called "blue;" whereas I mean nothing like this when I say, *of my awareness,* that at a given moment it is of the particular sort called "blue."

To speak of a blue awareness, I would insist, is improper in the same way it would be improper to speak of an iron metal. We can properly speak of a species of metal called "iron," but if we wish to use "iron" as an *adjective,* we have to apply it to something—for instance a kettle or a door—which stands to iron *not,* like "metal," *as genus to species,* but *as substance to property.*

I conclude here, then, that Professor Moore's criticism of the contention that blue is content of the awareness of blue is not a

[9] Moore, *op. cit.,* 26.

criticism of the contention that blue is a species of awareness—
which is what I mean when I assert that blue is content of the
awareness of blue. His criticism does not consider *this* contention
at all and therefore does not refute it.

10. *Does existential independence follow from the fact that
the awarness is* OF *blue?*—It is only because Professor Moore
does not in his paper consider as a possible meaning of "blue
awareness" the hypothesis that blue is a species of awareness
rather than a property of it, that he is able to dismiss the possi-
bility that "awareness is blue" as unimportant even if true—
saying that, in any case, the awareness is *of* blue, and "has to
blue the simple and unique relation the existence of which alone
justifies us in distinguishing knowledge of a thing from the thing
known."[10] For he believes this relation entails in all cases that
the known may exist independently of the knowing of it. But we
have seen that this is so only in some cases. We do indeed speak
of the tasting *of* a taste—e.g., of the taste called "bitter"—and
also of the tasting *of* quinine; but although "tasting" in each case
denotes a species of knowing, it obviously does not denote the
same species in both cases: the relation of tasting to taste (or to
bitter) is not the same as the relation of tasting to quinine or to
cheese, etc. Similarly, when we speak of the smelling *of* a smell
and of the smelling *of* a rose, of the hearing *of* a tone and of the
hearing *of* a bell, or—as Professor Moore himself points out
elsewhere[11]—of the seeing *of* a color, e.g., brown, and of the
seeing *of* a coin, we are obviously using "smelling," "hearing,"
"seeing," each in *two* senses notwithstanding that in each sense
it is a species of knowing, and notwithstanding that in each
sense the knowing is *of* something. Were any proof needed that
the senses are two, it would be provided by the following con-
sideration.

The two sentences "I see red" and "I see a rose" each repre-
sent an attempt to describe in English a judgment made by the
utterer—something he believes. Now it is possible that "red"
or "a rose" are not the right words to describe in English what

[10] *Ibid.*, 26.
[11] *Philosophical Studies*, 187.

he believes he sees; that is, either sentence may be an *incorrect wording* of his belief. But in the case of the sentence "I see red" the belief itself, which he uses that sentence to describe, cannot possibly be a mistaken belief. It cannot be erroneous because that which he believes is not anything more at all than is actually and literally seen by him at the moment. In the case of the sentence "I see a rose," on the other hand, not only as before may the sentence be an incorrect wording of his belief, but now in addition *his belief itself may be mistaken:* that, which he believes he sees, may not be what he believes it to be. It may be something else which *looks* the same as what he believes to be there, but the other characters of which are very different; for these other characters, e.g., tactual, olfactory, gustatory ones, etc., of course cannot literally be *seen.* Odor, taste, hardness, can be "seen" only in the elliptical sense that the colors literally seen *predict* to us a certain odor, taste, etc. But whenever what we believe is something the nature of which is predicted or signified even in part instead of literally and totally observed at the moment, error is possible.

The relation between seeing and seen or more generally between knowing and known is thus not as Professor Moore's paper asserts "a simple and unique relation" (unless considered generically only) but is of at least the two kinds just illustrated. Moreover if, as I contend, the first of these two relations between knowing and known is the very relation between cognizing and a cognitum *connate* therewith, then in *no* case of that first relation is the known existentially independent of the knowing thereof. Therefore, from the fact that in *all* cases of knowing the knowing is *of* something, *nothing general* follows as to the existential independence or dependence of the known upon the knowing.

To prove such independence in a given case it would be necessary to show that when we speak of, e.g., the tasting of bitter or the seeing of blue, the tasting is existentially related to the bitter or the seeing to the blue not (as I contend) as cognizing is to cognitum (subordinately) connate therewith, but on the contrary, as, for instance, green is existentially related to sweet. But this is not shown by anything in Professor Moore's paper. As

just pointed out, the fact that the sensing or seeing is *of* blue does nothing to show it and, as I shall now make clear, neither does a certain additional fact to which Professor Moore appeals.

11. *Does existential independence follow from the introspective distinguishability of the awareness from the blue?*—Professor Moore asserts that in any case of awareness of blue it is possible (even if not easy) to distinguish by careful introspective observation the awareness from the blue. This I readily grant, but I deny that it constitutes any evidence at all of the existential independence it is adduced to prove, for the fact that the awareness is observationally distinguishable from the blue leaves wholly open the question which is crucial here. This question is whether the awareness is distinguishable from the blue as for instance green is from sweet—i.e., as a case of one species from a case of a logically independent species—or on the contrary (as I contend) as a case of a genus is distinguishable (by abstractive observation) within a case of any one of its species—for instance, as a case of the generic activity, "to dance," is by abstractive observation distinguishable within any case of the species of that genus called "to waltz." That is, we can observe that a person is moving with the specific rhythm and steps called "waltzing;" and then we can abstract our attention from the specific nature of the rhythm and steps and notice only the fact (common to the waltz, polka, one-step, fox trot, etc.) that he takes steps in a rhythmical manner, i.e., that he is "dancing." Indeed, observation *merely* that the genus "dance" is the one to which belongs a case of activity concretely before us is what would normally occur if—perhaps through the rapid opening and shutting of a door—we had only a brief glimpse of the dancing going on in a room.

To prove that blue and awareness are distinct in the manner which entails existential independence, we should have to have the same sort of evidence on which is based our knowledge that green and sweet are existentially independent: we have observed, for instance, that some apples are green and not sweet, and that some are sweet and not green. That is, we should have to observe—i.e., to be aware—that at a certain time blue exists but awareness does not, and that at a certain other time awareness

exists but blue does not. Of the latter we have a case whenever what we are aware of is something other than blue, for instance, sweet or green, etc.; but of the *former* it is impossible that we should ever have a case, for to be aware that one is not at the time aware is a contradiction.

This situation, it is true, does not prove that blue is existentially *dependent* on awareness of blue; yet just that sort of situation is what would confront us if blue *were* existentially dependent on awareness of blue; therefore that the situation we do confront *is* of that sort is circumstantial evidence, so far as it goes, of such dependence.

12. *Comment on some relevant remarks of Dr. Broad's.*—It might be claimed, however, that the introspective observation by which, in awareness of blue, we distinguish the awareness from the blue is not of the abstractive kind I have described, but on the contrary of the same "total" kind for the awareness as for the blue. This is perhaps what Professor Moore means to assert when he says that "to be aware of the sensation of blue is . . . to be aware of an awareness of blue; awareness being used, in both cases, in exactly the same sense."[12]

Some light will perhaps be thrown on the issue by examination of certain remarks made by Dr. C. D. Broad. He observes that a sensation of red (the case would of course be the same with blue) seems obviously to involve an act of sensing and a red "object." But it is of particular interest to note his further remark that it does not seem similarly obvious "that a sensation of headache involves an act of sensing and a 'headachy' object."[13]

To me also it is evident that there is a difference between the two cases; and the important point is that, on Professor Moore's view, there ought not to be any. *Both* cases ought to be introspectively analyzable alike into an awareness—a sensing—and an "object," viz., respectively, red and headache. The explanation of the difference is, I submit, as follows.

The eye, which is the sense organ with which the sensation of red is connected, is an organ susceptible of being oriented and focussed. That is, the eye is capable of *looking*; and it does look

[12] *Ibid.*, 25.
[13] *Scientific Thought*, 254.

in this sense whenever any color is seen or even imaged, for the eye always has *some* orientation and *some* accommodation. But with any orientation and accommodation of the eye there goes a certain sort of kinaesthetic sensa (the sort connected with the muscles of the eyeball and of the lens). And these *kinaesthetic sensa*, I submit, are what Dr. Broad finds present in the sensation of red but absent in that of headache; for the latter is not, like the former, connected with an organ susceptible of orientation and accommodation and is therefore not, like the former, accompanied by characteristic kinaesthetic sensa. The difference Dr. Broad notices is really present, but it is not rightly described as presence in the one case of an "act of sensing" absent in the other. What he calls an "act of sensing" (or we can say more specifically, of "seeing") is in fact only the kinaesthetic sensa which accompany the physical act of *looking*. Similarly one must distinguish between acts of *hearing, smelling,* etc., and the kinaesthetic sensa which always accompany the physical acts of *listening, sniffing,* etc.

The red, indeed, is existentially independent of the accompanying ocular kinaesthetic sensa for, on the one hand, a completely blind person (who of course does not see even black) has them and, on the other hand, if the eye muscles of a normal person were anaesthetized he could undoubtedly nevertheless sense red. But kinaesthetic sensa are not an "act of sensing" the red. The genuine act of sensing, on the contrary, is distinguishable in the sensation of headache as well as in that of red; but it is not distinguishable from the red and the headache *as* red is from kinaesthetic sensa or from sweet, but, I now urge again in the light provided by removal of the confusion just discussed, *as* a case of the dance is distinguishable within any case of the waltz.

The point is now reached where I believe that the first part of the task I undertook has been accomplished. I submit, namely, that the preceding pages have shown that Professor Moore's argument to prove that blue can exist independently of the sensing or the being aware of blue neither proves this nor proves it to be more probable than not. I now therefore turn to the second part of my task, which is to show that blue, bitter, or any

other "sensa" cannot exist independently of the experiencing thereof. This will be proved if I prove that blue, bitter, etc., are, as I have claimed, species, not objects, of experiencing.

13. *The hypothesis that bitter, blue, etc. are "directly present" to the mind.*—For this positive attempt I shall take as starting point a fact already mentioned. It is that if, in answer to the question "What do you taste?" we answer at one time "I taste bitter" and at another time "I taste quinine," the relation of the tasting to bitter is *different* from that of the tasting to quinine. Or, to take another example, if, having been asked "What do you see?" we answer at one time "I see blue" and at another "I see some *lapis lazuli,*" it is obvious that the relation of the blue to the seeing of it is not the same as that of the *lapis lazuli* to the seeing of it. Or again, if to the question "What do you hear?" we answer "I hear middle C," and at another time "I hear a bell," it is evident that the relation of middle C to the hearing of it is different from that of a bell to the hearing of it.

That it is different is obvious, but if it needed any proof it would be found in the fact that the judgment expressed by "I hear a bell" is the judgment that the cause of my hearing the tone I hear at the moment is a thing of the kind called a bell; or that the judgment "I see *lapis lazuli*" is the judgment that the cause of my seeing the blue I see is a substance of the kind called *lapis lazuli;* or that the judgment "I taste quinine" is the judgment that the substance, presence of which on my tongue is causing me to taste the bitter taste I am tasting, is a substance of the kind called quinine. That is, in these examples, to taste or see or hear an "object" is to take a taste or color or tone one is experiencing as *sign* that the cause of the experiencing of it is, respectively, something of the kind called quinine, *lapis lazuli,* a bell. To have *this* relation to one's experiencing of a taste, color, or tone is, in these examples, what being "object" tasted, seen, or heard consists of.

Therefore if bitter, blue, and middle C are also to be spoken of as "objects" respectively tasted, seen, and heard, it can be only in some *other* sense, not yet considered, of the word "object;" for obviously it could not be maintained that "I taste bitter" means (as in the case of quinine) that the cause of my

tasting the bitter I taste is presence on my tongue of a substance called bitter taste, for "bitter" is not the name of any kind of substance but of a kind of taste.

Our situation is then this. We have considered so far two sorts of relation a cognitum may have to the cognizing of it: one, the relation I have called "content of," and the other, the relation ordinarily called "object of," illustrated by the example of quinine as cognitum of tasting. *This* sense of "object of" I shall label *sense A*, for convenience of reference. Now our problem was: is bitter (or blue, etc.) *content of*, or *object of*, the tasting (or the seeing, etc.) thereof? Admittedly, it is not "object of" the tasting *in sense A*. But this does not force us to conclude that bitter is (as I maintain) content of the tasting if there happens to be some *third* sort of relation, which a cognitum could have to the cognizing of it, and which is also called "object of" but constitutes what we shall now label *sense B* of "object of." The question therefore now is whether there is such a third sort of possible relation, and if so what exactly it is. The epistemologists who believe there is, usually describe it as "direct presence" of the blue or bitter to, or "immediate apprehension" of these by, the mind or consciousness. As against them I maintain that either these phrases are only other names for what I have called "content of," or else they are figures of speech for which no literal meaning that is not absurd is available. I shall now attempt to make the latter evident.

The facts which, without our noticing it, suggest to us the employment of the words "direct" or "immediate" in the phrases mentioned consist of examples of directness or immediacy such as the direct contact of quinine with the tongue, or the immediate presence of a piece of *lapis lazuli* before the eyes. The presence is in these cases "direct" or "immediate" in the sense that *there is nothing discernible between* the object and the sense organ—no medium or instrument discernible at the time between them. And when these same words—"direct" or "immediate" presence—are used to describe also the relation between bitter or blue and the mind, the only *literal* meaning they can have there is that the latter relation *resembles* that of the *lapis* to the eye or the quinine to the tongue in the respect

that, in both relations, *there is nothing discernible between* the terms they relate.

But if (as of course we must where blue or bitter and the mind are the terms) we divest the word "between" of the only sense, viz., the *spatial,* which it had when quinine and the tongue or *lapis* and the eye were the terms, then, I submit, the words "nothing between" describe *no hypothesis at all* as to the nature of the relation of the blue or bitter to the mind. This means that when one of the terms of a certain relation is the mind, then—since the mind is not, like the head or sense organs, an entity having a place in space—nothing whatever is being said as to the nature of that relation by employing the words "direct presence" to describe it unless some definite meaning *other than the spatial one* is explicitly provided for those words. But everybody seems either to have assumed their meaning to be obvious and not incongruous to the cases concerned, or else to have defined the words ostensively only, as meaning the sort of relation there is between blue or bitter, etc. and consciousness of these. But of course to define "direct presence" thus only ostensively is not in the least to *analyze* the sort of relation the words apply to. In particular, it is not to offer the least evidence that analysis would not reveal it to be the very relation I have called "content of."

Aside from this, however, even if one supposes that bitter tastes are entities which would exist even if no minds existed, and one should be willing to accept the absurdity that not only minds but also bitter tastes (and likewise, of course, nauseas, dizzinesses, fears, etc.) have like tongues and quinine places in space and can move about or be moved about independently of each other so that a bitter taste or a nausea could become "present" to a mind in the sense of travelling to its spatial neighborhood until nothing remained spatially between them—even then, I submit, one would have to accept the further absurdity that this mere spatial juxtaposition *without that mind's being in any way affected by it,* i.e., *without any change being caused in that mind by it,* would constitute cognition of bitter by that mind. For if one were to say that the juxtaposition does cause in the mind a specific change, viz., one to be called not

"smelling" or "hearing" etc., but "tasting," this would amount to erecting bitter taste into as strictly a physical substance as quinine, and therefore to saying that tasting bitter taste and tasting quinine are both "tasting" in essentially the same (causal) sense. Yet it was obvious and admitted from the start that "tasting" does not have the same sense in both cases.

But further still, even if "presence of bitter taste in the spatial neighborhood of a mind" were not an absurdity, and even if such "presence" did cause in that mind a change called "tasting," even then there would still remain to give an account of that mind's *intuitive cognition of its own tasting at the time it occurs,* i.e., of the event *in that mind itself* caused to occur by the advent of the bitter taste in the spatial neighborhood of that mind. And this would face us then anyway with the need for my hypothesis that "tasting bitter taste" is the name of a specific variety of the activity called "tasting," viz., the variety called "tasting *bitterly*" (in the literal not the figurative sense of this adverb), and that what the activity cognizes on every such occasion is its own specific nature on the occasion.

But everything for the doing of which we need a relation of a kind other than that of quinine to tasting is, I submit, adequately done for us by the relation just described, which I maintain is the one of bitter to tasting; and this relation does not entail the absurdities required to give a literal sense B (distinct from both "content of" and sense A of "object of") to the "direct presence" hypothesis. Moreover, because the two relations "content of" and "object of" in sense A adequately account for every case, Occam's razor enables us to dismiss the still other nominal supposition—which might be resorted to *in extremis,* that bitter is "object of" tasting in some unique and indefinable other sense C of the words.

14. *Taste is a species, not an object, of experience.*—If the discussion in the preceding section has succeeded in what it attempted, it has shown that the phrase "direct presence to a mind" either is but another name for the relation between cognitive activity and the cognita connate therewith, or else is only a figure of speech for which no literal meaning not ultimately involving absurdities is forthcoming. If this has been

shown, then the allegedly third hypothesis, which *prima facie* seemed meaningful and was the only one seeming to offer an acceptable alternative to mine, has been disposed of. I shall not rest my case here, however, but will now attempt to show that when the issues are sharply presented my assertion that blue, bitter, etc., are not objects of experience, nor species of objects of experience, but species *of experience itself*, is the very assertion common sense then finds itself ready to make. What is needed for this is only to put the question in a manner making it impossible for our judgment to be confused by the ambiguity which may still cling to the phrase "object of" in spite of what was said in the preceding section. To make the meaning of the question unmistakably clear, I then ask first what would be indubitable examples of the four possible kinds of accusatives (viz., of cognita), of "experiencing." I submit the following:

The *alienly coördinate* cognitum of "experiencing" is "object" or "objective event."

The *connately coördinate* cognitum of "experiencing" is "experience."

An *alienly subordinate* cognitum of "experiencing" is "quinine," or "a rose," etc.

A *connately subordinate* cognitum of "experiencing" is "taste," or "smell," etc.

I believe the first three examples will be readily accepted as correct; but the fourth might be disputed, for if it is accepted my case is won.

"Taste," "smell," etc., I may be told, are not, as the above would imply, *species* of experience but *"objects"* of experience. If this is said, however, I ask what then would be right examples of *connately* subordinate cognita of experiencing; or—which is equivalent since experience is the connately coördinate cognitum of experiencing—what then would be right examples of *species* of experience? I believe it would not be disputed that tasting, smelling, etc., are species of experiencing; and I submit it is equally natural and proper and indeed unavoidable to say that taste and smell are species of experience, or that there is a species of experience called "taste." For the only alternative to this is to say that taste is an "object" of experience in the same

sense that quinine is an object of experience; and this is plainly false.

Moreover, one who would deny that taste is a species of experience is called upon to say what then would be the cognitum coördinately connate with the species of experien*cing* called "tasting." If it is not taste, what then might it be? I for one can no more think of an answer than if I were asked what would be the coördinately connate accusative of striking if it were not stroke.

15. *Bitter is a species, not an object, of taste.*—To emphasize the point of the considerations just advanced, they will now be reiterated, but at the more determinate level where the relation of bitter to tasting is in question instead of that of taste to experiencing. Again I ask, what would be indubitable examples of the four possible sorts of cognita of tasting, and I submit the following:

The *alienly coördinate* cognitum of "tasting" is "physical substance."

The *connately coördinate* cognitum of "tasting" is "taste."

An *alienly subordinate* cognitum of "tasting" is "quinine."

A *connately subordinate* cognitum of "tasting" is "bitter."

Here again, to say that bitter is not a species but an "object" of taste is to say that bitter is related to tasting in essentially the same manner as quinine is to tasting; and this is patently false. Moreover, one who would deny that when bitter is tasted what is tasted is a species of taste is called upon to say what then would be a cognitum *connately* subordinate to tasting. If bitter is not such a cognitum, what then might be one? Again here, I can no more think of an answer than I could to the question what might be a subordinately connate accusative of striking if jab were not one.

16. *Linguistic inertia is responsible for the error that taste is object of experience.*—It is easy to see how one is led into the error that taste is an object of experience or bitter an object of taste. What leads one into it is the tendency—which we may call linguistic inertia or linguistic optimism—to believe that when a word is the same it means the same, and that when it is not the same it does not mean the same. The sameness in this

case is that of the word "of," which occurs equally and in grammatically similar positions when we speak of the experiencing *of* taste and of the experiencing *of* quinine; or of the tasting *of* bitter and of the tasting *of* quinine. The temptation to believe that "of" means the same in both halves of each pair is likely to vanish only when we realize that we likewise speak of the striking *of* a jab and of the striking *of* a man—in which case it is quite obvious that the two "of's" do not mean the same relation.

On the other hand, because the two words "experiencing" and "taste," or "tasting" and "bitter," are not *linguistically* connate, linguistic inertia tempts us to believe that the cognitive activity and the cognitum in each case, for which those words stand, are not connate either. And this temptation again is likely to vanish only when we realize that "dancing" and "waltz," or "striking" and "jab," or "jumping" and "leap," etc., are not *linguistically* connate either, but that in each case the accusative nevertheless is obviously connate (subordinately) with the activity.

17. *"Bitter" as name of a species of taste vs. of a property of some substances.*—The adjective "bitter" can be applied both to tastes and to substances: we speak both of a bitter taste and of a bitter substance. Owing to linguistic inertia, this tempts us to believe that the relation between what the adjective and the noun stand for in the one and in the other case is the same relation. But that the relation is on the contrary very different in the two cases becomes obvious if we note that the expression "bitter taste" expands into "taste of the species called 'bitter'," whereas the expression "bitter substance" cannot similarly be expanded into "substance of the species called 'bitter'" (since "bitter" is not the name of any species of substance), but only into "substance having the *property* 'being bitter'." In the case of "bitter taste" the relation of bitter to taste is that of *species to genus;* whereas in the case of "bitter substance" the relation of bitter to substance is that of *property to substance.* The various properties of a substance are mutually conjunct; the various (coördinate) species of a genus on the contrary mutually disjunct. A property, moreover, is essentially of the nature of a law: to say that a substance has the property "being bitter" is

to say the substance is such that, if placed on the tongue, then the sort of taste called "bitter taste" occurs. But when one speaks of "bitter taste," the adjective "bitter" is not here similarly the name of a certain law but the name of a certain quality.

18. *Special sources of confusion when visual sensa are taken as examples.*—My argument has been formulated at most places in terms of gustatory sensa, but if it is valid for them it obviously is equally so for sensa of any other kinds. The reason for having presented the argument in terms of an example from the realm of taste rather than from the favorite one of sight was that the question at issue being a very difficult one, its exact nature could be exhibited more clearly by a simple example than by one where —as in the case of sight—special risks of confusion are present. The chief of these arises from the fact that the organ of sight, viz., the eye, yields to us not only color intuitions but also place and shape intuitions. This fact means that when our eye is focussed upon, for instance, an apple, we see not only a color (say, green) but also "see" a *place* at which the color is. But simultaneously (because our own nose as well as the apple is in front of our eye) we see, although inattentively, also another color (say, pink) and a place at which it is, different from the place of the green. And the fact that the place at which the green is seen and that at which the pink is seen are *literally*, i.e., spatially, *external* to each other seems to provide for some philosophers an irresistible temptation to believe that the green attended to (and the pink too if attention is called to it) are "external" also in the *metaphorical* sense the word has when we speak of externality *to the mind*, i.e., are existentially independent of their being experienced. Obviously, however, spatial externality to each other of the places at which two colors are seen, or of the places of two physical things such as our own eye and an apple, is something totally irrelevant to the question whether the colors, (or, for that matter, the physical things,) are "external to the mind" in the sense of existing independently of their being experienced.

19. *Summary and conclusion.*—The essential steps of the argument of this paper may now in conclusion briefly be reviewed. First, attention was called to the distinction between

accusatives connate with and alien to a given activity, and to the fact that an accusative of either sort may in point of generality, be either coördinate with or subordinate to the corresponding activity. It was then pointed out that any accusative connate with a given activity exists only in the performances of that activity and therefore in particular that any cognitum connate with a given cognitive activity exists only in the performances of it. That is, the *esse* of any cognitum connate with the cognizing is its *cognosci*. The question as to whether a sensum, e.g., blue or bitter, can or cannot exist independently of the *percipi* of it then reduces to the question whether the blue or bitter is a cognitum (subordinately) connate with or on the contrary alien to the cognizing thereof. My contention, I then stated, is that the sensum is a cognitum (subordinately) connate with the cognizing of it, i.e., that what is cognized (intuitively not discursively) in cognition of it is the specific nature the sensing activity has on the given occasion; and that, in just this sense, blue or bitter are "contents" of sensing and not "objects," i.e., not alien cognita, of sensing. It was next pointed out that Professor Moore's criticism of the "content" hypothesis concerns a hypothesis *other* than the one just described, which therefore remains a possible alternative to his own hypothesis that blue or bitter are "objects" of sensing. But since Professor Moore's paper does not disprove or even consider that alternative hypothesis, and that hypothesis entails that the blue or bitter would exist only in the sensing thereof, his paper does not prove what it seeks to prove, viz., that there is no cognitum of which it is true that its *esse* is its *percipi*. I then passed to the attempt to show that blue, bitter, etc., *are* cognita connate with the sensing thereof, and therefore that their *esse* is their *percipi*. To do so, I first pointed to the fact—stated by Professor Moore himself in another paper—that seeing brown and seeing a coin, hearing middle C and hearing a bell, tasting bitter and tasting quinine, are not "seeing," "hearing" and "tasting" in the same sense in both cases; and therefore that if the coin, the bell, and the quinine have to the seeing, hearing, and tasting the relation "object of," then brown, middle C and bitter either are not "objects of" these activities at all, or else are "objects of" them

in some *other* sense of the term. The allegation that "direct presence to the mind" describes such an other sense was then examined and shown to be false; and this left as the only answer in sight concerning the relation of sensa to the sensing of them, the one I had advanced. I then further attempted to show that it is the very answer common sense renders when the question is thoroughly freed of its ordinary ambiguity. Finally, some explanations were added to show how the error that sensa are "objects" of cognition arises. The upshot of the argument is that the distinction between sensing and sensum, to which appeal is commonly made nowadays and for which Professor Moore's paper is generally regarded as the warrant, is an *invalid* distinction, if it is taken as the one from which would follow the possibility of existential independence of the sensum from the sensing. On the other hand, there *is* a valid distinction between sensum and sensing, but it is the one I have described, and from it what follows is that the existence of the sensum consists in the sensing thereof.

Whether my argument, of which this is but a brief summary, succeeds in the two tasks it undertook to perform is something that must now be left to the decision of the reader.

C. J. Ducasse

Department of Philosophy
Brown University

9

Paul Marhenke

MOORE'S ANALYSIS OF SENSE-PERCEPTION

MOORE'S ANALYSIS OF SENSE-PERCEPTION

IF, in Moore's writings, we look for an analysis of sense-perception which he himself would regard as conclusive, final, and complete, we look in vain. It is Moore's considered opinion that no one knows the answer to all the questions that he asks about sense-perception. Unlike most philosophers who have undertaken the analysis of perception, Moore therefore does not advocate a theory of perception in the sense of a complete and definitive body of positive doctrines about the nature of sense-perception. When the many papers in which Moore has considered the analysis of sense-perception are arranged in chronological order, we can divide the answers to the questions he raises about sense-perception into three groups. The first group consists of definitive and final answers, i.e., answers which Moore has never repudiated in any of his writings. The second group consists of answers which, in some or all of the papers, he advances as tentative and provisional only. The third group consists of answers which are definitive in earlier papers, but are advanced as doubtful or tentative, or else are repudiated altogether, in later papers. As the answers that fall into the first group are in a distinct minority,—definitive answers being the exception rather than the rule,—we should be giving an incomplete account of Moore's reflections on the nature of sense-perception if we identified his analysis of sense-perception with the answers which have survived his own criticisms. In order to make this account complete it is necessary to consider also the views he has expressed with assurance on one occasion and retracted on another, as well as the views he has advanced as tentative and provisional only. By Moore's analysis of sense-perception we shall accordingly mean all the views, whether definitive

or tentative, which Moore has advanced regarding the nature of sense-perception. Needless to say, since Moore is himself quite dubious regarding the answers to most of the questions that arise in the analysis of sense-perception, we can in most cases safely ignore the chronological order of the papers on sense-perception without running the risk of charging Moore with now holding opinions which he held only on an earlier occasion.

This account of Moore's analysis of sense-perception will be limited in two important respects. In the first place, it will be concerned only with Moore's analysis of the *perception of physical objects*. There are of course several other problems with which the philosophical analysis of sense-perception is concerned, and many of these have engaged Moore's attention from time to time. My excuse for ignoring Moore's opinions regarding these problems is simply that Moore himself undoubtedly considers the analysis of the perception of physical objects as the most puzzling of these problems. At any rate, in his published writings he has turned to the solution of this problem far more frequently than he has turned to the solution of the others. In the second place, this account will be concerned mainly with Moore's analysis of the *visual perception* of physical objects; other modes of perceiving such objects will receive little if any attention. I can justify this second limitation only by pleading Moore's own example of limiting the questions he raises about the perception of physical objects in most of the papers to their visual perception.

Many philosophers who have investigated the nature of the perception of physical objects have all too often confined their investigation to the case of visual perception, tacitly assuming that their analysis of visual perception was also an analysis of the perception of physical objects in general. Although this preoccupation with visual perception has often led to serious error with regard to other modes of perception, Moore's own self-imposed limitation is quite harmless. For Moore is neither advocating a theory of perception that covers all the different modes of perception, nor even a theory of visual perception, if such a theory is understood as an answer to all the questions he

raises about visual perception. Hence, since even the analysis of visual perception proves recalcitrant, Moore is never in danger of falling into the error of overhastily extending his conclusions to other modes of perception. His failure to produce definitive answers about the analysis of visual perception guards him against the common error of assuming that there are no differences between visual and other modes of perception and that the theory of perception can therefore be based on the analysis of visual perception alone.

We shall now, first of all, consider Moore's analysis of visual perception in relation to a special class of cases in which the object perceived satisfies the following conditions. (1) The object is seen as single, i.e., we do not have double vision. (2) The object is opaque. (3) The object can be discriminated and distinguished from other objects so that we can make judgments about it. (4) We see the whole object, i.e., we are not prevented from seeing any part of its surface by other physical objects.[1] We have all frequently seen physical objects when all of these conditions are satisfied. We have also frequently asserted or entertained propositions about such objects on the occasion of seeing them, propositions such as "This is a tree," "That is a cigarette," "This is an automobile," etc., etc. These examples are typical of the facts and propositions, familiar to all of us, about which Moore now formulates his questions. In Moore's opinion a proposition such as "This is a cigarette" not only is very often true, but is very often *known* to be true. But, if this is the case, we all understand the meaning expressed by this proposition. However, to say that we understand the meaning of this proposition is not equivalent to saying that "we *know what it means*, in the sense that we are able to *give a correct analysis* of its meaning." Moore holds, on the contrary, that the question of the correct analysis of propositions of this sort is "a profoundly difficult" question to which "no one knows the answer."[2]

[1] Cf. Moore, G. E., "The Nature of Sensible Appearances," *Aristotelian Society Supplementary Volume* VI, 180.

[2] "A Defence of Common Sense," in *Contemporary British Philosophy*, Second Series, 198.

What are we to understand by "the correct analysis" of propositions such as "This is a cigarette"? Moore leaves this question, a rather crucial one, unanswered, or at least he never answers it explicitly. Now an analysis can obviously not get under way until we have specified the conditions to which the analysis must conform. And unless these conditions are specified it is impossible to determine whether the proposed analysis is correct or incorrect. When a chemist undertakes to analyze an unknown substance, he knows what these conditions are: he must break the substance down into known elements or into simpler known substances. Similarly, when Russell considers the question of the analysis of propositions about described individuals and the analysis of propositions about classes, the conditions he specifies are that the propositions shall be analyzed into propositions that employ only the primitive ideas of generalization, negation, disjunction, and propositional function. Without these conditions we would neither know how to proceed in analyzing propositions of this sort, nor would we be able to determine the correctness of the analysis.

Although Moore never specifies the conditions to which the analysis of perceptual propositions shall conform, he is of course not unaware of these conditions. A proposition which is alleged to be an analysis of a perceptual proposition must contain among its components a proposition about a sense-datum, and it must contain a proposition about a physical object. But Moore is not at all sure what proposition it is that we know about a sense-datum when we know, for example, that this is a cigarette. Further, he is not at all sure whether the proposition about the physical object is not itself further analyzable into propositions about sense-data. Moore's predicament might be compared to the predicament in which Russell would have found himself, had he proposed to himself the problem of analyzing propositions about described entities or propositions about classes in terms of the notions of generalization, negation, disjunction, and propositional function alone, and had then failed to produce a proposition containing only these notions. Moore's failure and Russell's success shows that the problem which Moore proposes to solve is an incomplete problem. It is not enough to

specify the conditions to which the analysis must conform; it is equally necessary to have a criterion by which the correctness or incorrectness of the proposed analysis can be tested. In the instance of the logical analysis of propositions about classes we have such a criterion: the proposed analysis enables us to derive the usual properties of classes. In the instance of the epistemo-logical analysis of perceptual propositions we have no such criterion. It is no wonder that an answer to the question as to the correct analysis of perceptual propositions is not forthcoming when it is not known what sort of an answer would be acceptable.

In order to show that perceptual propositions involve proposi-tions about sense-data in their analysis, Moore undertakes first of all to demonstrate the existence of sense-data. Let us suppose then that we see a physical object A, and that the four conditions that were specified above are all satisfied. Whenever it is true, then, that we see A "there will always be a part of A's surface which we are at the moment seeing." In other words, to see a physical object is to "see" (in another sense of "see," of course) a part of its surface. Now whenever it is true that we see a part of the surface of a physical object, it is also true that we "see" a sense-datum. When we see A

we are directly aware of, and can easily pick out or discriminate with no appreciable degree of indefiniteness, one object and one only of which the following five propositions are all true, viz., (a) that, if we raise the question, we are tempted to suppose it to be identical with *the* part of A's surface which we are seeing, (b) that we do not, nevertheless, know for certain that it is a part of A's surface at all, (c) that it certainly does, in a sense, sensibly appear to us to have certain sensible qualities, though, unless it *is* identical with *the* part of A's surface which we are seeing, the sense in which it "sensibly appears" to have them is a different (and more fundamental) one than that in which this part of A's surface sensibly appears to have certain sensible qualities, (d) that, among all the objects which are at the moment in the same sense sensibly appearing to us to have sensible qualities, it is the only one which we have the slightest temptation to identify with the part of A's surface which we are seeing, (e) that, if we were at the time to make any judgment about A of the kind which we should express to ourselves by "*That* is hard," "*That* is red," "*That* is a chair," etc., etc., every such judgment would undoubtedly be a judgment about it—that is to say, every such judg-

ment would consist in asserting *something or other* about it, though, of course, *what* it asserted about it would not necessarily be that *it* was red, or hard, or a chair, etc., nor even that it was part of the surface of a thing which possessed those predicates.[3]

"Sense-data," Moore says in another place, "are the sort of things *about* which such judgments [i.e., judgments of perception] always seem to be made—the sort of things which seem to be the real or ultimate subjects of all such judgments."[4] Hence, when I see A, I know A only by description as "*the* thing which stands in a certain relation to this sense-datum."[5] But to the question as to what this certain relation may be "no philosopher has hitherto suggested an answer which comes anywhere near to being *certainly* true."[6]

This demonstration of the existence of the sense-datum is fundamental in the analysis of perceptual propositions. If Moore is correct in holding that perceptual propositions are analyzable, in part, into propositions about sense-data, it follows that we must distinguish at least two and possibly three different uses of "see" and of the demonstrative "this." "Seeing A" must be distinguished from "seeing a part of the surface of A," and "seeing a part of the surface of A" may have to be distinguished from "seeing a sense-datum," depending on whether it is possible to identify the sense-datum that is "seen" with the surface that is "seen" when we "see" A. Similarly, we shall have to distinguish the use of "this" as in "This is an A" from its use in "This is a part of the surface of A," and possibly the latter use in turn from its use in "This is a sense-datum." If we distinguish the three corresponding uses by means of subscripts, the stages in the analysis of the proposition "I see an A" can be sketched very rapidly. (a) "I see an A" is equivalent to "I see$_1$ this$_1$ and this$_1$ is an A." (b) "This$_1$ is an A" is equivalent to "This$_2$ is a part of the surface of A," or, alternatively, "The thing which has a surface of which this$_2$ is a part is an A." (c) "This$_2$ is a part of the surface of A" is equivalent to "This$_3$ (i.e., the sense-

[3] "The Nature of Sensible Appearances," 181.
[4] "Some Judgments of Perception," *Philosophical Studies*, 231.
[5] *Ibid.*, 233.
[6] "A Defence of Common Sense," 219.

datum) stands in a certain relation to this$_2$ (i.e., the surface)." If this$_3$ is identical with this$_2$, then when I perceive A what I am knowing about the sense-datum is that it is a part of the surface of A. If this identification can be maintained, we shall have to distinguish only two different uses of "this" and of "see." If it cannot be maintained, we shall have to distinguish three uses of "this" and, correspondingly, three uses of "see." The proposition "I see$_2$ this$_2$ and this$_2$ is a part of the surface of A" is in that case equivalent to "I see$_3$ this$_3$ and the surface to which this$_3$ has a certain relation is a part of the surface of A."

This is Moore's answer to the question "What am I judging about the sense-datum *a* when I judge that I see A?" This is the only definitive answer he has ever given to this question. We turn next to the problems raised by this answer. What is the relation of this$_3$ (the sense-datum) to this$_2$ (the surface)? When I judge that I see A, I do not merely know that there is some relation between the sense-datum and the surface; for I can know a general proposition of this sort only if I know, in a particular instance, what this relation is.

In "The Status of Sense-Data" Moore gives a definitive answer to the question "What is the relation between the sense-datum and the surface?" In this paper he professes himself certain that the surface of an object which we see$_2$ is not identical with the sense-datum which we see$_3$. In later papers he retracts the opinion that it is certain that the sense-datum cannot be identical with the surface we see. In the earlier paper Moore gave a definitive answer, because in that paper he assumed as certain the premises on which the argument which Broad has called the argument from synthetic incompatibility is based. In "Some Judgments of Perception" he rejects one of these premises, and in "A Defence of Common Sense" he rejects the view that it is certain that the sense-datum is not identical with the surface, without, however, citing his reasons for abandoning the earlier view.

The two premises which Moore accepts without question in the earlier paper are these: (1) Physical objects have certain *real* spatial properties and they stand in certain *real* spatial relations; (2) The sense-datum that corresponds to a physical sur-

face may have spatial properties which differ from those of the surface, and two or more sense-data that correspond to two or more physical surfaces may stand in spatial relations which differ from the spatial relations of the surfaces. If a sense-datum is elliptical, whereas the surface to which it corresponds is circular, the sense-datum cannot be identical with the surface. If sense-datum *a* is larger than sense-datum *b*, whereas the corresponding surfaces *A* and *B* stand in the converse relation, then these sense-data cannot be identical with their corresponding surfaces. For if physical objects have real spatial properties, then two different determinate spatial properties which fall under the same determinable are synthetically incompatible, i.e., they cannot both inhere in the same subject; if physical objects stand in real spatial relations, then two different determinate relations which fall under the same determinable relation cannot both connect the same subjects at the same time.

If this is a valid argument, it should suffice to establish the thesis of the non-identity of sense-datum and physical surface and to establish it conclusively. But philosophers have always endeavored to buttress this thesis by supplementary arguments, and Moore is no exception. In "Some Judgments of Perception" he appears to hold that the mere difference of two qualities, qualities that are not synthetically incompatible, is sufficient to ensure the non-identity of sense-datum and physical surface.[1] A tactual and a visual sense-datum, he there argues, cannot be identical, because they are qualitatively different. The one, for example, is warm and smooth, whereas the other is not, and they can therefore not both be identical with the physical surface to which they correspond. Now the mere fact that these sense-data are qualitatively different can obviously not yield the conclusion that they are not identical, contrary to the opinion of many philosophers, Moore included. We can easily specify a sense of "sameness" that permits the identification of a sense-datum that is circular and red with one that is warm and smooth. The argument may be admitted to have force only in so far as the visual and tactual qualities are not merely different but are

[1] Cf. "Some Judgments of Perception," 243.

synthetically incompatible. We are therefore not obliged to recognize this supplementary argument as an independent argument. If the argument from synthetic incompatibility is valid, then a sense-datum which is tactually circular cannot be identical with one which is visually elliptical, and they can therefore not both be identical with the physical surface to which they correspond. The supplementary argument, in so far as it has any force, is therefore only another variant of the argument from synthetic incompatibility.

Moore suggests, in "Some Judgments of Perception," that the conclusion of the argument from synthetic incompatibility can be avoided if the second premise can be successfully challenged. This premise is the assumption that a sense-datum of a circular surface often has a shape which is different from the shape of the corresponding surface, or that sense-datum *a* is larger than sense-datum *b*, whereas the corresponding surfaces stand in the converse relation. Moore challenges this assumption: I do not *see* that the shape of the sense-datum is different from the shape of the surface of the object to which the sense-datum corresponds, but this shape merely *seems* to be different from that of the surface; I do not *see* that sense-datum *a* is larger than sense-datum *b*, when the corresponding surfaces are in the converse relation, but *a* merely *seems* to be larger than *b*. Moore even applies this language of seeming to the supplementary argument.

The sense-datum presented when I touch this finger is not perceived to *be* different in any way from that presented to me when I see it, but only to *seem* so—that I do not perceive the one to be coloured and the other not to be so, but only that the one *seems* coloured and the other not.[8]

If this view, which Broad has afterwards developed into the "multiple relation theory of appearing," is correct, then the kind of perceptual experience which is expressed by "*a seems* so and so" "involves an ultimate, not further analysable, kind of psychological relation."[9] Moore, of course, does not claim that the theory is correct. But if it is correct, then it remains

[8] *Ibid.*, 245.
[9] *Ibid.*, 245-246.

possible that the sense-datum and the surface to which it corre-
sponds are identical. We are still far from a demonstration that
the two are identical, but, if the theory is correct, it at any rate
undercuts the argument from synthetic incompatibility which,
if this argument is correct, makes it certain that the two are not
identical.

On the multiple relation theory of appearing I am asked to
believe that a sense-datum which seems elliptical is really circu-
lar, that the perceptual situation contains a constituent which is
circular, but that it contains nothing which is elliptical. If this
is so, why do I judge that the sense-datum seems elliptical? If
there is nothing that *is* elliptical, why do I not report that the
sense-datum appears square? Further, why do I sometimes
make the mistake of judging that the sense-datum *is* elliptical,
if there is nothing in the perceptual situation that is elliptical?
One cannot ask these questions without thinking that the multi-
ple relation theory of appearing is an hypothesis invented *ad hoc*
in order to preserve the identity of the sense-datum and its
corresponding surface. Now Moore, to be sure, does not advance
the multiple relation theory of appearing as a theory he regards
as certainly true; the theory is advanced as tentative only. Nev-
ertheless, the theory is unique in an important respect: Moore
can find no grounds on which to reject it. In the instance of
other tentative theories that deal with the question "What is
the relation between the sense-datum and the corresponding
surface?" he finds good reasons for doubting the correctness of
the answer. In the instance of the multiple relation theory of ap-
pearing alone he confesses that he finds none. He suggests that
he may be talking nonsense in advancing this theory, but that,
if he is, he is no longer able to distinguish sense from nonsense.

The demonstration of the diversity of sense-datum and physi-
cal surface depends on the acceptance of two premises. (1) If
a sense-datum appears to have the quality Q then it really has
the quality Q, or, alternatively, if an object appears to have the
quality Q then there is something (i.e., a sense-datum) which
has the quality Q. (2) Physical objects have certain *real* spatial
properties and they stand in certain *real* spatial relations. If one
or the other of these premises is false, the identity of sense-

datum and physical surface is not indeed assured, but it remains at least as a possibility. The multiple relation theory of appearing rejects the first premise, in maintaining that the relation of "seeming" is an ultimate and not further analyzable relation. It has apparently never occurred to Moore to challenge the second premise. In the "Defence of Common Sense" he still thinks that the argument from synthetic incompatibility can be disposed of by rejecting the principle "which has been held to be certainly true by most philosophers, namely the view that our sense-data always really have the qualities which they sensibly appear to us to have,"[10] at least in so far as this argument relies on the difference between the real shape of the physical surface and the sensed shape of the corresponding sense-datum. But in the "Defence of Common Sense" he does express the view that the appearance of two sense-data in the double vision of a single object is a fatal objection to the rejection of this principle. He apparently does regard it as quite certain now that if I appear to see a couple then there is something which is a couple.

Since I am as anxious as Moore to preserve the possibility of identifying sense-datum and physical surface, and since I cannot convince myself that the first premise is false in either the instance of single or of double vision, I shall briefly explore the possibility of rejecting the second premise. For, if (1) is allowed to stand, the possibility of identifying sense-datum and physical surface must depend on the question whether (2) can be successfully challenged. I agree with Moore in believing that physical objects have certain *real* spatial properties and that they do stand in certain *real* spatial relations. But I think that I do not agree to this thesis in the sense in which Moore understands it. In my opinion the second premise is ambiguous; in my opinion the question whether it is true hinges on the meaning we attach to the word "real." The thesis may mean (a) That physical objects have certain spatial properties and that they stand in certain spatial relations even when we do not perceive them, or (b) That physical objects have certain *intrinsic* spatial properties and that they stand in certain *intrinsic* spatial relations. I assent

[10] P. 220.

to (a) without any reservations; I agree that coins are circular and that the moon is larger than an orange, whether I am there to perceive this or not. I also assent to (b), but I doubt whether Moore and I would agree as to what properties may be regarded as intrinsic or even as spatial. To give an illustration of the distinction between intrinsic and extrinsic properties, suppose we examine the capital letters T and O. The letter T consists of a cross bar which has one point in common with a vertical bar; this property of the letter I regard as intrinsic. The letter O consists of a closed curve; this property I also regard as intrinsic. The cross bar of the letter T makes a right angle with the vertical bar; this property I do not regard as intrinsic, but as extrinsic. The letter O has the form of an ellipse; this property I likewise regard as extrinsic. In general, the so-called topological properties of spatial configurations are all intrinsic; their metrical properties are not intrinsic, but extrinsic.

I suspect that Moore regards spatial properties such as shape and size, and spatial relations such as "larger than," as intrinsic. Unless they are so regarded, the second premise, in combination with the first, does not entail the non-identity of sense-datum and corresponding physical surface. If P and Q are intrinsic properties and are different determinates with respect to the same determinable, then nothing can have both of these properties at the same time. But if they are not both intrinsic this does not follow. If, for example, both of the properties are extrinsic, a thing can have them both, namely if it has them in different relations. In other words, if the properties are extrinsic they are not synthetically incompatible, unless we merely mean that a thing can not have them both in the same relation.

In rejecting the commonly accepted view that the geometrical properties of physical objects are intrinsic, we reject the view that these properties are independent of the instruments we use in ascertaining what these properties are. That these properties are logically dependent on the instruments of measurement we employ is to-day a familiar idea. The length of a segment, for example, is not an intrinsic property of the segment, but a property which the segment has only in relation to another segment: the length of a segment is a relation between two seg-

ments, namely that of their congruence. When, for example, we say that the length of a segment is one yard, we mean that the extremities A and B of the segment can be brought into coincidence with the extremities C and D of a yardstick. Objects, therefore, have length only in relation to an instrument of measurement. One might think that, though length is not an intrinsic property, it is at any rate an invariant property. If so, the argument from synthetic incompatibility could proceed as before, if we make "real" synonymous with "invariant." But length is not an invariant property. The length of an object will depend on the objects we agree to regard as rigid. When we choose a measuring instrument, we choose an object that is rigid by definition or by convention. Depending on the convention we adopt, two segments that are equal in length relative to one standard of measurement may be unequal relative to another. Length, therefore, is relative, and not invariant or absolute. But the relativity of length entails the relativity of size, shape, and other geometrical properties, inasmuch as these properties are functions of length. The shapes and sizes of objects therefore depend on the convention of rigidity we have adopted, and shape and size are therefore not invariant properties. The shapes and sizes we assign to objects can be altered by an appropriate alteration of the standard of rigidity.

That the geometrical properties of physical objects are relative to the objects we have agreed to use as instruments of measurement is a thesis that has become familiar through the writings of Poincaré. Let us briefly consider Poincaré's argument. Suppose we have a system of three rectangular coördinates X, Y, Z. In the XY plane of this system we describe a closed curve F. We also connect with this system an observer O, whom we shall suppose to be able to move about freely in the system, and we supply him with a measuring rod M. We now suppose the system XYZ to be transformed into another system X'Y'Z' in accordance with the transformation equations $x'=kx$, $y'=y$, $z'=z$, where k is a constant greater than 1. These equations transform the closed curve F into the closed curve F'. And, since every object connected with the XYZ system of coördinates takes part in the transformation, the observer and his measuring

rod are of course no exception; observer O is transformed into observer O' and measuring rod M is transformed into measuring rod M'.

After the transformation has taken place the observer will obviously be unable to detect any alteration in the shape or size of the closed curve. If, as observer O, he found, by measuring the diameters of the curve, that the curve was a circle, he will, as observer O' likewise find that the curve is a circle. Moreover, he will be unable to detect the change by examining the sensible appearance of the curve. If the curve looked circular to him before the transformation, it will still look circular to him after the transformation. As observer O' he has no means at his disposal for ascertaining that a change has taken place, since he himself takes part in the transformation when the system XYZ is transformed into the system X'Y'Z'.

Let us now suppose that observer O is transformed into observer O', as before, but that an exact duplicate of observer O is nevertheless preserved. In other words, let us suppose that we have two systems of coördinates XYZ and X'Y'Z', equipped as before, and that the x', y', and z' coördinates are connected with the x, y, and z coördinates by the transformation equations x'=kx, etc. Instead of one curve F, one observer O, and one measuring rod M, which are transformed into F', O', and M', we now have two curves F and F', two observers O and O', and two measuring rods M and M'. Let us also suppose that the two observers can make observations on one another's systems. The reports they make regarding the shape and size of the configurations F and F' on the basis of their observations must obviously be inconsistent; at any rate there must be a verbal inconsistency in their reports. For suppose that O reports F to be both sensibly and metrically circular. If so, F' will also be sensibly and metrically circular as determined by the observations of O', since, by hypothesis, the system X'Y'Z' is a point for point transformation of the system XYZ. But O will report F' to be sensibly and metrically elliptical, and similarly O' will find that F is both metrically and sensibly elliptical. The two observers, if we assume them able to communicate, will be unable to agree regarding the metrical and sensible shape of the figure

connected with their respective coördinate systems. Observer O will attribute what he regards as the erroneous results of O' to the fact that O' does not notice that he moves about in a field of force which elongates his measuring instrument when he brings it into the direction of the X'-axis. And observer O' is of course equally certain that the erroneous results of O are explained by the fact that O is moving about in a field of force, not noticed by him, which contracts his measuring rod when he turns it into the direction of the X-axis. The two observers cannot agree, because they do not have a common standard of rigidity. O's measuring rod, as determined by the measurements of O', is found to contract when it is placed parallel to the X-axis, whereas the latter's measuring rod, as determined by the measurements performed by O, is elongated when it is set parallel to the X'-axis. Each observer, accordingly, concludes that the measuring rod of the other is not rigid. O interprets the behavior of M' as being due to a universal field of force which elongates all bodies in the direction of the X'-axis, and conversely, O' interprets the behavior of M as being due to a universal field of force which contracts all bodies in the direction of the X-axis. Their disagreement is therefore merely an expression of the difference in the conventions they have adopted, and hence purely verbal. Relative to the standard of measurement chosen by O, F is circular and F' elliptical, and relative to the convention adopted by O', F is elliptical and F' circular. Their reports lose the appearance of incompatibility when we remember that shape and the other metrical properties of objects are not intrinsic.

In order to refute the argument from synthetic incompatibility, in so far as this argument depends on the assumption that the spatial properties of physical objects and of sense-data are intrinsic, it is sufficient to show that the spatial properties of the former are extrinsic. It is not necessary to show that the spatial properties of sense-data are likewise extrinsic. We have now shown that the spatial properties of physical objects are extrinsic. But we have done more than this; we have also shown that the spatial properties of sense-data are extrinsic, not intrinsic. To observer O the configuration F looks circular, F' elliptical, i.e.,

when O compares the diameters of F and F′ with a standard
sense-datum, he finds that the diameters of F are all of the same
length, whereas the diameters of F′ are not all of the same
length. To observer O′ the configuration F′ looks circular while
F looks elliptical, i.e., when he compares the diameters of F′
and of F with a standard sense-datum, he finds that the diam-
eters of F′ are all of the same length, whereas those of F are
not all of the same length. The shape, and similarly the size,
of sense-data is therefore a function of other sense-data, and
no more intrinsic than the shape and size of physical objects.

If the spatial properties of sense-data and of physical objects
are not both extrinsic, the refutation of the argument from syn-
thetic incompatibility can be secured only at the expense of
assuming a grave liability, namely that of the distinction be-
tween sensible and metrical shape and size. For, if the spatial
properties of physical objects alone are extrinsic whereas the
spatial properties of sense-data are intrinsic, then we are re-
quired to draw a distinction between metrical and sensible shape
and size. I have called this distinction, which some philosophers
find no difficulty in accepting, a grave liability for the following
reason. If we make a distinction between metrical and sensible
circularity, then, since the one property is extrinsic whereas the
other is intrinsic, these two properties differ from one another
not merely as two species of the same genus, but as two distinct
genera. The metrical shape in that case will differ from the sen-
sible shape in exactly the same way as that in which the sensible
color differs from the physical color. Hence from the proposi-
tions "This is geometrically circular" and "That is sensibly circu-
lar" it would be fallacious to infer that this and that are circular,
just as it is a fallacy to infer from the propositions "This is physi-
cally red" and "That is sensibly red" that this and that are both
red.[11] If the argument from synthetic incompatibility were to be
refuted by drawing a distinction between sensible and metrical
properties, therefore, we would be accusing the philosophers
who have relied on this argument of overlooking a very elemen-
tary distinction, namely, of overlooking the ambiguity of a

[11] Cf. Broad, C. D., *The Mind and Its Place in Nature*, 171f.

word, just as some behaviorists have overlooked the ambiguity of the word "color." Now I do not think that the mistake made by these philosophers was as elementary as that. I think that they were correct in holding the view that the word "shape" in the phrase "shape of a physical surface" has exactly the same meaning as the word "shape" in the phrase "shape of a sense-datum." Their only mistake was the assumption that the shape of either a sense-datum or a physical surface is an intrinsic property.

Hence, although the refutation of the argument from synthetic incompatibility does not depend on the demonstration that the spatial properties of sense-data are extrinsic, it is still necessary to absolve the philosophers who have used this argument from the charge of having overlooked a transparent ambiguity. There is, of course, no reason why a philosopher should not distinguish between geometrical and sensible circularity, if he merely intends to distinguish between the perceived shape of an object and the shape it has independently of the fact that it is perceived. If this is the intended distinction, it is a relational distinction; sensible and geometrical circularity are distinguished by the fact that the former is sensed whereas the latter is not necessarily sensed. But the advocates of the distinction apparently have not meant merely this. They have argued that geometrical and sensible shape are two distinct sorts of shape that have nothing in common. And they have implied, therefore, that the users of the argument from synthetic incompatibility have been misled by a word.

As there is nothing to recommend the distinction other than the fact that its acceptance enables one to dispose of the argument from synthetic incompatibility, I shall not rely upon it. Let us consider instead how we proceed in determining the shapes and sizes of sense-data. This consideration will reënforce the conclusion we drew earlier that the spatial properties of sense-data, like the spatial properties of physical objects, are metrical properties and therefore extrinsic.

In order to show that the spatial properties of sense-data are extrinsic, we have to show that these properties are relative to a standard of rigidity. The question will therefore be asked, Do

we employ a standard of rigidity when we determine the spatial properties of sense-data, and, if so, what standard? In answering this question let us first suppose, with Berkeley, that the visual field is flat. As a standard segment we select one of the sense-data that compose this field, e.g., the sense-datum that corresponds to a pencil held at arm's length. By moving the arm this sense-datum can be made to move over the whole visual field. This sense-datum we define as rigid, i.e., we define it as maintaining the same sensible size. Length, as in the instance of physical length, is a relation between two segments, i.e., that of the coincidence of their extremities. The sense-datum that corresponds to telephone pole A, for example, is shorter than the sense-datum that corresponds to telephone pole B, i.e., the extremities of A can be brought into coincidence with the sense-datum of the pencil, whereas sense-datum B overlaps this sense-datum. Independently of a standard of comparison it is obviously impossible to compare two different sense-data in respect of length or size. But if the length of sense-data is relative to a sense-datum taken as standard, it at once follows that shape and size, which are functions of length, are also relative.

This result can be stated in a more convincing form if we do not distinguish between sense-datum and physical surface, and assume instead that the flat visual field of Berkeley is composed of physical objects. As before, a pencil held at arm's length is our standard of measurement. With respect to this standard a man who walks down a road away from us becomes shorter and shorter, a flat circular disk that is turned on its axis changes its shape to that of an ellipse. In visual space a physical object behaves as if it were moving about in a field of force. Its sensible length may decrease while its physical length remains constant. Let us suppose, for example, that the extremities of the pencil can be brought into coincidence with the extremities of a telephone pole. If we now take a second pencil whose extremities are also in coincidence with the extremities of our standard and proceed to move this pencil towards the telephone pole, its sensible length decreases. If it were to maintain the same sensible length, i.e., if its extremities were to remain in coincidence with our chosen standard, its physical length would have to increase,

until it reached the physical length of the telephone pole. A physical object that always maintained the same sensible size as it moves about in physical space would be an object that has a variable physical size. If there were such an object, and if I defined it as rigid, it could therefore be employed in the determination of the metrical properties of perceived objects.

Different perceivers employ different standards of rigidity. The standard of rigidity employed by B will be judged as variable by A. For as B moves his pencil about in his visual field, as he determines the geometrical properties of his visual field, A will find that this pencil changes its visual length as B moves it about. A and B will be in the position of the two observers in our previous example who found it impossible to come to a verbal agreement regarding the geometrical shape of the figure in each other's systems. Like them A and B do not have a common standard of measurement.

This account of the matter requires considerable modification, because Berkeley was wrong in supposing that the visual field is flat. Since Berkeley thought that the sensible shapes and sizes of objects are identical with their perspective shapes and sizes, he denied that sense-data are seen at different sensible depths. But the visual field is obviously not flat. One consequence of this is that, in general, the apparent size of an object exceeds its perspective size, the apparent shape of an object differs from its perspective shape. The telephone poles in the distance appear to be smaller than those near at hand, but not as small as they should appear if I saw them in their perspective size. A coin that is seen from the side looks elliptical, but the ellipse, if it is an ellipse, is not quite as flat as the ellipse I would draw if I made a perspective drawing of the coin.

But if the sense-field is not flat, then the sense-datum of the pencil cannot be brought into coincidence with the sense-datum of the telephone pole, for the first sense-datum is not at the same depth as the second. We are therefore obliged to re-examine the definition of length. We can obviously not say that we select a sense-datum as standard which always maintains the *same* sensible size as its sensible depth increases, for the statement that the sense-datum maintains the same sensible size im-

plies a comparison with a standard sense-datum. When we say that a sense-datum maintains the same sensible size as its sensible depth increases we are comparing it with a standard sense-datum: the determination of the lengths of sense-data, as well as the determination of their other spatial properties, implies therefore the possibility of comparing in respect to length sense-data that have different depths. But this requires a modification of the definition of length. The length of a sense-datum whose extremities are C and D cannot be defined as the relation of coincidence of C and D with the extremities A and B of a standard sense-datum. I tentatively suggest the following definition. If sense-data S_1 and S_2 had the same depth, then sense-datum S_2 would have the length AB, if the extremities C and D of this sense-datum could be brought into coincidence with the extremities A and B of standard sense-datum S_1. Hence, since measurement in the strict sense is not possible, we are limited to making more or less inaccurate comparisons when the sense-data have different depths. When a circular coin appears elliptical, we can judge quite accurately that one axis is shorter than the other axis, but it is a well known fact that we cannot determine the exact ratio with anywhere near the degree of accuracy with which we can determine the perspective ratio. At any rate, it remains true that the spatial properties of a sense-datum are functions of other sense-data. The apparent size of an after-image, for example, is a function of its environmental sense-data. When the after-image is projected on my thumbnail it looks small, but when I project it against the wall of a distant building it looks very large. Examples of an analogous sort illustrate the dependence of the shape of a sense-datum on the context of sense-data in which it is seen. The size and shape of a sense-datum are therefore not intrinsic properties, but properties which the sense-datum has only in relation to other sense-data.[12]

Common sense is always credited with believing that in perception we are directly aware of physical objects. Common sense, it should be pointed out, is not greatly discommoded by

[12] Cf. Randle, "Sense-Data and Sensible Appearances in Size-Distance Perception," *Mind*, n.s., XXI, 284.

the perspectival deformation of physical objects in perceptual space; people who hold the common sense belief go right on believing that they directly perceive the telephone pole in the distance, in spite of the fact that it looks much smaller than the telephone pole in the foreground which they know to be no longer than the one they see in the distance. Even philosophers who have convinced themselves of the validity of the argument from synthetic incompatibility are incapable of divesting themselves of this belief. This belief, it should also be pointed out, is capable of being defended only if it is admitted that the spatial properties of physical objects and of sense-data are extrinsic. Whether we hold the common sense view of the world or whether we are philosophers, we find no difficulty in believing that we continuously see the top surface of the penny, in spite of the fact that the shape of this surface changes from circular to elliptical as the penny is turned or as we change our position. This conviction entails that the shape of the surface is not an intrinsic property of it.

The common sense belief that I see the same surface of the penny, whether this surface looks circular or elliptical, implies a sense of "same" which is compatible with diversity. In one sense of "same," an elliptical sense-datum is obviously not the same as a circular sense-datum. If they were identical in every sense of "same" we should be unable to distinguish between them. When, therefore, we say that they are the same, we are not also accepting the view that there is no difference between an ellipse and a circle. In order to illustrate the sense in which the term "same" is here employed, suppose we consider a rubber membrane which has depicted on it the drawing of a face. When this membrane is stretched, the metrical properties of the drawing are obviously altered. But certain properties of the drawing will remain invariant; the face will still have one nose, two eyes, two ears, etc. In one sense of "same" the face after the transformation is the same as the face before the transformation, in another sense of "same" it is a different face. The judgment of sameness is made with regard to the invariant properties of the drawing, the judgment of difference with regard to its metrical properties. Similarly, when the elliptical and the circu-

lar sense-datum are both identified with the physical surface, the judgment of sameness is made with regard to the invariant properties alone.

With this we can conclude our examination of the argument from synthetic incompatibility. I do not claim that this draws the teeth of the argument, for this argument has several teeth. But we can claim that we have drawn at least one tooth. Moore, as far as I know, considers the existence of mirror images only as another formidable barrier that prevents the identification of sense-datum and physical surface.

When we see a thing double, we certainly have *two* sense-data each of which is *of* the surface seen, and which cannot therefore both be identical with it; and that yet it seems as if, if any sense-datum is ever identical with the surface *of* which it is a sense-datum, each of these. so-called "images" must be so. It looks, therefore, as if every sense-datum is, after all, only "representative" of the surface, *of* which it is a sense-datum.[13]

I think we can deal with mirror images without resorting to a representative theory, but I do not propose to draw this tooth on this occasion. Curiously enough Moore never mentions the other variants of the argument from synthetic incompatibility by which the representative theory is supported. He pays no attention to the contention that sense-datum and physical surface cannot be identified because the *position* of the sense-datum may be different from the position of the physical surface to which it corresponds. Nor does he pay any attention to the contention that the two cannot be identified because the date of the sense-datum is always different from the date of the physical surface, or rather of an event in that surface, to which the sense-datum corresponds. These arguments seem to be at least as formidable as the argument from the existence of mirror images. However, these arguments likewise I shall leave unrefuted.

Although we have now vindicated the possibility of identifying sense-datum and physical surface, the question still remains whether the two actually are identical. How does one answer a question of this sort, and how does one determine whether the answer is correct? If there were good grounds for holding either

[13] "A Defence of Common Sense," 220.

that there are no physical objects or that no one can know that there are, then a sense-datum could either not be identical with the surface of a physical object, on the first alternative, or one could not know this, on the second. But of course, Moore does not think that there are good grounds for holding either of these alternatives. In his "Defence of Common Sense" he has clearly indicated his disagreements with those philosophers who have held either that none of the propositions that constitute the common sense view of the world are true or else that no one *knows* such propositions to be true, even though they may of course *be* true. Moreover, when Moore says that he *knows* propositions of the indicated sort, e.g., that this is a thumb, to be true, he intends this claim to be incompatible with the claim of other philosophers that one can know only that propositions of this sort have a high degree of probability. Now if Moore knows that the proposition "This is my thumb" is true, he can obviously know this only because he sees his thumb, i.e., because he "sees" a sense-datum of a certain sort. What, then, are the considerations that determine the answer to the question regarding the relation of this sense-datum to the surface of his thumb? Moore has told us that this is "a profoundly difficult" question to which "no one knows the answer."

There are problems in fields other than philosophy which are still unsolved. No one knows whether or not there is a transfinite number between *a*, the cardinal number of a denumerable class, and *c*, the cardinal number of the continuum. The problem remains perhaps unsolved either because it is insoluble, or because the mathematical apparatus that is successfully employed in the solution of that *kind* of problem is inadequate for the solution of *this* problem, or because the solution is beyond our analytical and deductive powers. Mathematicians do not believe that this problem is either insoluble or that its solution is beyond our deductive powers. They may of course decide, after prolonged failure to solve the problem, that the mathematical methods so far employed are inadequate and that the solution must be deferred until more powerful methods are devised. But at least they can indicate the direction in which the solution must be sought. Can Moore do this for his unsolved problem?

If so, what philosophical apparatus has been successfully employed in the solution of the *kind* of problems of which *this* problem is a particular instance? If this question were answered, we would at least know in what direction to proceed in order to find a solution of *this* problem. In short, until we know what we are to understand by "philosophical analysis" and until we know by what criteria the correctness of a proposed analysis may be determined, the problem as to the relation between sense-datum and physical surface must remain insoluble because the problem is incompletely formulated.

If Moore is correct in holding that we *know* that there are physical objects, we can obviously know this only because we see them. But I would have no evidence for the existence of a physical object of a certain sort which is strong enough to support the claim that I *know* that, e.g., this is a thumb, unless the sense-datum I "see" is identical with a part of the surface of this thumb. If the sense-datum were merely representative of this thumb, I could not *know* that this is a thumb, though this belief might then be true with some degree of probability, as some philosophers have held. Hence in *knowing* that this is a thumb, I likewise know that this sense-datum is a spatial part of this thumb, for the only evidence I have for the "belief" that this is a thumb is that I see a spatial part of this object. I should therefore regard the identity of sense-datum and physical surface as an immediate consequence of Moore's view that we *know* propositions such as "This is a thumb."

In "The Nature of Sensible Appearances" Moore argues that the plain man, i.e., the man who shares with Moore the common sense view of the world, has no "beliefs" about sense-data, and in particular no "beliefs" about the relation of sense-data to physical objects. I take him to mean that the correct analysis of a judgment of perception or of any other proposition that belongs to the common sense view of the world is not itself a part of the common sense view of the world. Moore accordingly rejects the view of Dawes Hicks and of Broad to the effect that when the plain man sees his thumb he knows or believes that a certain sense-datum, the objective constituent of the perceptual

situation, is a spatial part of the surface of his thumb. "Most plain men," Moore says, "never entertain beliefs of this kind at all. What I think is that, *on philosophic inspection*, it does *seem* to be true that this sense-datum *is* a part of the surface of my thumb, and that, *therefore*, I am directly apprehending a part of this surface."[14] Hence, according to Moore, if by philosophic inspection we should arrive at the decision that phenomenalism or that representative perception, one or the other, analyze sense-perception correctly, this analysis would not be inconsistent with the plain man's knowledge that this is a thumb. These theories, Moore appears to hold, are not demonstrably inconsistent with any proposition that belongs to the common sense view of the world.[15] For, in his opinion, the plain man does not "believe" that he perceives his thumb directly, i.e., that the sense-datum he "sees" is part of the surface of his thumb. Nor does the plain man have any "beliefs" regarding the nature of physical objects; he never speculates upon the question whether or not it is true that physical objects consist of actual and possible sense-data. Hence it is useless to invoke his common sense authority against phenomenalism and representative perception. The question has to be relegated to the philosopher, but unfortunately the philosopher has so far not succeeded in settling the question by philosophic inspection.

I think it is fair to say that most philosophers regard theories such as phenomenalism and representative perception as inconsistent with common sense. But Moore will not have it so. One reason why he cannot make up his mind regarding the rival theories is his denial that common sense beliefs and common sense behavior entail a theory regarding the nature of sense-perception and the nature of physical objects. He is willing to reject a theory if it can be shown to be inconsistent with common sense. But if the plain man knows only that this is a thumb without also knowing that the sense-datum he sees is a part of its surface, theories such as phenomenalism and representative perception can obviously not be shown to be inconsistent with com-

[14] *Loc. cit.*, 187.
[15] Cf. "A Defence of Common Sense," 220f.

mon sense. Both theories are equally able to give an analysis of the proposition of the plain man that this is a thumb. At this point we are therefore again faced with the question "Which of these rival theories gives us the correct analysis of sense-perception?" I am sure that no philosopher will ever find the answer until we know what a correct analysis is.

PAUL MARHENKE

DEPARTMENT OF PHILOSOPHY
UNIVERSITY OF CALIFORNIA

10

C. A. Mace

ON HOW WE KNOW THAT MATERIAL
THINGS EXIST

ON HOW WE KNOW THAT MATERIAL THINGS EXIST

A CHARACTERISTIC and significant feature of Moore's philosophical position is the lively contrast between what he claims to know with certainty and that concerning which he expresses only the most tentative opinions or even profound perplexity. There should, of course, be nothing surprising in the fact that a reflective thinker may be very sure of some things and very uncertain of others. If it be surprising that this should be the case with Moore it is so only because it is usual for philosophers to display either a more or less consistent dogmatism or a more or less consistent sense of doubt. But in this, as in other ways, Moore in his capacity as philosopher is in accord with the ordinary man in the exercise of ordinary thought. It is however not so evident, and it is of interest to inquire, whether in more detail the pattern of certainty and doubt in Moore's philosophy is the pattern of certainty and doubt in the common sense view of the world. It would be rather strange if this were so, and important if it were not. It would seem strange if it be the case, since the reflection would follow: What, then, is the philosopher doing if at the end of prolonged inquiry he is certain merely of what he knew to begin with, and if he has resolved no doubts? It is important if the case be otherwise, for then it might seem that the philosophical thinker can do something more than expose the errors of earlier philosophers. It would follow that there are doubts the philosopher may resolve.

In his "Defence of Common Sense" Moore has specified some of the propositions which in his opinion he knows with certainty to be true; and has exemplified some of the classes of propositions concerning which he is uncertain. Moore asserts, firstly,

that he knows with certainty that there exists at present (i.e., at the time at which he wrote these words) a living human body, which is his body; that this body was born at a certain time in the past, and has existed continuously ever since; that ever since it was born it has been either in contact with or not far from the surface of the earth; that at every moment since it was born there have also existed many other things having shape and size in three dimensions; that very often there have existed other things of this kind with which it was in contact; that among the things of this kind which have formed part of the environment there have, at every moment since its birth, been large numbers of other living human bodies each of which has, like it, been born at some time, continued to exist, and has at every moment of its life been either in contact with or not far from the surface of the earth. He knows too, that the earth has existed for many years before his body was born, that large numbers of human bodies have at every moment been alive on it and that many of these bodies had died and ceased to exist before his own body was born. Moore further asserts that he knows that each of us has frequently known with regard to himself everything which he, Moore, claims to have known with regard to *himself*.

In all this it is clear that Moore is claiming to know with certainty only such things as anyone in the ordinary way would say he knew with certainty. But the position might seem to be different in regard to some of the things concerning which Moore expresses doubt and a measure of surprise. Although he is in no degree sceptical regarding the truth of such propositions as 'The earth has existed for many years past' and 'Many human bodies have each lived for many years upon it', i.e., propositions which assert the existence of material things, he is nevertheless very sceptical 'as to what, in certain respects the correct *analysis* of such propositions is'. Again, whilst he is quite sure that we know that the earth has existed for many years, he is extremely hesitant regarding *how* we *know* such things. *"We are all,"* he thinks, *"in this strange position that we do* KNOW *many things, with regard to which we* KNOW *further that we must have had evidence for them, and yet we do not*

know HOW *we know them, i.e. we do not know what the evidence was.*"[1]

There are several situations of this general kind, all of which are strange, but some are stranger than others. There is, for example, the kind of case to which Moore persistently refers, that in which I know that many material things existed before I was born. Now if one of these things be selected, say the Great Pyramid, and any plain man be asked how he knows that it existed before he was born, the plain man may for a moment at least be at a loss for an answer. But though nonplussed he would not be completely nonplussed; and if he could not say precisely what the evidence was upon which he was relying he could say something regarding the *sort* of the evidence that is relevant to the case. His hesitation might arise from nothing more than the difficulty of selecting from many considerations those which were in fact his own grounds of belief or the grounds which under the circumstances are likely to be the most persuasive. In the end he might say, for example, that he knew that the Pyramid existed before he was born because his own grandfather had himself seen it in his early youth. In any case he would be likely to suggest evidence of this kind—viz., as evidence for the fact that one material thing existed at a certain time, some statement which took it for granted that some other material thing existed at that time. And in all such cases the evidence will differ according to the time in question, and will be more or less complicated according as the time falls within or outside the span of human memory.

There is a rather simpler case in which the evidence is of a somewhat different kind. If we take a couple of glances at some material thing and then are asked how we know that this thing existed throughout the time between glances we are again at a loss for an immediate answer. We know that it existed during this intervening time, but we do not know how we know this to be the case.

The strangest fact of all, however, is the fact that we cannot say with assurance how we know that a material thing exists

[1] "A Defence of Common Sense" (*Contemporary British Philosophy*, Second Series), 206.

even when we are actually looking at it. When I look at and consider the Great Pyramid I know that it has existed for a long time before I was born. I know that it exists between my separate glances at it and I know that it exists at the moment at which I am actually seeing it. Here are three distinct cases, though they are, of course, intimately connected. If I did not know that the thing existed between my glances I should not know that it existed before I was born, and if I do not know that it exists when I am looking at it I should not know that it existed between my glances. It is therefore natural to begin with the question: How do I know that a material thing exists when I am perceiving it?

Now it is, indeed, strange that we should be in the position of knowing beyond all doubt that tables and chairs, pyramids and mountains exist and that we should be nonplussed and perplexed when asked to say how we know that they exist at the times when we are actually perceiving them. Clearly it is not enough to say: I know that they exist because I am perceiving them (though this is true), since part of what we know we do not know directly, but know on evidence. The question demands that the evidence be stated.

What exactly is the difficulty? Is it that the evidence is of a kind that only a philosopher can discover, or that the proof is long and involved? This seems unlikely. It is surely a significant fact that we do not remember a time when we did not know that material things exist. We do not remember discovering the fact, and we do not remember being told that there are material things in general, as we may remember being told of the existence of the Pyramids. Nor do we have to teach our children that material things exist. Even dull and mentally defective children seem to have discovered this before we teach them anything, and the proof does not seem to be so subtle or so involved that some people only (and not all) reach the right conclusion.

In a simple case, as when I see my own hand, the situation is this. There is something which I see which I do not *always* know for certain to be a material thing, and there is something concerning this that I do know directly, i.e., know without further evidence. But what I know when I know that 'This is a human hand' is something more than this and something that I do not

know directly, but know on evidence. Thus, in order to say how I know what I know when I know that this is a human hand—in the case in which I am actually looking at it—I must be able to say

(i) What I know directly when I see what I see when I look at my hand,

(ii) What, in more detail, I am knowing when I know that this is a material thing, and

(iii) What I require to know in addition to (i) in order that (ii) may follow.

The difficulty we find in saying how we know what we know when we know that *this* is a human hand may arise in very considerable measure from the fact that we cannot decide what it is that we know directly in virtue of what we see; and we cannot decide what in more detail it is that we are knowing when we know that *this* is a human hand. Accordingly it is less surprising that we cannot decide what is required in addition to (i) that (ii) may suitably follow.

With regard to the first point, viz., what I know directly when I look at a human hand—there is a widely held opinion among philosophers that what I know directly is something that I know in virtue of perceiving a "sense datum;" so that in general terms the answer to the question—how do I know what I know when I know that *this* is a human hand? is to be given as follows: First I specify what I know directly when I perceive a sense datum of a human hand. Then I specify in more detail what I know when I know that this is a human hand. And I have then to discover and state what else I require to know, and under what conditions I know it, so that 'This is a human hand' follows from the conjunction of this further evidence and what I know when I perceive the sense datum of a human hand.

This account of the matter introduces the technical term "sense datum" to which certain obscurities attach, and concerning the existence of which doubts have been raised. It was, however, one of the very distinctive and very exciting features of the "Defence of Common Sense" that an attempt was there made to remove the obscurities and to dispel the doubts. The critical passage ran as follows.

Some philosophers have I think doubted whether there are any such

things as other philosophers have meant by "sense-data" or "sensa." And
I think it is quite possible that some philosophers (including myself, in the
past) have used these terms in senses, such that it is really doubtful
whether there are any such things. But there is no doubt at all that there
are sense-data, in the sense in which I am now using that term. I am
at present seeing a great number of them, and feeling others. And, in
order to point out to the reader what sort of things I mean by sense-data,
I need only ask him to look at his own right hand. If he does this he
will be able to pick out something (and, unless he is seeing double, *only*
one thing) with regard to which he will see that it is, at first sight, a
natural view to take that that thing is identical, not, indeed, with his
whole right hand, but with that part of its surface which he is actually
seeing, but will also (on a little reflection) be able to see that it is
doubtful whether it can be identical with the part of the surface of his
hand in question. Things *of the sort* (in a certain respect) of which
this thing is, which he sees in looking at his hand, and with regard to
which he can understand how some philosophers should have supposed
it to *be* the part of the surface of his hand which he is seeing, while
others have supposed that it can't be, are what I mean by "sense-data."
I therefore define the term in such a way that it is an open question
whether the sense-datum which I now see in looking at my hand and
which is a sense-datum of my hand is or is not identical with that part
of its surface which I am now actually seeing.[2]

In this passage Moore introduces his new way of pointing
out how he proposes to use the term "sense datum," and it is
now clear that, at the time, many of us failed to appreciate quite
what the change implied. In fact, had Moore realized the ex-
tent to which it was possible, for some of us at least, to fail to
understand him he might have abandoned the use of the term
"sense datum" altogether. "Sense data," as the term had pre-
viously been employed, were admittedly very queer things.
All sorts of strange things had been said about them which we
were inclined to think were true. We had thought of them as
things which might perhaps be mental or 'in the mind'. Then
we had been led to think of them as a kind of 'neutral stuff',
neither mental or 'in the mind' nor, on the other hand, material
or literally part of material things. We had thought too, that,

[2] *Ibid.*, 217-218.

whilst it might be logically possible that they might exist un-
perceived, they seemed nevertheless to be so dependent on the
body of the percipient that the chances were that they existed
only when sense organs were stimulated in an appropriate way.
There were other ways in which they seemed extremely queer,
and at first sight what Moore had now to say about them made
them queerer still. We thought of them, in fact, as continuing
to be queer in most of the ways we had previously supposed
but now with the *additional queerness* that they might not, as
he goes on later to point out, really possess the characters which
they appeared to have. Quite probably nothing was further
from Moore's mind than this; and all that he wanted us to
believe about them was precisely what he said concerning them,
viz., that sense data are things which might in fact be parts of
the surfaces of things and with regard to which it is natural
to believe that they are. But, though the passage cited makes it
clear that Moore is using the term sense data in such a sense that
there can be no doubt the sense data exist, there are several
respects in which the use of the term still remains obscure.

To begin with, it is not quite clear to how many sorts of
things the term is now supposed to apply. It is not clear whether
Moore wished really to insist that sense data are things with
regard to which it is natural to believe that they are parts of
surfaces, or whether he meant that they are things with regard
to which it was natural to believe that they were surfaces, *'for
instance'*. Would he have described as sense data other things
with regard to which it was natural to believe that they are some
other parts of some material thing, parts of its inside for in-
stance? What shall we say in the case in which I look at a
coloured glass cube of the kind exhibited in opticians' windows?
In this case there is one thing and one thing only which I per-
ceive and which it is natural to suppose is identical with a whole
material thing. I perceive what I might very naturally describe
as a volume of coloured matter bounded by a six-sided surface.
Is this three-dimensional thing which I directly perceive a sense
datum in Moore's new use of the term? Or, consider the case
in which I attend to my right hand. There is one thing which
I can pick out as that which I am looking at and which it is

natural to suppose is a part of the surface of my hand. And when I touch my right hand with my left, there is something that I feel which it is natural to suppose is also a part of the surface of my hand—part of the same part. Both of these things (if there are here two things) Moore would call sense data. But there is also something which I feel (in another sense) with or in my right hand itself which it is natural to believe is part at least of the inside of my hand. Is this to be called a sense datum too? This, though it does not seem to be part of the surface of my hand, nevertheless appears to be a part of my hand in much the same way as the inside of the coloured glass cube beneath the surface appears to be a part of the cube. Then again if I move my hand in a certain way I can hear a faint crackly noise which I attribute to the movement of the joints inside my hand. Am I to say that what I hear and what I naturally suppose is 'emitted' by my hand is also a sense datum?

Things corresponding to these things, described as 'patches of colour', sounds, etc., were all called "sense data" as this term was previously employed, and they were all supposed to be things of the same sort. They might perhaps have been described as constituting a 'natural kind', much as 'sensations', 'presentations' or 'impressions'—as these were previously conceived—might have been. But a part of a surface, a whole cube and a crackle would not have been described as a natural kind; and in the same way we should not describe 'what it is natural to regard as part of a surface', 'what it is natural to regard as a whole cube' and 'what it is natural to regard as a noise emitted by something' as forming members of a natural kind—though they have of course the common character of 'being something or other which it is natural to regard as something or other'. Otherwise they are almost as heterogeneous a collection of things as it is possible to list together.

It is important to decide whether we shall allow such a wide extension of the term sense data; and it may be important to specify a good many of the things to which the term applies in order to answer the question: How do I know that this is a human hand? How do I know whether what appears to be

part of the surface of a human hand really is part of its surface? Why is it *natural* to regard what I see when I look at my hand as part of the surface of my hand? Certainly, among the answers that first come to mind are: I know that that which I see is a human hand because I feel as well as see it. I know that what appears to be part of the surface of my hand is part of the surface because I can *feel* the inside underneath it. And that, too, is why it is 'natural' to regard what I see as part of its surface. These, of course, are not full or conclusive reasons, but they may be part of what is required to give full and conclusive reasons.

In any case there would seem to be no reason why Moore should restrict the use of the term sense datum to the things that we see and touch and which we naturally regard as parts of *surfaces*. The emphasis would seem to be rather on the fact that what we see, touch, etc., is something which it is natural to regard as *some part* of a material thing (in the sense in which a part of a surface of a material thing is part of a material thing) or as intimately connected with a material thing in the way in which a noise emitted from a thing is connected with it.

But when the emphasis is placed here another query arises. When we attend to the whole setting in which sense data, in this sense, are found, there are other things which may be 'picked out' which we do not naturally regard as parts of the surfaces of material things but rather as empty spaces between material things.

Walking through a wood at night, for example, we may pick out something which at one moment we might naturally regard as part of the surface of some object, but at another we might naturally regard as an opening in the trees. The same distinction is illustrated in the familiar oscillations of the 'figure-ground phenomenon' in which a part of the diagram can be seen in two ways, either as a figure or as a space between two figures. Shall we say that in both cases what we so pick out is a "sense datum?" This question becomes important if we study the process of picking out something which it is natural to regard as part of a surface in what psychologists have described as a 'genetic' way; when we consider, for example, what account to give of the situation in which a baby looks for the first time

at its own hand. In Moore's phrase the sense datum is what I can pick out *if* I look at my own right hand. Is this the same as saying it is what I can pick out *when* I look at my own right hand? Almost certainly not, if by 'when' we mean 'whenever'.

Moore is clearly thinking of the case in which I look at my right hand under certain tacitly presupposed conditions—conditions which are very reasonably supposed to obtain when someone is reading a book. That is to say, we should at least exclude such conditions as those obtaining when I look with a jaundiced eye and in a very dim light at the reflection of my hand through some distorting medium. 'Normal conditions' are presumably specifiable conditions, and it may be very important indeed that we should in fact specify them; important because there are other things that I know under these conditions which constitute part of my reasons for saying that 'This is a human hand'. To say how I know what I know when I know that this is a human hand may well consist in part in specifying what else I am perceiving or have previously perceived under such conditions. The presupposed normal conditions would also, presumably, exclude those that obtain when a baby looks at his hand for the first time, even though he does so under the most favourable conditions of vision; and, if this be so, the conditions require to be specified as, for example, those obtaining 'when I look at my hand in the light of the experience gained through turning it over, waving it backwards and forwards, thumping it on the table and generally conducting a variety of elementary practical experiments upon it'.

That something rather complicated of this kind is wrapped up in the expression 'if I look at my right hand' is further indicated by the clause which asserts that, under the conditions presupposed, what I so pick out is something with regard to which it is the *natural view to take* that it is part of the surface of a human hand. What does Moore mean by saying that the view is '*natural*' to take?

We may of course use the expression 'it is natural to regard A as B' merely to assert that so to regard it is something which happens in accordance with the laws of human nature. In this sense it is presumably quite natural for primitive people to be-

lieve that persons appearing in dreams are spirits wandering from their bodies. But clearly Moore is not so using the expression here. Sometimes we use the expression as equivalent to 'it is very understandable that A should be regarded as B'. And from this it is possible to slide by imperceptible gradations through the sense in which it is equivalent to 'it is not unreasonable to regard A as B' to the sense in which it is equivalent to 'it is *reasonable* to regard A as B'. It is not unlikely, moreover, that Moore is here using the expression in this sense. It well may be that he would be prepared to say that, under the circumstances tacitly assumed, it is in some degree reasonable to regard what I pick out when I look at my right hand as identical with part of the surface of my hand. If so, this is of the highest importance. If there are reasons for so regarding it, these are what we want to know in order to say how we know that a human hand exists.

But the statement 'if I look at my right hand what I can pick out is something with regard to which it is the natural view to take that it is a part of the surface of my hand' must be taken in conjunction with the statement that refers to what, on the other hand, some philosophers have supposed regarding what I so pick out.

It is unlikely that Moore would stress what some philosophers have supposed or doubted just because they have supposed or doubted those things. Almost anything that can be supposed or doubted has been supposed or doubted by someone; whereas what in the present case has been supposed by philosophers is treated with respect. Hence there is a temptation to conclude that what Moore is wishing to do is to draw attention to the fact that under certain conditions it is natural and reasonable to regard what I see as part of the surface of my hand and that under other conditions it is natural and reasonable to suppose that it is not. But there are indications that Moore is not really prepared to commit himself to this simple and straight antithesis.

When we consider the grounds on which some philosophers have doubted whether what I can pick out in the manner described when I look at my hand is part of the surface of my hand,

it is clear that some of these do not constitute adequate reasons for doubt. Some have doubted it simply because what is so picked out under certain circumstances differs from what is so picked out under others, when the part of the surface in question is identical in the two cases. But, as Moore points out, this is no reason for doubt, if we have no reason to suppose that what is so picked out must really possess the properties that it appears to have. On the contrary, if what is so picked out were in fact identical with the part of the surface in question this is precisely what we should expect, for we have many reasons for believing that the same surface may appear to have different properties under different conditions even when it really has the same properties all the time.

There is however another source of doubt to which Moore would seem to attach considerably greater weight. "When we see a thing double (have what is called 'a double image' of it)," he says, "we certainly have *two* sense-data each of which is *of* the surface seen, and which cannot therefore both be identical with it."[3]

But I find it extremely difficult to see why Moore thinks that this differs in any essential respect from the former case. We know that there is only one surface and we know that this one surface appears to be in two different places. It appears in one place to my right eye and in another to my left, just as it may appear to be of one colour to my left eye and of another colour to my right eye, and just as it appears, say, red to the eye and warm to the hand. And, if one surface may appear simultaneously to be in two different places, why should not one "sense datum" do exactly the same? If there is any reason to suppose that the sense datum is identical with a part of a surface this is what we should expect. The difficulty is that so far no criterion has been proposed for deciding when to say of anything whatever 'Here are two different things' and when to say 'Here is one and the same thing appearing at the same time in two different places'.

The fact that Moore does not regard even the difficulty about double images as constituting a fatal objection to the view that sense data are identical with parts of material things

[3] *Op. cit.*, 220.

explains, perhaps, why he does not quite commit himself to a straight antithesis between what it is natural to believe under one set of conditions and what it is natural to believe under another set of conditions, but considers rather the antithesis between what it is natural for anyone to suppose under normal conditions and what some philosophers have as a matter of fact supposed under rather peculiar conditions.

But, now, how do these amplifications help us to answer the question, 'How do I know that this is a human hand'? Clearly, they do not help us very much until we can also specify in more detail what we are knowing when we know that this is a human hand.

Moore considers three possibilities; (1) That what I know is that what I am seeing is really part of the surface of a human hand. (2) That what I know is that what I am seeing has some unique relation to part of the surface of a human hand. (3) That what I know is that if certain conditions should be fulfilled I should see, feel, hear other things that are related to what I am seeing in some rather complicated way.

To the second and third of these views there are objections to which it is difficult to find a suitable reply. The first view (which seems to be the one that Moore would like to accept) has the great merit that it would seem to be the view that the plain man would readily accept. Against this view also Moore finds, as we have seen, what he regards as a serious objection, but an objection which may perhaps be met.

But even if Moore's objection be met, and it is the case that what I see really is part of the surface of my hand, we have still to answer the question: How, when I *do* know that it is part of the surface of the hand, do I know *this*? What else must I know, when I am seeing what I do see when I look at my hand, in order to know that what I am seeing is in fact part of the surface of my hand?

Now, to answer this question what we have to do is to consider the case in which I look at something and, at first, on the data available, do not know whether it be part of the surface of a material thing or not, and then obtain further information in the light of which I reasonably decide that it is.

We have, in fact, three kinds of cases to consider. There is

the case in which I look at what is in fact part of the surface of a human hand under normal conditions and am disposed to regard what I see as part of the surface of a human hand. There is, secondly, the case in which I look at what is in fact part of the surface of a human hand but under conditions which are such that I am disposed to regard what I see as not a part of the surface of a human hand. And there is the third case in which I look at what is in fact part of the surface of a human hand under circumstances in which it does not occur to me either to regard it as part of the surface of a human hand or to doubt whether it can be part of a human hand—circumstances in which, for example, I may merely in an open-minded way wonder what it is that I am seeing.

Situations such as the last mentioned occur with considerable frequency, and they would seem in general to be the simplest cases, the cases in which there is a minimum of prior or concomitant information. One would hazard the guess that this is the situation in which a child is when he first looks at his hand, and it is certainly the situation in which we all are very often when we see something the like of which we have not seen before. In the two other cases there would always seem to be more information at hand. We can either feel or hear something whilst we look at what we see, or we have just previously heard, felt or seen something else, and it is in virtue of what we are also feeling or hearing or have just heard, felt, or seen that we are tempted to believe, disbelieve or doubt with regard to what we see whether it is part of the surface of a hand, and to believe, disbelieve or doubt whether it has the properties it appears to have, or is where it appears to be.

The comparison of these simpler situations with the two more complex situations suggests further that in the former it is not natural to regard what we pick out for attention as part of a material thing and it is equally not natural to doubt that it is part of a material thing, and that, whenever we doubt whether it is part of the surface of a material thing, there is always some other information at hand in virtue of which we are inclined to believe that it is part of the surface of a material thing. In these more complex situations the antecedent and concomitant observations are pretty extensive and varied.

So, too, we note that, when I know that anything is a material thing, what I am knowing constitutes a rather formidable body of facts. I am often knowing, for example, that it now has other sides in addition to those that I am actually seeing, that it has an inside as well as an outside, that it continues to exist between my separate glances at it, that though many of its properties appear to change according to my position in regard to it, all of its properties are not dependent upon my relation to it. And each of these facts would seem to be known in different ways, i.e., on different evidence. The whole story of how I get to know each of these facts, though it may be quite simple in principle, is intricate in detail. The evidence will consist not only in observing different sorts of data but also in observing a variety of 'unique and peculiar' relations between the data. It is, for example, not enough to observe that when I see a surface I also feel an inside, I have also to observe the relation of the surface to the inside. This is a unique relation differing, for example, from the relation between the surface I see and the surface I feel.

But though collectively a formidable body of facts, and although their relations are intricate in detail, the constituent items of information are easy to obtain, so easy in fact that they are obtained very early in life. The child knows that his hand has an inside as well as an outside because he can feel it. He has no difficulty in noticing that what he comes to regard as the inside of his right hand is differently related to what he sees when he looks at his hand from what he feels when he feels what he regards as the inside of his left foot. He learns that his hand has another side besides that which he sees at any moment by turning it round, and by observing the difference between the changes that occur when something comes into existence and the changes that occur when something merely comes into view. He learns that changes in the properties which things appear to have depend upon his behaviour; but he learns at the same time that these changes do not depend upon his behaviour alone. The details of the way in which these things are dis-covered admit of long and tedious description, and for precise analysis require perhaps to be expressed in the elaborate nota-tion of factorial analysis. But, if this be in general the *sort of way*

in which we get to know what we know when we know that
material things exist, the strange fact from which we started is
in principle explained.

We find it difficult to say how we know what we know in
these situations because the evidence consists of a long, if simple
and conjunctive, list of observations which require to be sorted
out and distinguished from irrelevant circumstances. But is this
the *sort of evidence* that Moore is looking for when he asks
how we know what we know when we know that material
things exist and have existed for a long time before we were
born? Or has he in mind evidence of an entirely different kind?

If this is the sort of evidence for which he is asking then we
have got, in principle, the answer to our earlier question: How
far does the pattern of certainty and doubt in Moore's philosoph-
ical position agree with the pattern of certainty and doubt
in the common sense view of the world? The agreement would
seem to be complete. Moore's certainties are the certainties of
the plain man. His doubts and his hesitancies are also doubts
and hesitancies which the plain man would express when asked
to say in more detail what he knows and how he knows it. But
what is more important than this is the fact that Moore's doubts
would be resolved in the plain man's way. The kind of evidence
to which we have referred in deciding whether what we see
when we look at our hands really is part of our hand, and
whether it exists when we close our eyes, is evidence of the sort
to which the plain man, if pressed, would almost certainly refer.
The "Defence of Common Sense" is accordingly a defence of
common sense procedures as well as of common sense results.

If Moore's methods are correct, the conclusion would seem
to follow that the function of the philosopher is not to find
new and technical evidence either for or against common sense
beliefs but to incite or provoke the plain man to find the answers
to the questions posed—the answers which he "naturally" gives,
if sufficiently pressed and kept to the point.

C. A. MACE

BEDFORD COLLEGE
UNIVERSITY OF LONDON

11

Arthur E. Murphy

MOORE'S "DEFENCE OF COMMON SENSE"

MOORE'S "DEFENCE OF COMMON SENSE"

MOORE'S essay,[1] which I propose to examine in this paper, is, in my judgment, one of the few really decisive contributions to philosophical enlightenment which this century has given us. For some of us who first encountered in it the method and something of the substance of Moore's way of philosophizing, it was a work that really changed our minds, so that we could no longer look at philosophical problems in the same way after we had read it, or proceed in the same manner to variants of the traditional solutions. Yet it was, and has remained, very difficult to understand, as the confused and conflicting interpretations and evaluations it has evoked sufficiently testify. It is the source of this difficulty that I want here to investigate. My suggestion is that it arises from the fact that there is much more involved in the philosophical position Moore is defending than his essay makes explicit, and that there are stages or levels of subtlety in his analysis of the nature and knowability of statements forming part of "the common sense view of the world" not sufficiently distinguished in his analysis. Hence it has been possible for otherwise competent critics to dismiss as "strenuously simple," a needlessly elaborate restatement of the obvious, what is in fact the most penetrating attack upon the problem of knowledge of recent times. In attempting to distinguish these stages and to supply what seem to be missing steps in the argument, I shall, of course, run the risk of misinterpreting Moore as badly as have many of his other critics. And I shall have, at some crucial points, to claim that he has either been mistaken in his philosophy or misleading in his exposition of it. If I am wrong, I hope

[1] "A Defence of Common Sense" in *Contemporary British Philosophy*, Vol. II.

that he will show me how and where. Meanwhile, I shall state the case as I see it. It seems to me a good case and one the better understanding of which by our contemporaries would be a considerable aid to adequate and accurate philosophizing.

I

The first stage in Moore's statement of his "philosophical position" with respect to the truth and knowability of certain statements customarily referred to in epistemological circles as part of "the common sense view of the world" seems quite straightforward. He takes great pains to specify the kinds of statement he is talking about and to add that it is statements of these kinds and not "the common sense view of the world" in general[2] that he claims to know for certain, in some cases, to be true. What he holds is that he understands, in their ordinary or popular sense, statements about the existence and behavior of his own body, other material objects in the observable environment, and other selves whose bodies are parts of this same environment, and that he knows with certainty that some of them are true. Since many philosophers have held that all statements about e.g. material objects are false, or partially false, or at least that none can be certainly known to be true, this claim would seem to serve as the appropriate prelude to metaphysical or epistemological controversy of a familiar sort. The striking thing about Moore's procedure, however, is that he does not move on to such controversy in the orthodox way. He does not, that is to say, attempt to refute the epistemological or metaphysical theories of those with whom he disagrees on metaphysical or epistemological grounds. Instead he appeals to the fact that statements of this sort actually are understood by all of us and are known to be true, on the level on which their truth would be esablished if anyone were really in doubt as to their factual accuracy, as distinct from their philosophical analysis and validation. If I know that I have a body, and I certainly do know this, then I know that at least one material object exists. The proof that there is such a material object is the proof that I do in fact have a body, and this can be established so

[2] *Ibid.,* 207.

conclusively on the level of familiar experience that only "a fool or an advanced thinker" would be rash enough to doubt it. But if there are material objects, and if we do in this way know for certain that there are, then any philosophy which denies that there are, or that this is known, must be mistaken, since it conflicts at this point with what is known to be the case. It ought, therefore, to be rejected, even if we were unable to say in detail what was wrong with it epistemologically or metaphysically, as being incongruous with conclusively established matters of fact.

It is the abruptness of this appeal to what is simply known to be the case, as distinct from what considerations based on the ultimate nature of reality or a critical doctrine as to the epistemological possibility of "knowledge of the external world" would lead us to conclude, that has made Moore's procedure so disquieting. Yet, on the level on which he is working, it is surely the right sort of consideration to adduce. The statements he defends as part of the common sense view of the world are of the sort people make when they are getting about in their palpable material and social environment and distinguishing what is illusory or deceptive in it from what can be established, often quite conclusively, as substantial matter of fact. They find, as we all do, that things are not always what they seem, that what looks like a solid object or a familiar face may prove, on further inspection, quite other than it appeared. But they also learn the precautions to take in guarding against such mistakes, and are frequently able, under fortunate but familiar conditions, to know for certain that what they say is so. To prove them wrong in this would be to prove that what they say is not so, or that there are at least good grounds for supposing that they have in some way been deceived. If someone who is in a position to know tells me that the person I thought I recognized as Mrs. Roosevelt is really not she but only someone resembling her, a pertinent doubt is raised in my mind. But if I am told that I could not really have seen Mrs. Roosevelt because only sense data are really seen while the First Lady must always be, for me, an hypothesis or "leap of animal faith" and that even after all reasonable inquiries on the empirical, factual level have

given confirmatory results I ought still to be in doubt as to
her real identity, in the sense in which, in my original statement,
I affirmed it, I should properly recognize the comment as im-
pertinent and, in the circumstances, trifling. It should have been
obvious from the context that I claimed to see her in the way
in which people are seen, not in the way in which epistemologi-
cal data are sensed, and that the certification appropriate to my
knowledge of her identity is that by which perceptually observ-
able matters of fact are established as known, not that proper
only to logical demonstration, aesthetic intuition or sense aware-
ness. If it is my common sense claim that the philosopher is
examining, then it is in this sense that he ought to understand
it, and indeed would understand it if he were actually con-
cerned with the factual accuracy of my report or the adequacy
of the evidence for it, rather than with his own epistemological
stipulations as to the criteria to which *real* knowledge must
conform.

If, then, anyone seriously claims that we do not know for
certain the truth of some of the statements Moore enumerates
as parts of the common sense view of the world, when these are
understood in their ordinary or popular sense, the appropriate
answer seems to be the one he gives, namely, that we do know
some of them quite well, as well, indeed, as facts of this sort
could be known, and hence that any theory which claims that
they are not true or not known is evidently mistaken. The
proper way to "defend" common sense is to show, in specific
instances, that what it claims to know *is* known, and known in
the manner which, in the ordinary or popular sense of our
familiar usage, enables us in favorable instances to know for
certain—the way in which some people have known that they
saw Mrs. Roosevelt, and that there was no doubt whatever
about it.

This, so far as it goes, is not only a good "defence of common
sense," it is a model of what such a defence ought to be. For it
evaluates the knowledge claims it examines in terms of their
own intent and ascribes to them the validity they are capable of
maintaining in the kind of activity in which they have an un-
ambiguous use and application. The result is in one sense mod-

est, but it is also quite fundamentally important. There are a great many questions about the nature of the world and the adequacy of our knowledge of it that cannot be answered by reference to what, in this way, we know to be the case. Common sense is a good guide to certain of the more obvious facts about our existence, but there is much that is beyond its scope. To make it the measure of all truth or the privileged source of philosophic wisdom would be a serious mistake. Fortunately, it is a mistake which Moore's method gives us no excuse for making. The "Defence of Common Sense" does not solve the riddle of the Universe or disclose a unique faculty for "just knowing" the nature of things. It does, however, give a plain indication of pedestrian, palpable and sometimes important facts that we do know and can depend on. And it is philosophically conclusive as against any of the romanticisms and scepticisms of the time which attempt to undermine the cognitive authority of literal, matter of fact knowledge by their pseudo-profound demonstrations that we "really" know nothing for sure and must, in consequence, resort to dubious intuitions or leaps of faith to find grounds for believing that there is an "external world" which is other than a figment of our own thought or imagination. The final answer to such scepticism lies in what we know and in the reasonable assurance that this is in fact what we take it to be. And such, as I understand it, is the answer that Moore has given.

II

So much for the first level on which the defense of common sense can be made. It is a proper and reasonable one and the conclusions reached on it will not be set aside by subsequent analysis. But the issues raised at this level are not the only ones, or even the usual ones discussed in philosophical criticisms of "common sense" and its claims, and it has required a certain amount of artful innocence even thus far to avoid more allegedly "ultimate" problems. There is indeed a sense in which "we all understand" such statements as that my body has existed for many years past, and a sense in which we know for certain that they are true. But this is not the sort of understanding that philosophers have normally been seeking when

they inquired into the meaning of common sense beliefs, nor the kind of certainty they have expected of "knowledge" *rightly* so called. And in these further senses it is unhappily the case that we do not understand statements about observed material objects until they have been subjected to an analysis which "common sense" is quite unprepared to make, and that the usual result of such analysis is a version of what we were supposed to be "really" knowing on the common sense level, which makes it very difficult to believe that anything of the sort is known after all. Hence the assurance we previously achieved seems not what is wanted philosophically, while when we do go on to ask the "ultimate" epistemological questions "common sense" proves to be a highly dubious oracle, properly viewed with the suspicion habitually directed on it in speculative circles.

It is for this reason, I think, that many philosophers have been dissatisfied and sometimes irritated with Moore's "Defence." They have first supposed that he was maintaining that a faculty called common sense can provide certainly correct answers to the kind of question about e.g. our knowledge of material things which they found philosophically exciting. And they have rushed up heavy artillery to attack this supposed "position." When they began to see, however, that what was actually defended was common sense about its ordinary factual and non-epistemological business, not common sense as a pretender to the kind of certainty and "ultimacy" which are the objects of their own aspirations, they have tended to feel that the analysis, though perhaps accurate, is philosophically irrelevant. No doubt in *that* sense we understand such statements without benefit of critical philosophy and by ordinary criteria "know for certain" that some of them are true. But what of it? The philosopher's quest has not been for fact, empirically established, as the identity of Mrs. Roosevelt can in some cases surely be, but for something that is necessarily the case, as a valid logical demonstration is necessary, or something wholly and immediately "present to the mind" as a sensed datum is present to it. Does Moore mean to say that I "know for certain" that my body as a material object has existed for years past in some such ultimate or philosophically important sense of "know for certain" as

this? If so, there are plenty of critics who will show that he is wrong, by observing sapiently that I do not "really see" the back of a solid object, looked at from the front, in the way in which I see the datum which common sense would (mistakenly) regard as its front surface and that there are any number of ways in which I might be wrong about an object which thus "transcends the datum," where I could hardly be mistaken about the datum itself. If, however, he is only claiming for common sense the common or garden variety of empirical certainty, in terms of which it makes sense and is true to say that while the possibility of error is not excluded *ab initio* by the peculiar nature of the object known and my direct cognitive relation to it, it is excluded in this instance by the fact that I do definitely know what the object is, in the respect specified, and hence certainly *am* not mistaken, why does he not say this plainly? It would then be possible for professional epistemologists to view the defense of common sense with the tolerance proper to such lowly breeds of knowing and proceed to deal, by their own more exacting standards, with really basic issues.

It must be admitted, I think, that Moore's own language has given some ground for misunderstanding on this matter. And I am not at all sure that the difficulty is a merely linguistic one. There seems to me no doubt that when Moore says he "knows for certain" facts about observed material objects and other selves he *ought* to be claiming the kind of certainty that is got in our ordinary traffic with such objects and persons—by observing and working with them and checking our observations with those of our fellows. Such certainty is the fruit of empirically familiar transactions and presupposes neither the presence of the object as a datum of sense nor an insight into the logical necessity of its being as it is. It would be absurd to expect that sort of certainty in this sort of situation, and Moore is not a philosopher who mistakes absurdity for profundity. I shall assume, therefore, that when he says he knows such facts for certain he means no more than any one of us would mean when, in the course of his commerce with his observable environment, he distinguished what was established for certain from what was empirically uncertain or doubtful. Malcolm has given a very

helpful account of this use of "certainty" in a recent number of *Mind*[3] and he seems to be confident that his view follows that of Moore. It would be reassuring to know that such is the case.

Yet if Moore is using "know for certain" in this sense, much misunderstanding could have been avoided if he had said explicitly that this was what he meant. For, as Malcolm observes, "People, listening to Moore, sometimes get the impression that Moore thinks that it is by some sort of *intuition* that he discovers whether the truth of a statement is certain. They get the impression that Moore thinks that certainty is a simple, indefinable quality like yellow, which unaccountably attaches to some statements and not to others."[4] I cannot help thinking that in some instances it is some such impression that Moore's words naturally convey. Thus, in answer to the question whether he really knows the statements he has been discussing (e.g., that "my body has existed for many years past") he says "I think I have nothing better to say than that it seems to me that I *do* know them, with certainty."[5] Assertions of this sort do seem to suggest that the final decision in these matters lies with an esoteric faculty of just *knowing* which is not susceptible of further elucidation. And it is not to be wondered at that, in default of a more specific account of the way in which empirical certainty is established, those who are on the lookout for philosophical mysteries should have found one in Moore's reiteration that it just seems to him that he *does* know for certain facts which other philosophers have professed to find extremely doubtful.

Whether or not there has been any mystery here, it should now be clear that for the adequate defense of common sense there need be none. In the sense in which "know for certain" would be understood by all of us in cases where the factual accuracy of statements on the common sense level is in question we do know for certain that some are correct and in such instances we are quite certainly not mistaken. In the sense of "know for certain" which many philosophers have habitually employed

[3] Malcolm, N., "Certainty and Empirical Statements," *Mind*, n.s., Vol. LI, No. 201, January, 1942.
[4] *Ibid.*, 40.
[5] *Op. cit.*, 206.

when they looked to logical demonstration or sense awareness or some other such faculty for an immediate grasp of a kind of object about which we could not possibly be mistaken, we do not know for certain that statements on the common sense level are true. And it would be absurd to suppose that we did.

There is a further central point on which there is much less excuse for misunderstanding. Moore has taken pains to distinguish understanding what common sense statements of the sort he is defending mean, in the sense in which we all do understand, from knowing the correct analysis of the propositions which these statements express. What knowing the analysis of a proposition consists in, on Moore's view, it would not be easy to say in any general way. Fortunately, however, it is not necessary for our purposes to settle this point. The instances Moore offers make it plain that to analyze a proposition about an observed material object (e.g., "This is my hand") is to indicate the sense datum "which is *a* subject (and, in a certain sense, the principal or ultimate subject) of the proposition in question"[6] and to state what it is that I am knowing about this sense datum and its relation to the material object observed (whether e.g., it is a part of the surface of that object) when I know that "this is my hand." Now this is just the sort of thing that epistemologists have been interested in finding out and which they have supposed any one else to be "really" saying when he said that an object which he could perceptually identify and observe was his own hand. The common sense view of our knowledge of material objects would, in this usage, be a "common sense" version of this "analysis," that is, presumably, what a person equipped with common sense but otherwise innocent of epistemology would say about the relation holding between a sensed datum and an observed material object in such cases. Hence, when epistemologists attack the common sense version of our knowledge of material objects, what they are attacking is not the quite legitimate claim of sensible men to know what their tested experience warrants them in asserting, but their probably misguided assertions about a quite different issue on which they have usually not reflected at all and on which they

[6] *Ibid.,* 217.

are not qualified to speak. What is sometimes called the "common sense view" in the theory of knowledge is also frequently referred to as "naïve realism." It receives very rough handling in the text books and there is in fact not much to be said for it.[7] What is remarkable is not that professionally critical philosophers should have found it objectionable but that they should have supposed that in refuting this labored version of a mistaken venture into epistemology by supposedly "plain men," they were somehow casting doubt on the genuineness of the factual knowledge of material things which plain men do possess and about whose authenticity there is no genuine doubt at all.

It is at this point that Moore makes his major contribution to this level of the discussion. What he shows is that it is quite possible to understand statements about observed material objects and other selves, in their ordinary or popular meaning, and to know their truth for certain, without knowing what their correct analysis is or which among competing epistemologies gives the right account of what it is that we are "ultimately" knowing when we know them. And the proof is the familiar one: we do know some such statements with certainty while no analysis that has yet been offered comes even near to being certainly correct.[8] This brings the whole issue between common sense and epistemology to a new focus. For on the one hand it explicitly leaves open questions that could not properly be settled on the common sense level, and thus relieves common sense of any suspicion of dogmatic and illegitimate pretensions, and on the other it enables us as philosophers to treat as settled issues that on that level *are* settled. We are thus released from the curious sort of scruple supposed to be a mark of critical refinement which leads men—simply because no convincing epistemological version of what knowing such facts "really" consists in has yet been devised—to profess uncertainty about facts they know perfectly well. The essential point, once more, is not that the plain man has some primitive but infallible way

[7] See, on the frailty of common sense thus interpreted, C. D. Broad, *The Mind and Its Place in Nature*, 184ff. and on "naïve realism," similarly described, H. H. Price, *Perception*, chapters II and III.

[8] *Op. cit.*, 223.

of knowing the answer to the problems which excite epis-
temologists, but that he requires no such knowledge in order
to justify his claim to "know" in a quite clear and proper sense,
the existence and observable nature of objects and persons in
his environment. And if any epistemologist claims that such
facts as these are not known, or that they ought, on analytic
grounds, to be regarded as highly doubtful, he is quite certainly
mistaken.

III

We seem here to have reached an irenic conclusion and to
have attained the kind of linguistic enlightenment which now
passes for critical philosophy in many circles. If we adopt
Moore's "language" with its specified criteria for "understand-
ing" and "knowing with certainty" then it is "proper to say"
that we understand and know with certainty such statements as
he defends. If, however, we use "understanding" and "know-
ing with certainty" in the epistemologist's sense, then we cannot
be said to understand these statements until we know their
analysis or know them with certainty unless we can show how
they are reducible to statements about objects known in a more
"ultimate" and eligible way, or logically derivable from what
we "know" of such objects. In *that* sense common sense does not
understand what it asserts or know with anything approaching
certainty what its knowledge of the external world ultimately
consists in. Hence "in a sense" Moore and the critics of common
sense are both right. Their dispute is not about any matter of
fact, since each would presumably agree that what the other
says about common sense is true, in the sense in which it has
now been interpreted. Their difference is really about the
language to be used in describing facts which are not themselves
in question. And since language tolerance is the order of the
day we might diplomatically conclude that either language will
serve, according to one's preference, and that concerning pref-
erences there can, of course, be no dispute.

There is a measure of truth in such a conclusion, but as it
stands it is more misleading than helpful. For actually neither
party to the dispute would be appeased by it, nor would it settle
the primary issue between them. It does, however, serve to

indicate more clearly what this issue is, and thus to bring us to the level of philosophical criticism on which it can adequately be adjudicated. The epistemologist does not merely want to use the terms "know for certain" and "understand" in a peculiar way. He wants to suggest by this usage that only what is understood or known in this way is "really" or "ultimately" understood or known at all, and hence that what is not thus known is somehow philosophically suspect and dubious until its credentials are certified by reference to this ultimate or final knowledge. The understanding which is sufficient for common sense purposes is therefore philosophically of a makeshift and derivative sort, since it does not make plain the *ultimate* subjects of the propositions which its statements express—the sense data which are (in a sense) the ultimate and principal subjects of the propositions we know when we observe material objects. While, therefore, a certain provisional validity may be assigned to such statements, it is not the sort which as philosophers we can finally accept, and it appears to require a ground, support or validation in something more ultimately understood and really known.

The major value of Moore's way of doing philosophy, as I see it, is that it enables us to see the arbitrariness, or rather the inanity, of this whole approach to the subject. What does it mean to say that while we know material objects by perceptually observing them, such knowledge is not ultimate or final or philosophically satisfying? What sort of knowledge of material objects should we expect to have? To be sure we gain our perceptual information about such objects through such expedients as looking at them, and what we thus see of them is the way they look, under the conditions in which they can be observed. But how else would a human organism see a material object? Should we have a better or more ultimate knowledge of it if we turned our attention from the object seen to the sense datum, which the epistemologist isolates for inspection, and then theorized about the relation between this datum and the material object which he holds that we must ultimately be knowing when we discover, by perceptual observation, the nature of material objects around us? It would be interesting to know how much

reliable information about the observable properties and be-
havior of material objects has been secured by this process.
Actually, we do not in this way get a better sort of knowledge
about the objects with which common sense was concerned or a
surer foundation on which to base its claims. If anyone is in
doubt as to the existence or nature of the objects in his environ-
ment he will not be reassured or enlightened by the analytic
procedure the epistemologist recommends. This procedure no
doubt has its uses, but to suggest that one of them is to reveal
the *real* ground or basis for what perception on the common
sense level discloses is wholly to misconceive its function. There
is no other, better or more ultimate way of knowing the facts
about the world which intelligent perceptual observation dis-
covers than through the continued use of just such observation.
Both epistemology and the exact sciences are dependent upon
it for information without which they could not stir a step, and
the notion that some esoteric intuition or speculative gadget
is required to validate its claims and render assurance philo-
sophically assured is quite mistaken. The way in which we know
material objects and other selves on the level of common sense
is the way in which, as philosophers acquainted with the various
methods of knowledge getting and the manner of their suc-
cessful use, we should expect to know them. And insofar as the
language of the epistemologists has led, and was designed to
lead, men to suppose that this was not the case, it is not a mere
preference for a "proper" terminology but a preference for
philosophical good sense about the appropriate tests for factual
knowledge that should lead us to condemn it. The information
perceptual observation gives us of the existence of a material
world is not just something we may be permitted to "call"
knowledge if we get comfort out of the use of that term in that
connection. It is what in the light of all that good sense, science
and philosophy can tell us about the world and our ways of
finding out about it, is actually established as matter of fact
beyond all pertinent or reasonable doubt, by the best method
available for that purpose. The "advanced thinker" may con-
tinue to sigh for some more "ultimate" revelation, some higher
dispensation which would reduce the world to a logically neces-

sary system or a collection of sense data so that he might *really* know it in the way he has settled on in advance as the only *ultimate* way of knowing. But his continued refusal to credit as knowledge whatever fails to satisfy his stipulation is neither linguistic penetration nor philosophic wisdom. It is simply a particularly stubborn refusal to accommodate his preconceptions about what knowing ought to be to the facts about the ways in which trustworthy information is acquired and tested. The fool and the advanced thinker have more in common at this point than Bradley, in his witty coupling of them as confirmed doubters, seems to have understood.

What we need to say, then, to make good a philosophical defense of the known truth of the familiar statements which form part of the common sense view of the world, seems to require three levels or stages for its saying. On the first it is affirmed that there *is* a sense, which we all understand, in which it is proper and true to say that we know for certain that some such statements are true, and that, since they are thus known, anyone who claims that they are not is certainly mistaken. This disposes of any philosopher who has claimed that common sense thus interpreted could not attain to certain knowledge of matters of fact. On the second level these senses of understanding and knowing for certain are distinguished from others familiar to epistemologists, and it is made plain that while the claims of common sense interpreted in this further way would be quite indefensible, there is no good reason for so interpreting them, since what is known on the common sense level can be known without this further knowledge which in fact neither common sense nor the epistemologist reliably possesses. On the third level it is maintained that the kind of understanding and knowing so far defended are precisely the sort which a philosophically comprehensive estimate of the world we live in and our ways of finding out about it should have led us to expect in this situation. Such knowing does not conform to the pattern of clarity and certainty which a philosopher intent on reducing the world to logic or analyzing it into sensations would require, but it is wholly arbitrary and unreasonable to demand that it should. And while it is not "final" as satisfying the

epistemologist's or metaphysician's aspirations, it is quite "ulti-
mate" as a source of reliable and in some cases certainly truthful
information not otherwise procurable about the world around
us. We know, for example, that there is an external world be-
cause we perceive it, and neither epistemological ingenuity nor
metaphysical construction has so far revealed any other or better
way of knowing this important fact or any surer ground for
believing in it than that which perceptual observation, on the
level of common sense experience, provides. It is not merely as
men of common sense but as philosophers that we acknowledge
the cognitive authority of factual information thus derived and
build upon it. The respect for fact on this familiar level is very
far from being the sum of philosophic wisdom, but it is an
essential part of it, and many ambitious systems have failed
lamentably for want of just the sort of fundamental sanity
which it provides. Thus in defending common sense against its
critics and exhibiting once more its primary and authentic
cogency, Moore has made an important contribution to philo-
sophical good sense. And the store of good sense in contempo-
rary philosophy is not so great as to justify any of us in neglect-
ing or underestimating that contribution.

It would be pleasant to conclude this discussion here, and on
the note of gratitude which Moore's essay merits. There is,
however, a further and troublesome point which ought to be
cleared up, and about which, so far as I can see, Moore is very
probably mistaken. It concerns the function of "analysis," as
outlined in the final section of his essay,[9] and it has an important
and disturbing bearing on what had previously been said in
defense of common sense. Moore *seems* to hold quite definitely
that it is possible to "know for certain" that such a statement as
"this is my hand" is true without knowing the analysis of the
proposition to which it refers. For he holds repeatedly and em-
phatically that he does know a statement of this sort about his
own hand, while he maintains that no analysis of it with which
he is acquainted is known by him or anyone else to be the right
one "with any approach to certainty." This seems right, and

[9] *Ibid.*, 216-223.

consistent with the position here outlined. Yet when he does analyze "this is my hand" he says that he is quite certain that it has for a subject "and in a certain sense its principal or ultimate subject" a sense datum, and his question about the analysis of the proposition is stated as if it were a question about what I am knowing to be true *about this sense datum* whenever I know that "this is my hand." Is the datum itself a part of the surface of my hand? Or is it the appearance of the hand, the latter being not itself directly perceived but known by description as the object related to the sensum in a certain way? Or is the sensum simply one of a class of data (none of which, of course, is itself a hand) so that what I am knowing is some predictable relation among such data? Apparently Moore does not know any of these things, since he regards each of the versions offerred as very dubious. Yet he never questions that something of this sort must be what he is knowing when he knows (on the common sense level) that "this (perceptually indicated) is a hand." I find this difficult to accept or to reconcile with what went before. So far as I can see the proposition Moore knew and could verify did not have a sense datum for its principal and ultimate subject at all. No sense datum need be referred to and no proposition of the sort discussed about its relation to one's hand need be known in order to know with certainty that what is observed is in fact a hand. And this is fortunate since, on Moore's showing, we do not know what this relation is. If we had to be knowing what only a correct epistemological analysis, not yet satisfactorily performed, would disclose when we know that "this is a hand," there would thus be considerable ground for scepticism about common sense knowledge after all. In fact, the assumption that something of the sort *must* ultimately be what we are knowing, appearances to the contrary notwithstanding, is one of the most familiar sources of such scepticism. Moore rejects the sceptical conclusion, but he seems, at least at times, to have retained the assumption from which it was naturally derived. Yet his own philosophy provides the grounds for rejecting this asumption as gratuitous and misleading. Once common sense statements are interpreted in the context of their familiar use and testable validity, the claim that they are "ulti-

mately" about the way in which sense data belong to or represent material objects becomes extremely unplausible. I can verify the fact that "this is my hand" quite conclusively, but how is the fact that a sensed datum is, in a peculiar sense of part, a "part" of its surface to be verified? And how can it properly be said that the latter is what I am knowing when I know the former, when, after patient analysis, it does not appear to be known at all? That the ultimate subjects of perceptual knowledge are sense data, and that what the propositions common sense knows about observed material objects assert is what a correct epistemological analysis would finally reveal about such data is not something which the analysis of common sense discloses in, but something that traditional epistemology imposes upon, the perceptual situation. The persistance of this conviction in a philosophy which provides the means for its effective elimination is impressive evidence of the tenacity of the traditional point of view.

I may be mistaken in supposing that Moore has here reverted to a theory incompatible with the philosophical commitments of his defense of common sense. Perhaps I have missed some subtlety in this version of analysis which removes the apparent puzzle about what we must be knowing, and cannot see that we do know, when we are knowing what we obviously know for certain. But whether or not there has been confusion here, it should be clear that there need be none in the philosophical position I have outlined. Propositions about perceived material objects need have no more "ultimate" subjects than their ostensible subjects, the material objects perceptually indicated and observed. And the known truth of such propositions need not wait upon any epistemological analysis of sense data, for it was not about the results of such analysis that the propositions were asserted. Any such result, moreover, if it is a correct analysis, must be compatible with the fact that such propositions as "this is my hand" are known to be true. And with this we return to the position previously outlined.

DEPARTMENT OF PHILOSOPHY
UNIVERSITY OF ILLINOIS

C. H. Langford

THE NOTION OF ANALYSIS IN MOORE'S PHILOSOPHY

12

THE NOTION OF ANALYSIS IN
MOORE'S PHILOSOPHY

ANY examination of Professor Moore's philosophical posi-
tion would be incomplete without a discussion of his no-
tion of analysis, since, as is well known, this notion plays a
decisive rôle in determining the character of his views. Like
other philosophers, Moore has of course used analysis for the
purpose of answering philosophical questions and clarifying
philosophical ideas. But a man may employ the method of
analysis without recognizing that he is doing so, and we must,
in any case, distinguish between giving analyses of philosophi-
cal ideas and making use of the notion of analysis. When, for
example, Moore somewhere tentatively suggests that an action
is right if and only if it will be productive of at least as great a
balance of good over evil as any other action open to an agent
on a given occasion, he is merely suggesting an analysis of right
conduct; but when he tells us that the notion of the good is un-
analyzable, or again that perceptual judgments are analyzable,
he is making use of the notion of analysis.[1]

Perhaps the most important use which Moore makes of this
notion is in his defense of the doctrine of common sense, where
he is concerned to refute certain opposing views.[2] There is, for
example, the view that the common notion of time is self-
contradictory, in such a way that no temporal judgment except
a negative one can be wholly true, since nothing can literally
happen before, or simultaneously with, or after anything else.

[1] See *Principia Ethica*, 37, and *Philosophical Studies*, 220ff.
[2] "A Defence of Common Sense," in *Contemporary British Philosophy*, Second
Series, 193-223, and see also "The Conception of Reality," reprinted in *Philo-
sophical Studies*, 197-219.

Moore holds, if I have understood him correctly, that any argument to the effect that time is unreal must involve some analysis of the notion of time, and that the conclusion of such an argument will itself show this analysis to be incorrect. Possibly some people who have tried to show that time is unreal, by arguing that the notion of time itself entails a contradiction, have been unaware that they were making use of an analysis of this notion; possibly others have been aware of this and have held that the analysis employed was plainly a correct one; but however that may be, it follows from the doctrine of common sense that the conclusion of such an argument must be taken to refute its premises, and one of these premises will be that such and such is a correct analysis of the notion of time.

A somewhat similar example is to be found in another startling view, which has been advanced by some philosophers, to the effect that human beings never do actually see physical things, such as tables, chairs, and trees, despite the fact that they constantly suppose themselves to do so. What people actually see, according to this view, are various sensible appearances; and they systematically confuse these appearances with physical objects. Any one who advances an argument purporting to establish such a view, however, must tell us what it means to see a physical object, must give an analysis of that common notion. Moore would say, I believe, that from the mere fact that, were this proposed analysis correct, nobody could ever have seen a physical thing, it follows that the analysis is actually incorrect. Finally, Professor Moore has said many times over that he can on occasion know a given proposition to be true without at the same time knowing how to give an analysis of that proposition in certain respects. In enunciating this doctrine he is, of course, making use of the notion of analysis.[3]

It is indeed possible to deny that analysis can be a significant philosophical or logical procedure. This is possible, in particular,

[3] Thus: "I am not at all sceptical as to the *truth* of such propositions as 'The earth has existed for many years past', 'Many human bodies have each lived for many years upon it', i.e., propositions which assert the existence of material things: on the contrary, I hold that we all know, with certainty, many such propositions to be true. But I am very sceptical as to what, in certain respects, the correct *analysis* of such propositions is." "A Defence of Common Sense," 216.

on the ground of the so-called paradox of analysis, which may be formulated as follows. Let us call what is to be analyzed the analysandum, and let us call that which does the analyzing the analysans. The analysis then states an appropriate relation of equivalence between the analysandum and the analysans. And the paradox of analysis is to the effect that, if the verbal expression representing the analysandum has the same meaning as the verbal expression representing the analysans, the analysis states a bare identity and is trivial; but if the two verbal expressions do not have the same meaning, the analysis is incorrect. One is tempted to say that there must be some appropriate sense of "meaning" in which the two verbal expressions do have the same meaning and some other appropriate sense in which they do not. A view answering to this requirement will be discussed below. But it is possible to argue that having the same meaning does not entail triviality, owing to important grammatical differences between the verbal expressions involved, and a view to this effect will also be considered.

So far as I know, Professor Moore has not attempted to apply his method of analysis to the notion of analysis itself. He has made remarks concerning this notion which serve to clarify it in certain respects, especially in his discussion of indefinability in *Principia Ethica*,[4] but he has not, I believe, attempted to examine systematically the question what relation it is that must hold between an analysandum and an analysans in order that the latter should correctly analyze the former. On his own view, it is not necessary that he should do this. But the important part played by the notion of analysis in his philosophical position makes it nevertheless desirable. I am therefore going to proceed in the following way. I am going to present two views of the nature of analysis, to be called the first and the second view, in the order of their presentation. I am going to do this in connection with a series of examples, some of which are designed merely for illustrative purposes and others of which have a degree of intrinsic importance. The purpose of this procedure is twofold. I want first of all to induce Professor Moore to state more explicitly his own position regarding the nature of analysis, and I

[4] Sections 6-13 and *passim*.

want also to ask, in the case of each of the two views, whether the analysis of the notion of analysis suggested tends to support those doctrines in the expression of which Professor Moore makes use of this notion. Any analysis of the notion of analysis must of course be self-applicable, and the question whether a given view adequately characterizes itself will be an important question concerning its correctness.

We may first direct attention to a remarkable and important characteristic of language. There are, in the English language, sentences which have never been used, and some of these will be uttered and immediately understood tomorrow for the first time. There are, similarly, descriptive phrases, such as "the tallest mountain in the state of Virginia," which we understand without instruction and which we ourselves employ without hesitation on the first occasion of their use. If it were not for this property of language, we should find it impossible either to convey new information or to record new observations. A language in which the meaning of each sentence had to be independently specified would be a mere collection of idioms, and any assertion that was intelligible would be trite. There are, indeed, in any natural language sentences whose meanings have to be independently specified. "It looks like rain" is such an English sentence; unless we use it in reference to a waterfall or to rain that is actually falling. It is not, of course, that the sentence "It looks like rain" cannot be used to express many different judgments; on different occasions of its use, this sentence, like a standard one, will express judgments varying in their indexical elements, such as time, place, and the like; but it differs in principle from a standard sentence in that its meaning cannot be derived from the meanings of its component parts. There are also English sentences which are quasi-idiomatic in character. Why, for example, should we be told, "All that glitters is not gold," which ought to mean, according to standard grammatical principles, that all things that glitter are not gold, but actually means, according to idiomatic usage, that some things that glitter are not gold? Why, again, is the assertion "It has not stopped raining" false if made on a sunny day? And why is it that the statement "I haven't seen him recently" does

not entail "I haven't seen him sober recently"? Such sentences would be misinterpreted by a foreigner who was making use of his dictionary and grammar book.

The distinction between a phrase or sentence which can be understood on the first occasion of its use and one which cannot has long been employed by linguists to distinguish a standard expression from an idiom. I am going to borrow this term "idiom" for my present purposes, and I am going to proceed immediately to misuse it in two ways. First, an idiomatic expression looks as if it had a grammatical form. This is a pointless restriction for my purposes, and I propose to call a single word an idiom if only it is such as could not be understood on the first occasion of its use and is not an abbreviation or a contraction of a verbal expression which could be. In the second place, I am not going to be at all careful to refer only to verbal expressions as idioms. A verbal expression is idiomatic in virtue of an idea which it expresses, and I am going to say that an idea is idiomatic if it has been formed, not with the aid of grammar, but by cognitive contact with objects to which it applies, or, in other words, if it has been ostensively defined.

Charles Peirce has called a concept a conscious habit. In so doing, he presumably meant to hold that a concept was the power to recognize objects as being or not being of a certain sort, and that this power was developed through experience of objects of the kind in question as well as of other objects. Such a characterization seems unobjectionable, and indeed instructive, when applied to ostensively defined ideas or idioms; but it does not apply to an idea like that expressed by "the tallest mountain in Virginia." This latter may be thought of as a resultant or function of several conscious habits, but it is not itself a habit in any sense at all. Let us consider, however, an idea which is idiomatic and which therefore might properly be called a conscious habit. When we ask in English, "Does A know the meaning of the word chair?" we commonly intend to ask, "Does A know that the word chair means such-and-such?" Yet one might play upon an ambiguity here and reply, "Yes, A knows the meaning of the word chair, because he knows the meaning of the word *Stuhl* and these are the same, although he speaks no English." But if

A had been deaf and dumb from birth and had yet had good vision and the like, might he not in this sense know the meaning of the word chair? In other words, might he not know what a chair *is*? I suppose that to know what a chair *is* is to know how to recognize chairs, how to discriminate them from other objects and from one another, in short, to know how to form the class of chairs. We may therefore say that A knows what a chair is if he has formed a certain conscious habit of recognition.

The first view that I am going to suggest concerning the nature of analysis can now be adumbrated. Suppose that we have before us an analysis of a single idiomatic idea. Then, in passing from the analysandum to the analysans, we shall observe that there is, in some sense or other, a decrease in idiomatic content. The analysans will be more articulate than the analysandum; it will be a grammatical function of more than one idea. One who uses the verbal expression representing the analysandum will mention objects of a certain class; one who uses the verbal expression representing the analysans will mention these same objects, but will mention them descriptively by reference to other kinds of objects. The two verbal expressions will therefore not be synonymous; but the analysandum and the analysans will be cognitively equivalent in some appropriate sense.

Suppose that we are trying to teach a child by an ostensive procedure what a square object is, or, in other words, that we are trying to teach him how to form the class of square objects. We may present to him a great variety of things, some of which we designate as square and others as not square, in the hope that he will catch on and be able to proceed on his own initiative. It is, I imagine, possible to develop a high degree of discrimination by such a procedure, and we may suppose this to have been accomplished. Then, on each occasion on which the child recognizes an object as being square, there will be something else that is true: it will always also be true that the object in question has *four* sides. But we must not hastily conclude that he will recognize or be able to recognize this fact. For to recognize that a square has four sides requires knowing what the number four *is,* and this is tantamount to knowing how to form the class of quadruples. In order that a child should know what the

number four is, it is necessary that he should be able to know such things as: the sides of a square, the legs of a dog, the wheels of an automobile, and the noises *one, two, three, four*, are alike in being quadruples. It would hardly be plausible to maintain that the ability to effect such comparisons is involved in the ability to discriminate objects which are square from those which are not. Yet that an object have four sides will be a necessary condition that it be recognized as being square. And we may therefore conclude that a fact can be causally effective in recognition even though it is not itself recognized.

Perhaps the simplicity of this example makes it less suitable for illustrative purposes than a somewhat more complicated example. The reader will know how to recognize a cubical object, such as a die, a cube of sugar, or a cubical container. Let him then answer immediately the question: How many edges has a cube? In order to recognize an object as being a cube, it is not necessary to form the class of its edges and compare this class in respect of number with other classes; it is not necessary to know, for example, that the edges of a cube are, in a certain respect, apostolic, that a cube is related to the Apostles in that both they and its edges are twelve. And if a person does not happen to know how many edges a cube has, but proceeds to find out by counting, then having twelve edges can be no part of his notion of what a cube is, since, if it were, he would then not know what it was the edges of which he was counting. Such a person will recognize an object as being cubical, however, only if it has twelve edges in point of fact. I am trying to maintain that the property of being a cube is not a truth-function or any other logical function of the property of having twelve edges.

Before we go on to examine further examples of analysis, I think I had better clear up three points which, if left in abeyance, would very likely cause confusion. I have spoken above as if, given an idiom to be analyzed, an appropriate analysans would be a function exclusively of other idioms. But in fact I wish to allow the analysans to be a function of the analysandum as well. This is because I wish to say that when we point out that being a cube entails having twelve edges, we have given an analysis of this notion, in the sense that we have explicated it in a certain

respect, and yet, of course, having twelve edges cannot stand to being a cube in the relation of analysans to analysandum as explained above. I am therefore going to make use of the triviality that P implies Q if and only if P is equivalent to P & Q in order to be able to say that "X is a cube if and only if X is a cube with twelve edges" is an analysis of the notion of being a cube. When the analysans is not a function of the analysandum, we may say that the analysis *removes* an idiom, and when it is a function of the analysandum, we may say that the analysis *mitigates* an idiom. This way of putting the matter is of course formally arbitrary and without theoretical significance; it serves merely to enable us to maintain a more uniform terminology than would otherwise be possible. To be sure, the purpose of an analysis is often that of superseding an idiom by a merely verbal definition in terms of the analysans, and this cannot be accomplished if the analysans is a function of the analysandum. A moralist, for example, may wish to give an analysis of the notion of telling a lie; he may say: "A man is telling a lie if and only if he is asserting a proposition with a view to inducing a hearer to judge that he, the speaker, believes the proposition when in fact he does not believe it or positively disbelieves it." Having given this analysis, however, the moralist may thereupon lose interest in the analysandum and propose to use the words "telling a lie" as short for the verbal expression representing the analysans, although it will not have been a verbal definition that was initially in question, as can be seen from the fact that a common notion controlled the choice of the analysans. Perhaps one reason why we so frequently speak of giving a definition of a common idea, rather than of giving an analysis of it, is that we so often wish to allow the analysans to supersede the analysandum in this way. It must be recognized, however, that this is possible only when an analysis removes an idiom, and not merely mitigates one.

A question also arises concerning the proper way in which to formulate an analysis on the present view. I propose often to use the causal mode of speech: "Anything that was a cube would be a cube with twelve edges and conversely." This serves to obviate the plainly false presumption that the equivalence in

question is merely material; and I think that the causal mode is not incompatible with a stronger relation, that "would be" is not incompatible with "would necessarily be." Moreover, although anything that was a cube with twelve edges would necessarily be a cube, I am not at all sure that the converse relation is anything stronger than a causal one. For the most obvious objection to such a view does not appear to be conclusive. It is, namely, that when a property P causally entails a property Q, we know very well what an object would be like which had P but not Q, whereas the notion of finding a cube without twelve edges is not an intelligible expectation. But the view is that the causal connection in question determines our conscious habits of recognition, and it is not to be expected that we should be able to frame an idea contrary to a principle which governs the process of conceiving itself. This is all very feeble, and I shall not refer to it again; but it forms part of my excuse for adopting the causal mode of speech.

Finally, I have allowed myself throughout a certain falsifying idealization, in that I have not taken account of the phenomenon of vagueness, but have spoken as if the several ideas which occur in an analysis were quite precise. This is of course not the case; indeed, when it is the purpose of an analysis to issue in a definition, the motive is usually that of supplanting a relatively vague idea by a more precise one. Consider a layman's notion of an isosceles triangle. He will perhaps be able to classify triangles as isosceles or not isosceles with considerable facility; but we may suppose that when he is presented with an equilateral triangle, he is simply baffled and does not know what to say. This will reveal a point of vagueness in his idea, and I think we must allow that "having at least two equal sides" and "having exactly two equal sides" are both correct analyses of this vague idea.[5] It actually often happens that the question

[5] We must guard against an error of conventionalism at this point, which consists in saying that the person in question has not made up his mind whether to call an equilateral triangle isosceles or not, as if it were a matter for decision in a particular case. It is the purpose of a general idea, however, to effect decisions beforehand, and anybody who clearly means "having at least two equal sides" or clearly means "having exactly two equal sides" has already determined the answer to the question whether or not an equilateral triangle is isosceles, even if he has

whether an analysis is or is not strictly correct is unimportant. Consider, for example, the definition of a lie just given, as a proposition knowingly so expressed as to induce a hearer to judge that the speaker believes the proposition when in fact he does not believe it or positively disbelieves it. One might object that this allows a speaker to be lying and at the same time speaking the truth, if only he is himself in ignorance of the fact; or one might object that a man must positively disbelieve what he asserts in order to be lying. But so soon as all the different things that might be meant can be clearly set out, what is actually meant on a given occasion becomes irrelevant. This circumstance has, I believe, caused some people to fail to see the importance of analysis. It is true that no mathematician cares much nowadays about Newton's notion of an integral, because more powerful ideas are available. But one who is interested in the foundations of mathematics will be very much interested in the common notion of a natural number, because no satisfactory analysis of this idea exists. Or consider the important class of causal propositions. The statement "Everyone who has attempted to swim this stream has succeeded, but if I had tried I should have failed" is self-consistent, because the first clause expresses a merely factual universal; whereas "Any good swimmer who had tried to swim this stream would have succeeded, but had I been a good swimmer and had I tried I should have failed" is self-contradictory, because this statement is causal throughout. Some logicians arbitrarily construe causal propositions merely as universals of fact, and thereupon translate them into a truth-function formalism. Contrary to all appearances, they may be right; but until some one produces a convincing analysis of these propositions, we shall simply not know what our logic is adequate to.

I want to consider one further simple example of analysis, before going on to a more substantial illustration. In some boxes of children's colored crayons, there is no crayon which

never thought of such a triangle and never will. It is, moreover, not a significant procedure in classification to group objects together merely in virtue of the fact that they are to be designated by the same word, after the fashion of a pun.

is labeled Orange, but instead there is a crayon called Red-Yellow. I suppose that the manufacturers have here provided us with an analysis of a common idiom, which we might express on the present view by saying: "Anything that was orange would be intermediate in color between red and yellow, and conversely." Possibly the converse is dogmatic, but part of the example will survive even if it is disallowed. We may suppose a person who has lived always in a world plentifully supplied with objects orange in color, but who has never seen anything either red or yellow. He will be unable to understand the analysis here suggested, and this will not be due merely to a defect in vocabulary. Yet such a person would not recognize an object as being orange in color unless it was a fact, which he would be unable to recognize, that the object in question possessed a color which was intermediate between red and yellow. We may suppose, further, a second person, who has seen all his life things that were red and yellow, but has never observed anything orange in color. Will it be possible to define for him the term orange so that he will be able to recognize objects to which the term is applicable when they are presented to him? It is to be emphasized that there is no requirement that he be able to imagine beforehand what an object orange in color would be like; people with poor visual imagery cannot do this whatever their experiences of color may have been. The requirement is merely that he be able to distinguish objects as answering or not answering to the definition; and we may suppose this to be possible, as it appears to be . Then there is a sense in which the expressions "being orange" and "being intermediate in color between red and yellow" do not have the same meaning, and there is another sense in which these expressions do have the same meaning. They have the same meaning in the sense that they mean the same things and yet, as Moore has on occasion put the matter, it is no accident that they do, as it would be if the terms red and round happened to apply to exactly the same objects. The sense in question is therefore stronger than that of having the same denotation and is yet not so strong that the two verbal expressions can be said to be synonymous.

It seems desirable not to confine attention to trivial instances of analysis, but to consider examples which have a degree of intrinsic importance as well. It is difficult to find illustrations of this kind which can be presented briefly, but perhaps the example I have chosen will not prove too tiresome.

Let us consider the notion of a command, and that of an imperative sentence which is employed in giving a command. It is sometimes stated in textbooks on logic that to give a command is not to express anything true or false, that imperative sentences do not express propositions. In contrast to such a view, I am going to try to show that giving a command involves expressing a proposition, or, in other words, that the sense of an imperative sentence is indistinguishable from that of the corresponding indicative sentence. If this can be shown, then, according to the theory of analysis we are considering, the idiomatic content of the notion of giving a command will have been mitigated.[6]

Everyone will recognize that there is a loose sense of "meaning" in which an imperative sentence and the indicative sentence corresponding to it do not have the same meaning. This is the sense in which the question "Is it raining?" and the assertion "It is raining" do not have the same meaning. If I use the first of these sentences, that means that I want to know whether or not it is raining, whereas if I use the second, that means that I think it is. But of course neither of the sentences states anything about one who uses it, and a speaker who does so is not talking about himself. Nevertheless, when in ordinary circumstances I use the indicative sentence "It is raining," I intend one to whom I am speaking to judge from my linguistic behavior that I believe what I say and am not considering it as a question or as an hypothesis. We may call what a man does not state, but intends his linguistic behavior to signify, his pragmatical meaning, and we may distinguish this from the sense of his words, which is the proposition expressed by them.[7]

[6] Max Black has argued that to give a command is to express an ordinary contingent proposition, with a view to showing that necessary propositions cannot be construed as imperatives. See *Analysis*, Vol. 4 (1936-37), 28-32, and a review in *The Journal of Symbolic Logic*, Vol. 3 (1938), 92-93.

[7] This term has been used by Charles Morris in the same or a similar sense.

Although the distinction here in question is a familiar one, and has often been drawn,[8] I want to cite an example which is due to A. M. MacIver and which is worth repeating on its own account.[9] Suppose some one to remark: "He thinks that he has been to Grantchester but he has not." The person referred to may entertain this proposition as an hypothesis. But suppose he actually asserts the proposition: "I think that I have been to Grantchester but I have not." This sounds self-contradictory, and the reason is that he will actually be saying that he thinks he has been to Grantchester, whereas the but-clause in the indicative mood will signify or mean pragmatically that he does not think so.[10]

Consider, then, a command of the form "John, close the door," and suppose this command actually to be given on a certain occasion. Suppose, further, that on the same occasion some one remarks: "He will close the door." When we consider what observations would determine whether or not this command was obeyed and what observations would determine whether or not the corresponding prediction was true, we see that these are indistinguishable, and that in fact the two sentences have the same sense, or express the same idea, namely, that of John's closing the door. To be sure, if John did not close the door, we should say that the person who made the prediction had been in error, but should not say this of the person who gave the command. That, however, is because the indicative mood signifies that the speaker believes what he expresses, whereas the imperative mood does not, and we must distinguish between error, which pertains to beliefs, and falsehood, which pertains to propositions. Now

[8] It has been drawn by Moore in his *Ethics*, 125.

[9] See *Analysis*, Vol. 5 (1937-8), 43-50, and *The Journal of Symbolic Logic*, Vol. 3 (1938), 158.

[10] The course of Moore's argument in "A Defence of Common Sense" will be clearer if this distinction between formal and pragmatical contradiction is carefully observed. For in saying that certain philosophers contradict themselves when they assert, in effect, "There have been many other human beings beside myself, and none of them, including myself, has ever known of the existence of other human beings," Moore is not holding that a formal contradiction can be derived from the sense of these words, but only that the pragmatical meaning of such an assertion is incompatible with its literal meaning.

the sense of an indicative sentence is a proposition, and therefore the sense of an imperative sentence is a proposition. Hence, to give a command is to express a proposition.

It may be plausibly argued on the present view that most English-speaking people do not know what a proposition is. And this does not mean merely that they use no word which is synonymous with the word proposition. It means also that they have never compared objects with one another in respect of the fact that they are propositions and have never distinguished such objects from others. Of course English-speaking people know very well what an assertion is and what a command is; they know also what it is to express hope or fear, as in "I hope that you will have lunch with me" or "I am afraid that it will rain;" and all these require the use of propositions. But on the present view it does not follow that because making an assertion, giving a command, and expressing a hope, all involve the use of propositions, one who knows what assertions, commands, and hopes are knows also what a proposition is. It follows only that anything which did not involve the use of a proposition would not be recognized as an assertion, a command, or the expression of a hope.[11]

[11] In a sentence such as "I hope that you will have lunch with me," it is the that-clause which expresses the hope and the whole sentence which states that what the that-clause expresses is a hope. Commands, also, are sometimes put in this form, as in "I command that you close the door," and confusion will arise if we fail to observe that the whole sentence in such a case does not express a command, but rather states that what the that-clause expresses is a command. It is true that there is a current dogma according to which that-clauses do not express propositions at all, but rather function as exhibits or names of themselves, just as in the question "How do you spell Ann Arbor?" mention is made of a word and not a city. The motive which gives rise to this curious view is as follows. If that-clauses express propositions, these propositions will almost always have non-extensional occurrences, and the desire is that all functions of propositions should be truth-functions. The view, however, is easily false and may be disregarded. Consider, for example, the statement "The ancients believed that the earth was flat but it was not," and note that the but-clause has an extensional occurrence, whereas the that-clause has a non-extensional occurrence. If, now, the that-clause is construed as not expressing a proposition, then up to the but-clause the earth has not been mentioned, and it becomes unintelligible what the "it" of the but-clause refers to and what it was that was not what. Let us speak more virtuously, according to the view in question, and give the that-clause a name; let us call it Henry. Then: "The ancients believed Henry but it wasn't."

The foregoing interpretation of the nature of analysis probably cannot be true. Yet it quite possibly correctly characterizes a good many examples of analysis which might be cited; and I want to ask how this interpretation bears upon Moore's doctrine about analysis in its relation to judgments of common sense. According to the doctrine in question, common-sense judgments are never systematically in error, but only inadvertently so. We may on occasion judge an object to have a certain color when in fact it does not have that color; there are ways of checking such errors and explaining how they arise. But we must not allow the paradoxes of perception to lead us to the view that we are in error all day long in supposing objects to have this or that color, or indeed any color at all. We may construe common-sense judgments in surprising ways, but our interpretations must show how these judgments can be true, not that they cannot be true. A phenomenalist interpretation of judgments of perception, for example, might seem surprising to a common-sense person, just as the definition of a cardinal number as a class of similar classes might seem surprising to a working mathematician, but this would not show these proposed analyses to be incorrect. On the view of analysis we are considering, this is understandable; for it is not held that the analysandum and the analysans must be identical in a correct analysis, but only that they must be equivalent in the sense of having the same truth-conditions. The view has it that there are two species of entailing, one synthetic and the other analytic. In either case, if P entails Q, the truth-conditions of Q will be among those of P; but if the relation is synthetic, the observations involved in verifying Q will not be among those involved in verifying P. In certifying in the ordinary way that an object is a cube, we do not certify anything from which it can be shown by formal deduction that the object in question has twelve edges. In other words, "X is not a cube or X has twelve edges" is not a truth-value tautology.

We come now to examples of analysis which apparently do not conform to the foregoing theory. And we may, as before, consider a trivial example to begin with. It will be admitted that since an elephant is an animal, a grey elephant is a grey

animal. But it will hardly be admitted that, since an elephant is an animal, a small elephant is a small animal. This very mild paradox, which could hardly puzzle anyone, arises in the following way. Consider how we may proceed to verify a statement of the form "X is a grey animal:" we may first observe that X is grey and then observe that X is an animal. But the sentence "X is a small animal" has the same grammatical form, and we are therefore tempted to suppose that the verification of the proposition expressed will be similar: that we may first observe that X is small and then observe that X is an animal; whereas the actual procedure is of course to observe that X is an animal and is also smaller than animals generally are. It is a requirement of good syntax that propositions whose verifications are not analogous should not be symbolized by analogous sentences, because it is with the aid of grammatical analogies that we are able to understand new sentences.

Now if the two verbal expressions "X is a small Y" and "X is a Y and is smaller than most Y's" really are synonymous, as they appear to be, and if we have here given an analysis, then the proposition "Anything that was a small Y would be a Y smaller than most Y's and conversely" cannot express that analysis; for since, by hypothesis, the two verbal expressions are synonymous, this proposition will be indistinguishable from "Anything that was a small Y would be a small Y and conversely," which is certainly not an analysis. Nor can we express the analysis by saying that the expression "X is a small Y" means that X is a Y which is smaller than most Y's, because this again will be indistinguishable from saying that the expression "X is a small Y" means that X is a small Y. We shall apparently have to put the analysis in the form: "X is a small Y" means what is meant by "X is a Y and is smaller than most Y's." Both the analysandum and the analysans will then be verbal expressions, not concepts or propositions as before, and the analysis will be to the effect that the two verbal expressions are synonymous. This might be called a logical analysis, because it construes the meaning of a sentence as identical with that of the conjunction of two other sentences. And note that a statement of the form "Either X is not a small Y or X is smaller than most

Y's" will be a truth-value tautology even though it is not explicitly so represented.

We may consider next an almost equally simple example, which nevertheless has been of some importance historically. In regard to A-propositions of the traditional logic, English-speaking people commonly speak Aristotelian, and not Boolean. That is to say, an English-speaking person who wishes to tell the truth does not make a statement of the form "All A's are B's" unless he is convinced that there are A's. If this were not so, then to the question "Are all your brothers older than you?" the answer "Yes, I have no brothers" would sound normal, as it would to one who spoke Boolean. Consider, moreover, how we go about verifying such a proposition. Suppose that you are looking into a room in such way that you cannot see the whole room, but can see a number of people seated there and cannot see anyone who is standing or otherwise disposed. Even if it is in fact the case that you are seeing all the people in the room, you will not be seeing that you are seeing them all, and you will not be prepared to assert "Everyone in that room is seated;" it will still be necessary to make sure that there is no one there whom you are not seeing and who is not seated. We can easily convince ourselves from such examples that a sentence of the form "All A's are B's" means what is meant by "There are A's and there are no A's that are not B's." This is typical of many instances of logical analysis, and the point about it is that the two sentences involved seem to have precisely the same meaning; in verifying a statement of the form "All A's are B's" we seem always to verify both that A's exist and that A's which are not B's do not exist.

The view which these examples suggest is that an analysis is a translation, although not of course just any translation, but one satisfying a further requirement. This further requirement concerns the adequacy of the analysans in contrast to the analysandum as an expression of what is meant; and I think we may still maintain that it is sufficient to have the analysans less idiomatic than the analysandum, but this time in a grammatical sense, and not in the sense in which an idea may be said to be idiomatic when it is ostensively defined. There is, for example,

a pretty clear sense in which "There are A's and no A's are not B's" is less idiomatic than "All A's are B's." One who had never heard a sentence of the form "All A's are B's" could not understand such a sentence; but one who had learned the meaning of "and" from other contexts could construct the meaning of a sentence of the form "There are A's and no A's are not B's" out of the meanings of its component parts.

This view of analysis is, I believe, one which has been suggested on occasion by Professor Moore. And since it seems on the face of it less favorable to his doctrine about analysis in its relation to judgments of common sense than the other view here presented, we must ask how the distinction between knowing a statement to be true and knowing an analysis of that statement may be justified, even if all analysis is, as we are now supposing, logical analysis, the difficulty being that if the analysandum and the analysans have the same meaning, the analysis will apparently be trivial.

It is to be noted that to say we know the meaning of a sentence or other verbal expression is to say something about a power or capacity, and not something about an actual process of knowing. To know the meaning of a sentence is to know how to use that sentence whenever an occasion for its use arises, and it need not be immediately obvious that two verbal expressions have the same meaning if it is true that they do have. Although it is correct to say that we know what a sentence means if we know what states of affairs would answer to its meaning and what ones would not, it is incorrect to say that we fully realize what a sentence means when we observe that some given state of affairs does answer to its meaning. If, for example, upon finding yourself in a certain room, you make the judgment "All books in this room are on that shelf," and if you observe that there are some thirty books on the shelf and none anywhere else, you will have observed one particular sufficient condition of the truth of what you judge; but you will not have observed thereby that, had there been just three books on the shelf, your judgment might have been equally true. If, on the other hand, you had seen a half-dozen books lying on a table in the room, you would have observed a particular sufficient condition of the

falsity of your judgment, but you would not have observed in so doing that, had the room been wholly devoid of books, your judgment would have been equally false. The meaning of a sentence is revealed discursively in a variety of situations, and it is for this reason that a good notation with a standard syntax is all but indispensable for logical purposes.

Let us consider an example of two notational conventions where one notation is less idiomatic than the other in a certain respect. We find among natural languages two devices for indicating the rôles ascribed to the several terms mentioned in a relational statement. Thus in English, in order to say that one person a sees another b, we mention a first to indicate that he plays the rôle of the observer and b second to indicate that he plays the rôle of the observed. We employ, that is to say, a convention concerning the order in which terms are to be mentioned. In an inflected language, on the other hand, such a convention is unnecessary, the rôles of the several terms being distinguished by inflection of their names. And even in English "He saw me and him saw I" is intelligible and adequate, despite its want of grace and beauty. Thus, in effect, we write in English Sab to say that a and b stand in the relation of seeing with a as the observer and b the observed. Sometimes, however, we want to assign more than one rôle to a single term, as when we want to say that a sees himself, and then we write in effect Saa, mentioning a twice over to indicate that he plays both rôles. But we might just as well follow the pattern of inflected languages and make use of subscripts attached to the names of the several terms. Thus we might write Sa_1b_2 to say that a sees b, Sa_2b_1 to say that b sees a, and Sa_1a_2 to say that a sees himself. It might seem, moreover, as if these two notational devices had the same power of expression; but this is not the case. For it happens not only that one and the same term may play more than one rôle in a relational complex, but also that one and the same rôle may be played by more than one term. Let Mab represent that relation which holds between a and b in virtue of the fact that they are both members of the class of men. Then to write "Mab and Mba" is to say the same thing twice, because verifying that a and b are men is indistinguishable from verify-

ing that b and a are men; to mention a term either in the first place or in the second is to ascribe to it the rôle of a co-member in the class of men. Or let Icd mean that c and d are intersecting lines. Then since no conceivable observation could certify either Icd or Idc without certifying both, these expressions are synonymous. This is a good example of a bad notation, because Icd and Idc look like Sab and Sba, which are importantly different in meaning. But just as we write Sa_1a_2 to indicate that one and the same term plays each of two rôles, so we may write Ic_1d_1 to indicate that two terms play one and the same rôle. In a language employing order of mention, however, this property of relations must remain unsymbolized, simply because we cannot repeat a position as we can a subscript. Thus there will be a difference in meaning without a corresponding difference in notation, and that is characteristic of idiomatic expressions.

Considerations like these tend to show that logical analysis is not trivial, even though the analysandum and the analysans have precisely the same meaning. It seems clear also that the first view considered above, to the effect that all analysis pertains to ideas and not to verbal expressions, cannot be true; although it does not follow that there is no such thing as conceptual analysis in the sense there described. It may well be that both sorts of analysis occur, as they appear to do; indeed, I shall presently try to show that Moore is committed in *Principia Ethica* to exactly this view. But the question I am now concerned with is this. If all analysis is formal in the sense of the second view, what bearing does this have on Moore's doctrine about the relation of analysis to judgments of common sense? It follows, I think, that the analysans in a correct analysis must not be too Pickwickian, as some people have held the Frege-Russell definition of a cardinal number to be. That the analysandum and the analysans have the same meaning need not be at all obvious, but it cannot be just obvious that they do not. It follows, further, that analysis can do no more than clarify judgments of common sense by expressing them precisely; and it is therefore difficult to see how there can be any ideas which are peculiar to philosophy or to logic. For these reasons, I think that the distinction between knowing a statement to be

true and knowing an analysis of that statement will be a more significant distinction if giving an analysis does not always consist in translating one verbal expression into another, but sometimes consists in passing from one idea or complex of ideas to another.

I want, finally, to examine what Professor Moore has to say about analysis in his discussion in *Principia Ethica*, and to suggest that what he there tells us implies a view to the effect that there are two kinds of analysis, one conceptual and the other formal, in the sense of the two views here considered.[12] He says, in the first place, that the notion of the good is indefinable, because it is simple, like the color yellow. And, clearly, being indefinable entails being unanalyzable, as he himself explicitly states.[13] He therefore commits himself to saying that the notion of the good is not a function of other ideas, and is thus formally unanalyzable in the sense of the second view described above. But he then goes on immediately to explain that, although the notion of the good cannot be defined, the good itself, which is what answers to this notion, in his opinion can be, and that if it cannot, his enterprise will be pointless. Such an assertion is puzzling when taken alone, but what he means seems reasonably clear from the context. He tells us that he hopes to find characteristics which belong to everything that is good, and even characteristics which belong to an object if and only if it is good. Suppose, then, that pleasantness is a characteristic of such a sort that we can say: "Being intrinsically good implies being pleasant." This sounds like saying: "Being a cube implies having twelve edges" or "Being orange implies being intermediate in color between red and yellow." The implication in question could hardly be merely material because, if it were, although the proposition might be true in fact, we should have no way of knowing this, and Moore hopes to discover some propositions like this one to be true. On the other hand, the proposition could hardly be a truth-value tautology because, if it were, not only the good but the notion of the good would be analyzable. Yet, since the implication will not be merely material, we shall

[12] See especially sections 6-10 of *PE*.
[13] *Ibid.*, 17.

be able to say in some sense: "Anything that was intrinsically good would be pleasant." The only question remaining is whether this will be a synthetic a priori proposition or will be merely causal in the sense of a scientific law. From what Moore tells us concerning the intuitive character of facts about the good, as contrasted with the empirical character of facts about right conduct, I think we may conclude that the proposition will be a priori.[14] The reason why Moore is able to speak as if all analysis were formal, in the sense of the second view, is that he has spoken equivocally of defining an idea and defining an object, as if these were definable in the same sense.

C. H. LANGFORD

DEPARTMENT OF PHILOSOPHY
UNIVERSITY OF MICHIGAN

[14] Pp. 142ff.

13

Norman Malcolm

MOORE AND ORDINARY LANGUAGE

MOORE AND ORDINARY LANGUAGE

I

IN this paper I am going to talk about an important feature of Professor Moore's philosophical method, namely, his way of refuting a certain type of philosophical proposition.

I shall begin by giving a list of propositions all of which have been maintained or are now maintained by various philosophers. Every one of these statements would, I am sure, be rejected by Moore as false. Furthermore, if with regard to each of these statements, he were asked to give a *reason* for rejecting that statement, or were asked to *prove* it to be false, he would give a *reason* or *proof* which would be strikingly similar in the case of each statement. I want to examine the general character of this common method of proof in order to show the point and the justification of it. I think that showing the point and the justification of Moore's method of attacking this type of philosophical statement will throw great light on the nature of philosophy, and also explain Moore's importance in the history of philosophy.

The following is my list of philosophical statements:

(1) There are no material things.

(2) Time is unreal.

(3) Space is unreal.

(4) No one ever perceives a material thing.

(5) No material thing exists unperceived.

(6) All that one ever sees when he looks at a thing is part of his own brain.

(7) There are no other minds—my sensations are the only sensations that exist.

(8) We do not know for *certain* that there are any other minds.

(9) We do not know for *certain* that the world was not created five minutes ago.

(10) We do not know for *certain* the truth of any statement about material things.

(11) All empirical statements are hypotheses.

(12) *A priori* statements are rules of grammar.

Let us now consider Moore's way of attacking these statements. With regard to each of them I am going to state the sort of argument against it which I think Moore would give, or at least which he would approve.

(1) Philosopher: "There are no material things."

Moore: "You are certainly wrong, for here's one hand and here's another; and so there are at least two material things."[1]

(2) Philosopher: "Time is unreal."

Moore: "If you mean that no event ever follows or precedes another event, you are certainly wrong; for *after* lunch I went for a walk, and after that I took a bath, and after that I had tea."[2]

(3) Philosopher: "Space is unreal."

Moore: "If you mean that nothing is ever to the right of, or to the left of, or behind, or above anything else, then you are certainly wrong; for this inkwell is to the left of this pen, and my head is above them both."

(4) Philosopher: "No one ever perceives a material thing."[3]

Moore: "If by 'perceive' you mean 'hear', 'see', 'feel', etc., then nothing could be more false; for I now both see and feel this piece of chalk."

(5) Philosopher: "No material thing exists unperceived."

Moore: "What you say is absurd, for no one perceived my bedroom while I was asleep last night and yet it certainly did not cease to exist."

[1] See Moore's "Proof of an External World," *Proceedings of the British Academy*, Vol. XXV, 1939.
[2] See Moore's "The Conception of Reality," *Philosophical Studies*, 209-211.
[3] This is the philosopher who says that all we really perceive are sense-data, and that sense-data are not material things, nor parts of material things.

(6) Philosopher: "All that one ever sees when one looks at a thing is part of one's own brain."[4]

Moore: "This desk which both of us now see is most certainly not part of my brain, and, in fact, I have never seen a part of my own brain."

(7) Philosopher: "How would you prove that the statement that your own sensation, feelings, experiences are the only ones that exist, is false?"

Moore: "In this way: I know that *you* now see me and hear me, and furthermore I know that my wife has a toothache, and therefore it follows that sensations, feelings, experiences other than my own exist."

(8) Philosopher: "You do not know for *certain* that there are any feelings or experiences other than your own."

Moore: "On the contrary, I know it to be *absolutely* certain that you now see me and hear what I say, and it is absolutely certain that my wife has a toothache. Therefore, I do know it to be absolutely certain that there exist feelings and experiences other than my own."

(9) Philosopher: "We do not know for certain that the world was not created five minutes ago, complete with fossils."[5]

Moore: "I know for certain that I and many other people have lived for many years, and that many other people lived many years before us; and it would be absurd to deny it."

(10) Philosopher: "We do not know for certain the truth of any statement about material things."

Moore: "Both of us know for *certain* that there are several chairs in this room, and how absurd it would be to suggest that we do not know it, but only believe it, and that perhaps it is not the case!"

(11) Philosopher: "All empirical statements are really hypotheses."

Moore: "The statement that I had breakfast an hour ago is

[4] "I should say that what the physiologist sees when he looks at a brain is part of his own brain, not part of the brain he is examining." Bertrand Russell, *The Analysis of Matter* (1927), 383.

[5] Cf. B. Russell, *Philosophy* (1927), 7. This is a way of expressing the view, that no statements about the *past* are known with certainty.

certainly an empirical statement, and it would be ridiculous to call it an hypothesis."

(12) Philosopher: "*A priori* statements are really rules of grammar."

Moore: "That 6 times 9 equals 54 is an *a priori* statement, but it is most certainly wrong to call it a rule of grammar."

It is important to notice that a feature which is common to all of the philosophical statements in our list is that they are *paradoxical*. That is, they are one and all statements which a philosophically unsophisticated person would find shocking. They go against "common sense." This fact plays an important part in the explanation of the nature of Moore's attacks upon these statements.

Let us examine the general nature of Moore's refutations. There is an inclination to say that they one and all *beg the question*. When the philosopher said that *a priori* statements are rules of grammar he meant to include the statement that 6 times 9 equals 54, among *a priori* statements. He meant to say of *it*, as well as of every other *a priori* statement, that it really is a rule of grammar. When Moore simply denies that it is a rule of grammar, he seems to beg the question. At least his reply does not seem to be a fruitful one; it does not seem to be one which ought to convince the philosopher that what he said was false.

When the philosopher says that there are no material things, is it not the case that part of what he means is that there are no hands; or, if he would allow that there are hands, part of what he means is that hands are not material things? So that Moore's refutation, which asserts of two things that they are hands, and asserts that hands are material things, in one way or another begs the question.

And when the philosopher says that one does not know for certain that there are any sensations, feelings, experiences other than one's own, part of what he means to say is that one never knows for certain that one's wife has a toothache; and when Moore insists that he does know for certain that his wife has a toothache, he begs the question. At least it seems a poor sort of

refutation; not one which ought to convince any philosopher that what he said was wrong.

I hold that what Moore says in reply to the philosophical statements in our list is in each case perfectly true; and further-more, I wish to maintain that what he says is in each case a *good* refutation, a refutation that shows the falsity of the state-ment in question. To explain this is the main purpose of my paper.

The essence of Moore's technique of refuting philosophical statements consists in pointing out that these statements *go against ordinary language*. We need to consider, first, in what way these statements do go against ordinary language; and, second, how does it refute a philosophical statement to show that it goes against ordinary language?

When Russell said that what the physiologist sees when he looks at a brain is part of his own brain, not part of the brain he is examining, he was of course not referring to any particular physiologist, but to all physiologists, and not only to all physi-ologists, but to every person whomsoever. What he meant to imply was that whenever in the past a person has said that he sees a tree or a rock or a piece of cheese on the table, what he has said was really false; and that whenever in the future any person will say that he sees a house or a car or a rabbit, what he will say really will be false. All that will ever really be true *in any case whatever* in which a person says that he sees some-thing, will be that he sees a part of his own brain.

Russell's statement is a most startling one. Nothing could be more paradoxical! And what sort of a statement is it? Did Russell mean to imply that whenever in the past any physiolo-gist has thought that he was seeing someone else's brain he has been *deceived?* Suppose that, unknown to the physiologist, a section of his cranium had been removed and furthermore there was, also unknown to him, an ingenious arrangement of mirrors, such that when he tried to look at a brain in front of him, what he actually saw was a part of his own brain in his own skull. Did Russell mean to say that this is the sort of thing which has always happened in the past when a physiologist has tried to

examine a brain, and which will always happen in the future? If he were making this straight-forward empirical statement, then it is clear that he would have no evidence whatever for it. It is not the sort of empirical statement that an intelligent man would make.

No, Russell was not making an empirical statement. In the normal sort of circumstances in which a person would ordinarily say that he sees the postman, Russell would agree with him as to what the particular circumstances of the situation were. Russell would not disagree with him about any question of empirical fact; yet Russell would still say that what he really saw was not the postman, but part of his own brain. It appears then that they disagree, not about any empirical facts, but about what *language* shall be used to describe those facts. Russell was saying that it is really *a more correct way of speaking* to say that you see a part of your brain, than to say that you see the postman.

The philosophical statement, "All that one ever sees when one looks at a thing is part of one's brain" may be interpreted as meaning, "Whenever one looks at a thing it is really more correct language to say that one sees a part of one's brain, than to say that one sees the thing is question." And Moore's reply, "This desk which both of us see is not a part of my brain," may be interpreted as meaning, "It is correct language to say that what we are doing now is seeing a desk, and it is not correct language to say that what we are doing now is seeing parts of our brains."[6]

When the dispute is seen in this light, then it is perfectly clear that Moore is right. We can see that the philosophical statement which he is attacking is false, no matter what arguments may be advanced in favor of it.[7] The "proofs" of it may

[6] It must not be assumed that Professor Moore would agree with my interpretation of the nature of the philosophical paradoxes, nor with my interpretation of the nature of his refutations of those paradoxes. That Moore does employ such refutations anyone knows, who is familiar with his language and discussions. But this paper's analysis of the philosophical paradoxes and of Moore's refutations is not one that Moore has ever suggested.

[7] What led Russell to make the statement was his being led to the view (1) that what we really see are "percepts:" and (2) that each person's "percepts" are

be ever so tempting, but we are right in rejecting them as false statements without even examining them. For it is obvious to us upon the slightest reflection, that a person may wish to see the Empire State building; and that a way in which we might describe in ordinary language, what happened when he fulfilled his wish, would be by saying the words "He is now seeing the Empire State building for the first time;" and that we would never accept as a correct description of what happened, the words "He is now seeing a part of his brain." What Moore's reply reminds us of is that situations constantly occur which ordinary language allows us to describe by uttering sentences of the sort "I see my pen," "I see a cat," etc. and which it would be outrageously incorrect to describe by saying "I see a part of my brain." It is in this way that Moore's reply constitutes a refutation of the philosophical statement.

Let us consider the philosophical statement "We do not know for *certain* the truth of any statement about material things," and Moore's typical sort of reply, "Both of us know for *certain* that there are several chairs in this room, and how absurd it would be to suggest that we do not know it, but only believe it, and that perhaps it is not the case—how absurd it would be to say that it is highly probable, but not certain!" The view that we do not know for certain the truth of any statement about material things, and the wider view that we do not know for certain the truth of *any* empirical statement, are very popular views among philosophers.[8] Let us notice how sweeping and how paradoxical is the philosopher's state-

located in that person's brain. Neither of these statements expresses an empirical proposition.

[8] E.g., ". . . all empirical knowledge is probable only." C. I. Lewis, *Mind and the World-Order* (1929), 309.

"We have . . . found reason to doubt external perception, in the full-blooded sense in which common-sense accepts it." Bertrand Russell, *Philosophy* (1927), 10.

". . . we can never be completely certain that any given proposition is true. . . ." Russell, *An Inquiry into Meaning and Truth* (1940), 166.

". . . no genuine synthetic proposition . . . can be absolutely certain." A. J. Ayer, *Language, Truth, and Logic* (1936), 127.

". . . statements about material things are not conclusively verifiable." Ayer, *The Foundations of Empirical Knowledge* (1940), 239.

ment that we never know for certain that any statement about material things is true.

In ordinary life everyone of us has known of particular cases in which a person has said that he knew for certain that some material-thing statement was true, but that it has turned out that he was mistaken. Someone may have said, for example, that he knew for certain by the smell that it was carrots that were cooking on the stove. But you had just previously lifted the cover and seen that it was turnips, not carrots. You are able to say, *on empirical grounds,* that *in this particular case* when the person said that he knew for certain that a material-thing statement was true, he was mistaken. Or you might have known that it was wrong of him to say that he knew for certain it was carrots, not because you had lifted the cover and seen the turnips, but because you knew from past experience that cooking carrots smell like cooking turnips, and so knew that he was not entitled to conclude from the smell alone that it was *certain* that it was carrots. It is an empirical fact that *sometimes* when people use statements of the form: "I know for certain that p," where p is a material-thing statement, what they say is false.

But when the philosopher asserts that we never know for certain *any* material-thing statements, he is not asserting this empirical fact. He is asserting that *always* in the past when a person has said "I know for certain that p," where p is a material-thing statement, he has said something false. And he is asserting that *always* in the future when any person says a thing of that sort his statement will be false. The philosopher says that this is the case no matter what material-thing statement is referred to, no matter what the particular circumstances of the case, no matter what evidence the person has in his possession! If the philosopher's statement were an empirical statement, we can see how absurdly unreasonable it would be of him to make it—far more unreasonable than it would be of a man, who knew nothing about elephants, to say that an elephant never drinks more than a gallon of water a day.

The philosopher does not commit *that* sort of absurdity, because his statement is not an empirical one. The reason he

can be so cocksure, and not on empirical grounds, that it never has been and never will be right for any person to say "I know for certain that p," where p is a material-thing statement, is that he regards that *form of speech* as *improper*. He regards it as improper in just the same way that the sentence "I see something which is totally invisible," is improper. He regards it as improper in the sense in which every self-contradictory expression is improper. Just as it would never be proper for you to describe *any* experience of yours by saying "I see something which is totally invisible," so the philosopher thinks that it would never be proper for you to describe any state of affairs by saying "I know for certain that p," where p is a material-thing statement.

Among the philosophers who maintain that no material-thing statement can be certain, Mr. Ayer is one who realizes that when he makes this statement he is not making an empirical judgment, but is condemning a certain form of expression as improper. He says,

We do indeed verify many such propositions [i.e., propositions which imply the existence of material things] to an extent that makes it highly probable that they are true; but since the series of relevant tests, being infinite, can never be exhausted, this probability can never amount to logical certainty. . . .

It must be admitted then that there is a sense in which it is true to say that we can never be sure, with regard to any proposition implying the existence of a material thing, that we are not somehow being deceived; but at the same time one may object to this statement on the ground that it is misleading. It is misleading because it suggests that the state of 'being sure' is one the attainment of which is conceivable, but unfortunately not within our power. *But*, in fact, *the conception of such a state is self-contradictory*. For in order to be sure, in this sense, that we were not being deceived, we should have to have completed an infinite series of verifications; and it is an analytic proposition that one cannot run through all the members of an infinite series. . . . Accordingly, what we should say, if we wish to avoid misunderstanding, is not that we can never be certain that any of the propositions in which we express our perceptual judgments are true, but rather that *the notion of certainty does not apply to propositions of this kind*. It applies to the a priori propositions of logic and mathematics, and the fact that it does apply to them



is an essential mark of distinction between them and empirical propositions.[9]

The reason, then, that Ayer is so confident that it never has been and never will be right for anyone to say of a material-thing statement that he knows it for certain, is that he thinks it is self-contradictory to say that a material-thing statement is known for certain. He thinks that the phrase "known for certain" is properly applied only to *a priori* statements, and not to empirical statements. The philosophical statement "We do not know for certain the truth of any material-thing statement," is a misleading way of expressing the proposition. "The phrase 'known for certain' is not properly applied to material-thing statements." Now Moore's reply, "Both of us know for certain that there are several chairs in this room, and how absurd it would be to suggest that we do not know it, but only believe it, or that it is highly probable but not really certain!" is a misleading way of saying "It is a proper way of speaking to say that we know for certain that there are several chairs in this room, and it would be an improper way of speaking to say that we only believe it, or that it is only highly probable!" Both the philosophical statement and Moore's reply to it are disguised linguistic statements.

In this as in all the other cases Moore is right. What his reply does is to give us a *paradigm* of absolute certainty, just as in the case previously discussed his reply gave us a paradigm of seeing something not a part of one's brain. What his reply does is to appeal to our language-sense; to make us feel how queer and wrong it would be to say, when we sat in a room seeing and touching chairs, that we *believed* there were chairs but did not know it for certain, or that it was only highly probable that there were chairs. Just as in the previous case his reply made us feel how perfectly proper it is in certain cases to say that one sees a desk or a pen, and how grossly improper it would be in such cases to say that one sees a part of one's brain. Moore's reply reminds us of the fact that if a child who was learning the language were to say, in a situation where we were

[9] A. J. Ayer, *The Foundations of Empirical Knowledge,* 44-45. My italics.

sitting in a room with chairs about, that it was "highly probable" that there were chairs there, we should smile, *and correct his language*. It reminds us of such facts as this:—that if we were driving at a rapid speed past some plants in a cultivated field, it might be proper to say "It's highly probable that they are tomato plants, although we can't tell for certain;" but if we had ourselves planted the seeds, hoed and watered them, and watched them grow, and finally gathered the ripe tomatoes off them, then to say the same thing would, to use John Wisdom's phrase, "raise a titter." By reminding us of how we ordinarily use the expressions "know for certain" and "highly probable," Moore's reply constitutes a refutation of the philosophical statement that we can never have certain knowledge of material-thing statements. It reminds us that there *is* an ordinary use of the phrase "know for certain" in which it is applied to empirical statements; and so shows us that Ayer is wrong when he says that "The notion of certainty does not apply to propositions of ths kind."

Indeed the notion of *logical* certainty does not apply to empirical statements. The mark of a logically certain proposition, i.e., an *a priori* proposition, is that the negative of it is self-contradictory. Any proposition which has this character we do not *call* an empirical statement. One of the main sources of the philosophical statement, "We can't ever know for certain the truth of any empirical statement," has been the desire to point out that empirical statements do not have logical certainty. But this truism has been expressed in a false way. The truth is, not that the phrase "I know for certain" has no proper application to empirical statements, but that the sense which it has in its application to empirical statements is *different* from the sense which it has in its application to *a priori* statements. Moore's refutation consists simply in pointing out that it has *an* application to empirical statements.

II

It may be objected: "Ordinary men are ignorant, mis-informed, and therefore frequently mistaken. Ordinary lan-

guage is the language of ordinary men. You talk as if the fact
that a certain phrase is used in ordinary language implies that,
when people use that phrase, what they say is *true*. You talk
as if the fact that people *say* 'I know for certain that p,' where
p is a material-thing statement, implies that they *do* know for
certain. But this is ridiculous! At one time everyone said that
the earth was flat, when it was actually round. Everyone was
mistaken; and there is no reason why in these philosophical
cases the philosophers should not be right and everyone else
wrong."

In order to answer this objection, we need to consider that
there are two ways in which a person may be wrong when he
makes an empirical statement. First, he may be making a mis-
take as to what the empirical facts are. Second, he may know
all right what the empirical facts are, but may use the wrong
language to describe those facts. We might call the first "being
mistaken about the facts," and the second "using incorrect
language" or "using improper language" or "using wrong
language."

It is true that at one time everyone said that the earth was
flat, and what everyone said was wrong. Everyone believed
that if you got into a ship and sailed west you would finally
come to the edge and fall off. They did not believe that if you
kept on sailing west you would come back to where you started
from. When they said that the earth was flat, they were wrong.
The way in which their statement was wrong was that they were
making a mistake about the facts, not that they were using
incorrect language, they were using perfectly correct language
to describe what they thought to be the case. In the sense in
which they said what was wrong, it is perfectly possible for
everyone to say what is wrong.

Now suppose a case where two people agree as to what the
empirical facts are, and yet disagree in their statements. For
example, two people are looking at an animal; they have a
clear, close-up view of it. Their descriptions of the animal are
in perfect agreement. Yet one of them says it is a fox, the
other says it is a wolf. Their disagreement could be called
linguistic. There is, of course, a right and a wrong with respect

to linguistic disagreements. One or the other, or both of them, is using incorrect language.

Now suppose that there were a case like the one preceding with this exception: that the one who says it is a wolf, not only agrees with the other man as to what the characteristics of the animal are, but furthermore *agrees that that sort of animal is ordinarily called a fox.* If he were to continue to insist that it is a wolf, we can see how absurd would be his position. He would be saying that, although the other man was using an expression to describe a certain situation which was the expression ordinarily employed to describe that sort of situation, nevertheless the other man was using incorrect language. What makes his statement absurd is that ordinary language *is* correct language.

The authors of the philosophical paradoxes commit this very absurdity, though in a subtle and disguised way. When the philosopher says that we never really perceive material things, since all that we really perceive are sense-data and sense-data are not material things nor parts of material things, he does not disagree with the ordinary man about any question of empirical fact. Compare his case with the case of two men who are proceeding along a road. One of them says that he sees trees in the distance; the other says that it is not true that he sees trees—that it is really a mirage he sees. Now this is a genuine dispute as to what the facts are, and this dispute could be settled by their going further along the road, to the place where the trees are thought to be.

But the philosopher who says that the ordinary person is mistaken when he says that he sees the cat in a tree, does not mean that he sees a squirrel rather than a cat; does not mean that it is a mirage; does not mean that it is an hallucination. He will agree that the facts of the situation are what we should ordinarily describe by the expression "seeing a cat in a tree." Nevertheless, he says that the man does not *really* see a cat; he sees only some sense-data of a cat. Now if it gives the philosopher pleasure always to substitute the expression "I see some sense-data of my wife," for the expression "I see my wife," etc., then he is at liberty thus to express himself, *pro-*

viding he warns people beforehand so that they will understand him. But when he says that the man does not *really* see a cat, he commits a great absurdity; for he implies that a person can use an expression to describe a certain state of affairs, which is the expression ordinarily used to describe just such a state of affairs, and yet be using incorrect language.

One thing which has led philosophers to attack ordinary language, has been their supposing that certain expressions of ordinary language are self-contradictory.[10] Some philosophers have thought that any assertion of the existence of a material thing, e.g., "There's a chair in the corner," is self-contradictory. Some have thought that any assertion of the perception of a material thing, e.g., "I see a fly on the ceiling," is self-contradictory. Some have thought that any assertion of the existence of an unperceived material thing, e.g., "The house burned down, when no one was around," is self-contradictory. Some have seemed to think that statements describing spatial relations, e.g., "The stove is to the left of the icebox," are self-contradictory.

Some have seemed to think that statements describing temporal relations, e.g., "Charles came later than the others, but before the doors were closed," are self-contradictory. Some philosophers think that it is self-contradictory to assert that an empirical statement is known for certain, e.g., "I know for certain that the tank is half-full."

The assumption underlying all of these theories is that an ordinary expression *can* be self-contradictory. This assumption seems to me to be false. By an "ordinary expression" I mean an expression which has an ordinary use, i.e., which is ordinarily used to describe a certain sort of situation. By this I do not mean that the expression need be one which is frequently used. It need only be an expression which *would* be used to describe situations of a certain sort, if situations of that sort were to exist, or were believed to exist. To be an ordinary expression it must

[10] I think that this is really behind *all* attacks upon ordinary language. For how could a philosopher hold, on non-empirical grounds, that the using of a certain expression will *always* produce a false statement, unless he held that the expression is self-contradictory?

have a commonly accepted *use;* it need not be the case that it is ever *used.* All of the above statements, which various philosophers have thought were self-contradictory, are ordinary expressions in this sense.

The reason that no ordinary expression is self-contradictory, is that a self-contradictory expression is an expression which would *never* be used to describe *any* sort of situation. It does not have a descriptive usage. An ordinary expression is an expression which would be used to describe a certain sort of situation; and since it would be used to describe a certain sort of situation, it *does* describe that sort of situation. A self-contradictory expression, on the contrary, describes nothing. It is possible, of course, to *construct* out of ordinary expressions an expression which is self-contradictory. But the expression so constructed is not itself an ordinary expression—i.e., not an expression which has a descriptive use.

The proposition that no ordinary expression is self-contradictory is a tautology, but perhaps an illuminating one. We do not *call* an expression which has a descriptive use a self-contradictory expression. For example, the expression "It is and it isn't" looks like a self-contradictory expression. But it has a descriptive use. If, for example, a very light mist is falling—so light that it would not be quite correct to say that it was *raining,* yet heavy enough to make it not quite correct to say that it was *not* raining—and someone, asking for information, asked whether it was raining, we might reply "Well, it is and it isn't." We should not say that the phrase, used in this connection, is self-contradictory.

The point is that, even if an expression has the appearance of being self-contradictory, we do not *call* it self-contradictory, providing it has a use. Nor do we say of *any* expression which is used to describe or refer to a certain state of affairs that *in that use* it is self-contradictory. It follows that no ordinary expression is, in any ordinary use of that expression, self-contradictory. Whenever a philosopher claims that an ordinary expression is self-contradictory, he has misinterpreted the meaning of that ordinary expression.

A philosophical paradox asserts that, whenever a person uses

a certain expression, what he says is false. This could be either because the sort of situation described by the expression never does, *in fact,* occur; or because the expression is self-contradictory. Now the point of replying to the philosophical statement, by showing that the expression in question does have a descriptive use in ordinary language, is to prove, first, that the expression is not self-contradictory; and, second, that therefore the only ground for maintaining that when people use the expression what they say is always false, will have to be the claim, that *on the basis of empirical evidence* it is known that the sort of situation described by the expression never has occurred and never will occur. But it is abundantly clear that the philosopher offers no empirical evidence for his paradox.

The objection set down at the beginning of this section contains the claim that it does not follow from the fact that a certain expression is used in ordinary language that, on any occasion when people use that expression, what they say is true. It does not follow for example, from the fact that the expression "to the left of" is an ordinary expression, that anything ever *is* to the left of another thing. It does not follow from the fact that the expression "it is certain that" is an ordinary expression applied to empirical statements, that any empirical statements ever *are* certain. Let us, next, consider this question.

The expression "There's a ghost" has a descriptive use. It is, in my sense of the phrase, an ordinary expression; and it does not follow from the fact that it is an ordinary expression that there ever have been any ghosts. But it is important to note that people can learn the meaning of the word "ghost" without actually seeing any ghosts. That is, the meaning of the word "ghost" can be explained to them in terms of the meanings of words which they already know. It seems to me that there is an enormous difference in this respect between the learning of the word "ghost" and the learning of expressions like "earlier," "later," "to the left of," "behind," "above," "material things," "it is possible that," "it is certain that." The difference is that, whereas you can teach a person the meaning of the word "ghost" without showing him an instance of the true application of that word, you cannot teach a person the meaning of these

other expressions without showing him instances of the true application of those expressions. People could not have learned the meaning of the expressions "to the left of," or "above," unless they had actually been shown instances of one thing being to the left of another, and one thing being above another. In short, they could not have learned the meanings of expressions which describe spatial relations without having been acquainted with some instances of spatial relations. Likewise, people could not have learned the use of expressions describing temporal relations, like "earlier" and "later," unless they had been shown examples of things standing in these temporal relations. Nor could people have learned the difference between "seeing a material thing," and "seeing an after-image" or "having an hallucination," unless they had actually been acquainted with cases of seeing a material thing. And people could not have learned the meaning of "it is probable that," as applied to empirical statements, and of "it is certain that," as applied to empirical statements, unless they had been shown cases of empirical probability and cases of empirical certainty, and had seen the difference or differences between them.

In the case of all expressions the meanings of which must be *shown* and cannot be explained, as can the meaning of "ghost," it follows, from the fact that they are ordinary expressions in the language, that there have been *many* situations of the kind which they describe; otherwise so many people could not have learned the correct use of those expressions. Whenever a philosophical paradox asserts, therefore, with regard to such an expression, that always when that expression is used the use of it produces a false statement, then to prove that the expression is an *ordinary* expression is completely to refute the paradox.

III

An empirical statement can be paradoxical and not be false. A philosophical statement cannot be paradoxical and not be false. This is because they are paradoxical in totally different ways. If an empirical statement is paradoxical, that is because it asserts the existence of empirical facts which everyone or almost everyone believed to be incompatible with the existence

of other well-established empirical facts. But if a philosophical statement is paradoxical, that is because it asserts the impropriety of an ordinary form of speech. It is possible for everyone to be mistaken about certain matters of empirical fact. That is why an empirical statement can be paradoxical and yet true. But it is not possible for an ordinary form of speech to be improper. That is to say, ordinary language is correct language.

When a philosopher says, for example, that all empirical statements are hypotheses,[11] or that *a priori* statements are really rules of grammar,[12] Moore at once attacks. He attacks because he is sensitive to the violations of ordinary language which are implicit in such statements. " '49 minus 22 equals 27' *a rule of grammar?* 'Napoleon was defeated at Waterloo' an *hypothesis?* What an absurd way of talking!" Moore's attacks bring home to us that our ordinary use of the expressions "rule of grammar" and "hypothesis" is very different from that suggested by the philosophical statements. If a child learning the language were to call "49 minus 22 equals 27" a *rule of grammar,* or "Napoleon was defeated at Waterloo" an *hypothesis,* we should *correct* him. We should say that such language is not a proper way of speaking.

The reason that the philosopher makes his paradoxical statement that all empirical propositions are hypotheses, is that he is impressed by and wishes to emphasize a certain similarity betwen the empirical statements which we should ordinarily call hypotheses and the empirical statements which we should ordinarily call, not hypotheses but absolutely certain truths. The similarity between the empirical proposition the truth of which we say is not perfectly established, but which we will assume in order to use it as a working hypothesis, and the empirical proposition the truth of which we say is absolutely certain, is that neither of them possesses *logical* certainty.

[11] "Empirical statements are one and all hypotheses. . . ." Ayer, *Language, Truth and Logic,* 132.

[12] I do not know that *exactly* this statement has ever been made in print, but it has been made in discussions in Cambridge, England.

That is, neither of them has a self-contradictory negative. The falsehood of the absolutely certain empirical proposition, as well as of the hypothesis, is a logical possibility. The philosopher, wishing to emphasize this similarity, does so by saying that all empirical statements are really hypotheses. Likewise, one of the main sources of the paradoxical statement that no empirical statements ever have absolute certainty but at most high probability, lies, as we have said, in the desire to stress this same similarity. This linguistic device of speaking paradoxically, which the philosopher adopts in order to stress a similarity, does of course ignore the *dis*similarities. It ignores the dissimilarities, which *justify* the distinction made in ordinary language, between absolutely certain empirical propositions and empirical propositions which are only hypotheses or have only high probability.

Let us consider another example of the philosophical procedure of employing a paradox in order to emphasize a similarity or a difference. Philosophers have sometimes made the statement "All words are vague." It is the desire to emphasize a similarity between words with vague meanings and words with clear meanings which has tempted the philosophers to utter this paradox. The meaning of a word is vague, if it is the case that in a large number of situations where the question is raised as to whether the word applies or not, people who know the use of the word and who know all the facts of the situations are undecided as to whether the word does apply or not, or disagree among themselves without being able to come to any consensus of opinion. Let us call such situations "undecidable cases." A word is vague, then, if with regard to the question of its application there is a *large* number of undecidable cases. But even with respect to the words which we should ordinarily say have clear meanings, it is possible to produce undecidable cases. The only difference between the clear words and the vague ones is that with respect to the former the number of undecidable cases is relatively smaller. But then, says the philosopher, the difference between a large number of undecidable cases and a small number is only a difference of

degree! He is, therefore, tempted to say that *all* words are really vague. But, we might ask, why should not the use of the words "vague" and "clear," in ordinary language, simply serve to call attention to those differences of degree?

Similarly, a philosophizing biologist, finding it impossible to draw a sharp line separating the characteristics of inanimate things from the characteristics of animate things, may be tempted to proclaim that all matter is really animate. What he says is philosophical, paradoxical, and false. For it constitutes an offense against ordinary language, in the learning of which we learn to call things like fish and fowl animate, and things like rocks and tables inanimate.

Certain words of our language operate in pairs, e.g., "large" and "small," "animate" and "inanimate," "vague" and "clear," "certain" and "probable." In their use in ordinary language a member of a pair *requires* its opposite—for animate is *contrasted* with inanimate, probability with certainty, vagueness with clearness. Now there are certain features about the criteria for the use of the words in these pairs which tempt philosophers to wish to remove from use one member of the pair. When the philosopher says that all words are really vague, he is proposing that we never apply the word "clear" anymore, i.e., proposing that we abolish its use.

But suppose that we did *change* our language in such a way that we made the philosophical statements true—that is, made it true that it was no longer correct to call any material thing inanimate, no longer correct to call any empirical statement certain, no longer correct to say of any word that its meaning is clear. Would this be an improvement?

It is important to see that by such a move we should have gained nothing whatever. The word in our revised language would have to do double duty. The word "vague" would have to perform the function previously performed by two words, "vague" and "clear." But it could not perform this function. For it was essential to the meaning of the word "vague," in its previous use, that vagueness was *contrasted* with clearness. In the revised language vagueness could be contrasted with

nothing. The word "vague" would simply be dropped as a useless word. And we should be compelled to adopt into the revised language a new pair of words with which to express the same distinctions formerly expressed by the words "clear" and "vague." The revision of our language would have accomplished nothing.

The paradoxical statements of the philosophers are produced, we have suggested, by their desire to emphasize similarities or differences between the criteria for the use of certain words. For example, the statement that no empirical propositions are certain arises from the desire to stress the similarity between the criteria for applying the phrases "absolutely certain" and "highly probable" to empirical propositions; and also from the desire to stress the difference between the criteria for applying "certain" to empirical statements, and for applying it to a priori statements. The desire to stress various similarities and differences tempts the philosophers to make their paradoxes.

The reason I have talked so much about the nature of paradoxical philosophical statements and the temptations which produce them, is to throw light on Moore's rôle as a philosopher. A striking thing about Moore is that he never succumbs to such temptations. On the contrary, he takes his stand upon ordinary language and defends it against every attack, against every paradox. The philosophizing of most of the more important philosophers has consisted in their more or less subtly repudiating ordinary language. Moore's philosophizing has consisted mostly in his refuting the repudiators of ordinary language.

The rôle which Moore, the Great Refuter, has played in the history of philosophy has been mainly a destructive one. (His most important constructive theory, the theory that good is a simple indefinable quality like yellow, was itself a natural outcome of his own destructive treatment of innumerable attempts to define "good.") To realize how much of philosophy consists of attacks on ordinary language, on common sense, and to see that ordinary language must be right, is to see the

importance and the justification of Moore's destructive function in philosophy.

It might be asked: "You say that the philosopher's paradox arises from his desire to stress a similarity or a difference in the criteria for the use of certain expressions. But if the similarity or the difference does really exist, and if all that his philosophical statement does is to call attention to it, why not let him have his paradox? What harm is there in it?" The answer is that if that were the whole of the matter, then there would be no harm in it. But what invariably happens is that the philosopher is misled by the form of his philosophical statement into imagining that it is an empirical statement. "There is no certainty about empirical matters" is so very much like "there is no certainty about the future of the present generation." "What one really sees when one looks at a thing is a part of one's brain" is so very like "What really happens when one sees a thing is that light rays from it strike the retina." Misled by the similarity in appearance of these two sorts of statements, and knowing that the paradoxicalness of empirical statements is no objection to their being true, the philosopher imagines that his paradox is really true—that common sense is really wrong in supposing that empirical matters are ever certain, that any words ever have clear meanings, that anything other than a part of one's brain is ever seen, that anything ever does happen later or earlier than something else, and so on.

When the philosopher supposes that his paradox is literally true, it is salutary to refute him. The fact that the authors of the paradoxes nearly always fancy themselves to be right and common sense to be wrong, and that they then need to have it proved to them that their statements are false, explains Moore's great importance in philosophy. No one can rival Moore as a refuter because no one has so keen a nose for paradoxes. Moore's extraordinarily powerful language-sense enables him to detect the most subtle violations of ordinary language.

Two things may be said against Moore's method of refuta-

tion.[13] In the first place, it often fails to convince the author of the paradox that he is wrong. If, for example, the paradox is, that no one ever knows for certain that any other person is having sensations, feelings, experiences; and Moore replies "On the contrary, I know that you now see and hear me," it is likely that the man who made the paradox will not feel refuted. This is largely because Moore's reply fails to bring out the linguistic, non-empirical nature of the paradox. It sounds as if he were opposing one empirical proposition with another, contradictory, empirical proposition. His reply does not make it clear that what the paradox does is to attack an ordinary form of speech as an incorrect form of speech, *without disagreeing as to what the empirical facts are,* on *any* occasion on which that ordinary form of speech is used.

In the second place, Moore's style of refutation does not get at the sources of the philosophical troubles which produce the paradoxes. Even if it shows the philosopher that his paradox is false, it only leaves him dissatisfied. It does not explain to him what it was that made him want to attack ordinary language. And it does not remove the temptation to attack ordinary language by showing how fruitless that attack is. In short, even if Moore does succeed in making the philosopher feel refuted, he does not succeed in curing the philosophical puzzlement which caused the philosopher to make the paradox which needs to be refuted.

Although Moore's philosophical method is an incomplete method, it is the essential first step in a complete method. The way to treat a philosophical paradox is first of all to resist it, to prove it false. Because, if the philosopher is pleased with his paradox, fancies it to be true, then you can do nothing with him. It is only when he is dissatisfied with his paradox, feels refuted, that it is possible to clear up for him the philosophical problem of which his paradox is a manifestation.

However, to say that Moore's technique of refutation is the essential first step in the complete philosophical method does

[13] This must be taken as qualifying my previous statement that Moore's refutations are *good* ones.

not adequately describe the importance of the part he has played in the history of philosophy. Moore's great historical rôle consists in the fact that he has been perhaps the first philosopher to sense that any philosophical statement which violates ordinary language is false, and consistently to defend ordinary language against its philosophical violators.

NORMAN MALCOLM

DEPARTMENT OF PHILOSOPHY
PRINCETON UNIVERSITY

14

Morris Lazerowitz

MOORE'S PARADOX

14

MOORE'S PARADOX

IT has frequently happened that philosophers have held seriously views which seem to go completely counter to ever so many beliefs of common sense. Different philosophers have said, with the assured air of stating incontrovertible fact, that

(1) Physical objects exist only while being perceived;

(2) Material bodies are unreal;

(3) Time is unreal;

(4) Space is unreal;

(5) No one can know with certainty that any other person exists.

These theories, and many others like them, appear to be about matters of fact, open to establishment or disestablishment by observation and experimentation. In this respect they resemble propositions found in ordinary science text-books, e.g., the proposition, which parallels (1), that mercury exists in a solid state only at a temperature less than 38.86 degrees below zero Fahrenheit, or the proposition, which parallels (5), that human beings cannot hear sounds of high pitch readily audible to dogs. And by backing these theories with proof philosophers give the impression of destroying the most assured beliefs of ordinary life, of being like scientists who demonstrate facts, e.g., that the speed with which an object falls does not depend upon its weight, which reduce some of our strongest convictions to mere superstitions. All these philosophical theories have this in common, that from each of them it seems to follow that *no* propositions of very large classes of propositions of ordinary discourse are *ever* true; and some of these propositions each of us, ordinary people as well as scientists, should unhesitatingly

371

say we know to be true. From (1), namely, that physical objects exist only while being perceived, the shocking consequence seems to follow that every proposition asserting the existence of an object which happens not to be perceived by anyone, e.g., the film inside my camera, is always false. From the view (2) that material bodies are unreal the equally shocking consequence seems to follow that every proposition stating the existence of material objects, e.g., the proposition that I have a pen right now in my hand or the proposition that I have a hand, is always false. And the views (3), (4), and (5) appear to have similar consequences with regard to all propositions of the classes of temporal propositions, spatial propositions, and propositions about our knowledge of other selves, namely, that none of them is ever true.

These views and many others in philosophy should consequently be cause for serious concern, since so much of what we take as absolutely unquestionable, not only in ordinary life but in scientific investigation, is apparently brought into question. Professor Moore has taken this as a cause for concern, making it one of his main objects to combat such views and to defend Common Sense against their consequences. Against them he has maintained that many propositions of the classes which, according to these views, never contain true propositions *are* often true; i.e., that there are many true temporal and spatial propositions, many true propositions stating the existence of unperceived physical objects, many true propositions with regard to our knowledge of other selves. In proof of this, and consequently in refutation of these views, he has contended that he knows, and similarly for everyone else, that:

There exists at present a living human body, which is *my* body. This body was born at a certain time in the past, and has existed continuously ever since . . . and, at every moment since it was born, there have also existed many other things, having shape and size in three dimensions (in the same familiar sense in which it has), from which it has been *at various distances* (in the familiar sense in which it is now at a distance both from that mantel-piece and from that book-case, and at a greater distance from the book-case than it is from the mantel-piece). . . . And, just as my body has been the body of a human being, namely myself

. . . so, in the case of very many of the other human bodies which have lived upon the earth, each has been the body of a different human being. . . .[1]

It is plain that an important part of what Moore does in attempting to refute philosophical theories from which it follows, or at any rate seems to follow, that no propositions of certain classes of propositions expressed in ordinary discourse are ever true, is to refer to plain matters of fact which it would simply be a farce to deny. Thus, for example, against the views that space and time are unreal he cites such facts as those to the effect that he was "born at a certain time in the past" and that he has a body. Obviously, similar facts hold for anyone who ever held that space and time are unreal, and are, furthermore, perfectly well *known* by those who hold these views. A peculiar feature of such views, which immediately becomes evident from Moore's refutations, is that phenomena of the sort the existence of which they deny are so plainly before all our noses that it is startling to have them referred to in refutation of important philosophical views. This is what Moore often does; he calls attention to facts which make important philosophical views look ridiculous. The strange thing, if we stop to think of it, is not that anyone who has been taken in by these views has overlooked what is so obvious, but that he should have accepted or even been troubled by views which go against what he has *not* overlooked. It leads us, furthermore, to wonder what could ever have made anyone formulate them.

Demonstrations of the sort Moore uses against them would, in ordinary life as well as in science, be absolutely conclusive, to see which requires no special training. They are of the form "α is a *fact;* theory T is logically inconsistent with α; therefore T is false." In ordinary life, as well as in science, we *give up* theories which are logically inconsistent with facts which we *know.* In philosophy, however, as Moore has pointed out, this frequently does *not* happen. In connection with philosophical theories which seem obviously inconsistent with innumerable

[1] "A Defence of Common Sense," *Contemporary British Philosophy,* v. II, 194-5.

propositions expressed, or implied, in scientific and ordinary discourse, Moore has formulated what is one of the most important paradoxes in philosophy. He has pointed out that philosophers ". . . have been able to hold sincerely, as part of their philosophical creed, propositions inconsistent with what they themselves *knew* to be true, and . . . this has really frequently happened."[2] This is an astonishing paradox; and by expressing it Moore brings to sharp focus a discontent with philosophy which ever so many people have felt but have never been able to express in any clear way. It may be recalled that Professor Broad, for example, felt it necessary to defend philosophy against the vague charge that it is "moonshine."[3] Moore's refutations show that a great deal of philosophy is "moonshine" *of some sort.* They bring out a likeness between many philosophical views and grotesque fiction, a likeness between them and stories like that of the hunter whose reply to the question as to how he escaped from wild beasts which had completely surrounded him, was, "I didn't escape; they ate me up." Moore's paradox makes this likeness even stronger; but, what is perhaps more important, it brings out a marked difference between them: the difference, namely, that philosophers who express views inconsistent with what they know nevertheless hold those views *sincerely.* It thus sobers us and addresses our attention to the problem as to what makes this *possible.* This, it seems to me, is the *real* problem: to see what it is about the *nature* of the views and the arguments used in their support that makes it possible for philosophers to hold them in the face of plain matter of fact, with which, as seems to be the case, the views are inconsistent. And in this paper it is my purpose to consider this problem.

If the refutations Moore formulates are looked at in conjunction with his paradox a fact appears which may seem as surprising as the views against which they are brought. Moore attempts to confute philosophers by calling attention to facts of a sort which, according to his paradox, they already know and therefore have not overlooked or ignored. Now, we may say that a

[2] *Ibid.,* 203.
[3] C. D. Broad, *Scientific Thought,* 11.

necessary condition which a fact α must satisfy in order to establish the falsity of a proposed theory T is that a person who holds T will give it up on getting to know α, given both that the person holding T is sincere and also that the inconsistency between α and T is absolutely obvious, requiring no process of ratiocination in addition to looking at both in juxtaposition. Facts of the sort Moore directs attention to in attempting to confute certain philosophers are, if inconsistent with their theories, *obviously* inconsistent with them; nothing, for example, could be more obvious than the inconsistency, if there is one, between a fact of the form "I have a body" and the view that there are no material bodies. In spite of such facts being perfectly well known by them, philosophers nevertheless persist in holding their views. That is, *knowing* such facts does not make them *give up* their views; and the only conclusion possible, it seems to me, is that such facts are not inconsistent with *their* views, however incomprehensible this may seem. Thus, as I shall try to show, Moore's paradox, according to which they *do* know such facts, leads to the conclusion that his "refutations" are not refutations.

It may be pointed out in this connection that conflicting attitudes on the part of Moore himself can be detected, that his attitude toward his own refutations is ambiguous. The sort of facts to which he refers in demonstrating the falsity of philosophical views like (1)-(5) creates the impression that the views are so patently false as to make it completely unaccountable how anyone could ever hold them. And one can only gather that his attitude regarding them is that they are not worthy of serious concern. He has, as a matter of fact, given expression to this attitude:

This, after all, you know, really is a finger: there is no doubt about it: I know it, and you all know it. . . . The questions whether we do ever know such things as these, and whether there are any material things, seem to me, therefore, to be questions *which there is no need to take seriously:* they are questions which it is quite easy to answer, with certainty, in the affirmative.[4]

[4] *Philosophical Studies,* "Some Judgments of Perception," 228. Italics my own.

Moore does, however, take such questions quite seriously; he has written and continues to write on them.[5] In spite of his contention that "they are questions which it is quite easy to answer, with certainty, in the affirmative" he has thought answers in the negative, i.e., views such as that time is unreal and that material bodies are unreal, to be sufficiently important to *defend* Common Sense against them. This, it seems to me, reasonably leads to the supposition that he grants them an importance which is precluded by the attitude evinced by his refutations. His constant concern to refute them shows his attitude to be that they *are* important. If, consequently, this concern is taken seriously, as it should be, it must be concluded that his attitude with regard to his refutations is ambiguous. It must be supposed that he himself, in a concealed way, is uneasy as to whether his "refutations" are refutations.

In this essay I wish to show that his "refutations" are not refutations, and also, more generally, that the views the falsity of which they are designed to establish, *have no refutations*. I wish to show how his paradox together with his refutations throw light on the *nature* of the views, so that it can be seen that those views have no refutations.

Moore is unquestionably right in saying that philosophers *know* facts of the sort he uses to confute them, e.g., facts to the effect that they were born at a certain time in the past, have bodies, own things which at various times are perceived by no one. In case it is thought that what Moore says is doubtful, a good way to test a person who makes academic assertions which are inconsistent with what we think he knows all along is to observe how he acts in relevant situations. We take as a criterion of a person's knowledge with regard to various matters of fact, not only his academic claims, but also his behavior in the presence of such facts; and if his behavior is and continues to be incompatible with his claims, we discount them as *just talk* and accept his behavior as indicative of what he *really* knows. For example, if an entirely competent and honest doctor were

[5] Cf. his "Proof of an External World," Annual Philosophical Lecture, Henriette Hertz Trust, *Proc. Brit. Acad.*, Vol. XXV (1939).

persistently to say that no disease is incurable, and nevertheless continued to treat cases, say, of leprosy the way other competent doctors treat them, as cases of a disease which cannot, as yet at any rate, be cured, we should reject what he says, regardless of his sincerity, as puzzling talk and be perfectly certain that he *knows* that leprosy is an incurable disease.

The views with regard to space, time, material bodies, etc., against which Moore defends Common Sense, give rise to the idea that *ordinary* behavior is inappropriate to reality; and that if people only knew better they would change their behavior to suit the facts—this would seem to be the practical consequence of establishing such views. It is consequently to be expected that philosophers who hold such views will act differently. It is to be expected that philosophers who hold that no one can know with certainty that any other person exists will greet' their friends with at least *some* hesitance, with the mental aside, "For all I know, this may be nothing but a subjective show; after all, I don't really know that other people exist." The idea of travelling in trains should immediately bring up a picture of certain disaster in the mind of anyone who held that physical objects exist only while being perceived, because " a railway train would only have wheels when it is not going, since, while it is going, the passengers cannot see them."[6] When one considers how people would behave if the conductor were suddenly to shout that the train, in which they were going at sixty miles an hour, no longer had its wheels, it might well be expected that some philosophers would never leave home.

It would seem reasonable to expect *some* difference in behavior on the part of philosophers who sincerely hold views like (1)-(5). None, of course, as Moore's paradox anticipates, is discernible. It is a fact that the superior knowledge which philosophers give the impression of having results in no different behavior from that met with in ordinary life. Despite a philosopher's unquestionably sincere claim to have demonstrated the unreality of time, like any other person he consults his watch, hurries to an appointment, and apologizes for being

<hr>

[6] Moore's example, used by B. Russell in *The Analysis of Matter*, 210.

late. Despite his view about the unreality of space, he complains that the distance from his home to his lecture room is too much for him to walk of a morning or that an ugly building is between his study window and a fine view. Despite his view about the unreality of material objects, he is as careful as any normal person to avoid oncoming cars when crossing the street and remarks with satisfaction on the thickness of the steel door of the bank vault in which his valuables are kept. And, aside from the fact that no uncertainty whatever can be detected in his behavior, it is a safe bet that he does not make any mental aside about the possible non-existence of other people when he hails his friend, accepts his offer of a cigarette, and walks down the street with him. For he fails to show the slightest signs of doubt in circumstances which should bring out his doubt in its most acute form, namely, when he tries to convince others of the correctness of the view that no one can know with certainty that other people exist.

On the contrary, circumstances can easily be imagined in which such views could be used to *reassure* a philosopher who is in *real* doubt or in some actual state of anxiety about ordinary situations. If, for example, we were to tell him that the automobile which he had locked in his garage has vanished, that it is no more, he would behave like any ordinary person: he very naturally would be upset, want to notify the police, certainly regret that he had not insured it. If, in answer to his question as to what had happened, whether it had burnt, or been struck by lightning, we say it was none of these but only that it was locked in the garage and so was not being perceived, there is no question but that he would be relieved. That is, when he understands that the only reason for our saying his automobile is no more is his own philosophical view that physical objects exist only while being perceived, he is reassured that his automobile *does exist*. Similar situations can be imagined in connection with the other views. For example, when he begins to apologize for having come a half hour late to dinner and we insist he is not late, like any other person he expresses relief and wonders what is wrong with his watch. When we go on to explain that he could not have come late because, according to his own view, time is

unreal, he thinks we are good-natured about the whole thing and goes on with his explanation as to why he *was* late. It is a curious feature of views like (1)-(5) that, if they are given as reasons for statements with regard to ordinary matters of fact, they are treated as *jokes*.

It is clear that Moore is entirely right in saying that philosophers who hold these views *know* facts of the sort which by their views they seem plainly to deny. Their ordinary behavior shows this. Even their academic talk frequently shows this, as he has pointed out:

> . . . all philosophers who have held such views have repeatedly, even in their philosophical works, expressed other views inconsistent with them: i.e., no philosopher has been able to hold such views consistently. One way in which they have betrayed this inconsistency, is by alluding to the existence of other philosophers. Another way is by alluding to the existence of the human race, and in particular by using "we" . . .[7]

And they are not struck by the absurdity of saying "none of *us* can ever really know that any human being besides himself exists," or of starting a lecture with the statement, "In the course of this lecture I propose to demonstrate the unreality of time," because not for a moment is the existence of other people or of temporal phenomena in question. If they were in question the proponents of the views could not fail to *see* the absurdity. Regardless of what they hold academically, such facts are never *really* in question; everything goes to show that philosophers know them *even while* expressing their views.

This makes it look as though holding such views and attempting to "prove" them is nothing but a solemn pretense, a sort of intellectual game of make-believe which many adults like to play. But to suppose this is as far from the truth as anything could be. Moore is certainly right when as part of his paradox he states that philosophers hold such views "sincerely." Their behavior shows this as clearly as it shows that they know facts which seem to be in obvious contradiction to their views. Undoubtedly they hold their views sincerely, and undoubtedly they know facts which appear to render their views false. Con-

[7] "A Defence of Common Sense," 202-203.

sequently, it is, so far as I can see, a correct paraphrase of Moore's paradox that philosophers have held ". . . sincerely, as part of their philosophical creed, propositions inconsistent with what they themselves knew to be true," to say that philosophers have held "*sincerely*, as part of their philosophical creed, propositions which they *knew to be false*." And if his "refutations" are refutations, then philosophers *have* held views they knew to be false. This is impossible, and the only conclusion, it seems to me, is that his "refutations" are not refutations of their views. To see this it is first necessary to see that views like (1)-(5) are not empirical.

It is in the first place natural to look on the disputes between Moore and other philosophers as being empirical. The views, by the way they are expressed, seem for one thing to imply the falsity of ordinary *empirical* propositions, such as the proposition that in 1893 F. H. Bradley published arguments for the unreality of time. And if they did imply the falsity of propositions which are such that they could logically have a truth-value other than the one they in fact have, they would themselves have to be empirical, be such that they could logically have a truth-value other than the one they have. For another thing, Moore actually adds to the illusion that the disputes are with regard to matters of fact. The manner in which he expresses his demonstrations, viz., α is a fact, α is inconsistent with T, therefore T is false, does this. I.e., he uses language which gives the impression that he brings empirical facts to bear against the views; and since only empirical propositions can be inconsistent with such facts, or have implications with regard to them, the impression is naturally created that the disputes are about empirical facts.

Looked at in this way, however, the disputes between Moore and other philosophers become completely incomprehensible: for they *remain unresolved*. When in ordinary life an empirical theory is in question recourse to the facts, if they are available, will settle the matter. This seldom, if ever, happens in philosophy. There is a story that once, when Zeno propounded his theory about the impossibility of motion, Diogenes, in refutation of the view, got up and walked several times across the

room. But there is no story of Zeno having given up his view, nor, so far as is known, of Bradley having given up his. In ordinary life, having one's attention called to facts which are incompatible with a given view makes one discard it. This, as is to be expected from Moore's paradox, does not happen in philosophy. For, since philosophers hold their views *while* (and in spite of) *knowing such facts,* recourse to the facts will not result in the views being given up. Consequently the disputes cannot be looked upon as empirical. To do so leads to the self-contradictory conclusion that philosophical disputes with regard to matters of fact *cannot* be settled empirically. The only way to avoid this contradiction is to say that the disputes are not empirical. The following considerations show this most plainly.

Let us examine the statement, "Time is unreal." If, to use Moore's expression, it is translated "into the concrete,"[8] it looks as though what a philosopher who makes it means to assert is that ". . . nothing ever happens before or after anything else; nothing is ever simultaneous with anything else; it is never true that anything is past; never true that anything will happen in the future; never true that anything is happening now; and so on."[9] "Time is unreal" means the same as "There are no temporal facts." Parenthetically, it may be remarked that translating philosophical views into the concrete is an important part of Moore's technique; for by it he gets rid of misleading pictures which are naturally associated with the views, e.g., the picture of time as a sort of mysterious object.[10] It is such pictures, the empirical counterparts of philosophical statements, that in part makes the views so intriguing and at the same time prevents one from seeing what they actually come to. By removing the pictures he deprives the views of an important part of their mystification. But to do this is not enough. To return from the digression, if "Time is unreal" is taken to mean that there are no temporal facts, the view looks plainly to be empirical:

[8] *Philosophical Studies,* "The Conception of Reality," 209.

[9] *Ibid.,* 210.

[10] Note Bradley's remark: "It is usual to consider time under a spatial form. It is taken as a stream, and past and future are regarded as parts of it. . . ." *Appearance and Reality,* 39.

"There are no temporal facts" bears a great similarity to "There are no centaurs." But the empirical look is a deceptive feature, both of the view and of its translation. If the attention of a philosopher who holds the view and grants the translation is called to various events that just took place and are now taking place, he will continue to maintain that there are no temporal facts, and perhaps repeat his argument for maintaining that view. It looks as though he wanted to deny the facts. But these he *knows* and cannot *honestly* deny. Consequently, it must be supposed that he does not *really* wish to deny them at all, however to the contrary appearances may be. It must be supposed that the view is of such a nature that the facts simply *do not count against it.*

No known facts count against it, and furthermore, it is easy to see that no *imaginable* or *describable* facts could do so either. Suppose we say: "This is all very strange: You do not deny the existence of various events which Moore calls 'temporal facts'; nevertheless you insist that time is unreal. What, to help clear up the mystery, would you describe, over and above such things, which, if there were anything of that kind answering to the description, would make you give up the view? Talking, walking, having tea, and the like are not, it would appear from your view, really temporal. Perhaps we have all been laboring under an illusion about such things; tell us what the real thing is like." *This he cannot do.* He cannot describe anything, over and above the phenomena he rejects as being temporal which he would say was the real thing, really temporal. Unlike the bored seeker for excitement who complains that nothing ever happens, he cannot say what it would be like for anything to happen. Nothing in actual experience, in recollection, in present experience, or in fulfilled expectation, is acceptable as disestablishing his view, and neither is anything which could be described, regardless of whether it exists or not. Unlike "Centaurs are unreal," "There are no temporal facts" is such that nothing which we can picture to ourselves would falsify it. It is plain from this that the philosopher who asserts "Time is unreal" is not using it to express a proposition which could imaginably be false, i.e., *an empirical proposition.* Similar considerations hold for the other

views. Consequently, if Moore's refutations are looked on as demonstrations in which empirical facts are brought to bear against the views, it must be conceded that his "refutations" are not refutations.

Once it becomes clear that in holding views like (1)-(5) philosophers are not asserting empirical propositions, the natural thing is to think that they are asserting necessary ones. As a matter of fact, philosophers who have held such views have themselves frequently thought this. Russell has said with regard to common beliefs that they are "cocksure, vague, and self-contradictory."[11] And Bradley has said: "Time, like space, has most evidently proved not to be real, but a self-contradictory appearance."[12] It may be gathered from this that Bradley supposes himself, by his views with regard to time and space, to be implying not merely that there are no temporal and spatial facts but that it is logically impossible for there to be any. He thinks himself to be holding views from which it follows that ordinary spatial and temporal propositions, e.g., the propositions to the effect that half my sheet of paper is covered with writing and that it has taken me twenty minutes to accomplish this, are not merely false but are self-contradictory. And the statement "Time is unreal" is to be taken on this supposition as expressing a *necessary* proposition, namely, "Time is self-contradictory" or, to translate it "into the concrete," "It is logically impossible for there to be temporal events." This interpretation also requires that we revise our idea of the nature of the disputes between Moore and other philosophers. His refutations, just as the philosophical views, have to be considered as different from what the language in which they are expressed naturally leads one to think they are, viz., demonstrations in which views are countered with empirical facts. What they come to, as necessitated by the supposition that the philosophical views in dispute are necessary ones, can easily be seen by bringing out a further fact about those views.

"Time is unreal," when the intention is to use it as the expression of a necessary proposition, presumably means the same as

[11] *Philosophy*, 3.
[12] *Appearance and Reality*, 43.

"It is logically impossible for there to be any temporal facts."
In place of the latter form of expression it is more usual to use
the words "There *cannot* be any temporal facts." Compare
now "There cannot be any temporal facts" with "Water cannot
flow uphill." It is a simple matter to imagine or to picture to
oneself water flowing uphill; we know what it would be like
for there to be a state of affairs which would make false the
proposition that water cannot flow uphill. In other words, part
of understanding "Water cannot flow uphill" consists in know-
ing what it would be like for water to flow uphill. And in
general, in the case of every sentence of the form "x cannot
. . ." which expresses an empirical proposition, understanding
the sentence consists in part in knowing what it would be like
for a situation described by "x *does* . . ." to obtain. Thus, "Water
flows uphill" describes something which the original sentence
says cannot obtain. However, with regard to no sentence which
expresses a necessary proposition is this ever the case. On the
contrary, understanding a sentence of the form "x cannot . . . ,"
in which "cannot" has the meaning of *logical* impossibility, is
inconsistent with knowing what it would be like for there to be
states of affairs described by "x does" This can be seen
by noticing with regard to "There cannot be any temporal facts"
that, if understanding it entailed knowing what it would be like
for there to be anything described by "There are temporal
facts," or if "temporal facts" described anything which "There
cannot be any temporal facts" says cannot exist, it would not
express a necessary proposition. For situations could then be
imagined which would render the proposition expressed by it
false. Only by preventing "temporal fact" from having a
descriptive use, by preventing any phenomenon, actual or im-
aginable, from being *called* a temporal fact, does "There cannot
be any temporal facts" become an expression for a necessary
proposition. By using sentences to express necessary propositions
we prevent certain expressions from having a use: " 'There
cannot be any temporal facts' expresses a necessary proposition"
means the same as " 'Temporal fact' has no use." It is clear
then, that the *information* conveyed by sentences expressing
necessary propositions is *verbal*. Now I do not wish here to

suggest that necessary propositions are verbal; I do not wish to be understood as holding any view whatever with regard to their nature. For it seems to me that the question, "Are necessary propositions verbal?" *has no answer;* and the thing that has made some philosophers *give* it an answer in the affirmative is that they have noticed an important similarity between sentences for necessary propositions and those for linguistic ones, viz., that the information both sorts of sentences convey is verbal. This feature of similarity is not, however, sufficient for *truly* asserting that necessary propositions are verbal. And I do not wish to be understood as claiming to assert this; although what I have suggested might be said to be self-contradictory on the grounds that the proposition expressed by a sentence which conveys verbal information must itself be verbal. The information conveyed by sentences expressing necessary propositions is verbal, and as the word "verbal" is at present used in the English language it is not *true* to say that necessary propositions are verbal.

If expressions for the philosophical theories, "Physical objects exist only while being perceived," "Material bodies are unreal," "Time is unreal," etc., are viewed as being such that the information derived from understanding them is verbal, or, more specifically, is about the use of an expression, the disputes between Moore and other philosophers must be interpreted in this light. The philosopher who asserts that time is unreal, or that there cannot be any temporal facts, informs us that expressions using verbs with tense have no use: that such sentences as "Moore lectured for an hour on perception this afternoon," "Moore is now having tea," "Tomorrow he will lecture on definite descriptions," express self-contradictory propositions, and consequently describe nothing actual or imaginable and are devoid of sense. Moore's refutations, in which philosophical theories seem to be countered with empirical facts, must then be interpreted to be attempts at showing the views wrong by showing that ordinary propositions expressed by sentences involving verbs with tense are not self-contradictory. Now the *only* way in which it can be demonstrated that such propositions are not self-contradictory is to show that the sen-

tences which express them are used in ordinary discourse to
describe various situations, actual or imaginable. Hence, when
in refutation of "Time is unreal" Moore points out that Zeno
held the view more than two thousand years before Bradley did,
he may be construed as arguing: "The sentence 'Zeno held the
view that time is unreal more than two thousand years before
Bradley held it' describes what happened or what can be imag-
ined as having happened; therefore the proposition it expresses
is not self-contradictory; therefore the theory from which it
follows that the sentence does express a self-contradictory prop-
osition is false." The disputes between Moore and other phi-
losophers, on the supposition that philosophical statements ex-
press necessary propositions, are to be reckoned as disagreements
in which the points at issue are verbal, i.e., points as to whether
ordinary expressions of various sorts have a use. It is highly
doubtful that Moore would agree that this is what the disputes
come to, although he at least seemed to hint at this when he
said: ". . . I have assumed that there is some meaning which is
the ordinary or popular meaning of such expressions as 'The
earth has existed for many years past'. And this, I am afraid,
is an assumption which some philosophers are capable of dis-
puting."[13] This is, however, what the disputes do seem to me to
come to, *if* it is supposed that the philosophical statements ex-
press necessary propositions.

Moore's paradox may now be paraphrased to read as follows:
philosophers ". . . have been able to hold sincerely, as part of
their philosophical creed, views according to which expressions
of various sorts, which they *know* are used in ordinary discourse
to describe real or imaginary states of affairs, have no use or
sense." To formulate it in terms of the concrete example, "Time
is unreal," Moore is to be understood as saying that philosophers
who hold this view know that expressions involving verbs with
tense have descriptive use in ordinary language. Also, on the
supposition that philosophical statements express necessary
propositions, so that the points at issue in the disputes are verbal,
views (1)-(5) are to be taken as constituting in effect an attack

[13] "A Defence of Common Sense," 198.

on the *language* of Common Sense: as views according to which no sentence of very large classes of sentences employed in ordinary discourse ever describe anything at all, that they make no sense. Moore's defense of Common Sense is to be construed as a defense of the *language* of Common Sense; and the refutations, which by the way in which they are expressed give the impression that he brings empirical facts to bear against the views, are to be considered as linguistic in intent. "A railroad train *has* wheels while it is going and no one sees them" translates into *"It makes sense* to say 'A railroad train has wheels while it is going and no one sees them'." "Here is a hand" translates into " 'Here is a hand' does not express a self-contradictory proposition, it does have a descriptive use in the language, it is not a senseless expression." This, now, may seem to be a satisfactory way of looking at the matter. Again, however, as on the first interpretation of the disputes between Moore and other philosophers, difficulties emerge.

It is difficult, in the first place, to see why Moore should think it necessary or at all important to defend Common Sense against attacks on its language by philosophers, who in ordinary life find it quite satisfactory for their communicative needs. There clearly is no actual need to defend Common Sense against such attacks. They are *just* academic, and have had no influence whatever on ordinary language. Changes have of course occurred in it, but they have not been brought about by any philosophical attacks. Zeno, for instance, stated the view that motion is impossible, the verbal point of which is that expressions using verbs denoting an action are senseless; but Common Sense still uses such expressions, and no doubt will continue to use them regardless of what philosophers say. Even philosophers continue to use them, despite their views. It is not easy to see what would ever make anyone hold views like (1)-(5); but neither is it easy to see why anyone should show any concern at all to refute them. And again, it seems to me, if Moore is right in asserting as part of his paradox that philosophers *know* that ordinary expressions using verbs with tense, verbs denoting an action, nouns which are general names for material ob-

jects, etc., are used in ordinary life to describe various matters, then his "refutations" are not refutations. His refutations show views which are in conflict with the language of Common Sense to be false; but since philosophers continue to maintain *their* views in spite of such refutations and in spite of knowing what they do about ordinary language, it must be the case that his refutations are not refutations of *their* views. Their views are still to be construed differently.

Moore is entirely right in saying that philosophers know the facts about the language of Common Sense to which his demonstrations call attention. Again, if the test of behavior is applied to them, this becomes plain. A good test for ascertaining whether a person knows that expressions of various sorts make sense is to observe how he uses them and how he responds to other people's use of them. And it is a fact that philosophers use and respond to the use of ordinary expressions in the same way in which people who do know their use commonly respond. Philosophers know how to ask for the time of day, the distance to a place to which they wish to walk, whether there are films inside the camera, etc.; and by their behavior they show that they understand other people's use of such expressions. There is no doubt whatever that in everyday life they use and understand the language of ordinary people. And even though on the foregoing interpretation their *views* may make them appear to be like foreigners who are ignorant of the language they hear but who believe that it makes no sense because it makes no sense to them, all evidence points to the contrary. Even in their academic talk they betray their knowledge of the language. This recalls Moore's remark: ". . . all philosophers who have held such views have repeatedly, even in their philosophical works, expressed other views inconsistent with them; i.e., no philosopher has been able to hold such views consistently."[14] This may now be taken as stating that philosophers who have held views, the verbal points of which are that ordinary expressions of various kinds have no use, have repeatedly, even in their philosophical works, made statements using such expres-

[14] "A Defence of Common Sense," 202.

sions. Consider, for example, Bradley's remark: "Time, like space, has most evidently proved not to be real, but to be a self-contradictory appearance. I will, in the next chapter, reinforce and repeat this conclusion by some remarks on change."[15]

Again it looks as if holding such views is nothing but a deception. The natural feeling in connection with Bradley's remark is that by inadvertence he has given the game away and that a more careful philosopher would not have done so. But Moore is right when he states, as part of his paradox, that philosophers hold such views sincerely. I should say that the lack of caution shows that it is not a deception: these philosophers have nothing to hide, otherwise they would be more circumspect. And it shows more than this. It reveals that what they know about the language does not count against *their* views, against what they really mean to say. If what they knew did falsify their views, Moore's "refutations" would refute them. But then the disputes between him and other philosophers would again be incomprehensible: they remain unresolved. Since philosophers understand the language and know how to use it, and since his demonstrations only call attention to what they already know, they must see that his refutations do establish the falsity of views according to which great parts of language in everyday use make no sense. The fact that they see this and do not give up their views would be entirely unintelligible if facts of the sort he adduces were incompatible with their views. Undoubtedly it would not disturb Bradley in the least to have it pointed out to him that in conjunction with his theory about time he says: "I will, in the next chapter, reinforce and repeat this conclusion by some remarks on change." It should; if what he says is inconsistent with his view he should give it up. But, since what he himself has said does not make him relinquish the theory, it can only be supposed that *his* theory does not conflict with the language he uses. What philosophers know cannot be used to disestablish their theories; and since Moore's demonstrations call attention to what they already know, it must be admitted that his "refutations," viewed as arguments

[15] *Appearance and Reality*, 43.

employing facts to the effect that expressions in ordinary use make sense, are not refutations of their views. If this is so, it will be plain that the philosophical views *have no refutations*. If no considerations, either of the sort which disestablish empirical theories or of the sort which disestablish *a priori* ones, are *relevant* to them, then they are neither empirical nor *a priori*. It makes no sense to speak of refuting them, nor, for that matter, of proving them. This is important, because it leads to seeing what the views really are.

Philosophers do of course speak of proving their theories, and actually produce arguments for them. This is what makes philosophical theories impressive, despite their looking like "moonshine." Arguments for views like (1)-(5) are of course also arguments against Common Sense, and Moore has challenged them. He has said: "I think we may safely challenge any philosopher to bring forward any argument . . . which does not at some point, rest upon some premiss which is, beyond comparison, less certain than is the proposition which it is designed to attack."[16] To be sure, if an argument attacks *known* fact it may safely be challenged; and if Moore's demonstrations establish the falsity of the views they also establish the incorrectness of arguments of which the views are consequences. It is important, however, to notice what a philosopher *does* when faced with facts of the sort to which Moore's demonstrations refer. When in ordinary life, as well as in scientific investigation, a person is faced with facts of a sort with which his argument conflicts, he looks for a mistake in his reasoning. Even when he fails to discover what is wrong with it, he admits that it is wrong. This is the normal reaction: to give it up, to look for the mistake. This the philosopher does not do. When faced with a fact which apparently disestablishes his view he brings forward an argument. *He counters facts with arguments.* If, for instance, Bradley's attention were called to the fact that he concludes his chapter on "Space and Time" with the words "I will, in the next chapter, reinforce and repeat this conclusion by some remarks on change," he undoubtedly would say that his argument

[16] *Philosophical Studies*, "Some Judgments of Perception," 228.

has not been understood and ask that it be looked at again with more care.

What are we to understand from his behavior? Is it that he wishes to maintain and to have us see that his argument is correct? This could hardly be the case; he cannot both know the facts and urge that it is nevertheless a correct argument against them. His behavior must be interpreted differently. It is plain that he wants us to look at the argument rather than at the facts, as if the facts were somehow beside the point; this shows that his concern is not to have us see that his argument is not mistaken, but *something else*. When he complains that his argument has not been understood, he means that *the nature* of his argument has not been understood. His argument is not designed to establish the truth of any view, empirical or *a priori*. It is meant to back *a verbal recommendation*. His "views" are really proposals with regard to the use of ordinary expressions; this is the explanation of the problem as to what has made it *possible* for philosophers to ". . . have been able to hold sincerely, as part of their philosophical creed, views inconsistent with what they themselves *knew* to be true." And the thing which prevents its being seen that his "views" are not inconsistent with known fact and that his "proofs" are only reasons for making verbal recommendations is the manner in which he expresses himself. He uses the language of assertion rather than the language of proposal. Instead of saying "Let us not use the word 'time' (or the word 'now'), let us delete it from the language," he says "Time is unreal," and so creates the impression that he is framing theories, *a priori* or empirical. Instead of saying "Let us not use 'know' in sentences referring to other people," he says "No one can know that other people exist." Instead of saying "Let us not use 'not perceived' in sentences referring to physical objects," he says "Physical objects cannot exist unperceived." This creates the illusion that they are "theories," and gives rise to the attendant puzzling stalemates. He does the same with his "proofs" and so furthers the illusion that he is concerned to establish the truth of theories. An examination of a well known philosophical proof, for the

"view" that time is unreal, will help make this clear.

It has been argued:

The question at once before us will be as to the "now's" temporal contents. First, let us ask if they exist. Is the "now" simple and indivisible? We can at once reply in the negative. For time implies before and after, and by consequence diversity; and hence the simple is not time. We are compelled then, so far, to take the present as comprehending diverse aspects. How many aspects it contains is an interesting question. According to one opinion, in the "now" we can observe both past and future. . . . All that we require is the admission of some process within the "now." For any process admitted destroys the "now" from within.[17]

In other words, with regard to the question, "How much time does now consist of?," it is only possible to say either that now consists of zero time or of some unit of time, however small. Neither of these alternatives, however, is possible. If it consists of zero time, then "as a solid part of time, the 'now' does not exist."[18] And if it consists of some time interval, has duration, then it contains "an after and before,"[18] which is self-contradictory. This looks like the "proof" of a view with regard to the nature of time; the language in which it is expressed tempts us to imagine that what it shows is that "now" has a self-contradictory meaning and that sentences using "now," or verbs in the present tense, say what is self-contradictory. What it really is and what philosophers wish to accomplish with it is not, however, difficult to see. "Now cannot consist of some stretch of time," in which "cannot" expresses logical impossibility, conveys the same information as "It makes no sense to say that now consists of $\frac{p}{q}$ seconds." What it shows is that the word "now" is not used as the name of a time interval, like "hour," "second," etc. On the other hand, "Now cannot consist of zero time" conveys the same information as "It makes no sense to say that now consists of zero time," and tells us that "now" is not used as a synonym for it. These two things can also be seen

[17] *Appearance and Reality*, 40-41.
[18] *Ibid.*, 41.

by considering the question "How much time does 'now' contain?" The fact that it is formulated shows that the use of "now" is in *some* respects like the use, e.g., of "minute:" compare with "How much time is there in a minute?" But unlike the latter question it has no answer; or, if there is an inclination to make up an answer, one might say it consists of no *definite* time. This shows that the use of "now" differs radically from the use of "minute," "second," "half a second," etc.

These two facts about the word result in conflicting tendencies; they lead us, so to speak, in opposite directions. Consider, for example, the statement "Now is the time for the equinoctial storms." In it "now" has a use which bears *some* resemblance to the use of "month" in "During this month we may expect equinoctial storms:" it does not mean "zero time." This makes us tend to exaggerate the similarity and to speak of "now" as if it were the name of a unit of time. But noticing that it is *not* leads to the opposite extreme; it tends to make us exaggerate the difference to the point where we wish to deprive "now" of a use having any such resemblance. This produces a feeling of uneasiness about the word which is based on a desire to make irregular words behave in strict ways. And what the philosopher wants is *to get rid of the word* and so rid himself of his uneasiness. By his argument he shows us what a queer irregular word it is, and tempts us to aquiesce in his recommendation, which he misleadingly expresses in the words, "The 'now' is self-contradictory," "Time is unreal." What he really means is this: " 'Now' is not the name of a unit of time, nor does it mean no time; let us stop using it." Moore of course knows these facts and apparently they produce in him no desire to give up the word. In general, with regard to views like (1)-(5), his defense of Common Sense is a defense against *changing* the language of Common Sense; and his refutations are simply counter-proposals, to be understood as recommendations not to follow academic wishes to alter it.

MORRIS LAZEROWITZ

DEPARTMENT OF PHILOSOPHY
SMITH COLLEGE

15

Alice Ambrose

MOORE'S "PROOF OF AN EXTERNAL WORLD"

MOORE'S "PROOF OF AN EXTERNAL WORLD"[1]

I N his "Proof of an External World," read to the British
Academy,[2] Professor Moore is concerned to establish the
proposition "that there exist things external to our minds."
Certain sceptical philosophers appear to doubt the truth of this
proposition, and hence Moore, although he does not doubt it,
considers it a matter of some importance "whether it is possible
to give *any* satisfactory proof"[3] of it, and if it is possible, to
produce one. If no proof can be given then one is left the alter-
native of claiming to know this without proof or of being forced,
as Kant thought, to accept the existence of things outside us
"merely on *faith.*"[4] In this paper Moore gives an argument
which he considers "a perfectly good proof,"[5] and which if
conclusive would remove what Kant characterized as a scandal
to philosophy—the scandal of being unable to counter anyone's
doubts with a proof. The proof Moore gives he asserts to be a
good one, provided he knows what is asserted in its premise.[5]
And he claims he does know this.

The proof consists in proceeding from the assertedly known
premise, "Here is a hand," to the conclusion which logically
follows from it, "there exists a thing external to us." It is
analogous to a very common form of argument, viz., to that

[1] I am indebted for many of the ideas of this paper to discussions with Mr.
Morris Lazerowitz and to papers of Mr. John Wisdom. See especially Wisdom's
paper, "Philosophical Perplexity," *Proc. Aris. Soc.*, Vol. XXXVII.
[2] Annual Philosophical Lecture, Henriette Hertz Trust, *Proc. Brit. Acad.*, Vol.
XXV, 1939.
[3] *Ibid.*, 275.
[4] *Critique of Pure Reason*, Preface to Second Edition, B xxix, note. (Kemp
Smith's translation.)
[5] "Proof of an External World," *Proc. Brit. Acad.*, Vol. XXV, 298.

in which an existential assertion is established by pointing out a specific instance. One proves that there is an officer of the law in a given village by pointing out the local sheriff, that there is a coin in the collection plate by pointing out a penny. "That (pointing) is a sheriff of village K" entails "There is an officer of the law in village K" and "There (pointing) is a penny in the collection plate" entails "There is a coin" In the same way Moore points out a hand (i.e., a physical object, i.e., as he explains, an object to be met with in space[6]), and from this it follows that there is an external object. "Here (pointing) is a hand" entails "There exists a hand," which entails "There exists an external object." This proof he says fulfills conditions which we require to be fulfilled in order for a proof to count as rigorous:[7] the premise is known to be true, it is different from the conclusion inferred from it, it logically implies the conclusion.

It is clear that Prof. Moore considers the proposition, "There are external objects," to be an empirical one. It follows from a proposition which is established by empirical evidence, viz., the evidence of the senses. One has merely to show two hands and one has established that there are external objects. But though Moore thinks this proof is conclusive he is well aware that the sceptic will not be satisfied.[8] The latter's dissatisfaction arises from requiring a proof of what Moore has not tried to prove and which, according to Moore, needs no proof because it is known without proof.[9] Now the sceptic requires a proof of what Moore has not tried to prove, namely, the *premise*, "Here is a hand," because he considers that its truth cannot, as Moore claims, be *known*, any more than the truth of what follows from it. Moore's proof will not answer the sceptic if the latter is as ready to question the truth of such premises as that of the conclusion, and if, as the sceptic certainly would hold, it is the truth of such premises about which he is in doubt. If the sceptic were to admit that there were hands but deny that there were objects

[6] *Ibid.*, 295.
[7] *Ibid.*, 297-8.
[8] *Ibid.*, 298.
[9] *Ibid.*, 299-300.

external to us, then and only then would Moore's proof be a refutation. It would be shown that "being a hand" entails "being such as to be met with in space," which in turn entails "being external to us." But to a sceptic who is quite willing to admit that "being a hand" entails "being an external object," Moore's proof will not be to the point.—It will not refute his claim that it cannot be known there are hands.

It is characteristic of philosophical controversies that "refutations" of a theory so often fail to appear conclusive to the propounders of it. And this is not due to any incapacity to follow the "refutations." In connection with the controversy under consideration it is my purpose to investigate why neither Moore's "refutation" nor any "refutation" will serve to convince the sceptic, and why no argument the sceptic produces will seem conclusive to Moore. This will require investigating what it is each wishes to do and what argumentation for establishing one conclusion or the other comes to.

It is misleading to say Moore's proof will not succeed in dispelling the sceptic's doubt about the existence of hands; for this suggests that some other proof—one, say, in which he was made to touch as well as to see hands—would succeed where this one fails. We shall see that this is not the case at all. It is also entirely misleading to take the sceptic's dissatisfaction as indicating that Moore is easily convinced there are external objects, while he, the sceptic, is very hard to convince. We have only to see that no possible amount of further evidence would alter the sceptic's claim about the limitations of our knowledge, to see that any other proof of the kind described would be as unacceptable as the one propounded. For consider the sceptic's response to attempts at convincing him: Suppose one said, "See, here is a hand." The sceptic would reply, "I can only know that I seem to see a hand. For all I know no external object may be there at all. I could be dreaming or having an hallucination." Suppose then one made him touch one's hand. The response would be the same. And the use of *all* his other senses in connection with appropriate objects would evoke the same response. The curious thing about this attempt to convince him is that both he and his opponent differ with respect to whether they

know, when both are in possession of precisely the same information. In saying, "See, here is a hand," Moore's experience differs in no important respect from that of the sceptic. And the experience of each is of the kind which serves, under ordinary circumstances, to justify one's claim to know. For example, no detective, on being shown an incriminating letter his sleuths had hoped to find, would say, "I can still only believe there is such a letter." He would dispute his sleuths, in case he lacked confidence in them, only so long as they had seen the letter and he had not. But he would say that he knew there was such a letter as soon as he had seen what they saw.

In the argument between Moore and those philosophers who say they doubt the existence of hands, he and they both are being shown a hand, and Moore would have information which they lacked only if during the time the hand was shown they had been seeing nothing at all—e.g., had been suffering from psychic blindness. Under such circumstances there would be such a thing as new evidence when the blindness passed, which evidence would be supplemented by touching the hand, pressing it, pinching it, etc. All possible sensory evidence taken together would be said to justify one's claiming to know there was a hand. But in the circumstances in which the sceptic is described as disagreeing with Moore neither one of them is blind. And although both are in a position to see, touch, and feel the hand, and although both are in possession of equally good apparatus for receiving visual and tactual sensations, the sceptic would maintain against Moore that neither he nor Moore knew a hand to exist. He would maintain this no matter what further senses were brought into play. That is, he would preclude the information given by all the senses together from constituting testimony sufficient for proof, so that there would be no such thing as sufficient evidence in comparison with which the testimony of any one sense would be incomplete evidence. All evidence will be incomplete. This is why any attempt at "proof" by appeal to the senses will be unacceptable.

The sceptic's claim that one can never know, but only believe, that external objects exist suggests that though the evidence furnished by the senses is insufficient to give us knowledge it is

evidence of such a sort as to warrant belief. In that case he should be able to say what evidence now lacking would be sufficient to give us knowledge. It might well be that no human being is at present able to come into possession of such evidence, but if evidence is relevant to establishing the existence of external objects he should be able to state what evidence would satisfy him. But now what evidence *could* establish the existence of external objects if the evidence of all the senses together cannot? What is lacking? The sceptic cannot say, because he cannot say what *in addition* to feeling, seeing, tasting, etc., is to be done in order to establish the existence of external objects, i.e., what in addition to doing the "ordinary" things. Surely nothing is lacking if nothing in addition to what we ordinarily do in getting to know, even when we are being most cautious, can be described. It is thus not the case that the sceptic is super-careful, hard to convince, that he requires more evidence than it is practicable for anyone to produce. For if he were merely *hard* to convince, it is conceivable that evidence should be produced which would overcome his resistance. It does not make sense to speak of convincing him when nothing additional to what we call "convincing a person" can be described.

The peculiarity of the sceptic's claim that no one has or can have knowledge of the existence of external objects although no conceivable evidence for establishing their existence is lacking, becomes clear on contrasting it with: "No one can know who committed the sabotage since all witnesses, the criminal included, died in the explosion;" or by contrasting "No evidence is sufficient for establishing the existence of external objects" with "No evidence submitted is sufficient for establishing the identity of the criminal." It is clear that "No one can know who committed the sabotage" is an empirical statement, justified by the empirical fact that all witnesses are dead. "No evidence submitted is sufficient for establishing the identity of the criminal" is also an empirical statement, true, say, because of the ineptitude of the sleuths. And being empirical, we know what it would be like for each of these to be false. We could describe conditions under which we should know who committed the sabotage, and we could describe what kind of addi-

tional evidence would be sufficient for establishing the guilt of a suspect. But when the sceptic says no one can know that external objects exist, he cannot describe what prevents him from knowing, what obstacle stands in his way. Nor can he describe what kind of thing he would need to know in order for evidence for the existence of external objects to be complete. He cannot because he wants to say that *there are no describable circumstances* in which anyone could be said to know that external objects exist. This comes to saying that "no one knows external objects exist" *cannot* be falsified, that is, that it is *not an empirical assertion* about our ability to know. His assertion does look very much like empirical assertions such as "I cannot know there are mountains on the far side of the moon," which is true because of certain obstacles (which I can describe) which I lack the ingenuity to overcome. But the fact that no empirical justification can be given for the sceptic's assertion and that there is no way of describing how one could get to know external objects exist shows it is not at all like this. This fact shows, rather, that the sceptic is arguing for the *logical impossibility* of knowledge and not for any empirical fact. He is arguing that any such statement as "I know there is a dollar in my purse" is logically impossible, and hence that "I do not know there is a dollar in my purse" is necessarily true.

But now it is hard to suppose the sceptic is arguing that such propositions are necessarily true when it is plain that as language is ordinarily used they are not: "I do not know there is a dollar in my purse" makes an assertion about me, and "I do know there is a dollar in my purse," far from being self-contradictory, as it would be if the former were necessary, makes another assertion about me. The sceptic is aware that language is at present so used that each of these statements describes what could be the case. What then does his argument come to? When the sceptic points out that "the senses might be deceiving one— one might be having an hallucination," he cannot be *showing* "I do not know hands exist" to be necessary. For our present language is such that it is not necessary. Yet it is clear from what has been said previously that the sceptic cannot be urging the

truth of an empirical statement: His avenues of information are equally as good as Moore's, information of the same kind is before them both, with no relevant facts lacking, and yet he holds in opposition to Moore that neither this information nor any information provided by the senses could constitute proof that there is a hand. Now if the sceptic is not showing either that his claim is logically necessary or that it is as a matter of fact true, he must have some other reason for adducing the consideration about the possibility of sense-deception. There still remains the alternative of adducing this to show that "no one knows of the existence of hands" *should be* necessary. Can this be what the sceptic intends? Of course it is plain that he does not *say* "no one knows that hands exist" should be necessary. He argues as if it were necessary, and as if he were calling attention to considerations which make this clear. That this procedure conceals what he is actually doing will I think become plain by examining, as a first step, what follows from "the sentence 's' expresses a necessary proposition."

Consider the statement, " 'There are no round squares' expresses a necessary proposition." This entails that the phrase "round squares" has no possible application. Similarly, consider the italicized in the following: "The sceptic argues as if *'no one knows that hands exist' expresses a necessary proposition.*" This is to argue as if "knowing hands exist" had no application. Certainly the sceptic, in urging that under no describable circumstances could one be said to know any kind of external object exists, behaves as though the phrase in question was actually not used to apply to anything. It is clear of course that it does have a use in present language, just as it is clear that "no one knows hands exist" does not express a necessary proposition. It is also clear that the sceptic is not making a simple mistake which could be pointed out by calling attention to these two linguistic facts. Moore quite rightly takes issue with the sceptic, but their dispute is not to be settled merely by showing the sceptic that he is using language incorrectly. The sceptic knows that "knowing hands exist" has use, and that "no one knows there are hands in the world" is used to express some-

thing which can be *either* true or false. He is holding that they *should not* be so used, only he does not say so explicitly. He is holding that "no one knows there are hands" *should be* necessary, only he conceals this beneath the indicative form of his expression. The sceptic asserts that no one knows hands exist as though this *already* were a necessary truth. But actually what he is doing is making a disguised proposal that it be accepted as a necessary truth.[10] And in doing this he is proposing, or recommending,[11] that certain expressions in our language be deprived of their use, i.e., that certain expressions shall have no sense. "Knowing there are hands," "knowing there are coins," etc., will not make sense, although "believing there are hands" will. In pointing out that one's senses might be deceiving one, the sceptic is urging what he considers a good reason for revising present language. The revision would consist in discarding the use of such expressions as "I know there is a tree in the garden" to assert empirical facts.

Moore's attempt to establish the existence of external objects shows that he conceives the sceptic to be doing something quite other than I have stated here. If my view of what the sceptic is doing is correct it is obvious why no argument Moore brings forward will provide an answer to him. Because the sceptic is proposing a revision of language, no facts either about one's mental capacities or about correct linguistic usage will shake the conviction with which he asserts that no one can have knowledge. The kind of argument Moore gives by way of an answer indicates that he supposes the sceptic to be in fact doubting whether there is an external world. He produces empirical evidence which if conclusive should dispel that doubt. I want now to consider what Moore's argument comes to, whether he is doing what he seems to suppose he is doing (namely, establishing the truth of an empirical proposition, "There are external objects"), and why the considerations the sceptic brings forward fail to alter Moore's contention that he knows.

The point of Moore's argument would seem to lie in producing the rational conviction that there are external objects.

[10] Pointed out in discussion by Mr. Lazerowitz.
[11] John Wisdom, "Philosophical Perplexity," *Proc. Aris. Soc.*, Vol. XXXVII, 71.

It is obvious that it is the sceptic and not the ordinary man who is to be convinced, since the ordinary man needs no convincing. Yet his argument is the sort used to convince the ordinary man of the existence of something *in question*, e.g., a dime in a box. A dime is pointed out in order to establish that a thing of that sort exists. But as for the further step in the argument, namely, the inference of "There is an external object" from "There is a dime," it could not *convince* the ordinary man of the existence of an external object since this would not be *in question*. And had it been in question, as it supposedly is in the case of the sceptic, pointing out a dime would by no means serve to convince him that there is a coin there. If the existence of external objects is in question, then calling attention to a visual experience no different in important respects from many past experiences which the sceptic has precluded from constituting proof will not convince him. The force of Moore's argument lies in its analogy to an ordinary empirical argument for establishing to the satisfaction of the ordinary man the existence of something in question. But in fact it is a sort of linguistic pantomime of such an argument, lacking analogy with it in essential respects: Proving that an external object exists by showing that there is a coin in a box is like proving there is a tree in the process of proving that there is a treasure hidden under the tree. Pointing out a dime in a box can settle an argument about the existence of a coin because pointing calls attention to a thing with features differentiating this thing from things of other kinds. But can one "point out an external object" and thereby settle any question about whether there is a thing of that kind? If one can by pointing out either a dime or a coin establish the existence of a coin, it looks as though one could establish the existence of an external object by pointing out either a coin or an external object. For the classification "external object" seems merely the most general term of the series, "dime," "coin," "external object;" that is, it seems to be a name for a kind of thing, only a more general name than "coin," just as "coin" is a name for a kind of thing, only a more general name than "dime." But is "external object" a general name? Can one "point out an external object" as one can any kind of thing?

These questions can be settled by comparing the phrase "external object" with a term about which there can be no doubt it is a general name, viz., "coin." Suppose one wished to teach a person the word "coin." One would point out a number of things to which this term applied, and also some to which it did not, for example, tax tokens. The teaching would consist in calling attention to features which this kind of thing had and in some cases to features had by other things from which it was to be distinguished. One could urge the person to make sure the thing was a coin and not a tax token by looking closely. Whether the person learned the word "coin" would be tested by asking him to carry out the orders, "Bring me a coin," "Bring me a tax token," etc. Obviously he could fail to carry out these orders by bringing some other kind of thing than what was asked for. Consider now teaching someone the phrase "external object." The difficulty would be that one could not *point out* anything to him which was not an external object. One could not urge him to look more closely to make sure the thing was an external object and not some other kind of object. Nor would one explain what kind of object was in a box by telling him there was an external object in it. Further, the order, "Bring me an external object," has the peculiarity that anyone who brought one anything at all could not fail to carry it out. Carrying out the order would provide no means of testing whether the person had learned the use of "external object." We have not provided for the possibility of making a mistake, and hence there is no way of testing whether we have taught him. In fact there is no way of teaching him if there is no possibility of testing whether he has learned what we have taught. These considerations show, it seems to me, that "external object" is not a general name for some kind of thing, designating features distinguishing that kind of thing from some other kind. One can only bring something which this names if one can fail to bring it. If this is the case then one cannot *point out* an external object, so that no argument about the existence of external objects could be settled by "pointing out an external object."

This shows that Moore's proof is not analogous to an ordinary empirical argument for establishing something in question.

There is no possibility of directly establishing that there is an external object since "external object," unlike "coin," is not a general name for some kind of thing. The force of Moore's argument lies in its obvious similarity to proving there is a coin in a collection plate by pointing out a dime. So soon as one sees that the existence of external objects is not to be established by the same empirical methods serving to establish the existence of a coin because of the lack of analogy between "external object" and "coin," his proof loses force. If "There is an external object" is to be established at all, it will be only because one has established something from which it follows. It *cannot* itself be established in the way the antecedent of the entailment is. By contrast, in pointing out a dime one could establish directly either that there was a dime, or what is entailed by this, that there was a coin. One would not have established the existence of a coin *only* because one had established the existence of something from which its existence follows. The existence of a coin can be established by pointing out a coin, but the existence of an external object cannot be established by pointing out anything.

The lack of analogy between "There is a coin" and "There is an external object" with respect to proof has its counterpart in a lack of analogy with respect to disproof. There is no possibility of disproving, by any of the methods employable in disproving that there is a coin in the plate, that there is an external object. If someone were to question whether there was a coin in the plate, one could disprove that there was either by showing him that there was nothing at all in the plate or by showing him that every object in the plate was a button. But if someone were to question whether there were external objects, could one show empirically that there were no objects at all? Philosophers who have tried to prove that there are no external objects have made no pretense of using empirical methods to do so, attempting to show that there *could be* no external objects, i.e., that it is logically impossible that there should be. Further, it is clear that one could not, by way of disproof, show anyone that one had been mistaken about the object before them both (as one could with the coin) and that the object was in fact not an external one. This is impossible for the same reason that it is

impossible to carry out the order, "Bring me an object which is not an external one." The phrase "object which is not an external one," like "external object," is not a general name for a kind of thing.

Even though pointing out an instance of a kind of thing will not establish "There is an external object" because "external object" is not a name for a kind of thing, it might seem that as long as this proposition is entailed by one which is so established, it would itself be established indirectly. This will be seen not to be the case by examining the entailment, " 'There is a dime' entails 'There is an external object'," and comparing it with " 'There is a dime' entails 'There is a coin'," or by comparing the two necessary propositions, "A dime is a coin," "A dime is an external object." To hold that "A dime is a coin" expresses a necessary proposition entails holding that anything which is a dime satisfies all the criteria for applying the word "coin"—criteria such as "being a piece of metal," "being stamped by public authority," "being made for use as money," etc. It is to be noted that these criteria distinguish this kind of object from other kinds, so that producing an object satisfying these criteria will make it true that there is an object of this kind and will falsify the opposite assertion. Now what, different from this, is being said in saying that "There is a dime" entails "There is an external object," or that "A dime is an external object" is necessary? From what has been said above about the phrase "external object" I think it will be clear that holding "A dime is an external object" expresses a necessary proposition does not entail holding that anything which is a dime satisfies all the criteria for applying the phrase "external object." For this phrase is not used to apply to any kind of thing. One will therefore not have established the existence of any thing of the kind "external object" in producing a dime. Nevertheless Moore is doing something very important, with reference to the sceptic's claim, in asserting such entailments as " 'There is a dime' entails 'There is an external object'." An analysis of "being an object external to all our minds" shows the importance of what he is doing. Each of the terms of the following list, some of which are equivalent to each other, gives a partial

analysis of this concept: "being such as to be met with in space," "being an object of possible experience," "being such as could be perceived," "being accessible to one or more senses," "being such that one mind could perceive it at two different times or that more than one mind could perceive it at the same time." It will be noted that all of these involve the notion of possibility. "A dime is an external object" will mean in part "A dime can be perceived," "A dime can be seen, or felt . . . or . . . ," "A dime can be perceived by two different persons," etc. The possibility asserted is obviously a logical possibility. And if "A dime is perceived by two persons" expresses something logically possible, then it makes sense to say "A dime is perceived by two persons." The above list provides then, not criteria for applying the phrase "object external to all minds," but criteria for its *making sense* to say certain things about dimes, hands, and other things for which it would express something necessary to say they were external to all minds. Moore's statement that " 'There is a hand' entails 'There is an external object' " calls attention to criteria for applying "external object words," so that if a thing of a given kind is an external object it follows that such expressions as these make sense: "Smith and I both saw the thief," "I found a gold piece in the box," "I heard the lion and later saw it," "The suit I saw today was the same one I saw yesterday," etc. It is clear that if these expressions make sense, then one knows what it is like for what they express to be true. Now what they express implies the existence of a thief, a gold piece, a lion, a suit, respectively. So if one knows what it is like for them to be true, one knows what it is like for "There exists a thief," ". . . a gold piece," ". . . a lion," ". . . a suit" to be true. And if one knows what it is like for these to be true, it makes sense to say "I know there is a thief is true," etc. Thus Moore, in calling attention to the entailment between "There is a hand" and "There is an external object," calls attention to criteria for the use of such words as "hand," "dime," and the like, and in doing this shows that in English it makes sense to say "I know there is a dime in the box." That is, Moore's argument (although it does not establish the truth of an empirical proposition about the existence of a kind of thing, external objects) has as

a consequence that it is *logically possible* to know there are coins in a box. We recall that the sceptic argued as if it were logically impossible.

Of course Moore appears to have attempted something quite different from showing the logical possibility of having knowledge. For to show this is not to show any matter of fact. Moore seems to assert that as a matter of fact he knows there is at least one external object. Throughout, he gives the impression of defending common sense against the sceptic (who at times likewise appears to be asserting a matter of fact about what we can or cannot know). Yet his defense of common sense consists in "proving" a proposition which is not a common sense belief (such as "There is food in the refrigerator"). And he tries to allay doubts which are not common sense doubts: that external objects exist does not come in question in the way the existence of a treasure does. And then it turns out on closer examination that his attempted proof of "There is an external object" is not at all analogous to "There is a coin in the plate," which it should be if it were to prove what he intends. He has, however, countered the sceptic's claim that it *cannot* be known there are hands. For it follows from what he has said in the course of his argument and in his analysis of the notion "external object" that "knowing there is a hand" expresses something logically possible.

Now to say that "knowing there is a hand" expresses something logically possible is to say this expression makes sense. As language is ordinarily used it is clearly true that this expression and others like it do make sense. And that this is true can be seen independently of any argument. The importance of insisting, as Moore has done, that one can know there are hands, lies in what the sceptic has done. It will be recalled that the sceptic argued as though such expressions as "knowing there are hands" had no application, that is, did not make sense. He argued this although he knows they do in fact make sense, doubtless using them himself under ordinary circumstances to express something. This being the case it will not settle the dispute for Moore to show the sceptic he is using language incorrectly. For as was argued earlier, the sceptic is *recommending* that it be

correct to say only that one believes there are hands and incorrect to say one knows this. Moore's argument constitutes an insistence on retaining present usage—on retaining "know" as well as "believe" to preface statements about physical objects. It is the sceptic's recommendation which makes Moore's insistence relevant. And though Moore never expresses his argument against the sceptic as an argument concerning the sense of phrases such as "knowing there are hands" (nor even as an argument concerning whether knowing of the existence of hands is logically possible), it is the great merit of Moore's position that it makes one see, by calling attention to ordinary usage, that the sceptic's linguistic recommendation is objectionable. This merit appears upon examining the consequences of accepting his recommendation:

The sceptic, in proposing as necessary "no one knows of the existence of any external object" is in fact proposing that ordinary language be changed, so that under no circumstances shall it be correct to say "I know there is a button in the box," but only that I believe this. Now how is the usage of the word "believe" affected by this recommendation? The sceptic himself does not say, but there are obviously only two courses open to him: to insist that no change in its present usage is necessitated, or to recommend a modification of its present usage so that it would mean what we now mean either by "know" or by "believe." Let us consider these alternatives in turn. Were the sceptic to maintain that the usage of "believe" is unchanged by his recommendation about the use of "know," while depriving it of a correlate functioning in the way "know" at present does in connection with propositions about external objects, he would involve himself in contradiction. As the word "believe" is ordinarily used it functions as a contrast term to "know." We say such things as: "I believe it's true, but I wish that I knew," "I believe she's innocent, but I shall pretend I know it," "I used only to believe there was a buried treasure. Now I know it." With the sceptic's revision of language no such contrast would be possible since it will not make sense to say one knows such a thing. Can the word "believe" then retain its present usage if it is deprived of its correlate "know?" It is clear from the following

consideration that it cannot and that the sceptic would involve himself in contradiction were he to maintain that it did: As indicated by the above instances of the correct usage of "believe," saying that one believes something entails the logical possibility of knowing what is only believed. Thus the sceptic could not without contradiction hold that "believe" retains its ordinary use and at the same time hold that knowing that external objects exist is logically impossible.

He does not in fact commit himself to this contradiction since he has not committed himself at all on the usage of the term "believe." And he could escape it either by introducing into language a new word functioning as "know" now does in such statements as "I know there's a chair in the next room," the word "believe" at the same time retaining its present usage, or by extending the usage of "believe" so that it would function both where we now use "believe" and where we now use "know." In either case his position would be as objectionable, for another reason, as it would be were he to deprive "believe" of any correlate functioning in the way "know" does and at the same time insist that no change is necessitated in its usage. For suppose he were to introduce another term "x" functioning as "know" does, so that "I believe there's a chair in the next room" would entail the logical possibility of "x-ing" there is a chair. It is clear that this notation does exactly what the old one did—no more, no less—and that it is therefore completely pointless to introduce it. The same obtains were the sceptic, upon eliminating "know" as a preface to empirical propositions about external objects, to extend the usage of the term "believe" so that it would function both where we now use "believe" and where we now use "know." It is clear that this notation in which a new term "believe" takes over the function of both "know" and the present term "believe" has no advantage whatever over the old one. If anything, it has a disadvantage, in that what is meant when one says "I believe Smith is in the next room" might not be clear. "Believing" this will mean either knowing it or merely believing it, and unlike pun words, the context of "believe" will not indicate which meaning is intended. It would be natural to eliminate

the ambiguity by using "believe" where we now use "know" and "merely believe" where we now use "believe." Such a notation would contain in itself the seeds of the sceptic's discontent with the old notation. It might give rise to exactly the considerations which moved the sceptic to desire revision in the first place, so that the sceptic might now insist that one should say one "merely believes" there are external objects. In any case if the sceptic's revision of the language with respect to "know" were to have as a concomitant the introduction of a new term to do what "know" does or the extension of the usage of "believe" to achieve this, it is clear that there would be no point whatever in making it.

It is the great merit of Moore that by calling attention to the present usages of "know" and "believe," he leads one to see that none of the courses open to the sceptic with respect to the term "believe" is unobjectionable. He makes one see that present language is adequate to express all we want to express, despite there being circumstances in which we cannot answer the question, "Do you know there is a rat in the room or do you only believe it?"

Consideration of this kind of question is what leads the sceptic to suggest revision of the language. It is the fact that there are no criteria distinguishing sharply between veridical experience, illusion, hallucination, and dream experience which the sceptic uses to justify his holding one can never know that hands, say, exist. Since there are circumstances in which we ask ourselves, without knowing the answer, "Am I dreaming? Am I having an hallucination?" the sceptic feels justified in asking, "How can you know in *any* circumstances that you are not dreaming or having an hallucination?" He points out that dream experiences can be exactly similar to those of waking life, that every veridical experience can be exactly duplicated by an illusory one, i.e., that there are no criteria, no marks, for distinguishing in all cases the one from the other. The possibility of confusing one kind of experience with the other is sufficient to show that there are no clear distinctions between them. The sceptic then uses this fact as substantiation of what appears to be an *hypothesis:* "You might in the case

of all experiences be dreaming or having an hallucination."
But this is no hypothesis such as, "You might have appendicitis." He means to say that it is logically possible that one is
dreaming when one has the kind of experience one claims to
have in waking life and that it is therefore logically impossible
to know that one is not dreaming. Now if it is logically impossible to know one is not dreaming, the phrase "knowing
one is not dreaming" makes no sense. The same holds for
"knowing one is not having an illusory experience." Further,
"S does not know he is not dreaming" and "S does not know
he is not having an illusory experience," will now express
something necessary and will lose their use to express empirical
facts; the sceptic of course knows that, as language is ordinarily
used, they do assert something to be as a matter of fact true,
and hence he can be understood as recommending that they
should not.

The kind of reply Moore gives to the sceptic, even though
not intended as an objection to a "recommendation," is in
fact a flat rejection of it. To the sceptic's claim 1. that one
does not know there is a hand before one, and to his reason
for holding this, 2. that one can never know one is not dreaming, Moore replies: 1. "How absurd it would be to suggest
that I did not know it, but only believed it, and that perhaps
it was not the case!"[12] and 2. "I have conclusive evidence that
I am awake."[13] The importance of these replies of Moore's
lies in their conjunction with his admission that he cannot
prove what the sceptic insists must be proved before one can
know any fact about hands: the premise, "Here's a hand," from
which "There is an external object" follows. Moore concedes
that this premise cannot be proved, since "in order to do it [he
would] need to prove for one thing, as Descartes pointed out,
that [he was] not dreaming."[13] Nevertheless, he denies forthrightly that this is any reason for saying one does not know.
"I can know things, which I cannot prove."[13] And among the
things he claims he can know without proof is that here is a
hand. Further, since he claims to have "conclusive evidence"

[12] "Proof of an External World," *Proc. Brit. Acad.*, Vol. XXV, 296.
[13] *Ibid.*, 299-300.

he is awake (even though he cannot say what all the evidence is, as he would be required to do were he to prove it), this also must be a thing he can know without proof.

The difference between Moore and the sceptic, and the importance of Moore's answer, lies in what each says about the impossibility of proving one is not dreaming. When Moore admits that he cannot prove he is not dreaming he is calling attention to the same fact the sceptic used to persuade one that one should not say one knew of the existence of hands. This is that there are no *sharp* criteria for the application of the terms "dreaming," "not dreaming," "having an illusory experience," "having a veridical experience." The sceptic in demanding a proof of "Here's a hand" before one can say one knows such a thing is requiring the exhibition of sharp criteria for distinguishing between dream and waking life. "Know" and "prove" would thereby have an interchangeable usage. By contrast, what Moore in effect goes on to say is that the lack of sharp criteria is no reason whatever for saying one can never know one is not dreaming or having an illusory experience, that the fact that there are some criteria for the application of these terms, even though they are not such as to distinguish sharply in all cases between dream and waking life, is sufficient for holding one can know there is a hand before one. To require that in every conceivable circumstance we should say we believe rather than know this, because we sometimes cannot answer the question, "Do you know there is a rat in the room or do you only believe it?" is like requiring us to say we never know when to use the word "heap" because we cannot say exactly how many grains are required; or when to use the word "bald" because we cannot say how many hairs are the maximum; or when to use the word "fowl" because we cannot say exactly the number of months required to make a chicken old enough.

It is clear that Moore is in effect insisting on retaining conventions already established in the language about the usage of the words "know" and "believe," and that the consequence of what he says is the preservation of the linguistic *status quo*. He has not himself shown the pointlessness of the sceptic's attempted revisions of language, for he has not seen clearly

ALICE AMBROSE

what the sceptic is doing and consequently has not shown what he is doing. But in calling attention to ordinary language (and Moore is constantly calling attention to what is correct) he takes us the first step toward seeing what the sceptic is doing and that what he is doing is pointless. For reminding one of how language is ordinarily used is a way of making one feel there is something absurd about what the sceptic propounds. When the sceptic says one cannot know there is a hand before one, Moore exclaims, "How absurd it would be to suggest that I did not know it, but only believed it, and that perhaps it was not the case!"[14] His reply is like that of the ordinary man who does not allow himself to become entangled in a philosophical dispute—it dismisses the sceptic's conclusion by contradicting it but without countering his argument. The great importance of such a reply is to make one feel as the ordinary man feels, as though there is something ridiculous about it. The mere contrast between ordinary language and the language of the philosopher was sufficient to make Hume say, ". . . and when after three or four hours' amusement I . . . return to these speculations, they appear so cold, and strain'd, and ridiculous, that I cannot find in my heart to enter into them any farther."[15] It has been Moore's rôle in philosophy to shock philosophers who tend to become oblivious to this contrast into a realization of it. Because he is himself a great philosopher, Moore can succeed in this, whereas the ordinary man's remarks would have no influence. For the ordinary man can so easily be lured into talking in the same way. Moore *in doing philosophy* constantly holds ordinary language before one, so that one is made to feel, not only upon returning to one's views but while philosophizing, that they are "strain'd and ridiculous." Once one feels this one has taken the first step toward seeing why—toward seeing that a "rectified" language only says in another way what ordinary language does. Our language is such that when we philosophize, certain considerations constantly tempt us to revision, while considerations which would make us see our language needs no revision and is adequate to express all we want to say, are

[14] *Ibid.,* 296.
[15] *The Treatise of Human Nature,* Bk. I, Pt. IV, 97 (Scribner's Selections).

discounted and forgotten. We are tempted to think that the sceptic weaves a verbal material which is much finer than the coarse fabric of ordinary discourse. But in forcefully reminding us of current usage, Moore sets us on our way to seeing that like the imposters of the tale of The Emperor's New Clothes, the sceptic is weaving nothing at all, and that in fact the Emperor is naked.

<div align="right">ALICE AMBROSE</div>

DEPARTMENT OF PHILOSOPHY
SMITH COLLEGE

16

John Wisdom

MOORE'S TECHNIQUE

16

MOORE'S TECHNIQUE

IN the preface to his *Principia Ethica* Moore wrote "It appears to me that in Ethics, as in all other philosophical studies, the difficulties and disagreements, of which its history is full, are mainly due to a very simple cause: namely to the attempt to answer questions, without first discovering precisely *what* question it is which you desire to answer."

I remember with what renewed hope I read these words. I was beginning the study of philosophy and had been reading Johnson's *Logic* and Stout's *Groundwork of Psychology* and there had grown in me an unspoken fear that I should never understand the stuff. Here, in Moore, was someone first rate suggesting that philosophers themselves do not know very well what they are talking about. And what a pleasure was the simple, direct, childlike quality of what followed in *Principia Ethica*. I was reminded at once of the dialogues of Plato.

And how delighted I was with Moore's lectures. But here I must confess—what I did not at the time own to myself—I was shocked and disappointed when Moore began his lectures on the Soul by saying that he agreed with Ward that the existence of the Soul or Self is an "inexpugnable assumption." True he explained that what he meant was that such sentences as "I see this," "I feel sick," sometimes express facts and this did seem very unexceptionable. But I felt that though to doubt such things is of course eccentric, nevertheless it is not satisfactory, it is not satisfying, to set aside these doubts without any answering of them, without any attempt to say how we know what we know if we know anything at all. As Mr. J.W. Harvey writes in a paper to the Aristotelian Society

the attitude of 'common sense' is by no means so brusque and dogmatic and unqualified as Moore would intimate. It is more like this: '*Of course* all these facts are true, and I am quite sure they are; but I suppose that in the strictest sense of all I can't claim to *know* them absolutely. I should be mad to deny them or even to doubt them, and yet—'.[1]

I have often noticed in people beginning philosophy that when they are confronted with this move of Moore's "The question isn't 'Do we know these things'? but 'What is the analysis of what we know in knowing these things'?" then they feel that they came to buy one thing and that the man behind the counter is trying to sell them "something just as good—better in fact."

They came for guidance in profound enquiry as to whether what they had always regarded as unquestionable *is* unquestionable. Moore tries to turn them by making their profound questions seem ridiculous and telling them that what they really want is an analysis of what it is they hold unquestionable. In short, Moore's cheerful acceptance of "we know this, but we don't know how we know it" bothers people.[2] They feel it is *unphilosophical*. Moore is well aware of this. In one of his most recent publications, "Proof of an External World,"[3] he quotes Kant "It still remains a scandal to philosophy . . . that the existence of things outside of us must be accepted merely on *faith*, and that, if anyone thinks good to doubt their existence, we are unable to counter his doubts by any satisfactory proof." Moore proceeds to offer a proof that things outside us exist. That they exist follows, he says, from what one knows when, lifting first one hand and then the other, one says "Here's one hand and here's another." He then writes (p. 298): "I am perfectly aware that, in spite of all that I have said, many philosophers will still feel that I have not given any satisfactory proof of the point in question." And on the last page he explains that he thinks that one reason why people think his proof unsatisfactory is that they think that if he can't *prove* his premiss then he does not *know* it. This he holds to be "a definite mistake." That is, he insists that

[1] *Proceedings of the Aristotelian Society* for 1940-41, 157.

[2] It is not that Moore never asks "How do we know?" but that this never leads him to ask "Do we know?"

[3] *Proceedings of the British Academy*, Vol. XXV, 1939.

one may know a thing without being able to prove it.

To this, I am sure, people would reply "Of course *some* things are known without proof. One knows without proof that $1+1$ makes 2, and one knows immediately and without proof that one feels sick or that one sees the appearance of a dagger. But it's different with 'There's a real dagger there'. That is not known immediately. If it is known, it is known on the basis of other knowledge which collected together establishes it. But is there anything we know from which we can really establish for certain that there is a real dagger there? If so what is it? This is what we are concerned with. We know well enough what we mean when we say 'There's a dagger in the air—a real dagger'. The question which interests us is 'How do we know that what we mean is so'?"

This brings us to another way in which Moore's practice with its implication as to the proper business of philosophy dissatisfies people. When Moore said that he was going to start from the position that we know that the soul exists in the sense that such a sentence as "I feel sick" expresses a fact, then I felt "If you are sure of that why bother about anything more? Who cares about the analysis? What is this analysis you make so much fuss about?" I had expected an inquiry into an age-old doubt, into whether we really know that we have souls. Was I to be persuaded to spend my time cutting capers defining these statements which, with more than religious dogmatism, Moore refused to question? It was the same with the existence of matter. I had expected an investigation of the suggestion that all is illusion, that the earth and all that's on it is nothing but the image of a dream, the echo of a thought. Instead I was presented with the double image argument[4] to prove that when, on seeing a brown elliptical sense datum in my purse, I say "That's a penny" I am not judging with regard to the sense datum that it's part of the surface of a penny. I had supposed that we should discuss whether what ordinary men took to be certain and well justified could be passed as such after careful investigation by experts. I had come to ask whether Idealism was true and matter a myth, just as I had come to Moore's lectures on the soul in

[4] *Contemporary British Philosophy*, Second Series, 220.

order to find out whether Materialism was true and minds and souls a fond illusion born of desire that there should be more behind the faces of our friends than there is behind the faces of our clocks, which after all know the time and can't bear a cold bath. And, of course, I wasn't peculiar in this. Many people come to philosophy because they want a basis or a substitute for religion. To adapt the words of the editor of *Contemporary British Philosophy*, they hope to explore with the help of the best guides "the frontier provinces of human experience" and to gain "authentic tidings of what lies beyond."

Instead, Moore offers a game of Logic, and a peculiar one at that; for it lacks much that gives satisfaction in ordinary logic and mathematics. In it no architecture of proof is possible, and with that goes too the Q.E.D. with its note of agreement achieved and triumphant discovery.

This brings us to a new source of dissatisfaction with Moore's account of philosophy. It isn't done in the way it should be done, if its questions and conclusions are such as he says. Its logic is not the logic of logic and arithmetic. Consider. Do philosophers (1) prove by chains of demonstrative reasoning what they wish to say or (2), without attempting to support in any way one thing by another, just set out the self-evident or what appears to them self-evident? This question gives one a queer feeling because one wants to answer that they do both and neither. It isn't that they do the one with some of the things they say and the other with other things they say. It is that in the case of their most characteristic claims they seem to rely upon a mixture of self-evidence which isn't quite clear with proof which isn't quite conclusive. And when one of them such as Spinoza or McTaggart, or even Moore in his short demonstrations, attempts a "geometrical" technique, other philosophers become a little nervous and embarrassed, feeling that somehow this won't do, like hunting people when one of their number, respected because undoubtedly he goes very well, insists on coming out in clothes deplorably reminiscent of the racing stable. It is true that, when we read, for example, Hume's appendix on the analysis of right and good or Broad on theories of the nature of matter, we find that a number of what Mill might call "considerations capable

of influencing the intellect" are advanced. But they are not connected chainwise. They *independently* bear upon the issue.

It is true that, on Moore's account of philosophy as analysis of what is ordinarily meant by ordinary and familiar sentences, we should not expect long chains of reasoning. The question, "When I say of a picture that it is good, does this amount to a claim about how people feel to it?" doesn't lend itself to long demonstrative argument. After all, if we know what we mean by the one and what we mean by the other, then surely it is easy for us to tell whether what we mean by the one is or is not what we mean by the other? And surely we do know what we mean by these sentences. Moore allows and insists that we know what we mean by everyday sentences in the sense that we understand them, but he also insists that we don't know what we mean in the sense that we don't know the analysis of what we mean.[5]

It is I feel a defect in his essay that he gives no explanation of what it is to know the analysis of what is meant by an expression nor of how this is difficult. Disciples of Moore[6] have said that to know the analysis of the proposition P is to find a sentence 'P₁' which more clearly than the sentence 'P' reveals the structure of P.

To use Moore's example, I know the analysis of the proposition *Alfred is the brother of Bill* when I notice that it is what can also be expressed by "Alfred and Bill are males and Alfred and Bill have the same parents." With this account of what analysis is the difficulty in finding the analysis of a proposition P is the difficulty of finding a sentence 'P₁' which, although it means the same as the sentence 'P', reveals more clearly the structure of the proposition they both express. "And surely," Moore would say, "even when we know what two sentences mean, it is sometimes difficult to tell, to see,[7] whether what the one means is the same as what the other means."

[5] *Contemp. Brit. Phil.*, 198.

[6] A. E. Duncan-Jones, *Aristotelian Society Suppl.* Vol. XVI, "Does Philosophy Analyse Common Sense?" especially p. 148. John Wisdom, *Aristotelian Society Suppl.* Vol. XIII for 1934.

[7] In this substitution of "see" for "tell" lies the ruin of the logico-analytic technique. In the substitution of "ascertain" for both lies the power of the formal mode which transforms philosophy from a matter of insight into one of industry.

This complaint "I can't see clearly" is a complaint character-istic of one who does philosophy as if it were analysis, as if it were logic. The complaint "I can't see clearly" is understand-able in a complicated subject matter (notational game) such as mathematics. But philosophical issues have not this sort of com-plexity. Have they some other sort of complexity dealt with by philosophical calculation, advancing of considerations? But what, on the logico-analytic account of philosophy, would this other sort of complexity be? We are not told; even the need of it as an explanation of difficulty in philosophy is not recognised. We are left complaining that, though we can see very well the propositions expressed by two sentences, we can not see whether or no they are identical. At once the impotence of the analytic technique gives rise to suspicion which finds expression in the question "Why can't we see? What mist is it that forever obscures the timeless ranges of the abstract?"

This line of enquiry "What is philosophical analysis? What makes definition difficult[8] and philosophical definition specially difficult?" is one way of seeing what is good and what is bad in Moore's saying that what philosophers ought to concern them-selves with is "what is the analysis of . . . ?" But here I want to do this in another way, namely by seeing how far he is wrong (a) in saying that philosophers ought not to have concerned themselves with the truth of everyday statements but with their analysis, (b) in saying that in fact they have concerned them-selves with the truth of the statements and not with their analysis.

To begin with, notice that not only is it puzzling why philoso-phy should be so difficult if it is a matter of inspection—there is the further point that mostly it is not done by inspection but by 'advancing considerations capable of influencing the intel-lect'. Even amongst the purest analysts there lingers still the use of the words 'plausible', 'unplausible'—shocking survivals of the scientific theory, i.e., the theory that philosophy is science, only grander and stricter.

Professor C. D. Broad indeed has never been properly cured

[8] *Aristotelian Society Suppl.* Vol. XVI, A. E. Duncan-Jones, "Does Philosophy Analyse Common Sense?" 148.

of this idea. To the horror of his friends he would suddenly lapse into representing rival philosophical theories as rival hypotheses about what must be the case among the entirely unobservable or obscurely observable in order to account for what is undoubtedly the case amongst the immediately observable. The business of philosophers becomes at once that of finding which is the most probable of these hypotheses in view of the varied and conflicting evidences we have which bear upon them. No wonder that, though Broad sometimes speaks, like Moore, as if philosophy were the job of finding the analysis of what is naturally indicated by phrases like "I am seeing a chair," "I am hearing a bell," he more often speaks of it as if it were the finding of the most probable hypothesis explanatory of what we can in the strictest sense observe—as if it were science, only more so. What happens is this. When Broad tackles a philosophical difficulty he finds himself carrying on the dispute in a certain way; he finds himself considering arguments for and against. One can not speak of the logic of a study in one way and of its conclusions in another. Consequently Broad often speaks of philosophy as though it were a matter of finding out how much is probably true of what we ordinarily mean by such statements as "The earth has existed for many years past," "I have half a crown left." He often speaks as if, although these statements in so far as they merely record and predict the observable are unquestionable, they are nevertheless questionable in respect of a hypothesis tacitly assumed in them. In so far as the statement that a bucket of water is spinning and the earth stationary merely records and predicts appearances it is unquestionable. It is only in so far as it "involves the hypothesis of absolute motion" that it is questionable.[9] And isn't the probability of this hypothesis a scientific matter?

How well this way of putting things suits us! It fits our feeling that for practical purposes it is mad to doubt such statements as "I have half a crown left" and also our feeling that somehow one who questions whether we really know them deserves to be taken seriously. It fits our feeling that philosophy is

[9] See C. D. Broad on Absolute and Relative Motion in *Scientific Thought*, and *The Mind and Its Place in Nature*, 187.

somehow about what world we are in and not merely the make up of the meanings of words. Finally it fits the fact that philosophy is difficult in the way of estimating the force of different and opposing reasons, and something that is decided neither by simple gazing nor by climbing long ladders of proof.

But alas, gently and persuasively as this way of looking at philosophy is introduced by Broad, the brutal fact remains that if we follow him we shall be exposed to Moore's too innocent astonishment. For we shall be talking like Moore's philosopher[10] who, when asked whether he does or doesn't believe that the earth has existed for many years past, replies

It all depends on what you mean by the 'earth' and 'exists' and 'years': if you mean so and so, and so and so, and so and so, then I do; but if you mean so and so, and so and so, and so and so, or so and so, and so and so, and so and so, or so and so, and so and so, and so and so, then I don't, or at least I think it is extremely doubtful.

I can't face cutting such a figure as this. Nor can Broad, really. That's why he says ". . . no one doubts that such phrases as 'I see a bell', 'I feel a bell', 'I hear a bell', indicate states of affairs which actually exist from time to time. People do not begin to quarrel till they try to *analyse* such situations." Again he says "I will call such situations as are naturally indicated by phrases like 'I am seeing a chair', 'I am hearing a bell' by the name of Perceptual Situations. I take it then that everyone agrees that there are such things as Perceptual Situations."[11]

But, though Broad says these things, he also says in the very same paragraphs,

People do not begin to quarrel till they try to *analyse* such situations, and to ask what must be meant by 'I', by the 'bell', and by 'hearing', if it is to be true that I hear a bell. When they do this they are liable to find that the only senses of 'I', 'bell' and 'hear' which will make the statement true are very different from those which we are wont to attach to these words.[12]

[10] *Cont. Brit. Phil.*, 198.

[11] *The Mind and Its Place in Nature*, 140-141.

[12] See also *The Mind and Its Place in Nature*, 184-186, "I think that it is now abundantly evident that very little can be done for common-sense." "*Any* theory that can possibly fit the facts is *certain* to shock common-sense somewhere."

The stresses and strains which have made even such a man as Broad contradict himself here are the very ones I want to bring to light. Let us think how he might try to explain away the contradiction. The things he says elsewhere suggest two ways in which he might try to do this. First he might say, "When I say that no one doubts that such phrases as 'I hear a bell' indicate situations which from time to time exist, I mean nothing incompatible with what is after all a fact; namely that some people raise doubts about the existence of selves or minds and about the existence of physical objects. All I mean when I say that we are all agreed that such situations as are naturally indicated by phrases like 'I see a bell', 'I hear a bell', exist, is that in so far as these statements merely tell us which pattern of the observable may now be expected they are very often quite right and that no one doubts this. When I say that when we look into the matter of what must be meant by 'I', 'bell' and 'hear', if the statement 'I hear a bell' is to be true, then we are liable to find that these must be senses very different from the ordinary and that some people doubt the existence of selves and bells, what I mean is that in the ordinary use of these expressions *they imply hypotheses* as to what lies beyond the observable, beyond 'the frontiers of human experience', and that these hypotheses are entirely doubtful."[13]

We have seen how this talk suits us; but we have also noticed that it involves saying "You ask 'Do we know that the earth has existed for many years past'? It all depends on what you mean by 'the earth' etc." In fact we have noticed that it involves our being unable to answer the plain question "Have you a shilling for the gas?" with a "Yes" or a "No."

To avoid this, Broad might reply in another way, and what he says on p. 148 of *The Mind and Its Place in Nature* shows that quite likely he would reply in another way, namely as follows: "What I mean is that 'I hear a bell', in so far as we assume nothing about the analysis of what it expresses, is often undoubtedly true, that is, the situation it describes from time to time exists. But to describe this situation by the phrase 'I hear a bell' inevitably suggests a certain mode of analysis for the situation.

[13] Cf. *The Mind and Its Place in Nature*, 185.

It suggests that it consists of me and the physical object whose name appears in the phrase, related directly by an asymmetrical two-term relation which is indicated by the verb. And this suggests that the admitted existence of the situation guarantees the existence of me and of the bell, which in their turn guarantees respectively the existence of selves and of physical objects."

We shall find that this answer takes us back to Moore's account of philosophy and so does not give us the advantages which Broad seemed to promise us. For it is impossible excusably to say that I have sixpence although neither sixpences nor any other material things exist without turning this apparent negative hypothesis or existential denial into the analytic proposition "Material things are nothing over and above sensations, i.e., though they are not fictions, they are logical fictions." How far this is excusable, i.e., how far this is not an entirely unheard of use of "Matter exists" is also the question of how far philosophers have been doing what Moore says they should have been doing and of how far they have not been doing what Moore says they have been doing. It is a somewhat intricate investigation.

Notice to begin with that in saying that I may have a sixpence, although there are no sixpences and Matter doesn't exist, Broad is again trying to get the best of both worlds. To avoid shock to common sense, he says that undoubtedly the situations we describe by "I know the earth has existed for many years past," "I hear a bell," "I've got sixpence" exist. To avoid shock to the philosophers, he says that nevertheless the questions "Does matter exist?" "Does mind exist?" are serious questions because the existence of the situations does not guarantee the existence of the earth, of the bell, of me, of the sixpence. Undoubtedly I've got sixpence, but may be there are no sixpences.

Put like this what Broad says sounds just absurd. It is absurd, but of course it isn't just absurd. One can readily feel that Broad says what he does because he knows that, once he allows that it is unquestionable that two hands exist, then he will have to allow that it is unquestionable that Matter exists, unless he says that hands aren't material things or else that the existence of material things does not imply the existence of Matter. At the same time

he feels that "Matter exists" is *not* unquestionable in the way that "I have raised my hands" is.

In this he is in good company and *ipso facto* right. For Berkeley denied that Matter existed but denied that he denied the existence of the gardener's cherry. And when Wittgenstein heard Moore's proof of an external world he said: "Those philosophers who have denied the existence of Matter have not wished to deny that under my trousers I wear pants." In fact, Moore's proof is too good to be true—like all good proofs in philosophy its value depends upon its invalidity. I must explain myself. To claim that Moore's proof is valid is to claim that "Matter exists" is so linked with "I have two hands" that it can not be more questionable than "I have two hands." And yet, if this is so and "Matter exists" is as unquestionable as "I have two hands," then what is the point of the proof?

Someone may protest "This complaint can be brought against any demonstrative argument. In demonstrative argument the conclusion *at first* seems questionable and *then,* when in the course of proof its connexion with an unquestionable proposition is noticed, it itself becomes unquestionable."

This answer is available in those cases where demonstrative argument feels useful, i.e., in complex cases such as algebraic problems. My point at the moment is that this sort of answer is not available for Moore's proof. For it is quite incredible that the reason why philosophers have found "Matter exists" questionable whereas they have found "I have just raised my hands" unquestionable is that they have failed to see[14] a connexion between the two.

In the course of a good proof the level of certainty for the conclusion rises to that of the premisses and the level of certainty of the falsity of the premisses rises to the level of certainty of the falsity of the conclusion. When the level of the independent certainty of the premisses is great and there is nothing against the conclusion, as in mathematical calculations, then we speak of proving the truth of the conclusion from the truth of the premisses. When the independent certainty of the falsity of the conclusion is great, whereas the premisses are weak, then we speak

[14] See p. 430f. above.

of the falsity of the conclusion proving the falsity of the premisses. In the latter case we often speak of the falsity of the conclusion as a premiss and of the falsity of the premisses as a conclusion, and this conceals the reversibility of demonstrative argument. But the reversibility is there. Proof is like putting a pipe between two tubs of water. Now in mathematical argument it is possible to have a conclusion with nothing against it and *apparently* little for it, which is nevertheless connected absolutely with premisses with a high level of certainty, e.g., He has exactly 3068 sheep; for he has thirteen flocks of 236 sheep each. This is because the connexion, though flawless and absolute, is in complex cases not apparent. But the simpler the case the more impossible does this become, and always, when a simple demonstrative proof is offered of something which, before the proof was offered, seemed entirely questionable, one is suspicious, especially when the questionableness arises not from absence of forces for or against but from conflict of forces for and against. This is why Moore's proof is suspect. Such proofs are questioned because they are questionable, however unquestionable are their premisses and the steps involved in them. We can easily begin to see why they are questionable.

Short proofs of the questionable are usually sophistical and their sophisticalness is a play on words. In the simplest and crudest cases the words of the conclusion are ambiguous. This ambiguity in these cases is the explanation of our hesitation as to the conclusion and also of our suspicion of the proof. In one sense the words express something which undoubtedly follows from the premisses and is undoubtedly true and quite unexciting. In another sense the words express something which is exciting but which does not follow from the premisses. These however are the crude cases. They are so crude they hardly confuse us. We are merely amused by a man who argues "Each day he draws (in black and white) on the bank (of the river) so he must be very rich." The confusing cases are the subtler ones which rely not upon ambiguity, i.e., an already manifested conflict about the use of a word, but upon a hitherto concealed conflict as to the use of a word. For example, consider the case of Smith who raises Jones' salary on the day he said he would but *only* because he

fears Jones' leaving for another job. One philosopher may insist that this is not the keeping of a promise. Another philosopher may *prove* it is a case of promise keeping. He proceeds somewhat as follows: "Smith unquestionably has done that which he said he would do. A man who does what he has said he would do keeps his promise. Therefore Smith has kept his promise." All this proof really does for us is to bring out where and how we are undecided even when fully informed about a case whether to describe it as a promise keeping or not. But, although this is all the proof does, it is to be noticed that it can not fairly and plainly be called invalid. It neither involves a slip, such as affirming the consequent or taking seven eights to be sixty four, nor is it a case of ambiguity. This is why even this sample dispute may puzzle us. And in face of it people make the same desperate moves— questioning the unquestionable premiss that Smith has done what he said he would do or turning from that to questioning the unquestionable connexion between doing what one has said one will do and keeping one's promises. As in philosophy, unquestionable premisses have led by unquestionable steps to an entirely questionable conclusion. In these cases the difficulty is not removed by doing any of the only three things to be done, namely (1) deny the premiss, (2) protest at a step, (3) accept the conclusion. For, whichever one does, the repressed objectionableness of it leaves a haunting anxiety which in the end leads to rebellion in oneself or others.

We have already seen the same puzzlement and futile attempts at escape produced by Moore's proof of the existence of Matter. This is, I claim, because Moore's proof is sophistical in the subtle way I have been hinting at, though the sources of the sophistry or questionableness are here much more complicated than in the proof that Smith kept his promise. If Moore's proof is sophistical, questionable, that will be no more than was to be expected.

Philosophers who have not questioned that Moore has two hands or have hesitated to deny it have yet questioned and even denied that Matter exists. Now, as we have seen, it is not to be supposed that they did this because, although the latter unquestionably follows from the former, they failed to notice this con-

nexion. If this is not the explanation, what is? Moore submits that one reason is that philosophers question his unquestionable premiss. We have noticed Broad's inclination to do this and we can feel an inclination to do the same ourselves. It is indeed part of my contention that the unsatisfactoriness of Moore's proof lies partly in the premiss, because it is my contention that the unsatisfactoriness does not lie wholly in the premiss nor wholly in the connexion. But what at the moment I want to do is to question Moore's unquestionable connexion or step and to bring out the inclinations as to the use of "Matter exists" and "I put up my hand," which enable Moore to prove in an argument of one step from the unquestionable premiss "I put up my hand" the so much questioned conclusion "Matter exists" and enables Broad at the same time to question this step. What I want to do is not to insist that it is questionable whether there is a connexion between "I put up my hand" and "Matter exists," but to insist that the connexion is questionable—like the connexion between doing what one has said one will do and keeping a promise.

It is true that some philosophers who deny the existence of Matter try to be consistent to the bitter end and, when taxed with such a question as "D'you mean that I am not standing up and talking with you now?" reply: "Strictly, you are not." Our inclination to draw this inference and their inclination to accept it makes it not incorrect to say that "Matter doesn't exist" implies the falsity of statements about hands, six-pences, etc. On the other hand, very many philosophers when taxed with these concrete questions begin to hesitate and to say such things as "When I said that Matter doesn't exist I meant only that nothing exists over and above or beyond or below our sensations. When a scientist or ordinary man such as the gardener talks about cherries all he says is something about the pattern of sensations which we may expect and these statements are often true enough. What I wanted to insist upon was that their truth involves no more than a pattern amongst our sensations, although they are as we say about material things. For material things just are bundles of sensations or, more correctly, they are logical constructions out of sensations. They are not entities whose existence is inferred from sensations. Sensations do not provide a

basis for inference to entities other than themselves of which they are shadows on the *tabula rasa* of the mind. Such entities are fictions, and, if by material things you mean such entities, then material things are fictions like gorgons and harpies are fictions. But what I meant was that, though our talk about our sensations and physical things is on the model of a substance acting through the media of our sense-organs and nerves to throw shadows upon a screen in our brains, in fact this is only a figure of speech like when we say that I now can't lift the calf because his weight has so much increased or can't buy diamonds because their value has so much increased. In short, I meant that material things are logical fictions or logical constructions."

One feels inclined to reply: "If that's what you meant it's a thousand pities you didn't say so." Or could one reply: "It's a thousand pities you didn't say what you meant"? Could one? In view of the fact that on the covers of their books they print the warning 'Philosophy' and that so many of them inside misuse language like this, is it a misuse? For the first thing that strikes me about their sort of talk about Matter, I mean this hedging, modifying talk about Matter in the course of which "Matter doesn't exist" is transformed from an iconoclastic denial like "Fairies, unicorns, dinosaurs don't exist" into the analytic proposition "statements about material things can be analysed into statements about sensations," is its familiar ring. I am sure I have heard it before. Now I remember someone saying "There is really no such thing as beauty," (he covertly looks for shocked faces in his hearers) and a moment later saying "What we call the beauty of a thing is nothing but our feelings towards it." The modification which the iconoclast makes is a preparation for defending himself against the Moorian attack: "No such thing as beauty? No difference between Salisbury Cathedral and the Albert Memorial?"

Again I can hear someone say: "There are no such things as minds or souls, thoughts or feelings." Again shocked faces. Again a champion sets lance in rest and cries: "No difference between a dog who greets you and a toy which squeaks, no difference between the words of a friend and the chatter of a talking doll? Don't you believe that I understand what you are saying

to me?" The materialist is sure to reply: "Of course there is a difference, and of course I believe that you understand what I say. What I really meant to say was that personality and mind and understanding are just patterns of bodily movements. When a machine responds in a *very* complicated and mysterious way we say it has a mind."

In all these cases there is the same oscillation which we found in Broad between saying (a) that certain statements which we make in everyday life are never true or at least never justified because we put more into them than we ought, and saying (b) that they are all true and that "Beauty (Mind, Matter) doesn't exist" merely warns us that it is nothing over and above what is undoubtedly involved in the everyday statements, namely feelings of exhilaration, etc. (patterns of bodily movements, patterns of sensations). To put the matter another way: In all these cases people can not make up their minds between saying that everyday statements involving such and such a category of being, Beauty, Mind, Matter, Necessity, are all false because we put more into them than we ought, and saying on the contrary that they are all true, only we must be careful to remember that they don't involve more than they do.

Those who say the latter explain that when they say that X, the category, does not exist what they mean is that X's are nothing over and above what is indubitably involved in statements about X. Thus those who say that all the statements we make about Beauty are true explain that what they meant when they said that Beauty does not exist is simply that it is not something over and above our aesthetic feelings. And, to put things the other way round, we can easily imagine that James should not have said that emotions and thoughts just are organic sensations, that love is a heartache, thought a headache, but that he should have said instead that there are no emotions or thoughts; that there is no fear, only a shiver down the back and a feeling of the tensing of the galloping muscles, that there is no anger only a feeling of the clenching of the fist. Indeed, so easily, so nonchalantly, is this transition made from saying that "X's don't exist" to "X's are nothing but Y's" that we can not call eccentric those who say that this is what they mean by "X's don't exist."

And if we can't call them eccentric we can't call them wrong. For consider if a man insists on saying that $1 \times 0 = 1$, that $2 \times 0 = 2$, that $3 \times 0 = 3$ and so on and does this consistently, then it is as much as we can do to say he is wrong even if no one goes with him in the matter. If many go with him then to insist that he's wrong is like insisting that those who say that fox hounds are not dogs are wrong. May be they have called not only terriers but collies, Alsatians, retrievers and spaniels dogs. May be fox hounds have heads and ears and tails and paws and coats extremely like one or other of the sorts of animal which these people have called dogs. We can say if we like that these people use the word 'dog' in a narrow and arbitrary way.

All this doesn't prove them wrong if enough of them do it. The man who says that $2 \times 0 = 2$ allows very likely that $2 \times 3 = 2 + 2 + 2$ and that $2 \times 2 = 2 + 2$ and that $2 \times 1 = 2$ and the same for 3 and 4 and so on. But all this doesn't prove him wrong. Even if we try to trick him by saying, after going through many translations of multiplications into additions, "*And in general* where n and m are any two integers $n \times m = n + n + n$ etc. m times," he may still refuse to accept our conclusion. For he may say "Ah, but 0 is not an integer" or he may say "Ah, the rule holds for all integers except 0—which is different." And different it is, undeniably it is different.

Likewise Moore may argue, "(i) If collies are dogs and terriers are dogs, then if there are two collies sitting in the sun in the yard *or* two terriers chasing each other there *or* one collie sitting there and a terrier trying to make him play then there are dogs in the yard. (ii) If there's a pear and a peach on the wall then there's fruit in the garden. (iii) If there's a Packard and a Pierce Arrow on Fifth Avenue then the automobile still exists in New York. In general, if there's an X and a Y in O and both are Z, then there are Z's in O. Hence, if there's a sixpence in my pocket and a biscuit in the tin there are material things in the world." Moore may argue like this and, indeed, the argument sets out in words where that difficulty comes from which we feel in saying that though I've got sixpence there are no material things and matter doesn't exist. The difficulty lies in this, that to

speak so goes against all our habits in the use of all genus-species words. But the fact is the most general genus words, i.e., category words, are peculiar and are not related to their species words just like other genus words are related to their species words. In particular, when X is a category word there is an inclination to say: "When I said 'There is no such thing as X' or 'Really there are no such things as X's' I did not wish to imply what you might naturally suppose, that all statements about things which are X's are false; I meant only that X's are abstractions, logical fictions, logical constructions, i.e., that statements in which something is said about an X or X's can be analysed into statements which say something, though not the same thing, about Y's."

This inclination is widespread and obstinate. This in itself makes it impossible to complain to a philosopher who says that by "Matter doesn't exist" he means "Statements about matter can be analysed into statements which are not," that he is not saying what he means when he says "Matter does not exist." Nor of course is this all. There is no widespread inclination without a widespread cause, and when the cause isn't a slip it's an excuse, a reason. It seems quite natural to express the logical fact that statements about the average man can be analysed, reformulated, into statements which are about no such thing, in the form of an existential denial, namely, "The average man doesn't really exist." It's muddling to express oneself this way and it may temporarily confuse others and even oneself into suspecting those everyday remarks which one makes with the help of the expression "the average man" such as "The average man prefers a bitter to a gin and lime." It's muddling, but it's natural. It's natural because ordinary language suggests that the relation between the average man who somehow represents the tastes, etc., of individual men is related to them in the way that a member of Parliament is related to his constituency; and the existential denial very forcibly combats this. "Matter does not exist" does the same for the relation between material things and sensations, i.e., for the relation between statements about material things and statements about sensations.

We must conclude that often there is good reason for saying

of a philosopher who has said that "Matter doesn't exist" that he means that statements about material things are analysable into statements about sensations and that he is not without precedent and without excuse in doing so.

We have seen with the multiplication by o and the fox hounds how, in logic as in ethics and aesthetics, any statement supports itself, especially when made by an expert. So, when Berkeley says that "Matter doesn't exist" doesn't imply that the gardener is wrong in saying that there are cherries left on the trees, that goes a long way to prove this statement correct. And, when Broad agrees with him, that is further strong support. And we have felt the excuse they have for using "doesn't exist" in this way. We must notice however that they escape the power of Moore's proof only by making "Does Matter exist?" an analytic issue and thus claiming that what they have been doing is what Moore says they should have been doing, namely analysis, and thus losing the advantages which Broad seemed to promise us.

On the other hand, we shall find that Moore's claim that philosophers, when saying that Matter does not exist, have been discussing a negative existential hypothesis like "There are no unicorns" has plenty of excuses. As Moore pointed out to me, McTaggart said: "So Matter is in the same position as the gorgons and the harpies."[15] And, undoubtedly, people who say that Beauty and Goodness do not exist expect to shock us. So do those who say "There's no such thing as logical goodness or validity, only linguistic habits." So do those who say "There's no such thing as thought or feeling, only patterns of behaviour." And they do shock us. They send a fear into our hearts. Wheels turning other wheels they can see. "But," they ask, "what justification have you for claiming that these are the spirit of the living God?"[16] And for the life of us we can't answer. "I'll believe it when I see it," they say, and our hearts sink. For we know that having seen the wheels there'll be nothing more to see bar more wheels. "I'll believe it when I see it," says the native in the Sudan, when we tell him that water in our country sometimes gets so hard that a man can stand on it. "I'll believe

[15] McTaggart, *Some Dogmas of Religion*, Second Edition, 95.
[16] Ezekiel.

it when I see it," says the sceptical child, when we tell him that
all the movements of animals depend upon the beating of a
little organ hidden in the chest, that the state of the cheese
depends upon the presence of minute creatures breeding at a
frightful pace. And it feels as if it is the same admirable habit
of thought which leads to "Does the tree still exist when I can't
see it?" which in its turn leads to "Does a tree exist at all?"
True, with these last questions the hard-headed thinker finds
himself hoist with his own petard; like those who, having
broken the images of saints and thrown out the holy water of
superstition, find themselves with nothing in their hands but a
manuscript of uncertain date and the stones of the latest archae-
ological research. Here it begins to strike the sceptical philoso-
pher that there is something queer about his doubts, about his
negative hypotheses, about the shocks he intends for others,
about the popular illusions he aims to correct. For what surprise
has he in store for the gardener with his cherry? But what I
want to insist upon is that this feeling of queerness is still half
smothered while he still asks: "Are there material things, per-
manent and substantial, behind the fast fading shadow shows of
sensation? What right have we to suppose that what lies behind
what we observe is of this nature rather than that or indeed that
anything at all lies behind it?" While philosophers use such
words they appear to themselves and to others to advance a
negative hypothesis just like a man may advance the hypothesis
that, though there are lights on the ship that passes and its sails
are well set, there's no one aboard.

Pointing out that there is no difference in kind between the
cases where we should ordinarily claim to have knowledge that
there is a real, physical thing which is responsible for our sensa-
tions and cases where we should say that this is doubtful, the
sceptical philosopher goes on to say that there is never any real
reason to believe that there is anything beyond our sensations.
Surely all this makes it impossible to claim that by "Matter
doesn't exist" he means that Matter is a bundle of sensations.
His approach to his conclusion and the air with which he brings
it out are like those with which a man brings out the conclusion
"There's no one aboard." If his conclusion is really an analytic

proposition he certainly doesn't realise this himself nor do his hearers. I am thus led to say that if he is making an analytic claim and not a scientific claim but "he doesn't realise it," this is a situation which could also be fairly indicated by saying that he *is* still trying to make a scientific claim, like a man who is trying to run on an endless band which prevents his making any progress. We may even say of the runner that he runs though he makes no progress. So we may say with Moore that the sceptical philosopher is sceptical though his scepticism is inoperative, that he *is* advancing a negative hypothesis. We may fairly choose this way of describing the small but many differences between one who uses the words "Matter doesn't exist" and one who says "Matter doesn't really exist" or "Matter is nothing over and above sensations" or "Matter is just sensations."

The man who says "Matter doesn't exist," even the man who says "Matter doesn't really exist," feels very differently as he speaks from one who says "Statements about material things can be analysed into statements about sensations." But this is only a small part of the difference between them. When a man brings out a general statement we take it as a guide to what he will say and do in a thousand concrete cases. Now there is something queer and barren about the philosopher's "I don't believe there's any such thing as Matter" which makes it very different from "I don't believe there's a tiger in there at all." The "concrete consequences" are apt to disappoint the plain man who had half expected to see his ailing body disappear in "a vortex of pure thought." On the other hand, the man who says "Matter does not exist" is very different in his reactions to the implications of what he says from the man who says "Matter is a logical fiction." The former doesn't look at you as if you are mad if you infer that he denies that there are cherries on a tree or, more concrete still, that there will be any appearance of cherries when we go to look. It is indeed only at this last stage that the barrenness of his doubt is certain to come out. The man who says that "Matter is a logical fiction" regards you as mad or as not understanding the technical expression 'logical fiction' if you attempt to deduce anything exciting from what he says. The two are very different and it is not until we trace the concrete con-

sequences of "Matter doesn't exist" right down into what the man expects to see and what he doesn't that we begin to feel the inclination to say that, though he appears to advance a negative hypothesis, he's doing no such thing. Till then we notice more his differences from one who says merely that Matter is a logical fiction; till then the reactions of one who says "I don't believe in Matter" are very like one who says "I don't believe there's anyone aboard." His reactions are undecided over "Are there then no cherries on the tree?" Moore's proof forces him to decide, forces him to become unmuddled, to gain a grasp of what he wishes to do with his words "Matter doesn't exist," what he wishes us to understand by it.

When he begins to do this we find his decisions related to what he says in a way different from what we should expect on the analogy of "I don't believe there's anyone aboard" and much more like what we should expect from one who said "Matter is a construction out of sensations:"—the queerness of his negative hypothesis and its likeness to an analytic statement then comes out.

The queerness of the negative hypothesis "Matter does not exist" comes out in this way. Both the hypothesis that Matter does not exist and the hypothesis that it does are extremely extensive. Each is so extensive that there does not readily occur to one any simple means of verifying the other. For, like the hypothesis of absolute space, they are hypotheses to account for the observable—quite literally for all that is observable, not merely for all that has been observed. So of course whatever you saw on looking over the ship would be accounted for *both* by the hypothesis that Matter exists and by the hypothesis that it does not. So that it can favour neither. And this would be so *whatever you saw wherever you looked*. At once we understand why the doubt, "Does Matter exist?" seemed queer, why the shock, "There's no such thing as Matter," came to nothing. Broad is quite right, "Matter exists" and "Matter does not exist" are hypotheses about what lies behind the observable; only, let us repeat ourselves, they are hypotheses about what lies behind the observable, *all* of the observable. They are hy-

potheses, but so are the Copernican and Ptolemaic theories, so is the hypothesis of absolute space.

Nevertheless, although it is partly from bad reasons that the philosopher says "Matter does not exist" instead of "Matter is a logical fiction," it is also from good reasons.

For, though he is in many ways unlike a man who corrects a popular illusion, e.g., that all the decisions of the Government are dictated by the King, and in many ways it is wrong to say that he is bringing a shock to the plain man, this is not altogether wrong; and what he does is in many ways like what one who corrects a popular illusion does and unlike the mere translation of one class of sentences, e.g., one involving the word 'brother', into others which are applicable in exactly the same cases. Remember how the translation of sentences about the average man seems to make him vanish.

The hypothesis of the non-existence of Matter is not unique in this way. The hypothesis of the non-existence of Space is like it. And didn't the Copernican theory bring a shock to the man in the street? Because a lance is made of sugar icing and could give no real shock to anyone it doesn't follow that it doesn't give a shock at all to bad men who see it against the sky and hear a trumpet just as loud as one accompanying the use of a real lance.

Did the Copernican theory bring a shock to the man in the street who said the sun is sinking? Shall we say that, until Copernicus, ordinary people who said "The sun is sinking" spoke falsely? Or shall we say that they spoke truly in so far as they recorded and predicted the pattern of the observable, but that they spoke falsely in so far as their assertions involved the hypothesis that the sun goes round the earth? Or shall we say that they spoke truly, but that their way of describing the situation inevitably suggests a picture, a model, for recalling and predicting the facts about the heavenly bodies which is very cumbersome and inconvenient compared with the picture and model suggested by Copernicus' way of describing the situation? Or shall we say that they spoke truly, but that their way of describing the situation "inevitably suggests a certain mode of

analysis" for the situation which, "though it seems highly plausible while we confine our attention to certain ordinary cases, becomes very much less plausible when we attempt to apply it in certain more out of the way cases?"[17]

Many people still talk of the sun's sinking in the west. Do they now mean something different by this from what people used to mean? Or do they inconsistently, in their "unreflective moments," forget their scientific principles and in the press of life say things quite untrue or, if not quite untrue, then at least involving hypotheses false or unsupported?

What I am suggesting by asking these questions which have sometimes been called rhetorical but which I would prefer to call *riddle* questions ("Is a tomato a fruit or a vegetable?")— what I am suggesting is, that in these cases of people saying "The sun is sinking in the west" there is not all the difference one might expect between the claim that they are speaking falsely and making mistaken assumptions and the claim that they are speaking the truth but using a notation, an analysis, which in certain connexions is apt to mislead.[18] But, though I wish to suggest in this way that the question "Which are they doing?" is not quite what it seems, I do not wish to suggest that there are not some of them who more than others are more appropriately described in one way rather than the other, nor that these differences are not of great philosophical importance. If you are faced with a pre-Copernican and a post-Copernican way of saying that the sun is sinking and forced to say that one is false, you will certainly choose the pre-Copernican, although you know that one who uses the pre-Copernican formulation expects to see and hear nothing relevant to the sinking of the sun in any way different from what you expect. Here we can see how easily preference for a certain way of formulating facts of the class to which belongs the one we wish to state may well

[17] C. D. Broad, *The Mind and Its Place in Nature*, 148, 185 and 14, 15.

[18] *The Mind and Its Place in Nature*, 187, ". . . presupposes the doctrine of Absolute Space-Time . . . *starts with rather heavy liabilities, . . . has not carried its analysis far enough.*"

Also p. 189, ". . . presupposes *Absolute Space-Time, which is probably a sign of inadequate analysis.*" (Italics mine)

find expression in "denying a hypothesis involved in" another way of formulating them.

Likewise, though the philosopher who analyses material thing statements into statements about sensations may hesitate to say that one who says "The sun is sinking" instead of "Appearances are as of a sinking sun" speaks falsely, he will certainly, if forced to say that one statement is false or involves an unjustified assumption, choose the former or common sense formulation. So would I, although I know that one who uses the Matter-formulation expects to see and hear nothing relevant to the sinking of the sun in any way different from what I expect. Here again however it is natural (remember the average man) to express a preference for a certain way of formulating facts of the class to which the one we wish to state belongs, by "denying a hypothesis involved in" another way of formulating them.

"But," it may be said, "this pre- and post-Copernican case is quite different from the hypothesis of the existence of Matter. This Copernican hypothesis really is a matter of science and of different expectation."

Now I don't wish to claim that accepting the Copernican theory makes no difference to *any* expectation as to what one will see and hear, although a pre-Copernican and a post-Copernican expect the same from "The sun is sinking." But the acceptance of "Matter exists" or the analysis of it into sensations may also have remote effects on our expectations. Between the plain man and the philosopher who denies the existence of matter there may be differences in what they would expect to see or hear, although when one of them says "The sun is sinking" and the other says "Appearances are as of a sinking sun" there is no difference in what they expect to see and hear *in the way of a verification of this statement.* Consider someone who mistakenly thinks that all the sights we see and sounds we hear from a passing ship are made by a man with a bell and a lantern. Not only will this person have misplaced confidences about what he will see if he goes on board but he will be averse to accepting stories of patterns of sight and sound which can not be explained on his hypothesis or only with the utmost difficulty. In the same

way the man who believes that, who talks as if, the sights and
sounds we see and hear are due to material objects may be
averse to accepting stories of patterns of sight and sound which
can not be explained on his hypothesis. He may be misled like
this, although he is making no mistake comparable to the mis-
take of expecting to see someone when one goes on board the
ship. For example, he may reject your story of how you and
your friend saw rings round people's heads although you could
feel nothing, not merely on account of the rareness of such a
pattern but because your story has for him a sort of impossibility.
This impossibility as opposed to improbability arises from the
fact that he speaks in terms of sorts of *thing* and *not* of sorts of
pattern of sensation. For what sort of thing is a thing which
can be seen but not felt or photographed? This question in part
reflects the antecedent improbability which your story gets from
the rarity of the pattern it records, but it also gives your story
unfair unplausibility by assuming that, if your story is true at
all, it must be about a *thing*.

Talking of memory as looking back upon the past has the
same sort of effect. This way of talking of memory and percep-
tion as strings or beams of light running from the eye to objects
encourages the question "How could there be foreknowledge,
since this involves seeing what doesn't yet exist?" This question
"How *could* there be foreknowledge?" plays a part in determin-
ing whether we "believe in foreknowledge" and even in whether
we accept the stories we are told about the extraordinary powers
of Mr. So-and-so.

The fact is, what is being done by one who says "Matter
doesn't exist" is like—and also different from—what is being
done by one who says "Unicorns don't exist," "Uranium doesn't
exist." It is more like what is being done by one who says
"Gravity doesn't exist," or "Space doesn't really exist." These
last are more like suggestions for a formulating or analysing
of facts than they are like "There are no cherries left." At the
same time they may prepare one for certain patterns of sensation
which would have been more of a surprise if we had stuck to
older formulations. And they lead to a special reducing-of-
appearances-of-inferred-entities sort of analysis which is very

different from, though of course not quite unlike, the analysis of, for example, family relationships into parenthood and sex. And if, instead of "Matter doesn't exist," one says "Statements about material things are analysable into statements about sensations," one must remember what sort of analysis this is. In this way we see how near is "Matter is a fiction" to "Matter is a logical fiction" and at the same time recognise the difference between one who says the one and one who says the other. The Statements "Matter doesn't exist," "Matter doesn't really exist," "Matter isn't anything over and above our sensations," "Matter is a logical fiction," "Statements about material things can be analysed into statements about sensations" form a series. As the formulations become more and more logical and analytic and less scientific and like hypotheses, something is gained and something is lost.

For philosophy is not science nor the correcting of popular assumptions; and one way in which this is best brought out is by emphasising its likeness to logic. At the same time philosophy isn't logic and one way in which it isn't is best brought out by emphasising its likeness to science and to the correcting of popular assumptions. Philosophy is like other things too, poetry for example; so that we can not completely rely on any simple and winning formula, such as "Philosophy begins where science and logic meet." Nevertheless this formula is useful in considering the dispute as to whether philosophers are and should be concerned with questions about whether certain hypotheses involved in everyday statements are true, or are and should be concerned with the analysis of these everyday statements. Indeed, what I have tried to do is to bring out (1) how philosophy begins where the "justification" of a "hypothesis" involved in certain statements, e.g., Freud's about unconscious wishes, "explanatory" of certain facts, e.g., the patients' symptoms, dwindles to an "analysis" of the statements into the facts, and (2) how the analysis of statements begins to be philosophy as opposed to logic when it is the "justification" on the basis of certain facts of a "hypothesis" involved in those statements and "explanatory" of those facts. I have tried to show how philosophy begins where logic grows into science and science vanishes into logic. I have tried to bring out how far Moore is right when he

accuses philosophers of discussing "Does Matter exist?" as if it were a negative hypothesis, and how far this is an accusation, that is, how far Moore is wrong in saying that they ought not to inquire into the truth of hypotheses involved in the truth of everyday statements such as "Here is one hand and here is another," but ought only to enquire into the analysis of these statements.

It is almost impossible to realise now the difficulty of first noticing the peculiarity, the craziness, of the philosopher's doubts and of grasping how near what he is really doing comes to logic. How much Moore has done for philosophy in bringing this out is not yet fully realised. But I have hopes it will be; for we have him with us yet, and while we have we shall not lack the help of an unparalleled combination of sound sense, courage and power.

Summary

1. Moore says that everyday statements such as "I've got sixpence" are unquestionable, that only their analysis is questionable and that it's not questionable whether we know them, only how we know them.

2. But many of us feel that they are not *absolutely* unquestionable and that their logical analysis is not all we want and that we don't *really* know them till we can say how we know them. We feel too that the method of philosophy is not that of logic.

3. Broad, finding himself doing philosophy by weighing conflicting considerations, represents philosophical enquiry as a matter of estimating the probability of hypotheses about the *absolutely* unobservable in face of the endlessly extensive but chronically insufficient evidences which we have in the observable. He represents everyday statements as unquestionable in so far, but only in so far, as they involve no such hypotheses but merely record and predict the observable.

4. This appeals to us. But it involves questioning the unquestionable premiss "I've got two hands" or "I've got sixpence" from which Moore deduces that "Matter exists."

5. Consequently Broad wavers and sometimes, instead of questioning Moore's premiss, questions the *validity* of his proof.

For Broad suggests that the fact that "I've got sixpence" expresses a fact does not imply the existence of a sixpence, and thus does not imply the existence of a material thing, and thus does not imply that Matter exists.

6. None of these suggestions are *merely* absurd, especially is it not merely absurd to suggest that, though Moore, as opposed to a penniless tramp, is unquestionably right when he claims to have sixpence, it does not follow that the answer to the old philosophical question "Does Matter Exist?" is unquestionably that it does.

7. It is not, however, that it is questionable whether there is such a connexion as Moore claims between his having sixpence and the existence of Matter, it is that the connexion is questionable.

8. For many philosophers have used "Matter does not exist" so that one might almost say that they just mean that Matter is nothing over and above sensations.

9. This has also been expressed by "Matter is not a fiction, but a logical fiction," i.e., "statements about material things can be analysed into statements about sensations."

10. From this it appears that Broad may accept Moore's premiss without his conclusion that Matter exists, but only by making the philosophical issue "Does Matter exist?" a purely logical one such as Moore says it should be. Now it was to avoid this that we went to Broad.

11. Though it now begins to look as if Moore was quite wrong about what philosophers have been doing and quite right about what they should have been doing, in fact he is not quite wrong about what they have been doing and not quite right about what they should have been doing.

12. For, though philosophers who have said "Matter does not exist" have been like the philosophers who have said "Matter exists but is analysable into sensations," they have also been different. And the difference is important. For those who say "Matter does not exist" do not realise the difference between what they are doing which amounts to saying "All is illusion" and the advancing of a genuine hypothesis, e.g., "That dagger in the air is an illusion;" whereas those who say "Sentences

about material things can be translated into sentences about sensations" do not realise how what they are doing is related as a limit to the advancing of genuine hypotheses, and thus differs from such analysis as the analysis of family relationships or the analysis in logic of one form of proposition, e.g., Propositions of the form *The thing which is S is P,* into other forms.

13. "A llama is a hairy sort of woolly fleecy goat with an indolent expression and an undulating throat, like an unsuccessful literary man." Hilaire Belloc.

A goat is an animal in which cow, sheep and antelope vanish into one another. This formula is little use without an explanation of how they vanish into one another. But, given this explanation, the formula comes to have value as a mnemonic line.

A philosopher is an animal in which the scientist vanishes into the logician—not to mention here the poet and the psychoanalyst.

14. For the metaphysical and Copernican discovery of how nearly philosophy is really logic Moore did as much and perhaps more than any other man.

JOHN WISDOM

TRINITY COLLEGE
CAMBRIDGE UNIVERSITY

17

Richard McKeon

PROPOSITIONS AND PERCEPTIONS IN THE WORLD OF G. E. MOORE

PROPOSITIONS AND PERCEPTIONS IN THE WORLD OF G. E. MOORE

IN one of his earliest essays Mr. Moore professed a particular concern that his treatment of a technical question be recognized to extend beyond the boundaries of merely departmental interest. "What I have to say is not addressed to those who are interested in any particular science, such as logic, definition, or psychology, but to all who are interested in the question what the world is."[1] Mr. Moore has continued to be interested in the world. As early as 1903 he undertook the refutation of idealism in the interest of separating, at least in philosophical argument, the conditions of existence from those of knowledge; his account of his philosophical career, published in 1925, portrays it as a defense of Common Sense committed to convictions about physical facts, which Mr. Moore associates with convictions about the existence of his own body, and about mental facts, which he associates with convictions about his own experiences; as late as 1939 he returned to the demonstration of an external world.[2] Mr. Moore has accomplished this rehabilitation of the world by examining his own perceptions (which incline him, in terms borrowed from Hume, to a strong propensity to believe that the world exists) and the assertions of other philosophers (which he finds often involve, erroneously or verbally, the denial of that existence). Yet when he examines the characteristics of his re-established world or urges the im-

[1] "Identity," *Proceedings of the Aristotelian Society*, New Series (henceforth cited as *PAS*), vol. I (1900-01), 103.

[2] Cf. "The Refutation of Idealism," *Philosophical Studies* (London, 1922), 1-30; "A Defence of Common Sense," *Contemporary British Philosophy*, Second Series (New York, 1925), 193-223; "Proof of an External World," *Proceedings of the British Academy*, Vol. XXV (1939), 273-300.

The question which I should like to raise about Mr. Moore's world requires a distinction between what he says about the world and what he says about statements about the world. I find myself in complete agreement with Mr. Moore not only in the beliefs he asserts concerning the existence of things but also—what is even more unusual in philosophy—in the skepticisms he expresses concerning the existence of other things;[6] moreover I find his analyses of propositions which he believes or doubts shrewd, illuminating, and, in the senses in which he states them, true. Unfortunately I also agree with him in his frequent acknowledgment that the questions raised are unimportant and their solutions uncertain[7] and with his equally frequent statements of suspicion that no one ever held the propositions which he refutes.[8] I am not, as regards the first point, suggesting that Mr. Moore could tell us about things without making assertions about them, but I hope to show that Mr. Moore's choice of the analysis of assertions as a means of disclosing 'the predicates of things' (as he likes to put it) is one of the chief reasons why his philosophic labors seldom yield

[6] Cf., for example, "A Defence of Common Sense," 216.

[7] "The Refutation of Idealism," 4-5, where Mr. Moore begins the statement of his problem with the remark: "The subject of this paper is, therefore, quite uninteresting," and goes on to remark that he cannot hope to prove that it has even such importance as he thinks it has. Mr. Moore's scrupulous intellectual honesty seems to force him to the conclusion that except for unimportant questions there is no conclusive resolution; cf. *Philosophical Studies*, 96, 251-252, 275, 308-309, 339. Even if a proposition *is* important, however, it is apt to *seem* unimportant in the sense in which it is admitted to be true; cf. "Identity," 103: "My own view is that, whether what I say be true or false, it is certainly very important, and that is my main reason for raising the question of its truth. What I most fear, then, is not that it should be proved to be false, but that it should be admitted true without enquiry, on the ground that, though true, it is unimportant."

[8] *Ethics* (Home University Library, 1911), 77: "Whether this theory has ever been held in exactly the form in which I have stated it, I should not like to say." Cf. "The Conception of Reality," *Philosophical Studies*, 207ff, where Mr. Moore expresses doubts concerning whether or not Bradley committed the error attributed to him, and then argues that it is what Bradley ought to have meant. He feels similar doubts concerning his interpretation of James ("William James' Pragmatism," *Philosophical Studies*, 107-108), and these doubts run easily into Mr. Moore's general convictions about the ambiguity of words and the tendency of philosophers to contradict themselves and each other.

more than reasons which he grants are inconclusive for beliefs which all or most men share concerning the existence of things. I am not, as regards the second point, inclined to minimize the difficulties of determining the meaning of any assertion, resulting from the ambiguities of words no less than from the contradictions of philosophers, nor even to insist that the philosophic analysis of a doctrine should not be philologically or historically implausible,[9] for in the tradition from Aristotle to Whitehead philosophers have often made good philosophic use of their predecessors in spite of distortions and misinterpretations which would be unacceptable in an undergraduate theme. Philosophers seem to have used the doctrines of other philosophers, however, in one of two ways: either they assimilate what they conceive to be the content or matter of the doctrine (and then the manner of the statement or proof is no matter of concern) or they analyze the form of the statement and the presuppositions of the proof (and then the matter or content of the statement is subject to no independent control). Mr. Moore has initiated a mode of philosophical inquiry which operates subtly first to determine the matter of statements by identifying the common usages of words and the statement of common sense beliefs, and only then to clarify their meanings by analysis, in those rare instances in which it is possible not only to be certain in holding a common sense belief but also to state what that true belief means.[10]

[9] Mr. R. G. Collingwood's criticism of Mr. Moore's philosophical exegesis does not, nonetheless, seem to me excessive; cf. *An Autobiography* (Oxford, 1939), 22: "An important document of the [sc. 'realist'] school, or rather of the parallel and more or less allied school at Cambridge, was G. E. Moore's recently published article called 'The Refutation of Idealism'. This purported to be a criticism of Berkeley. Now the position actually criticised in that article is not Berkeley's position; indeed, in certain important respects it is the exact position which Berkeley was controverting."

[10] Although examples of Mr. Moore's method of analysis are so numerous and so explicit in the implementation of their method that one might be justified in assuming (to adopt Mr. Moore's turn of phrase) that everyone is perfectly familiar with what he means by 'analysis', little has been written to distinguish, in the welter of meanings recently attached to the process of 'analysis', the purposes and devices of Mr. Moore's analysis from the technicalities of the analyses affected by his numerous friendly disputants. Those of us who have not been able to follow the recent developments of Mr. Moore's thought on analysis as expressed in his lectures, might hesitate to set forth, as bluntly as he himself has, the limitations

Although Mr. Moore is, in my opinion, correct both in the propositions which he asserts to be true and in the refutations he directs against assertions which he holds to be false, the refutations miss the sense in which the propositions are truly defensible, whereas the propositions which are shown to be true are seldom important or, if they are important, the reasons for them are inconclusive. At the one extreme he has shown that *esse* is not *percipi* (in a sense which would not have disturbed Berkeley in his convictions), but at the expense of granting, at the other extreme, that *esse* is *praedicari* (in a sense which clearly departs from the common usage of 'predicate' and 'proposition'). Just as there is, I think, a sense in which Berkeley's fundamental proposition is correct, so too Mr. Moore's basic position is defensible in the sense in which he maintains it. Like Mr. Moore, I am convinced that the truth of his convictions does not depend on his analysis of any of them, but I am further convinced that his method of analysis does determine the truths he chooses to analyze. Some of the dangers of Mr. Moore's position may be seen in the evolution which 'propositions' have undergone in the uses of other philosophers: for Mr. Moore propositions are objects of experi-

which seem to attach to the method; cf. Mrs. Braithwaite's notes on a lecture from his course on *The Elements of Philosophy* published under the title "The Justification of Analysis" (*Analysis*, Vol. I [1934], 28-30). Mrs. Braithwaite assures us that, according to Mr. Moore, philosophy only analyzes words of which we already *know* the meaning, in the sense that we can use the word right, although we could not perhaps *say* what it means. "Moore doesn't think analysing of terms usually helps much to answer philosophic questions other than those of analysis, except that sometimes once you are clear as to the meaning of the terms in a question, it is either obvious what the answer is or obvious that the question is nonsense." Cf. the report (*ibid.*, Vol. II [1934-35], 31) of Mr. Moore's reply to a critic who found analysis 'useless, harmful, and impossible': "That there are certain questions which can significantly be asked, and which are not asked by science, such that when we try to answer them we are doing analysis (e.g., a common problem about perception, How am I using 'this' when I look and say 'This is an ink-well'?)" Mr. Moore treats similar problems somewhat more fully in "A Defence of Common Sense," 216-217 and 223. Cf. "Facts and Propositions," *PAS*, Supplementary Volume VII (1927), 171-206, for Mr. Moore's statement of his perplexities concerning the class of entities treated in Mr. Ramsey's 'logical analysis.' A. C. Ewing, "Two Kinds of Analysis," (*Analysis*, Vol. II [1934-35], 60-64) succeeds in displaying the pertinence of analysis to Mr. Moore's acceptance of 'common-sense propositions'.

ence;[11] for Mr. Russell propositions are primarily forms of words which express what is either true or false;[12] for the logical positivists (in at least one phase of their variations) verbal statements and propositions have themselves usurped the place of empirical facts and objects.[13] I do not mean to imply, however, that Mr. Moore has committed the simple error of supposing that since our knowledge of *things* can be expressed only in the form of *propositions*, therefore the conditions which govern the formation of true verbal statements are identical with the conditions which govern the existence of things. I wish only to draw attention to the consequences of Mr. Moore's

[11] "Experience and Empiricism," *PAS*, Vol. III (1902-3), 89: "It may seem strange to some that the object of an experience should be called a proposition. But such object may undoubtedly be 'the existence of such and such a thing', and it seems impossible to distinguish the cognition of this from the cognition 'that such and such a thing exists'. The object of experience, moreover, is undoubtedly true, and allows valid inferences to be drawn from it, both of which properties seem to be characteristic of propositions." In the case of true propositions, other than those which are objects of experience, the analysis is similar, although Mr. Moore's 'correspondence theory' (which holds between mental facts and their objects) requires that he deny that every proposition is a character of a fact; cf. "Facts and Propositions," *PAS*, Supplementary Volume VII (1927), 197: "And it seems, at first sight, to be perfectly obvious that every proposition, without exception, *is* either identical with or equivalent to some proposition, with regard to a certain character, to the effect that there is one fact, and one only, which has that character; this being, I imagine, why Mr. Johnson holds that propositions *are* characters of facts; although, of course, the mere fact that in the case of every *true* proposition, there is some character of a fact such that the proposition in question is either identical with or equivalent to a proposition to the effect that *there is a fact which has that character*, gives no justification whatever for the view that any proposition whatever, true or false, *is* a character of a fact."

[12] Cf. *Introduction to Mathematical Philosophy* (London, 1919), 155.

[13] C. G. Hempel, "On the Logical Positivists' Theory of Truth," *Analysis*, Vol. II (1935), 54: "But it must be emphasized that by speaking of statements only, Carnap and Neurath do by no means intend to say: 'There are no facts, there are only propositions'; on the contrary, the occurrence of certain statements in the protocol of an observer or in a scientific book is regarded as an empirical fact, and the propositions occurring as empirical objects. What the authors do intend to say, may be expressed more precisely thanks to Carnap's distinction between the material and the formal mode of speech." To say that a statement is about Africa or metaphysics would then *mean* that the word 'Africa' or the word 'metaphysics' occurs in the statement. Mr. Moore has himself shown the error of these later forms of analysis in his treatment of the extreme case of the object of fictional statements; cf. "Imaginary Objects," *PAS*, Supplementary Volume XII (1933), esp. 69-70.

careful avoidance, in his application of analysis to perceptions and propositions, of the two extremes: that of examining things and that of considering words. His concern is with predicates; the basic concepts of his philosophy are unanalyzable predicates; predicates are attached to things, involved in the expression of beliefs, subject to analysis in statements. Mr. Moore exhibits this peculiarity of his problem emphatically in his inquiry into the meaning of necessity:

My primary object in this paper is to determine the *meaning* of necessity. I do not wish to discover what things are necessary; but what that predicate is which attaches to them when they are so. Nor, on the other hand, do I wish to arrive at a correct verbal definition of necessity. That the word is commonly used to signify a great number of different predicates, which do actually attach to things, appears to me quite plain. But, this being so, we shall be using the word correctly, whenever we apply it to any one of these; and a correct definition of necessity will be attained, if we enumerate all those different predicates which the word is commonly used to signify: for the only test that a word is correctly defined is common usage. The problem which I wish to solve is different from either of these.[14]

The peculiarity of the question, as Mr. Moore observes, lies in the fact that it can not be treated in total isolation from the other two questions. Mr. Moore's world is distorted—so I hope to be able to show—by the priority he gives to his question of predicates: his iteration of the propositions which he and most

[14] "Necessity," *Mind*, New Series, Vol. IX (1900), 289. Cf. *Principia Ethica*, 37: "It results from the conclusions of Chapter I, that all ethical questions fall under one or other of three classes. The first class contains but one question—the question What is the nature of that peculiar predicate, the relation of which to other things constitutes the object of all other ethical investigations? or, in other words, What is *meant* by good? . . . There remain two classes of questions with regard to the relation of this predicate to other things. We may ask either (1) To what things and in what degree does this predicate directly attach? What things are good in themselves? or (2) By what means shall we be able to make what exists in the world as good as possible?" Cf. also "Is Existence a Predicate?" *PAS*, Supplementary Volume XV (1936), esp. 184-185, where Mr. Moore concludes his criticism of Mr. Russell by saying, "so that, according to him, existence is, after all, in this usage, a 'property' or 'predicate', though not a property of individuals, but only of propositional functions! I think this is a mistake on his part," and also p. 188 where he analyzes the proposition, 'This exists' as applied to a sense-datum.

other men believe falls ineffectively in the region between things (whose existence he repeatedly undertakes to demonstrate) and statements, his own and those of other philosophers (whose meanings he confesses are seldom susceptible of analysis).

Mr. Moore has recognized, as have few philosophers since Spinoza and his contemporaries, the importance of distinguishing between awareness and awareness of awareness, between the idea of an object and the idea of an idea. Yet, notwithstanding his conviction that cognitions can be explained best by means of their objects, his philosophic method is adapted primarily to treat of perceptions and propositions. He describes, somewhat nostalgically, a world of facts which has been neglected by philosophers and in which perceptions and propositions reflect distinctions found in existent things. He expresses the results of his philosophic analyses, however, in a world of theories, of statements and beliefs in which perceptions and the propositions of Common Sense, though unanalyzable, disclose dimly the existence, but few other characteristics, of an existent world[15] and in which the statements of other philosophers are, on analysis, unintelligible or false. The world of existences Mr. Moore divides into natural things—physical and mental—and another class of things which is not natural; the objects of cognition are divided into true and false things. Mr. Moore's philosophic problems arise from his natural conviction that these are mutually compatible classifications of a single world. Since there are two apparent incompatibilities in the classifications, he has two major philosophic problems. In the first place, he is convinced that there are existent things—among them (in his sense of existence) experiences, truths, and propositions—which are never, or have never been, the object of cognition; Mr. Moore feels that with respect to this conviction he is in

[15] "A Defence of Common Sense," 222-223: "Just as I hold that the proposition 'There are and have been material things' is quite certainly true, but that the question how this proposition is to be analysed is one to which no answer that has been hitherto given is anywhere near certainly true; so I hold that the proposition 'There are and have been many Selves' is quite certainly true, but that here again all the analyses of this proposition that have been suggested by philosophers are highly doubtful."

opposition to many philosophers. In the second place, Mr. Moore is convinced that cognitions are never explained by *non-existence*, and he meditates frequently on the important classes of cognitions—including all falsities and hallucinations and many truths—which do not have natural objects such as are the sources of sensations. This asymmetry in Mr. Moore's world accounts for all or for most of his efforts at refutation: there are uncognized existences; there are no cognitions without objects in some sense existent.

The occasional glimpses which Mr. Moore offers of his world of existences are ordered according to his preferred classification of things in which the basis of differentiation is the distinction of cognitions from their objects. Nature comprises one large class of objects, which is subdivided into mental and physical objects. By 'nature' Mr. Moore tells us he means and has meant the subject-matter of the natural sciences and also of psychology. It may be said to include all that has existed, does exist, or will exist in time.[16] In determination of the subject-matter of psychology Mr. Moore gives a vivid sampling of the contents of the Universe in so far as it includes natural entities.

It seems to me that the Universe contains an immense variety of different kinds of entities. For instance: My mind, any particular thought or perception of mine, the quality which distinguishes an act of volition from a mere act of perception, the Battle of Waterloo, the process of baking, the year 1908, the moon, the number 2, the distance between London and Paris, the relation of similarity—all these are contents of the Universe, all of them are or were contained in it. And I wish to ask with regard to them all, which of them are 'mental' or 'psychical' in their nature and which are not.[17]

'Natural objects', however, are not the sole constituents of the Universe, and not everything that is—so Mr. Moore tells us at least part of the time—exists. Metaphysicians have rightly

[16] *Principia Ethica*, 40.
[17] "The Subject-Matter of Psychology," *PAS*, Vol. X (1909-10), 36. Cf. "A Defence of Common Sense," esp. 208ff, where the distinction between 'physical facts' and 'mental facts' emerges at the basis of the important points of Mr. Moore's philosophical position.

recognized, in addition to physical objects and mental objects, another class of objects which do not exist or if they exist are not part of nature.

I call those philosophers preeminently 'metaphysical' who have recognised most clearly that not everything which *is* is a 'natural object'. 'Metaphysicians' have, therefore, the great merit of insisting that our knowledge is not confined to the things which we can touch and see and feel. They have always been much occupied, not only with that other class of natural objects which consists in mental facts, but also with the class of objects or properties of objects, which certainly do not exist in time, are not therefore parts of Nature, and which, in fact, do not *exist* at all.[18]

To this class of objects which are but do not exist (or which exist but are not natural) belong goodness, as distinct from things which are good, and truths themselves as well as the objects of some truths, such as numbers.

As the classification of existences depends on the differentiation of cognitions (which constitute one class of things) from two varieties of objects of cognition (which constitute two more classes of things), so in converse fashion the classification of cognitions depends on the differentiation of kinds, not of cognitions, but of objects.

It would seem, then, that though cognitions are distinguished from one another by intrinsic differences, these differences always correspond to some difference in the nature of their object. In dividing them, then, according to the nature of the objects, we shall be dividing them truly; and no other course seems open to us, since no one has yet succeeded in pointing out wherein the intrinsic difference of one cognition from another lies.[19]

Just as philosophers, when considering things, have sometimes ignored all except only natural objects (or even all classes of

[18] *Principia Ethica*, 110. Two pages later (*ibid.*, 112) Mr. Moore calls these same facts, of which he had said that they *are* but do not *exist*, 'what exists but is *not* a part of Nature'.

[19] "Experience and Empiricism," 83; cf. *ibid.*, 86: "It would seem, then, that the only method of distinguishing an experience from an imagination is by means of antecedents or accompaniments other than mental."

natural objects except only material or physical objects), so too they have sometimes, when considering cognitions, wholly ignored physical or material entities.

It is, however, commonly supposed that when we assert a thing to be perceived or known, we are asserting one fact only; and since of the two facts which we really assert, the existence of a psychical state is by far the easier to distinguish, it is supposed that this is the only one which we do assert.[20]

Some linguistic difficulties arise from the fact that language offers us no means of referring to such objects as 'blue' and 'green' and 'sweet', except by calling them 'sensations', or to such objects as 'causality' or 'likeness' or 'identity', except by calling them 'ideas' or 'notions' or 'conceptions'.[21] Even apart from such difficulties of nomenclature, however, there are entities or objects of experience which elude simple classification as physical things. Observation justifies us, thus, in concluding that certain kinds of things—pains, for example—do not exist when they are not perceived and that other kinds of things— colors, for example—do exist when they are not perceived.[22] Similarly those 'classes of mental events' which are called 'sensory experiences' and which might seem peculiarly dependent on physical objects, are not in fact limited to sensations proper, but include as well four other varieties: images, dreams, hallucinations, and after-images. In each of these experiences the entity which is experienced is distinct from the experience itself.[23] In general, sense-data or sensibles must be distinguished not only from our experience of them but also from the physical

[20] *Principia Ethica*, 134; cf. "Experience and Empiricism," 82: " 'Experience', then, denotes a kind of cognition; and, like 'cognition' and 'knowledge' themselves, the word stands for a double fact: (a) a mental state, and (b) that of which this mental state is cognizant. Thus 'an experience', like 'an observation', may stand either for the observing of something or for that which is observed." Cf. also "The Refutation of Idealism," 13: "I am suggesting that the Idealist maintains that object and subject are necessarily connected, mainly because he fails to see that they are *distinct*, that they are *two*, at all." Mr. Moore leaves no room to doubt that he means by the 'object' of sensation a 'material thing'; cf. *ibid.*, 30.

[21] "The Refutation of Idealism," 19.

[22] "The Nature and Reality of Objects of Perception," *Philosophical Studies*, 91-92.

[23] "The Status of Sense-Data," *Philosophical Studies*, 168-169.

objects which they sometimes resemble in shape.[24] Since sense-data exist,[25] Mr. Moore makes use of two classifications of objects of cognition which include between them all three kinds of existences. The one classification involves the contrast of things 'in my mind' (as Mr. Moore calls them following the usage of 'some philosophers') to 'external things' which he instances in another of the striking catalogues illustrative of what he means by things of various kinds.

My body, the bodies of other men, the bodies of animals, plants of all sorts, stones, mountains, the sun, the moon, stars, and planets, houses and other buildings, manufactured articles of all sorts—chairs, tables, pieces of paper, etc., are all of them 'things which are to be met with in space'. In short all things of the sort that philosophers have been used to call 'physical objects', 'material things', or 'bodies' obviously come under this head.[26]

The problem of the entities to be contrasted to material things in this sense—illustrated in "any bodily pain which I feel, any after-image which I see with my eyes shut, and any image which

[24] *Ibid.*, 195-196: "And the natural view to take as to the status of sensibles generally, relatively to physical objects, would be that none of them, whether experienced or not, were ever in the same place as any physical object. That none, therefore, exist 'anywhere' in physical space; while, at the same time, we can also say . . . that none exist 'in the mind', except in the sense that some are directly apprehended by some minds. And the only thing that would need to be added is that some, and some only, *resemble* the physical objects which are their source, in respect of their shape." Cf. "Is there 'Knowledge by Acquaintance'?" *PAS*, Supplementary Volume II (1919), 192: "Sense-data, for instance, are not propositions; and hence it follows at once that my acquaintance with a sense-datum cannot be said to be false in the sense in which ideas or judgments of mine can be said to be so; since to say of an idea or judgment of mine that it was false is simply equivalent to saying that it was a conceiving or affirming of a proposition, and that the proposition in question was a false one."

[25] "Is Existence a Predicate?" 188: "But my reason for holding that it is significant for me to say, for instance, of an after-image which I am seeing with my eyes shut, 'This exists', is similar to that which I gave in the last case [sc. in which a sense-datum is 'of' a physical object]: namely that it seems to me that in the case of every sense-datum which any one ever perceives, the person in question could always say with truth of the sense-datum in question 'This might not have existed'; and I cannot see how this could be true, unless 'This does in fact exist' is also true, and therefore significant."

[26] "Proof of an External World," 276; cf. the treatment of 'things in the mind' in "The Refutation of Idealism," 24-25.

I 'see' when I am asleep and dreaming"[27]—is the subject of Mr. Moore's recurrent meditation. Indeed, in spite of Mr. Moore's general disinclination to literary self-portraiture, the all but anonymous 'I' who asserts beliefs and refutes philosophers in his pages stands out sharply sketched in his accounts of a variety of perplexities concerning cognitions which have no direct physical object: concerning the existence of after-images induced by staring at four-pointed stars or electric lights, concerning the location of the images in mirrors or of the pain of his toothache or cut finger, or concerning the reality of what Sinbad the Sailor saw.[28] The other classification, though less bizarre, is more basic: "The first great division between objects of consciousness is between those which are true and those which are false."[29]

The difficulties which Mr. Moore encounters in treating the relation of cognition to its objects (which are not, of course, identical with the problems involved in the distinction of mental and physical facts) arise from the 'diaphanous' or 'transparent' character of the mental fact.[30] Because of it he embarks on the most persistent of his philosophic tasks, the examination of sense-data, and on the subtle construction of one of his simplest doctrines, the 'theory of representative perception'.[31] Sense-data do not suffice, however, to account for errors of judgment even about sensory experiences, and they do not bear on the problem of falsity in general. A third ingredient—words or assertions—is involved in the cognitions and the objects which Mr. Moore uses in his quest for predicates. They are related to mental and physical facts, as mental facts are related to their objects, but unfortunately they are seldom transparent either in relation to the meanings intended or to the objects meant. The inconsistencies and disagreements of philosophers in particular are largely the effects of language, and analysis is necessary to determine in each case what the question is, what statements

[27] "Proof of an External World," 289.
[28] Cf. "Proof of an External World," 278-282; "The Status of Sense-Data." 178-179; "The Nature and Reality of Objects of Perception," 93-96.
[29] "Experience and Empiricism," 83.
[30] "The Refutation of Idealism," 20 and 25.
[31] Cf. "A Defence of Common Sense," 217-219.

mean and imply, what beliefs are mutually consistent, what consequences follow from principles, and what reasons will justify a conclusion.[32] The opacity of propositions, therefore, is no less important than the transparency of perceptions in determining Mr. Moore's philosophic problems. There are three levels implied in his analysis: existent facts, cognitions which may be false as well as true, and statements which not only may be true or false, but also may be unanalyzable as well as analyzable. Mr. Moore is concerned to separate the *conditions* of being, cognition, and predication from each other; but to achieve that end he has identified the *contents* of any given true proposition on all three levels—what is analyzed is the fact, the perception, or the proposition. So far as existences are concerned, there are no simple substances such as were sought by some philosophers: rather judgments are concerned with 'organic unities' which can be recognized only by means of the predicates attached to them. So far as perceptions are concerned there is no problem of existence,[33] but examination of our cognitions alone would not afford reason for conclusions about the existence of the objects of cognitions; rather assumptions and beliefs commonly held are required for the support of truths about existence, although, to be sure, the truths would be no less true without that support.[34] False cognition is explained by reference to false propositions, much as true cognitions involve facts and true propositions; but whereas analysis is successful in revealing improper questions or ambiguous statements, the analysis of true beliefs is so difficult that Mr.

[32] *Principia Ethica*, vii: "It appears to me that in Ethics, as in all other philosophical studies, the difficulties and disagreements, of which its history is full, are mainly due to a very simple cause: namely to the attempt to answer questions, without first discovering precisely *what* question it is which you desire to answer." "Identity," 103: "For my own part I am convinced that the characteristic doctrines of most philosophers, no less where they agree than where they differ, are chiefly due to their failure to trace the consequences of admitted principles." "William James' *Pragmatism*," 116: "Certainly he may quite often imply a given thing which, at another time, he denies. Unless it were possible for a philosopher to do this, there would be very little inconsistency in philosophy, and surely everyone will admit that *other* philosophers are very often inconsistent." Cf. *Philosophical Studies*, 39 and 217-219.
[33] "The Character of Cognitive Acts," *PAS*, Vol. XXI (1920-21), 132.
[34] "The Nature and Reality of Objects of Perception," 86 and 95-96.

Moore does not seem to be certain of even a single instance. There is, as a result, a double dislocation in Mr. Moore's world. First, there is a dislocation from things to perceptions: one might be led to expect that, in a brave realistic world, *knowledge* about things would be constructed from examination of things; instead Mr. Moore demonstrates the *existence* of things from examination of knowledge. Second, there is a dislocation from cognitions to assertions: one might be led to expect that analysis of propositions might be directed to the clarification of *true* cognitions; instead Mr. Moore's analysis is directed to clarification of ambiguous statements or the destruction of *false* philosophic questions and puzzles. In lieu of examining things and their properties, Mr. Moore has demonstrated the *existence* of things from common *beliefs* about *perceptions;* in lieu of examining truths and the conditions of truth, he has found reasons for the *propositions* he believes in common *usage* and he has found difficulties in understanding the assertions of other philosophers because of inconsistencies among their propositions and beliefs.[35]

The philosophic problems which demand Mr. Moore's attention, therefore, fall under two main heads, and in both varieties of problems Mr. Moore is distracted from consideration of the question itself in order to rectify the statement of the question and to refute the solutions of other philosophers. The fashion in which the two sets of problems divide the field of philosophy between them is dimly suggestive of a Kantianism in reverse: the problems of ethics should be concerned with predicates of

[35] Cf. *ibid.*, 73: "But these philosophers would say *either* you are contradicting yourself, *or* you are not using the word 'exists' in its ordinary sense. And either of these alternatives would be fatal to my purpose. If I am not using the word in its ordinary sense, then I shall not be understood by anyone; and, if I am contradicting myself, then what I say will not be worth understanding." Questions of common usage and of the conveyance of meaning are, for Mr. Moore, independent of questions of ambiguity. You may understand what I say even though neither you nor I could analyze the meaning of my statement correctly; cf. for example, *ibid.*, 32-33: "When I say these words to you, they will at once suggest to your minds the very question, to which I desire to find an answer; they will convey to you the very same meaning which I have before my mind, when I use the words. You will understand at once what question it is that I mean to ask. But, for all that, the words which I have used are highly ambiguous."

things (rather than with precepts of conduct) and the problems of epistemology should be concerned with the existence of things (rather than with categories of understanding).[36] The problems of ethics center about the classification of things according to their predicates; philosophers have fallen into error in ethics because of their identification of a *predicate*, namely, 'good', with some one *thing*, and therefore Mr. Moore, instead of classifying things that are good, has refuted philosophers and has restated the questions of ethics. The problems of epistemology center about the analysis of perceptions; philosophers have fallen into error in epistemology because they have drawn unwarranted inferences from *cognition* to *existence*, and therefore Mr. Moore, instead of setting forth the truths (which are not part of nature and whose existence is not an object of experience), has refuted philosophers and has demonstrated the existence of material things and other Selves (which are part of nature). The types of errors committed by philosophers in these two sets of problems, it is to be observed, are as distinct from each other as are the problems: the one consists in identifying a predicate with a thing (or one thing with another thing), while the other consists in identifying one kind of thing with another kind, a mental thing with a physical thing.

Apart from theories, the most profitable course to take in ethics would be the enumeration and classification of the kinds of things that are intrinsically good or bad.

The fact is that the view which seems to me to be true is the one which, apart from theories, I think every one would naturally take, namely, that there are an *immense variety* of different things, *all* of which are intrinsically good; and that though all these things may perhaps have some characteristic *in common*, their variety is so great that they have none, which, *besides* being common to them all, is also *peculiar* to them —that is to say, which never belongs to anything which is intrinsically

[36] This reverse Kantianism, which is hinted by Mr. Moore himself when he advocates the reversal of Kant's Copernican revolution, suggests a third set of problems concerning which Mr. Moore might—to the profit and edification of his readers—express his views more fully. His treatment of the Ideal—and particularly of beauty—in the *Principia Ethica* together with his treatment of free will in the *Ethics* constitute the beginnings of a *Critique of Judgment* in reverse.

bad or indifferent. All that can, I think, be done by way of making plain what kinds of things are intrinsically good or bad, and what are better or worse than others, is to classify some of the chief kinds of each, pointing out what the factors are upon which their goodness or badness depends. And I think that this is one of the most profitable things which can be done in Ethics, and one which has been too much neglected hitherto. But I have not space to attempt it here.[37]

Eight years earlier Mr. Moore expressed similar views concerning the neglect of this important ethical inquiry: "Hence the primary and peculiar business of Ethics, the determination what things have intrinsic value and in what degrees, has received no adequate treatment at all."[38] That question is the second of the three questions which he undertakes to consider;[39] it is "the greatest and most difficult part of the business of Ethics;"[40] it is the question with which 'a scientific Ethics' would be concerned.[41] Yet even in the longer book he has not space to contribute to the classification of good and bad things. Instead he undertakes, with respect to the first question, What is meant by good? to refute philosophers who fall victim to the 'naturalistic fallacy'; and with respect to the second two questions, What things are good in themselves? and What ought we to do? he succeeds only in restating the problem.[42]

Mr. Moore's treatment of ethics consists largely, then, in refuting theories in which the 'naturalistic fallacy' is committed. This fallacy always implies that when we think 'This is good', what we are thinking is that the thing in question bears a definite relation to some one other thing. Since Mr. Moore's classification of things includes two kinds, natural things and things which are but are not natural, the predicate 'good' might be

[37] *Ethics*, 248-249.
[38] *Principia Ethica*, 26.
[39] *Ibid.*, 37.
[40] *Ibid.*, 138.
[41] *Ibid.*, 139.
[42] *Ibid.*, 223: "And that these two questions, having precisely the nature which I have assigned to them, are *the* questions which it is the object of Ethics to answer, may be regarded as the main result of the preceding chapters." These results, although novel to moral philosophers, will not, Mr. Moore thinks, seem strange to Common Sense (*ibid.*, 224).

associated or identified either with natural objects (of which the existence is admittedly an object of experience) or with objects which are only inferred to exist in a supersensible world. The naturalistic fallacy is therefore exemplified in two kinds of theories: in 'naturalistic ethics' and in 'metaphysical ethics'.[43] Mr. Moore's treatment of naturalistic ethics differentiates two kinds which parallel (though Mr. Moore does not give this reason for the division) the difference between physical and mental facts, the first variety of naturalism seeking the good in natural properties of things, the second asserting that nothing is good but pleasure. Metaphysical ethics requires a more complex analysis, because metaphysics may have some bearing upon practical ethics, that is, upon the question, What ought we to do?, but it can have no possible bearing on the question, What is good? The supposition that Metaphysics is relevant to ethics in the latter sense is the result of the assumption, due to ambiguity of language, that 'good' must denote some 'real' property of things, which in turn is often due to one of two erroneous doctrines: the logical doctrine that all propositions assert a relation between existents, and the epistemological doctrine that to be good is equivalent to being willed or felt in some particular way.[44]

In epistemological questions, on the other hand, Mr. Moore is never optimistic about the outcome of discussion, for the errors of philosophers arise from confusions of words, not from false association or identification of things; and since the analysis bears on arguments and beliefs, the results it achieves do not affect the truth of the belief or the conception of things, even when it does clarify the meaning of the conception or supply reasons to support the belief. His view of the prospects of

[43] *Ibid.*, 38-39.
[44] Much the same analysis applies to the more popular treatment of the same problems in *Ethics*. The same three questions are asked, but they are put in simpler form by the shrewd device of raising them in reverse order: first, the question of right action or what ought to be done; second, the question of things intrinsically good; finally, the question of intrinsic value. The treatment is simplified since treatment of the first two problems is reduced to demonstrating that 'right' and 'good' do not depend on mental attitudes—states of feeling, or willing, or thinking something—about actions or things.

analysis is equally gloomy whether he purposes to proceed negatively to demolish a doctrine or positively to demonstrate an existence. On the one hand, his refutation of Idealism, even if successful, proves nothing about reality or the Universe in general.

For my own part I wish it to be clearly understood that I do not suppose that anything I shall say has the smallest tendency to prove that reality is not spiritual: I do not believe it possible to refute a single one of the many important propositions contained in the assertion that it is so. Reality may be spiritual, for all I know: and I devoutly hope it is. . . . It is, therefore, only with Idealistic *arguments* that I am concerned; and if any Idealist holds that *no* argument is necessary to prove that reality is spiritual, I shall certainly not have refuted him. . . . The subject of this paper is, therefore, quite uninteresting. Even if I prove my point, I shall have proved nothing about the Universe in general.[45]

On the other hand, his demonstration of the existence of material as well as psychical things depends on the significances he attaches to his terms, and he must recognize that other philosophers, perhaps quixotically, have given those terms meanings which would impede his demonstration. He can only express doubts concerning the utility of alternative meanings, while the sole utility he can promise for his own is the possibility of asserting, at least problematically, the existence of material things or other Selves.

I do not know whether there is or is not any utility in using the terms 'material thing' or 'physical object' in such a sense as this. But, whether there is or not, I cannot help thinking that there is ample justification for using them in another sense—a sense in which from the proposition that there are in the Universe such things as inkstands or fingers or clouds, it strictly follows that there are in it at least as many material things, and in which, therefore, we can *not* consistently maintain the existence of inkstands, fingers, and clouds, while denying that of material things.[46]

In ethics Mr. Moore is tempted to classify kinds of things, but instead he argues that 'good' is an indefinable and unanalyz-

[45] "The Refutation of Idealism," 2-4.
[46] "Some Judgments of Perception," *Philosophical Studies*, 222.

able predicate and refutes the Naturalistic fallacy. In episte-
mology Mr. Moore is convinced that true ideas, even when
they refer to mutable facts, are always true,[47] yet he devotes
his most strenuous efforts to demonstrating the existence of
temporal things and to refuting Idealism.[48]

Mr. Moore's treatment of epistemology consists largely in
refuting forms or consequences of idealism. Like his refutation
of naturalism, his refutation of idealism falls into two parts,
not however because of confusions concerning kinds of things,
but because of the discrepancies of the things of his universe,
which were mentioned earlier in this essay. Mr. Moore is
concerned, part of the time, to demonstrate the existence of
uncognized things or of things other than cognitions; the rest of
the time he demonstrates the existence of an object for every
cognition even when the cognition—or indeed even, in the
extreme case of sensation, when the sense-data—is not *of* an
existent object. To achieve the first end, he refutes philosophers
who, like Berkeley, seem to have held that *to be* is *to be con-
ceived*;[49] to achieve the second end he refutes philosophers who,
like Bradley, seem to have held that *to be conceived* is *to be*,[50]

[47] "William James' *Pragmatism*," 137: "It seems to me, then, that if we mean
by an idea, not mere words, but the kind of idea which words express, any idea,
which is true at one time when it occurs, *would* be true at any time when it were
to occur; and that this is so, even though it is an idea, which refers to facts which
are mutable."
[48] It is interesting to observe that, although the naturalistic fallacy is the source
of error in ethics, idealists (who assimilate physical facts to mental facts) are in-
volved in almost every argument in epistemology, while materialists (who fail to
distinguish mental facts at all) deserve only passing mention in illustration of the
dangers of idealism (cf. "The Refutation of Idealism," 20). The converse which
would bear the relation to naturalism in ethics which materialism bears to idealism
in epistemology is *subjectivism*, which is mentioned in passing in *Ethics* (225) as
one of the defenses which might be used against Mr. Moore's attack on utilitarian-
ism. The differentiation of the problems of ethics from those of epistemology in
Mr. Moore's philosophy parallels roughly the late scholastic differentiation of
essence from existence.
[49] "The Refutation of Idealism," 5: "The trivial proposition which I propose
to dispute is this: that *esse* is *percipi*. This is a very ambiguous proposition, but, in
some sense, it has been very widely held."
[50] "The Conception of Reality," 215-216: "In other words, 'temporal facts',
and 'unicorns' are both quite certainly 'deliverances of consciousness', at least in the
sense that they are 'objects of thought'; being 'objects of thought' they are, in a

as well as philosophers who, like Ramsey, seem to have passed directly from *names* to *things* without pausing to consider understanding.[51] In ethics philosophers tend to forget that there are things other than natural things, or else they misjudge the character and relevance of those things; in epistemology philosophers tend to think either that all things are mental (misled in this by language) or else that all things are material (to which must be added only the language in which truth about natural things is expressed).

As a consequence of the peculiarities of Mr. Moore's method of analysis, then, his essays and books are devoted, not—as one might have anticipated from his statements of belief—to disclosing what the world is and what classes of things it contains, nor to demonstrating truths about things, but to discussing the disquieting and often surprising statements he finds in Berkeley, Hume, Kant, Bentham, Mill, Bradley, James, Russell, and a dozen other philosophers, or else to defending (in opposition to those same philosophers) beliefs and truths about existence which all men share but the meanings or analyses of which are doubtful.[52] The center of Mr. Moore's world is not things, but

wide sense, 'appearances' also, and I cannot help thinking that Mr. Bradley supposes that, merely because they are so, they *must* at least *BE*. . . . I suppose it will be quite obvious to everyone here that it is a fallacy; that the fact that we can think of unicorns is not sufficient to prove that, in any sense at all, there *are* any unicorns."

[51] Cf. "Facts and Propositions," 202-203, esp. 203: "Even if Mr. Ramsey were right as to the last two points, there seems to me to be one very important relation between the mental and objective factors, which he has entirely omitted to mention. He speaks as if it were sufficient that his ideal individual should have belief feelings attached to words, which were in fact *names which meant* the objective factors. It would surely be necessary also, not merely that those names should *mean* those objective factors, but that he should *understand* the names."

[52] Cf. "The Nature and Reality of Objects of Perception," 31: "There are two beliefs in which almost all philosophers, and almost all ordinary people, are agreed." These two beliefs, for which Mr. Moore's analysis yields no conclusive reason, although he avows overwhelming conviction about their truth (*ibid.*, 90 and 96), concern the existence of material things and of other selves, besides myself. Mr. Moore returns to the consideration of the same beliefs twenty years later to use them as fundamental points in the statement of his own philosophic position or, as he calls it, 'the Common Sense view of the world'; he represents it on that occasion as a view held by *all* philosophers, and by implication (since philosophers are

beliefs: the beliefs of other philosophers are sometimes true in certain respects or senses, but analysis of them most usually yields only errors consequent on words and on the confusions of verbal propositions; Mr. Moore's beliefs are concerned largely with the existence of natural things and of the properties of natural things. That they exist is established for the most part by analysis of Mr. Moore's perceptions. The world about which Mr. Moore writes is a world of things; the world in which Mr. Moore writes is a world of propositions and perceptions. For Mr. Moore's beliefs about the first world I have nothing but admiration and the conviction that he is right, but I distrust his analysis of the second: I think (1) that he is mistaken in the method he uses to analyze the statements of other philosophers and, therefore, that he misinterprets them; I think (2) that he is mistaken in his conception of the relation which such analysis of philosophic propositions bears to philosophic inquiry concerning things; I think (3) that he is mistaken in his supposition, which is a consequence of his method of analysis, that no proposition can be analyzed adequately and that no important proposition can be analyzed at all.

Mr. Moore's method of analyzing the statements of other philosophers consists (to describe it briefly) in enumerating possible meanings which might be attached to each of the im-

peculiarly prone to deviation from strict adherence to Common Sense) by *all* men. Cf. "A Defence of Common Sense," 207: "But it must be remembered that, according to me, *all* philosophers, without exception, have agreed with me in holding this: and that the real difference, which is commonly expressed in this way, is only a difference between those philosophers, who have *also* held views inconsistent with these features in 'the Common Sense view of the world', and those who have not." Mr. Moore is indebted to the Scottish School for a traditional problem of British philosophy as well as for the doctrine of Common Sense. The discussions he has started are well described in the statement of the earlier phases of opposition. "In 1812, as the present writer observed to him [sc. Dr. Thomas Brown] that Reid and Hume differed more in words than in opinion, he answered, 'Yes, Reid bawled out, we must believe an outward world, but added in a whisper, we can give no reason for our belief: Hume cries out, we can give no reason for such a notion, but whispers, I own we cannot get rid of it." "Dissertation on the Progress of Ethical Philosophy Chiefly during the Seventeenth and Eighteenth Centuries" (*The Miscellaneous Works of the Right Honourable Sir James Mackintosh* [London, 1854], Vol. I, 240, note).

portant or ambiguous words in the statement and then testing those meanings against 'common usage'. If the former test discloses ambiguities or inconsistencies, the statement is insignificant; if the second test discloses unusual verbiage, the statement is apt to be unintelligible. Mr. Moore conducts this analysis with great thoroughness and sincerity, yet he succeeds in exhibiting thereby his own great ingenuity more fully than the meanings of other philosophers. He does not use in this application of his analysis the formidable weapon of his courageous and sophisticated naïveté: generations of philosophers have smiled at Dr. Johnson's simple-minded refutation of Berkeley by striking a solid object, and only Mr. Moore has had the courage solemnly to demonstrate the existence of an external world by waving his hands and saying, 'Here is one hand,' then adding, 'and here is another';[53] yet he has never used the equally simple device of asking a philosopher what he meant before saddling him with self-contradictions and absurdities. He might have conducted this inquiry as simply as waving his hands: in the numerous cases of contemporary philosophers with whose meanings Mr. Moore has struggled, by asking in the common meaning of the word 'ask;' or in the cases of dead philosophers, by asking in the more derived meaning of trying to reconstruct the dialectic of their own discussion rather than imposing on them the methods of Mr. Moore's analysis.

My criticism of Mr. Moore's analysis of other philosophers may be illustrated by the methods which might have been used in this essay in analysis of what a philosopher, namely Mr. Moore, meant by some of the things he has said. There are three sets of terms to which I have attached importance in my interpretation: the terms associated by Mr. Moore with 'things,' those associated with 'belief,' and those associated with 'proposition.' All three of these sets of terms are used very broadly by Mr. Moore, and I am sure that the numerous statements in which they appear could be found to be—or alleged to be—in contradiction. It did not seem to me worth while to try to catch Mr. Moore in inconsistencies, since he has already admitted

[53] "Proof of an External World," 295.

that some of the views expressed in some of the papers repub-
lished in *Philosophical Studies* are inconsistent with views ex-
pressed in others,[54] and I have quoted from early papers which
he chose not to republish, doubtless because they express views
with which he is even less in agreement. It is not impossible
for the structure of a man's thought and argument to remain
little altered in any important respect while his modes of ex-
pression undergo changes which involve them in verbal incon-
sistencies, and it is not improper, therefore, to direct analysis
to the discovery of that basic structure.

In like fashion, it did not seem to me to be worth while to try to
check Mr. Moore's use of the three type terms against common
usage. Notwithstanding my respect for Mr. Moore's agility and
confidence in determining the common meanings of words, I
have not been impressed by the conclusions to which he has been
led by the process, for he seems usually to give exclusive cred-
ence to one side of a case which could be argued as well on the
other side. I should find, then, that Mr. Moore conforms to
common usage in employing the word 'thing' to apply not only
to 'things' which are, but also to 'things' which we think and
'things' which we say; but he also departs from common usage
(which is not always self-consistent) since it limits 'thing' to
material existences in time and space as contrasted to ideas and
statements. Mr. Moore conforms to common usage when he
uses 'belief' to include what we know and perceive, as well as
what we adhere to without knowledge or certainty or experience
of it, since it is common usage to say that seeing is believing.
Yet as good a case could be made for the contrary usage, and
indeed it has been made by philosophers who are no less certain
than Mr. Moore in pronouncing on common usage.[55] I have,
finally, no difficulty in understanding Mr. Moore when he says

[54] *Philosophical Studies*, Preface, vii-viii.

[55] Cf. for example, Shadworth H. Hodgson, "On the Relation of Knowledge to
Belief," *Proceedings of the Aristotelian Society for the Systematic Study of Phi-
losophy*, Old Series, Vol. I (1891), 70: "This is the commonly accepted significa-
tion of the term *belief*,—persuasion of a supposed fact which is neither immediately
known nor strictly demonstrated. Belief is therefore a particular mode of knowl-
edge as a general term, and not knowledge a particular mode of belief as a general
term."

that the object of experience is a 'proposition' or that 'predicates' attach to things, but I must believe that common usage, as well as Aristotle and Bertrand Russell, would limit the application of 'proposition' to forms of verbal expression and their meanings, although it is also quite possible that common usage is on the side of Bradley and Bosanquet in equating 'proposition' with 'judgment'.

The use Mr. Moore makes of this method of analyzing the statements of other philosophers brings us to the second point of my criticism of his analysis. It is not essential, as I suggested earlier, that a philosopher do justice to what another philosopher intended in order to use the statement of that philosopher for purposes of philosophic inquiry. Mr. Moore does not purport to examine his predecessors and contemporaries to determine what they mean in any sense that might be the concern of a historian of philosophy. Yet even when the latitudes proper to philosophic analysis of philosophic statements are recognized, Mr. Moore's interpretation of philosophic statements does not seem to be justified by philosophic method. A philosopher may take his departure from the statement of another philosopher to the end of determining what could have been meant by the statement, and the dialectical examination of what philosophers —or other men—have said might in that attempt be made to constitute a complete philosophy; Plato used such a method of examining common and philosophic statements. Or a philosopher might assemble the statements of other philosophers as a means of surveying the field of knowledge to which they are relevant, and then the refutation of those statements according to the meanings which they would have in his philosophy (whether or not they had the same meanings in their original contexts) would be a preliminary to the establishment of his own doctrines on grounds independent of those statements; Aristotle used such a method of refuting his predecessors. Mr. Moore's method falls between the two uses. His entire philosophy, like the philosophy of Plato, is woven inextricably about what other men have said; but unlike Plato he limits the inquiry into meanings by simple, lowly, and literal criteria of common usage and common sense. Like Aristotle he examines

these statements to separate out elements of truth and falsity in terms literally conceived; but unlike Aristotle he does not proceed from the refutation of philosophers to the construction of a philosophy by reference to things. At best the criticism of Mr. Moore's conception of the relation of philosophic inquiry to the analysis of philosophic propositions must be sketchy and indeterminate,[56] but even such brief statement of what seems to me wrong with it serves to emphasize once more the two directions in which Mr. Moore's analysis might, but does not, proceed: he does not (unlike Plato) tell us much about the eternal truths whose existence he is emphatic in granting; he does not (unlike Aristotle) classify the kinds of things although he argues that examination of things constitutes one of the important tasks of philosophy.

These two preliminary criticisms reduce, as might have been suspected, to instances of the third. The defects of Mr. Moore's criticism of philosophic statements and of his use of such criticism for philosophic purposes are themselves consequences of his conception of philosophic analysis. It is doubtful if much that is interesting can be learned either about the world or about philosophers' statements concerning the world by submitting to meticulous examination atomic and more or less isolated beliefs about it. Mr. Moore has succeeded by his analysis in exposing the errors of an epistemological doctrine and a logical doctrine, and in demonstrating that neither the structure of knowledge nor the structure of predication determines the structure of things. As a consequence, his entire philosophy is devoted, once the separation of the three has been ensured, to a vain effort to find legitimate connections between things, thoughts, and statements. His exposition of his philosophic position, in "A Defence of Common Sense," states the dilemma of his philosophic inquiries perfectly, and the five points which he enumerates are chosen shrewdly, despite his disingenuous warning that he may not have mentioned the most important points, to embrace the

[56] For fuller development of the example of Plato's and Aristotle's use of their predecessors and contemporaries in philosophy, cf. my article "Plato and Aristotle as Historians: a Study of Method in the History of Ideas," *Ethics*, Vol. LI (1940), 66-101.

scope of his problems. First, he enumerates the truisms—the beliefs of common sense—which he knows certainly to be true about material facts and mental facts, and reduces them all to a single truism which involves other human beings associated with him in these beliefs. Second, he argues that there is no good reason to suppose either that every physical fact is logically dependent upon some mental fact or that every physical fact is causally dependent upon some mental fact. Third, he asserts (and this negative doctrine is the one remnant of his non-natural things in this statement of his philosophy) that there is no good reason to suppose that all material things were created by God, or that there is a God at all, or that we shall continue to exist and be conscious after the death of our bodies. Fourth, he acknowledges his skepticism concerning the correct analysis of the propositions concerning material things which he holds to be certainly true. Fifth, he acknowledges a like skepticism concerning the true propositions about the existence of other Selves. The crux of the difficulty is in the connections of material and mental things: if Mr. Moore is wrong about them, his beliefs and his skepticisms fall to the level of personal confessions without philosophic interest or importance. The difficulty reduces to this: if Mr. Moore is correct in his contention that the structure of knowledge does not parallel or duplicate the structure of things (and I think that he is), then at least some of the important problems of philosophy should be sought in the structure of each, not in possible momentary influences of one on another. I should be interested to learn about the causal connections of the material things of Mr. Moore's real world, or about the epistemological connections of the mental things, or even about the logical connections of the propositions. If those connections were traced (and it seems to me that the inquiry is both meaningful and possible), the relations of understanding to propositions and to things would not constitute the formidable problem which Mr. Moore has made of it. Instead of tracing these relations Mr. Moore has, in effect, reduced logical necessity to a duplication—or a kind of inversely oriented parallel—of causal necessity, on the supposition that many philosophers think every physical fact to depend logically or

causally on some mental fact. For my part I am satisfied that the world exists and that natural physical things never depend, except incidentally, as artifice influences nature, on mental things. It is not a sign of ingratitude to Mr. Moore that, in the welter of philosophic disagreements which he has so often described, I should acknowledge the truth of beliefs which I share with him and the ingenuity of his analyses in support of them or in refutation of bizarre doctrines which merit refuting if philosophers have held them, and yet object to the ineffectiveness of his analysis so long as there is hope that important propositions can be established or that the statements of other men can be interpreted without distortion.

RICHARD McKEON

DEPARTMENT OF PHILOSOPHY
THE UNIVERSITY OF CHICAGO

18

V. J. McGill

SOME QUERIES CONCERNING
MOORE'S METHOD

SOME QUERIES CONCERNING
MOORE'S METHOD

IT is a happy circumstance that today in the company of most distinguished philosophers, we are able to point to at least one who *knows*, as other men do, that the earth has existed for many years past and is inhabited by other human beings, and because he knows these things refuses to accept theories which contradict them. Yet it is a matter of regret to some of us, who admire the clarity and rigor of Moore's philosophy, that it never gets beyond a narrow set of abstract problems and leaves the more urgent philosophical problems untouched. With a view to understanding this restriction of scope, at variance with the great tradition of European philosophy beginning with Plato, I wish to ask a number of questions concerning Moore's method.

The method Moore frequently, or even typically, employs to reach his conclusions is that of refuting an opponent by exhibiting a contradiction in what he says. He first cites a few statements of a certain philosopher which in his opinion seem, more adequately than others, to express a thesis which this philosopher wants to maintain, and then proceeds to show that these statements alone, or perhaps in conjunction with a few common sense premises, considered apart from their scientific and "social context," imply a contradiction. There is, of course, nothing objectionable about this procedure except that (1.) it may be only the words, badly chosen, which lead to the contradiction, in which case the thesis may survive historically, expressed in different language, and (2.) many theses which it is very important to refute may be so vague that self-contradictions cannot be found in them, whereas others are obviously false even after contradictions have been removed. Thus the view sometimes held in

Nazi Germany that "Aryan" science is bound to be different from "non-Aryan" science, is usually expressed so vaguely that self-contradictions could not be found; but even if it were expressed clearly, self-contradictions might not appear, or might be removed.

Everyone, however, would admit that in philosophy the method of refuting an opponent by exhibiting a contradiction in what he says, is sometimes an effective way of establishing conclusions, and also that sometimes it is not, that in some cases other methods are called for. The only reason for insisting upon a point so obvious is that a method once adopted and perfected may come to determine the selection of problems dealt with, so that problems which everyone would agree are exceedingly important are ignored simply because they cannot be handled by this perfected method or technique. There seems to be no question that this does often happen at least in some fields of inquiry. The feasibility of applying statistical methods and certain experimental techniques, for instance, has to a considerable degree determined the range of subjects considered suitable for psychological research in this country, and some psychologists are aware of the danger involved.[1] Is it not prima facie reasonable to say that what should determine the selection of problems to be treated, is not the available equipment, the most elegant techniques or the most conclusive methods, but the relative "importance"[2] of the problems?

Moore of course does not always, or even typically, refute an opponent by showing contradictions implied by his assertions only, without recourse to other premises; but very often his refutations make use of common sense premises. That is, a

[1] Thus Gardner Murphy says: "Undoubtedly a large part of our trouble has been an over-rapid development of research techniques which can be applied to the surface aspects of almost any social response and are reasonably sure to give a publishable numerical answer to almost any casual question. . . . Woe to that science whose methods are developed in advance of its problems, so that the experimenter can see only those phases of a problem for which a method is already at hand." Quoted from R. S. Lynd: *Knowledge for What?*, 18.

[2] A proposal for defining "importance" as applied to philosophical questions will be offered later. In the meantime, I will try to use the term in a natural sense, or as common sense would use it.

philosopher is refuted not only on the basis of what he says, but on the basis of what he says in conjunction with what common sense says. Only very rarely does Moore use a proposition of science to refute an opponent. This suggests a further question about his method.

Is it not a peculiarity of the most important problems, including philosophical problems, that they are concerned with the realization of better conditions of life for nations or vast numbers of people? It would be natural to say, I think, that the problems of planning the practical steps necessary to reach complete democracy or adequate housing conditions are extremely important, much more important than the problem of defining the terms "complete democracy" and "adequate housing" in a thoroughly satisfactory way. And I think that Moore himself would say that planning can proceed, learning as it goes, without perfect definitions.[3] But it is characteristic of such problems of practical planning, as opposed to problems of defining, that clearly no headway can be made in solving them without constant utilization of science, physical and social. For this reason and others it is difficult to see that Moore's problems, which he frequently describes as important or as "frightfully important," are important in this sense, although it may well be that they are important in some other sense.

The essay "William James' 'Pragmatism'" illustrates Moore's polemical method. He begins with a close scrutiny of certain of James' statements characterizing or defining pragmatism and concludes that they contradict either one another or certain common sense views. There is no doubt that he demonstrates ostensible contradictions in James' thought, and between James' thought and common sense certainties, and that he takes great pains to understand the precise contours of James' thought and to make allowance for inadvertencies of expression. Moore's refutations of James' contentions (1.) that all our true ideas are useful and (2.) that all ideas, which are useful, are true, seem altogether faultless. None the less, certain doubts arise con-

[3] See "A Defence of Common Sense," *Contemporary British Philosophy*, Second Series (New York, 1925), 193. Here it is implied that we can know certain propositions to be true without knowing their proper analysis.

cerning this refutation and his treatment of the pragmatist's position in general. Moore seems to believe that, since he has demonstrated a number of exceptions to the universal claims of pragmatism, he has refuted pragmatism. Yet the fact that pragmatism, undaunted, continues to dominate the philosophical scene, taking on ever more sophisticated forms, seems to suggest that Moore's disproof is decisive only against certain of James' formulations.

It is easy for Moore to show that there are exceptions to the universal proposition that all our true ideas are useful, and conversely; but Moore himself is not at all sure that James could have intended anything so absurd. He suggests that what James might have meant is only that some, or most of our true ideas, are useful, and conversely; but he also doubts that James would have gone to so much trouble to insist upon such an obvious commonplace. It is plain that Moore doubts not only that James could have meant to assert that all our true ideas are useful, and conversely, but also that he could have meant that only some or most are. This being the case, he might have decided that "all," "some" and "most," were perhaps not the words that James was emphasizing and that another approach might be more successful in bringing out his meaning, or rather his most "important" meaning.

After all, it is certainly possible to maintain, and sometimes to prove, that there are important connections between two concepts or classes, such as truth and utility, even though they do not coincide. If A and B are proved not to coincide, there are a number of alternatives besides: Some A is B (i.e., at least one A is B), and Most A is B. Another possibility could be expressed, for example, by a coefficient of correlation, and still another could be expressed by "A and B are such that if one pursues instances of a certain sub-class of B, one will obtain more instances of a certain sub-class of A than if one pursues anything else."

Moore does go on to consider very carefully other things that James might have meant. Did James mean that *every* true idea is useful whenever it occurs, or only on one of its occurrences, he asks, and he argues that the first would be plainly false and the second unprovable. Everywhere he is successful in showing

that if James meant what he literally seems to mean, he is saying either truisms, obvious dubieties or absurdities. But nowhere does he manage to explain how a thinker of James' caliber could be guilty of such things. It seems worth inquiring, therefore, whether there is not some other meaning in James' contentions, which has escaped Moore's attention. Certainly there are many passages in James which bear out another interpretation, and Moore himself quotes one of them.

"Must I," James says,

constantly be repeating the truth that 'twice two are four' because of its eternal claim on recognition? or is it sometimes irrelevant? Must my thoughts dwell night and day on my personal sins and blemishes, because I truly have them?—or may I sink and ignore them in order to be a decent social unit, and not a mass of morbid melancholy and apology?[4]

James goes on to say that "our obligation to acknowledge truth, so far from being unconditional is tremendously conditional" and that concrete truths "need be recognized only when they are expedient." Moore regards this as "indisputably true," and he employs it as evidence against James' view that every true idea is useful, or is always useful. But the passage is significant in quite another way. As in many other passages, James seems to be interested in bringing about a change in peoples' habits of thought and even in their conduct. Perhaps he is here attacking remorse as a duty and setting himself against the New England tradition of Puritanism. Again and again we see him fighting for faiths and ideals, for individual freedom, tolerance, democracy and a fuller realization of human potentialities as he understands them. We know that, originally a physician, James never lost interest in disease and its cure. The bedside manner is often apparent, whether he is discussing psychology, pedagogy, religion or metaphysical absolutes. It is noteworthy too that James lived at a time when the American frontier and free institutions seemed to open up boundless opportunities for individual development, if only certain prejudices, absolutes, and intolerances which stifle potentialities, could be removed. Another fact, quite important perhaps, is that James delivered

[4] "William James 'Pragmatism'," *Philosophical Studies* (London, 1922), 108.

the lectures on Pragmatism to popular audiences, not especially sensitive to fine distinctions or exact definitions, but intent upon any message with a bearing on their practical lives. These considerations, when summed up, seem to have some relevance to the question what James meant to say about truth and utility, and to illustrate in a sketchy way what we mean by "taking into consideration the social context" in which statements are made. It does seem that, if the social context of James' statements is not taken into account, we are apt to forget that his philosophy was, as many have recognized, a credo, a fighting faith, full of exhortation, good will and meliorism. We are apt to miss his real meaning and to be left without any explanation of the repercussions which followed in his wake.

It is difficult to escape the conviction that, if Moore had taken into account the social context of James' contentions, he might have reached quite different conclusions. In interpreting James' view as to the relation of truth and verifiability, for example, he might have recognized that the two views he attributes to James —namely, that (3.) we can verify all those of our ideas which are true, which Moore says is untenable and that (4.) all those of our ideas, which we can verify, are true: which is a truism— are not the only possibilities. Part of what James meant might have been that, so far as truths are concerned, it would be better if people paid heed, as science does, only to those which are verifiable; and that it would be better if they ceased to be perplexed, bedeviled and imposed upon by unverifiable "Truth," whether of pedagogy, religion or philosophy, which hamper the freedom of the individual and the fulfillment of his rich potentialities. At times indeed James seems to say not only that it would be better if people did, but also that they do, in large measure, behave in this manner; that the ideal is not utopian but is increasingly being realized, especially in the wide world as contrasted with academies of learning and philosophical schools.

Whether, however, this is the principal thing that James wished to say about the relation between verifiability and truth, one thing is clear: it is no commonplace, but is, on the contrary, quite "important," both in itself and in its historical influence.

Much the same comment could be made about other of

Moore's interpretations of James' meaning. It is quite possible that, when James seems to say that (1.) all of our true ideas are useful and that (2.) all of our ideas, which are useful, are true, what he means is something quite different. Certainly (1.) and (2.) are so glaringly improbable at sight that even Moore is doubtful whether they could have been intended, and caution seems to warn us to seek another interpretation. Possibly another interpretation will appear if we keep in mind that James, like Plato and the great idealist tradition, was not only interested in analysis and classification,[5] but also in bringing about changes in human life and in the world. Part of what James meant to say about utility and truth may have been that, if we pursue utility intelligently, using verification in our actual concrete experiences as the test, we shall come into possession of more "important" truths than by any other means; and also, that the quest of unimportant and unverifiable truths is futile and should be discontinued on pain of boredom and wasted lives. Here again is a contention which is not in the least a commonplace, nor is it really a tautology; for many people fail to reach important truths by not pursuing utility, just as many people waste their lives on unimportant truths, and it is certainly not tautologous to urge a reform.

But if James had used *this* kind of language to explain to his popular audiences the relation between truth, utility and verifiability, they would all have gone to sleep. Realizing that for his audiences "truth" was an honorific term, used on all sorts of occasions to curb impulse, invention and improvisation, James employed a paradox to shock and illuminate, as is the custom with skilful public speakers. It seems necessary, therefore, to consider the use of paradox and also what might be called "ideal definitions." Unfortunately, however, this will again involve the social context of James' statements and could take us far afield into rhetoric, history and James' biography. But, even though what Moore would regard as vague statements were unavoidable, there would be no help for it, if one were to be sure what James meant. James employs paradox very frequently

[5] As is known, James sometimes even speaks with disrespect of the apparatus of formal logic.

and effectively, and so do other philosophers, though not so often nor as brilliantly. I believe that, when in esthetics people identify beauty with utility (or with that which functions most efficiently), they are speaking paradoxically; for they must realize that there are exceptions. Their real aim is to incite people to renounce atrocious ornament, anachronistic design and non-functional devices of all kinds, so that function can stand alone all beautified by omissions. The rhetorical means they use are perhaps effective; for declarative language often has great imperative force. This was perhaps realized by John B. Watson, who clearly seemed to imply that consciousness or mind simply does not exist; whereas, as he once admitted, all he really meant was that mind, being an epiphenomenon, can be safely disregarded, that psychologists should confine themselves to a study of behavior, in which are to be found all the causal factors they seek.

"Ideal definitions" may also be relevant to an understanding of the pragmatic "definition" of truth. Examples of ideal definitions are furnished by "Man is a rational animal," or "Man is a tool-using animal" or "Man is a social animal." It is likely that Moore would reject these definitions, and similar ones, because there are, or could be, men who are not rational, do not use tools or behave socially. Yet it would have to be admitted that definitions of this kind are sometimes more useful than those in which *definiendum* and *definiens* coincide perfectly. It is therefore doubtful whether we are always justified in rejecting definitions merely because this coincidence fails. It is also doubtful, for that matter, whether we are always justified in rejecting statements expressed in the form All A is B just because we have established that Some A is not B. James, however, does not usually say All A is B but only A is B. It is Moore who adds the *all*.

It is quite possible, of course, that an author when he says A is B may, in a confused way, intend "All A is B" in a literal sense, but he may *also* intend it in a figurative, "ideal," paradoxical or Pickwickian sense. He may mean "the wages of sin is death" in a literal sense, in which case he is almost certainly wrong; or he may mean it in some other sense, perhaps in an

admonitory sense, in which case it might well be true. But anyone would admit, I think, that, whatever the precise figurative meaning of this expression may be, it is at any rate a far more "important" meaning than its literal meaning because no one would believe the statement in its literal sense. The same appears to be true with regard to James' statements about the relation of truth to utility and verifiability. James may have meant what Moore reluctantly, and with some doubts and misgivings, thinks he does; but he also may have meant what I suspect he did; and of course he may have meant both. In any case, the non-literal interpretation is the much more "important" one; so that, if James did mean both, this non-literal interpretation is the one which should be stressed, if only because it best accords with the intellectual stature and historical importance of the man.

Similar criticisms could be applied to Moore's treatment of James' further contention that "our truths are man-made." Here again he insists that at least not *all* of our truths are man-made, and again he demonstrates serious confusions of James' thought and expression. He shows that James sometimes confuses "making our beliefs come into existence," with "making our beliefs come true," and indeed the analysis is very sharp. Yet I cannot help thinking that part of James' meaning, the most "important" part, has entirely escaped him. And one reason for thinking this is that, according to Moore's interpretation, James' contention that "our truths are man-made" shows itself to be either an "accepted commonplace" or an obvious mistake; and I cannot believe that James would have come to speak, or the world to listen, if this was all that he meant. Moore asks:

Does he [James] mean *merely* the accepted commonplace that we make our true beliefs, in the sense that almost all of them depend for their existence on what has been previously in some human mind? Or does he mean also that we *make them true*—that their truth also depends on what has been previously in some human mind?[6]

Moore doubts that James meant merely the accepted commonplace, but thinks it likely that he did mean that *we make*

[6] "William James' 'Pragmatism'," *op. cit.*, 142.

our ideas true in the sense suggested by the second question, and he believes that on any plausible construction this turns out to be false. Yet he admits that we make *some* of our ideas true. His objection is again merely that we do not make them *all* true, and he reluctantly believes that James meant *all*. But, after what has been said, is it not a little arbitrary to suppose that James need have meant that *all* our ideas are man-made in this sense? It is difficult to think, as Moore does, that James believed that "I have a hand in actually making the sun rise, the wind blow, and the rain fall, whenever I cause my beliefs in these things," or that he believed any general proposition which immediately and obviously implies such absurdities. It seems to me pretty clear that James could have meant, and probably did in part mean, something far more plausible than this. He could have meant (a) that there is a class of very "important" propositions, such that their truth depends upon how people conduct themselves in society, (b) that in past periods this class of propositions had far fewer members than it has now, and (c) that if people will only, as they should, commit their ideas to test by verification and pursue useful ends unconscionably, the class could have far more members in the future. Although the sun and wind and rain do not come and go depending upon the mere existence of beliefs, as James must have known, people can so organize society, that sun and wind and rain become the servants, not the masters, of men, and I cannot help but think that this is part of what James had in mind.

Whether the meaning I have suggested is the only one, or the chief one, that James had in mind, I think that, at all events, it is the most "important" one. Indeed, it seems obvious to me that the distinction between melioristic philosophies, i.e., those which are really devoted to transforming the world into a better place, and non-melioristic philosophies, is about the most "important" distinction which could be drawn between philosophies. But apparently Moore does not think so; and it is a matter of some embarrassment for a veteran admirer of Moore, to find that whenever the discussion turns to something that seems to him obviously "important," Moore shows no enthusiasm and is inclined in fact to see in it only a commonplace. What

Moore says about truth in relation to the possibility of trans-forming the world into a better place is an example in point. "Men," he says,

certainly have the power to alter the world to a certain extent; and, so far as they do this, they certainly 'make true' any beliefs, which are beliefs in the occurrence of these alterations. But I can see no reason for supposing that they 'make true' *nearly* all those of their beliefs which are true.[6a]

Moore's interest here seems to be restricted to the question of "all," "nearly all," or "some." Because "all" is false, he sees nothing which could be true except "nearly all" or "some," i.e., at least one. But there is another possibility, namely: If certain possible changes are enacted, many more truths can be made true by human initiative and efficiency in the future than were made true in the past.

Criticisms of this kind are applicable to Moore's critique of James at several points, and to other of his writings. In dis-cussing James' view that truth is mutable, for example, Moore comes to the conclusion that James could not have meant merely that *some facts* are mutable and that words sometimes change their meaning; and that therefore he could only have meant something obviously untenable, namely: that an idea, true to-day, such as Julius Caesar was murdered in the Senate House, may in the future become false. But here again it seems possible that James might have been thinking of something quite differ-ent. He had little interest in the kind of subtle distinctions in which Moore excels, and it would have been natural for him to have followed common sense in sometimes using fact and propo-sitions interchangeably. What James may have wished to emphasize is that there is an exceedingly "important" class of facts (or propositions) with regard to which people falsely be-lieve that they eternally exist (or are eternally true), and that it would be a good thing for the world if this belief were changed. James has given examples of such propositions, and many other illustrations come to mind. For example, people often say that "human nature" is eternal in a sense which pre-

6a *Ibid.*, 143.

vents any great progress in the future. They sometimes claim that labor is essentially a commodity and speak of economic laws as if they were eternal, instead of generalizations (or idealizations) of occurrences under the present system of production. Surely this common habit of assuming that what is, must be, will be and was, rooted as it is in psychological resistances built up by early training and enforced by the entrenched interests of powerful groups in society, is a serious threat to reform. If James meant this only in part, I think we might forgive him his confusion of fact and proposition and the other mistakes that Moore's deft analysis detected.

Up to this point we have not attempted to prove that Moore was indubitably wrong in interpreting James as he did, but only to show that his *method* of investigation overlooks other possible interpretations, sometimes the most "important" ones. We have seen, for one thing, that Moore fails to take seriously the powerful activist impulse in James' philosophy, the ever recurring urge to change the conditions of life. Nor have we attempted to establish with certainty the whole, or even part, of what James meant. To do so much exegesis and long quotations from James' works would be necessary, and many biographical and historical facts would have to be examined, some of which were not available when Moore wrote his essay. Had this been our intention, we might have considered, for example, the circumstance that James begins his *Pragmatism* book with a vigorous polemic against the complacent doctrine that evil, however terrible and heart breaking, always contributes to the good. And, what is rare and fabulous in philosophical discussions, he starts his polemic with a common tragedy. It is the case of John Corcoran, an unemployed clerk, whose family has been evicted and is without food. In final discouragement, he commits suicide. Here in the first chapter is a touchstone to James' meaning. He wanted to emphasize what he considered practically important. He wished to bring about a change in people's practical attitudes and thereby, indirectly, to change the world. His pages are full of admonitions and directives to reform and, often, even his distinctly epistemological theories can only be so interpreted. Some of his best friends broke with him over his pragmatic and plural-

istic conception of philosophy. Thus Shadworth Hodgson wrote that it is the specific differentia of philosophy to lead us to "the discovery of what is universal, essential, necessary, in all experience such as human beings can be possessed of. Consequently (in my opinion) philosophy does *not* consist in the discovery of an individual's 'best working attitude'."[7] Critics less friendly to James, understanding the terms "cash-value" and "pay" literally, went so far as to describe pragmatism as the philosophy of business America (DeRuggiero, for example). So great, indeed, was the outcry against the reduction of philosophy to a handbook for financiers, engineers, doctors, and other men of action that James went out of his way to correct these misinterpretations. His explanation, however, does not deny the activist aspect of pragmatism, and what he says amounts, in the main, to this: true ideas are ideas that pay not only, nor primarily, in the physical world, but also, and primarily, in the realm of mind.[8]

If bent on establishing the principal meaning of James' theories, we should also have to consider how he answers the criticism that there are exceptions to the universal claims of pragmatism. He explains that Dewey's and Schiller's thought, and presumably his own,

is eminently an induction working itself free from all sorts of entangling particulars. If true, it involves much restatement of traditional notions. This is a kind of intellectual product that never attains a classic form of expression when first promulgated. The critic ought therefore not to be too sharp and logic chopping in his dealings with it, but should weigh it as a whole, and especially weigh it against its possible alternatives. One should also try to apply it first to one instance, and then to another to see how it will work. It seems to me that it is emphatically not a case for instant execution, by conviction of intrinsic absurdity or of self-contradiction, or by caricature of what it would look like if reduced to skeleton shape.[9]

One can disagree with pragmatism fundamentally and still recognize some truth in this rebuttal. It seems likely that James'

[7] *The Thought and Character of William James*, by R. B. Perry (Boston, 1935), vol. I, 651.
[8] *The Meaning of Truth* (London, 1909), 184-6.
[9] *Ibid.*, 54.

contention with regard to the relation between truth and utility *is*, in part, an inductive generalization. As such it is not disproved by exceptions, and need not be abandoned. The exceptions, of course, may be important, but perhaps only as incitements to further investigation, from which pragmatism might emerge, more complex and more adequate.

But it seems to me that philosophers do frequently assume that inductive generalizations can always be disproved by exceptions, and I think this is often seen in ethical discussions. Take the following example. It is clear that health is good, whether or not *every one* appreciates, desires, and acknowledges it. And it follows from this, and from facts available in exhaustive U. S. Government Medical Reports, that the Government is right in taking steps to improve income, housing, and diet, even though this program, at any given time, is opposed by powerful interests which do not think that it is necessary or wise. But there are philosophers who fail to see this, who argue that values are relative to the individual or group. If consistent, they would cite the fact that most, but not all, men desire health. An ethical relativist might argue that many men give up their health and homes for other ends and that therefore health, good housing, and diet, are not always good for such men, or not good in themselves (as if anything ever is "in itself"!). It is always possible to find exceptions in this universe of discourse. The Allied armies do not value the health of fascists, nor vice versa. Again, notable authority disagrees: Werner Sombart scoffs at the ideals of comfort, happiness, security; they are unworthy of Germans. But actually these exceptions simply turn into practical social problems. Many techniques can be used by society in dealing with ignorance and enthusiasm.

Some philosophers then find all values disputable and relative. But our example of "health" does not seem to me to be either disputable or relative. One does not argue with the doctor as to what sickness and health is; one only asks to be cured. The exceptions to this generalization do not disprove it. They simply present practical problems which doctors, nurses, and teachers are trained to deal with, just as they are trained to deal with

malingering and pernicious habits. On the other hand, of course, it is extremely difficult to explain *exactly* what one means by "health" or "adequate housing" and "proper diet," or to give a satisfactory analysis, and we have much to learn about all three; but it does not follow that there is any doubt about their being good, nor does it follow that they are good only relative to the individual (in the early Westermarck's sense, for example) or to groups or classes of society (in the sense, for example, that "A is good" means "A is desired by some group or class"). But, if I am not mistaken, Moore, although deploring the looseness of my language, would not disagree at this point. For in one of the most important passages in his whole philosophy, and in contemporary philosophy in general, Moore maintains that he is dead certain as to the truth of such propositions as "The earth has existed for many years past" and yet says that "I am very skeptical as to what, in certain respects, the correct *analysis* of such propositions is."[10] The reason why I think this is important is simply that practical action requires certain basic certainties without being able to wait for final analysis. Thus there would be no theoretic justification for practical action, if Moore were not right on this point. But this is not the only reason I think Moore's principle is important. Another reason is that there are many philosophers and practical men who by implication or direct statement, through inadvertence or social conditioning of one sort or another, deny it, with the result that practical action is often frustrated when it is long overdue. They say in effect: How can you act in this case, since you do not know *all* the facts and do not have a completely satisfactory analysis of the situation, whereas it is obvious that the maximum needed for an action are facts and analysis pertinent to this action?

Moore's cognate doctrine that it is possible to know with regard to a whole set of obvious propositions about the existence of material bodies and of past events, that they are all compatible with one another, simply because one knows that they are all true, is also, in my opinion, exceedingly "important." For surely

[10] *Contemporary British Philosophy*, vol. II (edited by J. H. Muirhead, London, 1925), 216.

practical action depends upon basic certainties[11] and cannot wait upon the completion of axiom sets and consistency proofs. And I cannot help thinking that, if Moore had had these principles in mind in his critique of James' theories, his objections would have been altogether different.

Our objection to James' pragmatism, in contrast to Moore's, is the old one that it simply doesn't work. Moore is quite right in objecting that James does not indicate, even vaguely, what ideas he supposes to be mutable, and which not. And it might be added that if, on James' view, truth does not always coincide with verifiability and utility, then James fails completely to indicate, even vaguely, what kind of truths are verifiable and useful or can be made so, and what kind of useful ideas are true or can be made so. This is certainly an embarrassing circumstance for the pragmatist, who wishes to stress practicality; for now it appears that his philosophy offers us no practical guide to thought or action. The root of the difficulty is that James understood the suffering of the individual but not the maladjustments of society from which it results, that he understood in part the etiology of individual disease but not the main trend of social causation. Perry remarks that

the root of James' politics is to be found not in his ethics and philosophy, but in the fact that he belonged to the educated class, and accepted on that account a peculiar rôle and a peculiar responsibility. He was a mugwump, and anti-imperialist, a civil-service reformer, a pacifist, a Dreyfusite, an internationalist and a liberal.[12]

Here is a liberal, but with no great confidence in organized methods of reform, such as trade unionism. The focus of his interest and his aspiration for significant living remained the individual, where "individual," in practice, meant any person who happened to come to his attention. Even in the nineteenth century, or early twentieth century, it is doubtful whether such a credo could furnish the best guide to life possible at the time, with the conditions and our knowledge being what they were. Today, at any rate, such a position is manifestly impossible. But

[11] The certainties, of course, may be certainties as to probabilities.
[12] Op. cit., 290.

James' philosophy, quite apart from his politics, fails to give us the kind of guidance that philosophy can give. There are some kinds of ideas that we can make true, although there may be others which lie beyond our influence. James does not utilize the knowledge of his time to discriminate between these. He admits that some phases of reality may be independent of human control, but fails to say, even vaguely, which they might be.

That reality is independent, [he says], means that there is something in every experience that escapes our arbitrary control. If it be a sensible experience it coerces our attention; . . . There is a push, an urgency, within our very experience, against which we are on the whole power-less, and which drives us in a direction that is the destiny of our belief. That this drift of experience itself is in the last resort due to something independent of all possible experience may or may not be true. There may or may not be an extra-experimental 'Ding an sich' that keeps the ball rolling, or an 'absolute' that lies eternally behind all successive deter-minations which human thought has made.[13]

What James feels sure of is only that *within our experience* some determinations are independent of others, and within our experience "some beings, if we ever suppose them, must be sup-posed to have existed previously to the supposing."[14] But if James is not even certain that there is an objective world, and does not distinguish in this passage, or any others, even vaguely, the laws and facts beyond our direct control from those which we can alter to our purpose, it does not seem that he has told us even as clearly as certain other philosophers have, which of our ideas we can make true, and which not,— and it does not seem that his philosophy can be called a practical success.[15] To improve the world one must know what can be changed and how. Actually James knows far more than he admits. He knows that there was a process of evolution prior to any consciousness,

[13] *The Meaning of Truth*, 69.

[14] *Ibid.*

[15] Robert Owen is a good example of a thinker who distinguished, far more clearly than James did, between ideas which we can make true and ideas we can't. Possessing advanced technological knowledge and an understanding of what could be done with human nature, he was able to make great humanitarian ideas come true.

and therefore he knows, of course, that there must have been something extra-experiential which kept the ball rolling. The robust common sense he invokes against his academic opponents would scoff at the idea that Archaean rocks, existing previously to the appearance of consciousness, are only intractable elements within experience. While James' skepticism, like that of Sanine or Bazarov, is an interesting historical phenomenon, it does not appear to be "important" in any other sense. The same could be said for his credulity which succumbed, without rational solicitation, to "refined" supernaturalism.

The persistence today of rationally unnecessary idealism and skepticism prompts a renewed appreciation of Moore's consistent realism and of his indefatigable efforts to define the position accurately. His most recent interpretation[16] of what we mean by "I see a box," namely: "I see x, and x is a considerable part of the surface of a box," seems far more satisfactory than earlier interpretations, according to which either the x or the box seemed to be replaced by sense-data, by things, that is, which only philosophers ever see (although, of course, we all see by means of sense-data, or with their help). In his essay "A Defence of Common Sense" Moore states, with remarkable clarity, a principle which is crucial to realism. He knows with certainty, he says, many such things as "The earth has existed for many years past," and he believes that other philosophers also hold these propositions to be certain. What distinguishes the position of some philosophers from his in this connection is simply that they not only maintain these propositions but also other propositions which are inconsistent with them. This view, however, and Moore's realism in general, is open to criticism. In the first place, why must the propositions of whose truth he is certain be limited to common sense propositions? He is certain that "The earth has existed for many years past," that "My body was born at a certain time in the past," and that "Ever since it was born it has been either in contact with or not far from the surface of the earth." Perhaps he is right in being more certain of such propositions than of any other kind; yet there must be many scientific things which he knows with almost as

[16] Lectures given at Columbia University, Spring 1942.

much certainty, and it is regrettable that he does not say so. It is unfortunate too, that Moore does not indicate the grounds of his knowledge. He asks himself the question: But do I really know all these things, such as "The earth has existed for many years past," to be true? "Isn't it possible that I merely believe them? or know them to be highly probable?" He replies: "In answer to this question, I think I have nothing better to say than that it seems to me that I do know them, with certainty."[17] And Moore apparently feels that, if it were a question of the existence of other people, the answer would be the same. He would answer that he thinks he has nothing better to say than that it seems to him that he *does* know with certainty that they exist.

But what, I think it is proper to inquire, are the grounds of this knowledge, or *are* there no grounds in Moore's belief? Perhaps the question could be answered by considering two kinds of experience that Moore may have had. He may on some occasion have judged that "I know with certainty that there is an inkwell on my table," but may subsequently have discovered that it was not true, and that accordingly he had not known this "fact" with certainty. Possibly there were many experiences of this kind. But there is another kind of experience he certainly did have. He has judged that "I know with certainty that the earth has existed for many years past," and he has never had the slightest reason to doubt it. Moreover, he has year in and year out, on a vast number of occasions, judged things which implied that "the earth has existed for many years past," and, although the things he judged may have turned out to be false on some occasions, there was never any reason to suspect that "the earth has existed for many years past" was false.

Whether Moore ever had experiences of the first sort I do not know. Perhaps with regard to the matter of the inkwell, he would never have said "I know with certainty" but "I am certain that," or something else of the kind. But, if he does reserve the expression "I know with certainty" to cases in which he judges such things as "The earth has existed for many years past," is there any other explanation of this fact than that for many years, on countless occasions, he has implied such things,

[17] *Contemporary British Philosophy*, vol. II, 206.

without ever having had any reason to suspect that they are false;
whereas, when he has on and off judged such things as that
he is certain that his inkwell is on his table, he has sometimes
found that the inkwell was not, as a matter of fact, there? In
other words, are not the grounds of his knowledge, in those
cases in which he knows with certainty, to be found in the vast
array of confirmations, or in the total lack of disconfirmations?

It is interesting to note, in any case, that contemporary Soviet
philosophers would also say that they know with certainty that
"the earth has existed for many years past" and, in fact, all the
other things which Moore states that he knows with certainty;
and I do not believe that they maintain, as do so many other
philosophers, any theories which are inconsistent with the ex-
pression of such certainties. In fact, these statements of Moore
are part of what these Russian philosophers mean by material-
ism. None of them would maintain, however, with regard to ma-
terial objects, that he has nothing better to say than that it seems
to him that he *does* know with certainty that they exist. One
reason is that they hold that "the human essence is no abstraction
inherent in each single individual. In its reality it is the en-
semble of the social relations."[18] This implies that, if an individ-
ual knows with certainty, it is by virtue of the fact that this in-
dividual is immersed in social relations and in the developmen-
tal process of history. It is as if it were said: This or that ex-
perience of the individual artifically abstracted from the whole
might be an illusion or a dream, but not the social reality, not
the whole course of history. Naturally it is exceedingly difficult
to sum up, briefly and clearly, the tremendously cumulative
force of this argument, an argument which is irresistible to
common sense and even to philosophers who do not insist on
abstract wire-drawn arguments. However, difficulty of formula-
tion does not in itself, as Moore would I think admit, invalidate
an argument. There are, perhaps, other arguments which are
difficult to express abstractly. Thus a man may be so certain,
and on good grounds, that his closest friend is trustworthy, that
he is willing to stake his life on it, and yet be quite powerless
to prove his point in an exact and rigorous argument. The same

[18] Karl Marx, *Theses on Feuerbach*, VI.

may be true of arguments for the existence of material bodies and of other selves.

Soviet philosophers also argue that Berkeleyanism has a way of terminating in solipsism or supernaturalism, neither of which is consistent with the facts of evolution or with other known facts. They regard solipsism as an impossible view that has perhaps never—in seriousness—been held. They would not say, as Russell does, that solipsism is a perfectly possible view, because they would not use "possible" in such a narrow logical sense, except perhaps in mathematical discussions. When it is a question of the existence of material things and of other selves in general, and not just that of the existence of certain classes of them, then obviously common experience, history, and all the sciences, would have their arguments to contribute, and the question would not be whether a position is *logically* possible, but whether it is physically, biologically, and historically possible, and possible in every other way. It is clear that their approach to the question of the existence of material things is extremely different from Moore's. They say that neither the emergence, nor the success, of a philosophy is wholly determined by the logical weight of its argument, but that social factors often help to determine not only the incidence and success, but even the logical structure of a philosophy. In many cases the philosopher himself testifies to his motivations. Berkeley, for example, recommended his philosophy as the only bulwark against materialism and atheism. And it is perhaps significant that, while the Medieval world, entrenched in its feudal structure, had no need of any Berkeleys and never even approached the question of solipsism, the eighteenth century with its rising entrepreneur individualism was the one to produce Berkeley. Certainly the "free market" civilization that developed thereafter,—boasting of its free merchants and "free" workers, alienated, of course, from the means of production and the product of their labor,—took Berkeley to its heart, or at least took him seriously, so that millions of hours were consumed in disputation about Berkeleyan idealism and solipsism, positions which society could not really be expected to accept. Is it possible that "the world is my (personal) idea" owes part of its plausibility

to the fact that the philosophers to whom it is plausible live in
a society which is based, not on coöperation, but on competition
in a declining stage, and in which individuals, including philoso-
phers, no longer possessing an essential place and function, be-
come in some measure, alienated from the social reality? Of
course it would be difficult to prove such a point logically, i.e., in
abstraction from biographies, histories, and scientific works. Yet
there seems to be no doubt that, if part of the plausibility of a
philosopher's contentions results from the character of the so-
ciety in which he lives, or from the character of the society in
which his critic lives, sociological investigation is a genuine part
of philosophical method. Everyone would admit this, of course,
in *some* cases. No one, presumably, would try to understand
Nazi philosophy without considering its social and political
background. But in the case of other philosophies this procedure
may be less evident. For example, it may be less obvious when
the plausibility of a philosophy depends, in part, on socio-politi-
cal commitments to which we are habituated, and which have
become in course of time fairly automatic and unconscious. Yet,
if one admits that reactionary philosophy may be "sociologically
conditioned,"[19] there seems *prima facie* no reason to deny that
progressive philosophy and "neutral philosophy"[20] may also be
so conditioned. Actually, it is often pointed out that Locke's
political philosophy, and perhaps his polemic against innate
ideas, were sociologically conditioned quite as much as Hobbes'
Leviathan. Doubtless many other cases could be cited, but proof
would require much historical research. However, I am not at
all sure that Moore would disagree, if I were able to state this
sociological view in a more exact and satisfactory way.

Collingwood, an Oxford idealist, has recently attempted[21]
to account for the neutrality of British realism, and some of the

[19] If a philosophy is "sociologically conditioned," neither its emergence at a
particular time, nor its plausibility at any given time, can be fully explained
without reference to the economic, political, and cultural traits of society at these
various times.
[20] A "neutral philosophy" is neutral with respect to the most important socio-
political issues of its time.
[21] *An Autobiography* (London, 1939), by R. G. Collingwood.

things he says appear to be partly true or at least suggestive. For example, he contends that philosophical statements are not true nor false when isolated from their historical context; that a philosophical position is, in some sense, an answer to a problem posed by history, so that if one does not know the problem, one cannot understand the answer. But Collingwood seems to forget all about this principle when he comes to examine British realism. He criticizes this philosophy for its theory of "propositional logic" and for its basic principle that "nothing is ever affected by being known" and claims that, at the behest of these false theories, the realists, and intellectuals in general, abandoned their social function and responsibility, relinquishing the rôle of guides in matters of morals and politics, which nineteenth century philosophers had freely assumed. This abdication on the part of the realists and of intellectuals in general resulted in an indifference to practical morals and ideals, a concern with which T. H. Green, and other idealists, had been much occupied. In the end, Collingwood seems to hold the realists responsible for Chamberlain, for the appeasement policy and for all the Munich horrors. But it is doubtful whether he could have meant anything so unplausible. That a fairly abstract philosophical theory could by itself change the whole latter course of British policy and of the British Empire itself is too preposterous. The converse, however, is rather plausible. It does seem likely that the growth of Empire and socio-political changes in general must have affected philosophy; that at one stage confidence and even enthusiasm might have been awakened, while at another some misgivings and doubts could be expected, a tendency to leave questions of public policy and practical morals to experts in various fields, who understand the technicalities, know how to compromise, and how to make the best of a bad business. If it is possible, then, that neutral philosophy is socially conditioned, this fact is worth investigating. In the absence of such investigations the weight of a philosopher's arguments can not be properly estimated, either by himself or by others.

Probably Soviet materialism is in accord with Moore's realism in other respects. For example, Lenin made it fairly clear that

we can know that matter exists without knowing the precise nature of matter, that materialism cannot be upset by new developments in atomic analysis;[22] and Moore, as we have seen, says something quite analogous to this.[23] But there are points of difference too important to be overlooked. Soviet materialism, following Marx, maintains not only that we can know that material things exist beyond direct control by mental processes. It also holds that material things can be *indirectly* controlled by mental processes and appropriate behavior, and that indeed the world can be transformed to meet human needs far more lavishly than other systems of thought allow, if only society, and especially economic production, is efficiently organized. Marx also emphasized practice in another way. In distinguishing his materialism from classical or mechanical materialism, he said

The defect of all existing materialism . . . is that the object, reality, sensuousness, is conceived in the form of the *object* or *contemplation* but not as *human sensuous activity, practi*ce, not subjectively. Thus it happened that the *active* side, in opposition to materialism, was developed by idealism—but only abstractly, since, of course, idealism does not know real sensuous activity as such.[24]

What was lacking in all previous materialisms was the recognition that theoretical knowledge cannot succeed apart from practical activity. It follows that, if we know that material things exist, and how they are to be controlled and utilized, it is only by reacting to them, by attempting to control and to utilize them. But Marx also said, "It is not the consciousness of men that determines their social being, but, on the contrary, their social being that determines their consciousness."[25] And I think one thing implied by this is that, if an individual knows with certainty that material things exist, he knows it because society "knows" it, and has throughout history operated successfully on this knowledge. Doubtless, if this could be put clearly enough, Moore might find some truth in it. Yet he does say,

[22] *Materialism and Empirio-Criticism* (New York 1927), 218-25.
[23] "A Defence of Common Sense," 193.
[24] Marx's *Theses on Feuerbach* (1845).
[25] *Critique of Political Economy*. Introduction.

as we have seen, that if his knowledge of material things were challenged, he would have nothing better to say than that he does know them with certainty.

One thing, however, is beyond dispute: Whether Soviet materialism or Moore's realism is right in these various particulars, the former position could never be stated with the elegant brevity which is possible with the latter. Moreover, the Soviet position, in any brief formulation, is apt to be open to the same sort of criticisms which Moore directed against James' pragmatism. For example, Marx does say that "the mode of production in material life determines the social, political and intellectual life processes in general,"[26] and the question could be raised whether *every* idea, law, and oil painting is so determined. Then it could be pointed out that Marx himself insisted that *some* are not, and that it is possible to exaggerate the economic factor in history; and that, in fact, Soviet philosophers and historians have emphasized this even more than Marx did. But it would not follow from this that the materialist conception of history is obviously false or that it is a commonplace.

It is not our purpose to inquire whether this conception is true, but only to raise the question whether some philosophical positions do not require, for their proper understanding and evaluation, methods quite different from those Moore typically employs. The Soviet position does seem worth investigating by some suitable method; for it implies that there is a close connection between materialism and meliorism, a connection which does not exist between idealism and meliorism; and this seems to me, if true, exceedingly important, especially for philosophers. If it could be shown by proper methods that idealism, or certain forms of idealism, considered in the present social context, tend to impede technological innovation and the adoption of the most efficient social organization, whereas materialism tends to promote these developments, then philosophy would actually have all the importance that the Soviets assign to it. If such connections do exist, then it might be that Moore's realism, and his careful analysis of judgments of perception,

[26] *Ibid.*

have in fact, all the value that they seem to have, not only for the proper understanding of material things,[27] but, indirectly, even for the integrity and efficiency of the present struggle against fascism. But such possibilities can, of course, only be tested by laborious historical research which accepts "evidence" in a liberal, non-departmental sense.

Up to this point I have frequently employed the word "important," probably very tediously, in its natural sense, or as common sense would use it. In this natural sense, a thing is "important" if it has a bearing on human welfare, if it promotes or hinders progress or the satisfaction of desires, if it is useful or harmful to human beings. The range of "importance," the question for whom a thing is important, is generally determined by the universe of discourse. I think that when Moore uses the word "important" he sometimes means that a problem or theory is important, not only for philosophers, but also for other men, perhaps for society in general, although sometimes he may restrict the range of the term to philosophers. But it is possible that what is important to philosophers, *qua* philosophers, may also be important to society. If a problem or theory has a certain relation to science or to philosophy, and science and philosophy as a whole are important to society, then this problem or theory is indirectly important to society. A theory such as Moore's realism could be indirectly important to society, as well as being directly important to philosophers,[28] if it is consistent with a whole set of propositions of science which are general and rich in consequences, in a sense in which idealism is not; and if it facilitates the solution of scientific, or melioristic, problems in a sense in which idealism cannot. But I do not see how any philosophical theory could be even indirectly important to society unless it is causally connected with something that is directly important to society, that is, unless it contributes, however indirectly, to the solution of problems on which human welfare depends. It would seem worth while, especially for philosophers, to inquire whether views such as realism and

[27] Moore does think such analyses necessary to understanding the nature of material things. See "A Defence of Common Sense," 217.
[28] I.e., useful in solving philosophical problems.

Soviet materialism do, or do not, have causal connections of this kind.

Since Soviet philosophers *assert* connections between material-ism, historical materialism, dialectic materialism and meliorism such that, if a man is a consistent materialist, he becomes a his-torical materialist, utilizing dialectic and taking advantage of the main trends of objective development to improve the world, whereas other philosophers do not admit analogous connections in their own systems, it may be helpful to carry the comparison of Soviet materialism with Moore's realism one step farther. Soviet philosophers, as is well known, insist that their material-ism is dialectical, and present many arguments against mechani-cal materialism and against what goes by the name of "formal" or "Aristotelian" logic. What Moore would think of such ar-guments is not altogether clear; for he has never written on dialectic in its historical and scientific relation; but it is likely, I think, that he is in agreement with at least part of what Bertrand Russell says in his article on "Vagueness."[29] There Russell states: "The law of excluded middle is true when pre-cise symbols are employed, but it is not true when symbols are vague, as, in fact, they always are." Why Russell thinks the law would be true if precise symbols *were* ever used, is not ex-plained. He seems to assume throughout the article that reality would certainly conform to the law of excluded middle, if only our language were sufficiently precise; but some of the evidence surely points the other way. What experience shows is that, if the law is ever true, it is true when we are talking about abstract sets (as in logic and mathematics,) and arbitrarily exclude a third possibility by definitions, stipulations, or unwritten con-ventions. When we are talking about the actual world, this cannot be done, and it is here, I submit, that the law breaks down. It fails when we deal with transitions, but it holds when our symbols are most precise, i.e., when we are dealing with abstract sets. The law of excluded middle is true, it might be said, when the world we are talking about is static, but it is not true when the world is in transition, which it always is.

Formal systems of thought applied to the actual world are

often relatively true, and certainly very valuable, but the occurrence of transitions continually necessitates shifts from one such system to another. New dichotomies must be established to take the place of the old, which can no longer be conceived as valid. Thus it is claimed that dialectical logic has the advantage that, while it recognizes the partial truth and value of formal systems, it also provides for and, by virtue of its preoccupation with history, is able in many cases to predict the shift from one formal system to another.[30] It could be argued that it is consequently in a position to anticipate and to profit by these transitions better than other philosophies, and that there is therefore an important connection between dialectical materialism and meliorism, a connection which does not exist between (say) Berkeleyan idealism and meliorism. And it might further be argued that this advantage is made possible by rejecting the law of excluded middle, and therefore the law of contradiction, as ontological principles.[31]

Whether these arguments would be found valid, if all the evidence were presented, is an exceedingly difficult question which I do not here propose to examine, much less to answer. My concern here is merely to point out that, if there is any chance that these arguments are valid, it is desirable that a suitable method be found to examine them. If it should turn out that Soviet philosophy has important connections with meliorism, then it is possible that in our own Anglo-American philosophy such connections could be discovered or developed. If it turns out that the arguments are invalid, it is possible to profit by Soviet mistakes.

[30] This claim is made for dialectical economics in a recent article by Lewis Feuer. Dialectical economics has the peculiarity that it states the conditions which bring about transition from one set of laws to another set. "A dialectical law," he says, "states the conditions of disequilibrium for a given economy; it likewise defines those minimum conditions within a novel economy which resolve that disequilibrium, and it specifies furthermore the developmental sequence of the first system which eventuates finally in those proportions of disequilibrium necessary and sufficient for transition to the second system." *Science and Society*, Fall 1941, 341.

[31] In "Concerning the Laws of Contradiction and Excluded Middle," *Philosophy of Science*, vol. 6, No. 2, April 1939, the author pointed out that, when the customary logical assumptions are made, the law of excluded middle and the law of contradiction are equivalent.

Moore has of course examined at least one philosophy which has been called "dialectical." But it seems doubtful whether the method he employs in this case, although brilliantly ample to his purposes, is suited to bring out certain important historical aspects of this philosophy. In his article "External and Internal Relations,"[32] he proves beyond any doubt that Bradley was absolutely wrong in maintaining that all relations are, or must be, internal. What Moore thinks people mean by saying that all relational properties are internal is that "if P be a relational property which belongs to A, then the absence of P entails not only numerical difference from A, but qualitative difference."[33] The dogma that all relational properties are internal implies, he argues, that Edward VII, who was in fact the father of George V, could not have existed without being the father of George V.[34] Against this Moore argues that "we can see in many cases that the proposition that this has that relation does *not* follow from the fact that it is this: that, for instance, the proposition that Edward VII was father of George V *is a mere* matter of fact."[35] Moore's analysis of the theory that all relations, or all relational properties, are internal is extremely thorough and seems to constitute a complete disproof of Bradley's thesis. But one question remains. Although he has analyzed almost every term of what he conceives to be Bradley's thesis, he never tells us what he means by "Edward VII," nor what he means by "this" in the statement that "we can see in many cases that the proposition that this has that relation does not follow from the fact that it is this: . . ." Moore might reply that he dogma of internal relations is false, no matter what natural meaning we assign to "Edward VII" or to "this;" and I think this is what he does mean to say. One thing he maintains is that there is at least one relational property P, and there is at least one thing A, such that A has P, but that A *could be* what A is, even though A did not have P. Moore might prefer to express it as follows: If A has P, then from the proposition with regard to any term *x* that it has not got P, it does not *follow* that *x* is

[32] *Philosophical Studies*, 276-310.
[33] *Ibid.*, 285-6.
[34] *Ibid.*, 290.
[35] *Ibid.*, 307.

other than A.[36] Thus Edward VII *could be* what he is, even
though he was not the father of George V, or, differently ex-
pressed: if Edward VII is father of George V then, from the
proposition with regard to any man that he is not the father of
George V, it does not *follow* that he is other than Edward VII.

But here it seems to me that whether Moore is right depends
on how such words as "Edward VII" and "this" are used, and
what meaning is assigned to them. Moore might invoke Rus-
sell's theory of proper names and definite descriptions; but
Hegel and Bradley have each given very different accounts of
the matter. Suppose it were said that, in order to get a *complete*
understanding of the meaning of Edward VII, one needs to
know all the facts of history, and that assertions such as "This
is a man," are assertions about the universe. I do not wish to say
that there is any chance that either of these things is true, but
only that, if they were true, and other things of the kind were
true, all relations might be internal, in a sense, after all.

What is really interesting in this connection is that the num-
ber and kind and importance of the relations which are internal
seem to depend on what meaning is assigned to terms, on how
many characteristics of a thing are included in its nature, or
how many characteristics it needs in order to be "what it is." If
we understand by "Edward VII" only "the son of Queen Vic-
toria who was born in London in 1841," then it seems that
hardly any of his relational properties are internal. If this is
what Edward VII is, then almost no relational properties follow
from what he is. But I think that, if asked what a person is, or
who he is, common sense would include other qualities. In the
case of Edward VII it would be added that he assumed the
throne in 1901 and ruled until his death in 1910. It might also
be added that he could not have been the man he was, if he had
not done certain things, and if the British Empire had not been
expanding, and if science had not put many facts at his disposal.
And if it were asked, how many such relational properties
should be included in the understanding of what a man is, I
can think of no other answer than that as many relational prop-
erties should be included as are useful (or necessary) to the

[36] *Ibid.*, 289.

understanding of persons in their relation to society. If it should be found that the identification of a man with a certain set of social characteristics makes it possible to deduce or predict more of his other characteristics than is possible when any other identification is made, and at the same time fits into the whole structure of science better than other identifications do, then it seems that the identification of a man with this set of social characteristics is the most important identification which could possibly be made. And common sense, I think, agrees, at least in practice. If it is inquired who a person is, the answer expected is that he works for such and such an employer, belongs to a certain profession, church, club, trade union, has a family of a certain sort, and holds certain views about other people. These characteristics are regarded as the best identification of a man, because they yield the most deductions and predictions as to his other characteristics. It follows, I think it could be demonstrated, that whether relations are internal or not depends upon the utility, for common sense and science, of certain classifications and identifications. But I am not sure that this is anything with which Moore would disagree, or that he would not regard it as totally irrelevant to what he has said.

Throughout this paper my sole purpose has been to make certain inquiries about Moore's method. At the beginning I noted with regret that Moore's philosophy is preoccupied with a few abstract problems and never gets around to the most urgent philosophical issues. It was suggested that his problems may have been chosen, not because they could be regarded as more important than other problems, but because they could be dealt with by a certain perfected method. Recognizing, however, what seems obvious, that Moore's philosophy is very important in some sense or other, I inquired what this sense might be. A number of Moore's doctrines were cited to illustrate what might be meant by referring to his philosophy as important, and a general theory of philosophical importance was suggested. A discussion of Moore's criticism of James' *Pragmatism* raised the question whether the kind of method Moore typically employs is suited to the understanding and evaluation of theories which emphasize the interdependence of theory and practice. Since

contemporary Soviet materialism has probably worked out the most elaborate view of the relation of theory and practice, it was thought profitable to make a few comparisons between this philosophy and Moore's realism. If materialisms, historical and dialectic, *do* have important connections with meliorism, the question arose whether it would not be possible to find, or evolve, such connections between Moore's realism and meliorism, or between other Anglo-American philosophies and meliorism. Our analysis, however, showed that Moore's method is, in a number of respects, ill suited to deal with these questions of practical import which, as the world advances to new crises, are increasingly felt to be the urgent task of philosophy.

V. J. McGILL

DEPARTMENT OF PSYCHOLOGY AND PHILOSOPHY
HUNTER COLLEGE

19

L. Susan Stebbing

MOORE'S INFLUENCE

MOORE'S INFLUENCE

I

THE title of this essay is as misleading as the contents will be inadequate to its subject-matter. For this I must offer an apology, not the less genuine for my having yielded against my own better judgement to the Editor's urgent request to write "something, however short." Brevity has some merits; inadequacy has none. The main defects of this essay are due to my own invincible incompetence; the selection of the subject is in no small part due to my misfortune. Originally I planned to discuss Moore's conception of philosophy with the intention of bringing out in detail the influence of Moore's thinking upon Bertrand Russell and of the effect of Russell's work upon Moore. It is a profitable occupation to read Moore's and Russell's writings in the chronological order of their appearance. Despite the dissimilarity in their respective approaches to philosophy, in their temperaments and in their style of writing, there is a unity in their conception of philosophy that is more important than their differences; each has been quick to see and to appropriate something of value from the other. How Russell was led to change his views because of Moore, then, later, Moore because of Russell and so on is a study at once interesting and instructive. It is some years since I made this approach to Moore's work; time is lacking now to reread so much and to think again in a manner worthy of the task. The notes I then made have suffered the fate of better things in this war. Being now destroyed beyond recall, I think longingly of the comments and queries with which these notes were so liberally interspersed—comments which have, in imaginative recollection, the

significance and acuteness one so easily attributes to an untestable past.

Serious illness prevented me from writing my essay at the proper time. Now, confronted with the titles of the contributions to this volume, I find that each of the single topics I would have gladly chosen has been already appropriated by others: one essay is to deal with Moore's notion of analysis, another with his technique, and a third with Moore and ordinary language. I am thus forced to the conclusion that what I had in mind to say will already have been better said by others. I do not admire writers who begin by apologizing for an essay which was not worth writing, which should never have been published, and which no apology can redeem. It is unpleasant to find myself in the awkward predicament of one who feels bound to apologize for doing badly what he (or, in this case, she) should never have attempted at all. Again, I neither like, nor am versed in, the personal mode of writing; yet, in this essay there will be personal impressions which I can only hope will not strike the reader as impertinent, in either sense of that word. The hope is not very robust.

II

The Preface to Moore's first book—*Principia Ethica,* published in 1903—opens with the following paragraph:

It appears to me that in Ethics, as in all other philosophical studies, the difficulties and disagreements, of which its history is full, are mainly due to a very simple cause: namely to the attempt to answer questions, without first discovering precisely *what* question it is which you desire to answer. I do not know how far this source of error would be done away, if philosophers would *try* to discover what question they were asking, before they set about to answer it; for the work of analysis and distinction is often very difficult: we may often fail to make the necessary discovery, even though we make a definite attempt to do so. But I am inclined to think that in many cases a resolute attempt would be sufficient to ensure success; so that, if only this attempt were made, many of the most glaring difficulties and disagreements in philosophy would disappear. At all events, philosophers seem in general, not to make the attempt; and, whether in consequence of this omission or not, they are constantly endeavouring to prove that 'Yes' or 'No' will answer

questions, to which *neither* answer is correct, owing to the fact that what they have before their minds is not one question, but several, to some of which the true answer is 'No', to others 'Yes'.

I have quoted this paragraph in full because it seems to me admirably to show how clearly, even thus early in his career, Moore came to see what is the proper method for philosophers to follow—a method which he has consistently followed, with what rigour and with what success is now well known. To think is to be asking oneself questions and seeking to find the answers to them; hence, to think clearly it is necessary to see exactly *what* the question is to which one wants an answer. It might be supposed that to do this is not difficult. This supposition, however, is a mistake; but it is a mistake into which we are all prone to fall. We do notice sometimes that other people make this mistake, but it is more difficult to detect our own failures both in seeing clearly exactly what the question is and in keeping it steadily in mind throughout the discussion, i.e., throughout the period when we should commonly say that we are 'thinking out the problem'. Owing to our failure to see clearly what the question is we sometimes believe ourselves to have evidence relevant to answering it when, in fact, we have *no* evidence relevant to the question we *say* we are answering, but only evidence relevant to a different question with which we have confused it. As Moore says: "the offering of irrelevant evidence generally indicates that the philosopher who offers it has had before his mind, not the question which he professes to answer, but some other entirely different one."[1] He adds: "Ethical discussion, hitherto, has perhaps consisted chiefly in reasoning of this totally irrelevant kind." Having seen this clearly, Moore believed himself able to claim that he had "endeavoured to write 'Prolegomena to any future Ethics that can possibly pretend to be scientific'." For this reason Moore was content to say, in concluding *Principia Ethica* with a discussion of 'The Ideal', that "the results of this chapter should be taken rather as illustrating the method which must be pursued in answering the fundamental question of Ethics, and the principles that must be

[1] *Loc. cit.*, ix.

observed, than as giving the correct answer to that question"—
namely, the question concerning intrinsic values. Again, "with
regard to the question 'What ought we to do?' I have endeav-
oured rather to shew exactly what is the meaning of the question,
and what difficulties must consequently be faced in answering
it, than to prove that any particular answers are true."[2] He
recognised that his judgements concerning the attributions of
intrinsic value did not display "that symmetry and system which
is wont to be required of philosophers."[3] "But," he continues,

if this be urged as an objection, I may respectfully point out that it is
none. We have no title whatever to assume that the truth on any sub-
ject-matter will display such symmetry as we desire to see—or (to use
the common phrase) that it will possess any particular form of "unity."
To search for "unity" and "system," at the expense of truth, is not, I
take it, the proper business of philosophy, however universally it may
have been the practice of philosophers.

Such being Moore's conception of 'the proper business of
philosophy', it is not surprising that he has never attempted to
produce anything in the least like a philosophical system. In
what is, I believe, his second published paper,[4] Moore remarked,
"the region of the incompletely known is the favourite abode
of a metaphysical monstrosity. In plain language, where facts
are not completely understood, some short-sighted metaphysical
theory is generally introduced as affording an easy road past the
difficulties which stand in the way of thorough investigation."
Moore has never been tempted to enter this easy road. This is
one of the reasons why Moore is so great a teacher.

Not all of those who recognise that Moore is a great phi-
losopher have approved of his characteristic merit—the steady
pursuit of methodical questioning. Dr. Rudolf Metz, the learned
historian of British Philosophy, proclaims: "In G. E. Moore we
have not only the pioneer of the New Realist Movement, but
also the driving force and dominating personality in all the
further course of its development," but he clearly is himself

[2] *Principia Ethica*, 223.

[3] *Ibid.*, 222.

[4] In a paper entitled "Freedom," read before the Aristotelian Society, 15th
November, 1897, and published in *Mind*, 1897.

dissatisfied with Moore's failure to produce systematic treatises. The judgement made by Dr. Metz is, I think, very interesting:

> Though we may call Moore the greatest, acutest, and most skilful questioner of modern philosophy, we must add that he is an extremely weak and unsatisfying answerer. When questioning is excessively luxuriant, answering must naturally be scanty. Solutions and results are hardly to be expected from Moore, and if they occasionally appear, they are only like crumbs that fall from the master's table. . . .
>
> Evidently this kind of philosophizing is eminently liable to be sicklied o'er with the pale cast of thought and gnawed by the tooth of scepticism. By restoring the true meaning of philosophic questioning, Moore has rendered an inestimable service; he has also put a strong curb upon the exuberant speculations of Hegelianism and Evolutionism, and levelled the path for clean, sober, and practical thinking. But as questioning has become with him an end in itself, and has risen from the position of a technique to that of a fine art, and as its task is that of clarifying problems rather than of solving them, it may evoke admiration but cannot satisfy thought. What Hume said of Berkeley applies to Moore: that all his arguments are purely sceptical, that they admit of no answer and produce no conviction. They confound and agitate the mind, but do not give it peace. They stir up the dust which lies around problems, but they effect no final clarification.[5]

I find myself in almost complete disagreement with this estimate of Moore's achievement. How can a skilful questioner be a "weak and unsatisfying answerer"? To ask questions it is not enough to frame interrogative sentences. An intelligent question itself indicates the form which any satisfactory answer to the question must take. What exactly does Dr. Metz understand by 'solutions and results'? What is it that he expects of a 'final clarification'? I suspect that what Dr. Metz wants is a neatly rounded off answer, accepted on the authority of the master and rounded off because it is the completion of a system. In other words, it looks as if Dr. Metz will not be satisfied unless unity and system are achieved. He contrasts *clarifying* problems with *solving* problems, as though Moore ought, sometimes at least, to have forsaken the difficult task of clarifying a problem in order to provide, *instead of clarification,* a final solution. But how can a problem be solved unless it be first clarified? To make

[5] *A Hundred Years of British Philosophy*, Eng. Trans., 540-541.

clear what the problem is, to distinguish the *different* questions which philosophers have been confusedly attempting to answer by a *single* answer, this is in itself a step towards solution and is, further, an essential precondition of any solution that ought to satisfy a thinker. Moreover, as Moore himself points out, in the passage quoted above from *Principia Ethica,* the attempt to analyse and distinguish the questions involved might lead to the disappearance of "many of the most glaring difficulties and disagreements in philosophy." No doubt the youthful Moore was here somewhat unduly optimistic, but it is certain that *some* 'problems' have, on analysis, turned out to be only pseudo-questions, so that the process of clarifying the problem has led not to its 'final solution'—in the sense desiderated by Dr. Metz —but to its complete *dissolution.*

I am not quite sure what Dr. Metz means by saying that questioning, with Moore, "has risen from the position of a technique to that of a fine art," but if he means that Moore is indulging in an artistic, as contrasted with an intellectual, pursuit, then I think he is wrong. I think this is what the statement must mean, and I suppose he thus judges because he does not really believe that the clarification of thought is an end worthy to be pursued. How should thought be satisfied better than by being clarified?

The application to Moore of Hume's comment on Berkeley seems to me to be peculiarly inept. I should say, on the contrary, that when Moore's arguments do not admit of any answer, then they produce conviction; when they do not produce conviction, then they lead on to further questioning. His arguments may rightly be said to 'agitate the mind', if by that be meant that they stir to fresh efforts to think more clearly; but not if the phrase be taken, as Dr. Metz seems to take it, in contrast to 'giving peace'. But perhaps these phrases should be regarded as mere rhetorical flourishes.[6]

[6] It is in this way that we should certainly take Dr. Metz's statement that Moore's kind of philosophizing "is eminently liable to be sicklied o'er with the pale cast of thought and gnawed by the tooth of scepticism." I have, unfortunately, not been able to compare the English translation with the German original, so that I do not know whether Dr. Metz is responsible for the Hamlet touch.

Moore is so little sceptical that he claims to know with certainty certain common sense propositions, an example of which might be "I am now holding up my hand." It will be sufficient to recall here Moore's "Defence of Common Sense" and his latest publication "Proof of an External World," both of which are being discussed elsewhere in this volume.[7] The point which I want to emphasize here is Moore's insistence that what we cannot help accepting in ordinary life must not be rejected when we are meditating in a philosopher's study. With regard to his proof of an external world Moore says:

but I do want to emphasize that, so far as I can see, we all of us do constantly take proofs of this sort as absolutely conclusive proofs of certain conclusions—*as finally settling certain questions, as to which we were previously in doubt.*[8]

Here again Moore is pursuing his method—to ascertain what it is we do actually believe and the grounds (if any) of our belief; and to ascertain what exactly it is we *know* and the grounds (if any) of our knowing what we do know. Moore contends that "I can know things, which I cannot prove." Of course we do often claim to know what we do not in fact know; we are then making a mistake. But, from the fact that we are sometimes thus mistaken, it does not at all follow that we *always* are. On the contrary, if it were not the case that we are sometimes not mistaken in thus claiming to *know*, we could not *know* that we ever were mistaken.

This is a contention which Moore has consistently maintained, and I hope I am correct in asserting that it affords the basis of what may be called his 'Common Sense View'. In his paper on "Hume's Philosophy," he says:

How is the sceptic to prove to himself that he does know any external facts? He can only do it by bringing forward some instance of an external fact, which he does know; and in assuming that he does know this one, he is, of course, begging the question. It is therefore quite impossible for any one to *prove*, in one strict sense of the term, that he does

[7] For this reason I do not give further illustrations of these propositions, nor do I discuss the "Defence" itself.

[8] From "Proof of an External World," *Proceedings of the British Academy*, 1939, 297. My italics.

know any external facts. I can only prove that I do, by assuming that in some particular instance, I actually do know one. That is to say, the so-called proof must assume the very thing which it pretends to prove. The only proof that we do know external facts lies in the simple fact that we do know them. And the sceptic can, with perfect internal consistency, deny that he does know any. But it can, I think, be shown that he has *no reason* for denying it.[9]

And again,

We may quite well *know* many things which do not logically follow from anything else which we know.[10]

The notion that we may have a *reason*, though not a logically *conclusive* reason for certain statements concerning direct observation, is, I believe, one of Moore's important contributions to philosophy. This contention constitutes, in my opinion, the main interest of a paper, written nearly forty years ago, which has not, so far as my recollection goes, received nearly so much attention as it deserves. This paper ("The Nature and Reality of Objects of Perception") was republished[11] by Moore in *Philosophical Studies*, and is, I presume, to be classed with the earlier papers about which he said, in the Preface to the *Studies*, that some of the views in some of these papers were views with which he no longer agreed but in which were said "things which are worth saying in a form which, however defective it may be, I doubt my own ability to improve upon." He there says:

I have constantly found that I was confusing one question with another, and that, where I had thought I had a good reason for some assertion, I had in reality no good reason. But I may perhaps remind you that this question, "How do we know so and so?" "What reason have we for believing it?" is one of which philosophy is full; and one to which the most various answers have been given. Philosophy largely consists in giving reasons; and the question what are good reasons for a particular conclusion and what are bad, is one upon which philosophers have disagreed as much as on any other question. For one and the same conclusion different philosophers have given not only different, but incom-

[9] *Philosophical Studies*, 159-60. The last italics are mine.
[10] *Ibid.*, 161. Italics in original.
[11] It first appeared in *Proceedings of the Aristotelian Society*, 1905-6.

patible reasons; and conversely different philosophers have maintained that one and the same fact is a reason for incompatible conclusions. We are apt, I think, sometimes to pay too little attention to this fact.[12]

When we reflect upon this fact it does seem—or at least *ought* to seem—puzzling that philosophers can draw different reasoned conclusions from the same fact, or can give different and incompatible reasons for the same conclusion. Moore suggests that this may be so because philosophers mistake one kind of reason for another, and so they suppose that what is in one sense 'a reason' is also a 'reason' in another sense, and further, that because in one sense no reason can be given, there is no reason at all. Accordingly Moore asks in what sense of 'reason' we have reasons for believing in an external world. He has defined "a good reason for a belief" as "a proposition which is true and which would not be true unless the belief is also true." He expresses this definition synonymously as follows: "A reason for a belief is a true proposition from which the truth of the belief *follows* from which it *could* be *validly inferred*." That the belief *follows* is, he points out, not to be taken to mean that it follows "according to the rules of inference accepted by Formal Logic." On the contrary, he uses the word 'reason' in a wide and popular sense. This sense he illustrates by an example which, with slight variations, he has given on several occasions. If *The Times* stated that the King was dead we should take that to be a good reason for believing that the King was dead. The statement in *The Times* would "render it positively probable" that the King was dead.

I shall use the phrase 'probable knowledge' for a belief based upon a reason of the kind just explained. I should at one time have felt an objection to the expression 'probable knowledge' as being either a misleadingly elliptical statement or as a contradiction in terms. But, unless I have profoundly misunderstood Moore (which is, unfortunately, not at all unlikely), I have learnt from him that this would be a mistake. It is, indeed, a mistake which lies at the base of Hume's criticism of our belief in external objects and of our belief in personal identity, and

[12] *Philosophical Studies,* 38f.

which, once made, makes Hume's reasoning seem to be more cogent than it is. For Hume took for granted that we could have *no* reasons for these beliefs unless they were *demonstrative reasons*, that is to say, unless premisses could be found from which the beliefs in question could be validly inferred in accordance with strict rules of formal logic. And these premisses must, in turn, be either likewise demonstratively inferrible or must be logically acceptable, on purely formal grounds, without any need for proof. Hume had no difficulty in showing that this was not the case, from which he concluded, erroneously I think, that we had no good reasons for believing in external things or in personal identity. Moore has, I think, led us to see that probable knowledge is no less *knowledge* than *demonstrative* knowledge, although it is not, and cannot claim to be, logically certifiable knowledge. In other words, probable knowledge really *is* knowledge.

By introducing this method into epistemological arguments Moore made a great step forward. He shewed—in the paper from which I have been quoting—that the nature and reality of objects of perception can be investigated by methods not wholly unlike the methods employed in the natural sciences. Moore certainly does not attempt to refute Hume's philosophical scepticism by producing a deductive metaphysic of justification. The attempt to justify common sense propositions by finding a place for them within a constructed metaphysical system would, I am sure, strike Moore as merely absurd. To begin, as Descartes began, or at any rate tried to begin, by doubting everything and then to conclude by asserting that most of what he had doubted had now been proved to be true is futile. This is no more possible in the case of common sense propositions than in the case of scientific propositions; nor is it more necessary in the case of the former class of propositions than it is in the latter. The logical character of the evidence for common sense propositions does not differ fundamentally from the logical character of the evidence for scientific propositions.

III

Moore has shewn that either we have not the slightest reason

for believing in the existence of other people and in the existence of external things or it is true that some things do really exist besides my own perceptions, thoughts, and feelings; that is to say, that there are things which are logically independent of my perceptions, thoughts, and feelings. These are called 'sense-contents' in the paper on "The Nature and Reality of Objects of Perception." Later Moore used the term 'sense-data'.

For some years the discussion in the Moral Sciences Club at Cambridge centered round the question of sense-data and their relation to common sense things. Bertrand Russell, as is well known, took sense-data to be the 'hardest' of 'hard data' and strove to shew that common sense things are logical functions of sense-data. With this view Moore was, I think, in considerable agreement. Russell's interest in the question was, however, quite different. What he sought was a basis for *certain* knowledge. I should be much surprised if he were to be in the least convinced by Moore's recent proof of an external world. Be that as it may, I cannot doubt that Russell's search for a basis of certainty for common sense propositions is a profound mistake. The mistake is, I am afraid, partly due to the influence of Moore's conception of sense-data.

It comes about in this way. In discussing the *analysis* of common sense propositions Moore certainly has suggested that the analysis must terminate in sets of propositions about sense-data. Such an analysis I once called 'directional analysis', and I tried to point out that directional analysis involves certain assumptions, one of which is the assumption that there are *absolutely* specific facts, which I there called '*basic* facts'. There seems to me to be no good reason for asserting that there are such basic facts. On the contrary, I think there are good reasons for saying that the notion of basic facts is a hang-over from the days when 'the problem of the external world' was envisaged as primarily a problem of justifying common sense beliefs, although it is Moore himself who has clearly shewn us that these beliefs do not stand in need of justification but only of analysis. Consequently, sense-data should not be regarded as having an essential and absolute priority, logically, epistemologically, or metaphysically. They are elements discriminated within a context,

and the discrimination is relative to the specific set of questions arising out of that context. Within that context the sense-data can be taken as basic, but, even so, they are not the termination of a directional analysis of common sense propositions, the direction of the analysis being likewise given by common sense. Just as is the case with scientific propositions so also in the case of common sense propositions, what is basic is to be determined by the purpose of the investigation; just as scientific propositions are not incorrigible, so too are common sense propositions not incorrigible.

I am afraid that Moore would entirely disagree with these contentions or, more likely, dismiss them as merely absurd. Nevertheless, I think that his work has encouraged certain philosophers in believing that common sense propositions (e.g., 'I see a table') must be directionally analysed into sets of propositions about sense-data. Certainly Mr. John Wisdom, professing (and, I believe, rightly professing) to follow the procedure of Moore, at one time laid great stress upon what I call directional analysis, which he re-named 'new level analysis'. His proposal to analyse 'nation-sentences' (e.g., "Germany hates Russia") into 'individual sentences' (e.g., "Fritz hates Ivan"), and these again into sense-data sentences suggests that he regarded sense-data as basic elements in an absolute sense, and, in consequence, as the necessary termination of the process of analysing. I have been contending that there is no good reason for thus regarding sense-data as not only isolable for a given purpose but as *isolated* entities. Sense-data are not that *from* which abstraction is made but are, on the contrary, themselves the result of a process of discriminative abstraction, although they are certainly *there* to be discriminated.

It is to Moore that we mainly owe the recognition of philosophy as essentially involving a critique of abstractions. It is here, I believe, that his most lasting influence will be found—not in the procedure of directional analysis of common sense propositions, but in what Wisdom has called 'same-level' analysis,— namely in the analytic definition of expressions and in the analytic clarification of concepts. Moore has himself achieved results of first-rate and lasting importance in his analysis of

"material implication and entailment," "reality," and "descriptive phrases." In his discussion of these problems, as in his treatment of the common sense view of the world, Moore has laid the greatest stress upon taking words in their ordinary meanings. He has shewn that many problems which have genuinely puzzled philosophers turn out on examination to be merely nonsense questions; in formulating these questions we have put together expressions which are in disagreement with the ordinary usages through which alone these expressions have meaning. The steady application of this method, which involves the constant demand for *instances* of the usages in question, does result in an extraordinary clarification of problems. This procedure has, I make no doubt, been carried further by Professor Wittgenstein, although his only published work suffers from his having accepted the Moore-Russell view of absolutely specific facts.

IV

By laying stress upon Moore's earlier publications I have tried to indicate how new was his method of philosophical inquiry and how consistently he has employed it. Moore's *views* have undergone a considerable change from the days when he was mainly influenced by Plato and Bradley, and later by Kant. But these changes of view have been the inevitable outcome of the method of inquiry and do not, I think, shew any fundamental change of standpoint. In this respect there is a marked difference between Moore and Russell. Occasionally one meets references to the 'Moore-Russell School'; but, in the continental sense of a school of philosophy, there is no such school. Nevertheless, the description has some use. Moore has deeply influenced his contemporaries and his students by letting them see his method at work, by the way in which he tackles problems and sets them in a new light. To be able to estimate the extent and importance of Moore's influence it would be necessary to know what goes on at his discussions and lectures and perhaps also in his private philosophical correspondence. Since there has been no Plato or Boswell to give us such a report, I shall venture to give some examples known to me personally. I hope I may do so without impertinence.

Unfortunately for myself, I never had the good fortune to be
technically a student of Moore's, since I left Cambridge just
before he returned to it as a lecturer. Nevertheless, I have often
been present at discussions with him and have occasionally heard
him lecture. In 1917 I read a paper to the Aristotelian Society,
perhaps one of the most muddled papers that have ever been
presented to that assembly. I was surprised to see Russell there
and I was, I recollect, not a little apprehensive, since the paper
contained criticisms of Russell which perhaps even then I sus-
pected to be at best but half-baked. To be apprehensive of criti-
cism is to fail as a philosopher; but the fact must be recorded that
I was apprehensive. At the outset of the discussion, not Russell
but a man whom I had never seen and took to be quite young,
began to ask me questions with a vehement insistence that con-
siderably alarmed me. "What ON EARTH do you mean by
that?" he exclaimed again and again, thumping the table as he
said "on earth" in a manner that clearly shewed he believed
there was no earthly meaning in what I had said. Soon, how-
ever, my alarm faded; the vehement philosopher had made
me forget not to be a philosopher—nothing mattered except
trying to find out what I did mean. In spite of my stumbling
replies he managed to elicit the reasons why I had been led to
the views I was trying to defend; he shewed me the baseless-
ness of many of my reasons, he unravelled the muddles and
enabled me to see more clearly the grain of sense that had been
at the back of my inept criticisms. That was my first meeting
with Moore, whose name I discovered only towards the end of
the discussion. I am inclined to think that this meeting of the
Aristotelian Society was somewhat peculiar in the annals of the
Society, for the reader of a paper was, before the end of the
discussion, convinced that her main contentions were entirely
wrong. One does not expect a philosophical society's meeting
to end in a conversion, yet such was the result in my case, owing
mainly to the vehement and vigorous clarity of Moore and his
patience in pursuing the question to its end, and in part to the
vigorous and politely ironical criticisms of Russell.

Converts are apt to backslide. So it was in my case. A year
later I misrepresented Moore's views in a short paper, hastily

written and ill thought out. Moore wrote to me and pointed
out the misrepresentation. It was, he said, an "inexcusable mis-
understanding." Nevertheless, when I replied, making such
defence as I could, Moore replied again. Although he repeated
that the mistake was "quite inexcusable," he took the trouble to
unravel my muddles, to point out what it was I *must* have meant
to say, if I intended to draw the conclusions I had drawn. Again
I replied and once again Moore answered the reply. These two
replies covered, in small writing, twenty-four and twenty-six
pages respectively of Cambridge foolscap. I refer to this incident
since it seems to me to show Moore's quality as a teacher. He
hates muddles; to clear up a muddle he will (as I know from
my own experience) take the trouble to write to an insignificant
person what is in effect a first-rate essay, with no thought of
publication, with no backward glance to see what use his corre-
spondent will make of the instruction so freely and patiently
given. Never has any academic lecturer been less concerned than
Moore that his students and correspondents might plagiarize
his views. It is enough for him that the views be clear. He
genuinely minds if people are in the outer darkness of a mental
fog.

'Moore does his thinking in front of the class', a student
(post-graduate, from another University) once complained to
me. 'And how else could he *teach?*' I replied. The reply was not
regarded as satisfactory: 'It is the business of a philosopher to
prepare his lecture carefully and to think it out in his study
beforehand', this student maintained, adding—to clinch the
matter, as it were—'Why, I reckon Moore has not more than
one idea in one lecture, so that scarcely anything has been done
by the end of the term.' To me it seemed that *one idea, one
lecture*, was a rather high proportion; but this student had been
used to lectures not only thought out beforehand but even
typewritten some years before. It is, of course, not true that
Moore does not 'think out his lecture in his study'; he spends
long hours over preparation. But his questioning mind does not
stay still; his lecturing is a continual thinking and rethinking;
he shows his students what thinking philosophically is by doing
his thinking in front of them. But he does not do so *in order*

to show them what thinking philosophically is; he does so because he is first and foremost a philosopher whose philosophy informs his life.

One final example. At a symposium of the Aristotelian Society, on "Internal Relations," the two symposiasts based their remarks on Moore's well-known paper on that subject. Moore expressed genuine surprise that they should do so. He expressed himself as unable to understand what he could *possibly* have meant by the views he had previously stated, and was quite convinced that they were wrong.

Anyone who has been able to learn something of Moore's way of thinking, who has profited by his clarity of exposition and has seen his single-minded devotion to the task of philosophy could not, I think, succumb to the muddle-headed creed of Fascism or National Socialism. For, to be embued with something of his critical yet positive spirit is to be forearmed against the forces of irrationalism. In these days that is not the least important consequence of Moore's influence upon those who learn from him.

<div align="right">L. SUSAN STEBBING</div>

BEDFORD COLLEGE FOR WOMEN
UNIVERSITY OF LONDON

G. E. Moore

A REPLY TO MY CRITICS

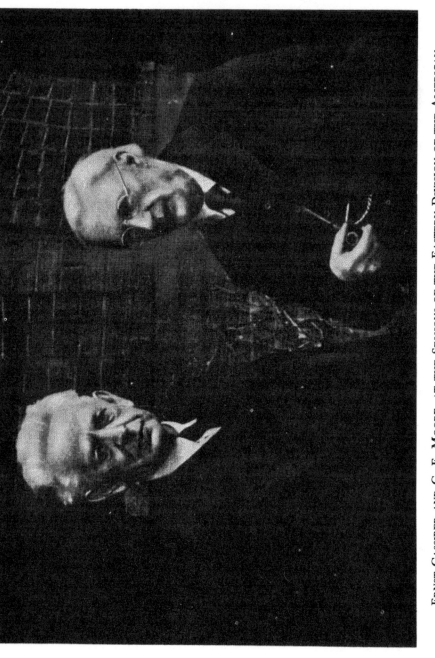

Ernst Cassirer and G. E. Moore, at the Sessions of the Eastern Division of the American Philosophical Association at Vassar College, Poughkeepsie, New York, December 31, 1941

A Reply to my Critics.

The essays collected in this volume seem to me to fall, pretty naturally, into three groups. There is, first of all, a group of essays which ~~discuss~~ discuss questions which have to do, in one way or another, with Ethics; there is a second group which discuss questions relating to sense-perception, and there is a third group which discuss more general questions — questions which may, I think, roughly be said to be questions relating to philosophic method.

The number of different questions raised, in one place or another, is immense, and I cannot possibly discuss them all. What I shall try to do is to pick out for discussion those which seem to me to be the most important, but even in the case of these, I cannot possibly discuss any single one of them as fully as it deserves. all that I can hope to do is to say, in each case, some things which are relevant to the issue raised.

I propose to group the questions to be discussed, under the three heads given above; and to deal with these ~~past~~ groups in the order given — first, questions relating to Ethics, then questions relating to sense-perception, & finally questions relating to philosophic method. Within each group I shall try to arrange the questions dealt with, as far as possible, in what seems to me to be a logical order. ~~decided to say something, in what seems to me the most apposite place, about the~~ ~~issues raised in each particular~~

I. Ethics

~~Is "right" the name of a characteristic?~~

1. On p. 000 of his essay ~~since~~ Broad says that a complete discussion of my "doctrine", that the word "good", ~~when used in the particular way which I had in mind~~, ~~in one of the ways in which I have used it in Ethics~~, "is a name for a characteristic which is simple & "non-natural"", would have to begin by raising the question "Is "good" a name of a characteristic at all?" And it goes to ~~me~~ that if this question were raised with ~~regard to the word "good"~~, in the usage in question, it also can or should be raised with regard to the words "right", "duty", "right" & "wrong" in their ethical usage. Of course, the question he means is the question whether "good", when used in that particular way, is a name of a characteristic; and I quite agree with him that this is the first question which should be discussed, if one wished to discuss completely the "doctrine" in question.

He himself, however, has not chosen not to discuss this particular question on this occasion, and I do not think that any of the other contributors have discussed ~~the former question~~ it either.

A REPLY TO MY CRITICS

THE essays collected in this volume seem to me to fall, pretty naturally, into three groups. There is, first of all, a group of essays which discuss questions which have to do, in one way or another, with Ethics; there is a second group which discuss questions relating to sense-perception; and there is a third group which discuss more general questions—questions which may, I think, roughly be said to be questions relating to philosophic method.

The number of different questions raised, in one place or another, is immense, and I cannot possibly discuss them all. What I shall try to do is to pick out for discussion those which seem to me to be the most important; but, even in the case of these, I cannot possibly discuss any single one of them as fully as it deserves: all that I can hope to do is to say, in each case, some things which are relevant to the issue raised.

I propose to group the questions to be discussed, under the three heads given above; and to deal with these groups in the order given—first, questions relating to *Ethics*, then questions relating to *sense-perception*, and finally questions relating to *philosophic method*. Within each group I shall try to arrange the questions dealt with, so far as possible, in what seems to me to be a logical order.

I. ETHICS

1. Is "right" the name of a characteristic?

On pp. 57-8 of his essay, Mr. Broad says that a complete discussion of my "doctrine," that the word "good," when used in one particular way which I had in mind, "is a name for a characteristic which is simple and 'non-natural'," would have to begin by raising the question "Is 'good' a name of a characteristic at all?" Of course, the question he means is the question whether "good," *when used in that particular way,* is a name

of a characteristic; and I quite agree with him that this is the first question which should be discussed, if one wished to discuss completely the "doctrine" in question.

He himself, however, has chosen not to discuss this particular question on this occasion, and I do not think that any of the other contributors have discussed it either. I do not therefore propose to discuss it myself. Fortunately, however, Mr. Stevenson has put forward a view about "typically ethical" uses of the words "right" and "wrong," which seems to me to raise exactly the same issues. If Mr. Stevenson's view is true, then, I think, an analogous view about the particular use of the word·"good," which is in question, must be true also; and it would follow that "good," in this usage, is *not* the name of any characteristic at all. I propose therefore to begin by discussing this view of Mr. Stevenson's.

Consider the sentence "It was right of Brutus to stab Caesar" or the sentence "Brutus' action in stabbing Caesar was right" or the sentence "When Brutus stabbed Caesar, he was acting rightly"—three sentences which seem all to have much the same meaning. Mr. Stevenson thinks (p. 80) that the definition " 'It was right of Brutus to stab Caesar' has the same meaning as 'I now approve of Brutus' stabbing of Caesar, which was occurring' " gives, *if amended in a particular way*, at least *one* "typically ethical" sense of these sentences. But he adds that he only thinks it does this "as closely as the vagueness of ordinary usage will allow." I take it that by the last clause he means that the sense which his amended definition would give to these sentences is more precise than any with which they would actually be used by any one who was using them in a way that was in accordance with ordinary usage; but he·thinks that, though more precise, it *approaches* at least *one* sense in which such a person might use them. He thinks moreover that the sense which it approaches is a "typically ethical" one; but in saying that his amended definition gives (approximately) at least *one* "typically ethical" sense, he is allowing that there may possibly be other "typically ethical" senses, equally in accordance with ordinary usage, which it does not give even approximately; and allowing also that there may possibly be other senses, equally

in accordance with ordinary usage, which are not "typically ethical" and which also his amended definition does not give even approximately. This is a generous allowance of possible senses, all of them in accordance with ordinary usage, with which these simple sentences might be used. But perhaps it is not too generous; and, guarded and limited as Mr. Stevenson's statement is, I think it is sufficient to raise important questions.

It would seem that, before we can discuss whether Mr. Stevenson is right in this guarded statement, we ought to know what his amended definition is. And he professes to give it on p. 84. He says that his amendment is a very simple one, and possibly it may be; but it is certainly not a simple matter to discover from what he says on this page, what the amendment he has in mind is. Let us, for the sake of brevity, call the sentence "It was right of Brutus to stab Caesar" "the *definiendum,*" and the sentence "I now approve of Brutus' stabbing of Caesar, which was occurring" "the *definiens.*" The original definition stated that the *definiendum,* when used in the particular sense (approximating to an ordinary one) which Mr. Stevenson wants to "give" us, has the same meaning as the *definiens.* This definition, Mr. Stevenson now says, does not, *as it stands,* give us the sense he means, but must be amended. And it is obvious, from what he says, that the required amendment will have something to do with "emotive meaning:" it will either mention the conception "emotive meaning" itself, or will mention some particular emotive meaning which a sentence might have. In order to help us to see what the required amendment (or, as he now calls it, "qualification") is, Mr. Stevenson tells us: " 'Right', 'wrong', and the other ethical terms, all have a stronger emotive meaning than any purely psychological terms." By this, I take it, he means to imply that the *definiendum* has a stronger emotive meaning than the *definiens.* And then he adds: "This emotive meaning is not preserved by" the original definition "and must be separately mentioned." And here, I take it, by *"must* be separately mentioned" he means "must" in the amended definition—in any definition which is to "give" the sense of the *definiendum* he wants to give. These two sentences are, I think, all the help he gives us. Well now, using this help, what *is* the

amended definition? Does it merely say: The *definiendum* (when used in the sense in question) has the same meaning as the *definiens*, but it has an emotive meaning which the *definiens* lacks? Or does it say: It has the same meaning, but it has a *stronger* emotive meaning than the *definiens*? If either of these is all, it certainly does not *give* us any sense whatever of the *definiendum* over and above what the *definiens* gives; it only tells us something *about* a possible sense. Or would it be a statement, which mentioned some particular emotive meaning, and said: The *definiendum* (when used in the sense in question) has the same meaning as the *definiens*, but it has also *this* emotive meaning which the *definiens* lacks? Or would it mention *both* some particular emotive meaning, *and* some particular degree of strength in which a sentence might have that emotive meaning, and say: The *definiendum* (when used in the sense in question) has the same meaning as the *definiens*, but it has *this* emotive meaning in a degree of strength above *this* degree, whereas the *definiens* only has it in a degree of strength below *this* degree? In these two cases, the amended definition really would give us a sense of the *definiendum*; but it is certain that Mr. Stevenson has not given us any amendment of this sort. Perhaps there are other alternatives besides these four: how on earth are we to tell which Mr. Stevenson means? The bare fact is that he has not given us *any* sense whatever of the *definiendum* over and above what the *definiens* gives, nor any amended definition which gives such a sense. But nevertheless I think it is possible to gather from what he says that he holds the following views. Let us, in analogy with a way in which Mr. Stevenson himself uses the word "cognitive" and also in analogy with the way in which he uses the phrase "emotive meaning," distinguish between the "cognitive meaning" of a sentence and its "emotive meaning." I think we can then say Mr. Stevenson thinks that the *definiendum*, when used in the sense he has in mind, has exactly the same "cognitive meaning" as the *definiens*, but nevertheless has not the same *sense*, because it has a different "emotive meaning." But what does this mean? How are we using the term "cognitive meaning"? I think this can be explained as follows. Some sentences can (in accordance with

ordinary usage) be used in such a way that a person who is so using them can be said to be *making an assertion* by their means. E.g., our *definiendum*, the sentence "It was right of Brutus to stab Caesar," can be used in such a way that the person who so uses it can be correctly said to be asserting that it *was* right of Brutus to stab Caesar. But, sometimes at least, when a sentence is used in such a way that the person who uses it is making an assertion by its means, he is asserting something which might conceivably be true or false—something such that it is logically possible that it should be true or should be false. Let us say that a sentence has "cognitive meaning," if and only if it is both true that it can be used to make an assertion, and also that anyone who was so using it would be asserting something which might be true or might be false; and let us say that a sentence, *p*, has *the same cognitive meaning* as another, *q*, if and only if both *p* and *q* have cognitive meaning, and also, *so far as* anybody who used *p* to make an assertion was asserting something which might be true or might be false, he would have been asserting exactly the same if he had used *q* instead. If so, then the view I am attributing to Mr. Stevenson is that if a person were using our *definiendum* to make an assertion, and were using it in the sense Mr. Stevenson has in mind, then so far as he was asserting anything which might be true or might be false, he might have asserted exactly the same by using the *definiens* instead, but that, if he had done this, he would *not* have been using the *definiens* in the same *sense* in which he actually used the *definiendum*, and would not therefore have been asserting that it was right of Brutus to stab Caesar, in the sense Mr. Stevenson means. In short, Mr. Stevenson is holding that there is at least one "typically ethical" sense in which a man may assert that it was right of Brutus to stab Caesar, which is such that, though the only assertion which might be true or false that he is making will be that he himself, at the moment of speaking, "approves of Brutus' stabbing of Caesar, which was occurring," yet from the mere fact that he is making this assertion it will not follow that he is asserting that Brutus' action was right, in the sense in question: that he is doing so will only follow from the *conjunction* of the fact that he is asserting that he "approves of Brutus'

stabbing of Caesar which was occurring," with the fact that he is using words which have a certain emotive meaning (*what* emotive meaning, Mr. Stevenson has not told us). There is, Mr. Stevenson seems to imply, at least one type of ethical assertion such that an assertion of that type is distinguished from a possible assertion, which would not be ethical at all, not by the fact that it asserts anything which might be true or false, which the other would not assert, but simply by its "emotive meaning."

Mr. Stevenson holds, then, if I understand him rightly, that there is at least one "typically ethical" sense in which a man might assert that it was right of Brutus to stab Caesar, which is such that (1) the man *would* be asserting that he, at the time of speaking, approved of this action of Brutus' and (2) would *not* be asserting anything, which might conceivably be true or false, *except* this or, possibly also, things entailed by it, as, for instance, that Brutus did stab Caesar. And I think he is right in supposing that, limited as this statement is, it is inconsistent with what I have stated or implied in my ethical writings. I have, I think, implied that there is *no* "typically ethical" sense in which a man might assert this, of which *both* these two things are true; and I have also implied, I think, that there is no "typically ethical" sense of which *either* is true. I will say something separately about each of these two separate contentions of Mr. Stevenson's.

(1) I am still inclined to think that there is no "typically ethical" sense of "It was right of Brutus to stab Caesar," such that a man, who asserted that it was right in that sense, would, as a rule, be *asserting* that he approved of this action of Brutus'. I think there certainly is a "typically ethical" sense such that a man who asserted that Brutus' action was right in that sense would be *implying* that at the time of speaking he approved of it, or did not disapprove, or at least had some kind of mental "attitude" towards it. (I do not think Mr. Stevenson means to insist on the word "approve" as expressing quite accurately what he means: I think the essence of his view is only that there is *some* kind of "attitude," such that a man would be asserting, if he used the words in the sense Mr. Stevenson means, that he had, at the time of speaking, that attitude towards it.) But I

think that, as a rule at all events, a man would only be *implying*
this, in a sense in which to say that he *implies* it, is *not* to say
that he *asserts* it nor yet that it *follows* from anything which
he does assert. I think that the sense of "imply" in question is
similar to that in which, when a man asserts anything which
might be true or false, he *implies* that he himself, at the time of
speaking, believes or knows the thing in question—a sense in
which he *implies* this, even if he is lying. If, for instance, I
assert, on a particular day, that I went to the pictures the pre-
ceding Tuesday, I *imply*, by asserting this, that, at the time
of speaking, I believe or know that I did, though I do not *say*
that I believe or know it. But in this case, it is quite clear that
this, which I *imply*, is no part of what I *assert*; since, if it were,
then in order to discover whether I did go to the pictures that
Tuesday, a man would need to discover whether, when I said
I did, I believed or knew that I did, which is clearly not the
case. And it is also clear that from what I assert, namely that I
went to the pictures that Tuesday, it does not *follow* that I be-
lieve or know that I did, when I say so: for it might have been
the case that I did go, and yet that I did not, when I spoke,
either believe or know that I did. Similarly, I think that, if a
person were to assert that it was right of Brutus to stab Caesar,
though he would be *implying* that, at the time of speaking, he
approved, or had some similar attitude towards, this action of
Brutus', yet he would *not* be *asserting* this that he would be
implying, nor would this follow from anything, possibly true or
false, which he was asserting. He would be implying, *by saying*
that Brutus' action was right, that he approved of it; but he
would not be *saying* that he did, nor would anything that he
said (if anything) *imply* (in the sense of "entail") that he did
approve of it: just as, if I say that I went to the pictures last
Tuesday, I *imply by saying* so that I believe or know that I did,
but I do not *say* that I believe or know this, nor does *what* I
say, namely that I went to the pictures, *imply* (in the sense of
"entail") that I do believe or know it. I think Mr. Stevenson's
apparent confidence that, in at least one "typically ethical" sense,
a man who asserted that it was right of Brutus to stab Caesar,
would be *asserting* that he approved of this action, may be partly

due to his having never thought of this alternative that he might be only *implying* it. But I think it may also be partly due to his shrinking from the paradox which would be involved in saying that, even where it can quite properly be said that a man is *asserting* that Brutus' action was right, yet he may be asserting *nothing whatever that could possibly be true or false*—that his words have absolutely no *cognitive* meaning—except, perhaps, that Brutus did stab Caesar. This paradox, however, is, I think, no greater than paradoxes which Mr. Stevenson is willing to accept, and I think that very possibly it may be true. So far as I can understand it, I think Mr. Stevenson's actual view is that sometimes, when a man *asserts* that it was right of Brutus to stab Caesar, the sense of his words is (roughly) much the same as if he had said "I approve of Brutus' action: do approve of it too!" the former clause giving the *cognitive* meaning, the latter the *emotive*. But why should he not say instead, that the sense of the man's words is *merely* "Do approve of Brutus' stabbing of Caesar!"—an imperative, which has absolutely no *cognitive* meaning, in the sense I have tried to explain? If this were so, the man might perfectly well be *implying* that he approved of Brutus' action, though he would not be *saying* so, and would be asserting nothing whatever, that might be true or false, except, perhaps, that Brutus did stab Caesar. It certainly seems queer—paradoxical—that it should be correct to say that the man was *asserting* that Brutus' action was right, when the only meaning his words had was this imperative. But may it not, nevertheless, actually be the case? It seems to me more likely that it is the case, than that Mr. Stevenson's actual view is true.

There seems to me to be nothing mysterious about this sense of "imply," in which if you assert that you went to the pictures last Tuesday, you *imply*, though you don't *assert*, that you believe or know that you did; and in which, if you assert that Brutus' action was right, you *imply*, but don't *assert*, that you approve of Brutus' action. In the first case, that you do imply this proposition about your present attitude, although it is not implied by (i.e., does not follow from) *what* you assert, simply arises from the fact, which we all learn by experience, that in the immense majority of cases a man who makes such an asser-

tion as this does believe or know what he asserts: lying, though common enough, is vastly exceptional. And this is why to say such a thing as "I went to the pictures last Tuesday, but I don't believe that I did" is a perfectly absurd thing to say, although *what* is asserted is something which is perfectly possible logically: it is perfectly possible that you did go to the pictures and yet you do not believe that you did; the proposition that you did does not "imply" that you believe you did—that you believe you did does not *follow from* the fact that you did. And of course, also, from the fact that you say that you did, it does not follow that you believe that you did: you might be lying. But nevertheless your saying that you did, does *imply* (in another sense) that you believe you did; and this is why "I went, but I don't believe I did" is an absurd thing to say. Similarly the fact that, if you assert that it was right of Brutus to stab Caesar, you *imply* that you approve of or have some such attitude to this action of Brutus', simply arises from the fact, which we have all learnt by experience, that a man who makes this kind of assertion does in the vast majority of cases approve of the action which he asserts to be right. Hence, if we hear a man assert that the action was right, we should all take it that, unless he is lying, he does, at the time of speaking, approve, although he has *not* asserted that he does.

(2) Let us next consider the second part of Mr. Stevenson's view: namely the part which asserts that in some "typically ethical" cases, a man who asserts that it was right of Brutus to stab Caesar, is not asserting anything that might conceivably be true or false, *except* that he approves of Brutus' action, and possibly also that Brutus did stab Caesar. By this I mean a view which is merely negative: which does *not* assert that there are any cases in which such a man *is* asserting that he approves of Brutus' action; but which only asserts that there are cases in which he is *not* asserting anything *else*, leaving perfectly open the possibility that in all such cases he is not asserting *anything at all*, which could conceivably be true or false. Mr. Stevenson, of course, does not express any belief that there are any cases in which such a man, using the *definiendum* in a "typically ethical" sense, would not be asserting *anything at all*, which might con-

ceivably be true or false. But he does imply that, if you consider all propositions, other than the propositions (1) that he now approves of Brutus' action and (2) that Brutus did stab Caesar and (3) the conjunction of these two, then there are cases in which such a man is not asserting any single one of these *other* propositions. This is the view of his I want now to consider.

It certainly is inconsistent with views which I have expressed or implied. I have certainly implied that in all cases in which a man were to assert in a "typically ethical" sense that it was right of Brutus to stab Caesar, he would be asserting something, capable of truth or falsity (some proposition, that is) which both (a) is not identical with any of the three propositions just mentioned, (b) does not follow from (3), and (c) is also a proposition from which (1) does not follow: some proposition, therefore, which might have been true, even if he had not approved of Brutus' action, and which may be false, even though he does approve of it—which is, in short, completely independent logically of the proposition that he does approve of the action.

What are we to say about these two incompatible views—the second part of Mr. Stevenson's view, and the view, implied in my writings, which I have just formulated?

I think I ought, first of all, to make as clear as I can what my present personal attitude to them is. I certainly think that this second part of Mr. Stevenson's view *may* be true: that is to say, I certainly think that I don't *know* that it is not true. But this is not all. I certainly have some inclination to think that it *is* true, and that therefore my own former view is false. And, thinking as I do, that the first part of Mr. Stevenson's view is false, this means that I have some inclination to think that there is at least *one* "typically ethical" sense of the sentence "It was right of Brutus to stab Caesar," such that a man who used this sentence in that sense and used it in such a way that he could be properly said to be *asserting* that this action of Brutus' was right, would nevertheless not be asserting anything at all that could conceivably be true or false, except, perhaps, that Brutus did stab Caesar: nothing, that is, *about* Brutus' action except simply that

it occurred. And, going far beyond Mr. Stevenson's cautious assertion, I have a very strong inclination to think that, *if* there is at least *one* "typically ethical" sense of which these things are true, then of *all* "typically ethical" senses these things are true. So that I have some inclination to think that in *any* "typically ethical" sense in which a man might assert that Brutus' action was right, he would be asserting nothing whatever which could conceivably be true or false, except, perhaps, that Brutus' action occurred—no more than, if he said, "Please, shut the door." I certainly have *some* inclination to think all this, and that therefore not merely the contradictory, but the contrary, of my former view is true. But then, on the other hand, I also still have *some* inclination to think that my former view *is* true. And, if you ask me to which of these incompatible views I have the *stronger* inclination, I can only answer that I simply do not know whether I am any more strongly inclined to take the one than to take the other.—I think this is at least an honest statement of my present attitude.

Secondly, I want to call attention to the fact that, so far as I can discover, Mr. Stevenson neither gives nor attempts to give any reason whatever for thinking that his view is true. He asserts that it *may* be true, i.e., that he does not know that it's not, and that he *thinks* it is true; but, so far as I can see, he gives absolutely no positive arguments in its favour: he is only concerned with showing that certain arguments which might be used against it are inconclusive. Perhaps, he *could* give some positive reasons for thinking that it is true. But, so far as I am concerned, though, as I say, I have some inclination to think it is true, and even do not know whether I have not as much inclination to think so as to think that my former view is so, I can give no positive reasons in its favour.

But now, how about reasons for thinking that Mr. Stevenson's view is false and my former one true? I can give at least one reason for this, namely that it *seems as if* whenever one man, using "right" in a "typically ethical" sense, asserts that a particular action was right, then, if another, using "right" in the same sense, asserts that it was not, they are making assertions which are logically incompatible. If this, which seems to be the

case, really were the case, it would follow that Mr. Stevenson's view is false. But, of course, from the fact that it *seems* to be the case, it does not follow that it really is the case; and Mr. Stevenson suggests that it seems to be the case, not because it really is the case, but because, when such a thing happens, the two men, if both are sincere, really are *differing in attitude* towards the action in question, and we mistake this difference of attitude for the holding of logically incompatible opinions. He even says, in one place (p. 82), that he thinks I was led falsely to affirm that two such men really are holding logically incompatible opinions, because I "could not understand how people could differ or disagree in any sense" without holding logically incompatible opinions.

Now I think that as regards this suggestion as to how I was led to affirm that two such men are holding logically incompatible opinions, Mr. Stevenson has certainly not hit the right nail on the head. I think that, even when I wrote *Principia Ethica*, I was quite capable of understanding that, if one member of a party, A, says "Let's play poker," and another, B, says "No; let's listen to a record," A and B can be quite properly said to be disagreeing. What is true, I think, is that, when I wrote the *Ethics*, it simply had not occurred to me that in the case of our two men, who assert sincerely, in a "typically ethical" sense of "right," and both in the same sense, the one that Brutus' action was right, the other that it was not, the disagreement between them might possibly be merely of that sort. Now that Mr. Stevenson has suggested that it may, I do feel uncertain whether it is not merely of that sort: that is to say, I feel uncertain whether they are holding incompatible opinions: and therefore I completely agree with Mr. Stevenson that, when I used the argument "Two such men can't be merely asserting the one that he approves of Brutus' action, the other that he does not, because, if so, their assertions would not be logically incompatible," this argument was inconclusive. It is inconclusive, because it is not certain that their assertions are logically incompatible. I even go further, I feel some inclination to think that those two men are *not* making incompatible assertions: that their disagreement *is* merely a disagreement in attitude, like

that between the man who says "Let's play poker" and the other who says "No; let's listen to a record:" and I do not know that I am not *as much* inclined to think this as to think that they are making incompatible assertions. But I certainly still have *some* inclination to think that my old view was true and that they *are* making incompatible assertions. And I think that the mere fact that they *seem to be* is *a* reason in its favour, though, of course, not a conclusive one. As for Mr. Stevenson's cautious view that, in at least *one* "typically ethical" case, they are merely disagreeing in attitude and not making logically incompatible assertions, he, of course, gives no reason whatever for thinking it true, and I can see none, though I am perhaps as much inclined to think it is true, as to think that my old view is. How on earth is it to be settled whether they *are* making incompatible assertions or not? There are hosts of cases where we do know for certain that people *are* making incompatible assertions; and hosts of cases where we know for certain that they are not, as, for instance, if one man merely asserts "I approve of Brutus' action" and the other merely asserts "I don't approve of it." Why should there be this doubt in the case of ethical assertions? And how is it to be removed?

I think, therefore, that Mr. Stevenson has certainly not *shewn* that my old view was wrong; and he has not even *shewn* that this particular argument which I used for it is not conclusive. I agree with him that it is not conclusive. But he has not *shewn* that it is not; since he has simply asserted that in at least one "typically ethical" case two such men *may* be merely differing in attitude and not holding incompatible opinions: he has not shewn even that they *may*, i.e., that it is not certain that they aren't, far less that it is ever the case that they *are*. But there is one statement which I made in my *Ethics*, which he has definitely shewn to be a mistake; and I think this mistake is perhaps of sufficient interest to be worth mentioning.

I asserted that from the two premisses (1) that, whenever any man asserts an action to be right or wrong, he is *merely* making an assertion about his own feelings towards it, and (2) that sometimes one man really has towards a given action the kind of feeling, which he would be asserting that he had to it

if he said it was right, while another man really has towards the same action the kind of feeling, which he would be asserting that he had to it if he said it was wrong—that from these two premisses there *follows* that the same action is sometimes both right and wrong. But this was a sheer mistake: that conclusion does *not* follow from these two premisses. In order to see that it does not, and why it does not, let us take a particular case. Suppose it were true (a) that the best English usage is such that a man will be using the words "It was wrong of Brutus to stab Caesar" *correctly*, i.e., in accordance with the best English usage, if and only if he means by them neither more nor less than that he himself, at the time of speaking, disapproves of this action of Brutus'; and that hence he will be using them *both* correctly *and* in such a way that what he means by them is *true*, if and only if, at the time when he says them, he does disapprove of this action. (Of course, a man may be using a sentence perfectly correctly, even when what he means by it is *false*, either because he is lying or because he is making a mistake; and, similarly, a man may be using a sentence in such a way that what he means by it is *true*, even when he is not using it correctly, as, for instance, when he uses the wrong word for what he means, by a slip or because he has made a mistake as to what the correct usage is. Thus using a sentence *correctly*—in the sense explained—and using it in such a way that what you mean by it is *true*, are two things which are completely logically independent of one another: either may occur without the other.) Let us, for the sake of brevity, use the phrase "could say *with perfect truth* the words 'It was wrong of Brutus to stab Caesar'," to mean "could, if he said them, be using them *both* correctly *and* in such a way that what he meant by them was true." It will then follow from the supposition made above that a man could, at a given time, say with perfect truth the words "It was wrong of Brutus to stab Caesar," if and only if, at the time in question, he was disapproving of this action of Brutus'; that from the fact that he is disapproving of this action it will *follow* that he could say those words with perfect truth, and from the fact that he could say them with perfect truth it will *follow* that he is disapproving of that action. Let us simi-

larly suppose it were true (b) that a man could at a given time say with perfect truth the words "It was right of Brutus to stab Caesar," if and only if at that time he were approving of this action of Brutus'. And let us finally suppose it were also true (c) that some man, A, has actually at some time disapproved of this action of Brutus', and that *either* the same man, A, has also, at another time, approved of it *or* some other man, B, has at some time approved of it. The question is: Does it follow from (a) (b) and (c) taken jointly, that Brutus' action in stabbing Caesar was both right and wrong? If this does not follow, in this particular case, then from my two premisses (1) and (2) it does not follow that sometimes an action is both right and wrong, and I was making a sheer mistake when I said it did.

Now from (a) (b) and (c) together it *does* follow that at some time somebody could have said with perfect truth the words "It was wrong of Brutus to stab Caesar" and also that at some time somebody could have said with perfect truth the words "It was right of Brutus to stab Caesar." And at first sight it is very natural to think that if somebody could have said with perfect truth the words "It was wrong of Brutus to stab Caesar," it *does* follow that it *was* wrong of Brutus to stab Caesar, and similarly in the other case. It is very natural to identify the statement "Somebody could have said with perfect truth *the words 'Brutus' action was wrong' "* with the statement "Somebody could have said with perfect truth that Brutus' action was wrong;" and then to ask: If Brutus' action wasn't wrong, how could anybody possibly have ever said with perfect truth that it was? Indeed, I think the latter form of statement very often is used, and can be correctly used, to mean the same as the former; and it is a peculiarity of premiss (1), and therefore also of (a), that it follows from them that it *could* be correctly used in a different sense, and that, if so used, then from "Somebody could have said with perfect truth that Brutus' action was wrong" it really would follow that Brutus' action was wrong, although from "Somebody could have said with perfect truth *the words* 'Brutus' action was wrong' " it would *not* follow that it was wrong. But, even apart from this identification, there are thousands of cases in which from a proposition of the form "Some-

body could have said with perfect truth *the words 'p' "* p does follow: e.g., from "Somebody could have said with perfect truth the words 'Brutus stabbed Caesar' " it really does follow that Brutus did stab Caesar; if he didn't, then nobody could ever possibly have said these words with perfect truth. It was, therefore, very natural that I should think that from (a) and (c) taken together it really would follow that Brutus' action was wrong, and from (b) and (c) taken together that it was right. But nevertheless it was a sheer mistake. What I had failed to notice was that from (a) it follows that from "Somebody could have said with perfect truth *the words* 'Brutus' action was wrong' " it does *not* follow that Brutus' action was wrong. For we saw that, if (a) were true, then "Somebody could have said with perfect truth *the words* 'Brutus' action was wrong' " would be simply equivalent to "Somebody has at some time disapproved of Brutus' action;" while, also, anybody who was using the words "Brutus' action was wrong" correctly would mean by them simply that he himself, at the time of speaking, disapproved of Brutus' action. Hence, if (a) were true, anybody who said "From the fact that somebody could have said with perfect truth 'Brutus' action was wrong' it follows that Brutus' action was wrong" would, if he were using the last four words *correctly,* be committing himself to the proposition that from the fact that somebody has at some time disapproved of Brutus' action it follows that he himself, at the time of speaking, disapproves of it—which is, of course, absurdly false. If, on the other hand, he were not using the last four words correctly, what he was asserting to follow from the fact that somebody had at some time disapproved of Brutus' action would not be that Brutus' action was wrong, but something else which he was incorrectly using those words to mean. Hence, if (a) were true, it would not follow from the fact that some-one could at some time have said with perfect truth "Brutus' action was wrong," that Brutus' action was wrong. Anybody who said that it did, would mean by saying so (if speaking correctly), something different from what anyone else who said it would mean; and each of all those different things would be absurdly false. And hence it was a sheer mistake to infer that because from (a) and (c) jointly, it

would follow that some-one could have said with perfect truth *the words* "Brutus' action was wrong," therefore it would also follow that Brutus' action was wrong: the latter would not follow, though the former would. If on the other hand, instead of the statement "Some-one could have said with perfect truth *the words* 'Brutus' action was wrong',' " we consider the statement which I contrasted with it above, namely, "Some-one could have said with perfect truth that Brutus' action was wrong," this latter, if (a) were true, *could* mean, if said by me, "Some-one could have said with perfect truth that I now disapprove of Brutus' action" from which, of course, it would follow that I do now disapprove of Brutus' action.

Perhaps, all this could have been said much more simply. Perhaps Mr. Stevenson has said it more simply. But in any case I completely agree with him that it was a sheer mistake on my part to say that from premises (1) and (2) it would follow that the same action was sometimes both right and wrong; and it is he who has convinced me that it was a mistake.

Perhaps, I ought, finally, to explain why I said above that, if Mr. Stevenson's view about "typically ethical" uses of the word "right" were true, then "right" when used in a typically ethical way would not be "the name of a characteristic;" and that if "right" were not, then "good," in the sense I was principally concerned with, would also not be.

Of course, it is not strictly true that this follows from Mr. Stevenson's view. As I have emphasized, he cautiously limits himself to saying that in at least *one* typically ethical use, "right" is used in a particular way, leaving open the possibility that, even if, when used in that way, it would not be "the name of a characteristic," yet there may be other ethical uses in which it is the name of a characteristic. But it seems to me that if there is even *one* ethical use such as Mr. Stevenson holds that there is, then probably *all* ethical uses are like it in the respect which makes me say that if used as Mr. Stevenson thinks it sometimes is, it would not be the "name of a characteristic."

Why, then, did I say that "right," if used in the way Mr. Stevenson describes, would not be "the name of a characteristic?" I am afraid my reason was no better than this. If "right"

were used in the way in question, it would follow both (1) that no two people, who, using it in that way, said of the same action that it was right or would be right, would ever be saying the same thing about it, since one would be saying that he, at the time of speaking, approved of it, while the other would be saying that *he* did, and also (2) that no single person who said of the same action on two different occasions that it was right or would be right, would ever be saying the same thing about it on the one occasion as he said about it on the other, since on the one occasion he would be saying that he approved of it at *that* time, and on the other would be saying that he approved of it at that other, different, time. In short, "right," if used in Mr. Stevenson's way, would mean something different every time it was used in predication. And it seemed to me, and does still seem to me, that to say of a word that, in one particular use, it is "the name of a characteristic" would naturally be understood to mean that, when used in that way, it does mean the same both when used at different times and when used by different persons. If it does not, then, there is no one characteristic of which it is the name. Of course, it might be said, that "right," when used in the way Mr. Stevenson describes, would be the name of one and only one "characteristic" each time it was used, though of a different one each time; though this would have to be qualified by saying that on each occasion, though it was the name of a characteristic, it was not *merely* the name of a characteristic, since it also had "emotive meaning." I think this would be in accordance with the way in which philosophers use the term "characteristic" (and, I imagine, the way in which Mr. Broad was using it), since they do sometimes so use it, that if I say now "I approve of Brutus' stabbing of Caesar," I am attributing to this action of Brutus' a certain "characteristic," namely that of being approved by me now. This is, of course, a very different use of the word "characteristic" from any which is established in ordinary speech: nobody would think of saying, in ordinary conversation, that this action of Brutus' has, if I do approve of it now, a characteristic which it would not have had, if I had not: we ordinarily so use "characteristic" that "being approved of now by me" or "being spoken of now

by me" could not be "characteristics" of that action at all: but nevertheless there is, I think, a well-established philosophical usage in which they would be, provided I do now approve of that action or do now speak of it; and I imagine that Mr. Broad was using "characteristic" in this philosophic way. It must then be admitted that "right," if used in the way Mr. Stevenson describes, would, in this sense of "characteristic," be the name of a characteristic each time it was used, though of a different one each time, and though it would never be *merely* the name of a characteristic, since it would also always have "emotive meaning." But this fact, it seems to me, would not justify us in saying that, in this use, it was the name of a characteristic; since this latter phrase would naturally be understood to mean that, in this use, it was the name of *one and the same characteristic when used at different times and by different persons.*

But to say that "right," in its ethical uses, is not "the name of a characteristic" might also mean something else, which I think probably Mr. Broad had in mind, when he said it was a question whether "good" (in that particular usage) is a name for a characteristic at all. Suppose it were the case that, as regards at least *one* "typically ethical" use of "right," what I called above the first part of Mr. Stevenson's view were false, while the second were true, so that "It was right of Brutus to stab Caesar," when used in this way, had absolutely no *cognitive* meaning at all (except, perhaps, that Brutus did stab Caesar) but were merely equivalent to some such imperative or petition as "Do approve of Brutus' stabbing of Caesar!" Then, in this case, "right," so used, would not be the name of a characteristic, in the sense that a person who asserted, in this sense, that it was right of Brutus to stab Caesar, would not be asserting anything at all that could possibly be true or false, except, perhaps, simply that Brutus did stab Caesar: by asserting that Brutus' action was right, he would not be asserting anything at all *about* that action, beyond its mere occurrence. That "right" is, in this sense, not the name of a characteristic, is, of course, not a view which can be attributed to Mr. Stevenson, since he only maintains that the second part of his view is true in cases where the first part is true too, i.e., where "It was right of Brutus to stab

Caesar" has *some* cognitive meaning each time it is uttered, though a different one every time and for every person that utters it. But I said above that I thought it more likely that the second part of his view is true, and the first false, than that both are true together; and if this were so then "right" would, in this more radical sense, not be "the name of a characteristic."

I must say again that I am inclined to think that "right," in all ethical uses, and, of course, "wrong," "ought," "duty" also, are, in this more radical sense, not the names of characteristics at all, that they have merely "emotive meaning" and no "cognitive meaning" at all: and, if this is true of them, it must also be true of "good," in the sense I have been most concerned with. I am *inclined* to think that this is so, but I am also inclined to think that it is not so; and I do not know which way I am inclined most strongly. If these words, in their ethical uses, have only emotive meaning, or if Mr. Stevenson's view about them is true, then it would seem that all else I am going to say about them must be either nonsense or false (I don't know which). But it does not seem to me that what I am going to say is either nonsense or false; and this, I think, is an additional reason (though, of course, not a conclusive one) for supposing both that they have a "cognitive" meaning, and that Mr. Stevenson's view as to the nature of this cognitive meaning is false.

2. *Relations between "good" and "ought"*

I think it is true that, among the many different senses in which the word "good" is used, there is one particular sense which is *the* sense which I have been mainly concerned to talk about in my ethical writings. Perhaps I may sometimes have confused this sense with other closely allied senses. But I think it is true that, in the main, there is just one sense with which I have been principally concerned. I have often used the expression "intrinsically good" as a synonym for "good," when used in this particular sense, and I have also sometimes used the expression "has intrinsic value" as a synonym for "is good," when "good" is used in this particular sense.

I have tried, in many different ways, to make clear *which* of the many different senses in which "good" is used was the

one I was talking of; and at least one of the ways in which I tried to make this clear was a positive mistake. Namely, in my paper on "Is Goodness a Quality?"[1] I said that I thought that the particular sense of "good" with which I had been concerned, was one in which "is good" meant "is an experience which is worth having for its own sake." This was a sheer mistake as to my own usage; since the sense of "good" with which I had been principally concerned was such that to say of a state of things in which two or more people were all having experiences worth having for their own sake that it was "good" in the sense in question would not be self-contradictory, whereas to say of such a state of things that it was *itself* an experience worth having for its own sake would be self-contradictory. I still think it is true that any experience which is worth having for its own sake *must* be "good" in the sense I was concerned with; but it was a sheer error to imply that, conversely, any state of things which is "good" in the sense in question must be an experience worth having for its own sake.

Let me try now, in a new way, to say *which* sense of "good" is the one I was concerned with. Everybody, I suppose, is familiar with the grammatical statements that "better" is the comparative (or "comparative degree") of "good," and "good" the positive (or "positive degree") of "better." Now it seems to me that just as there are many different senses in which the word "good" is used, so there are many different senses in which the word "better" is used; and that, if you consider any two different senses of "better," there will be one sense of "good" and one only which is the "positive" of one of the two, and a different sense of "good" which is the "positive" of the other. And I think that the sense of "good" with which I have been chiefly concerned can be pointed out by specifying one particular sense of "better," and saying that the sense of "good" in question is the one which is the "positive" of "better" in the sense specified.

Which sense of "better" is the one which is the comparative of the sense of "good" with which I have been principally concerned? I think this is a question which can only be answered

<hr>

[1] *Proceedings Aristotelian Society,* Suppl. Vol. XI, 121-124.

by giving examples of intelligible statements in which "better" is used in the sense in question. And I propose to give two such statements. The first is the statement, which was, I believe, made by Leibniz, that this world is *better* than any other possible world would have been—a statement which is more familiar, when expressed in the form, "This is the *best* of all possible worlds." The second is a statement which seems to me to have been implied, if it has not actually been asserted, by Quantitative Hedonistic Utilitarians: viz., that of any two possible worlds, neither of which contained any pleasure at all, but both of which contained some amount of pain, then, if the one contained less pain than the other, that one would be a *better* world than the other, no matter what they might be like in other respects. Both of these two statements seem to me to be *intelligible*, whether we agree with them or not. And I do not think they would be intelligible, unless in them "better" were used in a sense in which it often is used in common speech.

Now, as I pointed out in my *Ethics* (pp. 63-64), we often use "better" in such a way that from the proposition that one thing, A, is *better* than another, B, it does not follow that either A or B is "good" in the sense which is the "positive" of the sense of "better" in question. "A is better than B" is often used in such a way that it follows from "B is worse than A;" and it is quite clear that "B is worse than A" does not imply that either A or B is good. Thus, if we say, for instance, that one knife is better than another, it is quite clear that we may be expressing correctly a true proposition, even if neither knife is a good knife: there is no contradiction in saying "This knife is better than that, but they are both very bad." And the same rule holds with regard to many "comparatives" and their corresponding "positives:" e.g., from the fact that one blot is *larger* than another, it by no means follows that either is *large;* it may quite well be the case that both are very small, in spite of the fact that "large" is the "positive" of "larger." Now this rule holds with regard to the sense in which "better" is used in the two propositions quoted above. From the proposition that one possible world would be better than another, it by no means follows that either would be "good," in that sense of "good" which is

the "positive" of the sense of "better" in question. I suggested, indirectly, in my *Ethics*, that to say of a possible world that it would be a "good" world, in this sense, is logically equivalent to saying that it would be *better* that the world in question should exist than that *there should be no world at all:* that is to say that from the proposition with regard to a possible world that it would be a good world, *it follows* that it would be better that the world in question should exist than that there should be no world at all; while also from the proposition, with regard to a possible world, that it would be better that it should exist than that there should be no world at all, it *follows* that the world in question would be a good world. And I am still inclined to think that this is true of "good," in the sense with which I was concerned, that is to say, of that sense of "good" which is the "positive" of the sense in which "better" is used in the two propositions given above. But now, the senses of "good" and "better" in question would be related in this way, if to say of a possible world that it would be "good," in this sense, simply *meant* that it would be better that the world in question should exist than that no world at all should exist— if, that is to say, this sense of "good" were, in this particular way, *definable in terms of* the sense of "better" in question. For if "A would be a good world" simply *meant* "It would be better that A should exist than that there should be no world at all," then it would follow that "A would be a good world" was *logically equivalent* to "It would be better that A should exist than that there should be no world at all." But though from the proposition that this sense of "good" was, in this way, definable in terms of this sense of "better," it would follow that these two propositions were logically equivalent (if "good" and "better" were used in the senses in question), I do not think it follows from the proposition that they are logically equivalent, that the sense of "good" in question *is* definable in terms of the sense of "better" in question. And I am in fact very doubtful whether this sense of "good" *is* definable in terms of this sense of "better"—whether, that is to say, "A would be a good world" simply *means* "It would be better that A should exist, than that there should be no world at all."

Now in *Principia* I asserted that there was a necessary connection between this sense of "better" and the notion of *moral obligation*. On p. 147 I say that the assertion "I am morally bound to perform this action" is *identical with* the assertion "This action will produce the greatest possible amount of good in the Universe," and a few lines lower down I imply that this latter assertion is identical with the assertion "The whole world will be *better,* if this action be performed, than if any possible alternative were taken." Of these two latter expressions I think that the last expressed my meaning better than the former; for I do not think I wished to deny that, in a case where you had no chance of producing any good whatever, but where you would cause there to be *less evil,* if you did one thing than if you did anything else within your power, it would be your duty to do the thing which would minimise the amount of evil (e.g., *Principia Ethica,* p. 25): and to say that in such a case you would be "producing the greatest possible amount of good" seems to me to be an inexcusably loose and misleading way of speaking. But, however that may be, I did commit myself to the view that the assertion "I am morally bound to perform this action" is *identical with* the assertion "The whole world will be *better* if I do this action than if I were to do instead anything else that I could do."

Now this assertion in *Principia* that these two expressions were *identical* in meaning entailed the view that the notion of moral obligation could be *defined in terms of* this particular sense of "better"—which I called "intrinsically better:" that, therefore, "intrinsically better" was a more fundamental notion than the notion of moral obligation. But I very soon came to doubt whether this was the case. As a matter of historical fact, I think that Mr. Bertrand Russell, in his review of *Principia,* pointed out that it was very paradoxical to say that "This is what I ought to do" is merely a shorter way of saying "The Universe will be a better Universe if I do this than if I were to do instead anything else which I could do;" he suggested that this can hardly be true, and I was inclined to agree with him. Accordingly, in my *Ethics,* I refrained from making this paradoxical assertion (although in *Principia,* p. 147, I had asserted

that it was "demonstrably certain"!); I still thought that it *might* be true (*Ethics*, 61); but all that I was inclined to assert was that the two statements were *logically equivalent, not* that they were *identical.* The view that they were *logically equivalent* I still did try to defend and argue for. But unfortunately in the *Ethics* (as also, I think, in *Principia*) I did not clearly distinguish between the proposition "The Universe will be intrinsically better, if I do this action, than it would be if I did any other action within my power" and the proposition "The total results (or 'consequences') of this action will be intrinsically better than would be the total results of any other action within my power," where this latter proposition is understood in a sense in which it is *not* equivalent to the former. One natural way, and perhaps the most natural way, of understanding the expression "the total consequences of the action, A," is one in which among the consequences of A nothing is included but what is the case *subsequently* to the occurrence of A, so that the "total consequences of A" means everything which is the case *subsequently* to A's occurrence, which is also such that it would not have been the case if A had not occurred. And it now seems to me important to insist that from the proposition that the total consequences of A, *in this sense,* would be better than would be the total consequences of any other act open to the agent, it does *not* follow that the Universe will be better if he does A than if he had done anything else in his power; and also that from the proposition that the Universe will be better if he does A than if he had done anything else in his power, it does not follow that the total consequences of A, *in this sense,* would be better than would be those of any other action open to him. One reason for saying this, but only one, is that the occurrence of A in the circumstances in which it occurs may itself have some intrinsic value, which may make a difference to the value of the Universe, whereas, by definition, it can make none to the value of the *total results* of A, understood *in this sense;* since the total results are now defined as consisting exclusively of what is the case *subsequently* to the occurrence of A. It will be obvious that the distinction which I am here drawing between the conception "act of which it is true that the Universe will be

better, if it be done, than if any other act open to the agent were done instead" and the conception "act of which the total consequences will be better than would be those of any other act open to the agent" is in some respects similar to that which Mr. Broad draws (p. 48) between the conception "optimising act" and the conception "optimific act." Mr. Broad also, if I understand him rightly, would insist that of his pair of conceptions neither entails the other—would insist, that is to say, that from the proposition that an act is "optimising" it does not follow that it is "optimific," and also that from the proposition that an act is "optimific" it does not follow that it is "optimising." There are, however, differences between his pair of conceptions and mine—one obvious one, and another less obvious—upon which I need not dwell. What I do want to insist upon is that when in *Ethics* (pp. 170, 195) I defended the view that the question whether an action is right or wrong always depends upon its actual total consequences, I was, I am afraid, not distinguishing between the two views (1) that, in doing a given action, I shall have done my duty, if and only if the total consequences of the action *subsequent* to its occurrence are intrinsically better than those of any other action I could have done instead, and (2) that, in doing a given action, I shall have done my duty, if and only if *the world* is intrinsically better, owing to my having done that action, than it would have been if I had done anything else that I could have done instead.

Now Mr. Frankena, on p. 94, attributes to me the view that "The right act or the act which we ought to do is always and necessarily the act which promotes as much intrinsic good in the universe as a whole as possible." And, if I understand him rightly, he regards two other expressions which he uses a little later (p. 95) as merely alternative ways of expressing exactly the same view. These are: "The right or obligatory act is always and necessarily the act which is most conducive to intrinsic good" and "Our only ultimate duty is to do what will produce the greatest possible balance of intrinsic value." But I do not think that the first of these three expressions does express the same view as either of the other two; and the view which it does express seems to me to be one which I have certainly

never held. This is because the expression *"the* act which pro-
motes as much intrinsic good . . . as possible" implies that among
the acts open to an agent at a given time there is never more
than *one* which would produce as much intrinsic good as any
of the other acts open to him. I think I have always held that
there are sometimes open to an agent at a given time two or
more acts, any one of which would produce *as much* intrinsic
good as the other or others; so that in such cases there would
be no act which was *the* act which would produce as much as any
other open to him. I have held that, in such cases, any one of
these acts which produce *as much* as any act open to him, would
be an act which it was *right* for him to perform, and that there-
fore there would, in such cases, be no act which was *the* right
act for him to perform and no act which he *ought* to perform;
since to say of an act that it is *the* right thing for him to do or
that he ought to do it implies that no other act would be right
for him. I cannot, therefore, accept Mr. Frankena's first expres-
sion as expressing any view that I have ever held. But how
about the other two? These two expressions are not open to the
objection I have made against the first, since here, instead of
saying "*as much* intrinsic good . . . as possible" as he does in
the first, he says, "*most* conducive to intrinsic good," "will
produce the *greatest* possible balance of intrinsic good;" and
there cannot, of course, be two or more actions open to an agent
at a given time, each of which will produce *more* intrinsic good
or a *greater* balance of intrinsic value than any other open to
him: to say that there were would be a contradiction, whereas
to say that there are two or more each of which will produce
as much as any other open to him is, of course, not a contradic-
tion. But both of these two latter expressions are, I think, am-
biguous in both of two ways which I have just pointed out (pp.
558, 559). (1) They might be understood in such a way as to
imply that no action can ever be our duty unless it produces
some intrinsic good; a view, which, though, as I have admitted,
I have sometimes expressed myself as if I held it, I do not
think that I ever really held; since, as I have said, I think I
always held that if the only choice open to us were between two
actions, neither of which would produce *any* intrinsic good, but

one of which would make the Universe *less bad* than the other would, then it would be our duty to do the former (p. 558). (2) If they are not understood in this way, they might still be understood to mean either (*a*) that an action is our duty if and only if its *subsequent* effects would be intrinsically better than those of any other action open to us, *or* (*b*) that an action is our duty, if and only if, the world as a whole would be better, if it were done, than if any other action open to us were done. And if either of these two views is what Mr. Frankena means, then I think I must plead guilty to having held them both. Of these two alternatives, it would appear from what he says under (b) on p. 95, that he meant the former. But there is still one point in the expressions he uses, to which I think it is important to call attention. In the first and second expressions, though not in the third, he inserts the word "necessarily." He says my view is that "The right or obligatory act is always and *necessarily* the act which is most conducive to intrinsic good." Suppose we understand the phrase "which is most conducive to intrinsic good" to mean merely "of which the *subsequent* effects would be intrinsically better than those of any other action open to the agent." The view he is attributing to me is then, apparently, not merely the view that an action is our duty, *if and only if* its subsequent effects would be intrinsically better than those of any other action open to us, but also the view that this is *necessarily* so. What does this come to? I think the clearest way of expressing what it comes to is to say that the view which he is attributing to me is the view that from the proposition "The total subsequent effects of this action would be intrinsically better than those of any action I could do instead" there *follows* "I ought to do this action." And I am glad that Mr. Frankena put in the "necessarily," because, although I do not know that I ever clearly said so, I think this is a view which I have held and implied. What I think perhaps Mr. Frankena has overlooked is that, so far as I have held or implied this, I have also held or implied the converse—namely that from "I ought to do this act" there *follows* "The subsequent effects of this act would be intrinsically better than those of any thing else that I could do instead." In other words, I was maintaining that there is what

Mr. Paton (p. 118) calls "a necessary and *reciprocal* connection" between the notion "act which ought to be done by *x*" and the notion "act whose subsequent effects would be intrinsically better than those of any other act which *x* could do instead."

But now let us suppose that the view which Mr. Frankena meant to express by those three different expressions which he seems to take (wrongly) to express exactly the same view, was the view that from the proposition "This action would have better total subsequent effects than any other open to me" there *follows* the proposition "I ought to do this action, I am morally bound to do this action, it is my duty to do this action." I will now, for the sake of brevity, call this view "Principle 6," though it is only what he meant to express by the first of the two sentences to which he prefixes the number "6" on p. 94.

Mr. Frankena goes on to say that Principle 6 has two parts (pp. 94-5). What he calls "the second part" is, so far as I can make out, *identical* with Principle 6 itself (a curious use of language!); and what he calls "the first part" is, so far as I can make out, a proposition which he takes to be entailed by Principle 6, but not to entail it, and to be in that sense a "part" of it. It is this first part which he says he proposes to discuss; and he formulates this also in three different ways. He says that it is the view (1) "that the intrinsically good ought to be *promoted*" (2) "that a thing's having intrinsic value *so far* makes it a duty to produce it if possible" (3) "that we have, in Sir David Ross's terms, a *prima facie* duty to *promote* what is intrinsically good."

Now Mr. Frankena seems to think that these three expressions all express exactly the same view. But it seems to me that (1) and (3) cannot possibly express the same view, if "promote" is used in the same sense in both. I do not think I understand at all completely how Sir David uses the expression *"prima facie* duty;" but I thought he had made one thing plain, namely, that he uses it in such a way that from "it is a *prima facie* duty for me to do so and so" it does *not* follow that it is my duty to do the thing in question. Does he not hold that it is a *prima facie* duty to keep a promise, but that nevertheless it is not absolutely always a man's duty to keep a promise? Does he not hold

that the fact that it is a *prima facie* duty to keep one is a very strong, but *not an absolutely conclusive*, reason for supposing that it is my duty to keep one in a particular case? Perhaps I have misunderstood him; but, if not, then I think that (1) and (3) cannot possibly express the same view, if "promote" is used in the same sense. (1) says, presumably, that it is "always and necessarily" a duty to promote what is intrinsically good, whereas (3) says that it is *only a prima facie* duty to do exactly the same thing!

But I am sorry to say that I do not understand at all clearly what *any* of Mr. Frankena's three expressions means. "The intrinsically good ought to be promoted." What *does* this mean? I think I could understand the words if Mr. Frankena meant by them "The intrinsically good ought to be promoted *as much as possible*," but only because this seems to be merely another way of expressing Principle 6 itself. But we have seen that Mr. Frankena does not intend this statement to be *identical* with Principle 6: he thinks it is only a *part* of what Principle 6 says, meaning, so far as I can see, that it is entailed by Principle 6, but does not entail it—that it says *less* than Principle 6 says. But, if so, *what* that is less can it be saying? I am completely puzzled. And Mr. Frankena himself seems to have felt that the meaning of the expression is not very clear, since he immediately proceeds to give, as an alternative way of saying the same thing, his second formulation. This is: "A thing's having intrinsic value *so far* makes it a duty to produce it if possible." Here what puzzles me is the words "so far." What *do* they mean? Obviously they are quite essential; for, if they were simply omitted, we should get the proposition "A thing's having intrinsic value makes it a duty to produce it if possible"—a proposition which Mr. Frankena must have known that neither I nor any one else in their senses would ever have thought of asserting. It is too obviously *not* true that whenever it is in our power to produce anything whatever that is intrinsically good, it is always our duty to produce that thing. This is a case, in which, in a new sense, *"Le mieux est l'ennemi du bien:"* it is so often the case that when it is in our power to produce something intrinsically good, it is also in our power to produce instead some-

thing intrinsically *better*, and this fact is fatal to the claim that it is always our duty to produce any intrinsically good thing which we can produce. This must be why Mr. Frankena put in those words "so far." But what did he *mean* by them? What does the whole sentence, when they *are* put in, mean? I can make only one suggestion as to its meaning. Perhaps the view which Mr. Frankena is attributing to me and maintaining to be entailed by Principle 6 is this: That the fact that an action, which I could do, would produce *some* intrinsically good thing is always some reason (though far from a conclusive one) in favour of the hypothesis that I ought to do that action: or, in other words, that such a fact is always *favourably relevant* to the hypothesis that I ought to do the action in question. Perhaps this is all that "so far" means. If this is the view which Mr. Frankena is attributing to me, I admit that I think it is a true view, though I cannot tell whether it is or is not a "part" of Principle 6, that is to say, whether or not it follows from Principle 6. I do think that the fact that a state of affairs would be intrinsically good is "always and necessarily" *some* reason in favour of the hypothesis that an action which would produce that state of affairs ought to be done, though I think that, by itself, it is only a very weak reason indeed—not nearly strong enough (if I understand Sir D. Ross rightly) to entitle us to say that it is a *prima facie* duty to do such an action; for which reason I do not think that Mr. Frankena's suggestion (p. 106) that "*x* is intrinsically good" might mean "If we are capable of producing *x*, then we have a *prima facie* duty to do so" can possibly be true.

I am, therefore, very puzzled as to *what* view Mr. Frankena is attributing to me when he attributes to me the view that "The intrinsically good ought to be promoted." But I think that, fortunately, in order to discuss his criticisms of me, it is by no means necessary to know what he does mean by this expression; since, though he *says* that this is the proposition he is going to discuss, his actual discussion seems to me to be by no means confined to it. At the end of his paper (pp. 109f) he professes to give a summary statement of the points he has tried to make in it; and I hope I shall not be doing him an injustice, if I assume that this really is a summary of what he wished to say,

and confine myself to commenting, one by one, on the statements he here makes.

(1) His first point is this:

"Obligation cannot be defined in terms of value, as it is in *Principia Ethica,* if value is either simple or intrinsic in Moore's sense, and possibly not in any case."

Now what I did in *Principia,* as I have pointed out above, was to assert (p. 147) that "the assertion 'I am morally bound to perform this action' is *identical* with the assertion 'This action will produce the greatest possible amount of good in the Universe';" from which it follows that "obligation" can be defined in terms of "greatest possible amount of good." I was, of course, using "good" here in one only of its many meanings —namely, that one with which I have always been principally concerned; and hence we must suppose that when Mr. Frankena says that *Principia* defines obligation in terms of "value," he means by "value" just this particular sense of "good." If he does not, then, *Principia* does *not* define obligation in terms of value.

Mr. Frankena is, then, asserting that if this sense of "good" is either (a) simple or (b) "intrinsic" in my sense, then the statement just quoted from *Principia,* which I will now, for the sake of shortness, call "view A," cannot be true. Let us consider (a) and (b) separately.

(a) What are Mr. Frankena's reasons for asserting that, if this sense of "good" is *simple,* then view A must be false—that view A is logically inconsistent or incompatible with the view that this sense of "good" is simple? It seems to me that he has certainly not set out his reasons for saying so in any clear or orderly manner; but after a great deal of search up and down his paper, and a great deal of thought, I think I can now state his reasons clearly enough to make it clear why I do not think that they are good reasons.

On page 100, Mr. Frankena makes the metaphorical statement that by regarding goodness as a simple intrinsic quality and also at the same time holding view A "*Principia* transforms statements of the form 'We ought to do X' into *mere statements of fact*" or, as he puts it in the next sentence "into *simple reports*

or predictions of actual occurrence." What is the non-meta-
phorical way of saying what he here says metaphorically? I
think it is clear that what Mr. Frankena means is that, if good
were simple, then it would follow that statements of the form
"X will produce the greatest possible amount of good" were
"mere statements of fact;" and that hence, from the *conjunction*
of the hypothesis that good is simple with view A, which says
that statements of this form are *identical* with statements of the
form "I ought to do X," it would follow that statements of the
latter form were also "mere statements of fact." Now this, if
true, would at once entitle us to say: *If* statements of the form
"I ought to do X" are *not* "mere statements of fact," then the
statement that good is simple, *and* view A, cannot both be true.
But how are we to get from this to Mr. Frankena's *unconditional*
statement that the view, that good is simple, and view A cannot
both be true—that from the view that good is simple, *by itself,*
it follows that "obligation cannot be defined in terms of good?"

Now, so far as I can see, Mr. Frankena neither has, nor gives,
any other reason for saying that the view that good is simple and
view A are incompatible, except the one I have just quoted,
namely, that *if* statements of the form "I ought to do X" are *not*
"mere statements of fact," *then* these two views are incom-
patible. And this will only be a good reason if he is using the
expression "mere statement of fact" in such a sense that from
the fact that a statement is of the form "I ought to do X" it
follows that it is *not* a "mere statement of fact." I think that he
is in fact so using it. But, if so, in what sense *is* he using it? I
think one answer is that he is so using it that to say of a state-
ment that it is "a *mere* statement of fact" is identical with say-
ing that it is *not* "normative." This would yield the required
result, if (as I think is also the case) he is so using "normative"
that to say of a statement that it was a statement to the effect
that some agent *ought* to do something but was *not* a normative
statement would be self-contradictory. It would then be true
that from the fact that a statement was of the form "I ought to
do X" it *follows* that it is not a mere statement of fact. I think
that this use of "is a mere statement of fact" to mean neither
more nor less than "is *not* normative" is one perfectly good and

natural use of that expression. But I think it is important to emphasize that there is another perfectly good and natural use of it, which is such that it is by no means so clear that statements of the form "I ought to do X" are *not* mere statements of fact. In a later passage of his essay Mr. Frankena says: "To my mind what makes ethical judgments seem irreducible to natural or to metaphysical judgments is their apparently normative character, that is, the fact that they seem to be saying of some agent that he ought to do something. This fact, so far as I can see, is the only ground on which ethical judgments can really be regarded as essentially different from the factual or existential judgments of science or of metaphysics" (p. 102). Mr. Frankena here speaks as if the fact that a statement was a statement to the effect that some agent ought to do something would be a *good* ground (I do not think he holds it to be a *conclusive* one) for holding that it was not "reducible to factual or existential statements." And I think that another perfectly good and natural use of the phrase "mere statement of fact" is such that it would be a contradiction to say of a statement which was "reducible to factual or existential statements" that it was *not* a "mere statement of fact." And it is by no means clear that statements of the form "I ought to do X" are *not* reducible to factual or existential statements, nor therefore that they are not, in *this* sense, "mere statements of fact." This, therefore, is a use of "mere statement of fact" in which "*p* is a mere statement of fact" is *not* identical with "*p* is not normative." It is quite clear that statements of the form "I ought to do X" *are* normative, but not clear that they are not "reducible to factual or existential statements."

I think, therefore, that the step in Mr. Frankena's argument by which he proceeds from the *conditional* statement "*If* propositions of the form 'I ought to do X' are not mere statements of fact, then view A and the view that good is simple are incompatible" to the *unconditional* statement "View A and the view that good is simple are incompatible" is only valid, if he is using the expression "are not mere statements of fact" to mean neither more nor less than "are normative," where "normative" is so used that it would be a contradiction to say of any statement that

it *was* a statement of the form "I ought to do X" but was *not* "normative." But if so, a rather queer consequence follows which Mr. Frankena does not seem to have noticed. He says, we saw, though only in the metaphorical language in which one can speak of "transforming" one statement into another, that from the conjunction of view A with the view that good is simple, it *follows* that statements of the form "I ought to do A" are *not* normative: and, *if* his premiss that from "good is simple" there follows the proposition "statements of the form 'X will produce the greatest possible amount of good' are not normative" is true, then the conjunction in question really does entail this consequence. But what he does not seem to have noticed is that the very same conjunction *also* entails *the contradictory of this consequence.* For from view A, *by itself,* there follows the consequence that statements of the form "X will produce the greatest possible amount of good" *are* normative; for view A asserts that statements of this form are *identical* with statements of the form "I ought to do X," and, if so, since the latter must be "normative," the former must be "normative" too. Thus, where he says (p. 100) that there is no "normative character" "either in the *Principia* notion of intrinsic value or in the *Principia* notion of right or duty," we must admit that, *if* his premiss that "if good is simple, then statements of the form 'X will produce the greatest possible amount of good' are not normative" is true, then it follows from *Principia's* conjunction of view A with the view that good is simple, that *neither* statements of the form "X will produce the greatest possible amount of intrinsic good" *nor* statements of the form "I ought to do X" are normative. But, if we admit this, we must also insist that from the conjunction of the same two views in *Principia* it *also* follows that statements of *both* forms *are* normative. The truth is that, if by his ambiguous expression "there is no normative character either in the *Principia* notion of intrinsic value or in the *Principia* notion of right or duty," Mr. Frankena means anything which *does* follow from his premiss, then, *if* that premiss of his is true, it is *both* true that there *is* a normative character in these "*Principia* notions" *and also* that there is not. By speaking as if it were the second only which would be true,

if his premiss were true, and omitting to notice that its contrary would also be true, Mr. Frankena gives an entirely false impression of the consequences of *Principia's* combination of view A with the view that good is simple.

And the reason why he gives this false impression and fails to notice that from view A *by itself* it would follow that there was a normative character in these "*Principia* notions," may, I think, lie partly in the fact that he is using the ambiguous expressions "the *Principia* notion of intrinsic value" and "the *Principia* notion of right or duty" in a sense in which it does *not* follow from his premiss that there is no normative character in these notions. One natural way in which these expressions can be used and understood is that in which to say that there is "a *Principia* notion" of duty is to say that *Principia* uses the word "duty" in a sense different from any ordinary one. If, and so far as (for I think he was probably confused), Mr. Frankena is using "the *Principia* notion of" in this sense, then, it must be emphasized that there is no such thing as a "*Principia* notion of intrinsic value" or as a "*Principia* notion of right or duty;" and hence it cannot be true that these notions have either a normative or a non-normative character, since there *are* no such notions. *Principia* does not use the words "good," "right," "ought," "duty" in any sense other than one in which they are used in common speech; and hence there is no such thing as a "notion of duty" which is peculiar to *Principia*, in the sense that it is a notion for which the word "duty" stands in *Principia* but for which it does not stand in ordinary speech. It is worth while to emphasize this, because sometimes philosophers do give new senses to old words, and then proceed to use those old words in the new sense they have given. All that I am saying is that in *Principia* I did *not* do this in the case of those four words nor yet in the case of the expressions "wrong," "obligation," "morally bound to." All that I did do was to make propositions *about* the ordinary senses of those words, *not* to introduce new senses. Thus in the case of "good," all that I did was to assert (very likely wrongly), in the case of *one* of the senses in which that word is ordinarily used, that that sense was

a simple notion: I was not assigning to it a new sense, which *was* a simple notion. And in the case of view A, all that I was doing was to assert (certainly wrongly, as I now think) that the ordinary sense of expressions of the form "I am morally bound to do X" was such that it was *identical* with the sense of expressions of the form "X will produce the greatest possible amount of good." This is why from view A, *by itself*, it follows that the sense of expressions of the latter form must be "normative." It follows, because the *ordinary* sense of expressions of the form "I am morally bound to do X" is such that it would be a contradiction to say of such a statement that it was *not* normative. If on the other hand, I had been introducing a *new* sense of "morally bound"—introducing a new "notion" of moral obligation—as perhaps Mr. Frankena half imagined that I was, then it would not have followed in the least that expressions of the form "X will produce the greatest possible amount of good" were "normative." Thus Mr. Frankena's statement that "there is no normative character in the *Principia* notions of intrinsic value and of right or duty" is a statement which does *not* follow from his premiss that "if good is simple, then statements of the form 'X will produce the greatest possible amount of good' are not normative," if any part of what he means by it is that *Principia* uses the expressions "good," "right," and "duty" in non-ordinary senses. It will only follow from his premiss, if what he means by it is "it follows from the conjunction of *Principia*'s view that good is simple with its *view* A, that *neither* statements of the form 'I ought to do X' *nor* statements of the form 'X will produce the greatest possible amount of good' are 'normative'." But, in that case, it is equally true that it follows from the conjunction of these two *Principia* views that statements of both forms are normative, and that therefore "the *Principia* notions" of good and duty *are* normative.

But now let me set out in an orderly form what I take to have been Mr. Frankena's reasons for saying that if good is simple, then view A can't be true. I think his steps were as follows:

From the statement (1) Good is simple
 there follows
 (2) Statements of the form "X is good" neither include nor are identical with any statement about obligation;

 but from (2) there follows
 (3) Statements of the form "X is good" are *not* "normative;"

 and from (3) there follows
 (4) Statements of the form "X will produce the greatest possible amount of good" are not "normative;"

 and from (4) there follows
 (5) Statements of this latter form are not identical with statements of the form "I ought to do X."

But if (2) follows from (1), and (3) from (2), and (4) from (3), and (5) from (4), then (5) follows from (1). *Q. E. D.*

Now, so far, I have been occupied in explaining why I think Mr. Frankena is right in saying that (5) follows from (4); and I have called his assertion that (4) follows from (1) his "premiss." It is, of course, *a* premiss from which he draws the conclusion that (5) follows from (1). But we now see that it is not an *ultimate* premiss: it is derived from the premisses that (2) follows from (1), (3) from (2), (4) from (3). I think his "premiss" that (4) follows from (1) is false; and the main reason why I think it is false, is because I think that he is wrong in thinking that (3) follows from (2). This contention of his that (3) follows from (2) is, I think, the root contention of his essay; and I think it is just a mistake. Let me explain why I think so.

This word "normative," which occurs in the expressions of (3) and (4), is a word which plays a very large and important part in Mr. Frankena's essay. It is a word which has often been used by other ethical philosophers, and we all have *some* idea

what is meant by it. Mr. Frankena makes no deliberate and explicit attempt to explain how he is using it. It is true that in the passage on p. 102, which I have recently quoted, he speaks as if the proposition that ethical judgments have an "apparently normative character" were identical with the proposition that they "seem to be saying of some agent that he ought to do something;" and if to say that a judgment *appears* to be normative were the same thing as to say that it *seems* to be saying of some agent that he ought to do something, then it would seem to follow that to say of a judgment or statement that it *is* normative must be the same thing as to say of it that it *does* say of some agent that he ought to do something. But even if Mr. Frankena did intend to say in this passage that that is how he uses "normative," I think it is quite certain that it is not true that that is how he *does* use it. For in an earlier passage (p. 99) he implies that if "the fact that A is intrinsically good" included or were identical with "the fact that certain agents, actual *or possible,* should do something about A or take a certain attitude toward it" then "intrinsic goodness" would "have a normative character as such." And he thus implies that any statement which included or were identical with a statement of the form "It *would be* the duty of any agent, who was in such and such circumstances, to do so and so, *if there were any such agent*" would be "normative as such." But it is obvious that such a statement does not say of any agent that he ought to do something: it only says that, *if there were an agent in certain circumstances,* then it *would be his duty* to do so and so; and Mr. Frankena could not possibly have said that such a statement was "normative as such," if he had been using "is normative" to mean the same as "says of some agent that he ought to do so and so." The later passage, therefore, does not give a correct account of Mr. Frankena's actual use of "is normative," even if Mr. Frankena thought that it did. He certainly does not use "is normative" as *identical* in meaning with "says of some agent that he ought to do something." All that is true is that he does so use "normative" that the fact that a statement "says of some agent that he ought to do something" is a *sufficient* condition for its being "normative:" it will, as I said before, follow from the

fact that a statement does do this that it is "normative." But it is not true that he so uses "normative" that this is also a *necessary* condition for a statement's being normative: he does *not* so use "normative" that from the fact that a statement is normative it follows that it says of some agent that he ought to do something. For he so uses the term that if a statement merely says of a *possible* agent that, *if there were* an agent in certain circumstances, then it *would be* his duty to do so and so, then the fact that a statement says this is also a *sufficient* condition for its being normative.

But does he so use "normative" that it is a *necessary* condition for a statement's being normative that it should *either* include or be identical with a statement that some agent ought to do something *or* include or be identical with a statement that, if there were an agent in certain circumstances, it *would be* his duty to do so and so? No: for he so uses it that another condition would be *sufficient* for its being normative. Thus he implies that statements of the form "X is intrinsically good" would be normative if it followed "from the very nature of intrinsic goodness that it ought to be promoted" (p. 96) or, as he puts it elsewhere (p. 99), if it were "of the nature of the good that it should be brought into existence." And this implies also that if it "follows from the very nature" of what you say of an action, when you say that it will produce the greatest possible amount of good, or when you say that the world will be better, if it be done, than if any other action in the agent's power were done instead, that the action in question ought to be done, *then* such statements will be normative.

When, therefore, Mr. Frankena makes his step from (2) to (3), he is assuming that the proposition "Statements of the form 'X is intrinsically good' neither include nor are identical with any statement about obligation" *entails* the proposition "No statement about obligation *follows from the very nature* of what you assert about a thing when you say it is intrinsically good." And this assumption of his seems to me to be a sheer mistake. It is a mistake which is embodied in the pair of questions with which he opens his discussion. He asks (p. 96): "Does it follow from the very nature of intrinsic goodness that

it ought to be promoted? *Or* is the connection between intrinsic value only a synthetic, even if necessary, one?" Obviously he thinks that these are mutually exclusive alternatives: that if there is only a *synthetic* necessary connection between intrinsic value and obligation, then no statement about obligation can "follow from the very nature" of a statement of the form "X is intrinsically good." It seems to me, on the contrary, that it may quite well be true *both* that the connection is only "synthetic" *and also* that nevertheless a statement about obligation *follows from the very nature* of a statement about intrinsic value. And this is the very same question as the question whether (3) follows from (2). For by the expression "the connection is only synthetic" Mr. Frankena plainly means "the connection is *not* analytic;" and he is so using "analytic" that the connection between intrinsic value and obligation will be "analytic" *only* if statements of the form "X is intrinsically good" or of the form "X will produce the greatest possible amount of good" or of the form "The Universe will be intrinsically better, if X be done, than if anything else in the agent's power be done instead," all *include or are identical with* some statement about obligation.

My reason for thinking that Mr. Frankena is making a mistake in assuming that statements about obligation can only *"follow from the very nature"* of statements about intrinsic value, if statements of the latter sort *include or are identical with* statements of the former sort, can be very briefly given. Consider what Mr. Langford says, in his excellent essay (p. 327), about the relation between "being a cube" and "having twelve edges." He seems to me to give conclusive reasons for saying that there is a sense of "includes or is identical with" in which the statement "This is a cube" does *not* "include" the statement "this has twelve edges;" and it is, of course, obvious that it is not identical with it. But surely it is no less obvious that, in spite of this, one can say, with perfect truth, "It follows from the very nature of a cube that anything which is a cube has twelve edges." That is to say, the statement "It follows from the very nature of φ that what has φ also has χ, *only* when the statement that a thing has φ includes or is identical with the

statement that it has χ" is false. If so, then it may follow from the very nature of "intrinsic value" that what has intrinsic value "ought to be promoted," in spite of the fact (if it be a fact) that a statement that a thing has intrinsic value neither includes nor is identical with the statement that it ought to be promoted. Consequently, if what I have said about the relation between "being a cube" and "having twelve edges" is correct, it follows that Mr. Frankena's assumption that a statement about obligation cannot "follow from the very nature of" a statement about intrinsic value, unless statements of the latter sort always "include or are identical with" some statement of the former sort, is just false.

I confined myself above to saying that what Mr. Langford shows is that there is *a* sense of "include" in which "This is a cube" does *not* "include" "This has twelve edges;" and, in saying this, I implied that there may perhaps be other senses of "include" in which "This is a cube" *does* include "This has twelve edges." I am inclined to think that if anybody ever does so use the word "include," he is misusing it; but perhaps Mr. Frankena might say that, whether it is a misuse or not, that was how he was using it. If he was so using it, that would be a complete answer to my argument against his step from (2) to (3); but he would be able to claim that *this* step was correct only at the cost of having to admit that his step from (1) to (2) was invalid. For it is only if "include" be used in a sense in which "This is a cube" does *not* include "This has twelve edges," that there follows from "Good is simple" the proposition that "This is good" does not include any statement about obligation. For the sense in which I asserted in *Principia* that the sense of "good" I was concerned with was simple or indefinable, was one in which these two statements were identical with the statement that the propositional function "*x* is good" (where "good" is used in the sense in question) does not *include* any notion other than that expressed by "good," in precisely that sense of "include" in which the function "*x* is a cube" does *not* include the function "*x* has twelve edges." I think, therefore, Mr. Frankena is in a dilemma: if his step from (2) to (3) was not wrong, then his step from (1) to (2) *was*

wrong; they can't both be right; and whichever of the two is wrong, the fact that it is wrong is equally fatal to his argument.

I think, then, Mr. Frankena's assertion that, if good is simple, then view A must be false, is itself false, and that he only arrived at it through failure to notice that (3) does *not* follow from (2).

(b) How, then, about his assertion that, if good is "intrinsic in Moore's sense," then view A must be false?

His reasons for saying this are, so far as I can make out, exactly the same as his reasons for saying that, if good is simple, view A must be false, except that in (1) we have to substitute "intrinsic in Moore's sense" for "simple." They are, therefore, fallacious for exactly the same reason, namely, that (3) does not follow from (2). But here there is an additional fallacy, in the case of which I have an extreme difficulty in understanding how Mr. Frankena could possibly commit it. For here it is just simply *not* the case that (2) follows from (1). In the case of "simple" I admitted that (2) does follow from (1), if in (2) "include" is used in a proper sense. But in the case of "intrinsic in Moore's sense" (2) just simply does *not* follow from (1), *however* "include" be used in (2). It looks as if Mr. Frankena had merely failed to understand how I did use "intrinsic" and I cannot understand why.

It looks as if he must have thought that I was so using "intrinsic" that there would be a contradiction in maintaining *both* that "intrinsically good" was "intrinsic" *and* that nevertheless a statement of the form "*x* is intrinsically good?" was *identical* with a statement to the effect that so and so would be a duty; just as there really is a contradiction in maintaining *both* that "intrinsically good" is simple *and* that a statement of the form "*x* is intrinsically good" is *identical* with such a statement about obligation. But I am at a loss to understand how he possibly could have so misunderstood me. He quotes and makes use of my definition of "intrinsic" as meaning "depending solely on the intrinsic nature of what possesses it." And it is, of course, quite obvious, as he himself points out, that the question whether, under certain circumstances, an agent ought to produce A might depend solely on the intrinsic nature of A. And yet he seems

to have thought that I might deny this obvious fact! He says (p. 107) "Moore might argue that it is quite clear that intrinsic value depends only on the intrinsic nature of a thing, and that *therefore* it cannot consist in any normative relation to anything else." How on earth could he come to think that I could possibly use such an argument? I can only make two suggestions as to what may have misled him. (a) It may be noticed that throughout his essay Mr. Frankena constantly makes use of the phrase "intrinsic quality:" the word "intrinsic" occurs far more often in this combination than by itself: and over and over again he makes assertions as to what would follow from the hypothesis that "good," in the sense I am concerned with, is an "intrinsic quality," with the result that the reader is always unable to tell whether Mr. Frankena thinks that the supposed consequence follows from the hypothesis that "good" is a quality, or from the hypothesis that "good" is intrinsic, or only from the hypothesis that it is both together. Now in *Principia* I certainly did assert or imply that "good" was a "quality;" and from this hypothesis it really does follow, just as much as from the hypothesis that "good" is simple, that a statement of the form "A is intrinsically good (i.e. 'good' in the sense I am concerned with)" cannot possibly include or be identical with any statement about obligation. This really does follow, if "quality" be used in the sense in which it is used in *Principia,* and also, I should say, if it be used in any sense in which it can properly be used; though it would not follow if it were used in the sense in which McTaggart chose to use it in his *Nature of Existence.* Is it possible that why Mr. Frankena thought the same consequence would follow from the hypothesis that "good" was "intrinsic" in my sense, was because he thought I was so using "intrinsic" that "is intrinsic" meant the same as "is an intrinsic quality?" I think this is a possible partial explanation; but, of course, there would still remain the puzzle as to why on earth he should have thought that I did not distinguish between "is intrinsic" and "is an intrinsic quality." (b) Another possible partial explanation of why he should have misunderstood me is as follows. On page 97 he attributes to me the views: "A thing's intrinsic goodness does not depend in any way on its

relations to anything else. Intrinsic goodness is a quality and not a relational property, and it is a quality whose presence in a thing is due entirely to that thing's own character." Now Mr. Frankena may perhaps have thought that the property which you are asserting to belong to a thing, A, if you assert, with regard to certain possible circumstances, that it *would* be the duty of any agent who was in those circumstances to produce A, is "a relational property;" and that I was using "intrinsic" in such a sense that it would be a contradiction to say of any relational property that it was intrinsic to what possessed it. But is the property which you assert to belong to A, if you merely assert that, it *would*, under certain circumstances, be the duty of a *possible* agent, to produce A, a "relational property" at all? I suppose anybody who pleases might call it so: but it is *not* such that the question whether A possessed it or not would "depend on the relations of A to anything else"—even if A had *no* relations to anything else, even if A were the whole Universe, A might quite well possess it; and it is *not* such that there is any contradiction in maintaining that it is "intrinsic" in my sense. I am afraid I may myself have been partly responsible for this mistake (if Mr. Frankena made it), through a careless use of the term "relational property." Mr. Frankena probably knows that I have maintained elsewhere that some relations are "internal" and others "external," and that also some "relational properties" are "internal" and others "external." Now my use of "intrinsic" is such that it would be a contradiction to say of an *external* relational property that it was intrinsic; but no contradiction at all to say of an *internal* one that it was so. And perhaps (I do not know) I may sometimes have carelessly said "relational property," when what I meant was "*external* relational property." However that may be, it seems to me to be a matter of extreme importance, if anyone wants to understand the consequences of my view that the sense of good I was concerned with is "intrinsic to" what possesses it, that he should distinguish sharply between assertions as to what *would* be the obligations of *possible* agents, and assertions as to what are, were, will be or would be the obligations of *actual* agents. If the sense of "good" in question is "intrinsic" in

my sense, then from a proposition of the form "A would be good" it cannot possibly follow that *I* ought to promote A (even in the complicated sense I gave above), since it cannot follow from it that I exist: and hence also such a statement cannot possibly either include or be identical with any statement about the obligations of an *actual* agent. But there may quite well follow from it a statement as to what *would* be the duty of a *possible* agent in certain circumstances: and hence also my view that "good" is intrinsic is quite consistent with the view that "A would be good" includes or is identical with a statement of that sort about *possible* agents.

I think, therefore, that Mr. Frankena's first point is a mistake both in the case of "simple" and in that of "intrinsic." So far as I can see, from the proposition, that if "good" were simple, then "A is good" could not either include or be identical with any statement about obligation, it does *not* follow either (a) that, if "good" is simple, then "A is good" cannot be "normative," nor (b) that "this action will produce better results than would any other action open to the agent" cannot be *identical* with a statement about obligation. Mr. Frankena certainly gives no reason for supposing that either consequence follows from his true proposition; and I don't believe that he could give any *good* reason for saying so, because I believe that there *is* no good reason. And as for the hypothesis that "good" is intrinsic in my sense, it does not even follow from this that the statement "A is good" cannot be *identical* with a statement about obligation.

(2) Mr. Frankena's second point is this:

"If value is either simple or intrinsic, then it cannot be normative, non-natural, or definable in terms of obligation, and then there is no reason to regard it as indefinable in non-ethical terms."

Here again we must, of course, suppose Mr. Frankena to mean by "value" that particular sense of "good" with which I have been principally concerned.

It is clear that this second point contains at least seven separate points; but fortunately I have already dealt with four of them under (1). I have admitted that one of the four is true,

namely, that if my sense of "good" is simple, it cannot be defined in terms of obligation; but all the other three I have disputed. I have said that from the hypothesis that "good" is simple, it does *not* follow that it is not "normative;" and that from the hypothesis that it is intrinsic it does *not* follow *either* that it is not "normative" *or* that it is not definable in terms of obligation. And I have given reasons for saying so.

3. *Meaning of "natural"*

But with the introduction of the term "non-natural" two entirely new points are raised. Before I deal with them, however, I think I had better first say something as to what I meant by the term "natural." This is a question which does not seem to have troubled Mr. Frankena: he tells us boldly (p. 98) that by saying that intrinsic goodness is non-natural I meant to say "partly, that it is not an object of perception, partly that it is not a psychological idea, partly that it depends on a thing's nature in a certain peculiar way, and partly that it is somehow non-existential or non-descriptive." Mr. Broad, however, has, very justly, been troubled by the question what I meant by it; and I think I had better say here what I can say about Mr. Broad's discussion of this question.

(a) With one point which Mr. Broad makes I entirely agree. I implied in *Principia*, p. 41, that the difference between those properties of natural objects which I called "natural," and "good" which I declared *not* to be natural, was that all natural properties *could* exist in time *by themselves*, whereas the property which was that particular sense of the word "good" with which I was concerned, could *not*. Mr. Broad says he does not believe that those properties of natural objects which I called "natural," e.g., the property of being brown or that of being round, in the sense in which a penny may be brown and round, could exist in time all by themselves, i.e., without being, at any time at which they did exist, properties of some natural object which also existed at that time and possessed them. I entirely agree with Mr. Broad as to this. I not only don't believe that such properties could exist in time by themselves; I feel perfectly sure that they could not. This suggestion which I made in

Principia seems to me now to be utterly silly and preposterous. And I also agree with Mr. Broad that it is wrong to say, as I did say, of the natural properties of a thing that "they are rather *parts* of which the thing is made up than mere predicates which attach to it."

I agree, then, that in *Principia* I did not give any tenable explanation of what I meant by saying that "good" was not a natural property.

(b) Mr. Broad is also perfectly right in thinking that the distinction about which I spoke on pp. 272-275 of *Philosophical Studies,* and about the nature of which I there said I was puzzled, is the very same distinction which I should have expressed in *Principia* as the distinction between intrinsic properties which were "natural" and intrinsic properties which were *not* "natural." But I think he is hardly right in saying that I was in that essay "intending to explain" this distinction. It is rather the case that my purpose was to call attention to the difficulty of seeing clearly in what the difference consisted. All that I attempted to do was to give what I called a "vague expression of the kind of difference I felt there to be" between the two kinds of properties.

Mr. Broad calls this essay of mine in *Philosophical Studies* "very difficult," and expresses some doubt as to whether a summary, which he gives, of the views I expressed in it, is correct.

Of course, the summary which he gives is not a summary of nearly all the views I expressed in it. But I think the views which he attributes to me really were my views, except perhaps in two respects.

(α) He speaks, under (ii) (pp. 59f), as if he thought I held that there were different determinate *kinds* of goodness. Now, of course I have always held that there are many different *senses* in which the word "good" is used; and in that essay I did speak as if there were several different *kinds* of value—the two which I had mainly in mind, because I held them both to be "intrinsic" kinds, being, as I made plain, beauty, on the one hand, and, on the other, that particular sense of "good" with which I have been mainly concerned. But when Mr. Broad speaks of different *kinds* of goodness I do not think he means *either* different

senses in which the word "good" is used—different character-
istics of which it is a name—*or* what I meant by different kinds
of "value:" I do not think he is so using the word that beauty
would be a *kind* of "goodness." I think he must have been
using "goodness" as the substantive of that particular sense of
"good," with which I have been mainly concerned, and thinking
that I regarded this sense of "good" as (in Mr. W. E. John-
son's language) a "determinable" under which there were sev-
eral different "determinates," just as different shades of yellow
are different "determinates" under the "determinable" "yel-
low." Different shades of yellow can quite properly be spoken
of as different "kinds" of yellow; primrose yellow is one kind
of yellow, and buttercup yellow is another. But, if this is what
Mr. Broad meant, then he is attributing to me a view which
I never held. I never supposed that the sense of "good" with
which I was principally concerned was a "determinable," and
that there were other more determinate characteristics related to
it as different shades of yellow are related to yellow.

(β) Under (iii) Mr. Broad says he thinks I should "identify
the non-natural characteristics of a thing with those which *are*
determined solely by its intrinsic nature and yet *are not* in-
trinsic." He is, therefore, suggesting that I should be willing
to say of a characteristic which was determined solely by the
intrinsic nature of what possessed it that it was *not* "intrinsic;"
and, in particular, to say of the particular sense of "good" with
which I was concerned that it was not "intrinsic." But I was
never willing to say this. In my use of the word "intrinsic"
by itself it would be a contradiction to say that a characteristic
which was determined solely by the intrinsic character of what
possessed it was not "intrinsic;" and, of the sense of "good"
with which I was concerned, I was never willing to say that it
was not "intrinsic." I held, as Mr. Broad knows, that this sense
of "good" was an *intrinsic* kind of value; and I so used the
word "intrinsic" *by itself* that what is an intrinsic kind of value
must be "intrinsic:" indeed I actually say (p. 272) that beauty
is "intrinsic." The fact is that, in that essay, I was guilty of an
exceedingly awkward piece of terminology. I chose (p. 272) to
so use the expressions "intrinsic predicate" and "intrinsic prop-

erty," that there was no contradiction in saying, e.g., of beauty, that it was a "property" and was "intrinsic," and yet was *not* an "intrinsic property." Obviously this was an extremely awkward thing to do. Anyone would naturally suppose that what was both a "property" and "intrinsic" must be an "intrinsic property." And Mr. Broad seems to have inferred, similarly, that what was a "property" (or "characteristic") and was *not* an "intrinsic property" cannot be "intrinsic;" and hence to have supposed that since I did hold that the sense of "good" in question was not an "intrinsic property" I must have been holding that it was not "intrinsic." Perhaps, however, in attributing to me the view that this sense of "good" is not "intrinsic," Mr. Broad was not attributing to me any view which I did not hold: perhaps, he was merely using "is not intrinsic" as a synonym for "is not an intrinsic property" in the very peculiar sense in which I was using the latter expression.

However that may be, Mr. Broad, in the next paragraph (p. 60), continues to speak as if I held the particular sense of "good" with which we are concerned not to be "intrinsic," and as if I had made a distinction between two kinds of properties which depend only on the intrinsic nature of a thing and called the one kind "intrinsic" and the other "non-intrinsic." It is quite true that I had made a distinction between two kinds of properties which depend only on the intrinsic nature of a thing; but I had not called the one kind "intrinsic" and the other "non-intrinsic:" I had called both "intrinsic," but had made a distinction between those which, besides being "intrinsic," were also "intrinsic properties," and those which, though "intrinsic," were not "intrinsic properties"—a manner of speaking which I admit to be very awkward, but which nevertheless did not express a self-contradictory view, since I was so using (very awkwardly) the expression "intrinsic property" that in order to be an "intrinsic property" it was not sufficient that a property should be "intrinsic"—it must also have some other feature which distinguishes it from other properties which are "intrinsic" but are not "intrinsic properties." I will assume that this is the distinction of mine about which Mr. Broad goes on to speak, although he expresses it differently; and will now drop

the awkward terminology of *Philosophical Studies,* and speak instead of a distinction between intrinsic properties which are "natural" and intrinsic properties which are *not* "natural;" since I think that the feature, additional to that of being "intrinsic," which a property must possess in order to be what I called in *Philosophical Studies* an "intrinsic property," is the very one which would have led me, in *Principia,* to call it a *natural* intrinsic property. The question is: What is this feature? What is the difference between a "natural" intrinsic property and one which is *not* natural? Mr. Broad says truly enough that in *Philosophical Studies* I give no clear account of this distinction. But he goes on to say something which is not true. He says that *all* that I say is that a complete enumeration of the natural intrinsic properties of a thing would give a *complete* description of it; but that a description of a thing can be complete even if it omits the non-natural intrinsic properties of it. But this is *not all* that I said on page 274, because I said two other things as well. I said both (1), not only that a complete enumeration of the natural intrinsic properties *would* give a complete description, but also, in the next sentence, that no description could be complete which *did not* enumerate all the *natural* intrinsic properties. And I said also (2), in the preceding sentence, something very different: namely that natural intrinsic properties "seem to *describe* the intrinsic nature of what possesses them in a sense in which predicates of value never do."

Now in saying these two things, (1) and (2), I was suggesting two radically different accounts of the difference between natural and non-natural intrinsic properties. I think that at the time I cannot have been aware that they were radically different; since I seem to offer (1) as if it were an explanation of (2). But they *are* radically different; and what I now think is that, whereas the account which (1) suggests is certainly untenable, because (1) is certainly false, the account which (2) suggests may possibly be true. Let us consider (1) and (2) separately.

(1) The account of the difference between natural and non-natural intrinsic properties which (1) suggests, is that an intrinsic property of a thing is "natural" if you cannot give a *complete* description of a thing which has it without mentioning

it, and that, if you can, then it is *not* natural. And I now think
that this account of the difference is certainly untenable, because
it is certain that some of the *natural* intrinsic properties of a
thing need not be mentioned in giving a complete description
of it, i.e., because (1), which says that *all* must be mentioned,
is certainly false. And my reason for saying that (1) is certainly
false is as follows. Suppose a man, on closing his eyes, has the
experience of seeing, towards the middle of the dark field
which we usually see when our eyes are shut, a round red patch,
which is an after-image of something which he saw just before
he closed his eyes. He is then having an experience which *in-
cludes the seeing of a round red patch*. And the property which
we should ascribe to the experience which he was having by
saying that it "included the seeing of a round red patch" would,
of course, be a "natural" intrinsic property of the experience in
question: it would be an intrinsic property of that experience,
because any experience which did *not* include this could not
possibly be identical with that experience, and because any
other experience which was exactly like the experience in ques-
tion would necessarily also include the seeing of a round red
patch. But now it might be the case that the red patch which he
saw was of some specific shade of red—scarlet, for example;
and, if so, then his experience would *also* have another "natural"
intrinsic property, namely that of including the seeing of a
round *scarlet* patch. Now this property of "including the seeing
of a round *scarlet* patch," is a property such that any experience
which has it *must* also have the less specific property of "includ-
ing the seeing of a round *red* patch": you cannot see a scarlet
patch, without seeing a red patch, since any scarlet patch must
be red, though you can perfectly well see a red one without see-
ing a scarlet one, since there is no necessity that a red patch
should be scarlet. But, this being so, it seems to me quite evi-
dent that, if the red patch which our man was seeing happened
to be scarlet, then, in order to give a *complete* description of
his experience, it would be quite unnecessary to mention the
natural intrinsic property which it had of "including the seeing
of a *red* patch:" to mention this property *as well as* the more
specific one of "including the seeing of a *scarlet* patch," would

bring you no nearer to giving a complete description of his experience than if you mentioned the latter alone. There are, therefore, natural intrinsic properties of an experience which it is quite unnecessary to mention in order to give a complete description of an experience which possesses them: any natural intrinsic property the possession of which is *entailed* by the possession of a more specific natural intrinsic property which a thing possesses, is one which it is unnecessary to mention in order to give a complete description of the thing in question. And, this being so, my statement that "no description of a thing could be *complete* which omitted any [natural] intrinsic property of it" was simply false. I made it, no doubt, because I was confusing this false proposition with the following true one: No description of a thing could be *complete* which omitted any of those among its natural intrinsic properties, which are *such that no other natural intrinsic properties which the thing possesses entail them*. But since the proposition I did make was false, it follows that you cannot (as I thought you could) distinguish the "natural" intrinsic properties of a thing from those which are *not* natural, by saying that the former are those which it is necessary to mention in order to give a *complete* description of the thing in question, the latter those which it is not necessary to mention for that purpose. It is quite obvious that the property of "including the seeing of a round red patch" is a *natural* intrinsic property, in spite of the fact that it would not be necessary to mention it in order to give a *complete* description of an experience which had it.

Now Mr. Broad, in explaining the reasons why he finds it "most difficult to accept" the account which he supposes me to have been suggesting, in this passage of *Philosophical Studies*, of the difference between "natural" and "non-natural" intrinsic properties, makes a distinction between what he calls "ultimate" and "derivative" characteristics. He says that goodness is certainly "derivative" and then argues that "pleasantness," which is of course a "natural" characteristic in the sense I meant, is "derivative" also; his conclusion being that it is *impossible to identify the non-natural characteristics of a thing with those among its intrinsic properties which are derivative*. With this

conclusion I completely agree; but I do not think I had ever either thought or suggested that this identification was possible. It is true, indeed, that I should never have thought of suggesting that goodness was "non-natural," unless I had supposed that it was "derivative" in the sense that, whenever a thing is good (in the sense in question) its goodness (in Mr. Broad's words) "depends on the presence of certain non-ethical characteristics" possessed by the thing in question: I have always supposed that it did so "depend," in the sense that, if a thing is good (in my sense), then that it is so *follows* from the fact that it possesses certain natural intrinsic properties, which are such that from the fact that it is good it does *not* follow conversely that it has those properties. But I do not think I ever supposed that it was *only* non-natural intrinsic properties which were "derivative" in this sense: the natural intrinsic property which I have just mentioned, namely that of "including a seeing of a round red patch," is, I should say, certainly "derivative" in this sense; and I think I should always have said so. I think, therefore, that this conclusion of Mr. Broad's, though I agree with it, is in no way inconsistent with any suggestion I have ever made as to the difference between "natural" and "non-natural" intrinsic characteristics.

But though I agree completely with this conclusion of Mr. Broad's, I do not agree completely with the reason he gives for it; since I think that pleasantness, in at least one of the senses in which we may call an experience "pleasant," and that one a sense which Mr. Broad actually has in mind, is *not* an intrinsic characteristic of the experience said to be pleasant; and hence the fact that it is "natural" can have no tendency to show that there are any natural derivative *intrinsic* characteristics. Let me explain. I personally find the experience of tasting caviare pleasant; but I believe that some people do not find it pleasant; and I see no reason to suppose that an experience of mine, which was a tasting of caviare, might not be exactly like an experience of another person, which was a tasting of caviare, and that yet my experience might be pleasant to me, while his exactly similar experience was not pleasant to him. If so, then the property which I assert to belong to my experience

when I say that it is pleasant, cannot be an intrinsic property of that experience; and it seems to me that one of the properties which we frequently are ascribing to an experience, when we say that it was pleasant, is, as in this case, a purely external property—a property which it is quite conceivable that that experience should not have had. But now contrast this with another use of "pleasant." Suppose that on a particular occasion I am not only tasting caviare but also finding it pleasant. I may want to speak of this more inclusive experience which is not only an experience of tasting caviare but also *an experience of feeling pleased with the taste.* And of this more inclusive experience I may also say that it is "pleasant," meaning by this, not, as before, merely that I find it pleasant, but that (as I have sometimes expressed it) it *contains* pleasure—that is to say, that it is an experience of a sort such that to say that a person is having an experience of that sort is to say (among other things) that he is feeling pleased. If we use "pleasant" in this second sense, as I think we often do, then pleasantness *is* an intrinsic property of any experience which is pleasant, since it is obvious that no experience which did not contain pleasure could be exactly like one which did. A state of things which can be properly described by saying that it is a state of things in which some person is *both* tasting the taste of caviare *and* being pleased with the taste, cannot be exactly like a state of things which can be properly described as a state of things in which some person is tasting the taste of caviare but *not* being pleased with the taste; although a state of things which can be properly described by saying that somebody is *tasting the taste of caviare* can quite well be exactly like another state of things which can be properly described in the same way. It seems to me, therefore, that we use "pleasant" as applied to experiences, in two very different ways, in one of which it *does* stand for an intrinsic property of the experience said to be pleasant, while in the other it does *not,* but only for a purely external property. And, if so, it will not do to argue that because pleasantness is always "natural" and also, in one of its senses, "derivative," therefore there are some natural *intrinsic* properties which are derivative. It seems to me that the reason which Mr. Broad

gives for saying that pleasantness is derivative is one which only applies to pleasantness in the sense in which it stands, *not* for an intrinsic, but for a purely external property. It seems to me that his question: What makes this experience pleasant? is equivalent to: What intrinsic characteristics of this experience is it that I (or "others" or "all men") find pleasant? *not* to: From what intrinsic characteristics of this experience does it *follow* that it is pleasant?, because, in cases like those he instances, there are *no* intrinsic characteristics from which it *follows* that the experience in question is pleasant: "pleasant" is being so used that the proposition that experiences with those intrinsic properties are pleasant to me, or others, or all men, is merely an empirical proposition, not a necessary one. Whereas the question: What makes this experience good? *is* equivalent to the question: From what intrinsic characteristics of this experience does it *follow* that it is good?, and the proposition that experiences with those intrinsic properties *are* good is not an empirical but a necessary one.

But to return to the two different accounts of the distinction between natural and non-natural intrinsic properties which I suggested (but in a different terminology) on page 274 of *Philosophical Studies*, and which were suggested by the two statements of mine which I called above (1) and (2). I have now given my reasons for saying that the statement I called (1) is certainly false, and that therefore the account of the distinction which it suggests is certainly untenable.

Let us now turn to (2) and the account which it suggests.

(2), translated into the language of *Principia*, is the proposition that "natural intrinsic properties seem to *describe* the intrinsic nature of what possesses them in a sense in which predicates of value never do." This was a suggestion that there is *a* sense of the word "describe"—*one* of the senses in which that word is ordinarily used—such that, in ascribing to a thing a property which is not a natural intrinsic property, you are not describing it *at all*, whereas, if you ascribe to a thing a natural intrinsic property, you always are describing it *to some extent*, though of course the description may be very vague and very far from complete. This is a suggestion which it still seems to me

may possibly be true; and Mr. Broad seems to have entirely overlooked the fact that I had made it—very excusably, since the fact that in the very next sentence I go on to say the things I have mentioned about *complete* description shows, I think, that I was myself confusing these two very different accounts of the distinction between those intrinsic properties which are natural and those which are not. I hope it is clear how these two different accounts of the distinction differ. The one with which I am now concerned, and which I think may be true, says: Properties which are intrinsic properties, but *not* natural ones, are distinguished from natural intrinsic properties, by the fact that, in ascribing a property of the former kind to a thing, you are not describing it *at all*, whereas, in ascribing a property of the latter kind to a thing, you are always describing it *to some extent*. The other, which is certainly false, says: The former kind are distinguished from the latter, by the fact that the former need not be mentioned in a *complete* description of a thing which possesses them, whereas the latter must be.

I think therefore that I did offer on page 274 of *Philosophical Studies* an account of the difference which in *Principia* I should have expressed as the difference between intrinsic properties which are *not* "natural" and intrinsic properties which *are* "natural," which may possibly be true. The account is that an intrinsic property is "natural" if and only if, in ascribing it to a natural object, you are *to some extent* "describing" that object (where "describe" is used in one particular sense); and that hence an intrinsic property, e.g. the sense of "good" with which we are concerned, is not "natural" if, in ascribing it to a natural object you are not (in the same sense of "describe") describing that object *to any extent at all*. It is certainly the case that this account is vague and not clear. To make it clear it would be necessary to specify the sense of "describe" in question; and I am no more able to do this now than I was then. But I do think it important to emphasize that, *if* (in Mr. Broad's language) "good," when used in the sense we are concerned with, is "the name of a characteristic at all"—*if*, that is to say, some view like Mr. Stevenson's about "right," or my modification of it, is *not* the right account of this sense of "good"—then, there

is a problem to be faced, since this sense of "good" certainly seems to be of an importantly different *kind* from those intrinsic properties which in *Principia* I called "natural" and in *Philosophical Studies* I spoke of, so awkwardly, as if they alone were "intrinsic properties," although there were other properties which were "intrinsic"! And I think it is possible that *a* solution of the problem is to be found in the different way in which they are related to one particular sense in which we use the word "description." *This* suggestion of mine Mr. Broad has, of course, not criticised, because he had not noticed that I had made it.

(c) Having failed to find either in *Principia* or in *Philosophical Studies* any account of the distinction between "natural" and "non-natural" intrinsic properties which he considers to be tenable, Mr. Broad goes on (p. 62) to offer an account of the distinction which he does consider to be tenable. And on the account which he gives I have no criticism to offer: it seems to me quite possible that it may be true. He insists that, in giving this account, he is only *describing* natural characteristics, not *defining* "natural;" and it is quite possible that the description which he thus gives of natural intrinsic characteristics, and the description which I suggested in *Philosophical Studies* when I suggested that natural intrinsic properties *describe* what possesses them in a sense in which non-natural ones don't, should, though different, *both* of them be true: it may be that *both* of these descriptions (and others as well) do apply to all *natural* intrinsic characteristics, and to none that are not natural.

4. Relations between "good" and "ought" resumed

We may now return to the two statements, contained in Mr. Frankena's second point, in which he uses the word "non-natural." These are: (a) If the sense of "good" with which I have been principally concerned is *simple*, then it cannot be non-natural, (b) if it is *intrinsic*, then it cannot be non-natural. What are Mr. Frankena's reasons for making these two assertions?

It seems to me that here again he has not presented his reasons in at all a clear or orderly manner. But, so far as I can

see, one of two premises which he uses to arrive at these two conclusions is that which he expresses, on page 102, in the already quoted words: "To my mind, what makes ethical judgments seem irreducible to natural or to metaphysical judgments is their apparently normative character, that is, the fact that they seem to be saying of some agent that he ought to do something. This fact, so far as I can see, is the only ground on which ethical judgments can be regarded as essentially different from the factual or existential judgments of science or of metaphysics." Now we already know that he supposes (falsely, in my opinion) that if good were either simple or intrinsic, it could not be normative; and it is the conjunction of this premiss with the premiss expressed in the words just quoted, which constitutes, I think, his reason for the conclusion that if good were either simple or intrinsic it could not be non-natural. It is true that the conjunction of these two premisses will not yield precisely *that* conclusion: it could, at most, yield the conclusion that if good were simple or intrinsic, then, *so far as Mr. Frankena can see*, there would be *no ground for supposing it to be non-natural*. But I think that this more modest conclusion is all that he really wishes to assert: the statement in point 2 that, if good were simple or intrinsic, *it could not be non-natural*, is merely a dogmatic exaggeration of his real opinion. But, however that may be, and whatever be the connection which he really wishes to assert to hold between being "normative" and being "non-natural," it is obvious that *one* of the two premisses upon which his conclusion depends is false, if, as I have argued, it is not true that if good were either simple or intrinsic it could not be normative. He has therefore failed to give any good reason *either* for the conclusion that if good were simple or intrinsic there would be *no ground* for supposing it to be non-natural *or* for the immensely stronger conclusion that if good were simple or intrinsic, it *could not be* non-natural. He has failed to do this because, as I have tried to show, he has failed to give any good reason for the premiss that if good were simple or intrinsic, it could not be normative.

I have now dealt with six of the points contained in Mr. Frankena's point 2; and I said at the beginning that there were

at least seven points contained in it. *Verbally* there is at least
one other; for after making the six assertions I have discussed,
he goes on to say "and *then* there is no reason to regard [good]
as indefinable in non-ethical terms." The consequence which he
here asserts to follow from something or other, namely that
"there is no reason to regard good as indefinable in non-ethical
terms," is of course *verbally* different from any of the three con-
sequences, about which he has so far asserted (falsely) that all
three follow from the hypothesis that good is simple, and also
(falsely) that all three follow from the hypothesis that good is
intrinsic; and undoubtedly, if Mr. Frankena were using the
expression "indefinable in non-ethical terms" in any sense which
it can properly bear, it would be not merely verbally but really
different. But there is, I think, a very strong reason for suppos-
ing that Mr. Frankena is misusing this expression; that when
he says "indefinable in non-ethical terms" he does not really
mean "indefinable in non-ethical terms," and that what he does
mean is precisely what he has previously expressed by "non-
natural," so that he is here not mentioning a new consequence at
all, but only an old one expressed in new words. The reason
for suspecting this is as follows. Mr. Frankena is certainly im-
plying, if he is not asserting, that from the hypothesis that good
is simple it *follows* that there is no reason to regard good as
"indefinable in non-ethical terms." What he appears to be
asserting is that this follows from the conjunction of the three
propositions which he has asserted (falsely, in one case, and
without any good reason in one other) to follow from the propo-
sition that good is simple; and he thus *implies* of course that it
follows from this proposition itself, since if p entails q, and q
entails r, it follows that p entails r. But now let us consider this
assertion which he implies to be true: "If good is simple, there
is no reason to regard it as indefinable in non-ethical terms."
Now I used "simple," as Mr. Frankena has noticed, to mean
the same as "indefinable." Mr. Frankena is then committing
himself to: "If good is indefinable, there is no reason to regard
it as indefinable in non-ethical terms." What an extraordinary
proposition! On the contrary, if good is indefinable, it *follows*
that it is indefinable *in any terms at all*, whether ethical or non-

ethical. How then can it possibly follow from the hypothesis that it is indefinable that there's no reason to regard it as indefinable in terms of one particular sort? I feel very confident that Mr. Frankena did not really mean to commit himself to this extraordinary proposition. I think he was misusing the expression "indefinable in non-ethical terms" to mean "not identical with any notion expressible in non-ethical terms." Some notions *expressible* in non-ethical terms may quite well be *indefinable;* and hence there is no such absurdity in saying that from the hypothesis that good is indefinable it follows that there is no reason to suppose that it is not *expressible* in non-ethical terms, as there is in saying that from this hypothesis it follows that there is no reason to suppose that it is not *definable* in non-ethical terms. This non-absurd proposition is, I believe, all that Mr. Frankena meant to commit himself to; and I see no reason for distinguishing between the proposition "good is expressible in non-ethical terms" and the proposition "good is natural." I think therefore Mr. Frankena is here only presenting us with his old consequence "There is no reason to regard good as non-natural" under a new name. And he has no good reason for supposing that this consequence *does* follow either from the hypothesis that good is simple, or from the hypothesis that it is intrinsic, because, as I said before, part of his reason is the false assumption that if good is simple it cannot be normative.

(3) Mr. Frankena's third point is: "If value is normative or non-natural or indefinable in non-ethical terms, then it is definable in terms of obligation; it cannot have only a synthetic connection with obligation, and it cannot be either simple or an intrinsic quality." And I think I have already discussed, and given my reasons for disagreeing with, every one of the many assertions contained in this point.

(4) Mr. Frankena's fourth point is a really new one. He asserts: "Moore does not seem to have any adequate grounds for rejecting the view that intrinsic value is definable in terms of obligation."

Now, in the passage in his essay (p. 106) in which, I suppose, Mr. Frankena would say that he was giving reasons for the proposition that I "have no adequate grounds for rejecting the

view that intrinsic value is definable in terms of obligation," he does not use the word "adequate." He begins the passage by saying "I cannot see that Moore has any *good* reasons for not adopting this view"—the view in question being that "value" is "definable in terms of 'ought' or 'right'." And he ends it by saying "My last main contention is that the objections which Moore has given or may give to the view that value is definable in terms of obligation are not *conclusive*." And I mention this in order to emphasize the point that to have *good* reasons for a view is a very different thing from having *conclusive* reasons for it. In the present case I am inclined to say that there are *good* reasons for the view that the sense of "good" with which I have been mainly concerned is not definable in terms of "ought," but I should hesitate to claim that there are *conclusive* reasons for it. If, therefore, by "adequate" Mr. Frankena means "conclusive," I do not wish to dispute this point of his; but if he wishes to contend that I have no *good* reasons for this view, then I do wish to dispute it.

He begins by suggesting a definition of "intrinsically good" in terms of "duty," which he apparently thinks may be a correct one. His definition is: "X is intrinsically good" means "If we are capable of producing X, then we have a *prima facie* duty to do so;" and he adds that he is using the expression "*prima facie* duty" "in Ross's sense." This definition of his I have already mentioned (p. 565), and given a reason for thinking that it cannot possibly be true. My reason was that if, as I think is the case, Sir D. Ross so uses the expression "*prima facie* duty" that you cannot say with truth of any characteristic which a possible action possesses, that the fact that it possesses it renders it a "*prima facie* duty" to do that action, unless the fact that it possesses it is a *strong* reason for supposing that it is your duty to do that action, then the mere fact that a possible action would produce *some* "intrinsically good" result does *not* render it a *prima facie* duty to do that action, since the fact that an action has this characteristic is only a very *weak* reason for supposing that you ought to do that action. I should say of this reason for rejecting Mr. Frankena's proposed definition that it is not merely a *good*, but an *absolutely conclusive* reason for rejecting

it. But of course this is only the case, if I am right as to the way in which Sir D. Ross uses the term *"prima facie* duty." If I am wrong as to this, then I cannot criticise this proposed definition of Mr. Frankena's, since I do not know what the proposed definition is—I do not understand the expression *"prima facie* duty."

We saw above, however, that Mr. Frankena seems to identify the proposition that "a thing's having intrinsic value makes it a *prima facie* duty to produce it if possible" with the proposition that "a thing's having intrinsic value *so far* makes it a duty to produce it if possible" (p. 563). This identification is, of course, a mistake, if I am right as to Sir D. Ross's use of *"prima facie* duty;"* but since Mr. Frankena does make it, it is possible that what he meant by his proposed definition was: "X is intrinsically good" means "If we are capable of producing X, then we have *so far* a duty to do so." I have already discussed the meaning of Mr. Frankena's perplexing use of the words "so far" in the first of these two expressions, and explained that the only meaning I can attach to them is that in which "a thing's having intrinsic value *so far* makes it a duty to produce it if possible" means neither more nor less than "a thing's having intrinsic value is *some* reason for thinking (is favourably relevant to the hypothesis) that we ought to produce it, if possible." And I have admitted that I do think that from any proposition of the form "X is intrinsically good" there *does follow* "If an action, which we can do, will produce X, that is *some* reason for thinking that we ought to do that action." I have now to admit that I also think that, conversely, from the proposition "The fact that an action, which we can do, will produce X, is *some* reason for thinking that we ought to do that action" there follows the proposition "X is intrinsically good." It is easy to make a mistake as to whether this is true. Suppose, for instance, that an action which you can do is to post a cheque to a man, and that a result which this action will produce is that he will receive the money, and that in this way a debt that you owed him will be paid. The fact that his receipt of the money will be the payment of a debt that you owe him *together with* the fact that your action will result in his receipt of it are certainly

some reason for thinking that you ought to do the action which will result in his receiving it: and yet the mere fact that he receives that money is certainly not intrinsically good. But, in this case, it is obvious that the mere fact that, as a result of your action, he will *receive the money*, is *no reason at all* for supposing that you ought to send the cheque. It is not an intrinsic character of his receipt of the money that it is *the payment of a debt owed by you:* exactly that state of affairs which constitutes his receipt of the money *might* have occurred without its being the payment of a debt: the property which we ascribe to his receipt of the money by saying that it was the payment of a debt is a purely *external* property of the event in question. But if we say that the *mere* fact that a given action will produce a result X is *some* reason for supposing that that action ought to be done, we ought not to mean that the fact that it produces X *together with* the fact that X has some external properties, such as being the payment of a debt or the fulfilment of a promise, is *some* reason for supposing this: the *two* facts that the action will produce X *and* that X has a certain external property are obviously *not* identical with the *mere* fact that the action will produce X. And, so far as I can see, whenever it is true to say that the *mere* fact that an action will produce a result X, apart from any facts about the external properties that X may have, is a reason for supposing that the action in question ought to be done, then X must be intrinsically good. Of course, it is perfectly correct to say that, in such a case as I have instanced, one result of your action will be the payment of your debt; and the fact that the action will have this result really is some reason for supposing that you ought to do it. But if what we are talking of is the event or state of affairs, which will have the external property that it is a payment of your debt, then the fact that your action will produce *this* result is *no reason at all* for supposing that you ought to do the action, because it is a result which is not intrinsically good.

I think, therefore, that if what Mr. Frankena means to assert is that the propositional function "*x* is intrinsically good" may be *identical* with the function "the fact that an action which you can do would produce *x* is *some* reason for supposing that you

ought to do that action," then *one* condition necessary for the possibility of this being true really is fulfilled: namely that there is a two-way necessary connection between these functions —they are "logically" equivalent to one another. But nevertheless I think there is a *good* reason, if not a conclusive one, for doubting whether they are identical. Let us return to Mr. Langford's instance of the functions "*x* is a cube" and "*x* has twelve edges." There is, I should say, no doubt whatever that the two functions "*x* is a cube" and "*x* is a cube *and* has twelve edges" are "logically" equivalent to one another: each function follows from the other. But Mr. Langford seems to me to give a conclusive reason for saying that they are not identical: namely that you can know that a thing is a cube without knowing that it has twelve edges. Cannot a similar reason be given in the case of the two functions, which we are supposing Mr. Frankena to take to be identical? Is it not possible to *think* that a thing is intrinsically good without thinking that the fact that an action within our power would produce it would be a reason for supposing that we ought to do that action? It certainly seems as if we can; and this seems to me a *good*, even if not *conclusive*, reason for supposing that the two functions, even though logically equivalent, are *not* identical: a good reason, therefore, for supposing that intrinsically good cannot, in *this* way, be defined in terms of "ought."

But Mr. Frankena goes on to mention, as if he thought it might possibly be true, a third way in which it might be suggested that "intrinsically good" could be defined in terms of obligation. He quotes from p. 66 of my *Ethics* the statement: "To say of anything, A, that it is 'intrinsically good', is equivalent to saying that, if we had to choose between an action of which A would be the sole or total effect, and an action which would have absolutely no effects at all, it would always be our duty to choose the former, and wrong to choose the latter;" and then he asks "Why is this statement not a definition?" I think the proper answer to *that* question is: Because it is merely a statement that two functions are logically equivalent—that each follows from the other; and such a statement cannot properly be called a "definition." But I do not think that this is the question

which Mr. Frankena meant to ask. I think what he meant to ask was: Why should not Moore, *instead of* saying that the two functions are equivalent, have said that they are *identical?*—have said, that is, that the second gave a definition or analysis of the first? The answer which I should now give to *this* question is similar to the one which I have given to the last suggested definition of "good" in terms of obligation: namely that it seems as if we can *think* that a thing is intrinsically good without thinking that if our choice were confined to an action which would produce that thing or an action which would produce nothing at all, it would be our duty to choose the former action; and that therefore to think that the one is the case is not identical with thinking that the other is. And I think that this is a *good,* though not, perhaps, a conclusive reason, for holding that the two functions are not identical.

I ought, perhaps, to say at once that I do not now think that this statement of equivalence, which I made on p. 66 of *Ethics* is true: I do not even think that it was a correct way of expressing what I then really meant. But I am still inclined to think that something *like* this is really true. The statement which I should now be inclined to substitute for it is something like this: To say of anything, A, that it is "intrinsically" good is equivalent to saying that, if any agent were a Creator before the existence of any world, whose power was so limited that the only alternatives in his power were those of (1) creating a world which consisted solely of A or (2) causing it to be the case that there should never be *any world at all,* then, if he knew for certain that this was the only choice open to him and knew exactly what A would be like, it would be his duty to choose alternative (1), provided only he was not convinced that it would be *wrong* for him to choose that alternative. Here what is stated to be equivalent to "A is intrinsically good" is obviously even more complicated than what I stated in *Ethics* to be so equivalent, and consequently the paradox of asserting that the one function is *identical* with the other is even greater. I think this is a very good reason for holding that even if the two functions *are* logically equivalent they are *not* identical. If, in addition to the example of the two functions "*x* is a cube" and "*x* is a cube *and*

has twelve edges," another example be wanted of propositions which *are* logically equivalent but are (to all appearance) *not* identical, I may instance the kind of case which I discussed in my article on "Facts and Propositions." The statement "The sun is larger than the moon" is certainly logically equivalent to "If any one were to believe that the sun is larger than the moon he would be right:" each of these statements certainly *follows* from the other: and yet there is good reason to doubt whether the two statements are identical. Mr. Frankena seems to me to have been singularly blind to the fact that there are hosts of cases in which there is good, if not conclusive, reason for saying that two propositions, of which each follows from the other, are nevertheless *not* identical.

Besides these two functions, in which the notion of obligation occurs, I do not know of any others with regard to which it is even plausible to suppose that they are logically equivalent to the function "*x* is intrinsically good." But logical equivalence is a necessary, though not a sufficient, condition for identity. Since, therefore, in these two cases, I think there is good reason to suppose that the two functions in question, even if they are logically equivalent to "*x* is intrinsically good," are yet *not* identical with it, I do not agree with Mr. Frankena that I have no good reason to suppose that "intrinsically good" is *not* definable in terms of obligation.

(5) Mr. Frankena's fifth "point" is too long to quote, and I think there is only one assertion in it which is both "new," in the sense that it was not made in any of the other "points," and also needs to be discussed. This is the assertion: "Moore has no good arguments against the view that intrinsic value is definable in non-ethical terms, even though it is what makes a thing such that it ought to be pursued or brought into being by a competent agent."

Now I think that part at least of what Mr. Frankena means when he here says "Moore *has* no good arguments" is that I have not, in any of my writings, *given* any good arguments for the view that the sense of "good" with which I have been chiefly concerned cannot "be defined in non-ethical terms"—an expression which, as I explained above (pp. 594f), there seems

reason to think Mr. Frankena uses in such a way that it is in-distinguishable in meaning from "be a *natural* property." But I do not intend here to discuss the question whether I have anywhere *given* any good reasons for supposing this sense of "good" not to be a *natural* property. A far more important question is whether there *are* any good reasons for supposing so. And I am going to confine myself here to giving *one* reason, which seems to me to be a good one; *the* one, namely, which seems to me to meet the objection which Mr. Frankena has here specially in mind, as shown by his adding the clause "though it is what makes a thing such that it ought to be pur-sued or brought into being by a competent agent."

The wording of this clause shows, I think, that Mr. Frankena had in mind a point upon which he has insisted twice before, though his wording was different on each of these two occasions. On p. 100, he uses the expression "characteristic whose presence makes things such that they ought to be brought into existence" and a few lines further on "characteristic in virtue of which things which have it ought to be produced;" and on p. 105 he uses the expression "makes things such that they ought to be pro-moted" as applicable to a characteristic. I think it is quite plain that he intends all these different expressions to be mere synonyms for one another; and on both occasions he is insisting that a *natural* characteristic may be a characteristic of the kind in question. He says, for instance, that there is nothing which makes the view that pleasantness (though a natural characteris-tic) is of this kind "impossible in principle."

Now these expressions, of course, remind us of the expres-sion which he used earlier when he attributed to me the view that "a thing's having intrinsic value *so far* makes it a duty to produce it if possible." And I think there is no doubt that he intends them all to be mere synonyms for "characteristic whose presence in a thing *so far* makes it a duty to produce that thing if possible." Now I have already discussed the meaning of this expression and explained what is the only meaning I can attach to it. And, if Mr. Frankena *is* using all these expressions in that sense, then I think we must admit that a natural characteris-tic may be a characteristic of this sort. Indeed it *must* be the

case that at least one natural characteristic is of this sort, if (as I have admitted) intrinsic value is of this sort, and if also (as I have always maintained) a thing's intrinsic value always depends on its *natural* intrinsic properties. For, if there is any natural characteristic such that from a thing's possession of that characteristic it *follows* that the thing is intrinsically good, and which is, therefore, in that sense, "good-making;" and if from the fact that a thing is intrinsically good it *follows* that it is, *so far*, a duty to produce it, if possible; then from the mere fact that a thing has the *natural* characteristic in question it must also follow that it is, *so far*, a duty to produce it, if possible.

Now it seems to me that Mr. Frankena really thinks that the fact that a natural characteristic *may* be of this sort is an objection to my *combination* of the two views (a) that "intrinsically good" is *not* definable in terms of "ought" and (b) that nevertheless there is good reason to think that "intrinsically good" is non-natural. He thinks that if this sense of "good" were definable in terms of "ought," then there would be some reason to suppose it non-natural; but that, if it is not, then, in view of the fact that a natural characteristic may be of the sort with which we are now concerned, there can be no good reason to suppose that this sense of "good" is non-natural. I wish to give a reason, which seems to me a good one, for supposing that, in spite of this fact, this sense of "good" is non-natural, i.e., is not identical with any natural property; and this reason, it will be seen, is quite independent of the question whether this sense of "good" is definable in terms of "ought" or not, so that it will be a good one, even if this sense of "good" is *not* so definable.

Now I am afraid that, in order to state my argument concisely, it is necessary to use some *short* expression for that property which we attribute to a characteristic when we say that "its presence in a thing makes it *so far* a duty to produce that thing if possible." This is a long and cumbrous expression; so are the others which we have just seen that Mr. Frankena seems to use as synonyms for this; and so above all is the expression which I have suggested as the clearest way of saying what he seems to me to mean by these expressions, namely, "characteris-

tic such that, when a state of affairs possesses it, then the fact that an action, which an agent could do, would produce that state of affairs is favourably relevant (though only in a very weak degree) to the hypothesis that that agent ought to do that action." Now I do not believe that there is any short expression in ordinary use which is a synonym for this long one. If, therefore, as I think is necessary to state my argument concisely, I am to use a short expression as a synonym for this long one, I must choose one which would not naturally have the meaning with which I am going to use it. I am going, therefore, quite arbitrarily, just so long as I am discussing the present question, to use the rather barbarous expression "ought-implying property" as short for the very long and cumbrous expression which I have last written between commas. (It may be noticed that I have frequently in this essay used the words "property" and "characteristic," as if they were synonyms, and have changed about from one to the other, where no difference of meaning was intended. The use of either word in the sense in which I have been using them is, so far as I can see, an equally great departure from any use which they have in common speech; but the use of both in this sense seems to me to be pretty well established in philosophy; and I am here going to use "property" simply because it is shorter than "characteristic"). When I thus use the expression "ought-implying property" I hope no one will so misunderstand me as to suppose that when I call a property "ought-implying" I am meaning that it is a property such that any action, within our power, which will produce a thing which has that property ought to be done. I am quite arbitrarily (that is, without any consideration for what, if anything, the expression might be thought to mean naturally, in accordance with ordinary English usage) using it simply and solely as short for the long and cumbrous expression I have mentioned.

I have admitted, then, that at least one *natural* property is ought-implying; have admitted, therefore, that a *natural* property *may* be "ought-implying." But I have not admitted, and don't mean to admit, that any natural *non-intrinsic* property can be ought-implying. And I want to emphasize this because Mr. Frankena seems to assume that, once I have rejected the

view that intrinsic value is definable in terms of "ought," I can have no good reason for supposing that it is not identical with some *non-intrinsic* natural property. I think, on the contrary, that I have good reasons for this, namely those which I have for supposing intrinsic value to be an intrinsic property. But I am not now concerned with these: Mr. Frankena has not, so far as I can see, discussed the question whether there is any good reason to suppose that intrinsic value is an intrinsic property, and I don't intend to discuss it either. It is (as I think he has seen) a question which is open to discussion; since one way in which I have used the term "intrinsic value" is such that the proposition "intrinsic value is not an intrinsic property" is not self-contradictory. One way in which I have used it is as a mere synonym for that sense of "good" with which I have been principally concerned; and it is certainly not self-contradictory to say of this sense of "good" that, even if it is a property, it is not "intrinsic." To say that it is "intrinsic" is, in my use of that term, to say that it depends only on the intrinsic nature of what possesses it; and that it does so may be disputed without self-contradiction. But the question with which I am at present concerned is solely whether there is good reason for thinking that intrinsic value is not identical with any natural *intrinsic* property, in view of the admitted fact that at least one natural intrinsic property *is* "ought-implying." Mr. Frankena certainly thinks that there is no good reason for this, *if* there is no good reason to suppose intrinsic value to be definable in terms of obligation.

I think there is a good reason for thinking so, and now, after all this preface, I can state what the reason is which I take to be a good one, quite simply and shortly. It is a reason which consists of two propositions, namely (1) that there are an immense number of different natural intrinsic properties, all of which are "ought-implying," and (2) that there does not seem to be any natural intrinsic property, other than (possibly) the disjunction of them all, which is *both* entailed by them all and also "ought-implying." Now intrinsic value, of course, cannot be identical with each of a number of different natural intrinsic properties; and yet it is entailed by each of them. But it is certainly not identical with a disjunction of them all, even if there is such a disjunction; and if the number is infinite, as it well

may be, there *is* no such disjunction. If, therefore, there is no other natural intrinsic property entailed by them all which is also ought-implying, it follows that intrinsic value cannot be identical with *any* natural intrinsic property, since it certainly is ought-implying. This argument seems to me to be perfectly conclusive, if the premises (1) and (2) are true. But it seems to me that there is very good reason for supposing both (1) and (2) to be true. And it may be noticed that Mr. Frankena has not attacked directly either of them. He seems simply to have failed to notice that they are relevant to the point he is trying to make!

I have now discussed, I hope, (though, of course, not adequately) the principal contentions in Mr. Frankena's five points; and I do not intend to say any more about his essay, although I think that many other things which he says in it are false. But I have headed this section "Relations between 'good' and 'ought'," and I think it may perhaps be convenient if I conclude it by giving a list of the principal statements of equivalence, which I now think to be defensible, between either (1) propositional functions in which the sense of "good" with which I have been principally concerned, occurs, and propositional functions in which the notion of moral obligation occurs, or (2) propositional functions in which the sense of "better" which is the comparative of the sense of "good" in question, occurs, and propositional functions in which the notion of moral obligation occurs. In giving this list I shall, because, as things are, I think this is, after all, the most convenient way of making my meaning plain, use "intrinsically good" as a mere synonym for "good" when used in the sense in question, although, of course, this usage is liable to be misleading, since, as I have just emphasized, when "intrinsically good" is used in this way, there is no contradiction in saying of the property which you assert to belong to a thing when you say it is intrinsically good, that it is *not* an intrinsic property; and I shall similarly use "intrinsically better" as a synonym for "better" when it stands for the comparative of this property. I shall also state these equivalences not in terms of the word "equivalence" but in terms of the word "follows," because, although this involves longer statements, I think it makes it plainer what I am committing myself to. This word "follows"

is one which I have already frequently used in this essay, and sometimes I have put "logically" before it, and sometimes "logically" in inverted commas. I shall here use "follows," simply, to mean the same as "logically follows." The point of using "logically follows" is to emphasize that you are *not* using "follows" in one of the senses in which it can quite properly be used and which might be called "causally follows." Before aeroplanes were invented you could have said with perfect truth, on hearing that a man was in New York the day before yesterday, "Then it follows that he wasn't in London yesterday." And this is a way in which "follows" is often used in ordinary speech. But from the proposition that a man was in New York on one day, it doesn't, and didn't, *logically* follow that he wasn't in London the next: there isn't, and therefore never was, any *logical* impossibility in a man's being in New York one day and in London the next: the statement "He was in New York one day and in London the next" is not and was not self-contradictory. But if you use "follows" as applied to propositions as a synonym for "logically follows," then if q follows from p, the statement that p was the case and q was not is self-contradictory. This partially explains how I have been using "follows" as applied to *propositions:* I have been so using it that it can only be said with truth that a proposition q follows from another p, when it can also be said with truth that "p, but not q" is self-contradictory. And the point of putting "logically" in inverted commas before "follows" is to emphasize the fact that "logically follows" is used in different senses, and that it is only in the *widest* sense in which it is used, that the proposition mentioned does follow "logically" from the other proposition mentioned. Thus from the proposition, with regard to a given object that it is a cube, it certainly follows "logically" that the object in question has twelve edges; and it is certainly a contradiction to say of any object that it is a cube but has not got twelve edges; but I think "logically follows" is sometimes so used that if the proposition that an object has twelve edges only "follows *synthetically*" from the proposition that it is a cube, then it does *not* follow "logically" from it. I have been so using "follows," as applied to propositions, that one proposition can be truly said to follow from another *only* where it can also be truly said that

to deny the first and affirm the second would be a contradiction, but also so that a proposition *can* be truly said to follow from another *wherever* this is the case, whether it is a case of "following synthetically" or a case of "following analytically," however these two terms "synthetic" and "analytic" may be used. This, perhaps, partially explains how I have been using "follows" as applied to propositions. I am now going to apply it, as I sometimes have already, to propositional functions. But the use as applied to propositional functions can be easily explained by reference to the use as applied to propositions. To say that the function "*x* is male" *follows* from the function "*x* is a brother" is to say that from any proposition with regard to any particular living creature that that creature is a brother there follows the proposition that that same creature is male. What I want to emphasize is that, if I say "*x* is male" *follows* from "*x* is a brother," I am committing myself to the statement that, e.g., "King George VI is a brother but is *not* male" *is a contradiction;* and similarly in the case of any other pair of functions.

Let me now give my list of equivalences. Two are between a function in which "intrinsically good" (the notion, *not* the expression) occurs and a function in which the notion of moral obligation occurs; and two between a function in which "intrinsically better" occurs and a function in which the notion of moral obligation occurs. The first two I have already indicated roughly (pp. 598-600), but I think it is worth while to give them again in a more precise, and, as I think, a more accurate form.

(1) Each of the five functions enumerated below under A, namely,

follows from the function

B. "If there had been or was an agent who, before any world existed, knew that, if he chose, he could create a world which would have the natural intrinsic property φ, knew also that he could make this choice, and knew finally that if he did not make it *no world at all would ever exist,* then it *would have been or was the duty* of this agent, provided he did not think it would be wrong to make it, to make this choice."

And also B follows from each of the five functions enumerated under A.

(2) Each of the five functions enumerated under A follows from the function

C. "The natural intrinsic property φ is an "ought-implying' property." And also C follows from each of the five functions enumerated under A.

(3) Each of the five functions enumerated below under D, namely,

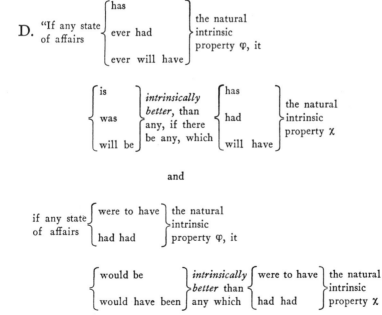

$$\text{D.} \quad \text{"If any state of affairs} \left\{ \begin{array}{l} \text{has} \\ \text{ever had} \\ \text{ever will have} \end{array} \right\} \begin{array}{l} \text{the natural} \\ \text{intrinsic} \\ \text{property } \varphi, \text{ it} \end{array}$$

$$\left\{ \begin{array}{l} \text{is} \\ \text{was} \\ \text{will be} \end{array} \right\} \begin{array}{l} \textit{intrinsically} \\ \textit{better,} \text{ than} \\ \text{any, if there} \\ \text{be any, which} \end{array} \left\{ \begin{array}{l} \text{has} \\ \text{had} \\ \text{will have} \end{array} \right\} \begin{array}{l} \text{the natural} \\ \text{intrinsic} \\ \text{property } \chi \end{array}$$

and

$$\text{if any state of affairs} \left\{ \begin{array}{l} \text{were to have} \\ \text{had had} \end{array} \right\} \begin{array}{l} \text{the natural} \\ \text{intrinsic} \\ \text{property } \varphi, \text{ it} \end{array}$$

$$\left\{ \begin{array}{l} \text{would be} \\ \text{would have been} \end{array} \right\} \begin{array}{l} \textit{intrinsically} \\ \textit{better} \text{ than} \\ \text{any which} \end{array} \left\{ \begin{array}{l} \text{were to have} \\ \text{had had} \end{array} \right\} \begin{array}{l} \text{the natural} \\ \text{intrinsic} \\ \text{property } \chi \end{array}$$

follows from the function

E. "If there had been or was an agent who, before any world existed, knew that, if he chose, he could create a world which would have the natural intrinsic property φ, knew also that he could make this choice, and knew finally that, if he did not make it, a world which had the natural intrinsic property χ would inevitably come into existence instead, then it *would have been or was the duty* of this agent, provided he did not think it was wrong for him to make it, to make this choice."

And also E follows from each of the five functions enumerated under D.

(4) The function, F. "The world is *intrinsically better*, because x chose to do the action y, when he could have chosen to do something else instead, than it would have been if he had made any other choice instead" follows from the function G. "x did his duty in choosing to do the action y," and also G follows from F.

I ought perhaps to explain that, in the three first statements of equivalence, (1) (2) and (3), I am using the phrase "natural intrinsic property" in such a way that any conjunction of natural intrinsic properties is itself a natural intrinsic property.

I can quite imagine that there will be some people who will think these statements of equivalence purely fantastic; and others, perhaps, who will be able to see that I have not succeeded in stating what I really meant. But I think there is some reason to think that *something like* each of these statements is really true. There seems to me to be equal reason in all four cases to suppose that the functions stated to be "logically" equivalent are nevertheless not *identical;* and it is worth noting that whereas, if F and G were identical, "ought" would be definable in terms of "intrinsically good" (as I asserted to be the case in *Principia*), in all the other cases, if the functions stated to be equivalent were identical, then "intrinsically good" or "intrinsically better" would be definable in terms of "ought." So far as I can see, there is just as much reason for supposing "ought" to be definable in terms of "intrinsically good" as the other way about; and the reason for rejecting the view that "intrinsically good" or "intrinsically better" are definable in terms of "ought" is of precisely the same kind and just as strong

as the reason for rejecting the view that "ought" is definable in terms of "intrinsically good." My present view is that both views should be rejected, and that, in the case of *all* the functions, which I have stated to be equivalent, the functions in question, though equivalent, are *not* identical.

5. Egoism

I think this is the proper place to say what I can about Mr. Broad's contention that a doctrine which he calls "Ethical Egoism" is not self-contradictory. I think this is the proper place, because I think that the doctrine in question either makes or entails an assertion about the relation between the notion which I have called "intrinsically good" and the notion of moral obligation.

That it does so is not immediately evident from Mr. Broad's definition of what he means by "Ethical Egoism." He says: "Ethical Egoism is the doctrine that each man has a predominant obligation towards himself as such." And he then goes on to say that this doctrine might be held "in milder or more rigid forms," and that the "extreme form" of it would hold that "each man has an ultimate obligation *only* towards himself." Now in both these definitions it is obvious that some assertion is being made about the notion of moral obligation, but it looks as if no assertion at all were being made in either about the notion "intrinsically good" or about any sense at all of the words "good" or "better." Mr. Broad, however, immediately proceeds to inform us that "according to the extreme form" of Ethical Egoism it is *part* of a man's duty, "to give *himself* the most favourable balance of *good* over bad experiences." Here, at last, an assertion is being made about the connection of moral obligation with *some* sense of "good." And a little further on Mr. Broad tells us that, if A is an ethical egoist, he *will* assert that it is not his duty to produce *good* experiences *as such*, without regard to the question of who will have them: he will assert that he has an obligation to produce *good* experiences in *himself*, and no such *direct* obligation to product them in any one else. It is obvious, therefore, that Mr. Broad does mean by "Ethical Egoism" a doctrine which makes *some* assertion about a connec-

tion between moral obligation and *some* sense of the word "good." And he also thinks that the very doctrine which he calls "Ethical Egoism" was a doctrine which I asserted in *Principia* to be self-contradictory. And, if so, it must be a doctrine which makes some assertion about the connection of obligation, not merely with *some* sense of the word "good," but with that particular sense which I have called "intrinsically good;" for none of the doctrines which I called "Egoism" in *Principia* and asserted to be self-contradictory was a doctrine about any sense of the word "good" except this one.

Mr. Broad means then by "Ethical Egoism" a doctrine which makes *some* assertion about the connection between the notion of moral obligation and the notion "intrinsically good." And he thinks, apparently, that no assertion which it makes about the connection of these two notions "contradicts itself in any way."

Now I still think that there is a *good* reason, though I do not say a *conclusive* one, for thinking that at least one assertion which the doctrine which Mr. Broad calls "the extreme form of Ethical Egoism" makes or implies, *is* self-contradictory. And I will confine myself to stating, as clearly as I can, what this assertion is, and explaining why I think it is self-contradictory. I do not think that any of Mr. Broad's own statements as to what the extreme form of Ethical Egoism states or implies are as clear as could be desired; and perhaps he will think that the doctrine he meant does not imply the assertion which I take it to imply, and that he never therefore implied that this particular assertion, which I take to be self-contradictory, was not self-contradictory. I hope, however, for better things, and that he will admit that he was implying that the very statement, which I take to be self-contradictory, is not self-contradictory. And, however that may be, I think it is important to see that there are reasons for thinking that this particular statement, which certainly might be naturally called a part or a corollary of "Ethical Egoism," is self-contradictory.

Consider the following statement: A. "If a man knew that, among the various choices which he could make on a particular occasion, one particular choice would procure *for himself* a more 'favourable balance' of intrinsically good over intrinsical-

ly bad experiences than any other, and knew also that no other choice he could make would be more favourable to the development of 'his own nature and dispositions,' then it would *follow, from this alone,* that it would not be wrong for him to make that choice, even if he also knew that the world would be intrinsically worse if he made that choice than if he made some other instead." Some "egoistic" views, even if none that Mr. Broad would call "Ethical Egoism," certainly, I think, imply that this statement is true. But now consider the following statement: B. "If a man knew that, among the choices open to him, one particular choice was such that the world would be intrinsically worse, if he made that choice than if he made some other that he could make, then it would *follow, from this alone,* that it would be wrong for him to make that choice." This statement, B, is one which I think there is some reason to suppose to be true, and, so far as I can see, it is implied by what Mr. Broad calls "Ethical Neutralism." Now Mr. Broad has seen, of course, that A is incompatible with B. What I think he has failed to see is that, if B is true, then A is *self-contradictory.* He accuses me (p. 47) of having, after showing that ethical egoism is inconsistent with ethical neutralism, jumped unjustifiably to the conclusion that ethical egoism was self-contradictory. But I did not conclude that ethical egoism was self-contradictory simply because I saw that it was incompatible with ethical neutralism and assumed that the latter was true. If I had, it would have been grossly fallacious; and, perhaps, I am capable of fallacy as gross as that. But in this case I think I wasn't guilty of a fallacy so gross; I concluded that ethical egoism was self-contradictory, not for that reason, but because I thought I saw that if ethical neutralism was true, it *must* be self-contradictory. And I think I was right, though I was miserably confused and miserably unable to put the argument in a clear form. Let me now try to put in a clear form the argument that if B is true, then A is self-contradictory. From B it follows by formal logic, if I am not mistaken, that if it is *not* wrong for a man to make one particular choice among those open to him on a particular occasion, then it *follows* that he does *not* know that the world would be intrinsically worse, if he made that choice than if he had made another: in other words, it fol-

lows from B by formal logic, that the function (α) "it would not be wrong for x to choose y" *entails* the function (β) "x does not know that the world would be intrinsically worse if he chose y, than if he made another choice open to him." But now the function (α) "it would not be wrong for x to choose y" is a function about which A makes an assertion. A asserts, among other things, that this function follows from or is entailed by the function (γ) "x knows that choice y would procure *for himself* a 'more favourable balance' of intrinsically good over intrinsically had experiences than any other he could make, and knows also that choice y would be at least as favourable to the development of *his own* nature and dispositions as any other he could make." A therefore asserts that (γ) entails (α). But B asserts that (α) entails (β); and therefore, *if* B is true, it is *self-contradictory* to assert that (γ) entails (α), but does *not* entail (β). But A, besides asserting that (γ) entails (α) (an assertion which is, in itself, not self-contradictory) *implies*, even if it cannot be said to assert, that (γ) docs *not* entail (β). It *implies* this by its concluding clause "even if he also knew that the world would be intrinsically worse if he chose y;" for the addition of this clause implies that it is *logically possible* that a man should have the knowledge mentioned in function (γ), and yet should *not* be ignorant that the world would be intrinsically worse if he made the choice in question. That is to say A, while asserting that (γ) entails (α), also at least implies, if it does not assert, that (γ) does not entail (β). And this, *if* B is true, is a contradiction. But we are supposing that there is *good*, if not conclusive, reason to think that B is true. It follows, therefore, if this argument is not fallacious, that there is just *as* good reason to think that A is self-contradictory.

There are, of course, hosts of other things that need to be said about this argument as an argument against a doctrine which could be properly called "Ethical Egoism." But one assumption, at least, which I am making, is, I think, not merely fanciful: namely that it is an essential part of any doctrine commonly meant by "Ethical Egoism" to maintain that it is at least *logically possible* that what is most conducive to the agent's own good should *not* be most conducive to general good

or, as Sidgwick calls it, Universal Good; and, if this is logically possible, it seems to follow that it must also be *logically* possible that an agent should *know*, in a particular case, that a choice open to him would be most conducive to his own good and *not* to Universal Good. Perhaps, however, there is some fallacy in the argument; and perhaps Mr. Broad will think that it is wholly irrelevant to anything that he meant by asserting that Ethical Egoism is not self-contradictory. But that it is *wholly* irrelevant, I do not believe.

6. *Independence of "good"*

Mr. Paton's essay is entitled "The Alleged Independence of Goodness;" and he holds, if I understand him rightly, that I have asserted, with regard to *one* sense of the word "good," that it is "independent" in two respects, with regard to which he himself holds that it is *not* independent in those respects. He holds (1) that "the goodness of a thing" (in this sense of "good") "must stand in some necessary relation to a rational will" (p. 113), and therefore is, in some sense, not "independent" of a rational will; and he holds (2) that "the goodness of a thing" (in this sense of "good") "may vary in different circumstances" (p. 113), and therefore is, in this sense, not "independent" of circumstances. I wish to say something on both these two points; and I begin with the first because it seems to me to be intimately connected with the subject of the relations between this sense of "good" and the notion of moral obligation.

(1) Mr. Paton holds that this sense of "good" not only stands in some necessary relation to the conception of "will," but that there is "a necessary and *reciprocal*" relation between it and will (p. 127). And part of what he means by this is, I think, what, in the terminology which I have been using, might be expressed by saying that there is at least one pair of propositional functions, in one of which the notion of will occurs, and in the other the notion of good (in my sense), which are "logically" equivalent to one another—each of the two *follows* from the other. And I want to make it quite plain that, so far as this is what he means, I completely agree with him. Take, for

instance, any one of the five functions listed under A on p. 608. Each of these is a function in which the notion of good (in my sense) occurs. And I there state that each of them is equivalent to the function B. Now B, as might be expected from the fact that the notion of moral obligation occurs in it, is itself equivalent to a function in which the notion of will occurs. And hence this function, in which the notion of will occurs, is in its turn equivalent to any one of the five functions listed under A. The particular function containing the notion of will, which I have in mind, is as follows. In the expression I have used for the function B, substitute for the concluding words "it *would have been the duty of this agent,* provided he did not think it would be wrong to make it, to make this choice" the following words "this agent, *if he had a rational will, would have made* this choice, provided that he did not think it would be wrong for him to make it." The function expressed by the whole sentence, when this substitution is made for those concluding words, is, it seems to me, quite certainly equivalent to B. For to say that *x ought* to do so and so is equivalent to saying that, *if* x had a rational will, he *would* do the thing in question—in at least one sense of the expression "rational will." That expression may be and is properly so used that to say that a person has a rational will is to say that, so long as he has it, he *will* do what he *ought.* I should myself say that this is a case not merely of equivalence but of identity—that the notion of having a rational will (in this sense) can be defined in terms of "ought;" that to say that so and so has a rational will just *means* that he makes the choices which he ought to make, or (in other words) which it is *rational* to make. But, however this may be, I think there is no doubt of the equivalence. And, if this is so, the question whether a thing which has, or had, or would have etc. a certain natural intrinsic property is, or was, or would be intrinsically good, does, in a very real sense, *depend* on the question whether a *rational will* would, under certain circumstances, have made a certain choice with regard to a thing having the property in question: unless a rational will *would have made* a certain choice, it cannot be the case that a state of affairs of the kind in question is, or was, or would be etc., intrinsically good.

So far, then, as Mr. Paton means this (if he does mean it) I completely agree with him. But I am afraid that this would not satisfy him. For the necessary and reciprocal connection which this asserts to hold between the sense of "good" with which I have been concerned and the notion of a rational will, is such that from it it does not in the least follow that any proposition to the effect that a state of affairs of a certain sort *is* or *would be* good (in the sense in question) entails that any rational will exists: it does not, therefore, assert or imply that any fact to the effect that a state of affairs of a certain sort *is* or *would be* good *depends* on the *existence* of a rational will; it only asserts that any such fact *depends* on the fact that a rational will, if any had existed in certain circumstances, would have made a certain choice. And I do not gather clearly, from what Mr. Paton says, that he does not also hold two other things, which it seems to me important to distinguish both from this one and from one another. These are (a) that from any fact to the effect that a state of affairs of a certain sort *would be* good (in the sense in question) it follows that a rational will *exists,* and (b) that from any fact to the effect that an *existing* state of affairs *is* good, it also follows that a rational will *exists.* If Mr. Paton does hold either of these two things, I cannot agree with him, for the following reasons. In the case of (a), it seems to me that a statement to the effect that a state of affairs of a certain sort *would be* good, if it existed, is a statement which, if true, would have been true, even if *nothing at all* had existed, just as much as the statement that a scarlet thing *would be* red: it seems to me to be a purely *a priori* or necessary proposition, which would have been true, even if there had been no world at all, and the truth of which does not, therefore, logically depend on the existence of anything whatever. (b) differs from this in that, in the case of (b), we are talking of the consequences of any hypothesis to the effect that a certain state of affairs which *exists* is good; and, of course, any such hypothesis cannot be true unless something does exist; its truth does therefore *depend* on its being the case that something exists. But it seems to me that the existence of a rational will is not one among the existential propositions which do follow from any such hypothesis. I agree with Mr. Paton

now, as I did not when I wrote *Principia,* that the existence of some *experience* is a proposition which does follow from the hypothesis that there exists a state of affairs which is good: I think now that no state of affairs can be good, unless its existence entails the proposition that somebody is having some *experience.* But to say that a rational will exists is to say that somebody has a certain *mental disposition,* not to say that somebody is having some *experience;* and I cannot see that any hypothesis to the effect that a particular state of affairs which exists is good, does entail any proposition to the effect that a *mental disposition,* of any kind whatever, exists.

(2) In support of his view that the question whether a thing is good, in the sense with which I have been concerned, *does* depend on the circumstances in which it occurs, and not merely, as I said, on its intrinsic nature, Mr. Paton quotes (p. 126) the case of Sir Philip Sidney, when, dying on the field of Zutphen, he ordered the cup of water which had been brought for him, to be given to another wounded soldier. But this case seems to me to shew the very opposite of what he takes it to shew. He speaks of Sir Philip's "action," in doing this, as "good;" and, of course, what he says is irrelevant to anything that I have held, unless he means that it was good in the particular sense that I have been concerned with. And he goes on to say, as shewing that the goodness of *this* action depended on the circumstances, that if Sir Philip had been quite well and had given the cup to a man who was not thirsty, "his action" would have had nothing like the same value. Now *what* action is it that Mr. Paton takes to have been good in the actual case? Is it any action which would *also* have occurred in the imaginary case? If not, then the fact that *some* action, which would have occurred in the imaginary case, would have had less value than the action which *did* occur in the actual one, can have no tendency to shew that the *same* action or exactly similar actions can have less value in some circumstances than in others. One thing which would have been common to the two cases, is that in both cases Sir Philip would have ordered a cup of water, offered to him, to be given to some one else; and *the giving of this order* really would have occurred under different circumstances in the two cases. But is it the mere giving of this order which Mr. Paton

takes to have been good in the actual case? I am quite certain
that it is not. What he takes to have been good in the actual
case is something which *would not have occurred at all* in the
imaginary case, *not* something which would have occurred in
both cases, only under different circumstances. It seems to me
that what Mr. Paton is doing is to confuse what *were* "circum-
stances" of *the giving of the order*, with what were "circum-
stances" of *the action he takes to be good*. The action which he
takes to have been good (and which I agree with him *was* good)
did not consist solely in the giving of the order (or the giving
of the cup, if Sir Philip did it with his own hands). Indeed the
giving of the order, or the cup, did not really form even a part
of the action we take to have been good. What *did* form a part
of it was Sir Philip's *choosing* to give the order, or, in Mr.
Prichard's phrase, *setting himself to* give it: for the action would
have been equally good if he had found that he was paralysed,
and that therefore his setting himself to give the order did not
result in his actually giving it, since paralysis prevented him
from saying a word or even making a gesture. But this *setting
himself* or choosing to give the order, though it is a part, is
not the whole, of what we consider good: for this is another
thing which would also have happened in the imaginary case.
What we consider good in the actual case is a state of affairs
which consists not merely in *this* choice being made, but in his
choosing *that the cup should be given to the other man, when
he himself was in pain and thirsty, and knew that the other
man was in pain and thirsty too*. And these "when-clauses" do
not here express *circumstances* under which the choice we admire
was made: they form part of a description of the *intrinsic nature*
of that choice: the choice which we admire was a choice *that the
cup should be given to the other man under these circumstances*,
not merely a choice that the cup should be given, which hap-
pened to occur under those circumstances. And here we get
something which would *not* have occurred in the imaginary case.
I feel sure that this is really at least a part of what Mr. Paton
thinks good in the actual case; and that hence what he calls "cir-
cumstances" of the action which he thinks good, are *not* circum-
stances of *that* action at all, but an essential part of it. There is an
immense difference between choosing, under circumstances *x*,

that a cup of water should be given to a man, and choosing *that a cup of water should be given to a man under circumstances x,* where *that the cup should be given under those circumstances* is *what* is chosen. What we admire, and call Sir Philip's "action" in this case, is a state of affairs of which a choice *that the cup should be given under those circumstances* is an essential part, *not* merely a choice that the cup should be given; and I doubt if even this is all. The state of affairs which we admire and think good probably includes not only the occurrence of a choice of this kind, but also the fact that Sir Philip felt pity for the man, and made the choice, partly at least, from pity. It probably includes other elements as well. It is this whole combination of facts, which we admire and think good; and *this whole combination* is something which would have been equally good under *whatever* circumstances *it* occurred.

What I am here asserting, let me emphasize, is *not* the proposition which Mr. Paton in his note, on p. 126, rightly calls a mere tautology: namely that "the goodness of an action is independent of the circumstances irrelevant to its goodness." What I am contending for is the very different proposition that what Mr. Paton here takes to be mere circumstances under which the action he admires occurred, are on the contrary a part of *the intrinsic nature* of the action he admires. The important question to ask is: *What* "action" is it that I am thinking to be good? It then becomes plain, in this case, that the "action" which is thought good in this case is an action, which *would not have occurred at all* under the imaginary circumstances Mr. Paton suggests, and is therefore *not* an action which would have had less value under those circumstances than under the actual ones. When we are clear as to *what* it is that we are thinking to be "good," in this sense, it becomes clear, I think, that anything *exactly like that,* would have been or would be equally good under *any* circumstances.

7. *"Postulates"*

What am I to say of Mr. Edel's essay? I can at least say this: That it seems to me extremely obscure and difficult; and that after several re-readings and much thinking about it, I feel that

I understand, with even tolerable clearness, only a very small part of what he says. It follows that his essay may, for all I can tell, contain numbers of very important truths, which I have been unable to detect, because I could not understand the language in which he has expressed them.

Owing to the fact that I do find his essay so obscure, I can say little more about it than that I do find it obscure. If I had now as much, say, as a clear month before me, which I could devote exclusively to trying to find out what Mr. Edel means by certain things which he says, I think I could probably find out, with some approach to clearness and certainty, what are the views which he is advocating on certain important matters, and what his reasons for holding those views; and *then* I could discuss them. But nothing like that amount of time is now available to me.

I can, however, and perhaps, in justice to Mr. Edel, I ought to, mention one particular thing which I find obscure. And I will choose as an illustration a matter which affects the whole scheme of his essay, and which is, I think, of some importance in other ways, and not merely as an illustration of what I find obscure in him. Mr. Edel entitles his essay "The Logical Structure of G. E. Moore's Ethical Theory," and on p. 138 he tells us that, in the "broad sense" in which he is using the term "logical structure," the logical structure of an ethical theory "consists of the equipment required to generate the enterprise of ethical enquiry." And in the previous sentence he has told us that one item in the equipment required for this purpose is "*postulates* governing the use of the terms employed" in the theory in question. This word "postulate" is a cardinal term in Mr. Edel's essay; he uses it again and again in order to express what he wants to say. But I am sorry to say that I am completely puzzled as to what he means by the word "postulate," so that I do not understand a single sentence of his in which that word occurs. Here are a number of alternative suggestions as to how he uses the word, each of which seems to me to be suggested by some of the things he says. Is he so using the word "postulate" that nothing but a *sentence*, a mere form of words, can be a postulate? The answer "Yes" to this question seems to

me to be suggested by his apparently holding that postulates always need "interpretation." Or is he so using it that *statements* can be postulates? He certainly says of things which he calls postulates that they *are* statements, or *state* so and so. Or is he so using it that nothing can be a postulate, but an *imperative* of some kind, e.g., a mandate or prescription? The answer "Yes" to this question is strongly suggested by the fact that on p. 142 he clearly implies that what he calls "Moore's postulates for the use of *good* in the sense of intrinsically valuable" are *rules prescribed* by me "to govern the construction of ethical statements and the use of ethical terms," as well as by his having said above that the "postulates" which form part of the logical structure of an ethical theory are "postulates *governing* the use of terms" employed in the theory. But if we answer "Yes" to all these three questions, we are involved in contradictions, since no *sentence* can be identical with any *statement* or with any *imperative*, and no *statement* can be identical with any *imperative*. How, then, *is* Mr. Edel using the word "postulate?" It might be suggested that he uses it in one sense in one place and in another in another; but, if so, he himself seems wholly unconscious that he is not using it in the same sense always. I am thoroughly puzzled; and the kind of puzzle in question can be brought out, in another way, as follows. On pp. 142-4 he professes to have given us five postulates, which he says he has "distilled from" my essay on "The Conception of Intrinsic Value." And what is quite certain is that he has given us five different *sentences*, to each of which he has prefixed one of the numerals, 1, 2, 3, 4, and 5. But *what* is it that he is here calling "postulates?" Is it these five *sentences* themselves? That seems one possibility, namely that he is using these sentences *autonymously*, each as a name for itself; but if so, then, he has *not* given us any statements or any imperatives. Any ordinary reader would certainly suppose that he was using the sentences to express or mention *statements*; and that what he is calling "postulates" are not these *sentences*, themselves, but certain statements which he is using these sentences to *mention*, though of course not to *assert*; and where his sentences are identical with, or seem to have the same meaning, as sentences which

occur in the essay of mine which he mentions, any ordinary reader would naturally suppose that *what* he is calling a "postulate" is the very thing which I had asserted in my essay. But, if so, then in these cases at all events, what he is calling a "postulate" is *not* "a rule prescribed by Moore to govern the use of" the term "good," in one of its senses. And yet Mr. Edel seems to say that *all* of these five things he calls "postulates" *are* such rules. And *if* they are, *if* they are imperatives which say "the word 'good', in this sense, is to be used in such and such a way," *what* is the rule which each prescribes? It is totally impossible to gather, from the sentences used, *what* rule each is supposed to prescribe. One is inclined to say: Would Mr. Edel kindly state, *explicitly*, i.e., in a sentence of the form "the word 'good', in the sense in question, is to be used in the way *w*," *what* rule each of these sentences is supposed by him to prescribe? Would he kindly *translate* each of them for us into a sentence, which *obviously* expresses an imperative, and also makes obvious *what* rule that imperative is prescribing?

I am totally unable to find my way out of this labyrinth which Mr. Edel has constructed. It seems to me quite possible that my ethical writings contain *no* "postulates" whatever, in the sense in which Mr. Edel uses that term; that, consequently, my "ethical theory" has *no* "logical structure," in the sense in which Mr. Edel uses that term, since postulates are essential to this; and that hence Mr. Edel set himself an impossible task in trying to discuss the logical structure of something which *has* no logical structure, and has given a fantastic mis-representation of my ethical views in asserting that they have a certain particular logical structure, when in fact they have (in his sense) no logical structure whatever.

8. *Freedom of Choice*

Mr. Garnett has convinced me, by what he says in his essay, that in my *Ethics* I was wrong on two separate points.

(1) I certainly did think, even if I did not expressly say so, that there was no gross departure from ordinary usage in using the term "*voluntary* action" in the way in which I proposed there (pp. 13-16) to use it: namely, in such a way that it is a

sufficient condition for calling an action "voluntary," that it should be an action which the agent *would* not have done, *if* he had chosen not to do it. I think Mr. Garnett is perfectly right in suggesting that there *is* a gross departure from ordinary usage in so using "voluntary." By saying that an action was "voluntary" we commonly imply not only this, but also that the agent *could* have chosen not to do it. As to this I perfectly agree with Mr. Garnett.

This, however, is only a point about the correct usage of a word. There is another point, as to which I agree with him, which is of much more importance.

(2) In *Ethics* (pp. 201-202) I said "It is very difficult to be sure that right and wrong do not really depend on what we *can* do and not merely on what we can do, *if* we choose," implying that I was not sure that they don't merely depend on the latter. I now think it was a mistake not to be sure of this. I think it is quite certain, as, I gather, Mr. Garnett does, that *ethical* or *moral* right and wrong, or (in Mr. Stevenson's phrase) right and wrong in any "typically ethical" sense, do *not* depend merely on what we can do, *if* we choose. Let me try to say clearly what I mean. In *Ethics* I thought that the mere fact that another action, which an agent *would* have done *if* he had chosen, would have had better total results than the action which he actually did do, was *perhaps* sufficient to entitle us to say that the action which he did do was morally wrong. I now think it is *certainly* not sufficient; and that one reason why it is not is that a *necessary* condition for its being true that his action was morally wrong is, that he should have been *able to choose* some other action instead. If he *could not* have chosen any other action than the one he did choose, then his action cannot have been morally wrong. I think now that this is *certainly* true, for *some* sense of "*could* have chosen." There is *some* sense of "could have chosen," and that *the* sense in which we naturally use it in this context, in which the proposition that an action was morally wrong, and, more generally, the proposition that the agent was morally responsible for it, certainly *entails* that the agent *could* have made a different choice from the one he did make. In *Ethics* I thought, and implied, that this was not certain.

On these two points, then, Mr. Garnett has convinced me that I was wrong. But on a third point he has not convinced me.

He implies (p. 190) that I was wrong in saying "If every event is caused, it must be true, in *some* sense, that we *never could* have done, what we did not do." That I was wrong in saying this he has *not* convinced me; and I venture to assert that the reasons which he proceeds to give for saying that I was wrong are such as ought not to convince any rational person that I was. He begins by saying "This" (i.e., my statement, just quoted) "assumes a uniformity and rigidity in the causal chain such as . . . must always remain unproven as between microcosmic events." Does my statement assume this? Whether it does or not, must, of course, depend on what Mr. Garnett means by that vague phrase "a uniformity and rigidity in the causal chain;" and that part at least of what he means is something which my statement does *not* assume, seems to me very plain from what he says about it. *What* is it that he is asserting "must always remain unproven as between microcosmic events?" Surely, part at least of what he is asserting must always remain unproven is that *microcosmic events always have causes*. And that this *is* part of what he means is confirmed by his drawing the conclusion: "It then becomes a very open question whether we '*never could* have done what we did not do'." Now my statement did *not* assume anything from which it follows that microcosmic events always have causes, nor anything from which it follows that it is *not* an open question whether we never could have done what we did not do. It seems to me that Mr. Garnett has here been confusing the proposition, which I did *not* make, that every event has a cause, with the proposition, which I did make, that, *if* any event has a cause, then it follows that there were antecedents of that event such that, when they had once happened, it became impossible that the event in question should not happen. But even if he was not, and if it is not true that part of what he meant by "assuming a uniformity and rigidity in the causal chain . . . which must remain unproven" was "assuming that every event has a cause," I think that what he says ought not to convince any rational person that I was wrong, until we know what he *did* mean by that vague phrase. And if

he did mean by it something which my statement *does* assume, what are his reasons for asserting that it is false? I can find none except his bare assertion that "the Heisenberg principle has shewn" that my statement must always remain unproven. Whether the Heisenberg principle has shewn that it can never be proved that, *if* an event has a cause, then there must be *some* sense in which that event could not have failed to happen, I venture to doubt; and I do not think that Mr. Garnett's bare assertion that it has ought to convince anybody.

I still, therefore, think that, *if* all our choices are caused (as Mr. Garnett insists is the case, pp. 191f), then it is true, *in a sense*, that we never *could* have made any choice which we did not make; and that, since it is certain that we do sometimes make choices which are morally wrong, and certain also that this entails that in those cases we *could*, in *some* sense, have made a choice which we did not make, then, *if* all our choices are caused, there must be two different senses in which we use the phrase "*could* have made a different choice," since in cases where we make a morally wrong choice, there is a sense in which we could have made a different one, whereas to say that our choice was caused, entails that there is a sense in which we could not.

In my *Ethics* I said I was very puzzled as to what the sense is in which, sometimes, we certainly *could* have made a different choice; and made some suggestions as to what the sense might be,—suggestions which I did not pretend to think at all certainly true. Mr. Garnett says (falsely, I think), on p. 191, that he has already given his reasons for supposing that the three conditions I had suggested as *perhaps* sufficient to constitute what we mean by saying that we *could*, in the sense in which being morally responsible entails that we could, are *not* sufficient. And then says that he will himself try to make clear what the sense is in which we sometimes could have done what we did not do.

This promise raised my expectations; for I am not at all satisfied with the suggestions I made in answer to this question in *Ethics*—even less satisfied now than I was then, and I was not at all satisfied then; and there is nothing I should like better than a *clear* answer to this question, even if it were not clearly

true. And the last thing I have to say about Mr. Garnett's essay is that I was bitterly disappointed by the way in which he has fulfilled his promise. So far from finding a *clear* answer to this question, I cannot find, in the remaining pages of his essay, any answer to it at all! All the things he says in those pages seem to me to be completely irrelevant to *this* question. They are, no doubt, relevant to other questions, and may be admirably true and important. But do they provide any answer at all to *this* question? I cannot see that Mr. Garnett has made even any approach to answering it. Let the reader, or let Mr. Garnett himself, read through those pages, and then collect himself and ask himself, plainly and directly: Well, after all, what *is* Mr. Garnett's answer to the question "What is the sense in which, when we make a morally wrong choice, we *could* have made some other choice instead?" I cannot imagine what the answer would be, unless it were: Why, he hasn't given any answer to it at all!

II. Sense-Perception

9. *Relation of "Sense-data" to Physical Objects*

Mr. Bouwsma and Mr. Mace both quote at length a passage from my "Defence of Common Sense," in which I profess to point out "what sort of things I mean by sense-data;" and Mr. Mace adds a few more sentences, immediately preceding the passage in question, in which I say that "there is no doubt at all that there are sense-data in the sense in which I am now using that term." And Mr. Mace and Mr. Bouwsma appear to say incompatible things about this passage. Mr. Mace says "The passage cited makes it clear that Moore is using the term sense-data in such a sense that there is no doubt that sense-data exist." Mr. Bouwsma, on the other hand, in his exceedingly able and original essay, first tries to shew that the directions which I give for "picking out" a specimen of the "sort of things I mean by sense-data" are *not* clear; and then, if I understand him rightly, gives reasons for thinking that there is no such thing to be "picked out" as I supposed there was and as he supposes me to have meant by "a sense-datum." He is, therefore, saying, *certainly*, that I did *not* make it *clear* that there are, and also,

I think, that, in his opinion, there are not any such things.

Now I think it is certain that Mr. Mace's statement, taken literally, is a mistake. The passage cited certainly does *not* "make it clear" that I was using the term in such a sense that there is no doubt that there are sense-data. All that it could have made clear, at the best, is that, in certain cases, objects which I should *call* "sense-data" may be "picked out;" it could not possibly have made clear that when I said that such objects *were* sense-data, I was not attributing to them properties which they did not possess. I *say,* in the passage, that what I mean by "sense-data" are things "*of the sort* (in a certain respect)" of which these objects, which I give directions for "picking out," are. But there is nothing in the passage to make it clear that I do mean this. It might well be that, through a mistake, I supposed these "picked out" objects to be "of a sort" of which they are *not,* and that what I *meant* by saying that they were sense-data, was, in part at least, that they were of this sort, of which I falsely supposed them to be. And in that case, even if it were clear that there are objects of the sort I said could be "picked out," it would not be the case that they were specimens of what I *meant* by "sense-data;" and it might well be the case that there are *no* specimens of what I *meant* by "sense-data."

And I think also that Mr. Bouwsma is certainly right in saying that the directions I gave, in this passage, for "picking out" a specimen of what I should *call* "a sense-datum," are not clear. They are not clear in at least two respects. What I *say* is that the reader need only look at his own right hand, and that then, *if* he is not seeing it double, he will be able to "pick out" an object which answers to the following description, namely that it is an object "with regard to which he will see that it is, at first sight, a natural view to take, that it is identical with that part of the surface of his hand which he is seeing, but will also (on a little reflection) be able to see that it is doubtful whether it can be so identical." And this fails to say clearly what I meant in at least two respects. (1) It fails to make it clear, whether or not I meant that the reader would be able to pick out an object answering to my description, even if he were seeing his right hand and were *not seeing anything else whatever.* I ought to

have made it clear that the operation of "picking out," of which
I spoke, could only be performed if he were seeing *something*
else *besides* his right hand. I do not know whether it is even con-
ceivable that a person should see his hand, without at the same
time seeing *something* else; but I ought to have made it clear,
that if this were to happen, my operation of "picking out" could
not be performed. It is necessary, for the performance of my
operation, that he should be seeing *something* else. It would
not be necessary that he should see anything else except, say, a
black background, against which he saw his hand. This would
be enough to enable him to perform the operation; but at least
as much as this would be necessary. (2) It also fails to make
clear that I was making the following assumption. I was assum-
ing that, whenever a person is seeing his right hand *and* some-
thing else, even if it be only a black background, he *must* be
seeing, in one special sense among those in which we use the
word "see," at least two "objects." This special sense of the
word "see" is the visual variety of what Berkeley called "*direct*
perception" and I in my "Status of Sense-data" (*Philosophical
Studies,* 173 ff.) called "direct apprehension." And *which* sense
of "see" it is, can only be explained by giving examples of cases
where "see" is used in that sense. I will give two. It sometimes
happens that if, after looking at a bright object, you close your
eyes, you have, while your eyes are shut, an after-image of the
object. And it is a quite correct use of "see" to say that you *see*,
though your eyes are shut, e.g., a round blue patch with a red
spot in the middle, which *is* an after-image; though it is also
correct to say that you *have* an after-image, which is a round
blue patch with a red spot in the middle. The sense in which
"see" is used here, is the sense with which I am concerned, and
I will, just now and for the purposes of this discussion, use "di-
rectly see" as a mere synonym for "see," *when used in this
sense;* without in the least implying that there is any proper
sense of "direct" in which "see," when so used, does stand for
a direct relation between you and what you see in this sense
(although, in fact, I think, there is), and also without implying
that there may not be other senses, in which "see" is used, which
may also, quite properly, be called "direct." In short, I am

going to use "directly see" as a mere synonym for "see," in this sense, without implying either that this sense can be properly called "direct," nor yet that it is the only one which can be properly so called; just as in this essay and others of my ethical writings I sometimes used "intrinsically good" as a mere synonym for "good," *when used in one particular sense,* without thereby implying that the sense in question is intrinsic (although, in fact, I think it is), nor yet implying that it is the *only* sense of "good" which can properly be called intrinsic. I have, therefore, now given one example of what I mean by "seeing directly." Here is another. When Macbeth says "Is this a dagger which I *see* before me?" the sense in which he is using "see" is that which I am now calling "directly see;" for it is, it seems to me, obviously the same as that in which we use "see" when we talk of "seeing" an after-image with closed eyes. Macbeth is represented by Shakespeare as having directly seen an "object" (though, of course, not a *physical* object, any more than an after-image, seen with closed eyes, is a *physical* object) to which he referred by the word "this," and about which he asked "Is *this,* which I see before me, a dagger?"; and we all understand perfectly well what *sort* of experience Shakespeare is representing Macbeth as having had. I am going, therefore, now to assume that the reader will understand what I mean by "directly see" or "see directly;" and so can return to the assumption which I was making, when I talked of "picking out" an object answering to that long description I gave. I was assuming that whenever a person is seeing his right hand *as well as* something else (e.g., a black background), he *must* be *directly seeing* at least two objects: he *must,* in fact, have a whole visual field, *all* the objects in which are *directly seen* by him; and, of course, as a rule, the objects in this field will be many more than two. And I will now, for the sake of conciseness and purely for the purposes of this discussion, introduce another technical term: as a mere synonym for the long phrase "visual field, *all* the objects in which are directly seen by *x*" I will use the shorter phrase "*x*'s *direct* visual field." I have, then, just said that I was assuming that whenever a person is seeing his hand *as well as* something else, he *must* be having a *direct*

visual field which contains at least two objects. And when I say *must*, I mean, of course, that it is not a mere empirical fact, learnt by observation, that whenever a person does the one he has the other: I mean that the propositional function "*x* is seeing at least two objects" *entails* the propositional function "*x* has a *direct* visual field which contains at least two objects" or "*x* is *seeing directly* at least two objects." One can say that it is *part of the very meaning* of the assertion that a person is seeing his own right hand *as well as* something else that he has a *direct* visual field containing at least two objects. This I was assuming, and it seems to me quite evidently true. But I ought to have explained that I *was* assuming it, and that when I said that the reader could "pick out" an object answering to that long description I gave, I meant that he could pick out such an object from among the *objects in his direct visual field*. Once this is explained, the answer to two questions which seem (quite justly) to have puzzled Mr. Bouwsma, when he thought (as the lack of clearness in my directions gave him a perfect right to do) that I might be referring to a case in which a man was seeing his own right hand and *nothing else whatever,* is quite plain: namely the questions (1) *From* what is Moore saying that a man will be able to pick out an object of that description? and (2) *What* is the remainder which would be left over when the object *is* picked out? The answer to (1) is: From his direct visual field. And the answer to (2) is: The rest of his direct visual field.

I think I have here been using "direct visual field" to mean exactly the same as Russell in his Lowell Lectures used the word "perspective" to mean. It is important to distinguish "visual field" from "*direct* visual field," because, if I am seeing my hand, it is quite correct to say that my hand is contained in my visual field, whereas it is quite certainly *not* the case that it is contained in my *direct* visual field, since it is certainly *not* "directly seen."

If I had given these two explanations, as I ought to have done, I think that part of the obscurity Mr. Bouwsma finds in my directions for "picking out" an object of the sort that I should *call* "a sense-datum" would have been removed. But

certainly it would not *all* have been removed; and he might
have said that a new obscurity had been introduced—namely,
that it was not at all clear what I meant by "see directly," nor,
therefore, what I meant by "direct visual field." He may say
now that this is not at all clear: that it is not at all clear that
there are two different *senses* in which we all commonly use the
word "see," one in which we use it when we talk of *seeing* an
opaque physical object, such as our own right hand, and another
in which we use it when we talk of *seeing* an after-image, with
closed eyes, and in which Macbeth used it when he talked of
seeing the object which he calls his "vision." He might say:
Why shouldn't the sense of "see" in which I *see* my hand be
exactly the same as that in which I *see* an after-image with
closed eyes? To this question a *partial* answer can be given by
saying: You certainly do not see *your hand* in the same sense
in which you see *that part of its surface* which is turned towards
you; and it is only the latter sense of "see"—that in which you
are seeing a particular part of its surface, and *not* seeing other
parts—which can possibly be identical with that sense of "see"
in which you see an after-image with closed eyes. But this is
only a *partial* answer, and I quite admit that my use of "see
directly" may be in some respects obscure, and may even in-
volve some fundamental mistake. But I cannot see that it does
the latter, and I cannot now try to clear up any obscurities
about it. We cannot tell what obscurities Mr. Bouwsma might
have found in an explanation which was not presented to him.
What I want now to go on to, is obscurities which he does find
in the *description* which I gave of the object which my reader
was to be able to pick out from his direct visual field.

And, first of all, Mr. Bouwsma seems to imply that I did not
give *any* description of the object which my reader was to look
for and pick out. He says (p. 204): "Commonly if one is asked
to pick out something, the something is described;" and goes
on to speak as if, in asking my reader to pick out something, I
had not done this which is commonly done. But this seems to me
to be a sheer mistake on his part. I *did* give a description of the
object my reader was to look for, though certainly in some re-
spects a queer sort of description. It was a description very

analogous to that which Mr. Bouwsma himself gives on pp. 205f, when he says one might be asked to pick out of a basket an object *answering to the description* that it was an object which had the characteristic that one saw that it was, at first sight, natural to take it to be a red marble, and also saw a little later that it was doubtful whether it could be a red marble. He seems to admit that this would be a description clear enough to enable one to know what to look for, and to *find out*, after looking, that there was in the basket no object answering to this description, *or* to *find out* that there was such an object and pick one out, *or* to find out (an alternative which he does not mention) that there was *only* one such object and pick *it* out. But, perhaps, Mr. Bouwsma does not think that this ought to be called a "description." If not, why not? And if this *is* a description, why is not what I gave a description?

Immediately after giving this description which is analogous to the description I gave, Mr. Bouwsma (p. 206) makes an assertion which has puzzled me very much. He asserts: "Professor Moore says there is something about which you first feel sure and then about which you doubt." I think he must mean that in describing the object which I say the reader will be able to pick out, I imply that the reader will first feel sure of something and then feel doubtful of the very same thing. But *what* is the thing which Mr. Bouwsma thinks I imply that the reader will first feel sure of and then doubt? I *do* imply that the reader will feel sure, with regard to some object which he is seeing, that it is *natural* to take that object to be identical with a part of the surface of his right hand; since I imply that he will *see* it to be natural to do this, and to say that he will *see* this is to say that he will feel sure of it. But this, that it is *natural* to take that object to be thus identical, is a thing which I don't imply that he will ever feel doubt about: what I imply that he will feel doubt about is the very different proposition that the object in question *is* identical with part of the surface of his right hand. If, therefore, Mr. Bouwsma thinks I imply that the reader will ever doubt that it is *natural* to take this object to be identical with part of the surface of his right hand, he is making a sheer mistake as to what I imply. But I do not think that he is making

this mistake. I *think* he means that I imply that the reader will at first feel sure of the very thing which I *do* imply that he will subsequently doubt of—namely that the object in question *is* identical with part of the surface of his hand. But do I imply this? Why does Mr. Bouwsma think I do? I *think* that the reason he thinks so is as follows. He thinks I imply that the reader will feel sure, with regard to an object which he is seeing, and which is in fact part of the surface of his hand, that it *is* part of the surface of his hand. And I *think* I do imply this. I *certainly* do imply that the reader will *in fact* be seeing part of the surface of his hand; and it is, of course, very rarely that an *adult* person does in fact see part of the surface of his hand, without *knowing* that the object which he sees, which *is* part of the surface, *is* part of the surface. With a *baby* it is different; a baby no doubt constantly sees part of the surface of his hand, without knowing that this object which he sees *is* part of the surface of his hand; and this, it would seem, is part of the reason why, as Mr. Mace suggests (pp. 291f), a baby could not perform the operation of picking out, which I say that my reader *will* be able to perform. Mr. Mace is certainly right in saying (p. 292) that it is *not* true that *whenever* anybody sees his right hand, he is able to perform this operation of picking out: and hence, when I say that the reader *will* be able to perform it, I am certainly implying that, in his case, *some* other condition, besides the one that he will be seeing part of the surface of his hand, will also be satisfied, and one such condition may be that he *knows*, with regard to the part of its surface which he is seeing, *that* it *is* part of the surface of his hand. I am, therefore, inclined to admit, that I was implying that my reader would *know*, with regard to a part of the surface of his hand which he was seeing, that it *was* part of the surface of his hand. But to say that he would *know* this, is not to say that he would *feel sure* of it: for, while it is true that an adult rarely sees his hand without *knowing* that it is his hand, it is not at all true that he rarely sees his hand without *feeling sure* that it is his hand. The truth is that we constantly use this word "know," in this kind of case, in a dispositional sense, which is such that I can truly be said to have *known* that an object which I saw was my hand, provided only that, *if* the

question had been raised, I should have *been able* to affirm with certainty with regard to the object which I saw that it was my hand; whereas we so use "feel sure" that I can only be truly said to *feel sure* that an object which I see is my hand, when the idea that that object is my hand is actually before my mind. Even if therefore I did imply that the reader would *know*, with regard to an object which he saw, that it was part of the surface of his hand, it does not follow that I implied that he would *feel sure* of this. But, in fact, I think I did imply that he would feel sure; since he certainly could not carry out the operation of picking out, of which I spoke, without having before his mind the idea, with regard to an object which he saw, that it *was* part of the surface of his hand, and I certainly was supposing that he did feel sure (and rightly) that it was. If, therefore, the proposition of which Mr. Bouwsma was thinking that I *said* my reader would feel sure, was the proposition, with regard to that part of the surface of his hand which he was seeing, that *it* was identical with part of the surface of his hand, let us grant that even if I did not *say* he would feel sure of this, I did imply it. But now did I either say or imply with regard to *this* proposition that he would ever come to doubt it? The proposition with regard to which I implied that my reader *would* come to doubt it, was a proposition, with regard to a certain object which he was *seeing directly*, that *that* object was identical with part of the surface of his hand; and it is only if this *directly seen* object was in fact identical with the part of the surface of his hand which he was seeing, that the proposition of which I implied that my reader would *feel sure* is identical with *this* proposition which I implied he would doubt. In thinking, therefore, (*if* this is what Mr. Bouwsma was thinking) that the proposition which I implied that my reader would come to doubt *is* identical with *this* proposition of which I implied he would feel sure, namely, that a certain object he is seeing, which is in fact part of the surface of his hand, *is* identical with a part of the surface of his hand, Mr. Bouwsma is assuming that the *directly seen* object, with regard to which I said my reader would doubt whether it was identical with the part of the surface of his hand which he is seeing, is, in fact, identical with that part. Hence, if

Mr. Bouwsma is wrong in this assertion he is also wrong in thinking that the two propositions *are* identical. And if *these* two propositions are *not* identical, then he is, so far as I can see, wrong in saying that there is any proposition whatever with regard to which I said or implied that my reader would first feel sure of it and then come to doubt it. What I was in fact supposing (and I did not imply anything other than this) was that the reader would *all along* feel sure that the *seen* object, which was in fact part of the surface of his hand, *was* identical with a part of the surface of his hand, and would continue to feel sure of *this*, even when he came to doubt whether the *directly seen* object, which I thought he could pick out, *was* identical with this *seen* object. And, if the *directly seen* object, with regard to which he feels this doubt is *not* identical with the *seen* object of which he feels sure that it *is* part of the surface of his hand, then there is no proposition of which he *both* feels sure *and* also doubts. But I did imply also that it is *possible* (that is, not *known* to be false) that the *directly seen* object *is* identical with the *seen* object, which *is* part of the surface of his hand. And hence I was implying the very curious view that a person may, at one and the same time, *both* feel sure of and actually know to be true a certain proposition, *and also* doubt whether that very proposition is true. I was not implying in this case, that this *is* what would happen to my reader; I was only implying that it *may* be what would happen to him. Elsewhere I have asserted that philosophers often *do* doubt the truth of a proposition, which, at the very time when they doubt it, they know to be true—an assertion which forms the subject of Mr. Lazerowitz's essay in this volume. But is it even *possible*, as I imply that it is, that, in our case my reader should get into this curious state of mind? I can only reply that, so far as I can see, it is *possible* that I am in it now myself. I am now seeing part of the surface of my hand; and I do now not only feel sure but know, with regard to this object I am seeing which *is* part of the surface of my hand, *that* it is part of the surface of my hand. And also I do *now*, at the very same time, feel some doubt as to whether a certain object, which I am *directly seeing*, is identical with the object which I am seeing which is part of the surface of my hand.

But to say that I feel doubt as to this, is to say that it is *possible* that it *is* identical. And, *if* it is identical, then I am both feeling sure of and doubting the very same proposition at the same time. I do not say, of course, that I *am* doing this. I only say that, so far as I can see, I don't *know* that I'm not. But it may well be thought that to say the latter is as bad as to say the former. Both are paradoxes; and there is reason to suspect that there must be something wrong in the premisses which lead me to say the latter. Yet I cannot see what *is* wrong with them, if anything is. Perhaps the most fundamental puzzle about the relation of sense-data to physical objects is that there does seem to be reason to assert the latter of these two paradoxes.

Mr. Bouwsma next proceeds to point out that this doubt, which I feel, as to whether a certain *directly seen* object which I can pick out *is* identical with that part of the surface of my hand, is very different from a doubt, which I might feel, under certain clearly possible circumstances, as to whether a certain surface which I saw and could pick out was part of the surface of a rubber glove or part of the surface of a hand. And it seems to me that, by making this comparison, he shews that, in spite of his just complaint that my directions for picking out a sense-datum were not clear, nevertheless he had understood them; he knew what description the object which I gave directions for picking out would have to answer to, though he thought that he was unable, by following my directions, to find any such object. But perhaps I am wrong about this. However that may be, he points out that a doubt as to whether a certain surface was part of the surface of a glove or of a hand, could be set at rest by such means as getting a nearer view of it, feeling it, etc. etc.; whereas *my* doubt could not be set at rest by any such means. This is, of course, perfectly true: my doubt is a philosophic doubt, and, like other philosophic doubts, certainly cannot be set at rest by any empirical observations. But Mr. Bouwsma goes on to say something which seems to me to be utterly unjustifiable: he says that my doubt differs from the other one in that it *cannot be resolved*; that there is *no* way of settling the question whether the *directly seen* object which I have picked out is or is not identical with that part of the surface of my hand

which I am seeing. So far as I can see, this question, of which
Mr. Bouwsma asserts so dogmatically that there is *no* way of
settling it, that "there is nothing to do but to go on doubting,"
is the very one about which Mr. Marhenke asserts that he "is
sure no philosopher will ever find the answer to it until we know
what a correct analysis is" (p. 280). Mr. Marhenke, then, thinks
it is *possible* that it should be settled; and as to this I think he is
clearly right as against Mr. Bouwsma. *I*, of course, do not know
how this particular philosophic question is to be settled, just as
I do not know, in the case of many other philosophic questions,
how they can be settled. But that ways of settling this and other
philosophic questions will not some day be discovered, I cer-
tainly do not know; and Mr. Bouwsma certainly does not know
it either. There is certainly something else to do besides going
on doubting; and that is to go on thinking about it.—But, per-
haps, I have misunderstood Mr. Bouwsma, and perhaps, after
all, he had misunderstood me.

But now, suppose that, under the circumstances I mentioned,
an object answering to the description I gave, amended as I
have now amended it, *can* be picked out: how does that help
us to know how I was using the term "sense-datum?" All that I
say on this head, in the passage quoted, is that "I mean by
sense-data" "things *of the sort* (in a certain respect)" of which
these "picked out" objects are. I do not say in *what* respect an
object must be of the sort of which these picked out objects are,
in order to be what I mean by "a sense-datum." And both Mr.
Bouwsma and Mr. Mace seem to have been misled by this ex-
pression of mine. Mr. Bouwsma says "It appears . . . that Pro-
fessor Moore means by a sense-datum only that sort of thing
which may be taken to be the surface of something or other. In
other words, Professor Moore confines his use of the phrase
sense-datum only to what others would describe as visual sense-
data" (p. 214). Now, of course, I am not in a position to deny
that I *appear* to Mr. Bouwsma to confine the term in this way: I
fully accept his statement that I appear to him to do so: and,
of course, it may be the case that I appear to do so not only to
him but to the majority of my readers. But the fact is that I
never either did confine, or intend to confine, the term in

this way. Mr. Bouwsma recognises (p. 214) that I did not in fact so confine it; he points out that I say in one place that I am "feeling" sense-data, and that if I am "defining" sense-data in the way in which I appear to him to be defining them, this is an inconsistency. But he goes on "At any rate his exposition excludes smells, tastes, and sounds." Here he is making a statement, not merely that my exposition *appears* to exclude smells, tastes, and sounds, but that it *does* exclude them. Can this statement possibly be justified? I certainly never either did refuse, nor intend to refuse, to call *directly apprehended* smells, tastes, and sounds "sense-data;" and I have always held that they were sense-data. And the only possible justification, that I can see, for Mr. Bouwsma's statement, is that which he would give, if he said: "Smells, tastes, and sounds are not *of the same sort, in any respect,* as visual sense-data: in saying, therefore, that you mean by sense-data *'things of the sort (in a certain respect)'* of which certain visual sense-data are, you *are* excluding smells, tastes, and sounds, even if you did not intend to." Now I am not at all prepared to admit that directly apprehended smells, tastes, and sounds are not of the same sort in *any* respect as directly seen objects. But I do think that my expression "things of the sort (in a certain respect)" was misleading, because, so far as I can see now, I was using that expression in such a sense that, even if the only respect in which all the different objects which I intended to call "sense-data" resembled the "picked out" visual objects was that they were *directly apprehended,* I should still have said that they were *of the same sort in a certain respect.* And I now think that such a use is misleading, because I do not think that the mere fact that two objects are both of them directly apprehended justifies one in saying that they are both of *the same sort in some respect.* I think I have always both used, and intended to use, "sense-datum" in such a sense that the mere fact that an object is *directly apprehended* is a *sufficient* condition for saying that it is a sense-datum; so that, according both to my usage and my intentions, directly apprehended smells and tastes and sounds are just as much sense-data as *directly seen* objects. If, therefore, Mr. Bouwsma was intending here to say anything about

my actual usage or intentions, he was making a simply enormous mistake. If, however, he was only intending to say that my *words*, in this passage, imply that only visual objects are to be called "sense-data," and was saying this on the ground that nothing but a visual object can be *of the same sort in any respect* as a visual object; then, I think, I must admit that there was *some* justification for his statement. So far as this was the case, my words failed very badly to say what I meant.

And I think they must have failed rather badly, because Mr. Mace, though he does not go so far as Mr. Bouwsma—does not, that is to say, accuse me of implying that, e.g., a directly apprehended noise *cannot* be a sense-datum—does say it is not clear that I did not wish to confine the name to "things with regard to which it is natural to believe that they are parts of surfaces" (p. 289), and evidently really doubts whether I should have called the directly seen object, which, when you see a transparent glass cube, it is natural to suppose to be identical with that cube, though there are also obvious reasons for doubting whether it is so identical, a "sense-datum," and whether I should have called a directly apprehended "faint crackly noise" a sense-datum. Certainly I did not, in *this* passage, *make it clear* that I should call such *directly apprehended* objects sense-data; but in fact I certainly always intended it to apply to any object whatever of any of the kinds Mr. Mace mentions, and others too, e.g., smells and tastes, provided the objects he means are *directly apprehended* objects. On my view, when you hear a "faint crackly noise," you are as a rule hearing a *sense-datum* which can properly be called "a faint crackly noise," but, unless this *directly apprehended* faint crackly noise is "purely subjective," like the "voices" which I understand that some people in an abnormal condition sometimes hear, it is also true that you are hearing a "faint crackly noise," which is a *physical reality* and can also be heard by other people; and there are the same sort of reasons for doubting whether the *directly apprehended* "faint crackly noise" is identical with the physical (or "real") "faint crackly noise," as there are for doubting whether the *directly seen* object which I am now "picking out" and which it is natural to take to be part of the surface of my hand really *is*

identical with the part of the surface of my hand which I am seeing. According to me there are reasons for thinking that we use "hear," as applied to sounds, in *two* different senses, just as there are reasons for thinking that we use "see" in *three* different senses (see Mr. Marhenke's essay, p. 260), and I should use "directly hear" as a synonym for *one* sense in which we use "hear," just as I use "directly see" as a synonym for *one* sense in which we use "see." The propositional function "*x* is hearing a physical (or 'real') sound" *entails* the propositional function "*x* is *directly hearing* a sound," and I used, and intended to use, "sense-datum" in such a way that any *directly heard* sound must be a sense-datum; but I think it is doubtful whether any *physical* sound which we hear is "directly heard" and whether, therefore, when we talk of "hearing" a *physical* sound (which is by far our commonest use of "hear," as applied to sounds), we are using "hear" in a sense in which "directly hear" is a synonym for it. I am at present "hearing" the ticks of a clock which is in the same room with me—that is to say, I am "hearing" a succession of *physical* sounds made by the clock. And I know perfectly well that, if I had had a certain amount of cotton wool in my ears, while the clock was making the same sounds which it is making, I should still have heard these sounds— the very same *physical* sounds which I am hearing—but they would have *sounded fainter* to me. But there are good reasons for thinking (I do not say, *absolutely conclusive* ones) that if these physical sounds had *sounded fainter* to me, then the sounds which I was *directly hearing,* and which it is natural to take to be identical with those physical sounds (in other words, the *directly heard* sounds which "correspond" to the physical sounds), would have *been* fainter than the corresponding directly heard sounds which I am now hearing. But there would have been then exactly as good reason for supposing those fainter *directly heard* sounds to be identical with the physical sounds I am now hearing as there is now for supposing the louder *directly heard* sounds I am now hearing to be identical with these same physical sounds. It seems, however, that two directly heard sounds, of which one is fainter than the other, cannot possibly be identical with one another; and that therefore

the *physical* "ticks" which I am now hearing cannot possibly be identical with any sounds which I am now *directly hearing;* since, if they were, they would also have been identical with the fainter *directly heard* sounds I should have heard, if I had had cotton wool in my ears; and it seems impossible that it should be true of the very same set of physical sounds both that it *is* identical with a louder set of directly heard sounds and *would,* under other circumstances, have been identical with a fainter set. But, if so, nothing which I am *directly hearing* can be identical with the physical "ticks" which I am hearing; and hence the sense of "hear" in which I am hearing these physical sounds cannot be the sense of "hear" in which "directly hear" is a synonym for "hear." There is, therefore, good (though, not conclusive) reason for thinking that the sense of "hear" in which we hear physical sounds is *not* the same as the sense of "hear" in which "directly hear" is a synonym for "hear." And this argument seems to me to be exactly analogous to one argument for thinking that the sense of "see" in which I am now seeing a certain part of the surface of my right hand is *not* the same as that sense of "see" which is such that "directly see" is a synonym for "see" when used in that sense. I know perfectly well that, if my present situation had been different from what it is only in the respect that I had been wearing blue spectacles instead of spectacles of plain glass, then the part of the surface of my hand which I am now seeing would have *looked to me* of a somewhat different colour from that which it now looks to me. But there are good (though not conclusive) reasons for thinking that if it had looked of a different colour, then the *directly seen* object, which would then have "corresponded" to this part of the surface of my hand, would have *been* of a different colour from the *directly seen* object which now "corresponds" to this part of the surface of my hand. But, if so, the *directly seen* object, which would then have "corresponded" to that piece of surface cannot possibly be identical with the piece of surface in question. And if *it* is not, then certainly nothing else which I am directly seeing is identical with that piece of physical surface. And hence there is a good (though not conclusive) reason for thinking that the sense of "see" in which I

am seeing part of the surface of my right hand cannot be identical with that sense of "see" which is such that "directly see" is a synonym for "see" when used in that sense.

I want, then, to make it quite plain that, so far as I know, the sense in which I used, and intended to use, "sense-datum," was such that anything whatever which is *directly apprehended* (using this term in the sense which I tried to explain in my "Status of Sense-data," in which it is a synonym for "directly perceived," in one, at least, of the senses in which Berkeley used that expression)—anything whatever which is *directly apprehended must* be "a sense-datum," whether it be a sound, a smell, a taste etc., or a visual object of any kind: I was so using it that a tooth-ache which you feel, is necessarily a "sense-datum." My departure from ordinary usage did not consist (as Mr. Bouwsma and Mr. Mace both suggest) in *confining* the application of the term to a *narrower* range of objects than that to which it had been usually applied, but rather (in a sense) in extending it to a *wider* range, since I was so using it that *physical realities* of certain kinds, *might*, so far as I could see, also be "sense-data." In the common usage, some characteristic which entailed "*not* a physical reality" was put into the connotation of "sense-datum:" "sense-datum" was so used that it would be a contradiction to say of any object that it was *both* a *physical reality and also* a "sense-datum." I intentionally so used it that it should not be, at all events, an *obvious* contradiction to say that some physical realities are *also* sense-data. It still would be a contradiction, even in my usage, to say this, if what I meant by "direct apprehension" was such that the function "*x* is directly apprehended" *entails* "*x* is *not* a physical reality." But it was not (and still is not) obvious to me that there is any contradiction in saying that some physical realities (including physical sounds and physical surfaces) are directly apprehended: I think there *may* be a contradiction in saying this, but it is not obvious to me that there is. And, *if* there is no contradiction in this, then I was so altering the connotation of "sense-datum" as to make it apply to a *wider* range of objects than usual, rather than confining it to a narrower one.

But, if this is so, if, as I think, I was so using "sense-datum"

that anything whatever which is *"directly* apprehended" *must* be a sense-datum, it is quite obvious that I could have told my readers how to find a specimen of the sort of thing I meant by "a sense-datum" in a much simpler way than that which I adopted in this passage from my "Defence of Common-Sense," which both Mr. Bouwsma and Mr. Mace quote. I could have said, for instance: "Stare at a lighted electric lamp for a little while, and then close your eyes: the after-image which you will then see is a specimen of the sort of thing I mean by 'a sense-datum'." This would have been quite as efficient a way of shewing the reader what sort of thing I meant by "a sense-datum" and that there *are* sense-data, in the sense in which I was using the term, as the complicated way I adopted. Nobody would then have doubted that there *are* things of a sort which I was proposing to *call* "sense-data," because nobody would have doubted that after-images are sometimes seen, when one's eyes are closed; but it would still, of course, have remained just as doubtful as it is now whether, in saying that such after-images *are* sense-data, I was not attributing to them properties which they do not possess, and just as doubtful as Mr. Bouwsma and Mr. Mace have found it, what *other* sorts of objects I should also call sense-data. Why did I not adopt this simple procedure? I think it is obvious now, that why I did not, was because I was there trying to do much more than what I said and thought I was trying to do. I was trying to shew, not merely how I proposed to use the term "sense-datum," and that there *are* sense-data, if the term be used in that sense, but also two quite different things as well, viz., (1) that the function "*x* is seeing a physical object" entails the function "*x* is seeing a sense-datum" (= "*x* is seeing some object *directly*"), or, in other words, that the sense in which we use "see" when we say that we see a thing which is a physical object, is such that the seeing of a physical object *necessarily involves* the seeing of a sense-datum, and also (2) that there is some reason to think that, even when an opaque physical object which we are seeing is not being "seen double" by us, no sense-datum which we are seeing is ever identical with any physical surface which we are seeing; or, in other words, that though the seeing of a physical object neces-

sarily involves *directly seeing some* object, yet there are good (but not conclusive) reasons for thinking that no physical object and no physical surface is ever *directly seen,* and that therefore the seeing of a physical object necessarily involves the *direct seeing* of an object which is not a physical reality at all. I think I was trying (very unsuccessfully) to say something of this sort; and that I was trying (much more successfully) to say the same things in the passage which Mr. Marhenke quotes on pp. 259-260.

There remains one other point in Mr. Bouwsma's essay, upon which I wish to say something. In the second section he seems to me to bring out in an admirable manner a point as to which I heartily agree with him. He shews, I think, quite convincingly, that if we consider those uses of the words "hear" and "smell," in which we use them when we say that we hear or smell, *not* a sound or a smell, respectively, but a *physical object* (his examples are "I hear a rat," "I smell a rat") there is a very important point in which such uses of "hear" and "smell" are *not* analogous to that use of "see" in which we say that we *see* a physical object, e.g., "I see a rat." He points out that we cannot hear a rat, without hearing a *sound,* nor smell a rat, without smelling a *smell,* whereas it is not true that we cannot see a rat, without seeing a *sight* which is related to the rat which we see in the same way in which, when we hear one, some sound which we hear must be related to him, and when we smell one, some smell which we smell must be related to him. (I am putting all this, in my own way; and perhaps Mr. Bouwsma would say that what I am saying is not at all what he meant.) It seems to me quite obvious that we so use "I hear a rat," that part at least of what we *mean* by this is that we are hearing a *physical* sound *made* by a rat: if this condition is not satisfied then it cannot be true that we are hearing a rat—that is to say, this cannot be true, if "I hear a rat" is being used in the way in which it is most commonly used. As for "I smell a rat" everybody knows that this is an expression which is often used *metaphorically,* and perhaps this metaphorical use is now its commonest use: but if it were used *literally* its use is such that it cannot be true that I am smelling a rat unless I am smell-

ing a *physical* smell *given off* by a rat. In the case, therefore, both of "I hear a rat" and "I smell a rat," there is a kind of *physical reality*, such that it is logically possible that a physical reality of that kind should have existed even if *no* rat had ever existed, of which it is true that we cannot be truly said to hear or smell a rat unless we are hearing or smelling (in a different sense) some physical reality of that kind, which was caused by the presence of a rat. But in the case of "I see a rat" nothing of this kind is true. There is no kind of physical reality, which might have existed even if there had been no rats, such that I cannot be truly said to be seeing a rat in the literal sense, unless I am seeing a physical reality of that kind, which was caused by the presence of a rat. A rat does not give off (as, I think, Lucretius imagined that it did) a sort of physical "image," such that, in order to be truly said to be seeing a rat, I must be seeing (in another sense) an image of this sort which was given off by a rat. It is true that in order to be truly said to be seeing a rat, I must be seeing *part of the surface* of a rat's body, and such a surface is, of course, a physical reality. But such a surface is obviously not related to a rat in the way in which a physical sound made by him or a physical smell given off by him is related to him. It is not, as they are, a kind of physical reality which could have existed even if no rats had ever existed—an *independent* kind of physical reality: it would be a contradiction to say that part of the surface of a rat's body existed, but that no rat had ever existed. And obviously it is not made or given off by a rat in the sense in which a sound, which he makes, or a smell which he gives off, are made or given off by him.

I heartily agree, therefore, with Mr. Bouwsma that there is, in this important respect, no analogy between hearing or smelling a *physical object* and seeing one; and I think the point is important, because I think philosophers are apt to overlook it. But Mr. Bouwsma goes on to suggest, if I understand him rightly, that the reason why I think that it *may* be the case that, if I am to be truly said to be seeing a physical surface, I must be seeing some *other* object (a sense-datum), is that I have been misled by the linguistic similarity between "I hear a rat," "I smell a rat," "I see a rat," to suppose that there must be some

kind of object related to the last, as a physical sound is to the first, and a physical smell is to the second. And here I cannot agree with him. I am perfectly certain that this has nothing whatever to do with my view that a certain visual object which I am now *seeing directly*, in seeing part of the surface of my hand, *may* not be identical with the part of the surface of my hand which I am seeing. I do not think I ever thought that seeing a physical surface was analogous to hearing a physical object, such as a rat, or a bell, or a motor-car, or to smelling a physical object such as a rat, or a rose, or an onion. I thought, and still think, that the true analogy to seeing a physical surface is not hearing a physical object, but hearing a physical *sound;* and, as I have just tried to shew, there seems to me to be just the same sort of reason for supposing that, in order to hear a *physical* sound, I must hear directly an object (also called "a sound") which *may* not be identical with the physical sound which I hear, as for supposing that in order to see a physical surface I must *see directly* a visual object which *may* not be identical with the physical surface which I see.

To conclude what I have to say about Mr. Bouwsma's essay: So far as I can gather, his view is that whenever we see any part of the surface of a physical object (at least when we don't see it double, i.e., have a double image of it; I don't know what he would say about cases when we *do* see it double) we see that part of its surface *directly*, i.e., in exactly the same sense in which we see an after-image when our eyes are shut, or in which Macbeth saw the object which he referred to by the word "this," when he asked "Is this a dagger, which I see before me?" It follows that, if he had understood how I was proposing to use the term "sense-data," he would have said that there certainly *are* sense-data, in *that* sense: that, for instance, every physical surface which is seen, is, so long as it is not seen double, a sense-datum. But I think that (largely through my own fault) he did not understand how I was proposing to use the term, and therefore thought that the sense in which I was proposing to use it, was such that he himself was inclined to think that, in *that* sense, there are no such things as sense-data. The substantial point on which he disagrees with me is, I think, this: He thinks that,

when in normal vision (i.e., *not* in double vision) we see a physical surface, there is no good reason whatever to suppose that we do *not* see it *directly;* no good reason whatever to suppose that the sense in which we do "see" physical surfaces is a sense which, though it involves that we are directly seeing *some* object, is not itself that sense of "see" as a synonym for which I have used "directly see." I cannot agree with him about this, and I have given what seems to me to be one good reason for disagreeing, in what I have said about the sense in which we "hear" a physical sound, and in comparing this with the sense in which we see a surface.

Mr. Murphy also, in the concluding pages of his essay (pp. 315-17)—pages which puzzled me very much when I first read them—is advocating, if I understand him rightly, a view very similar to Mr. Bouwsma's in both respects. He also, so far as I can see, must have misunderstood how I was using the term "sense-datum," since he thinks, apparently, that I was mistaken in holding that when, for instance, looking at my right hand and the sheet of paper on which I am writing, as I now do, I say to myself "This hand is touching this sheet of paper" (a proposition which I know for certain to be true), I am making an assertion about any "sense-datum." Now I certainly am making an assertion, if I say this to myself, about at least two objects which I *see directly,* and therefore about at least two "sense-data," in my sense of the term. Or does Mr. Murphy mean to deny that, in such a case, I am making any assertion at all about anything which I *see directly*—see, that is, in the same sense in which, when I have an after-image with my eyes closed, I see that after-image? I can hardly think that he can mean to deny this, and therefore I am driven to suppose that he did not understand that I was using "sense-datum" in such a sense that *anything whatever* which is "directly seen" must be a sense-datum. I think he must have supposed that I was using "sense-datum" in such a sense that the part of the surface of my hand and the part of the surface of this sheet of paper, which I am seeing, *cannot* be sense-data, and therefore was mistakenly attributing to me the view that, in making the assertion "This hand is touching this sheet of paper," I was making an assertion

about two objects which are *not* identical with any physical reality. His own view, then, I suppose, must be that I was making an assertion about my hand and about this sheet of paper, and about that part of the surface of each which I was seeing, and (since he can hardly deny that I was making an assertion about at least two things which I was "seeing directly") that the two latter "objects" (the two surfaces mentioned) were "directly seen:" which is exactly what, I gather, Mr. Bouwsma also would hold. But *this* view is in no way inconsistent with my view that I was making an assertion about at least two sense-data: on the contrary, once my use of "sense-datum" is understood, it is evident that this view of mine *follows* from Mr. Murphy's own view! But it is true that I also have *another* view—namely that there is good reason to suppose that, when I made that assertion, I was *not* seeing *directly* any part of the surface of my hand or of this sheet of paper, and that, therefore, since I certainly was making an assertion about *some* pair of objects which I was directly seeing, I must have been making an assertion not only about my hand and this sheet of paper, and about the parts of the surface of each which I was seeing, but *also* about a pair of directly seen objects *not* identical with any of these four. And I think it is very likely that Mr. Murphy is objecting, as Mr. Bouwsma was, to *this* view of mine. *This* view of mine is, of course, not inconsistent with Mr. Murphy's and Mr. Bouwsma's view (if this *is* their view) that, when I made that assertion, I *was* seeing *directly* both the part of the surface of my hand and the part of the surface of this sheet of paper which I was certainly *seeing:* it only says that there is good reason for doubting whether that view of theirs is true. But nevertheless I think it is quite likely that Mr. Murphy is objecting to it; and, if so, I have given an answer to that objection.—I think, however, that it is very likely that I have failed to catch Mr. Murphy's point here, or at least part of it; but I have done my best to state what I think he means, and how I should answer it, if he does mean that.

Mr. Marhenke, if I understand him rightly, is strongly inclined (as I am myself) to agree with Mr. Bouwsma and Mr. Murphy that we do constantly *see* *directly* parts of the surfaces

of physical objects; but he does not hold that there are no good reasons for thinking that we never do: on this latter point I think he agrees with me rather than with them. He opens his essay by giving a very careful and accurate account of the views, tentative or otherwise, but mainly tentative, which I have expressed on this subject in the various different essays in which I have written upon it, noting those cases in which I have expressed a change of view; and I think his account shews that he has understood me very completely. But though his account is *very* accurate, I think that in one respect it is not *quite* accurate. He implies that in "The Status of Sense-data" (*Philosophical Studies*, p. 186) I used the expressions "*real* spatial properties" and "*real* spatial relations;" and that I accepted without question the premiss that "Physical objects have certain *real* spatial properties and they stand in certain *real* spatial relations" (p. 261). Now, so far as I can discover, I did not use these expressions in that paper: what I did say (and I think this is what Mr. Marhenke must be alluding to) is that the upper sides of two coins, which I was seeing, were "*really* approximately circular," and that the upper side of the half-crown was "really *larger*" than that of the florin. But perhaps this difference of expression does not matter: perhaps Mr. Marhenke means by his expression "Physical objects have certain *real* spatial properties and stand in certain *real* spatial relations" only something which really is entailed by my assertion that a pair of physical objects (or rather their upper sides) were both "*really* approximately circular" and that one of them was "really *larger* than" the other. Assuming that he does only mean this, Mr. Marhenke goes on later to suggest (p. 265) that my proposition that the two surfaces were really approximately circular, and that the one was really larger than the other, may perhaps be *successfully challenged*; he suspects (p. 266) that, when I said this, *part* of what I meant may have been that "approximate circularity" was an *intrinsic* property of the two surfaces, and that the relation expressed by "larger than" was an *intrinsic* relation; and he thinks that if I did mean this I was mistaken. He holds that, though "topological properties" of spatial configurations are all intrinsic, their "metrical properties" are not; and that

since "approximately circular" is a metrical property, it is not intrinsic; and he draws the conclusion that there is no contradiction in saying that the surfaces of those coins both *were* approximately circular, and *also* were of a different shape.

In support of his view that "approximately circular," in the sense in which we say that *physical* objects sometimes are so, is an *extrinsic* and not an *intrinsic* property, he appeals to the idea that the metrical properties of physical objects are "logically dependent on the instruments of measurement we employ," and gives an argument from Poincaré to show that these metrical properties are "relative to the objects we have agreed to use as instruments of measurement."

But we find, to our surprise, that Mr. Marhenke regards this argument as proving, not merely that "approximately circular," as applied to physical objects, is extrinsic, but also that "approximately circular" in the sense in which we use it when we say "That *looks* approximately circular" is extrinsic too. He says, that if a certain "transformation" be supposed to have taken place, which affects an observer's *measuring rod* as well as the rest of the system supposed to be transformed, the observer will not, by *measuring* the diameters of a given physical curve before and after the transformation, be able to detect any change in the curve: if measurement gave the result that it was circular before the transformation, it will give the same result afterwards. But Mr. Marhenke adds: "If the curve looked circular to the observer before the transformation, it will still look circular to him after the transformation." By what warrant does he add this? How can the assumption that an observer's measuring rod has been transformed according to the same formula as his own body and all the rest of the *physical system* to which he belongs, possibly entail any conclusion at all as to how things will *look* to him before and after the transformation? Yet Mr. Marhenke repeats (p. 269) "We have now *shown* that the spatial properties of physical objects are extrinsic. But we have done more than this; we have also shown that the spatial properties of *sense-data* are extrinsic." I cannot help thinking that the latter assertion is a mere mistake; he has not *shewn* anything of the kind.

And he himself does not seem to think he *has* shewn it. For a little later (p. 271) he says: "In order to show that the spatial properties of sense-data are extrinsic, we have to show that these properties are relative to a standard of rigidity." Now he said before that he had shewn them to be extrinsic; and yet he had *then* certainly *not* shewn them to be "relative to a standard of rigidity!" And it seems to me that he certainly does not shew it now, by the argument which he proceeds to give. He says that we *might* define a given sense-datum, which can be made to move over the whole *direct* visual field, e.g., the sense-datum of a pencil, as rigid, "i.e., as maintaining the same sensible size." And, *if* we did, we should of course have to say, as he points out, that a second sense-datum, A, whose extremities could be brought into coincidence with that of the pencil, was shorter than a third, B, which overlapped that of the pencil. We *could*, of course, adopt such a convention as this. But where is the proof that we *have adopted* any such convention? I can find none at all, not even an attempt at proof, except Mr. Marhenke's bare assertion: "Independently of a standard of comparison it is obviously impossible to compare two different sense-data in respect of length or size." It must be remembered that by "a standard of comparison" he here means *some third sense-datum*, which is used as a standard of comparison, just as a measuring rod may be used as a standard of comparison for the length of two physical objects. And, when this is understood, it seems to me that this statement of his, which he has not attempted to prove, is quite fantastically untrue. If I understand him rightly, he is maintaining that, whenever a man says that one line *looks* longer than another, he is referring to some third sense-datum, and saying that *if* this third sense-datum were applied successively to the sense-data of those two lines, then certain facts in the way of overlapping or not overlapping would be observed; just as when a man says that of two physical lines one *is* longer than the other, part at least of what he often means is that if the same measuring rod were applied successively to each, then certain facts in the way of overlapping or not overlapping would be observed. He is maintaining that if, with closed eyes, I see two after-images, e.g., two round blue patches,

and say that the one on the left is larger than the one on the right, I am again saying something about a third sense-datum, to the effect that, *if* it were applied successively to the two patches, certain relations between it and the patches would be observed. Both these things, which he seems to me to be maintaining, seem to me to be quite obviously untrue. The truth is that it is quite obviously *possible* to compare two sense-data in respect of length or size, quite independently of "a standard of comparison." It is obviously *possible* to do this, because it is obvious that we all constantly do it.—But perhaps I have misunderstood Mr. Marhenke.

I conclude that, if Mr. Marhenke does mean what I have supposed him to mean, then this part of his vindication of the possibility of "identifying sense-datum and physical surface" (p. 265) has broken down.

10. *Subjectivity of Sense-Data*

Mr. Ducasse discusses my early paper called "The Refutation of Idealism," in which I argued that *in no case* is the *esse* of anything *percipi;* or, to put it in the sort of language I should now use, that in no case does it follow from the fact that a thing of a certain kind exists that that thing is perceived. Mr. Ducasse's view is that there is "a certain class of cases" in which *percipi* does follow from *esse;* though there is also another class of cases in which *percipi* does not follow from *esse.* In fact, he is, in this respect, taking the same sort of view which Berkeley took, when he said that the *esse* of "ideas" is *percipi,* but that there is at least one sort of existent which is *not* an "idea," and that the *esse* of existents of *this* sort is not *percipi.* And I may say at once that, on this point, I now agree with Mr. Ducasse and Berkeley, and hold that that early paper of mine was wrong. As an argument for my present view I should give the assertions that a toothache certainly cannot exist without being felt, but that, on the other hand, the moon certainly can exist without being perceived.

But Mr. Ducasse says that in his essay he has two objects. The first is to shew that, with regard to a class of cases, as to which I argued in that paper that their *esse* was *not percipi,* my argu-

ment did not prove, nor even render more probable than not, this conclusion for which I argued. And I should now agree perfectly that my argument did *not* even render this conclusion more probable than not. On the other hand, that Mr. Ducasse has *shewn* that it didn't, I do not know that I should agree. His second point is to shew that, in this class of cases, the *esse* of a thing *is percipi;* and it is about his arguments to shew this that I wish to say something.

It seems to me that, both in my paper and in Mr. Ducasse's essay, language is used, which makes it difficult to see what the point at issue really is. What *is* the class of cases with which we are concerned? And what are the sort of entities with regard to which Mr. Ducasse wishes to shew that their *esse* is *percipi*, while I in my paper said that the *esse* of those entities was not *percipi?* In my paper I used the unfortunate expression "the sensation of blue" and seemed to be merely saying that something or other to which I gave the name "blue" could exist at a time when no "sensation of blue" existed. But to *what* was I giving the name "blue?" and what did I mean by a "sensation of blue?" The latter expression is not an expression which is in common use, and badly needs explanation. Mr. Ducasse, on the other hand, uses the unfortunate expression "I taste bitter," and seems to be saying that something or other to which he gives the name "bitter" cannot exist at a time at which nobody is "tasting bitter." But to *what* is he giving the name "bitter?" And what does he mean by the expressions "I taste bitter," "He tastes bitter," "She tastes bitter?" The only way in which these expressions could be naturally used is, I think, as follows. We do say "Quinine tastes bitter" and everybody knows what *that* means. On the analogy of this, "I taste bitter" could be quite naturally used to mean what it would mean, if I said "If you bit me, you would find that I taste bitter, just as quinine does." But, of course, Mr. Ducasse is not using "I taste bitter" in *that* sense. I think he is using it, quite unnaturally, to mean what we should naturally express by "I am tasting a bitter taste" or, better still (and I think the fact that we should, quite naturally, use this expression, is significant) "I've got a bitter taste in my mouth."

In order to see what the issue really is, let us first clear one thing, which is *not* the issue, out of the way. It might naturally be supposed that I was using "blue" as a synonym for the longer expression "the colour 'blue'"—an expression which *is* used, with a pretty clear meaning, and for which "blue" is sometimes used as a synonym; and that similarly Mr. Ducasse is using "bitter" as a synonym for "the taste 'bitter'" or for "the taste called 'bitter'," an expression which he actually uses on p. 237. And we might also naturally suppose that such an expression as "the colour 'blue' *existed* at noon yesterday" or "the taste called 'bitter' *existed* at noon yesterday" means: There existed at noon yesterday something which *was* blue, or, *was* bitter or *had* the taste called "bitter." Then my proposition "'Blue' can exist at a time when no sensation of blue exists" might be taken to mean "Blue things may exist at a time when nothing is looking blue to anyone;" and Mr. Ducasse's "'Bitter' can't exist at a time when nobody is tasting bitter" to mean "No bitter things can exist at a time when nobody is tasting a bitter taste." And, with this interpretation, it would be quite obvious that I was right and Mr. Ducasse was wrong. It is obviously logically possible that a blue tie should exist at a time when nothing is looking blue to anyone, and that a parcel of quinine which *is* bitter should exist at a time when nobody is tasting a bitter taste.

But this is *not* the question at issue, though I think some of our expressions might quite naturally have led people to suppose that it is. In order to see what the issue is, it seems to me to be absolutely essential to see that such words as "blue" and "bitter" *may* be used in two very different senses. When we say of such things as a tie or a flag or an india rubber ball that they are blue, what we are saying about them *may* be something very different from what we are saying of an after-image, which we see with closed eyes, when we say that *it* is blue; and when we say of quinine or wormwood that they are bitter, what we are saying of them is certainly something very different from what we are saying of a taste which we are tasting or a taste "which is in our mouth," when we say that *it* is bitter. It may be thought that Mr. Ducasse is asserting that this latter is the case, in his section 17, p. 248. But it seems to me that the account which he

there gives of the difference is certainly false. For what he seems there to be supposing is that there is some *one and the same* entity, to which he gives the name "bitter," such that when we say that quinine is bitter, we are saying that this entity is "a property of" quinine, whereas when we say of a taste which we are tasting that *it* is bitter, we are saying of this same entity, that that entity is "a species of" the taste which we are tasting. This seems to me to be nonsense. It is quite true that we may say of the very same "property" which we are attributing to quinine when we say that it is bitter, that that property is *a species of* taste: the properties which we attribute to sugar when we say that it is sweet, and to sweat when we say that it is salt, are also *species of* taste, in exactly the same sense. And it is in the same sense of "species of" that we can say that the property which we attribute to a tie when we say that it is blue, is one *species* or *kind* of colour, and that which we attribute to another tie when we say that it is red, is another *species* or *kind* of colour; and that we can also say that scarlet is one *species* or *kind* of red and crimson another species or kind of red. But it is absolute nonsense to say of any particular colour which we are seeing that red is a "species of" *it*. And in the same way it is absolute nonsense to say of any particular taste which we are tasting that "bitter" is a species of *it*. What "the colour 'red'" and "the taste 'bitter'," are species of, are, respectively, "colour" and "taste." And to say that the colour "red" is a species of colour, is the same thing as to say that it is *a* colour. Similarly, to say of "the taste 'bitter'," that it is a species of taste, is the same thing as to say that it is *a* taste. It seems to me, therefore, that the difference between what we are saying of quinine when we say that *it* is bitter, and what we are saying of a taste which we are tasting when we say that *it* is bitter, cannot lie in the fact that we are saying of one and the same entity, called "the taste 'bitter'," in the first case, that this entity is "a property of" quinine, and, in the second case, that this entity is "a species of" the taste which we are tasting. What seems to me to be the case is that when we say that a taste which we are tasting is "bitter," we are not saying anything at all about the *property* which we are attributing to quinine when we say that it is bitter: certainly not the absurdity that this property which we

attribute to quinine is "a species of" the taste which we are tasting! On the other hand, when we say that a taste which we are tasting is bitter, we can be rightly said, as Mr. Ducasse says, to be attributing to it a certain *quality*—the quality of being bitter; and therefore also, in the wide philosophical sense in which, in this essay I have been using "property," a certain *property*, since in this usage, every quality is a property, though not *vice versa;* but, of course, we are not attributing to it any "property," in the narrower and more proper sense in which Mr. Ducasse is using "property," and in which he rightly says that to say of quinine that it is bitter *is* to attribute to it a certain "property." (I cannot, of course, agree with Mr. Ducasse when he says that a "property," in this sense, is "essentially of the nature of a law:" I agree that, in the case of any "property," in this sense, the *fact* that a given substance has that property is "of the nature of law;" but this does not entitle us to say that *the property itself* is of that nature.) And when we say of quinine that it is bitter, we are, I think, really saying that the *quality*, which we attribute to a taste which we are tasting, when we say that *it* is bitter *is related* in a certain way to quinine, though not, of course, that it is a quality of quinine, nor yet the absurdity that it is a property (in Mr. Ducasse's sense) of quinine; though when we say of a taste which we are tasting that it is bitter, we are not saying *anything at all* about the property, called "being bitter" or "having a bitter taste," which we attribute to quinine when we say that *it* is bitter. And there certainly *may* be (I think, almost certainly is) an analogous difference between what we are saying about a tie when we say that it is blue, and what we are saying about an after-image, seen with closed eyes, when we say that *it* is blue. When we say of such an after-image that *it* is blue, we are certainly attributing to it a quality, not a "property" in Mr. Ducasse's sense; whereas when we say of a tie that *it* is blue, we are, I think, almost certainly attributing to it a "property," in Mr. Ducasse's sense, and *not* the quality which we attribute to "sense-data" such as an after-image.

Now suppose all this is the case. We have then to recognize that the words "blue" and "bitter" are each used in two very different senses. The first pair of senses are those in which we

use them when we say that a tie is blue or quinine is bitter: and
here each word stands for a *property*, in Mr. Ducasse's sense of
that term, and a property which may belong to physical objects,
and hence certainly may exist when it is not being perceived.
The second pair of senses are those in which we use them when
we say of an after-image seen with closed eyes or of *any other
sense-datum* that *it* is blue, and of a taste which we are tasting
that *it* is bitter; and here each word stands for a *quality*, *not*
for a property, in Mr. Ducasse's sense, and a quality which cer-
tainly does belong to sense-data. Let us call the latter pair,
merely for the purposes of this discussion, "the sensible quality
'blue' " and "the sensible quality 'bitter';" and let us say, as
before, that to say that the sensible quality "blue" existed at
noon yesterday is to say that *something which had* that quality
existed at noon yesterday, and that to say that the sensible
quality "bitter" existed at noon yesterday is to say that *some-
thing which had* that quality existed at noon yesterday. We are
now at last in a position to state the real issue between Mr.
Ducasse and that early paper of mine. In that early paper I
really was asserting that the *sensible* quality "blue" (and, of
course, also, should have asserted the same of the *sensible* qual-
ity "bitter") *could* exist without being perceived: that there was
no contradiction in supposing it to do so. Mr. Ducasse's view
is that it *cannot:* that there *is* a contradiction in supposing it to
do so. And on *this* issue I am now very much inclined to think
that Mr. Ducasse is right and that I in that paper was wrong;
my reason being that I am inclined to think that it is as im-
possible that anything which has the sensible quality "blue,"
and, more generally, *anything whatever which is directly appre-
hended,* any *sense-datum,* that is, should exist unperceived, as
it is that a headache should exist unfelt. If this is so, it would
follow at once, that *no* sense-datum can be identical with any
physical surface, which is the same thing as to say that no physi-
cal surface can be directly apprehended: that it is a contradiction
to say that any is. Now at the end of the last section I said that
I was strongly inclined to agree with Mr. Bouwsma, Mr. Mur-
phy and Mr. Marhenke that physical surfaces *are* directly ap-
prehended. I am, therefore, now saying that I am strongly in-

clined to take a view incompatible with that which I then said I
was strongly inclined to take. And this is the truth. I am
strongly inclined to take both of these incompatible views. I am
completely puzzled about the matter, and only wish I could see
any way of settling it.

Well, it would be settled, I think, if Mr. Ducasse had proved
that his view is the true one. But I cannot see that he has proved
it. By way of shewing why it should be self-contradictory to
suppose that any sensible quality ever exists without being per-
ceived, he makes the ingenious suggestion that, when I see the
sensible quality "blue," this quality is related to my seeing of
it, in the same way in which, when a cricketer makes a particular
stroke at cricket, say a "cut," the kind of stroke he makes is
related to the striking of it: and it *is* a contradiction to suppose
that a "cut" exists, when nobody is making that stroke. But I
cannot see that Mr. Ducasse gives any good reason for suppos-
ing that when I see the sensible quality "blue" this quality *is*
related in this way to my seeing of it. And I am rendered more
sceptical as to whether it possibly can be, when I consider a fact
about which Mr. Ducasse says nothing. It seems to me evident
that I cannot see the *sensible* quality blue, without *directly
seeing* something which *has* that quality—a blue patch, or a
blue speck, or a blue line, or a blue spot, etc., in the sense in
which an after-image, seen with closed eyes, may be any of
these things. And though, so long as we are talking merely of
sensible *qualities*, there seems a certain plausibility in suggesting
that when we see such a quality it may be related to our seeing
of it, in the way in which a "cut" at cricket is related to the
hitting of it, all such plausibility seems to me to vanish as soon
as we realise that any experience which is a seeing of a visual
quality must also be a seeing of something which is *not* a quality
—a patch, or a speck, or a line, or a spot, etc., in the sense in
which an after-image may be one of these things. How is such
an object as this—the sort of object I am calling "a sense-
datum"—related to my seeing of it? Any complete account of
how the sensible quality "blue" is related to my seeing of *it*,
must include an account of how a blue after-image, seen with
closed eyes, is related to my seeing of *it*. Mr. Ducasse's account

of the former does not include any account of the latter, and I cannot see at all how it could be consistent with any plausible account of the latter. Although, therefore, I am still inclined to think that no after-image (and, therefore, also no "sense-datum") can possibly exist except while it is being directly apprehended—and, more than this, none that *I* directly apprehend can possibly exist except while *I* am directly apprehending it—I cannot see *why* there should be a contradiction in supposing the opposite, I cannot see *where* the contradiction lies. To the solution of *this* problem Mr. Ducasse's suggestion as to how sensible qualities are related to our experiencing of them does not help me at all. I cannot see that he has given any good reason at all for supposing that the *esse* of sensible qualities is *percipi*, though I believe that there *must* be some good reason.

III. Philosophic Method

11. *Analysis*

I cannot possibly do justice to Mr. Langford's essay. He seems to me to raise an immense number of very puzzling questions which deserve examination; but my time is very limited, and on many of those questions I do not at all know what to say. All I can try to do is "to state more explicitly my own position regarding the nature of analysis," which is what Mr. Langford (pp. 323f) says that he wanted to induce me to do; and even here I shall not be able to do more than to try to make clear some comparatively simple points.

I think that what Mr. Langford must primarily want is a statement as to how I myself have intended to use, and, so far as I know, actually used, the word "analysis." Other people may have used it in different senses, but I do not think he wants me to state my position with regard to what they may have meant by it. And as to how I have intended to use it (and, I believe, actually used it), I think I can say three fairly definite things.

(1) Let us, as Mr. Langford does, call that which is to be analysed the *analysandum*. He himself tries to explain to us what he calls two "different views as to the nature of analysis,"

but which, I think, might be called two different ways in which the word "analysis" might be used. And he seems to say that, if the word is used in the first way, the *analysandum* will be an "idea" or a "concept" or a "proposition," whereas if it is used in the second way it will be a "verbal expression" (p. 336).

Now I think I can say quite definitely that I never intended to use the word in such a way that the *analysandum* would be a *verbal expression*. When I have talked of analysing anything, *what* I have talked of analysing has always been an idea or concept or proposition, and *not* a verbal expression; that is to say, if I talked of analysing a "proposition," I was always using "proposition" in such a sense that no verbal expression (no sentence, for instance) can be a "proposition," in that sense. There is, of course, a sense in which verbal expressions can be "analysed." To take an example from Mr. Langford: Consider the verbal expression "*x* is a small *y*." I should say that you could quite properly be said to be analysing this expression if you said of it: "It contains the letter '*x*', the word 'is', the word '*a*', the word 'small', and the letter '*y*'; and it begins with '*x*', 'is' comes next in it, then '*a*', then 'small', and then '*y*'." It seems to me that nothing but making some such statement as this could properly be called "giving an analysis of a verbal expression." And I, when I talked of "giving an analysis," have never meant anything at all like this.

(2) Mr. Langford seems to imply (p. 336) that he thinks that to make the statement: "'X is a small Y' means what is meant by 'X is a Y and is smaller than most Y's'," could be properly called giving an analysis of the verbal expression 'X is a small Y'. I do not think it could. But I wish to make it plain that I never intended so to use the word "analysis," that by making a statement of this sort you would be *giving an analysis* at all. I think many philosophers (e.g., Mr. W. E. Johnson) have supposed that by making this statement you would be giving an analysis, not indeed of the verbal expression 'X is a small Y', but of the *concept* 'is a small Y'. And I may, perhaps (I do not know), sometimes have talked as if, by making a statement of this sort you were giving an analysis of some *concept* expressed by the verbal expression which appears be-

tween inverted commas: as if, e.g., by saying "'x is a brother' means the same as 'x is male and is a sibling'," I were giving an analysis of the *concept* "being a brother." But, if I have done so, it was merely through a confusion, which I shared with others, as to what you are doing when you make such a statement: had I seen what you *are* doing, I should never have called making such a statement "giving an analysis." For what are you doing? You are merely asserting, with regard to two verbal expressions, that they have (to use an expression of Mr. W. E. Johnson's) *some* the same meaning, or, at best, that they each have only one meaning, and that the meaning they have is the same. You are not *mentioning* the meaning of either, or saying *what* the meaning of either is; but are merely making a statement, which could be completely understood by a person who had not the least idea what either expression meant. A man might point out to me two expressions in a language of which I was completely ignorant and tell me that they had the same meaning, without telling me *what* they meant. So far as he was merely telling me that they had the same meaning, I should completely understand what he told me—namely that those two expressions had the same meaning. What could be a clearer statement? I see the two expressions to which he points, in a book that he shows me, and I know what is meant by saying that two expressions have the same meaning. But if this were all he was doing, he would not have told me anything at all about any *concept* or *idea*, which either of the expressions expressed; and would therefore certainly *not* have been giving me an analysis of any *concept*, just as, also, he would certainly *not* have given me an analysis of any expression.

I certainly, therefore, never intended to use the word "analysis" in such a way that a statement of this sort, which *merely* asserts that two expressions have the same meaning, would "give an analysis" at all.

(3) Another fairly definite thing which I can say about how I intended to use (and, I believe, used) the word "analysis," is that I certainly did not intend to use it in the *first* of the two ways described by Mr. Langford. Mr. Langford has convinced me of the three following propositions: (a) that

a man may know that an object which he sees is a cube without knowing that it has twelve edges; (b) that a man may verify that an object which he sees is a cube, without verifying that it has twelve edges; and (c) that it is incorrect to say that the expression "*x* is a cube," when used as we actually use it, is synonymous with the expression "*x* is a cube with twelve edges," when used with its standard English meaning. And I think that I always intended so to use the word "analysis" that from any *one* of these three propositions by itself, it would *follow* that the concept "having twelve edges" did not "enter into the *analysis*" of the concept "cube." It seems to me quite evident that from the function "*x* is a cube," there follows "logically" (and not merely "causally," as Mr. Langford suggests) the function "*x* is a cube and has twelve edges," and *vice versa*. But, in spite of the fact that these two functions are logically equivalent, I should have taken any *one* of the propositions (a), (b), and (c) as entailing the conclusion that the concept "having twelve edges" did not enter into the analysis of the concept "cube." Perhaps, I can formulate three conditions, which were necessary, if one was to be said to be "giving an analysis" in my sense, as follows: If you are to "give an analysis" of a given *concept*, which is the *analysandum*, you must mention, as your *analysans*, a *concept* such that (a) nobody can know that the *analysandum* applies to an object without knowing that the *analysans* applies to it, (b) nobody can verify that the *analysandum* applies without verifying that the *analysans* applies, (c) any expression which expresses the *analysandum* must be synonymous with any expression which expresses the *analysans*.

Now it will be seen, that if I am right in these statements as to my intended and actual usage of the word "analysis," it follows that my usage was not the same as *either* of the two possible usages described by Mr. Langford. It was not the same as his first usage, because of the necessary conditions for "analysis" in my sense, stated in (3). And it was not the same as his second usage, because in his second usage, as stated by him, the *analysandum* is a verbal expression, whereas, in my usage, the *analysandum must* be a concept, or idea, or proposi-

tion, and *not* a verbal expression. Mr. Langford calls his second usage a "formal" usage—a usage such that any analysis which is an analysis in that sense can be called a "formal" analysis; and in his concluding sentence he implies that I have spoken as if all analysis were formal. But, if I am right in what I said under (1) as to my usage, he is making a mistake in saying that I have implied this, provided that he himself is right in stating that it is a necessary condition for what he means by a formal analysis that the *analysandum* should be a verbal expression. But, if my sense of "analysis" is neither of those which Mr. Langford describes, what can it be? Is there a third alternative?

I will try to describe what I think my usage was. It must be emphasized, first of all, that, in my usage, both *analysandum* and *analysans* must be concepts or propositions, *not* mere verbal expressions. But, of course, in order to *give* an analysis, you must *use* verbal expressions. What will be the proper way of *expressing* what I should call an analysis? I can give several. Suppose I say: "The concept 'being a brother' is identical with the concept 'being a male sibling'." I should say that, in making this assertion, I am "giving an analysis" of the concept "being a brother;" and, if my assertion is true, then I am giving a *correct* analysis of this concept. But I might also give the same analysis of the same concept by saying: "The propositional function '*x* is a brother' is identical with the propositional function '*x* is a male sibling'." And I might also give the same analysis by saying: "To say that a person is a brother is the same thing as to say that that person is a male sibling." And one important thing to notice about these ways of expressing an analysis is that they all avoid the use of the word "means." It is, in my view, very important to avoid the use of this word, because by using it, you at once imply that the *analysandum* is a *verbal expression*, and therefore give a false impression as to what the assertion is that you really wish to make. I am afraid it is pretty certain that I have often, in giving analyses, used this word "means" and thus given a false impression; the fact being that for a long time I did not distinguish clearly between *defining* a word or other verbal expression, and *defining* a con-

cept. To define a concept is the same thing as to give an
analysis of it; but to define a word is neither the same thing
as to give an analysis of that word, nor the same thing as to
give an analysis of any concept.

But, now, if we say, as I propose to, that to make any of the
above three statements is to "give an analysis" of the concept
"brother," we are obviously faced with the puzzle which Mr.
Langford calls "the paradox of analysis." Suppose we use still
another way, a fourth way, of expressing the very same state-
ment which is expressed in those three ways I gave, and say:
"To be a brother is the same thing as to be a male sibling." The
paradox arises from the fact that, *if* this statement is true, then
it seems as if it must be the case that you would be making
exactly the same statement if you said: "To be a brother is
the same thing as to be a brother." But it is obvious that these
two statements are *not* the same; and obvious also that nobody
would say that by asserting "To be a brother is to be a brother"
you were giving an analysis of the concept "brother." It is
these facts, I think, which drive Mr. Langford to say that, in
what he calls a "formal" analysis, both *analysandum* and
analysans must be mere verbal expressions and that what is
stated in giving the analysis must be merely that two verbal
expressions have the same meaning. But I think this solution
of his is obviously wrong, because if *all* you were asserting was
that the first verbal expression had the same meaning as the
second, nobody would call the making of such an assertion the
"giving an analysis" *either* of the first expression *or* of any
concept. Now I own I am not at all clear as to what the solu-
tion of the puzzle is. An obvious suggestion to make is that, if
you say "To be a brother is the same thing as to be a male
sibling," you are making a statement *both* about the *concept*
brother and *also* about the two verbal expressions used; which
would explain why this statement is not the same statement as
the statement "To be a brother is the same thing as to be a
brother." But this suggestion would be compatible with its
being the case that the assertion "To be a brother is the same
thing as to be a male sibling" is merely a *conjunction* of the
assertion "The verbal expression '*x* is a brother' has the same

meaning as the expression 'x is a male sibling'" with some other assertion which is merely an assertion about the *concept* "x is a brother" and not an assertion about any verbal expression. But I do not think this can possibly be the case: what would the second assertion in this supposed conjunction be? I think that, in order to explain the fact that, even if "To be a brother is the same thing as to be a male sibling" is true, yet nevertheless this statement is *not* the same as the statement "To be a brother is to be a brother," one *must* suppose that both statements are in *some* sense about the expressions used as well as about the concept of being a brother. But in *what* sense they are about the expressions used I cannot see clearly; and therefore I cannot give any clear solution to the puzzle. The two plain facts about the matter which it seems to me one must hold fast to are these: That if in making a given statement one is to be properly said to be "giving an analysis" of a *concept*, then (a) both *analysandum* and *analysans* must be *concepts*, and, if the analysis is a *correct* one, must, in some sense, be *the same concept*, and (b) that the *expression* used for the *analysandum* must be a different *expression* from that used for the *analysans*.

These are two plain facts about the way in which I intended to use (and, I think, used) the term analysis, and a third may be added: namely this: (c) that the *expression* used for the *analysandum* must not only be *different* from that used for the *analysans*, but that they must differ in this way, namely, that the expression used for the *analysans* must *explicitly mention* concepts which are not explicitly mentioned by the expression used for the *analysandum*. Thus the expression "x is a male sibling" *explicitly mentions* the concepts "male" and "sibling," whereas the expression "x is a brother" does not. It is true, of course, that the former expression not only *mentions* these concepts, but also mentions the *way in which they are combined* in the concept "brother," which is, in this case, the way of mere conjunction, but in other cases may be very different from mere conjunction. And that the *method of combination* should be explicitly mentioned by the expression used for the *analysans* is, I think, also a necessary condition for the giving of an

analysis. From these two conditions there follows, I think, that the expression used for the *analysans* must be "less idiomatic," in Mr. Langford's sense, than that used for the *analysandum*. And this condition, in accordance with his view (which I consider mistaken) that in what he calls a "formal" analysis both *analysandum* and *analysans* are merely verbal expressions, he expresses (wrongly, as I think), by saying (pp. 337f) that the *analysans* must be less idiomatic than the *analysandum*.

This is all that I can say about my use of the term "analysis." For a full discussion of the subject it would be necessary to raise the question why I say that the concept "*x* is a male sibling" is *identical* with the concept "*x* is a brother," but refuse to say that the concept "x is a cube with twelve edges" is *identical* with the concept "x is a cube," although I insist that these latter *are* "logically equivalent." To raise this question would be to raise the question how an "analytic" necessary connection is to be distinguished from a "synthetic" one—a subject upon which I am far from clear. It seems to me that there are ever so many different cases of necessary connection, and that the line between "analytic" and "synthetic" might be drawn in many different ways. As it is, I do not think that the two terms have any clear meaning. I do not know, at all clearly, *what* I mean by saying that "*x* is a brother" is *identical* with "*x* is a male sibling," and that "x is a cube" is *not identical* with "x is a cube with twelve edges." It is obvious, for instance, that, in a sense, the expression "*x* is a brother" is *not* synonymous with, has *not* the same meaning as, "*x* is a male sibling," since if you were to translate the French word *frère* by the expression "male sibling," your translation would be *incorrect*, whereas if you were to translate it by "brother," it would not.

12. *Other Questions*

There still remain seven essays about which I have so far said nothing at all in this "Reply," namely those by Mr. Wisdom, Miss Ambrose, Mr. Lazerowitz and Mr. Malcolm; those by Mr. McKeon and Mr. McGill; and, lastly, Miss Stebbing's. And I have also said nothing about the *main* subjects of the essays of Mr. Murphy and Mr. Mace. But I think

that, fortunately, the greater part of this material does not call for any reply. It does not call for a reply, because, for the most part, the writers are not concerned with trying to shew that anything which I have said in my writings is false, but only with raising questions of a quite different sort about my work. And it is fortunate that it does not call for a reply, because my time is now very limited and I could not possibly discuss in it the new questions which they raise—questions about which nothing at all has been said in my published writings.

There are, however, a few things in what they say, which do call for a reply, and I will try to pick out the chief of these.

I have sometimes distinguished between two different propositions, each of which has been made by some philosophers, namely (1) the proposition "There are no material things" and (2) the proposition "Nobody knows for certain that there are any material things." And in my latest published writing, my British Academy lecture called "Proof of an External World," which is the subject of Miss Ambrose's essay, I implied with regard to the first of these propositions that it could be *proved* to be false in such a way as this; namely, by holding up one of your hands and saying "*This* hand is a material thing; therefore there is at least one material thing." But with regard to the second of those two propositions, which has, I think, been far more commonly asserted than the first, I do not think I have ever implied that *it* could be *proved* to be false in any such simple way; e.g., by holding up one of your hands and saying "I know that this hand is a material thing; therefore at least one person knows that there is at least one material thing." The first of these two propositions is listed as (1) in the list of philosophical statements given by Mr. Malcolm at the beginning of his essay, and the second is in important respects similar to, though not identical with, the statement which he lists as (8). Mr. Malcolm goes on to give, in the case not only of (1) and (8), but of all the twelve philosophical statements which he lists, "the sort of argument against" the statement in question which he thinks I should approve. And I think he is quite right that in every case I should approve of a statement of the kind he attributes to me as *a* good argument against

the "philosophical statement" in question. But nevertheless I should hesitate to say, in the case of (8) and therefore also in the case of the second proposition given above, that by using the sort of argument Mr. Malcolm gives I had *proved* that (8) was false, whereas I *have* said in the case of (1) that that sort of argument is a *proof* that (1) is false. There does seem to me to be an important difference between the two cases. In the case of the proposition "Nobody knows that there are any material things" it does seem to me more obvious that some further argument is called for, if one is to talk of having *proved* it to be false, than in the case of "There *are* no material things;" and this difference is, I think, connected with the fact that an immensely greater number of philosophers have held that *nobody knows*, than have held that *there are none*.

But now, with regard to my assertion that by holding up one's hand and saying "This is a material thing" one is *proving* that "There are no material things" is false, Mr. Wisdom, if I understand him rightly, thinks it important to point out that some philosophers have so used the expression "material thing" that there is no contradiction in saying "There are human hands, but there are no material things:" so used it, therefore, that from "This is a human hand" it does *not* follow that "There are no material things" is false. He not only says that they have so used the expression, but that it is excusable so to use it. And I fully admit that this is the case, and I ought perhaps to have said so: but I do not think I have ever implied that it was *not* the case. Some philosophers have sometimes so used the expression "material thing" that if "phenomenalism" (in one of its senses) is true, i.e., if the sun and the moon and the earth and human bodies etc. etc. are all merely "logical fictions" or "logical constructions out of sense-data" or "permanent possibilities of sensation," then these objects are *not* "material things;" and have used "there are no material things" merely to mean that phenomenalism, in this sense, *is* true. So used, the assertion "there are no material things" is merely an assertion that a certain kind of *analysis* of such a proposition as "This is a human hand" is true; and it is obvious that from the truth of the assertion "This is a human

hand" it cannot follow that this analysis is false. With this meaning of "There are no material things," then, it is really impossible to prove that that statement is false in the way I gave. But I think it is also the case that *some* philosophers have used "material thing" in such a sense that from "There are no material things" there *does* follow "There are no human hands;" and it was only of *this* usage of "There are no material things" that I meant to say that the proposition then expressed by these words can be proved false in the way I gave. I think Mr. Wisdom would admit that some philosophers have used "There are no material things" in this way, although he quotes (p. 431), with apparent approval, Wittgenstein as having said "Those philosophers who have denied the existence of matter have not wished to deny that under my trousers I wear pants." If by this Wittgenstein meant that *no* philosophers who have ever denied the existence of matter have ever wished to deny that pants exist, I think the statement is simply false. *Some* philosophers, at all events *sometimes, have* meant to deny this: they have meant to assert that no such proposition as that pants exist is true; and it was only against *this* assertion that I supposed my proof to be a proof. Perhaps the majority of philosophers who have said "Matter does not exist" have *not* meant this: I don't know. Perhaps the truth is that most have confused several different meanings with one another, and have passed from asserting it in one sense to asserting it in another, without noticing that it was different things they were asserting. But that *some* have *sometimes* meant this, is, I think, certain.

But, when it is understood that the proposition which I meant to refute *was* a proposition from which it follows that there are no human hands, the question remains: Can that proposition be refuted in that way? And Miss Ambrose seems to be implying that it can not—that I was making a definite mistake in saying that, what I gave as a *proof* that it is false, was a proof. She does not *say* this, but she does seem to imply it. And she gives two main reasons. (a) She insists that the conception "external object" is a very different *sort* of conception, in important respects, from such conceptions as "human hand"

or "coin;" and seems to suggest that though you can *prove* that at least one coin exists by producing a dime, you cannot prove that at least one external object exists in the same way. Now I have no doubt that she is right that there *are* extremely important differences between "external object" and "coin;" but as regards at least one respect in which she alleges that there is a difference between them, she is, I think, suggesting, if not saying, something false. She says (p. 406) "Consider now teaching someone the phrase 'external object'. The difficulty would be that one could not *point out* anything to him which was not an external object." Now if "point out" is taken literally to mean "point with the finger at," this may be true. But in a sense, which is, it seems to me, very relevant to our problem, it is not true. One *can* point out to a person an object which is *not* an external object by the method which I suggested just now for finding an object of the sort which I should call a "sense-datum." You can say to him: "Look at a bright light for a little while; then close your eyes; the round blue patch you will then see is not an external object." After-images, seen with closed eyes, are *not* external objects; and you *can* arrange that a person should see an after-image. And it seems to me that the contrast with objects of this sort enters into the meaning of "external object." But, whatever be the important differences between the conception "external object" and such a conception as "coin," I cannot understand what argument can be given to show that, *owing* to these differences, whereas producing a dime *can* prove that at least one coin exists, it *cannot* prove that at least one external object exists. It seems to me that Miss Ambrose not only has not given, but has not even attempted to give, an argument directed to proving precisely *this* point. (b) She also insists much on a point which she expresses by saying that a philosopher who says "There are no external objects" is not making an "empirical" assertion; arguing that he cannot be doing so, because no sort of empirical evidence would have any tendency to make him change his opinion. Now I think this argument is a good reason for saying that his *reason* for denying external objects is not an empirical one. And we know that often at least it is not: some philosophers have cer-

tainly held that there are none, on the ground that the conception "external object" is a self-contradictory one. And, of course, *if* "External objects exist" *is* a self-contradictory proposition, then the philosopher's statement "There are no external objects" is a tautology, like "There are no round squares," and no possible empirical evidence could have any tendency to show that it is false. But is this a reason for denying that he is making an empirical proposition? Of course, his *reason*, his statement that "There are external objects" is self-contradictory, is *not* an empirical statement. But he is, of course, wrong in thinking that "There are external objects" *is* self-contradictory, and, if so, "There are external objects" may really be an empirical statement. It seems to me that *my* statement, that there *are*, certainly *is* empirical. Why should it not be the case that from his false non-empirical statement that "There are external objects" is self-contradictory, the philosopher invalidly infers the empirical statement "There are no external objects?" This seems to me to be what has actually happened; and that, therefore, philosophers who say "There are no external objects" *are* making a false empirical statement, though they are *also* making a false non-empirical one, namely that "There are external objects" is self-contradictory. For these reasons, I cannot see that Miss Ambrose has given any good reason for her suggestion that I was mistaken in thinking that what I gave as a proof that there are external objects, really *was* a proof of this.

In giving the above (b) as an argument used by Miss Ambrose, I have transferred to the case of the philosopher who says "There are no external objects," what she in fact only says with regard to the philosopher who says "Nobody knows for certain that there are external objects." But her argument in this latter case could, I think, be transferred, as I have transferred it, to the former case. She states correctly that no empirical evidence would have any tendency to convince the philosopher who says "Nobody knows for certain that there are external objects," and infers that such a philosopher cannot be making an empirical proposition, and cannot, therefore, be making a proposition which could be refuted by any empirical evidence. And I should agree, as before, that the philosopher's *ground* for saying that

nobody knows is *not* empirical, but is some such proposition as
that it is self-contradictory to suppose anyone to know *for cer-
tain* that there are any external objects; but I should say, as
before, that such a philosopher, though he is making a false
non-empirical proposition is *also* making a false empirical one.
For the proposition I make, when I say now "I know that I am
sitting in a chair" is, I think, certainly an empirical one; and
any philosopher who says "Nobody knows that there are ex-
ternal objects" is I think certainly saying something incom-
patible with this proposition of mine, and therefore something
empirical, though I agree that he is *also* saying something non-
empirical. Miss Ambrose, however, goes on to argue that such
a philosopher is not only *not* saying anything empirical, but also
that he is *not* making the non-empirical proposition that "Some-
body knows of the existence of an external object" is self-
contradictory (p. 402). And her reason for asserting that he
is not making this non-empirical proposition appears to me to
be very weak indeed. She says that "the sceptic," i.e., the person
who asserts "Nobody knows that there are any external ob-
jects" "is aware that language is at present so used that the
statement 'I know that there is a dollar in my purse' describes
what could be the case." Is he? I think he would be very
likely to say that, though he knows that such language is often
used, yet he is *not* aware that it ever describes what could be the
case: that, on the contrary, it always asserts that something is
the case, which could not possibly be the case. And, on the
strength of this weak argument for the view that the sceptic is
not asserting the non-empirical proposition that "Somebody
knows that there are external objects" is self-contradictory,
and her former weak argument for the view that he is also
not asserting any empirical proposition, she goes on to make
the assertion that what he is really asserting, "though he does
not say so explicitly," is that nobody *ought* to use such an ex-
pression as "I know that there is a dollar in my purse" in the
way it is used; that, though "We know that there are external
objects" *is* not self-contradictory, "know" *ought* to be so used
that it would be self-contradictory (p. 403). She goes on to say
(wrongly, because this assumes that my refutation was intended

to be a refutation of "Nobody knows that there are external objects," whereas it was only intended to be a refutation of "There are no external objects") that my attempt to establish the existence of external objects shows that I conceived a sceptic to be doing something quite other than assert that "know" *ought* to be used in such a way. My attempt does not show this, because it shows nothing whatever about what I conceived a sceptic who says "Nobody knows that there are external objects" to mean by that assertion. But I think Miss Ambrose might just as well have argued: The sceptic who says "There *are* no external objects" cannot be asserting anything empirical, and also cannot be asserting the non-empirical proposition that "There are external objects" is self-contradictory, because he knows that language is at present so used that the statement "There are external objects" describes what could be the case, and hence what such a sceptic is asserting, though he does not say so explicitly, is that "external object" *ought* to be so used that "There are external objects" is self-contradictory. My statement that what I give as a proof that "There are no external objects" is false, really does prove this, does shew, I think, that I did not understand the person who says "There are no external objects" to mean merely that this expression *ought* to be so used that it would be a tautology like "There are no round squares;" for I could not have supposed that the fact that I had a hand proved anything as to how the expression "external objects" *ought* to be used. If, therefore, Miss Ambrose were right in saying that this proposition as to how "external objects" ought to be used is all that any philosopher who has said "There are no external objects" has ever meant by it, it would be true that I had made a gross mistake in supposing the proof I gave to be a proof that what some philosophers had meant by this was false. But I see no reason to accept Miss Ambrose's view that those who say "We don't know that there are any external objects" are merely making a recommendation as to how "know" *ought* to be used, nor yet, what I suppose would be her view, that those who have said "There are no external objects" were merely making a recommendation as to how "external object" *ought* to be used.

Mr. Lazerowitz also advocates the view that what philosophers have meant by such paradoxical assertions as that "Material bodies are unreal," "Time is unreal" is merely to recommend that we should not use words in the way we do. But he does not seem to me to bring forward any better arguments in favour of this view than Miss Ambrose does. He has, indeed, two fresh arguments. He says (a) that if they did mean anything more by them than this, we should have to suppose that they held sincerely views which they knew to be false; and that this is impossible (p. 380). To this, I should reply that he is right in saying that we should have to suppose that they held sincerely views which they knew to be false; but that there is no reason whatever to suppose that this is impossible—nor does he even try to give any. And he points out (b) that philosophers in these cases, "counter facts with arguments;" that they cannot, by (a), both know the facts and regard their arguments as correct arguments against them; that therefore they plainly want us to look at the arguments rather than the facts; and, *therefore*, their arguments are merely meant to back a verbal recommendation. The last "therefore" seems to me to be a simply enormous *non-sequitur!* Mr. Lazerowitz concludes that when, for instance, I tried to shew that Time is not unreal, all that I was doing was to recommend that we should not use certain expressions in a different way from that in which we do! If this is all I was doing, I was certainly making a huge mistake, for I certainly did not think it was all. And I do not think so now.

There is one statement of Mr. Wisdom's against which I must protest. He speaks on page 425 of "Moore's account of philosophy as analysis," as if I had somewhere said that philosophy consisted in analysis! It is true that he has somewhat qualified this statement a little earlier (p. 423) where he speaks of "Moore's practice with its implications as to the proper business of philosophy" where, by my practice, I think he means my habit of trying to analyse, and, by its implications, that by doing so myself I imply that other philosophers ought to do the same *and nothing else.* But it is not true that I have ever either said or thought or implied that analysis is the only proper

business of philosophy! By practicing analysis I may have im-
plied that it is *one* of the proper businesses of philosophy. But
I certainly cannot have implied more than that. And, in fact,
analysis is by no means the only thing I have tried to do.

Mr. McKeon and Mr. McGill, in their essays, both point out
that there are many philosophical questions with which I have
never tried to deal, and seem to imply that it is a matter for
regret, or even reproach, that I have not dealt with those ques-
tions. And it is, of course, true that there are ever so many
intensely interesting philosophical problems on which I have
never said a word: if by "a philosophy" is to be meant a com-
plete philosophy, there is no such thing as my philosophy. But
whether this is a matter for regret is another question. Mr.
McGill suggests that the reason why I have not dealt with
some of these other questions may have been that I was wedded
to certain particular methods, and that these methods were not
suitable for dealing with them. But I think I can assure him
that this was not the case. I started discussing certain kinds of
question, because they happened to be what interested me most;
and I only adopted certain particular methods (so far as I have
adopted them) because they seemed to me suitable for those
kinds of question. I had no preference for any method; I have
always chosen the problems I did choose *only* because they
happened to interest me most. I think it is probable that they
were also the kind of problem with which I was best fitted to
deal; so that it is perhaps no matter of regret that I have
not attempted other kinds, perhaps of more practical im-
portance, which I should only have dealt with worse than I
have dealt with those I did attempt. Mr. McKeon, I think,
is perhaps rather inclined to undervalue the importance of the
analysis of propositions. If the propositions you choose to
analyse are *true* contingent propositions, they can only be true
because they tell you something about reality, and, if so, then
I think the analysis of them will tell you something about
reality too. But I can quite understand anyone thinking that the
things I have not dealt with are far more important than those
I have dealt with.

On Miss Stebbing's essay I have only two comments to

make. I do not at all like her proposal (if this is what she is proposing, p. 525) to call the kind of knowledge I have now that I am sitting in a chair "probable knowledge." I hold that it is *certain* that I am now sitting in a chair, and to say that I have "probable knowledge" that I am, seems to me to suggest that it is *not* certain. And my second comment is that I think Dr. Metz was quite right in saying that I am an "unsatisfactory answerer." I did want to answer questions, to give solutions to problems, and I think it is a just charge against me that I have been able to solve so few of the problems I wished to solve. I think probably the reason is partly sheer lack of ability and partly that I have not gone about the business of trying to solve them in the right way.

Let me say, in conclusion, that the latter part of this "Reply" has been hastily written and may easily contain downright mistakes. And also that the amount of space that I have given to the different contributors' essays is no measure of the value I set upon them. The fact that I have said hardly anything about one contribution and a very great deal about another is not to be taken as a sign that I do not attach quite as much, or even more, value to the former than to the latter; nor yet, either, as a sign of the contrary.

G. E. Moore

PEACHAM, VERMONT
SEPTEMBER 1942

ADDENDUM TO MY "REPLY."

I HAVE, I am afraid, now, in 1952, changed my opinions very little from what they were ten years ago when I wrote "A Reply to my Critics." I have neither become convinced that any views which I then expressed were, in any important respect, wrong, nor, in those cases where I stated that I did not know the answer to a question I had raised, have I found any argument which seems to me to show conclusively what the right answer to that question is. But I may say, in excuse for my lack of progress in

this respect, that I have been able, partly owing to ill health, to read very little of what has been published since 1942 on the subjects with which my "Reply" is concerned. If I had been able to read more, I might perhaps have found that some of my views had been shewn to be wrong, or that on some of the questions as to which I was in doubt, one particular answer had been shewn to be the right one.

The most important criticisms, which I have seen, of what I said in my "Reply," are, I think, contained in an article by Professor A. J. Ayer, which he entitled "The Terminology of Sense Data," and which appeared in *Mind* in. October, 1945. I call these criticisms important, because, if what Mr. Ayer implies or says about my views were correct, it would follow that I had been wrong in at least two important respects. I think, therefore, that it is worth while to take this opportunity of explaining why I think that his criticisms of me on these two points are not correct.

The first point is as follows.

In my "Reply" (p. 645) I refer the reader to a passage which Mr. Marhenke quotes on pp. 259-60, and which is to be found in an article of mine to which he gives the reference in the first footnote on p. 257. In this article I stated four conditions, which are satisfied by ever so many cases of visual perception of physical objects, examples of which constantly occur to those of us, who have good enough eye-sight to see physical objects. Mr. Marhenke tries to state these four conditions on p. 257, but his statement of the fourth is very inaccurate. My own statement of it was: "Any two parts [of the physical object in question] which we are seeing are continuously joined to one another by another part which we are also seeing: that is to say, we are *not* seeing it only in the way in which I should be seeing my thumb, if a piece of string were lying across the middle of it, so that I saw its upper and its lower half, but did *not* see the thin strip joining the two which was covered by the string." This condition was put in by me in order to secure that, in the cases of visual perception which I wanted to consider, we should always be able to say correctly that we are seeing *only one* part of the object's surface, and therefore to use correctly the phrase "*the* part of its surface which we are seeing." If a string were lying across my thumb, in the way

explained, we could not speak correctly of "*the* part of its surface which I am seeing:" we should have to say I was seeing *two* parts of its surface, and not only one: although, as I go on to argue, in the very common case which I did want to consider, we can speak correctly of "*the* part of the surface of an object" which we are seeing, in spite of the fact that the part in question will, as a rule, *include* other parts of the object's surface.

Well, in my "Reply," I asserted, about all cases of visual perception of a physical object which satisfy those four conditions, the following two propositions: (1) That in the case of each physical object which any one of us is seeing under those conditions, each of us is always seeing one and only one part of the surface of the object in question; and (2) That in every such case each one of us is seeing an object which it is tempting to suppose to be identical with *the* part, which he is seeing, of the physical object's surface, but with regard to which, on the other hand, there are strong reasons for supposing that it cannot be identical with *the* part which he is seeing, of the physical object's surface. And I said I was in doubt whether, in those extremely numerous cases, the object which it is tempting to suppose to be identical with the physical surface in question, ever is really identical with that surface, and that I did not at present see any absolutely conclusive argument in favor of the view that it always is or of the view that it never is.

Now Mr. Ayer implies, though he does not actually say, that I was not asking any definite question when I asked whether these objects, answering to the description given in (2), one and only one of which is, in each of these common cases, undoubtedly seen, are or are not identical with the pieces of physical surface, one and only one of which is, in each case, undoubtedly seen. I say he only *implies* this, because all that he actually *says* is that I have not only supplied my readers with any definite question; which, of course, leaves open as a logical possibility, that I myself was asking a definite question, but had failed to convey it to my readers. I think, however, he obviously doubts whether I myself was asking any definite question; and, if I was not, then certainly I was wrong in an important manner, for I certainly thought I was. He even suggests (p. 298) that all I was doing,

when I thought I was doubting whether a definite proposition was true or false, was "hesitating over the choice of alternative verbal conventions."

What he actually says about the apparent question, which is all that he thinks I have presented to my readers, is that "we have no means of deciding it;" that it is not the case that "the truth or falsehood of the proposition which is supposed to be doubted, is already there to be discovered;" that its "actual truth or falsehood is not determinable." (p. 297) And his reason for thinking this is that he thinks we have no means of deciding any question, unless it can "be settled either by the method of empirical verification, or by the analysis of [some] standard usage of words, whether common or philosophical" (pp. 296-7); and that, in the case of my supposed question, it certainly cannot be settled in the first way (a thing which, he says correctly, I have myself admitted) and that also it cannot be settled by the analysis of any standard usage.

It is in this last assertion of his, that the correct answer to my question cannot be discovered by the analysis of any standard usage, that he seems to me to have gone hopelessly wrong. His only reason for saying so seems to be that there is no standard usage either of the philosophical term "sense-datum," or of the terms "directly apprehend" or "directly see;" and he is perfectly right that there is no standard usage of these terms. What he has failed to see is that my question can be put without any use of these expressions (I have actually so expressed it just above) and that the answer to it does depend upon the analysis of expressions which undoubtedly have a standard usage in ordinary life. The expressions I mean are those which consist in saying such words as "This is a penny" or "That is a penny" *together with* some standard gesture which seems to explain what object we are referring to by the words "this" or "that;" and if we could only discover the right analysis of what is meant by such expressions, my question would be answered. It is by "going on thinking" about the analysis of such expressions as these that I hope my question will some day be answered— perhaps, has already been answered in some work which I have not read. As it is, when I look at a penny under the conditions

stated, I certainly see one and only one part of its surface, and I certainly see one and only one object which it is tempting to suppose to be identical with that part of the penny's surface, but with regard to which I also know, from my reading of philosophy, that there are very strong reasons for doubting whether it can be identical with that part of the penny's surface. It is certain that if I say to myself "That is a penny" I am saying *something* about this object, and the simplest and most tempting view as to what I am saying about it is that I am saying "That is part of the surface of a penny;" but then I can think of many philosophic arguments which seem to show that if that were what I was saying, it could not possibly be true, and that therefore what I am saying when I say "That is a penny" could not be true. But it is certain that what I say, when I say "That is a penny" is true; certain also that when I say this I am saying *something* about this object; and if what I am saying about it cannot be that it is itself part of the surface of a penny, what am I saying abou it? These are questions which I cannot answer now any more than I could in 1942. But I think there is no doubt that they are perfectly definite questions, and that they have nothing whatever to do with any obscurities there may be in my explanations as to my use of the terms "sense-datum," "directly see," and "directly apprehend." I can ask myself precisely similar questions in thousands of other cases, viz. whenever I am seeing any physical object under the stated conditions. And it seems to me surprising that Mr. Ayer should not have seen that my question was concerned with the analysis of such standard expressions as consist in the uttering of such words as "That is a penny" *together with* a standard gesture to explain what object the word "that" refers to.

I conclude, then, that Mr. Ayer's first implied criticism is entirely baseless, owing to his surprising failure to see what the question was which I was asking.

Mr. Ayer's second criticism is one which I find more puzzling to deal with; and I am afraid it is necessary to go into considerable detail about it. But I will be as concise and as clear as I can.

Mr. Ayer thinks he has found an absolute proof that, *if* a pair of propositions, which he is not quite sure that I hold, are true, then the proposition that some "sense-data" (using that word in

my sense) *may possibly* be identical with "physical entities" (his expression) is false—that the proposition that some sense-data *are* thus identical is a self-contradictory proposition. Now I myself expressly say (p. 643) that I think that the proposition that some sense-data *are* identical with physical realities *may* be self-contradictory; so that, so far as this second criticism is concerned, it would only amount to an assertion that I was wrong in thinking that this proposition *may possibly* not be self-contradictory. However, I think that to prove even as much as this would be important. If Mr. Ayer really had proved this, he would have given a solution to one of my doubts.

I will in the future, for the sake of brevity, refer to the proposition "No sense-datum can possibly be identical with any physical entity" *(Mind, loc. cit.,* p. 300) as Mr. Ayer's main conclusion.

Now I began by saying that all Mr. Ayer professes to prove is that, if a certain pair of propositions are both true, then his main conclusion is true. These two propositions, as stated by him, are (1) " 'x is directly apprehended' entails 'x exists' " *(loc. cit.,* p. 299), and (2) "sense-data cannot be apprehended otherwise than directly"—a proposition which Mr. Ayer regards as necessary to his proof, but which he seems to add, as a sort of afterthought, on p. 300. Are these two propositions themselves true? Mr. Ayer does not discuss this question, because he has put his main problem in the form of an attempt to show that, *if* I hold them, then I am inconsistent in denying his main conclusion.

But let us raise the question: Are they true?

As regards the first proposition, I certanly think the way in which I was using "directly apprehend" and the way in which it is most natural and proper to use the word "exist," are such that it is true; though I do not agree with Mr. Ayer that to say that it is, is the same thing as to say that *"part of what is meant* by saying of something that it is directly apprehended is to say that it exists" *(loc. cit.,* p. 330, my *italics*). Mr. Ayer seems here, and elsewhere in this article, to be taking the old-fashioned view that every proposition of the form "p entails q" is "analytic" in the sense that to say so is to say that q is part of what you are asserting in asserting p—a view with which I do not agree. However,

I do think, as I have said, that if "directly apprehended" is used as I was using it, and if "exists" is used in the way in which it is most natural and proper to use it, then from any proposition of the form "*x* is directly apprehended" there does *logically follow* the corresponding proposition of the form "*x* exists." But the second proposition, that "sense-data cannot be apprehended other than directly," seems to me to be quite absurdly false. For I think that this pedantic philosophical word "apprehended," which I am sorry that I ever used, is so used that I can properly be said to "apprehend" sense-data which other people have or have had, when I know anything about those sense-data from what they tell me; and similarly that I can properly be said to be "apprehending" my own past sense-data, when I recall what they were like, though I am certainly not directly apprehending them. However, my refusal to agree to this second proposition, owing to my view as to how this absurd word "apprehend" has been used by philosophers, does not, I think, affect Mr. Ayer's point. For if you substitute, as I now think that I ought to have done, the words "directly perceived" for the words "directly apprehended," I am perfectly willing to agree not only that "x is directly perceived" entails "x exists," but also that sense-data cannot be *perceived* otherwise than directly. The fact is I think that I was using "directly apprehended" to mean exactly the same as can be better expressed by "directly perceived," although I think it is far from true that "apprehended" by itself can be properly used to mean the same as "perceived."

I think, therefore, that the two propositions (1) " 'x is directly perceived' entails 'x exists' " and (2) "no sense-datum can be perceived otherwise than directly," are both proved, and I think these two propositions would serve Mr. Ayer's purpose quite as well as the two he actually gives, of which the second seems to me so absurdly false. So far as his supposed proof of his main conclusion depends on these two propositions, I have no objection to make to it.

What I think there are serious objections to is the other proposition on which his supposed proof depends: namely the proposition "it always makes sense to say of any physical entity

that it is seen— . . . in a sense of the word 'see' . . . from which it does not follow that it exists" (*loc. cit.*, pp. 299-300). This is, of course, to say that we actually use the word "see" of physical entities in *one* sense in which to say of a physical entity that it is seen does *not* entail that it exists; and it implies, what I think Mr. Ayer would admit, that there is *another* sense of the word 'see', in which we actually use it of physical entities, such that to say of a physical entity that it is seen *does* entail that it exists. And in the quotation I have just given, Mr. Ayer, though I have omitted the words in which he says it, says the same of "perceive" in general, and of its various other species, "hear," "smell," etc.; namely that there is one sense in which we actually use "perceive" of physical entities, such that to say that one is perceived in that sense does not entail that it exists, and another such that to say of a physical entity that it is perceived in this other sense does entail that it exists; and similarly of "hear," "smell," etc. Now, for the sake of brevity, I will only consider the case of "see": if Mr. Ayer is right about "see," he is also right about "perceive" and the other species of perception; and if he is wrong about "see," he is also wrong about "perceive" and its other species. Is it true, then, that there is a sense of the word "see" in which we actually apply it to physical entities, such that to say of a physical entity that it is seen, in that sense, does not entail that it exists?

This is a surprising assertion. It is certainly not obvious that it is true. And we can say, I think, that Mr. Ayer has certainly not proved his main conclusion, unless he has brought forward some evidence sufficient to show that this particular premise which he uses is true. Has he produced such evidence?

The only evidence he brings forward is a proposition about our use of language in speaking of hallucinations, such as Shakespeare represents Macbeth as having had in the famous passage which begins "Is this a dagger which I see before me?" Of this experience which Macbeth is represented as having had, Mr. Ayer says that it is legitimate to describe it "either by saying that Macbeth saw a dagger which did not exist, or by saying that he imagined he saw a dagger, but did not really see [one]" (Mr. Ayer says "did not really see *it*," but surely he ought to have

said "did not really see *one*"? What is "it" supposed to refer to?) Now as regards the first of these expressions, I feel a little doubtful if anybody would describe Macbeth's supposed experience by exactly these words. It seems to me that we only could so describe it if we were using "which did not exist" to mean what we should more naturally express by "which was not a real dagger," and that this is a doubtful usage of "which did not exist." But I think Mr. Ayer is undoubtedly right if he only means that it is quite legitimate to describe the experience by saying that Macbeth really did see a dagger, but it wasn't a real dagger. Such a use of language, in the case of hallucinations, seems to me to be perfectly well established; e.g. it is a well established usage to say of a man, who in *delirium tremens,* suffers from an hallucination of snakes, that he is seeing snakes, but that they aren't real snakes. But to Mr. Ayer's second statement, that it is legitimate to describe the supposed experience of Macbeth "by saying that he imagined he saw a dagger, but did not really see [one]," I think there are still more serious objections. He is quite right in holding that we can say, "He did not really see a dagger." But is he right in saying we can say, "He imagined that he saw one"? I think not. We clearly can say that Macbeth conceived the possibility that what he saw was a dagger: this is shewn by his question, "Is this a dagger?" But that he imagined he saw one, seems to me to suggest more than this, namely that he was more inclined to think that he saw one than to think that he didn't; and there is nothing in Shakespeare to justify this. Moreover, if to say he imagined that he saw one, in one way says too much, in another way it says too little: cases of hallucination are not mere cases of imagination, and no one would naurally call them so. I think what Mr. Ayer should have said, is that we can legitimately describe the supposed experience by saying, "He was having a visual hallucination of a dagger, but was not really seeing one." And I think this substitution would make no difference to his point. Part of his point undoubtedly is that two apparently contradictory statements, can, in such cases, both be true, namely, in our case both (1) he was seeing a dagger and (2) he was not seeing a dagger. This seems to me to be clearly true; and it follows absolutely that *the whole*

phrase, "he was seeing a dagger," must be being used in a different sense (1) from that in which it is being used in (2).

But Mr. Ayer immediately proceeds to make from this truth two absolutely fallacious inferences. The first is that the word "see" must be being used in two different senses, in one sense in (1), and in a different one in (2). This simply does not follow. It never seems to have occurred to him that there is a possible alternative, namely that the words "a dagger" are being used in different senses in (1) and in (2). And that this possibility has not occurred to him is no doubt part of the reason why he makes his second fallacious inference, namely that (1) entails that he was seeing a physical entity. That it does not, can be easily seen by asking: Is Shakespeare representing Macbeth as seeing a physical entity, when he represents him as having a visual hallucination of a dagger? Of course the answer is: No. Mr. Ayer seems to have fallen into the mistake of supposing that because, in saying (1), we are using an expression, namely "was seeing a dagger," which in the immense majority of cases entails "was seeing a physical entity," we must be so using it when we say (1) in the comparatively extremely rare cases of hallucination, only with a different sense of "see."

I conclude that Mr. Ayer has entirely failed to prove his premise that there is a sense of the word "see," such that to say of a physical entity that it is seen, in that sense, does not entail that it exists.

And I think there is another independent reason for saying that he has failed to prove his main conclusion. Just as it apparently did not occur to him that the words "a dagger" might be differenly used in (1) and in (2), so it has apparently not occurred to him that, when he says we can say "Macbeth saw a dagger which did not exist," he may be using "exist" in a different sense from that in which I am using it when I say that " 'x is directly apprehended' entails 'exists.' " His supposed proof of his main conclusion entirely depends on supposing that "exists" is used in the same sense in both cases. But it seems to me quite certain that this is false. When he says, "a dagger, which did not exist," he means, I think, merely, "a dagger which was not a physical entity." But, when I say, " 'x is

directly apprehended' entails 'x exists,' " I certainly do not mean by "x exists" "x is a physical entity." This by itself, I think, is a conclusive reason for saying that he has entirely failed to prove his main conclusion.

G. E. MOORE

86 CHESTERTON ROAD
CAMBRIDGE (ENGLAND)
JULY 1952

EDITOR'S NOTE: The following three letters exchanged between Professors C. J. Ducasse and G. E. Moore (all dated early in 1943, shortly after the appearance of the first edition of this volume) continue the discussion between the two philosophers started in the original edition. The editor is grateful to Professor Ducasse and to the editors of *Philosophy and Phenomenological Research,* respectively, for their kind permission to republish these letters here, which first appeared in the above mentioned journal in March 1968 (Vol. XXVIII, No. 3, pp. 320-331).

December 3, 1968 PAUL A. SCHILPP

Professor G. E. Moore January 25, 1943
Department of Philosophy
Columbia University

Dear Professor Moore:

(I) I have just read, with great interest, your comments on my paper in the Schilpp volume just published. I fear that, by this time, you must be rather weary of the various papers it contains, and I therefore hesitate to say anything by way of comment on your comment. But it seems to me that your thought and mine on the essential point are now not very far apart, and that the remaining difference turns on an issue which, in the light of your reply, it is now possible to define briefly quite sharply, and perhaps to resolve.

(II) But first a word concerning your statement at the top of p. 656 that I seem to be supposing "that there is *one and the same* entity, etc." I am shocked that my words should have remained open to such an interpretation; for I fully

agree with you that such a supposition would be nonsense. Indeed, this is one of my basic contentions, which I had specially tried to make clear; and I am distressed to find that I failed in this. Anyway, that I agree it would be nonsense means that I completely agree also with all you say on pages 656 and 657.

(III) On p. 659 you give the reason why the hypothesis I offer as to the relation between the sensible quality blue and my seeing of it loses for you the plausibility it would otherwise have. It is thus in that reason that the question ultimately at issue resides.

(IV) With regard to your statement: "I cannot see the *sensible* quality blue, without *directly seeing* something which *has* that quality — a blue patch, or a blue speck, or a blue line, or a blue spot, etc. . . . ," I should like to remark first that, where the sensible quality concerned is instead the taste called bitter, or the tone called middle-C, no similar state of affairs seems to exist. If I image (i.e., intuit imaginatively) the taste called bitter, or the tone called middle-C (or have an after-image of either) I do not need to image also something else — some "object" — that "has" that sensible quality; indeed, not only do I not need to, but it seems to me I cannot even do so.

(V) But if this is the case, then in these two instances at least, the only thing you mention, as destroying the plausibility of my hypothesis as to the relation of sensing to sensum, is absent; and this would entail that the hypothesis then retains its plausibility at least in *these* instances.

(VI) But it would be strange, although of course not impossible, that the relation between seeing and the sensible quality blue should be generically different from that between tasting and the sensible quality bitter or between hearing and the sensible tone middle-C. This, then, suggests the desirability of re-examining the situation described in your statement quoted above.

(VII) The interpretation of that situation which seems to me the right one — and this is the point ultimately at issue — is as follows. What you describe as "a blue patch"

would seem to me better described as "a patch of blue" (or a speck, or a spot, etc., of blue) . For I believe that the meaning of "a patch of blue" is exactly parallel to that of "a snatch of tone" (or, of song) . The snatch is not an object that *has* the tone; a snatch of tone is simply a tone that endures only for a short time. "Snatch" is then a purely quantitative term — specifically, one referring to the extensive as distinguished from the intensive quantity of the tone. We could speak similarly of a snatch of the sensible quality bitter — meaning again that on the occasion concerned the time during which one is tasting the sensible quality bitter is brief.

(VIII) Now it seems to me that in the case of the sensible quality blue, the words patch, speck, spot, are similarly only quantitative terms. (Indeed, they are merely quantitative even when applied to substances, as, e.g., a patch of cloth, a speck of dust, a spot of ink) . Accordingly, I believe that we can say that the sensible quality blue *is had* by a patch of it only in the sense strictly analogous to that in which we could say that the sensible tone middle-C is had by a snatch of it.

(IX) If the sensible quality called the tone middle-C *qualifies* or *is had by* anything, what it qualifies or is had by is nothing other than some span of sensible time. "Qualifies" then means "exists during" that sensible span; and "occupies" also means in such a case nothing but this. And similarly, it seems to me that if the sensible quality blue qualifies anything, what it qualifies is only some region of sensible space. But because sensible space is multi-dimensional, whereas sensible time is unidimensional, to say that a sensible quality, e.g., blue, has some specific extensive quantity — some specific quantity in sensible space — is to say that it has some sensible *shape;* for quantity in "sensible space" means "in each of the dimensions of sensible space"; and the sensible shape and size that the sensible quality blue has is — the shape — nothing but the proportions between the extensive quantity of the blue in each of the dimensions of sensible space; and — the size — the total extensive quantity of the sensible blue.

(X) This implies that when we say, on the one hand that a substance *has* a property, and on the other that a region of sensible space (during a span of sensible time) *has* the sensible quality blue (or equally, of course, that the sensible quality blue during that time *has* a certain set of continuous places in sensible space), then we must be quite clear that we are using "has" in the second case in a sense as radically different from the sense it has in the first, as are radically different the two senses of the adjective "blue" when it denotes a *property,* and when it denotes a *sensible quality.* Specifically, when one says of a region of sensible space (and time) that it *has* the sensible quality blue, "has" means "is occupied by" (or, if one says that the sensible quality blue *has* a certain place in sensible space and time, "has" means "occupies" or "is located at"). But when one says that a substance *has* a certain property, evidently "has" does not there mean "is occupied by," for a substance is not a place and only a place can be "occupied" in the sense concerned.

(XI) Accordingly, it seems to me that your statements that "any experience which is a seeing of a visual *quality* must also be a seeing of something which is *not* a quality" is true, but that this something else which is not a quality is always only the set of continuous sensible places occupied by the sensible visual quality at that time, (That is, to "see" has not only a qualitative sense, but also a ubietive sense).

(XII) Thus, it seems to me that to speak of that something else as "an object" — the sort of "object" called "a sense-datum" — is illegitimate, for a region of sensible space-time would not ordinarily be called "an object"; and this illegitimate mode of speech is, I think, the ultimate source of all the difficulty. For to speak in that way amounts to reifying — substantializing — sense-data at least verbally; and this — through the mere power of the world "object" — suggests that one sense-datum might "have" now one sensible color and later another in some sense similar to that in which one substance can have now one property and later another; whereas what is possible is only that our seeing a certain sensible place should continue while our seeing the sensible

quality blue there does not continue. That is, sometimes a ubietive sense-datum — our seeing a certain sensible place — remains unchanged for a span of sensible time during which some qualitative sense-datum — e.g., the seeing of sensible blue — is changing; and sometimes it is the converse that occurs. If this more literal mode of speech is adopted, it seems to me that the only objection you mention to my hypothesis then vanishes.

(XIII) If so, then that hypothesis remains tenable; not only for tastes and tones but also for colors; and it also seems to provide an intelligible account of the facts that were to be explained. On the other hand, so far as I can see, this is not the case with any rival now in sight. It is only so much, and not of course that it is proved, that I should be inclined to claim for that hypothesis.

<div style="text-align:right">

Sincerely yours,
C. J. Ducasse

</div>

CJD:MS

<div style="text-align:right">

513 Ogden Avenue
Swarthmore, Pa.
February 8, 1943

</div>

Dear Professor Ducasse,

(I) Your letter of January 25 has given me a great deal to think about; and that is why I have delayed so long to answer it. But I still do not see clearly exactly what your view amounts to; and I still cannot find in what you say what I wanted — namely a good reason for supposing (what I think must be true) either (1) that, in any case in which I see an after-image with closed eyes, there is a contradiction in the suppositions (a) that that identical after-image might have existed at that very time without being seen by me, and (b) that it existed before I began to see it, and (c) that it existed after I ceased to see it; or (2) for the weaker proposition, that there is a contradiction in supposing that that identical after-image might have existed at some time without being seen *by anybody.*

(II) You begin by quoting my statement that "I cannot see the *sensible* quality blue, without *directly seeing* something which *has* that quality — a blue patch, or a blue line, or a blue speck, etc.," and saying that if we consider instead the sensible quality which is the taste called bitter, or that which is the tone called middle-C, no similar state of affairs seems to exist.

(III) But it seems to me that in these cases a state of affairs which is similar in very important respects does exist.

(IV) (a) It seems to me that there is no such thing as the *tone* called middle-C. What "middle-C" is the name of is a certain particular *pitch;* and, so far as I can see, there is no correct use of "tone" in English, which is such that "tone" in that usage is a synonym for "pitch." Of course, "middle-C" *is* the name of a *physical* pitch — a property of objective physical sounds; but it can also, I think, be quite properly used of an immediately given pitch, namely the pitch of the directly heard sound which would normally be heard by a person who was hearing an objective sound, which had the property of being of the physical pitch middle-C. And, taking "middle-C" as the name of this immediately given pitch, it seems to me that middle-C has to directly heard *sounds* the following relations, which are analogous in important respects to those which the sensible quality blue has to directly seen patches, spots, lines, specks, etc. (1) Just as blue may be the colour of *two* directly seen specks, which differ in shape or size or both, so middle-C may be the pitch of two directly heard sounds, which differ in timbre (or "quality") or in degree of loudness or in both. (2) Just as blue cannot be identical with any directly seen spot *of* which blue is the colour, so middle-C cannot be identical with any directly heard sound *of* which middle-C is the pitch. (3) Just as blue may be the colour of two spots, directly seen at different times by the same person, which are *exactly like* one another in all respects, so middle-C may be the pitch of two sounds directly heard by the same person at different times, which are exactly like one another in all respects, i.e., in degree of loudness and in "quality" as well as in pitch. (4) Just as

blue may be the colour of two spots exactly like one another, one of which is directly seen by one person and another by another *at the same time,* so middle-C may be the pitch of two sounds exactly like one another, one of which is directly heard by one person and the other by another *at the same time.* (5) Just as one cannot see blue without directly seeing some spot or speck, etc. *of* which blue is the colour, so, if a person who had the faculty of recognizing absolute pitch were to say "I hear middle-C" or "I hear middle-C in that chord", what he meant by this would be impossible unless he were directly hearing some sound, *of* which middle-C was the pitch.

(V) (b) As for the analogies between the sensible taste called "bitter" and the sensible colour called "blue", the following 3 propositions seem to me certainly true. (1) Just as many different spots, which differ in respect of shape or size or both are nevertheless all of them blue, so, many different tastes, which differ in respect of faintness or strength, or in "quality", or in both, are nevertheless all of them bitter. (2) Just as the colour called "blue" cannot possibly be identical with any spot, speck, etc., which *is* blue, so the taste called "bitter" cannot possibly be identical with any taste which *is* bitter. Just as it is impossible for the colour called "blue" to *be* blue in the sense in which a spot, speck, etc., may *be* blue, so it is impossible for the taste called "bitter" to *be* bitter in the sense in which any taste which *is* bitter is so. (3) Nobody can possibly be tasting the taste called "bitter", unless he is also tasting some taste which *is* bitter.

(VI) These three propositions correspond to (1), (2), and (5) above about the analogies between the sensible colour called "blue" and the sensible pitch called "middle-C".

(VII) Are there also true propositions about the taste called "bitter" corresponding to (3) and (4) about the pitch called "middle-C"?

(VIII) This depends on whether when, e.g., it can be truly said "I have in my mouth now exactly *the same* bitter taste which I had at this time yesterday, and which I haven't

had for twenty four hours," it must also be true to say "I have in my mouth now a bitter taste which is *exactly like* the bitter taste which I had in my mouth this time yesterday." And, in the case of (4), on whether, where it can be truly said "It seems that you have in your mouth now exactly *the same* bitter taste which I have in mine", it must also be true to say "It seems that you have in your mouth a bitter taste *exactly like* the one which I have in mine". The latter expressions imply that there is a sense of "taste" in which there can be *two* tastes exactly like one another. Obviously there is a sense of "taste" (viz., the one used in the former expressions) in which it is impossible that there should be *two* tastes exactly like one another: is there also a sense in which 2 tastes can differ *numerically only?* I am inclined to think there is, though I don't think we often use "taste" in this sense: whereas we certainly do constantly use "sound" and "spot, speck, etc." Never use them in such a sense that there *can't* be two exactly alike, though in the case of sounds we do do this, as when we say "I heard exactly the same sound repeated three times".

(IX) Now even if we grant that the sensible colour blue, the sensible pitch middle-C, and the sensible taste called "bitter", may all be related, the first to my *seeing* of it on any occasion, the second to my hearing of it, and the third to my tasting of it, in the way in which a "cut" at cricket is related to the hitting of it, it seems to me far less easy to see how a spot which *is* blue, a sound whose pitch is middle-C, or a taste which *is* bitter (where "sound" and "taste" are being used in senses in which there may be *two* sounds or tastes exactly alike) can be so related to our seeing, hearing or tasting of *them*.

Dealing with the case of seeing a blue spot (e.g., an after-image, seen with closed eyes, which is a blue spot), you say that "if the sensible quality blue qualifies anything, what it qualifies is only some region of sensible space". But we do not say of regions of sensible space that they *are* blue; what we *do* say is, e.g., that a particular after-image *is* blue; and an after-image is no more identical with a region of sensible

space, than is a blue book with a region of physical space. An after-image may gradually grow fainter, while it remains in the same sensible region: but that sensible region does not grow fainter. And an after-image may sensibly move from one region in sensible space to another: but no region in sensible space can move from one place to another in sensible space. I agree with you that there is a relation, which may naturally be called "occupation", such that to say that a resting blue spot exists at a given time is equivalent to saying that the sensible colour "blue" is, at that time, occupying a region in some sensible space. But then, in order that you may be seeing a resting blue spot, it is necessary that you should not only (1) be seeing the colour, blue, but also (2) seeing a region (or "place") in sensible space, and also (3) seeing the colour blue *as* occupying that seen place. And even if the colour blue could be related to your seeing as is a stroke at cricket to the hitting of it, I do not at all understand how a place could be related to an act of seeing in the same way, and still less what account can be given of seeing a colour *as* occupying a place. It seems to me, therefore, that in order to make the state of affairs really clear, far more needs to be said than anything you have said.

<div style="text-align: right">Yours sincerely,
G. E. Moore</div>

<div style="text-align: right">March 4, 1943</div>

Dear Professor Moore:

(I) It has taken me a long time to figure out just what I could say on some of the questions you raise. Since you perhaps did not keep a copy of your letter, I asked our secretary to make a typed copy of it, which I enclose. I have numbered its paragraphs, so that I may be able to refer to some of your statements here without quoting them in full.

(II) I agree that, to prove either of the propositions stated in your paragraph 1, more needs to be said than I did say either in my paper or in my previous letter. Some of this "more", I have attempted to say in another paper (on objec-

tive reference) of which I enclose a copy with some relevant passages marked in case you should wish to glance at them. But there are some things to be said on the questions you specifically raised.

(III) I admit that "middle-C" is the name of a pitch, not of a tone as I had carelessly said. Tone is the sort of thing that "has" pitch, timbre, and intensity. These together constitute the "what" of the tone. Any tone, in addition, "has" more or less duration; its duration being its extensive "how much", which may vary without its "what" varying; (whereas the intensive "how much", i.e., the intensity of the tone, seems to be truly one of the dimensions of its "what".) Further, if tone "having" a given "what" and a given duration *exists*, then it has in addition a date, i.e., a specific place in time — a specific "when". (For brevity, let it be agreed that "tone", "place", etc., will here throughout mean sensible tone, sensible place, etc., unless physical tone, physical place, etc., are explicitly referred to.)

(IV) Color, similarly — e.g., blue — is the sort of thing that "has" hue, saturation, and brightness — these being the three dimensions of its "what". Any color, in addition "has" some shape and size and some duration, i.e., it has a certain spatial and temporal "how much". But to say that a color *exists* is to say in addition that it "has" a specific place (or places) in space and in time — a "where" and a "when".

(V) Now, in the light of these remarks, it seems to me that your statement no. 1 in section (a) of your paragraph IV requires modification for at least two reasons. One is that shape or size are not true analogues of timbre (but duration is so;) and the other is that "blue" is, like tone, multidimensional; and that the true analogue of "middle-C" *pitch* would be some determinate *hue*. But "blue" is not the name of a determinate hue but the name of a large class of colors (the blues) that differ from one another as to determinate hue, determinate saturation, and determinate brightness. (Some determinate pitches have proper names, e.g., middle-C, but I do not believe any determinate hue has a proper name in common use.)

(VI) The rewording of your statement, which these two reasons seem to me to render necessary, would then be about as follows:

(VII) "Just as a certain hue may be the hue of *two* directly seen blues, which differ in saturation, or/and in brightness, or/and in shape, or/and in size, so middle-C may be the pitch of *two* directly heard sounds which differ in timbre, or/and in degree of loudness, or/and in duration".

(VIII) To say that the two blues, or the two sounds, are "directly heard" implies, it seems to me, that they are *two* not only as regards the "what" or/and the "how much" of each, but also as regards the "where" or/and the "when" — two-ness in respect of "where" or/and "when" of each being, so far as I can see, what so-called "numerical" two-ness means.

(IX) I should say, however (but I am not sure from your letter whether this is also what you hold) that it is possible for *identically the same quality* (the same "what") of blue, or of tone, to exist at two distinct places or times. That is, if "exactly alike" is applied to the *quality* of, e.g., the blue seen at one place and the *quality* of the blue seen at another place (or time), then "exactly alike" means "identical"; *one* quality only of blue is concerned, but the places (or times) at which it is seen are two. (And a similar remark would so far as I can see apply to shape and size, and to duration, no less than to quality.)

(X) Now, having in mind the tri-dimensionality of the "what" of any blue (as of any tone) ; the fact that any blue has also a "how much" (itself multidimensional) ; and that any blue seen also has some specific place in space and time; I do not understand what you refer to when you speak of a "spot" or a "speck", or a "patch", (which "has" the color blue, or of which blue is the color) if you mean that the "spot" is something distinct from and additional to the "what", the "how much", and "where" and "when" of the given blue. When I scrutinize a blue after-image, it seems to me that its "what", its "how much", and its "where" and "when", constitute an exhaustive analysis of it.

(XI) You say in paragraph X that "we do not say of

regions of sensible space that they *are* blue," etc. But this, on the contrary seems to me a perfectly natural, proper, and literally true thing to say. For example, if, lying on my back outdoors on a cloudless day, I look up, it seems to me that all that I directly see at the time is a region of space which is blue. (To bring the notion of "sky" into the account would be to inject into it some things which I perhaps believe or know, but which are not at the time visually sensed by me.) Moreover, we certainly often do speak of a warm place, a cold place, a noisy place, a smelly place; and I see no reason to suppose we are then speaking elliptically.

(XII) We do speak, of course, as you say, also of a blue after-image. But I take it that, as you use the word "after-image" in this example, you intend to abstract from the information it conveys as to how what is then directly seen was caused to be seen, and intend to use the word only to refer to the patch of sensible blue seen, itself. But if so, I cannot see that scrutiny of the after-image reveals it as consisting of anything else whatever than of a certain region of sensible space and of sensible blue (of a certain determinate hue saturation, and brightness) occupying that region at that time.

(XIII) Moreover, it seems to me that even with regard to an existing physical thing, such as the blue book or the piece of wood now before me, it is exhaustively analyzed into a certain "what" (which, however, in these cases, is complex, and is a complex of properties not of sensible qualities, viz., the set of properties that "wood-ness", or "blue-bookness" mean — each property of each set, of course, descriptively determinate) and a certain "where" and "when", occupied by that complex "what". To say that the book "moves" then means that this same "what" occupies different but continuous "wheres" at continuously successive "whens."

(XIV) Similarly, it seems to me that when I observe the "after-image" moving, all I observe is that different but continuous regions of sensible space sensibly become occupied by sensible blue at continuously successive sensible times

(the sensible shape and size of the sensible blue, remaining throughout the same) .

(XV) Again, to say that the after-image gradually grows fainter while it remains in the same sensible region does not, indeed, mean that the region grows fainter; but that the sensible blues seen there at continuously successive times are blues of continuously smaller intensities.

(XVI) I believe that when we say (1) that a color "has" a certain hue H, a certain saturation S, and a certain brightness B; when we say (2) that it "has" a certain shape, size and duration; and when we say (3) that it "has" a certain place in space and time; we are using "has" in three different senses. The best account I can give of each is this:

(XVII) In case (1) "has" H S B means: is the species of color which H S B together define. In this case, "has" introduces an answer to the question "what?", which question expresses a demand for more determinate qualitative information. Similarly, we might say of a "cut" at cricket that it is, perhaps, sharp, or strong; thereby stating, more determinately than by calling it simply a "cut", what *species* of hit it is. (I know nothing of cricket, so perhaps "sharp", or "strong", are not appropriate adjectives wherewith to describe a species of "cut". But if not these adjectives, then others.)

(XVIII) In case (2) "has" introduces an answer to the question "how much?" To this question, possible answers (incompletely determinate) would be "only a speck", or "a spot" or "a patch" or (somewhat more determinately) "a small square patch", etc. I suppose that, similarly, a "cut" at cricket could vary quantitatively in some way without varying in species.

(XIX) In case (3) "has" means "is at" or "occupies" and introduces an answer to the questions "where?" and "when?"

(XX) The question you raise, as to what account can be given of seeing a color *as* occupying (or being "at") a place is one to which I have given much thought. It has, of course, to be asked also with regard to occupation of a date, i.e., of a place in time. What I said about it in my paper on objective

reference — first as to sensible pressure and tactually sensible place, and afterwards more briefly as to sensible color and visually sensible place — represents the best answer I have so far been able to think of. What bothers me about it is that, where place in space is concerned, the answer presupposes that one already knows what it means to say that a given event is experienced *as at* a certain time: and an account of this seems to presuppose that one already knows what, e.g., seeing a color, *as at* a certain place, means.

(XXI) As regards the question you also raise, as to how a place could be related to an act of seeing in the same way as a "cut" is related to the hitting of it. I would not propose to say exactly that, but rather that the seeing of a place is an "emergent" or two specific acts, each of which is related to a species of sensing as a "cut" is related to hitting.

(XXII) By way of making clear what I mean by this, I would insist first that "seeing", when places are concerned, is not seeing in the same sense as when colors are concerned. The physiological events particularly correlated with the seeing of place are not retinal events or events in the optic nerve or optic cortex, but are events such as eye convergence, accommodation, and orientation, or the neural events these cause. Thus, the sensible qualities particularly concerned in the "seeing" of sensible place are kinaesthetic qualities, not color qualities (although there is no seeing a sensible place without seeing some sensible color there, nor any seeing a sensible color without seeing it at some place.)

(XXIII) What I would claim would then be this, that just as hitting a "cut" is a species of hitting (viz., hitting "cuttily"), so sensing blue is a species of sensing (viz., sensing "bluely"); and so is sensing kinaesthetically (or kinaesthetically in a determinate way) a species of sensing.

(XXIV) Further, the seeing a specific sensible place requires, but does not consist simply in, sensing kinaesthetically in a specific way. Rather, it is the psychological *emergent* of, together, this, and of possession of superior "clearness" by some one of the color qualities seen at the time. (I have attempted to describe this in detail in that paper on

objective reference, both in the case of tactually sensible place, and of visually sensible place.)

(XXV) This letter is, I realize, terribly long, and I hope you will not spend on it any more time or attention than you may feel inclined to. But I had to think out for myself the questions you raised, since the point ultimately at issue is perhaps the one most crucial of any for both the theory of knowledge and metaphysics; and I could do this carefully

only in writing. So I may as well send on what I wrote, long as it is.

<div style="text-align: right">Sincerely yours,
C. J. Ducasse</div>

CJD:MS

(XXVI) P.S. I have not said anything about "bitter", but I assume the case with it is more or less parallel to that of color and tone, so that no essentially new issue is involved.

BIBLIOGRAPHY OF THE WRITINGS OF
G. E. MOORE
To July, 1952
(With Selected Reviews)

Compiled by

EMERSON BUCHANAN
and
G. E. MOORE

WRITINGS OF G. E. MOORE
To July, 1952
(With Selected Reviews)

1897

IN WHAT SENSE, IF ANY, DO PAST AND FUTURE TIME EXIST? By Bernard Bosanquet, Shadworth H. Hodgson, G. E. Moore. *Mind,* n.s., v. 6, April 1897, pp. 228-40.
Read before the Aristotelian Society. Moore's contribution: pp. 235-40.

REVIEW of Léon Brunschvicg, *La modalité du jugement* (Paris, 1897). *Mind,* n.s., v. 6, Oct. 1897, pp. 554-9.

1898

FREEDOM. *Mind,* n.s., v. 7, April 1898, pp. 179-204.
Read before the Aristotelian Society, Nov. 15, 1897.

REVIEW of J. G. Fichte, *The Science of Ethics, as Based on the Science of Knowledge* (translated by A. E. Kroeger, edited by the Hon. Dr. W. T. Harris, London, 1897). *Int. J. of Ethics,* v. 9, Oct. 1898, pp. 92-7.

1899

REVIEW of M. Guyau, *A Sketch of Morality Independent of Obligation or Sanction* (tr. from the French, 2d ed., by Gertrude Kapteyn, London, 1898). *Int. J. of Ethics,* v. 9, Jan. 1899, pp. 232-6.

THE NATURE OF JUDGMENT. *Mind,* n.s., v. 8, April 1899, pp. 176-93.
Read before the Aristotelian Society.
Cf. Henry Dufumier, "Les théories logico-métaphysiques de MM. B. Russell et G. E. Moore," *Rev. de Mét. et de Mor.,* v. 17, Sept. 1909, pp. 620-53.

REVIEW of Bertrand Russell, *An Essay on the Foundations of Geometry* (Cambridge, 1897). *Mind,* n.s., v. 8, July 1899, pp. 397-405.

REVIEW of F. Bon, *Ueber das Sollen und das Gute* (Leipzig, 1898). *Mind,* n.s., v. 8, July 1899, pp. 420-2.

REVIEW of James Ward, *Naturalism and Agnosticism* (Gifford Lectures). *Cambridge Review*, v. XXI, no. 520, Nov. 2, 1899, p. 57.

1900

REVIEW of J. Gurnhill, *The Morals of Suicide*. *Cambridge Review*, v. XXI, no. 538, May 24, 1900, p. 340. Unsigned.

ANSWER to letter on above. *Cambridge Review*, v. XXI, no. 539, p. 352. Signed "Your Reviewer."

NECESSITY. *Mind*, n.s., v. 9, July 1900, pp. 289-304.

1901

IDENTITY. *Proc. Aristotelian Soc.*, n.s., v. 1, 1900-1901, pp. 103-27. Read Feb. 25, 1901.

THE VALUE OF RELIGION. *Int. J. of Ethics*, v. 12, October 1901, pp. 81-98.

A lecture delivered for the London school of ethics and social philosophy.

1902

MR. MCTAGGART'S "STUDIES IN HEGELIAN COSMOLOGY." *Proc. Aristotelian Soc.*, n.s., v. 2, 1901-02, pp. 177-214. Read May 5, 1902.

ARTICLES· in *Dictionary of Philosophy*, ed. by J. Mark Baldwin, Macmillan & Co., 1902.

In v. I articles on *Cause and Effect* and *Change*; in v. II articles on *Nativism, Quality, Real, Reason, Relation, Relativity of Knowledge, Substance, Spirit, Teleology, Truth.*

1903

PRINCIPIA ETHICA. Cambridge, University Press, 1903. xxvii and 232 pp.

Reprinted 1922, 1929. For Polish translation of this, cf. 1919.

Contents. Preface—I. The Subject-Matter of Ethics—II. Naturalistic Ethics—III. Hedonism—IV. Metaphysical Ethics—V. Ethics in Relation to Conduct—VI. The Ideal.

Reviewed by B. Bosanquet, *Mind*, n.s., v. 13, April 1904, pp. 254-61; by J. S. Mackenzie, *Int. J. of Ethics*, v. 14, April 1904, pp. 377-82; by E. B. McGilvary, *Philos. Rev.*, v. 13, May 1904, pp. 351-8; by Bertrand Russell, *Independent Review*, v. 2, March 1904, pp. 328-33.

Cf. E. E. C. Jones, "Mr. Moore on Hedonism," *Int. J. of Ethics*, v. 16, July 1906, pp. 429-64; E. F. Mettrick, "G. E. Moore and Intrinsic Goodness," *Int. J. of Ethics*, v. 38, July 1928, pp. 389-400; J. G. Riddell, "The New Intuitionism of Dr. Rashdall and Dr. Moore," *Philos. Rev.*, v. 30, November 1921, pp. 545-65; H. W. Wright, "The Objectivity of Moral Values," *Philos. Rev.*, v. 32, July 1923, pp. 385-400.

EXPERIENCE AND EMPIRICISM. *Proc. Aristotelian Soc.*, n.s., v. 3, 1902-03, pp. 80-95.
Read Feb. 2, 1903.

MR. McTAGGART's ETHICS. *Int. J. of Ethics*, v. 13, April 1903, pp. 341-70.
On McTaggart's *Studies in Hegelian Cosmology*.

THE REFUTATION OF IDEALISM. *Mind*, n.s., v. 12, Oct. 1903, pp. 433-53.
Reviewed by R. B. Perry, *J. of Philos.*, v. 1, Feb. 4, 1904, pp. 76-7.

Cf. A. K. Rogers, "Mr. Moore's Refutation of Idealism," *Philos. Rev.*, v. 28, January 1919, pp. 77-84; C. A. Strong, "Has Mr. Moore Refuted Idealism?" *Mind*, n.s., v. 14, April 1905, pp. 174-89.

REVIEW of Franz Brentano, *The Origin of the Knowledge of Right and Wrong* (English translation by Cecil Hague, Westminster, 1902). *Int. J. of Ethics*, v. 14, Oct. 1903, pp. 115-23.

REVIEW of David Irons, *A Study in the Psychology of Ethics* (Edinburgh and London, 1903). *Int. J. of Ethics*, v. 14, Oct. 1903, pp. 123-8.

1904

KANT's IDEALISM. *Proc. Aristotelian Soc.*, n.s., v. 4, 1903-04, pp. 127-40.
Read May 2, 1904.

JAHRESBERICHT über "Philosophy in the United Kingdom for 1902." *Archiv für Systematische Philosophie*, v. 10, 1904, pp. 242-64.

1905

REVIEW of Hans Cornelius, *Einleitung in die Philosophie* (Leipzig, 1903). *Mind*, n.s., v. 14, April 1905, pp. 244-53.

REVIEW of W. R. Boyce Gibson, *A Philosophical Introduction to Ethics* (London, 1904). *Int. J. of Ethics*, v. 15, April 1905, pp. 370-9.

THE NATURE AND REALITY OF OBJECTS OF PERCEPTION. *Proc. Aristotelian Soc.*, n.s., v. 6, 1905-06, pp. 68-127.
Read Dec. 18, 1905.

1907

REVIEW of George Santayana, *The Life of Reason, or, The Phases of Human Progress* (in five volumes, London, 1905-06). *Int. J. of Ethics*, v. 17, Jan. 1907, pp. 248-53.

MR. JOACHIM'S "NATURE OF TRUTH." *Mind*, n.s., v. 16, April 1907, pp. 229-35.
Cf. H. H. Joachim, "A Reply to Mr. Moore," *Mind*, n.s., v. 16, July 1907, pp. 410-5.

1908

PROFESSOR JAMES' "PRAGMATISM." *Proc. Aristotelian Soc.*, n.s., v. 8, 1907-08, pp. 33-77.
Read Jan. 6, 1908.

REVIEW of Gustav Störring, *Ethische Grundfragen* (Leipzig, 1906). *Int. J. of Ethics*, v. 19, Oct. 1908, pp. 108-18.

1909

REVIEW of Hugo Münsterberg, *Philosophie der Werte, Grundzüge einer Weltanschauung* (Leipzig, 1908). *Int. J. of Ethics*, v. 19, July 1909, pp. 495-504.

HUME'S PHILOSOPHY. *The New Quarterly*, Nov. 1909.

THE SUBJECT-MATTER OF PSYCHOLOGY. *Proc. Aristotelian Soc.*, n.s., v. 10, 1909-10, pp. 36-62.
Read Dec. 6, 1909.

Cf. G. Dawes Hicks, "Mr. G. E. Moore on 'The Subject-Matter of Psychology'," *Proc. Aristotelian Soc.*, n.s., v. 10, 1909-10, pp. 232-88.

1910

REVIEW of August Messer, *Empfindung und Denken* (Leipzig, 1908). *Mind*, n.s., v. 19, July 1910, pp. 395-409.

1911

REVIEW of Dimitri Michaltschew, *Philosophische Studien: Beiträge zur Kritik des Modernen Psychologismus* (Leipzig, 1909). *Mind*, n.s., v. 20, Jan. 1911, pp. 113-16.

1912

ETHICS. London, Williams & Norgate; New York, H. Holt, 1912 (Home University Library of Modern Knowledge), pp. v, 7-256.

Contents. I. Utilitarianism—II. Utilitarianism (concluded)—III. The Objectivity of Moral Judgments—IV. The Objectivity of Moral Judgments (concluded)—V. Results the Test of Right and Wrong—VI. Free Will—VII. Intrinsic Value.

For Spanish translation of this see 1929.

Reviewed by Harold P. Cooke, *Mind*, n.s., v. 22, Oct. 1913, pp. 552-6; by Walter B. Pitkin, *J. of Philos.*, v. 10, April 10, 1913, pp. 222-3; by Sydney Waterlow, *Int. J. of Ethics*, v. 23, April 1913, pp. 340-5.

1914

SYMPOSIUM: THE STATUS OF SENSE-DATA. By G. E. Moore and G. F. Stout. *Proc. Aristotelian Soc.*, n.s., v. 14, 1913-14, pp. 355-406.

Moore's contribution: pp. 355-80.

1915

SUGGESTIONS FOR THE COUNCIL OF TRINITY COLLEGE. *Cambridge Magazine*, v. 5, no. 7, 1915, p. 143.

1916

SYMPOSIUM: THE IMPLICATIONS OF RECOGNITION. By Beatrice Edgell, F. C. Bartlett, G. E. Moore, and H. Wildon Carr. *Proc. Aristotelian Soc.*, n.s., v. 16, 1915-16, pp. 179-233.

Moore's contribution: pp. 201-23.

1917

SYMPOSIUM: ARE THE MATERIALS OF SENSE AFFECTIONS OF THE MIND? By G. E. Moore, W. E. Johnson, G. Dawes Hicks, J. A. Smith, and James Ward. *Proc. Aristotelian Soc.*, n.s., v. 17, 1916-17, pp. 418-58.

Moore's contribution: pp. 418-29.

THE CONCEPTION OF REALITY. *Proc. Aristotelian Soc.*, n.s., v. 18, 1917-18, pp. 101-20.

Read Dec. 17, 1917.

1918

SOME JUDGMENTS OF PERCEPTION. *Proc. Aristotelian Soc.*, n.s., v. 19, 1918-19, pp. 1-29.
The Presidential Address. Read Nov. 4, 1918.

1919

SYMPOSIUM: IS THERE "KNOWLEDGE BY ACQUAINTANCE"? By G. Dawes Hicks, G. E. Moore, Beatrice Edgell, and C. D. Broad. *Aristotelian Soc., Supplementary Vol.* 2, 1919, pp. 159-220.
Moore's contribution: pp. 179-93.

EXTERNAL AND INTERNAL RELATIONS. *Proc. Aristotelian Soc.*, n.s., v. 20, 1919-20, pp. 40-62.
Read Dec. 15, 1919.

ZASADY 'ETYKI. Translated from the English original, *Principia Ethica*, by C. Znamierowski, Warsaw: Wydawnictwo M. Arcta, 1919, xxiv and 266 pp.

1920

SYMPOSIUM: IS THE "CONCRETE UNIVERSAL" THE TRUE TYPE OF UNIVERSALITY? By J. W. Scott, G. E. Moore, H. Wildon Carr, and G. Dawes Hicks. *Proc. Aristotelian Soc.*, n.s., v. 20, 1919-20, pp. 125-56.
Moore's contribution: pp. 132-40.

1921

SYMPOSIUM: THE CHARACTER OF COGNITIVE ACTS. By John Laird, G. E. Moore, C. D. Broad, and G. Dawes Hicks. *Proc. Aristotelian Soc.*, n.s., v. 21, 1920-21, pp. 123-60.
Moore's contribution: pp. 132-40.

PRINCIPLES OF LOGIC. *The Times Literary Supplement*, London, Aug. 11, 1921, p. 508 b-c.
Review of W. E. Johnson, *Logic*, Part I (Cambridge, 1921). Unsigned.

Brief reply by W. E. Johnson, *The Times Literary Supplement*, London, Aug. 18, 1921, p. 533 b.

AN ANALYSIS OF MIND. *The Times Literary Supplement*, London, Sept. 29, 1921, p. 622 b-c.
Review of Bertrand Russell, *The Analysis of Mind* (London, 1921). Unsigned.

1922

PHILOSOPHICAL STUDIES. London, K. Paul, Trench, Trubner & Co., Ltd.; New York, Harcourt, Brace & Co., Inc., 1922, viii and 342 pp.

Contents. I. The Refutation of Idealism—II. The Nature and Reality of Objects of Perception—III. William James' "Pragmatism"—IV. Hume's Philosophy—V. The Status of Sense-Data—VI. The Conception of Reality—VII. Some Judgments of Perception—VIII. The Conception of Intrinsic Value—IX. External and Internal Relations—X. The Nature of Moral Philosophy.

Reviewed by E. Jordan, *Philos. Rev.*, v. 33, Jan. 1924, pp. 88-98; by J. Laird, *Mind*, n.s., v. 32, Jan. 1923, pp. 86-92.

Cf. James Bissett Pratt, "Mr. Moore's Realism," *J. of Philos.*, v. 20, July 5, 1923, pp. 378-84; and Marie Collins Swabey, "Mr. G. E. Moore's Discussion of Sense Data," *Monist*, v. 34, July 1924, pp. 466-73.

1923

ARE THE CHARACTERISTICS OF PARTICULAR THINGS UNIVERSAL OR PARTICULAR? By G. E. Moore, G. F. Stout, and G. Dawes Hicks. *Aristotelian Soc., Supplementary Vol.* 3, 1923, pp. 95-128.

Moore's contribution: pp. 95-113.

1925

A DEFENCE OF COMMON SENSE. *Contemporary British Philosophy;* personal statements (second series), edited by J. H. Muirhead, London, Allen & Unwin; New York, Macmillan, 1925, pp. 193-223. (Library of Philosophy).

Cf. A. E. Murphy, "Two Versions of Critical Philosophy," *Proc. Aristotelian Soc.*, n.s., v. 38, 1937-38, pp. 143-60.

DEATH OF DR. McTAGGART. *Mind*, n.s., v. 34, April 1925, pp. 269-71.

1926

SYMPOSIUM: THE NATURE OF SENSIBLE APPEARANCES. By G. Dawes Hicks, H. H. Price, G. E. Moore, and L. S. Stebbing. *Aristot. Soc., Supplementary Vol.* 6, 1926, pp. 142-205.

Moore's contribution: pp. 179-89.

1927

REVIEW of A. N. Whitehead, *Religion in the Making* (New York, 1926), *The Nation and Athenaeum*, Feb. 12, 1927, p. 664.

Symposium: "Facts and Propositions." By F. P. Ramsey and G. E. Moore. *Aristot. Soc., Supplementary Vol.* 7, 1927, pp. 153-206.
Moore's contribution: pp. 171-206.

1929

Etica. Traducción de Manuel Cardenal Iracheta. Barcelona, Talleres y Editorial Labor, S.A., 1929. 194 pp. (Colección Labor, tomo 203).
(Translation of *Ethics*, 1912.)

Symposium: Indirect Knowledge. By G. E. Moore and H. W. B. Joseph. *Aristot. Soc., Supplementary Vol.* 9, 1929, pp. 19-66.
Moore's contribution: pp. 19-50.

1931

Preface. In *The Foundations of Mathematics and Other Logical Essays*, by Frank Plumpton Ramsey. Edited by R. B. Braithwaite, with a preface by G. E. Moore. London, K. Paul, Trench, Trubner & Co., Ltd.; New York, Harcourt, Brace & Co., 1931, xviii and 292 pp. (International Library of Psychology, Philosophy and Scientific Method).
Preface: pp. vii-viii.

1932

Is Goodness a Quality? By G. E. Moore, H. W. B. Joseph, and A. E. Taylor. *Aristot. Soc., Supplementary Vol.* 11, 1932, pp. 116-68.
Moore's contribution: pp. 116-31.

1933

Symposium: Imaginary Objects. By G. Ryle, R. B. Braithwaite, and G. E. Moore. *Aristot. Soc., Supplementary Vol.* 12, 1933, pp. 18-70.
Moore's contribution: pp. 55-70.

The Justification of Analysis. (Notes of a lecture, part of a course on *Elements of Philosophy*, given by G. E. Moore.) *Analysis*, v. I, 1933-4, pp. 28-30.

1936

Symposium: Is Existence a Predicate? By W. Kneale and G. E. Moore. *Aristot. Soc., Supplementary Vol.* 15, 1936, pp. 154-88.
Moore's contribution: pp. 175-88.

1939

PROOF OF AN EXTERNAL WORLD. *British Academy, Proceedings*, v. 25, 1939, pp. 273-300.
At head of title: Annual philosophical lecture. Henriette Hertz trust.
Read Nov. 22, 1939.

1942

AN AUTOBIOGRAPHY. In: Schilpp, Paul Arthur, ed., *The Philosophy of G. E. Moore*, Evanston and Chicago, Northwestern University, 1942. (*The Library of Living Philosophers*, v. 4.)
Written for the present volume.
A REPLY TO MY CRITICS. G. E. Moore's Rejoinder to his expositors and critics, in: Schilpp, Paul Arthur, ed., *The Philosophy of G. E. Moore*, Evanston and Chicago, Northwestern University, 1942. Written for the present volume.

1944

RUSSELL'S "THEORY OF DESCRIPTIONS." In: Schilpp, Paul Arthur, ed., *The Philosophy of Bertrand Russell*, Evanston and Chicago, Northwestern University, 1944. (*The Library of Living Philosophers*, v. 5.) pp. 175-225.

1952

ADDENDUM TO MY "REPLY." In: Schilpp, Paul Arthur, ed., *The Philosophy of G. E. Moore*, New York, Tudor Publishing Company, 1952. Written for the second edition.

1953

SOME MAIN PROBLEMS OF PHILOSOPHY. London, George Allen & Unwin Ltd. (The Muirhead Library of Philosophy) ; New York, The Macmillan Company, 1953, xxi and 378 pp.
Contents. I. What is Philosophy?—II. Sense-Data—III. Propositions—IV. Ways of Knowing—V. Hume's Theory—VI. Hume's Theory Examined—VII. Material Things—VIII. Existence in Space—IX. Existence in Time—X. The Notion of Infinity—XI. Is Time Real?—XII. The Meaning of 'Real'—XIII. Imagination and Memory—XIV. Beliefs and Propositions—XV. True and False Beliefs—XVI. Being, Fact and Existence—XVII. Truths and Universals—XVIII. Relations, Properties and Resemblance—XIX. Disjunctive and Other Properties—XX. Abstractions and Being.
Reviewed by Patrick Gardiner, *Spectator*, Oct. 1953, p. 434; by G. W. Cunningham, *Ethics*, v. 64, 1953-54, p. 331; by Richard Wollheim, *New Statesman and Nation*, v. 46, Nov. 1953, p. 646; *The Times Literary Supplement*, London, Jan. 22, 1954, p. 61; by A. Ambrose, *J. of Philos.*, v. 51, May 1954, pp. 328-31; by H. Ruja, *Personalist*, v. 35, 1954, pp. 304-05; (Anon) *Clergy Review*, v. 39, 1954, pp. 752-53; by R. M. Chisholm, *Philos. and Phenom. Research*, v. 15, June 1955, pp. 571-72; and by W. H. F. Barnes, *Philosophy*, v. 31, 1956, pp. 362-66.

1957

VISUAL SENSE-DATA in *British Philosophy in the Mid-Century*. London, George Allen and Unwin Ltd., First Edition 1957; Second Edition 1966. Edited by C. A. Mace.

Moore's contribution: First edition, pp. 205-211. Second edition, pp. 203-211.

1959

PHILOSOPHICAL PAPERS. London, George Allen & Unwin Ltd. (The Muirhead Library of Philosophy); New York, The Macmillan Company, 1959, pp. 17-324 (with a two-page Introduction by C. D. Broad).

Contents I. Are the Characteristics of Particular Things Universal or Particular?—II. A Defence of Common Sense—III. Facts and Propositions—IV. Is Goodness a Quality?—V. Imaginary Objects —VI. Is Existence a Predicate?—VII. Proof of an External World —VIII. Russell's "Theory of Descriptions"—IX. Four Forms of Scepticism—X. Certainty—XI. Wittgenstein's Lectures in 1930-33.

Reviewed by Richard Wollheim, *Spectator*, July 1959, p. 146; *The Times Literary Supplement*, London, Oct. 30, 1959, p. 629; by A. Shalom, *Les Etudes Philosophiques*, No. 4, 1959, p. 553; by V. C. Chappell, *Ethics*, v. 70, 1959-1960, p. 183; by A. R. White, *Philosophy*, v. 35, 1960, pp. 358-59; by W. H. Werkmeister, *Personalist*, v. 41, 1960, pp. 520-21; by W. F. Lofthouse, *London Quarterly and Holborn Review*, Jan. 1961, p. 72; by A. Ambrose, *Philos. Rev.*, v. 70, 1961, pp. 408-11; by J. Teichmann, *Mind*, v. 70, 1961, p. 280; by H. E. Root, *J. of Theolog. Studies*, v. 13, 1962, pp. 237-40; and by M. A. Raschini, *Giornale di Metafisica*, v. 21, 1966, pp. 682-84.

1962

COMMONPLACE BOOK 1919-1953. London, George Allen & Unwin Ltd. (The Muirhead Library of Philosophy); New York, The Macmillan Company, 1962, xvii and 407 pp. Edited by Casimir Lewy.

Contents. Notebook I (c. 1919) —Notebook II (c. 1926)—Notebook III (late 1930s to 1940) —Notebook IV (c. 1941-1942) —Notebook V (c. 1942-1943) —Notebook VI (Begun Feb. 1, 1944) —Notebook VII (Begun Feb. 9, 1946) —Notebook VIII (Begun at end of 1947) —Notebook IX (1948-1953).

Reviewed by D. M. MacKinnon, *J. of Theolog. Studies*, v. 14, 1963, pp. 555-56; by A. J. Ayer, *Twentieth Century*, v. 172, 1963, p. 120; by A. Shalom, *Les Etudes Philosophiques*, v. 19, 1964, p. 113; by A. Granese, *Rivista di Filosofia*, v. 55, 1964, pp. 343-47; and by M. Lazerowitz, *Philosophy*, v. 39, 1964, pp. 165-73.

1966

LECTURES ON PHILOSOPHY. London, George Allen & Unwin Ltd. (The Muirhead Library of Philosophy) ; New York, Humanities Press Inc., 1966, ix and 196 pp. Edited by Casimir Lewy.

Contents. Part I. Selections From a Course of Lectures Given in 1928-29: I. What is meant by "nature"?—II. Are material things real?—III. "Real" and "imaginary"—IV. Do we know that material things are real?—V. Sense-data and sense-qualities—VI. Sense-data, events and change—VII. Perceptual continuity —VIII. Identity and places—IX. The representative theory of perception.

Part II. Selections From a Course of Lectures Given in 1925-26: I. Classes and incomplete symbols—II. Necessity—III. Propositions and truth.

Part III. Selections From a Course of Lectures Given in 1933-34: I. What is analysis?—II. The justification of analysis—III. Questions of speculative philosophy—IV. Other philosophical questions—V. Philosophical methods.

Reviewed by A. J. Ayer, *New Statesman*, v. 72, Sept. 1966, p. 362; and by *The Times Literary Supplement*, London, Oct. 27, 1966, p. 984.

INDEX

Absolute, constancy of intrinsic value, 143; constant, 144, 152, 158, 159, 160; good, 123, 139; goodness, 98; idea, Hegel's, 21; isolation, 121, 147n, 167; necessity, 123; space-time, the doctrine of, 444n; value, 124

Absolutely, certain truths, 362; specific facts, 529

Abstract, the, 426

Abstraction(s), 126, 438

Abstractive observation, 239, 240

Action(s), 77ff, 88, 93, 107, 116, 122, 124, 126, 179, 180, 321; good, 115f; may be both right and wrong, 548f; non-voluntary, 95; rightness of, 96; value of, 95, 124; voluntary, 95; wrongness of, 96

Acts, 146; of will break causal chain, 190

Actual, agent, 579f; circumstances, 124; consequences, 95; occurrence, 100

Additions, 437

Adequacy of analysandum to analysans, 337

Aesthetic, beholding, 170; enjoyment, 122, 198; feelings, 436; intuition, 304; pleasure, 199; value, 176, 187

Aesthetics, 439

After-image(s), 361, 586, 629, 630, 632, 644, 647f, 652, 655, 657ff; apparent size of, 274; dependent on being perceived, 660; not external objects, 671

Agent, 99, 102f, 107f, 559ff, 567f, 573ff, 577, 579f, 593, 600ff, 604, 609f, 615f, 624

Agnostic, 11

Alexander, Samuel, 228

Alien accusative, 228, 231, 237, 250; symmetrical relations of, 229

Alienly, coördinate accusative, 229; coördinate cognitum, example of, 246f; subordinate accusative, 229f, 242; subordinate cognitum, example of, 246f

"Alleged Independence of Goodness, The," 615

Alleyn, Edward, 3

Altruism, 57; ethical, 44, 50; pure, 51; unlimited, 56

Altruistic, act, 49; obligation, 44

Amateur moralists, 72

Ambiguity of words and arguments, 432f

Ambrose, Alice, 667f, 670ff, 675; intent of her essay, 399; Moore's reply to, 668, 670-674

America, 39

American, philosophy, 137; universities, 39

Americans, 39

Analogous verification, 336

Analysandum, 326ff, 335ff, 340, 660f, 663-667

Analysans, 326ff, 335ff, 340, 663-667

Analysing, elements of process of, 528

Analysis, 90, 309ff, 315, 317, 321ff, 326ff, 332f, 335f, 338, 341, 423, 438f, 446f, 450, 456n, 470f, 660ff, 675; conceptual, 341; "directional," 527f; epistemological, 316; facts and action, 497f; formal, 340ff; its reference to things, 477; logical, 336; mode of, 429; Moore's philosophical, 478; Moore's theory of philosophy as, 425; Moore's use of term, 667; nature of, 323, 425; need of, for common sense beliefs, 527; "New level analysis," 528; objective bearing of, 474; of common sense propositions, 527; of matter, 347, 377n; of mind, 16; of notion of analysis, 324; of perceptual situations, 428; of philosophical statements, 474, 477; of propositions, 316, 408f, 474, 676; of questions, 522; of reality, 528f; of statements, 403, 447; one of the proper concerns of philosophy, 676; problem of its efficiency, 480; "same level analysis," 528; the respective loss and gain by the method of analysis, 447; versus truth in Moore, 426; what is philosophical . . . , 426

Analytic, 110; consequence, 608; necessary connection, 667; procedure, 313; proposition, 430, 435, 440f; relation, 335; judgment, 66; statements, 87, 107, 119; technique, the impotence of the . . . , 426

Animate things, 364

Answering of philosophic questions, 522

Apparent, shape, 273; size, 273; size of an after-image, 274

Appearance, 303, 316

obligation of, 55; isolable properties, 151, 157, 158, 161; rule, 174; usage, 164n

Common sense, 50, 51, 57, 120, 246, 274, 275, 301, 304, 305, 306, 307, 309, 311, 312, 313, 315, 317, 321, 322, 351, 365, 366, 388, 398, 430, 453, 460, 469n, 485, 502; analysis of, 317; and altruism, 54; and egoism, 54; and neutralism, 56; and obligation, 52, 55; and self-development, 54; and self-sacrifice, 49, 53; and ultimate ground of obligation, 54, 56; arguments against, 390; attitude, 422; beliefs, 306, 371, 456; datum, 307; defended against philosophy, 376f; defense of, 305; experience, 315; facts, overlooked by philosophers, 373, 375; faculty, 306; formulation, 445; individual and group, 55; in Sidgwick's works, 16; judgments, 335, 338; knowledge, 316; language of, 387; Moore's defense of, 372, 410; Moore's defense of the language of, 393; perceptions, 313; procedures, 298; propositions, 500, 523, 526, 527, 528; results, 298; things, 527; view, 277ff, 283, 298, 301ff, 314, 473f; basis of Moore's common sense view, 523

Companions, Moore's early, 10

Comparison of two values, 163

Complete description must include intrinsic properties, 144

Complex, 117, 122, 154; characteristic, 64, 65; good, 99

Concept, 325, 661, 662, 663, 666, 667; definition of, 664, 665

"Conception of Intrinsic Value," 59, 142, 145, 622

"Conception of Reality," 321, 346, 381n

Concept(s), analytic clarification of, 528

Conceptual analysis, 340, 341

Conclusions, certainty of, 431f; incompatible, 525; proofs of, 523

Concrete goodness, 122

Conduct, 171, 342

Conflict of attitudes, 87

Conformity in practical affairs, 176

Confusion, 90

Congruence, 267

Connate accusative(s), 228f, 237, 250; cognita, 250; connate cognita, absurdity of their independent existence, 244; connate cognita, are existentially dependent,

238; connate cognita, confused with alien cognita, 245

Connate cognita, genus-species relations, 245; dependent on cognitive activity, 232; exist only in the act of cognizing, 231; physical substance, 245

Connately coordinate accusative(s), 229ff

Connately subordinate accusative, 229, 231, 242, 248

Connately subordinate cognitum, example of, 246, 247

Connection, contingent, 67; necessary, 66, 116, 117, 118, 119, 120, 121; reciprocal, 118, 119, 120, 121; synthetic, 96, 99, 103, 104, 110; universal, 119

Connotation, 118

Conscientiousness, 198

Conscious beings and duty, 43

Conscious habit, 325, 329

Consciousness, 236, 243; as the common denominator of sensations, 226; relation of sense data to, 244

Consequences, 107, 121, 559f; best possible, 185, 186, 187; determine rightness of action, 183; determine their moral worth, 182; of argument, 85

Constancy of value, principle of, 152, 153

Contemplative vision, 170

Contemporary British Philosophy, 203, 204n, 257, 285n, 301, 302, 373n, 424, 425n, 428n

Content of awareness, 235, 236, 244, 245, 246; genus-species relationship, 236, 237; substance-attribute relationship, 236; of sensation, 250

Continuum, 277

Contingent connection, 67

Contradiction(s), 75, 79, 153; formal, 333; pragmatical, 333; refutation of, 483ff

Contributory goodness, 125

Conventionalism, 329

Conventional morality, 137

Copernican discovery of philosophy, Moore's, 450

"Copernican revolution," 454, 454n

Copernican theory, 443ff

Copernicus, 443

Correct, language, 362; usage, 548, 550

Correspondence theory, 458n

Creation, 346, 347

Creator, 600

Criteria, 304, 306, 311, 366; for the use

372; at Cambridge, 12, 530; attitude toward philosophic views, 375, 376; Bradley's influence on, 529; characteristics of his philosophical position, 283; characterized as "the greatest questioner of modern philosophy," 521; characterization of, 530f; childhood, 4; claims knowledge of physical objects, 278, 373; classical education, 5; common sense view, basis of, 523; conception of sense data, 214; conception of philosophy, 528; contention for reality of space and time, 373; contribution to philosophy, 524; criticism of "content" hypotheses, 236; criticism of *esse est percipi*, 225; "Defence of Common Sense," 306, 372; defense of language of common sense, 387, 393, 410; definitions, 137; definition of intrinsic value, 197; denies genus-species character of a "blue awareness," 237; denies intrinsic value of the ideal good, 198; destructive function in philosophy, 366; difficulties in theory of sense data, 213, 220f; directions for "picking out" sense data, 205; disciples, 425; educational development, *see separate entry below*; election to Fellowship of the British Academy, 37; "Elements of Philosophy, The," lectures and course, 457n; employs empirical facts, 383; epistemology, merit of, 411; ethical postulates, 142, 150, 152; on ethical choice, 186; ethical theory, 137, 145, 165, 174; ethical vocabulary, 138ff; facts with with he refutes philosophers, 375; on free will, 191; failure of his analysis of perceptual propositions, 258; grants causal efficacy of the will, 193; historical rôle, 368; importance in philosophy, 366; influence, 110, 114, 528f; interpretation of sensation, 227; language, 307, 311; lectureships at Cambridge, 28f; lectures given at Columbia University, 500n; logic, not that of arithmetic, 424; on the meaning of sense-data, 288, 638; method, 305, 523; method in epistemological arguments, 526; method of argument, 85; method of philosophical inquiry, 529; method of refutation, 366f; methodology, did not determine his subject matter, 676; and the misleading familiarity of his language, 208; modifies doctrine of good in *Principia Ethica*, 618; nature of dis-

putes with other philosophers, 383, 385, 387; on sense-data, 527; paradox of his ethical theory, 188; paradox of philosophy, 381; paradox paraphrased, 386; patterns of certainty, 298; philosophical method, 345, 367; philosophizing, 301; philosophy as analysis, 675; philosophy, notion of analysis in, 321; postulates, 176; and problems concerning sense data, 289; proof of existence of sense data, 259; proof of external world, 422, 431; proof, suspect character of, 432; "Proof of an External World" (essay by Alice Ambrose), 395-417; proof, unsatisfactoriness of, 434; proof, validity of, 431; propositions of which he is certain, 284; reasons for denying that right is a characteristic, 552; refutations, 367; refutation of *esse est percipi*, 226; refutation of idealism disproved, 241; refutations of philosophy, 376; "refutation" of the sceptic, 399; refutation of the unreality of time, 386; rejection of scepticism, 414; on relation between sense data and surfaces, 261; replies to his critics, *see separate entry below*; reply to the sceptic, 416; restricts sense data to visual and tactual area, 291; result of method, 529; rôle as a philosopher, 365; rôle in philosophy, 416; "Moore-Russell School," 529; Moore-Russell view of absolutely specific facts, 529; on sense data as alien cognita, 232; simplifies statement of his theory of sense data, 644; statement of his philosophical position, 302; statement of paradox concerning philosopher's views, 374; teaching at Cambridge, 28; teaching method, 32; technique of refuting philosophical statements, 349; temperament, 10, 24; theory of ethical right, 185; theory of philosophy as analysis, 425; theory of sense data, 203, 205ff; on "total" awareness, 240; translates philosophical views into the concrete, 381; Trinity Fellowship, 25; unparalleled combination of sound sense, courage and power in, 448; use of analysis, 422; use of term "natural," 293; utilitarian justification of praise and blame, 196f; validity of his theory of sense data, 217; view of common sense, 422; way of philosophizing, 312;